Beyoncé in the World

Edited by Christina Baade and Kristin McGee

Foreword by Janell Hobson

BEYONCÉ IN THE WORLD

Making Meaning with Queen Bey

in Troubled Times

Wesleyan University Press Middletown, Connecticut

Wesleyan University Press
Middletown, CT 06459
www.wesleyan.edu/wespress
© 2021 Christina Baade and Kristin McGee
All rights reserved
Manufactured in the United States of America
Designed by Mindy Basinger Hill
Typeset in Minion Pro

Library of Congress Cataloging-in-Publication Data

Names: Baade, Christina L. editor. | McGee, Kristin A. editor.

TITLE: Beyoncé in the world : making meaning
with Queen Bey in troubled times / edited by Christina Baade
and Kristin McGee ; foreword by Janell Hobson.

DESCRIPTION: [First.] | Middletown : Wesleyan University Press, 2021. |
Series: Music/culture | Includes bibliographical references and index. | Summary:
"Bringing together interdisciplinary scholars with expertise in gender and ethnic studies;
communication and cultural studies; and music, religion, history, and literature,
this volume draws on a diversity of perspectives and methods to investigate
the artistic meanings, cultural contexts, and significance of Beyoncé's
LEMONADE"— Provided by publisher.

IDENTIFIERS: LCCN 2021000702 (print) | LCCN 2021000703 (ebook) | ISBN 9780819579911
(cloth) | ISBN 9780819579928 (trade paperback) | ISBN 9780819579935 (ebook)

SUBJECTS: LCSH: Beyoncé, 1981—Criticism and interpretation. | Beyoncé, 1981—
Appreciation. | Beyoncé, 1981–. Lemonade. | Popular music—History and criticism. |
Sex in music. | Feminism and music. | African American women in popular culture.

CLASSIFICATION: LCC ML420.K675 B393 2021 (print) |
LCC ML420.K675 (ebook) | DDC 782.42164092—dc23
LC record available at https://lccn.loc.gov/2021000702
LC ebook record available at https://lccn.loc.gov/2021000703

5 4 3 2 1

CONTENTS

JANELL HOBSON

Foreword

I have a vivid memory of encountering Beyoncé Knowles-Carter while traveling through Rome in May 2013. I was on a tour of Italy with my mother, and we had already visited the famed Colosseum. In making our way back to our hotel, we had ventured through the labyrinthine tunnels of Rome's metro system running along Via Veneto. As native New Yorkers quite used to our subway system, we thought nothing of finding our way through another city's transit, but as foreign tourists with little to no fluency in the local language, we soon became disoriented at the never-ending, winding pathway of that metro until we landed on a familiar sight that fostered a sense of relief and recognition: a prominent H&M transit ad (see Figure 0.1) depicting our celebrated African American pop star, with whom we identified but whose sexualized persona seemed to transcend her racial and ethnic specificities.

This image was a strategic selection by the H&M clothing line to promote a "blonde bombshell" rendering of the pop star that most of its consumers preferred in comparison to her darker-haired image featured in the video for the singer's "Standing in the Sun" single advertising the company's summer collection that year. Set against a deep sky-blue backdrop and posing provocatively in a yellow bikini in the ad, Beyoncé's light skin gave the impression of a golden tan achievable across all racial complexions, even as her brown skin signaled her racial identity. The honey-blonde highlights of her luxurious hair combined "white" aspirations with the "bootylicious" Blackness of her bikini-clad curves that were almost slimmed down through Photoshop until Beyoncé intervened, while her golden bangles and the hibiscus placed in her hair situated her in a longer tradition of exotic beauty located in the tropical global South. Such an image contrasted with earlier footage of the pop star in braids and Afrocentric attire as she vacationed with her husband, Jay-Z, in Cuba for their wedding

FIGURE 0.1 Beyoncé in H&M Summer Collection Campaign (2013).
Photographed by Inez van Lamsweerde and Vinoodh Matadin.

anniversary the month before, a move that stirred controversy amid tensions between the United States and the Caribbean island nation. The beauty ideal depicted in the H&M ad traveled far more smoothly than the singer did visiting Cuba, as her image successfully blurred the US color line while traversing national borders, whether in the tropical climate of the Bahamian setting of the ad or in a world-cosmopolitan setting like Rome. Beyoncé's commercial image, while carefully constructed for global appeal, also provided local solace for two Black women navigating their way through a European city.

Returning home to the United States, I immediately encountered Beyoncé in a different way. This time, I was greeted by urgent voice-mail messages from a senior editor at *Ms.* magazine, who not only announced that my cover story, "Beyoncé's Fierce Feminism," had hit newsstands but that its cover drew sharp criticism and ire from its most devoted feminist readers (Hobson 2015). Many of these readers decried on the magazine's social media pages: *How dare the premier feminist magazine in the nation hail such a sex symbol as a "feminist"!* How much of this outright condemnation was based on Beyoncé's adherence to a beauty ideal deemed "oppressive" to women? How much of this discomfort is tied to her identity as a Black woman who is "racially other" enough to connote a heightened sexuality while also light enough to benefit from close proximity

to whiteness? And why was her image, a global marketing success, perceived to be incompatible with feminism?

It is quite easy to respond to such questions with the usual feminist talking points of appealing to the male gaze or commercializing political messages through women's objectification in the various media campaigns the pop star engaged, but Beyoncé wrested control of this discourse when, seven months after my *Ms.* cover story, she released her unprecedented self-titled visual album featuring sampled snippets from the TED Talk, "We Should All Be Feminists," by celebrated Nigerian author Chimamanda Ngozi Adichie (2013). This speech act not only gave the pop star the language to hit back at her critics with a political "diss," but it was also accessible through YouTube—a digital wellspring of inspirational speeches and commentary, homemade videos, vernacular dance moves, and various documentary footage from around the globe from which Beyoncé derives many of her artistic influences.

I offer this preamble as a way to highlight the provocative ways that Beyoncé disrupts lines, borders, and boundaries—racial, national, political, and digital—in her status as a world entertainer. This is a theme Emily J. Lordi already observed when she reviewed her self-titled album, in which she describes the pop star as "testing, respecting, and dissolving borders between different facets of the self" (Lordi 2013). With a career spanning over two decades, it is to Beyoncé's credit that she has managed to be "that bitch causing all this conversation," across a variety of themes that shape this rich book, *Beyoncé in the World: Making Meaning with Queen Bey in Troubled Times,* the latest contribution to the growing field of "Beyoncé Studies." Part of Beyoncé's achievement in being much talked about stems from her keen insight into the cultural zeitgeist of the different moments of each era, her stunning work ethic, her engagements with digital culture, and her political sensibility to think globally and act locally.

Fast-forward five years, after appearing in a transit ad in Rome, to 2018 when Beyoncé generated headlines for allegedly attempting but failing to gain access to the city's Colosseum for a film project. Given the glee some took in reporting on Beyoncé's failed "conquest," so to speak, in claiming the site for artistic use and cultural commentary—coming on the heels of the "Apeshit" music video that she and Jay-Z had filmed at the world-famous Louvre museum in Paris during their world tour and as a lead single off their joint album, *Everything Is Love*— we may recognize here how Beyoncé has significantly flipped the script of her global image in ways some might deem threatening. Instead of passively being displayed as a racially transcendent sex symbol, the pop star flexed some power

moves to appropriate symbols of Western civilization in the interest of Black aesthetics, as she and Jay-Z already demonstrated with their Louvre-based video. No longer adhering to a racially ambiguous image that marked her early success when she ascended to stardom, Beyoncé has emerged alongside her family and community—from her husband to her daughter, Blue Ivy, to her background dancers and artists—to not only assert a Black identity but to occupy, take up, and expand space in that Blackness.

This was deftly and subversively portrayed in the "Apeshit" video when a Black couple was staged before Leonardo da Vinci's masterpiece, *Mona Lisa,* as the woman picked the man's Afro (The Carters 2018). The juxtaposition of an eminent work of Western art with a Black couple engaging in such an intimate act of grooming and hair care—an act that African Americans have historically hidden from the white gaze to protect from its denigration (quite literally) of Black bodies and Black hair textures—illuminates the complex ways that Beyoncé continues to boldly disrupt arbitrary lines between public and private, white and Black, elite and vernacular, refinement and vulgarity (specifically in the use of profanity and a throwback to racist slurs in the song title), art and pop culture, and object and subject. The last point is most poignantly demonstrated through Beyoncé's repositioning of Marie-Guillemine Benoist's *Portrait d'une Negresse* (1800), the sole depiction of a Black woman in portraiture at the Louvre, which makes an appearance at video's end. Long reduced to a nameless "object" in Western art history, Benoist's *Negresse* was finally given subjectivity and called by her name, "Madeleine," as she opened the special exhibit, *Le Modèle noir de Géricault à Matisse,* curated by African American art historian Denise Murrell at the Musée d'Orsay in Paris in 2019. The year before, however, Beyoncé had already placed Madeleine in conversation with herself and her fellow Black women dancers, whose choreography in the space of the Louvre meticulously created "objet d'art" tableaux come to life.

Signifying on Black feminist artist Faith Ringgold's *Dancing at the Louvre* (1991) and dialoguing with her sister, Solange Knowles, who previously performed similar choreography with a troupe of Black women at New York City's Guggenheim Museum, Beyoncé continues to complicate her role on the world stage, not just as an entertainer but as a high-concept artist collapsing divisions between fine arts and popular culture. Moreover, Tanisha Ford (2019) suggests that we read Beyoncé not just as an artist but as a curator with her own artistic style of arranging multiple art projects. Labeling this style "Bey-arts aesthetics," Ford asserts, "[If] Bey were to have her own 'school of thought' or artistic style

and philosophy (akin to that of the École des Beaux-Arts), her style could be described as simultaneously ornate with slick, modern lines; both playful and thoughtful in the way it conjures and signifies; drawing from established fine arts canons while also centering a Black diasporic culture and epistemology" (2019, 196). Ford further recognizes how this artistic style developed through a curatorial impulse emanating from the pop star's engagement with public space. Like any other accomplished performance artist, Beyoncé uses the spaces allotted to her—from cultural institutions like museums, to the high-tech stages of her world tours, to the digital space of Instagram—to produce interactive art with her audience.

Her specific use of social media enabled the pop star to establish creative control over her artistic content and mold the voice she would offer the public. As Elodie Mailliet Storm notes, the Internet—from Tumblr, where she first posted a photo of her oldest child, baby daughter Blue Ivy, in 2012, to Instagram a year later, where she featured a Warhol-inspired Pepsi post as part of her $50 million endorsement deal with the company—empowered Beyoncé to redefine the ways in which she is "not just the model, she's become the medium itself" (2019, 94). The importance of her negotiating creative control within her Pepsi deal cannot be overstated as the pop star crafted a lucrative opportunity to maintain the autonomy of her art with corporate assistance.

While these conditions place her squarely within what Andi Zeisler (2017) laments as "marketplace feminism," Beyoncé's massive platform unleashed unexpected consequences for the feminist movement. It was her Pepsi-funded halftime show at the Super Bowl in 2013 that brought her to the attention of the Feminist Majority Foundation, alongside her Chime for Change global campaign, cofounded with Salma Hayek, championing gender equality, which subsequently prompted the request that I write an article for *Ms.* on Beyoncé's feminism. It was also through the jaws of commercialism that Beyoncé snatched the opportunity for artistic control over her self-titled album, which she released at the end of the year on her own terms through her surprise album drop via social media. This game-changing album further crafted a full sexual autonomy for her star persona—politicized by a feminist sample as well as a commitment to the visual medium as she accompanied each track with a corresponding music video in an unprecedented move to create what she called a "visual album."

As Candice Benbow (2019) reminds us, this autonomy reflects an earlier move by the pop star to "kill off" her alter ego, Sasha Fierce, the sexualized vixen that represented her public performative self—a figurative death that came on the

heels of her establishment of her independent company, Parkwood Entertainment, as well as her separation from her manager-father, Mathew Knowles. Beyoncé's creation of Sasha Fierce, Benbow notes, stems from the Southern Black church tradition in which she was raised and in which "Beyoncé could not escape the bifurcation of Black women's spirituality and sexual identity. . . . as church girls, many of us understood those 'Jesus tracks' and Sasha Fierce's existence as Bey's attempts to navigate the liminal space of fully owning her budding pop icon status and proving that she was still the same sweet girl from Houston" (2019, 132).

It is no wonder, then, that her self-titled album, *Beyoncé*, represented the full integration of both her respectable and sexual self once she asserted complete control in releasing her album. As Lordi observes, "If Beyoncé's 2008 album *I Am . . . Sasha Fierce* bifurcated 'Beyoncé' into two personae—good girl and bad diva—this album integrates myriad identities under the banner of a holistically multifaceted *Beyoncé*" (2013).

More than her sexual expression, *Beyoncé* also affirms a more self-assured political voice and even suggests—through her maturing journey from the little girl seeking approval on the opening track "Pretty Hurts" to the sexy Black mama she had become on the closing bonus track, "Grown Woman"—that her sexual agency intertwines with her feminist politics and that romantic love can start a revolution, as literally captured in the song and video for "Superpower," a track featuring duet vocals with R&B singer Frank Ocean. Here, Beyoncé opens the video decked out in sexy, military-green-and-black attire as she pulls a black mask over her face, giving the effect of a niqab-wearing or anarchist militant that recalls both the Arab Spring and Occupy Wall Street protests. She is soon joined by a diverse crowd across gender-variant, racial, and ethnic differences, engaging in what appears to be a social uprising, before she comes across a masked, young, Black man lying on the ground and cradles him, breathing new life into him as he joins her in the political protest. That the video ends with the protesting crowd confronting a police force in riot gear—as the lovers hold hands in their show of unified strength—uncannily foreshadows the 2014 racial unrest on the streets of Ferguson, Missouri, that launched the Black Lives Matter movement a year later.

It is worth noting that before the release of her self-titled album, Beyoncé and Jay-Z had attended a Trayvon Martin rally in Brooklyn during the summer of 2013 in the wake of the acquittal of George Zimmerman for his murder, which ignited the hashtag #BlackLivesMatter coined by Alicia Garza, Patrisse Cullors, and Opal Tometi. Given how Beyoncé and Jay-Z distracted from the rally with

their appearance, it was inevitable that both artists would turn to their art for more effective protest. Even then, Beyoncé's communication of her political views is often sporadic and carefully crafted, specifically in the way she mobilizes Instagram, an image-based site that has served as a canvas on which to paint her artistic vision or document her various conversations with art. This is seen in her sharing of photos of her family visiting Kara Walker's *A Subtlety,* the artist's first public installation in Brooklyn, or posing with Jay-Z before da Vinci's *Mona Lisa* in a private visit to the Louvre—a pictorial they would later recreate for the opening and closing shots of their "Apeshit" video; or introducing her millions of followers to the music of French-Cuban duo Ibeyi, whose single "River"—an ode to Oshun, the Yoruba/Santeria fertility orisha—accompanied the photo shoot for her September 2015 *Vogue* cover. Unbeknown to her fans, Beyoncé's wet-haired look and her elaborate gown for this Vogue shoot foreshadowed imagery from her magnum opus, *Lemonade,* her second visual album on which, incidentally, both Oshun and Ibeyi would make appearances the following year.

Unlike other celebrities who routinely express their opinions or engage in arguments on their social media accounts, Beyoncé creates a "partition," as it were, between her public persona and her private life, selectively choosing aspects of her life she is willing to share while aggrandizing those scenes to correlate to communal or public concerns, as we see with *Lemonade,* the subject of several essays in this book. This careful selection is in keeping with her "Bey-arts" aesthetic, to reiterate Ford (2019), in which both the sonic remixes and the visual imagery on this audiovisual project convey a conflation between the ornate and the modern, a temporal collapse between the past and the present, or as Beyoncé muses: "The past and future merge to meet us here" (Beyoncé 2016). This rendering of "Bey-arts" is also captured in the pop star's *Vogue* cover for the September 2018 issue, photographed by Tyler Mitchell, who was hand-picked by Beyoncé as *Vogue*'s first African American photographer. Her "flower crown" depicted on the cover gestures to both an Instagram filter option and the ornate style of classical art, while her *Vogue* feature eschewed the usual interview format and presented the pop star's first-person views on her body, her status as a mother to Blue and twins Sir and Rumi, and her multiracial Creole lineage in the Gulf Coast region, begun with the story of a white slave owner who married his Black slave. While tabloids eagerly shared the details of her genealogy, we didn't need their detective work when *Lemonade* aptly shed light on the legacy of slavery and violence echoed in Black women's pain in the present, glimpsed through sweeping cinematic landscapes of Louisiana

plantations, steampunk costumes merging Victorian style with contemporary fashions, and poetic musings (2016).

Interestingly, in the commentary for her Netflix documentary, *Homecoming* (2019), highlighting her historic concert at the 2018 Coachella Valley Music and Arts Festival, Beyoncé jokingly referenced how concert organizers simply wanted her to "bring her flower crown" to the show while she insisted on bringing the entire culture with her in a gesture that literally embodies what Anna Julia Cooper once wrote in 1892: "Only the BLACK WOMAN can say, 'when and where I enter . . . the whole Negro race enters with me.'" As the first Black woman to headline Coachella, Beyoncé brought it all: the Nefertiti crown; the performance of the Black national anthem, "Lift Every Voice and Sing"; the marching bands of Historically Black Colleges and Universities (HBCU); the Black J-Sette dancers, who are a staple at HBCU sports games; the step routines of Black fraternities and sororities; the break-dancers; the mashup of Nina Simone's "Lilac Wine" with her own "Drunk in Love"; the hip-hop, trap, reggae, and reggaeton jams that blare at every cookout, carnival, or neighborhood party in Caribbean and US-based Black and Afro Latinx communities; and— specifically for the documentary—the Black feminist statements of our most celebrated Black women, some of whom hail from the same HBCU culture that she celebrated: Toni Morrison, Alice Walker, Maya Angelou, and Audre Lorde. As Bey gushed about the Black excellence she had gathered and uplifted, "So much damn swag!" (Beyoncé 2019b).

That she followed her love of Black Southern HBCU culture, from her memories of growing up in Houston, Texas, with a wider embrace of the African continent, through her Afrobeat-inspired *The Gift*—an album accompanying her involvement with the live-action remake of Disney's *The Lion King*, set in Africa—demonstrates Beyoncé's tireless efforts to connect the local with the global and to celebrate Blackness everywhere, especially in the commercialized spaces she has accessed (2019a). We see this especially with her third visual album, *Black Is King* (2020), a visual spectacle of Africa and its Diaspora that fully restored the Black humanity at the heart of *The Lion King*, sponsored by Disney and made available on its streaming platform *Disney+*. This celebration is not without its problems, however.

The video for "Spirit," her original song for *The Lion King* (Beyoncé 2019c), was accused of plagiarizing the work of Congolese artist Petite Noir, who incidentally collaborated on previous projects with Beyoncé's sister, Solange. Similarly, *Black Is King*—widely praised as a masterpiece—nonetheless received accusations that Beyoncé, an African American artist, engaged in cultural appropriation of

diverse African cultures. Such accusations are a constant complaint throughout her repertoire in which Beyoncé is often viewed as "stealing," at worse, or "appropriating," at best, the work of unknown local artists: from the dance moves of the Mozambican group Tofo Tofo, whom she discovered on YouTube and invited to choreograph the video for "Run the World (Girls)" (2011); to her sampling without permission the voices of local queer celebrities in New Orleans for "Formation" (2016); to even claiming HBCU culture for Coachella when she herself never attended college.

These objections recall the earlier criticisms of feminists who accused the pop star of usurping, and thereby deradicalizing, their political message, perhaps best exemplified when she stood in front of a "FEMINIST" sign at MTV's Video Music Awards show in 2014 after performing a provocative pole dance. Beyoncé's fame, wealth, beauty, hyperfeminine sexuality, and light-skin privilege position her less for solidarity and more for exploitation. And yet as Tamara Winfrey Harris rightly argues, Beyoncé's public platforms have done the necessary work of enhancing the visibility of Black art, protest, and feminist statements. As Harris reminds us:

> Critics call for Beyoncé to toss off her extensions, makeup, and booty-baring sequined onesies, to eschew all talk of Lambos and yachts, to quit stacking money, money, and just talk revolution, when they know good and damn well that broke Bey without all the artifice wouldn't have a platform or power to speak on feminism or Blackness to the masses. . . . Getting rich may not be radical, but richness can be leveraged for radical things. (2019, 157)

Beyoncé's leverage of radical things on her corporate-funded platforms, alongside her curatorial statements via social media, is what enables us to now have a meaningful conversation within the academic and intellectual worlds that the chapter authors inhabit. The chapters assembled here make deep, provocative meaning of Queen Bey's complex repertoire—her performances, her messaging, and her embodiment. Editors Christina Baade and Kristin McGee have organized the fourteen essays into sectional and dialogical pairings, an effective approach that encourages a conversational quality for much of this scholarly discourse. These chapters cover Beyoncé's musical and cinematic lineage, her diverse fan communities, local and global framings, queer and faith-based responses to her star persona and music, and issues of protest, dissent, healing, and community.

That there is so much to say about Beyoncé conveys the serious power that she holds. Of course, power has been that elusive status the pop star has been

chasing since the early days of her solo career, as Daphne Brooks asserts in one of the earliest scholarly critiques on Beyoncé, featured in the special issue "Representin': Women, Hip-Hop, and Popular Music" that I had guest coedited with R. Dianne Bartlow for *Meridians* (2008). Taking note of the various ways Beyoncé issued demands and directions, wresting control of her music and relationships, as sonically demonstrated on her sophomore album, *B'Day* (2006), Brooks (2008) identifies the recurring motif of power as Beyoncé's ultimate goal across her artistic projects.

It is therefore unsurprising that her more recent album, *The Gift* (2019), would feature a song, "My Power," in collaboration with African American rapper Tierra Whack, Nigerian singer Yemi Alade, and South African pop artists Busiswa and Moonchild Sanelly. While not nearly as popular as her other track, "Brown Skin Girl," which does much to refute erasures of dark-skinned Black women—including her own earlier history, as exemplified by the H&M ad that I had encountered in Italy—"My Power" unapologetically asserts Beyoncé's success, shored up by the cultural, political, and economic power she has amassed, in the interest of a feminist and Black diasporic consciousness: "They will never take my power, my power, my power." Indeed, the visuals for the "My Power" video included in *Black Is King* emphasize the collective power embodied by Black female dancers of different sizes, shapes (including a pregnant dancer), ages (with a cameo of young Blue Ivy), and complexions that expand, command, and demand space for their fully evolved Black selves.

If *Lemonade* represents Beyoncé's local return to her Black Southern roots, *Black Is King* represents her status as global citizen, not just in her collaboration with diverse Afropop artists but also in the different film locations around the world used to convey her vision for a Black global community: starting from her own backyard before expanding to the Grand Canyon, Los Angeles, New York, London, Brussels, Lagos, Accra, and Johannesburg. As Beyoncé ruminates on *Black Is King*, "This is how we journey, far, and can still always find something like home." As we contemplate this book's title, *Beyoncé in the World,* let us also recognize how the pop star constantly invites us to rethink the borders, lines, and boundaries around "home." For while Beyoncé asserts a Black identity through *Black Is King*, it is equally important to acknowledge that as an African American with a Creole lineage including French ancestry, her takeover with her husband of Paris's Louvre Museum is equally based in a project of identity reclamation, as is her constant return to the South's Gulf Coast region of her childhood and her embrace of various local music broadcast to a global audience.

Beyoncé is very much an artist who is "at home" anywhere in the world—anywhere she can tour and perform as a world entertainer and build her international community of fans. This too is part of her power as one of the most provocative and talented pop artists for the millennial era. Let us hope the power Beyoncé has acquired resonates for the larger community of her Black and feminist audiences, not in a trickle-down effect but, rather, in permeating waves like the lyrical echoes and remixed hooks that reverberate throughout the Black music she has elevated for awe and appreciation on the world stage.

REFERENCES

Adichie, Chimamanda Ngozi. 2013. "We Should All Be Feminists." YouTube video, 30:15. Posted by TEDx Talks, April 12. https://www.youtube.com/watch?v=hg3umXU_qWc.

Benbow, Candice. 2019. "Living into the *Lemonade*: Redefining Black Women's Spirituality in the Age of Beyoncé." In *Queen Bey: A Celebration of the Power and Creativity of Beyoncé Knowles-Carter*, edited by Veronica Chambers, 129–39. New York: St. Martin's Press.

Beyoncé. 2016. *Lemonade*. Parkwood, Columbia.

———. 2019a. *The Gift*. Parkwood, Columbia.

———. 2019b. *Homecoming: A Film by Beyoncé*. Parkwood Entertainment.

———. 2019c. "Spirit." YouTube video, 4:30. Posted by Beyoncé, July 16. https://www.youtube.com/watch?v=civgUOommC8.

———. 2020. *Black Is King*. Parkwood Entertainment.

Brooks, Daphne. 2008. "'All That You Can't Leave Behind': Black Female Soul Singing and the Politics of Surrogation in the Age of Catastrophe." *Meridians: Feminism, Race, Transnationalism* 8, no. 1: 180–204.

The Carters. 2018. "Apes**t." YouTube video, 6:05. Posted by Beyoncé, June 16, 2018. https://www.youtube.com/watch?v=kbMqWXnpXcA.

Cooper, Anna Julia. *A Voice from the South*. Xenia, OH: Aldine Printing House, 1892.

Ford, Tanisha. 2019. "Beysthetics: 'Formation' and the Politics of Style." In *The Lemonade Reader,* edited by Kinitra D. Brooks and Kameelah L. Martin, 192–201. New York: Routledge.

Harris, Tamara Winfrey. 2019. "Interlude F: 'Formation' and the Black-Ass Truth about Beyoncé and Capitalism." In *The Lemonade Reader*, edited by Kinitra D. Brooks and Kameelah L. Martin, 155–57. New York: Routledge.

Hobson, Janell. 2015. "Beyoncé's Fierce Feminism." *Ms.*, March 7 [originally published spring 2013]. https://msmagazine.com/2015/03/07/beyonces-fierce-feminism/.

Hobson, Janell, and R. Dianne Bartlow. 2008. *Women, Hip-Hop, and Popular Music*. *Meridians: Feminism, Race, Transnationalism* 8, no 1.

Lordi, Emily J. 2013. "Beyoncé's Boundaries." *New Black Man*, December 18. https://www
.newblackmaninexile.net/2013/12/beyonces-boundaries-by-emily-j-lordi.html.

Storm, Elodie Mailliet. 2019. "Beyoncé, Influencer." In *Queen Bey: A Celebration of the
Power and Creativity of Beyoncé Knowles-Carter*, edited by Veronica Chambers, 91–102.
New York: St. Martin's Press.

Zeisler, Andi. 2017. *We Were Feminists Once: From Riot Grrrl to CoverGirl®, the Buying
and Selling of a Political Movement*. New York: Public Affairs Press.

Acknowledgments

This book was sparked when the two of us met in Madison, Wisconsin, on a Beyoncé panel at Feminist Theory and Music 13, a conference that has been sustaining feminist conversations in music studies for nearly thirty years. Or, actually, we re-met: in another life, we overlapped as music performance students at Northwestern University. Our thanks go out to everyone who sustained and inspired us in bringing this book into being.

We are grateful to the Music/Culture series editors, Deborah Wong, Jeremy Wallach, and Sherrie Tucker, for supporting this collection from the start. You made us feel that Wesleyan would be a good home for this work, a sense confirmed by our experiences working with our editor, Suzanna Tamminen, and the rest of the editorial and production team including Beverly Miller and Mary Garrett. Many thanks to Suzanna, the peer reviewers of the proposal and manuscript, and the copyeditor and production team at Wesleyan University Press, whose enthusiasm, professionalism, and excellent suggestions have improved this book at every step of its creation. Their constructive criticism and feedback regarding the reorganization of the parts as well as the focus on the book title greatly improved the relevance of this book. We also thank McMaster University's Arts Research Board for supporting this book with a SSHRC Exchange—Scholarly Publications Grant.

We thank all of the wonderful chapter authors who contributed original and inspiring work in relation to the growing field of Beyoncé studies, especially those with whom we worked closely throughout the process. Many were willing to undertake revisions of several different versions, and their keen focus and commitment made the process of co-collaborating and editing all the more pleasurable and educational. We also extend deep thanks to Marquita Smith for her important and significant editorial work on several of the chapters in this

book, as well as her exceptional feedback and contributions to the Introduction. Marquita coedited with us the special issue of *Popular Music and Society* on Beyoncé in 2019 that inspired all three of us to undertake this book. It was a privilege to work with such an insightful, incisive scholar.

Kristin's thanks: I thank my colleagues at the University of Groningen, Melanie Schiller and Chris Tonelli, for their conversations, as well as feedback on the possible role of such a book in an academic course. I am also grateful to my students in the first gender and sexuality course at the university, Gender and Sexuality: Contested Categories in a Global Context. In this course, students read particular versions of chapters in relation to this book and to the significance of Beyoncé studies outside the United States. As non-Americans, their unique perspective afforded valuable and inspiring insights for thinking about the influence of Beyoncé and her work outside the center of the global music industry. Finally, I thank Christina Baade for her excellent editorial and management work on this book. It was an immense pleasure working with such a motivated, skilled, generous, and intellectually sophisticated scholar.

Christina's thanks: I thank my colleagues at McMaster University, especially Faiza Hirji, for saying yes to Beyoncé with guest spots in her fabulous Religion, Race, and the Media course and for supporting a new graduate seminar about Beyoncé. I also thank the students in that seminar, Cultural Memory, the Media, and "Us"? The Case of Beyoncé, for their critical insights, engagement, thoughtfulness, and generosity with both the intellectual and artistic work we explored—and with each other. I remain grateful to Alana and Ernst for their loving support, along with their willingness to listen to lots of Beyoncé's music! Finally, I thank Kristin McGee for her editorial generosity and vision, as well as for being such a knowledgeable, committed, and accomplished scholar and collaborator over the past few years.

Beyoncé in the World

CHRISTINA BAADE, MARQUITA SMITH,

AND KRISTIN MCGEE

Introduction
Beyoncé Studies

This book was conceived, gestated, and born in the period between two surprise album drops, the unit by which so many Beyoncé fans and scholars have seemed to measure time since December 14, 2013. There were conversations that started in 2015 at the Feminist Theory and Music Conference in Madison, Wisconsin, and a call for papers that we wrote in 2016 as "Formation" dropped, which we sent out soon after the release of *Lemonade* (Beyoncé 2016a, 2016b).[1] As we sat down to edit our contributors' chapters and write the first draft of this introduction in June 2018, still reveling from Beyoncé's audacious staging of Black musical life and heritage in her "Beychella" performance, there, suddenly, was the "Apes**t" video and the album *Everything Is Love*, collaborations with her husband, Jay-Z (Carters 2018a, 2018b). As we made our final revisions to this Introduction, we had the documentary/concert film *Homecoming*, which allowed us to revisit Beychella, and *The Gift*, Beyoncé's *Lion King* album (2019b, 2019c). And with the proofs arrived *Black Is King* (2020), *The Gift*'s visual companion, streaming on Disney+, all amid a global pandemic. Clearly Beyoncé is an artist who does not stand still.

If Lemonade was ever just about a relationship in crisis, Becky with the good hair, and a fissure in the marriage of one of the richest, most influential celebrity couples, then "Aps**t," boldly set in the Louvre, assured us that the state of the Carters' (romantic, financial, creative) union was stronger than ever (Carters 2018a). The exceptionalist happy ending had been achieved. But of course Lemonade was never just about the Knowles-Carter marriage. Far more important, many have argued, most notably in *The Lemonade Reader* (Brooks and Martin 2019b), it was about Black Southern culture, African diasporic memory, and

Black feminist solidarity. It grappled with the gendered, intimate history of racial trauma; it worked through the troubles of the violent present (vividly countering the myths of postfeminism and postracialism before Muslim bans, Charlottesville, and #MeToo brought home the depths of those lies); and it showed a utopian vision of healing and community. Its vision focused on Black women, a vision that has continued to unfold in Beychella, *Homecoming, The Gift*, and *Black Is King*. The rest of us could listen, watch, and (mostly) sing and dance along, but our engagement also involved a recognition that we were not the most important audience for this work and that white epistemologies and tastes were not the best ways to measure its value (Gipson 2019; James 2019).

Were *Lemonade*'s utopian longings about making time and space in the present, or were they yearning for a different future? Likely, both. *Lemonade* required us to acknowledge our entanglement with the past and to reject the fantasy that it was ever over, that it could be forgotten. Indeed, "Formation," which both heralded the visual album's arrival and appeared as a percussive coda at its close, insisted that we were not post-anything, and would not be for the foreseeable future. "What happened at the New Wildins?" asked Messy Mya, the murdered comedian, in the vivid, haunting sample from the YouTube archive (Beyoncé 2016a). *What happened at Flint? At Puerto Rico?*[2] *At the border? At Louisville and Minneapolis?*[3] we might echo. Indeed, *Everything Is Love* dropped in 2018 amid wrenching headlines of children and their parents who were fleeing desperate circumstances in Central America and then being separated, incarcerated, and traumatized by us agents at the Mexico-us border.[4] "How could this happen here?" many Americans asked. *Not the first time*, responded anyone who knows the history of slavery, residential schools, and the white supremacy baked into the United States and other settler colonial nations (Alvarez Jr. 1995; De Genova 2002; Fassin 2011; Roberts 1999; Truth and Reconciliation Commission of Canada 2015).

If the surface story of *Everything Is Love* (and Beyoncé and Jay-Z's 2018 On the Run II tour, which it helped promote) is a couple's happy ending, couched in hip-hop's tradition of boasting, African American traditions that celebrate racial uplift through individuals' achievement, and neoliberal success, it also pointed to the power of loving beyond our "own." It recalled Bishop Michael Bruce Curry's interventionist sermon at Meaghan Markle and Prince Harry's May 2018 wedding, in which he insisted on the world-changing, justice-making, "redemptive power of love" ("The Royal Wedding" 2018).[5] From the vantage of 2019, when even mainstream white observers cannot deny the existence of white nationalism and xenophobia, April 2016 strikes us as a tipping point between narratives

of postracialism and the violent persistence of systemic racism. Globally, since 2016, we have seen the rise of overtly violent white nationalism, hostility to refugees and migrants, and growing social and economic insecurity. But back in 2016 in the United States, Barack Obama was still president, Black Lives Matter protesters filled the streets (founded in 2013 by Alicia Garza, Patrisse Cullors, and Opal Tometi, the early years of Black Lives Matter protest and organizing were foundational for the global, multiracial protests of 2020, which have made Black Live Matter "the largest movement in [US] history" [Black Lives Matter n.d.; Buchanan et al. 2020]), candidate Donald Trump said shocking things to his cheering supporters, and *Lemonade* insisted—presently, prophetically—on the importance of Black remembrance, survival, and love.

Beyoncé's two major releases of 2019, *Homecoming* and *The Lion King: The Gift* have built on these themes, celebrating the beauty and value of Black lives along two interrelated trajectories, one rooted in the specificities of African American life in the US South and the other along explicitly global lines. *Homecoming*, which documented Beyoncé's 2018 Beychella performance, was punctuated by quotations from speeches that influential African American thinkers and artists had made at Historically Black Colleges and Universities (HBCUs). Involving over a hundred musicians and dancers, the show drew extensively on HBCU marching band and dance traditions, including drumlines, baton twirling, J-setting, and stepping (developed in African American fraternities and sororities), and featured an extensive range of music from Beyoncé's catalog and other sources, including a stirring rendition of "Lift Every Voice and Sing," often called the Black national anthem. As Beyoncé observed about her goals during the eight months of rehearsals, "I wanted us to be not only proud of the show but of the process . . . thankful for the beauty that comes with a painful history. . . . I wanted everyone to feel grateful for their curves, their sass, their honesty, thankful for their freedom. . . . We were able to create a free, safe space where none of us were marginalized" (Beyoncé 2019c).

The ongoing inequality that makes the creation of a safe space so necessary for such work also helps explain why Beyoncé's empowering song, "Brown Skin Girl," released in July 2019, was so significant. Featuring Beyoncé and Jay-Z's daughter, Blue Ivy Carter, and a joyful, irresistibly hummable chorus, the song affirms the worth of dark-skinned girls and women and inspired the #BrownSkinGirlChallenge, in which participants celebrated their own and others' beauty with self-portraits and affirmative statements (Richards 2019). In the current context of white nationalist backlash and violence, celebrating the beauty of dark-

skinned Black women is a radical act. The song was part of another collaborative project: *The Gift*, Beyoncé's *Lion King* album, which she called "a love letter to Africa" (Beyoncé 2019a). Although it maps the film's plot with dialogue clips, *The Gift* (together with its companion visual album, *Black Is King* [2020]) was an entirely different project, exploring the emotional complexities of the story and opening up a far more compelling, Afro beats–inspired sonic world.[6] Developed on a much quicker time line than Beychella—and criticized for its omission of artists from Kenya and East Africa, where the film is set—the album brings together a range of popular Nigerian, Ghanaian, South African, and African American artists and producers, such as the breakout rapper Tierra Whack and the experimental singer and songwriter Moonchild Sanelly, who were featured in the assertively Black feminist "My Power" (Giorgis 2019; Beyoncé 2019b). Both *Homecoming* and *The Gift/Black Is King* underscored Beyoncé's role as a master curator, who brings together a diversity of artists, dancers, and musicians to create spectacular performances, videos, and music that meld artistry and politics with the sheer fun of pop.

This book reflects on the artistic, political, and cultural impacts, in the United States and globally, that Beyoncé's work, especially *Lemonade*, had in that different (but perhaps not so different) world of 2016 and the interventions it has continued to make through a series of live performances, broadcast events, and social media conversations. The power of *Lemonade*, "Formation," Beychella, and Beyoncé's other projects is rooted in the imbrication of the artistic and the political, in the synesthetic exploration and centering of Black Southern culture, African diasporic memory, and Black feminist community. To be sure, Beyoncé's work is also intertwined with the logics of neoliberal celebrity and a music industry increasingly oriented around experience and social networking. However, the notion that artistic expression can be free of commodification has always been a myth.

Lemonade's utopian vision demands a reckoning with the past, its artistic innovations driven not by an impulse for avant-garde rupture but rather by engaging with a lineage—as well as contemporary networks—of embodied, resistant performances by Black women. Daphne Brooks has described such strategies for resisting racist and sexist constraints as "spectacular opacity," in which Black female artists have "invent[ed] ways to maintain the integrity of Black female bodies [and voices] as sites of intellectual knowledge, philosophical vision, and aesthetic worth" (2006, 8). We insist that *Lemonade* did not represent a rupture in Beyoncé's career but, rather, built on the artistic vision that she has pursued

in her solo career since 2003 and, still earlier, in her work with Destiny's Child. This through line had continued in works like Beychella and *The Gift*.

Nonetheless, the critical response to *Lemonade* and "Formation" demonstrated how far the needle had moved from earlier debates about Beyoncé. Remember the debates about whether Beyoncé was truly a feminist? Whether she was Black enough? Whether she possessed musical agency or was a manufactured star?[7] In this collection, intersectional feminism, as a tool for understanding power and not just identity (B. Cooper 2016), the mattering of Black lives, and feminisms' (plural) diversity are points of departure. Connected to the collective power and identification with Beyoncé's multifaceted activism and intersectionality, this anthology also takes seriously Beyoncé's individual agency. Without losing the threads of neoliberalism, globalization, and long-standing inequalities in the music industry, several essays prioritize the intellectual, creative, and emotional labor of Beyoncé as a performer, singer, producer, dancer, and international pop star. Our contributors also examine the varied and fluid meanings that her work affords for her fans and other audiences in the United States and internationally. Drawing on gender and ethnic studies; communication and cultural studies; and music, film, religion, history, and literature, this book brings together a diversity of perspectives and interdisciplinary approaches to investigate the artistic meanings, cultural contexts, and significance of Beyoncé's creative work, especially *Lemonade*. In the rest of this Introduction, we map the field of what we call Beyoncé studies and then situate our book's contribution to it.

BEYONCÉ STUDIES?

The surprise album drop, the artful Instagram post, and the stunning performance have become dominant tropes in Beyoncé's creative output since 2013, markers of her ability to "stop time" and demand attention (Barber 2017, 206). These events—and Beyoncé's turn from around 2014 to 2018 away from speaking about her work—have driven the vital rhythm of think pieces, social media discussion, and the buzz of the Beyhive (Harvey 2017). They have also shaped the narratives found in the burgeoning academic and critical literature on the singer, which has grown from a few pioneering articles by Diane Railton and Paul Watson (2005), Daphne Brooks (2008), and Robin James (2008) in the 2000s to three edited collections (Trier-Bieniek 2016; Brooks and Martin 2019b; Chambers 2019), a monograph (Tinsley 2018), two special issues (in *Black Camera* [Li 2017a] and *Popular Music and Society* [Smith, Baade, and McGee 2019]), over twenty-five

additional articles and book chapters, and Candice Marie Benbow's *Lemonade Syllabus* (2016). As Beyoncé raps at the end of "Formation," her voice dripping vocal fry, "You know you that bitch when you cause all this conversation" (2016).

If there is one debate that unites the literature on Beyoncé, it is this: Is Beyoncé's art ultimately liberatory or oppressive? The question, of course, recalls the perennial cultural studies' debate over whether commodified entertainment gives us a false sense of freedom while keeping us enmeshed in unequal social structures—or whether it can fuel critique and even resistance. However, the question also recalls the high-stakes debates in social justice movements about whether activists should practice incrementalism or direct resistance, participate in the mainstream or build a subculture, pursue respectability or radicalism. The liberation-versus-oppression question is not unique to Beyoncé, but her artistic output catalyzes it in powerful ways—particularly when we consider some corollary questions: Why, how, and for whom?

In the literature on Beyoncé, the liberation/oppression question coalesces around three interwoven themes: image, agency, and neoliberalism. The image question builds on decades of feminist scholarship on the male gaze and the objectification of women's bodies in art and popular culture. Many scholars have focused on how Beyoncé embodies (or, in a few cases, challenges) normative notions of beauty and the ways her performances can be highly sexualized. Whereas some scholars conclude that Beyoncé reinforces the objectification of women (including herself), others suggest that she rehearses alternatives for women (and especially Black women) to embrace their bodies and sexuality in pleasurable and empowering ways. Many scholars insist that race is critical to this discussion, given the ways in which sexuality has historically been used to frame Black women as deviant or requiring surveillance and control—rather than as an expression of their subjectivity and humanity.

The debate over Beyoncé's image feeds into the next theme: the question of her agency (and sometimes that of her fans). In popular music studies, agency tends to be bound up with notions of authenticity and good taste; fans and artists who possess those things often have greater social power than those who do not. Thus, artists who are white and male and work in rock genres (though there is also space in this model for hip-hop producers and male rappers) are seen as having more creative agency and authenticity than pop singers, especially women, and particularly if they are Black (see, for example, Brooks 2010; Coates 1997; Kooijman 2014; Warwick 2007). Scholars who choose to work on Beyoncé have usually moved past this reductive, if surprisingly persistent, debate.

For them, the question is less about *whether* she has agency (or is authentic) and more about *how* she expresses it. Some base their arguments in Beyoncé's performances, star persona, and musical and artistic vision (on social media, in music videos, and in live performances), while others focus on her role as a celebrated public figure, discussing her work ethic, status as a businesswoman, and politics (especially feminist politics).

Finally, there is a robust debate in Beyoncé studies about whether the singer represents neoliberal values or challenges them. This debate recalls bell hooks's famous critique of Beyoncé for embodying the values of wealth and power (New School 2014). In this account, Beyoncé represents a (neo)liberal version of feminism that is more focused on individual women's achievements than on critiquing systematic inequalities. As an executive in the music industry and other business ventures, Beyoncé is simultaneously admired for her business acumen and despised as an opportunist. While much of the scholarship on her role as a neoliberal capitalist is more concerned with her celebrity image, including her status as a wife, mother, and businesswoman, some of it examines her creative process and artistic output. In particular, some scholars have offered a robust critique of Beyoncé as an artist who appropriates the words, choreography, and musical expression of others—queer artists, non-Western artists and cultures, and other marginalized people.

In the remainder of this section, we trace how these three themes have developed in the literature on Beyoncé, offering a rough periodization for this work: the trickle of scholarship focused on Beyoncé's work before 2013, the explosion of work in response to her self-titled 2013 album, and the most recent scholarship in the wake of *Lemonade*.

"Green Light": From "Crazy in Love" to Sasha Fierce, Beyoncé Studies before 2013

In June 2009, Michael Jackson, one of Beyoncé's pop role models, died.[8] Beyond a handful of essays, little scholarly attention had been devoted to the decades-spanning career of the influential pop musician, singer, and dancer.[9] In response, a number of scholars, including Susan Fast and Stan Hawkins (who coedited a special issue of *Popular Music and Society* on the singer), worked to address Jackson's musical contributions (2012). The limited scholarship on Jackson was symptomatic of a larger problem in popular music studies: the tendency of the field to overlook the creative work and tastes of women musicians, pop artists,

and musicians of color (categories that often intersect, of course). In his influential 2004 *New York Times* piece, "The Rap against Rockism," Kalefeh Sanneh offered an assessment of the problem: rockism, which meant "idolizing the authentic old legend (or underground hero) while mocking the latest pop star; lionizing punk while barely tolerating disco; loving the live show and hating the music video; extolling the growling performer while hating the lip-syncher" (2004). The solution was "poptimism," a critical stance that treated pop music as deserving serious attention. Rockism/poptimism rearticulated long-standing debates about the rock/pop binary, in which rock tended to be privileged as being more worthy of critical—and scholarly—attention. Indeed, poptimism built on the work of feminist popular music and hip-hop scholars who had long critiqued how cultural value is gendered and raced (Keyes 2000; Mahon 2011; Whiteley 1997). In the early 2000s, these claims were further animated by shifts in contemporary popular music: hip-hop began to infuse the sounds of the pop mainstream; digital disruptions in the industry destabilized the centrality of albums in favor of singles and music videos; and teenybopper pop, replete with boy bands like NSYNC, girl groups like the Spice Girls, and "girl" singers like Britney Spears and Christina Aguilera came to the fore (Weisbard 2014).

The first academic articles on Beyoncé emerged in this climate. They built on a substantial literature of feminist (including Black feminist) popular music scholarship, but also on the growing sense that mainstream pop had become a place of sonic and performative innovation (recall the hip-hop producers who were making beats for pop acts like Spears and Justin Timberlake). As a Black singer who had managed to cross over into mainstream pop, Beyoncé was poised to become a figure of particular interest, both as a member of her longtime girl group, Destiny's Child (which crossed over with "Independent Woman Part 1" [2000], and "Survivor" and "Bootylicious" in 2001), and with her 2003 solo album, *Dangerously in Love*. Early scholarship grappled with the particular challenges that she faced as a Black woman in the mainstream, coming to different conclusions about whether Beyoncé was able to express some sort of oppositional vision or simply reinforced negative stereotypes about Black women.

In 2005, Diane Railton and Paul Watson were the first scholars to publish an article that dealt with Beyoncé's work in a substantive way: "Naughty Girls and Red Blooded Women: Representations of Female Heterosexuality in Music Video." They placed the Black/white racial binary at the center of their analysis (in the process skimming over Christina Aguilera's Latina identity), drawing on histories of colonialism and ideologies of white domesticity to argue that Black

women's bodies were represented as accessible to the viewer in music videos, whereas white women's bodies, exemplified by Kylie Minogue, were distanced. Focusing on the video for "Baby Boy," from the 2003 album, Railton and Watson pointed to how Beyoncé's dancing body—particularly her buttocks—was sexualized and represented the "animalistic" (2005, 59).[10] Concerned with how Black women's bodies are "always and already" hypersexualized in racist culture, their analysis did not take up the question of Beyoncé's agency (62).

Beyoncé's second solo album, *B'Day* (2006), offered far more grist to scholars interested in understanding how the singer's work might also be an expression of her own agency—not least because she produced it in secret, away from the oversight of her father and her label (Brooks 2008, 196). In 2008, Daphne Brooks published a reading of the album, together with a discussion of Mary J. Blige, that asserted it represented "a new era of protest singing that sonically resists, revises, and reinvents the politics of Black female hypervisibility in the American cultural imaginary" (183). Brooks pointed to Beyoncé's control over the album's production, her all-woman touring band, and a broader context in which Black women have been both surveilled and marginalized to assert that *B'Day* moved beyond the objectifying dynamics of the virgin/whore dichotomy (2008, 184). Robin James made a similar claim that Beyoncé was resisting both the dichotomy and racist framings of Black women's bodies, focusing on her 2007 VMA performance of "Get Me Bodied," drawing out the performance's use of Afrofuturist aesthetics, an analysis that also addressed Rihanna's engagement with the aesthetic (2008).

A contrasting voice in this early literature was that of Ellis Cashmore (2010). Choosing Beyoncé's performance of "At Last" at President Obama's 2009 inauguration as his point of departure, he argued that Beyoncé was an exemplar of Black celebrity in which racism is treated as "a vestige of a bygone era" (Cashmore 2010, 138) that has been replaced by the values of a consumer society. In this framework, Beyoncé, with her bland persona, apolitical stance, and "on stage . . . caramel skin and straightened blonde hair [that] made her ethnicity ambiguous," represented a saleable commodity that was safe for white, and indeed global, audiences (Cashmore 2010, 138–40). Countering Brooks's "rhapsodic" essay, Cashmore asserted that Beyoncé's "consumerist morality" trumped any other message she might convey, even as she "slid comfortably into a tradition of exoticism that has been passed through the generations by Black female performers" (Cashmore 2010, 141, 144). For Cashmore, Beyoncé does have agency: she chooses objectification as a means to achieve self-commodification and

profit, in the process denying the continued impact of racism on less economically privileged people of color.

Cashmore's analysis distills the sense that a highly commodified star like Beyoncé cannot have anything but the most compliant politics. Indeed, the embeddedness of Beyoncé's wealth, celebrity status, and image within the systematic inequalities of neoliberalism has given a wide range of scholars pause, even after Beyoncé's more explicitly political turns with *Beyoncé* and *Lemonade*. However, many have argued that the relation between commodification and critique is far more complicated than an either-or choice—not least because of the difficult terrain that Black women performers have historically negotiated (the "tradition of exoticism" was hardly the result of free-floating choice; for many, it was simply the best of an unpalatable representational buffet that included minstrel-inspired mammies and maids). As Jaap Kooijman asserts, "Beyoncé does not (yet) embody a 'post-racial' era, but instead demonstrates how the discussion about commodification and the 'authenticity' of pop culture continues to be racially defined" (2014, 317).

This question of how Black women (and girls) negotiate their sexualities in such an unequal system was taken up by Kristen Pullen (2011) and Aisha Durham (2012) in the early 2010s. Pullen examined the YouTube archive of danced responses to "Single Ladies (Put a Ring on It)," arguing that it took shape as a complex mixture of commodification and counterpublic space, especially given that the majority of the videos were produced by Black women and girls. Meanwhile, in her analysis of the 2005 "Check On It" video, directed by the hip-hop-oriented Hype Williams, Durham turned her attention back to the music video format, a focus recalling that of Watson and Railton, despite their differing conclusions about agency. Durham argued that Beyoncé in the video challenged the male gaze by moving between two representational modes: the "backward gaze" of the hypersexualized, hip-hop booty, associated with working class, Southern street cred, and the respectable femininity of the Southern belle (2012, 38). For Durham, Beyoncé performs her agency through code switching (an agency enabled partly through her middle-class background—one affording her authenticity claims by stepping into the working-class persona but then believably stepping out of it): simply rejecting the backward gaze is not an option in this overdetermined, dualistic world. Writing with Brittney Cooper and Susana Morris, Durham expanded on this point in a 2013 *Signs* article on hip-hop feminism, in which they argued for moving beyond respectability politics to embrace sex positivity, a move that involved struggling with "percussive"

contradictions. These percussive complexities would take on new significance after 2013 as scholars responded to Beyoncé's feminist turn with her self-titled album and performance at the 2014 VMA Awards.

"Grown Woman," 2013

In the ten years after her launch as a solo act with *Dangerously in Love* in 2003, Beyoncé developed into a global superstar, a celebrity wife (of Jay-Z) and mother (with Blue Ivy's birth in 2012), and an icon of female empowerment, with anthems like "Run the World (Girls)," "Single Ladies," "Diva," and "Irreplaceable." In 2011, she also took over management of her career from her father and founded her own production company, Parkwood Entertainment, a shift traced in the 2013 biodocumentary *Life Is But a Dream* (Beyoncé 2013a). Unsurprisingly, there was a well-developed conversation about Beyoncé among her fans, including many Black feminist academics and cultural critics. But three key events catalyzed an explosion in the broader public discourse about the singer and inspired a surge in scholarly conversations about her: her surprise release in December 2013 of the artistically ambitious *Beyoncé* visual album (celebrated by many as a new audiovisual genre); her claiming of the term *feminist* with her sampling of Chimamanda Adichie's speech in the song "***Flawless," and her emphatic "feminist" performance at the VMA Awards in August 2014; and her decision, without fanfare, to stop giving media interviews and communicate largely through the image-oriented social media platform, Instagram.

The public debate about the genuineness of Beyoncé's embrace of feminism turned on the earlier debates about her image, agency, and associations with neoliberal values, but it also emerged at a point in the early 2010s when, first, a growing number of public figures began to identify explicitly as feminist and, second, when Kimberlé Crenshaw's (1989) notion of intersectional feminism found broader traction in public discourse. This represented a significant turn given the postfeminist values that had dominated public discourse (especially in celebrity culture) since the 1980s, in which feminist politics were disavowed, sometimes in favor of depoliticized empowerment discourses (think of the Spice Girls and "girl power") and sometimes on the grounds that gender inequality was no longer a problem (McRobbie 2004). But in the 2010s, feminism gained currency in social media discussions, celebrity culture, and discussions of the inequalities faced by (usually white) women inhabiting positions of economic and social privilege. This feminist turn manifested in books like Sheryl Sandberg's *Lean In* (2013), which

gave advice on how professional women could negotiate sexist workplaces; in the late 2014 launch of the UN-sponsored HeForShe movement led by spokespeople including the British actress Emma Watson; and in social media campaigns that raised awareness of systemic harassment and violence against women, including #YesAllWomen in 2014 and #MeToo (a hashtag that Tarana Burke had started in 2006 to draw attention to violence against women of color but was taken up by mainstream white feminists in 2017, following allegations about Harvey Weinstein and others). After decades during which the feminist label seemed relegated to activist and academic circles, feminism had entered the mainstream, offering slightly outré cool to celebrities like Beyoncé who once rejected the label.

Beyoncé became a flashpoint in this debate, not only because of her celebrity wattage, but also because her star persona was built around her status as a beauty icon, her embrace of empowerment discourses, and her engagement with sexuality in her fashion, choreography, and music videos—an engagement that she explored with greater explicitness in her self-titled album. Natalie Weidhase (2015), Janell Hobson (2016), Adrienne Trier-Bieniek (2017), and others have offered insightful accounts of these debates, and we highlight a few key themes here.

First, for some, like the UK singer Annie Lennox, Beyoncé's hypersexuality and her complicity with objectifying visual traditions undermined any claim to feminist politics. Indeed, scholars such as Laura Martinez-Jiminez, Lina Gálvez Muñoz, and Ángela Solano Caballero (2018), Kristin Lieb (2016), and Kai Arne Hansen (2017) reached similar conclusions.[11] Meanwhile, other scholars examined Beyoncé's celebrity image as a wife, mother, and businesswoman, concluding that she builds up liberal feminist and postfemininist representations of "having it all," in which her own exceptional accomplishments are celebrated in a way that overlooks considerations of structural inequality (Allen et al. 2015; Chatman 2015; Hopkins 2018). As Kim Allen, Heather Mendick, Laura Harvey, and Aisha Ahmad asserted, despite the ways that Beyoncé, as a Black woman, diversifies representations of "desirable femininity and maternity," the critical potential is circumscribed because, ultimately, "neoliberal capitalism seizes *any* body that can do its work" (2015, 921). These critiques echo bell hooks's much-quoted assertion that Beyoncé is a "terrorist" in her embodiment of traditional beauty, sexuality, and—especially—wealth and materialism (New School 2014).

And yet for many scholars writing about Beyoncé, her identity as a Black woman played a crucial role in explaining why her claiming of the feminist label should be taken seriously, with some coining terms like "Bey Feminism" or "Beyoncé Feminism." Such writers, like Natalie Weidhase (2015), Marquita

Smith (2017), and Marla Kohlman (2016), argued that the root of the debate about the believability of Beyoncé's feminist claims lay in the whiteness of mainstream feminism and in the particular and pervasive scrutiny to which Black women performers (and nonperformers) are subject. They could point to a tradition of Black women scholars and activists critiquing the narrow ways in which white-dominated feminist movements had defined feminist concerns: Sojourner Truth's "Ain't I a Woman" speech, Ida B. Wells's antilynching activism, the Combahee River Collective's manifesto, Audre Lorde's "Master's Tools," and Kimberlé Crenshaw's concept of intersectionality, to name only a few examples (Truth 1851; Wells 1892; Combahee River Collective 2000; Lorde 1993; Crenshaw 1989).[12] In particular, they made their case by building on Patricia Hill Collins's (2004) discussion of controlling stereotypes, Evelyn Higganbotham's (1993) and Brittney Cooper's (2017) accounts of respectability politics, and the Crunk Feminist Collective's (2013) embrace of sex-positivity and "fucking with the greys" (i.e., complexity) (Morgan 2002) to make their case. Brooks's (2008), Durham's (2012), and James's (2008) earlier examinations of how Beyoncé had negotiated overdetermined narratives of Black women's hypersexuality were also important points of departure. For these scholars, the question was less a matter of assessing feminist fealty and more a matter of finding new modes of surviving and thriving for women of color, especially Black women. As Melissa Harris-Perry asserted in her discussion of the explicit "Partition" video, the "experiences of black women's bodies are not exclusively those of destructive assault or morbid fascination. To be an embodied black woman is also to know joy, subjectivity, pleasure, and the latent capacity to enjoy being seen" (2015, ix).

It is important to note that these scholars' arguments were grounded not only in their own lived experiences (a critical entry point for many) but also in the intellectual and always political project of citation (McKittrick 2017). For example, consider the very different conclusions that Hansen (2017) and Harris-Perry (2015) reached about the "Partition" video, with its striptease segment and explicit account of married sex in a limousine. Hansen focuses his analysis of "Partition" on "the audiovisual staging of Beyoncé's gendered and sexualized body," explaining in a footnote that "a detailed discussion of ethnicity lies beyond the scope of this article" (2017, 178, n. 12), an explanation that fails to consider Crenshaw's arguments that race and gender are intersectional, mutually influencing categories that cannot be analyzed in isolation—a theoretical framework that, since it was introduced in 1989, has become a cornerstone of feminist research, particularly in North American contexts. This gap runs through the paper's bibliography;

Hansen mentions the existence of "previous studies" that have addressed questions of ethnicity "in detail," but he cites only James, a white scholar engaged with critical race theory (hooks's terrorist comment is an epigraph—her name is not in the works cited). What results is an intriguing analysis of sound, as well as a nuanced conclusion, that Beyoncé's video can seem empowering because it is playful and she professes to be a feminist in other contexts (Hansen 2017, 177). However, as Jaap Kooijman asserts (2019), had Hansen consulted more critical race scholarship (including the research of Black and other scholars of color), he might have produced richer interpretations. Indeed, as Harris-Perry observes, for many viewers, the liberating qualities of the video are not rooted so much in the video's playfulness or subversion as in the fact that it depicts sexuality on Beyoncé's own terms; it is framed as her fantasy because she is the one telling the story; perhaps it even leaves us the space to recognize that Beyoncé's fantasy may not necessarily be our fantasy (2015). This is a different sort of empowerment: it is a radical claiming of personal pleasure and joy, a celebration of intimacy; "being seen" is different from being objectified. As Naila Keleta-Mae explains in her even-handed assessment of "***Flawless," "When feminists deploy messy twenty-first century Black feminist thought to root for Beyoncé, it is . . . a profound expression of sisterhood that longs for critical space to be Black, feminist, and fly while thoroughly enjoying the spoils of capitalism. I would not call that anti-feminist but I would certainly call it messy" (2017, 244–45).

For researchers engaged with Black feminist scholarship, Beyoncé's claim to feminism was genuine because she offered a pathway to women (especially Black women) embracing their own bodies and sexual agency, an engagement with romantic love and motherhood that challenged framings of Black women as deviant, and an artistic vision through different modes of performativity and complexity. Several scholars have argued that what might look to mainstream white feminism like compliant heteronormativity—for example, her celebration in her music, performances, and publicity of her marriage to Jay-Z, as well as her pregnancies and motherhood—takes on very different meanings when one recalls the historic prohibitions against marriage or the pathologizing of Black single mothers (Smith 2017; E. Cooper 2016; Moss 2016; Baade 2019).[13] Indeed, several scholars have argued that the self-titled album offered new modes of egalitarian, even queered heterosexual sex (Holtzman 2017), subjectivity and pleasure within the seemingly normative spaces of marriage (Harris-Perry 2015; Brown 2016; Hall 2017), and expressions of "aggressive femme" identity (Mitchell 2016; see also Tinsley 2018).

Finally, many of these authors have provided insightful readings that examine how Beyoncé claims authority through different performative strategies in the visual album and other videos but also in her use of social media. Ashanka Kumari (2016), for example, explores Beyoncé's performative alter egos, noting not only their profusion—including Sasha Fierce (whom she "killed off" in 2010), Mrs. Carter, and Yoncé—but also the significance of her claiming them at all. Black women musicians have historically been expected to ground their work in some sort of authenticity (consider the risks of involved in crossing over for artists like Whitney Houston [Kooijman 2014]), whereas white women pop performers can explore a range of personas (consider Lady Gaga and Madonna). Meanwhile, James drew on queer performativity to assert that Beyoncé negotiated the male-dominated spaces of hip-hop videos by drawing on kinging practices (i.e., taking on masculine-coded performance strategies) in "Video Phone" (2015). And Kristin McGee extends Pullen's work to examine how Beyoncé's "***Flawless" choreography participates in histories of choreographic citation and appropriation, as well as stimulates a participatory community through the YouTube archive of danced responses by both amateurs and professional choreographers (2019). Furthermore, a number of scholars, including Melissa Avdeef (2016) and Noel Siqi Duan (2016), have examined Beyoncé's representations in social media, which at once reveal the labor that goes into her image while withholding the intimacy performed by so many stars on social media. In a climate of intermediality and online participation, the images, GIFs, and videos of Beyoncé's Instagram feed were performative and enigmatic, not straightforwardly autobiographical or observational.[14]

While fandom and poptimism informed many of these hopeful interpretations of Beyoncé's work in the 2013 album, there was also space for complexity and critique in the same work. Kimberly Chandler, for example, took up the question of Beyoncé's Creole heritage, not to question her genuineness as a Black woman but to point to the ways in which colorism and Creole identity, because of the historic plaçage system in which Creole women gained social power through sexual transactions, created a structure for accepting her as both sexualized and powerful (2016). Indeed, Chandler's work was representative of the complex ways in which much of this scholarship took up questions of gender, sexuality, and race. Rejecting the popular Obama-era conceit that the United States had entered a postracial era, they centered Beyoncé's Blackness—underlining its significance, resisting the tendency to treat it as a unitary category, and teasing out how Beyoncé negotiated the complex terrains of power, privilege, and belonging.

These concerns, a strand pulled out by scholars going back to Daphne Brooks (2008), would take on urgent, explicit shape in 2016. But in 2014, Beyoncé had come into scholarly purview with a visual album that offered pleasure, subjectivity, complexity, and an interpretive puzzle. Still, not everyone saw Beyoncé's project as being political or serious—but that would change with "Formation" and *Lemonade*.

"Forward," 2016: *"Formation"* and Lemonade

If the reception and scholarly discussion of *Beyoncé* can be seen as a debate over whether Beyoncé was truly feminist, pro or con, "Formation," Beyoncé's Black Panther tribute at the 2016 Super Bowl, and *Lemonade* spurred far more complicated discussions. The reasons are myriad, but consider a few. First, and most important, these works were explicit in their engagement with Blackness and especially Black Southern culture(s), effectively pushing any old color-blind claims about Beyoncé to the side.[15] Second, the growing Black Lives Matter movement, with its diffuse but highly effective organizational structure built around social media and direct action demonstrations, made anti-Black violence a national issue. Finally, the conversation about Beyoncé among fans, cultural critics, and scholars was already active and became more energized in the weeks between the surprise release of "Formation" on February 6, 2016 (the night before her performance at the Super Bowl) and the HBO premiere of *Lemonade* on April 23.

The critical and intellectual response to *Lemonade* was swift and prodigious. In addition to scores of think pieces in publications ranging from the *New York Times* to *Fader* (consider Emily Lordi's fantastic piece on the women artists sampled in "6 Inch"), 2016 saw a number of short scholarly reviews in academic journals such as *Film Criticism* (Pareles 2016; Lordi 2016; Ball 2016; Miles 2016; Vernallis 2016a, 2016b). The most significant of these early responses was the #LemonadeSyllabus (Benbow 2016). Candice Benbow proposed a collectively composed syllabus as a hashtag on Twitter three days after the album was released, inviting contributions of texts, images, and music that addressed its womanist and Black feminist themes. Over seventy scholars responded, recommending over 250 books and other materials. In striking contrast to the usual pace and limited accessibility of academic communication, Benbow launched the free syllabus online on May 6, 2016. The syllabus, downloaded more than 600,000 times, inspired dozens of *Lemonade* courses at universities around the world; more important, it became a resource for anyone interested in learning

about the Black feminist theory and cultural production that had informed *Lemonade* (Benbow 2019, xxi). As Eric Harvey observed, *Lemonade* helped "bring into formation a specific networked public," enabling Black women to drive the conversation around the album (2017, 123). This intellectual community—and its aim of centering Black feminist perspectives, critical rigor, and accessible writing—found further expression in two important essay collections from 2019: *The Lemonade Reader*, edited by Kinitra D. Brooks and Kameelah L. Martin, and *Queen Bey: A Celebration of the Power and Creativity of Beyoncé Knowles-Carter*, edited by Veronica Chambers.

In 2017, Stephanie Li edited a special issue of *Black Camera* that mapped the key themes emerging in scholarship on Beyoncé's 2016 work, including our own special issue of *Popular Music and Society*: serious analysis of Beyoncé's creative innovations (a reworking of the old agency questions), the centering of Black feminist thought, and a critical examination of her complicated relationship with Black queer and other minoritarian identities, affinities, and activism within a larger neoliberal framework (Li 2017a; Smith, Baade, and McGee 2019). Perhaps the voice that has advocated most insistently for Beyoncé's status as an artistic innovator is that of Carol Vernallis (2013), who has written extensively on music videos and the ways that their production and aesthetics have changed historically, including in their move onto YouTube and other online platforms. As a visual album, Vernallis (2017) argues that *Lemonade* is formally unprecedented, heralding a fourth turn in cinematic history.

One exciting element running through much of this work is the way it is driven by close engagement with the video and musical texts. For example, Ciara Barrett incorporates detailed analysis of several songs, including "Daddy Lessons" from *Lemonade*, to argue that the visual albums of Beyoncé and FKA Twigs are "radically formally innovative and assertive of a subjective, female authorial voice"; each challenges how the representational practices of both hip-hop videos and traditional film have marginalized Black women's authority (Barrett 2016, 41). Nonetheless, as Stephanie Li makes clear, although Beyoncé's artistic work is built around her exceptional artistic persona, "she does not present herself as a lone genius auteur" but rather acknowledges and even foregrounds the collaborative nature of her work with a wide range of creators, including family members like Solange Knowles (2017b, 107). Indeed, *Lemonade* is an exemplar of two important trends: the urge of those highly creative cultural producers who possess the economic and cultural capital to realize their visions to develop new forms of content to engage their fans in the changing online streaming environ-

ment (Vernallis 2017), and the broader flowering of artistically innovative and politically engaged concept albums by Black artists working in hip-hop, R&B, and hybrid musical genres.[16] As Kyra Gaunt argues, Beyoncé's virtuosic blending of business and transmedia artistry can be described using a range of labels: executive producer, auteur, and impresaria, a feminized version of the term for the producers of opera and theatrical spectacles going back to the eighteenth century (2019, 222).[17]

Close analysis has also yielded more complicated reflections about the relation among Beyoncé, her artistic inspirations, and her performance of political engagement (though we should also bear in mind the "bald hypocrisy that so often undergirds analysis of Black women's actions" [Harris 2019,157]). In a conversation with Tiffany Barber for the *Black Camera* special issue, Salamishah Tillet expressed the complicated impulses of the visual album: Beyoncé's "political consciousness is peaking at the same time that her artistry is flourishing"—and her artistry itself "can teach us the most about the line between homage and misappropriation, citation and exploitation" (Barber 2017, 215, 210). Beyoncé's persona is part of the puzzle: Tillet describes *Lemonade* as a biomythography (in the tradition of Audre Lorde's *Zami*), vividly capturing how the album's "truths" are not the verifiable truth of conventional memoir (Barber 2017, 211). This awareness also runs through Durham's reflections: Beyoncé's "maturation . . . as an artist and advocate mirrors the development of hip-hop feminism," particularly as she moved from earlier appropriations of Black Southern, working-class performative markers (e.g., twerking) to a more integrated position of solidarity with "people who did not hold the mic" (2017, 197, 202).

For many scholars who emphasize *Lemonade*'s liberatory themes, Black Lives Matter was the crucial catalyst for the album's intense engagement with Black culture and solidarity, especially among Black women. Marquis Bey asserts that *Lemonade* is Beyoncé's "theorizing" in response to Black Lives Matter, and Harvey quotes the director Melina Matsoukas's explanation: "She wanted to show the historical impact of slavery on black love, and what it had done to the black family" (Bey 2017, 170; Harvey 2017, 124). Although, according to Bey, Beyoncé may be positioned within the "Black normal" because of her wealth and status as a "mere" entertainer, she disrupts these sanitizing, safe frames by engaging in "an unapologetic display of Blackness and a queer-saturated 'slaying'" (Bey 2017, 166). The radical potential of this framework for fans, academics, and activists is amply demonstrated in Omise-eke Tinsley's book, *Beyoncé in Formation*, a "black feminist mixtape" that blends Black queer femme theory, cultural criticism, and

Tinsley's lived experience of Southern (and Texan, no less) Black "femme-inist" community to understand how Beyoncé's oeuvre, especially *Lemonade*, "offer[s] space for black women to creatively reinvent our genders, pleasures, and alliances in unexpected ways" (2018, 7). Tinsley and other scholars have shown how the visual album's disruptions went beyond the intense performativity of slaying, particularly in the film's last third. As Emily Lordi asserts, *Lemonade* celebrated and advocated for healing, interiority, and even (citing Zandria Robinson) "a collective stillness" among Black women (2017, 142). For all these scholars, the album represented an "emboldened," more politically engaged Beyoncé (Bey 2017, 170).

One important thread connecting interiority and healing with public, political expression is that of spirituality, a theme long underexplored in Beyoncé's work and by popular music scholars more generally. It is in this area that *The Lemonade Reader* makes some of its most important contributions, particularly in the way its authors explicate the visual album's engagement with Yoruba, Christian, and other hybrid entangled faith traditions (Beverley 2019; Brooks and Martin 2019a; Highsmith 2019; M. Jones 2019; N. Jones 2019; Peñate 2019; Tsang 2019). As Lindsay Stewart argues (drawing on Kameelah Martin), in *Lemonade* Beyoncé embodies the figure of the "black female priestess," who "can signal a 'safe space' for other black women" and expresses her power through possession and other practices "that cannot easily be read as protest or resistance" (2019, 24–25). Together, these scholars untangle *Lemonade*'s interplay of Black women's spirituality, interiority, community, and politics.

While we have focused on academic publications in this literature review, we would be remiss not to mention Veronica Chamber's collection, *Queen Bey*. It draws academics and public intellectuals like Brittney Cooper, Michael Eric Dyson, Candice Benbow, and Melissa Harris-Perry together with writers, social media personalities, and activists like Ylonda Gault, Kid Fury of *The Read* podcast, and Reshma Saujani, founder of Girls Who Code. Strikingly, its contributors, many creative workers themselves, focus not simply on Beyoncé's music and politics but also on her fashion (Edward Enniful, editor-in-chief for British *Vogue*), relationship with visual art (the curator Maria Brito 2019), and dance (the choreographer Fatima Robinson). The contributors also reflect on their own fandom, grounding their perspectives in their lives as gay men, Latinx people, and young, Black women. By centering personal accounts of often lifelong fandom, as well as offering insights into the full spectrum of Beyoncé's creative production, Chambers's collection (2019) fills many gaps in the academic literature.

Despite the possibilities that Beyoncé's work has offered for political expres-

sion, spirituality, community, and healing, some scholars working closely with Black feminist and queer scholarship want more—and offer important critiques that help us think more precisely about the "line between homage and misappropriation, citation and exploitation" (Tillet, quoted by Barber 2017, 210). Alicia Wallace, for example, takes issue with how "Formation" recenters the focus onto Beyoncé, building her brand while appropriating the tragedy of Hurricane Katrina and reinforcing colorism—most notably in the shot when she hangs her long blonde hair out a car window (2017). Sarah Olutola (2019) takes the critique of colorism further in her analysis of "Sorry," arguing that the darker-skinned, more muscular Serena Williams is depicted in a position that is subordinate to Beyoncé, who lounges for part of the video on a "throne." Indeed, the question of inclusion involves not just questions of colorism but also body size. As Ashleigh Shackleford asked, "How different would it have been if a Black fat femme had been incorporated into the *Lemonade* visual?" (2019, 11).

While Beyoncé has been celebrated for including representations of diasporic Blackness and queer identities, some scholars caution that inclusion can still be imbricated with appropriation. Olutola argues, for example, that the body painting in the bus sequences of "Sorry" is not an expression of diasporic engagement but rather a North American appropriation of African Blackness, which ultimately reinforces the dominance of the light-skinned star (2019). Lauren Kehrer examines how Beyoncé appropriates elements from the queer bounce subculture of New Orleans, seeing not remembrance of Messy Mya in "Formation," but an extraction that overlooks the context of her life and death (2019). Kehrer further offers an account of Beyoncé's halting engagement with GLBTQ rights; although Beyoncé now supports gay marriage and markets queer inclusive merchandise, she was, for example, slow to speak out on the Houston anti-trans ordinance in 2015 (2019). Mako Fitts Ward also draws attention to this mode of queer appropriation, tying it to a larger tendency by Beyoncé to appropriate "Blackness and Black feminist radical traditions" (2017, 148). For Ward, Beyoncé's performances involve "the glamour of radicalism, not its actual implementation" and a "false mode of Black communal liberation" (2017, 148, 153). Wallace reflects, "It is unfortunate that people are so starved for relatable and aspirational content that they are prepared to buy in, literally, to capitalist brands of social justice" (2017, 195).

Indeed, people *are* starved for such content. While there exist social justice movements that resist the logics of capitalism, it is hard to escape the system in

which we are all embedded. Harvey acknowledges the ways in which the social media response, content, and form of *Lemonade* are bound up with Beyoncé's brand, while also noting that the notion that a space of resistance exists outside this sphere is not particularly realistic (2017, 124). As Tamara Winfrey Harris writes, "Critics call for Beyoncé . . . to quit stacking money, money, and just talk revolution, when they know good and damn well that broke Bey . . . wouldn't have a platform or power to speak on feminism or Blackness to the masses. Political purists don't become pop stars" (2019, 157). Beyoncé has a wide reach as a capitalist and a celebrity, making her artistry and politics worthy of investigation. As people negotiating a deeply unjust world, hustling to survive while also struggling against inequality, Beyoncé's art, with all its pleasures, hopefulness, and unavoidable problems, speaks to (some of) us. This book enters the conversation not to solve the oppression-versus-liberation question but rather to explore more of the rich ground *Lemonade* invites us to sense and reflect on.

MAKING LEMONADE: WHAT WE DO IN THIS BOOK

This book brings together scholars from a range of academic backgrounds, countries, and subject positions. Four key commitments connect their essays and shape the book. First, we are committed to engaging closely with Beyoncé's artistic, performative texts (especially *Lemonade*), believing that they are worthy of our analytical and interpretive efforts on both aesthetic and political grounds. We bring this commitment not only to the recorded and live works that Beyoncé has created together with her collaborators, but also to those who have influenced or responded creatively to her persona and creations. Second, we are committed to exploring the specifically Black, woman-identified, and Southern contexts out of which this work developed and the communities to whom it particularly spoke. Third, we are committed to moving out from generalizations about fans, diaspora, and international fame to consider the actual and specific contexts and voices in which Beyoncé's work is received and reworked within and beyond North America. Fourth, and finally, we are committed to moving beyond binary and all-or-nothing frameworks to consider both how Beyoncé and her work are embedded in capitalist, neoliberal systems *and* how her work voices dissent and has been taken up by some audiences in hopeful and even healing ways.

 With these commitments weaving throughout this book, we have grouped the chapters into pairs that address seven key themes:

The paired structure shows the different approaches that can be productively brought to bear on these questions while also gesturing to the connections running between each. We will tease out these themes further as we introduce each part in the book.

NOT A CONCLUSION

When we set out on the intellectual journey that led to this book, very little academic work had been published on Beyoncé. Recalling the ways in which popular music scholarship has regularly overlooked the work of globally popular performers of color, we wanted to address this gap. Clearly, many other scholars who participate in popular music studies, Black studies, gender studies, communication studies, and cultural studies also observed this gap and moved to fill it, leading to the rise of "Beyoncé studies." While some might take issue with this bumper crop of academic work on Beyoncé, we would gesture to the hundreds of academic articles and books about the Beatles (the far from exhaustive *Music Index* reports over two hundred peer-reviewed journal articles alone) that have been—and continue to be—written. Surely if we can find scholarly bandwidth for the Beatles and Bob Dylan, we can devote more space to a performer from outside the male-dominated rock canon who continues to produce challenging, exciting, political music and performances; who has become established as a fashion icon and celebrity on social media and beyond; and who increasingly is engaged in public curatorship of Black artists working in visual art, fashion, and the performing arts.

We also acknowledge that if we are to resist the exceptionalist narratives that have congealed around Beyoncé in the process, the answer is not simply to have more Beyoncé scholarship. A host of musicians and performers, especially Black women, have been overlooked in scholarship on historical and contemporary popular music: we need to do more to locate, research, and trace these lineages,

histories, networks, and individuals. Beyoncé may be an entry point, but as Benbow's "Lemonade Syllabus" shows, the task of challenging controlling images, oppressive narratives, anti-Black violence, and systemic inequality goes beyond the work of a single celebrity (2016). If there is any lesson we should carry from *Lemonade*, it is that healing and change need to come from all of us.

NOTES

1. Feminist Theory and Music 13: Feminism and Black Critical Praxis in an Age of Scarcity, August 5–9, 2015, Madison, Wisconsin.

2. Beyoncé supported victims of Hurricane Maria in 2017 with proceeds from a remix by J Balvin and Willy Williams, in which she was featured (Hinks 2017). She continues to feature the song, "Mi Gente," in her performances, including a memorable rendition at Beychella. As Isabel González Whitaker (2019) points out, Beyoncé has a long history of singing in Spanish and addressing her significant Latin American audience.

3. The murders of Breonna Taylor, George Floyd, and *so many others* have taken place during the global coronavirus pandemic, which has exposed the deep impact of social and economic inequality. In the United States, this slow violence—so pervasive that it overwhelms any attempt to evoke it by naming a single place—has resulted in cases and deaths for Black, Latinx, and Indigenous people far above the rates for white people (Oppel, Jr., et al. 2020).

4. The desperate situation continues not only in US detention facilities but in impromptu camps of asylum seekers on the Mexican side of the border, under the Trump administration's Remain in Mexico plan (Kao and Lu 2019).

5. Bishop Curry's sermon takes on fresh resonance with the couple's decision to step back, following a relentless stream of racist media coverage, as senior members of the royal family (Hatzipanagos 2019).

6. Disney's live action movie featured Beyoncé in conventional roles: singing the film's uplifting theme song, "Spirit," and as the voice of the lioness Nala, Simba's love interest—roles that owe far more to human patriarchy than to matriarchal lion society (of course, these were also talking lions) (Favreau 2019). As Janell Hobson notes, *Black Is King* radically reclaims and reimagines this story (Hobson 2020).

7. Many journalistic and scholarly articles debated Beyoncé's feminism and artistic agency after 2013. Some of these debates are reviewed in Weidhase (2015). See also the powerful critiques of these framings by Birgitta Johnson (2019), Kyra Gaunt (2019), and others.

8. Beyoncé's pre-2013 releases also include the album *4* (2011). However, scholars have tended to focus on her first three albums: *Dangerously in Love* (2003), *B'Day* (2006), and *I Am . . . Sasha Fierce* (2008).

9. These essays included Kobena Mercer's influential analysis of Jackson's "Thriller" music video (1986).

10. The video was directed by Jake Nava, a stalwart who has directed other iconic Beyoncé videos like "Single Ladies (Put a Ring on It)" and "***Flawless."

11. An intriguing contrast to this work was Ebony Utley's finding, based on a series of focus groups with racially diverse teenage girls, that the girls saw Beyoncé as a feminist—but not as a role model, because of her overt sexuality (2017).

12. For example, some recalled Alice Walker's rejection of the feminist label and her coining of *womanism* as a mode far more inclusive of women of color (see Walker 1967).

13. Beyoncé's depictions of miscarriage and mourning further destabilize normative scripts of motherhood, as LaKisha M. Simmons argues (2019).

14. Indeed, the online rollout and surprise release of the self-titled album has been a focus for many scholars (see Philp 2014; Cupid and Files-Thompson 2016; Harper 2019). Many pointed out that the album's launch, despite its splashy release, was less surprising or revolutionary than one might assume at first glance—especially because of the fan labor involved in its viral spread.

15. Recall the over-the-top *Saturday Night Live* skit, "The Day Beyoncé Turned Black," in which white people collectively lose their shit after hearing "Formation" and realizing that Beyoncé is Black (2016).

16. Consider recent albums and videos by Lizzo, Kendrick Lamar, Janelle Monáe, Dev Hynes (Blood Orange), Jamila Woods, D'Angelo, Anderson Paak, Childish Gambino, Chance the Rapper, Solange Knowles, Juice Wrld, and Tierra Whack, to name only a few.

17. Of course, some critics still dismiss Beyoncé's status as an artistic innovator and agent, influenced, as Robin James (2019) and Birgitta Johnson (2019) have argued, by long-standing gendered and racial biases.

REFERENCES

Allen, Kim, Heather Mendick, Laura Harvey, and Aisha Ahmad. 2015. "Welfare Queens, Thrifty Housewives, and Do-It-All Mums: Celebrity Motherhood and the Cultural Politics of Austerity." *Feminist Media Studies* 15, no. 6: 907–25.

Alvarez Jr., Robert R. 1995. "The Mexican US Border: The Making of an Anthropology of Borderlands." *Annual Review of Anthropology* 24, no. 1: 447–70.

Avdeef, Melissa. 2016. "Beyoncé and Social Media: Authenticity and the Presentation of Self." In *The Beyoncé Effect: Essays on Sexuality, Race and Feminism*, edited by Adrienne Trier-Bieniek, 109–23. Jefferson, NC: McFarland.

Baade, Christina. 2019. "A Complicated Transformation: *Beyoncé*, 'Blue,' and the Politics of Black Motherhood." *Popular Music and Society* 41, no 2: 42–60.

Ball, Kevin. 2016. "Beyoncé's 'Formation.'" *Film Criticism* 40, no. 3.

Barber, Tiffany E. 2017. "A Conversation with Salamishah Tillet." *Close-Up: Beyoncé: Media and Cultural Icon. Black Camera: An International Film Journal* 9, no. 1: 205–16.

Barrett, Ciara. 2016. "'Formation' of the Female Author in the Hip Hop Visual Album: Beyoncé and FKA Twigs." *Soundtrack* 9, nos. 1&2: 41–57.

Benbow, Candice Marie. 2016. "Lemonade Syllabus." May 7. https://issuu.com/candicebenbow/docs/lemonade_syllabus_2016.

———. 2019. Foreword. In *The Lemonade Reader*, edited by Kinitra D. Brooks and Kameelah L. Martin, xx–xxii. New York: Routledge.

Beverly, Michele Prettyman. 2019. "To Feel Like a 'Natural Woman': Aretha Franklin, Beyoncé and the Ecological Spirituality of *Lemonade*." In *The Lemonade Reader*, edited by Kinitra D. Brooks and Kameelah L. Martin, 166–82. New York: Routledge.

Bey, Marquis. 2016. "Beyoncé's Black (Ab)Normal: Baaad Insurgency and the Queerness of Slaying." *Close-Up: Beyoncé: Media and Cultural Icon. Black Camera: An International Film Journal* 9, no. 1: 164–78.

Beyoncé. 2003. *Crazy in Love*. Columbia.

———. 2006. *B'Day*. Sony Urban Music, Columbia.

———. 2008. *I Am. . . Sasha Fierce*. Music World, Columbia.

———. 2011. *4*. Parkwood, Columbia.

———. 2013a. *Life Is But a Dream*. Parkwood.

———. 2013b. *Beyoncé*. Parkwood, Columbia.

———. 2016a. "Formation." YouTube video, 4:47. Posted by beyonceVEVO December 9. YouTube video, 4:47. https://www.youtube.com/watch?v=WDZJPJV__bQ.

———. 2016b. *Lemonade*. Parkwood, Columbia.

———. 2019a. *Beyoncé Presents: Making the Gift*. ABC television special, September 16.

———. 2019b. *The Gift*. Parkwood, Columbia.

———. 2019c. *Homecoming: A Film by Beyoncé*. Parkwood Entertainment.

———. 2020. *Black Is King*. Walt Disney Pictures. Parkwood Entertainment.

Black Lives Matter. N.d. "Herstory." Black Lives Matter. Accessed September, 7, 2020. https://blacklivesmatter.com/herstory/.

Brooks, Daphne A. 2006. *Bodies in Dissent: Spectacular Performances of Race and Freedom, 1850–1910*. Durham: Duke University Press.

———. 2008. "'All That You Can't Leave Behind': Black Female Soul Singing and the Politics of Surrogation in the Age of Catastrophe." *Meridians* 8, no.1: 180–204.

———. 2010. "'Once More with Feeling': Popular Music Studies in the New Millennium." *Journal of Popular Music Studies* 22, no. 1: 98–106.

Brooks, Kinitra D., and Kameelah L. Martin. 2019a. "'I Used to Be Your Sweet Mama': Beyoncé at the Crossroads of Blues and Conjure in *Lemonade*." In *The Lemonade Reader*, edited by Kinitra D. Brooks and Kameelah L. Martin, 202–14. New York: Routledge.

———, eds. 2019b. *The Lemonade Reader*. New York: Routledge.

Brown, Evette Dionne. 2016. "BDSM, Gazes, and Wedding Rings: The Centering of Black Female Pleasure and Agency in Beyoncé." In *The Beyoncé Effect: Essays on Sexuality, Race and Feminism*, edited by Adrienne Trier-Bieniek, 177–92. Jefferson, NC: McFarland.

Buchanan, Larry, Quoctrung Bui, and Jugal K. Patel. 2020. "Black Lives Matter May Be the Largest Movement in U.S. History." *New York Times*, July 3. https://www.nytimes .com/interactive/2020/07/03/us/george-floyd-protests-crowd-size.html.

The Carters. 2018a. "Apes**t." Posted by Beyoncé, June 16, 2018. YouTube video, 6:05. https://www.youtube.com/watch?v=kbMqWXnpXcA.

———. 2018b. *Everything Is Love*. Parkwood Entertainment, Sony Music Entertainment, S.C. Enterprises, and Roc Nation.

Cashmore, Ellis. 2010. "Buying Beyoncé." *Celebrity Studies* 1, no. 2: 135–50. https://doi.org /10.1080/19392397.2010.482262.

Chambers, Veronica, ed. 2019. *Queen Bey: A Celebration of the Power and Creativity of Beyoncé Knowles-Carter*. New York: St. Martin's Press.

Chandler, Kimberly. 2016. "Creole Queen: Beyoncé and Performing Plaçage in the New Millennium." In *The Beyoncé Effect: Essays on Sexuality, Race and Feminism*, edited by Adrienne Trier-Bieniek, 193–202. Jefferson, NC: McFarland.

Chatman, Dayna. 2015. "'Pregnancy, Then It's 'Back to Business': Beyoncé, Black Femininity, and the Politics of a Post-Feminist Gender Regime." *Feminist Media Studies* 15, no. 6: 926–41.

Coates, Norma. 1997. "(Re)evolution Now?: Rock and the Political Potential of Gender." In *Sexing the Groove: Popular Music and Gender*, edited by Sheila Whiteley, 50–64. New York: Routledge.

Collins, Patricia Hill. 2004. *Black Sexual Politics: African Americans, Gender, and the New Racism*. New York: Routledge.

Crenshaw, Kimberlé. 1989. "Demarginalizing the Intersection of Race and Sex: A Black Feminist Critique of Antidiscrimination Doctrine, Feminist Theory and Antiracist Politics." *University of Chicago Legal Forum* 1989: 140–67.

Combahee River Collective. 2000. "Combahee River Collective Statement." In *Home Girls: A Black Feminist Anthology*, edited by Barbara Smith, 264–74. New Brunswick: Rutgers University Press.

Cooper, Brittney. 2016. "Intersectionality." In *The Oxford Handbook to Feminist Theory*, edited by Lisa Disch and Mary Hawkesworth, 1–25. Oxford: Oxford University Press.

———. 2017. *Beyond Respectability: The Intellectual Thought of Race Women*. Champaign-Urbana: University of Illinois Press.

Cooper, Elizabeth Whittington. 2016. "Sex(uality), Marriage, Motherhood and Bey Feminism." In *The Beyoncé Effect: Essays on Sexuality, Race and Feminism*, edited by Adrienne Trier-Bieniek, 203–14. Jefferson, NC: McFarland.

Crunk Feminist Collective. 2013. "5 Reasons I'm Here for Beyoncé, the Feminist." *Crunk Feminist Collection*, December 13. http://www.crunkfeministcollective.com /2013/12/13/5-reasons-im-here-for-beyonce-the-feminist/.

Cupid, Jamila A., and Nicole Files-Thompson. 2016. "The Visual Album: Beyoncé, Feminism, and Digital Spaces," In *The Beyoncé Effect: Essays on Sexuality, Race and Feminism*, edited by Adrienne Trier-Bieniek, 94–108. Jefferson, NC: McFarland.

De Genova, Nicholas P. 2002. "Migrant 'Illegality' and Deportability in Everyday Life." *Annual Review of Anthropology* 31, no. 1 (2002): 419–47.

Duan, Noel Siqi. 2016. "Policing Beyoncé's Body: Whose Body Is It Anyway." In *The Beyoncé Effect: Essays on Sexuality, Race and Feminism*, edited by Adrienne Trier-Bieniek, 55–74. Jefferson, NC: McFarland.

Durham, Aisha. 2012. "Check on It: Beyoncé, Southern Booty, and Black Femininities in Music Video." *Feminist Media Studies* 12, no. 1: 35–49.

———. 2017. "Class Formation: Beyoncé in Music Video Production." *Close-Up: Beyoncé: Media and Cultural Icon. Black Camera: An International Film Journal* 9, no. 1: 197–204.

Durham, Aisha, Brittney C. Cooper, and Susana M. Morris. 2013. "The Stage Hip-Hop Feminism Built: A New Directions Essay." *Signs* 38, no. 3: 721–37.

Fassin, Didier. 2011. "Policing Borders, Producing Boundaries. The Governmentality of Immigration in Dark Times." *Annual Review of Anthropology* 40: 213–26.

Fast, Susan, and Stan Hawkins, eds. 2012. *Michael Jackson: Musical Subjectivities. Popular Music and Society* 35, no. 2.

Favreau, Jon, dir. 2019. *The Lion King.* Walt Disney Pictures.

Gaunt, Kyra D. 2019. "Beyoncé's *Lemonade* and the Black Swan Effect." In *The Lemonade Reader*, edited by Kinitra D. Brooks and Kameelah L. Martin, 215–33. New York: Routledge.

Giorgis, Hannah. 2019. "The Blind Spot of Beyoncé's *Lion King* Soundtrack." *Atlantic*, July 19. https://www.theatlantic.com/entertainment/archive/2019/07/disney-beyonce-lion -king-soundtrack-incomplete/594139/.

Gipson, L. Michael. 2019. "Interlude E: From Destiny's Child to Coachella—On Embracing Then Resisting Others' Respectability Politics." In *The Lemonade Reader*, edited by Kinitra D. Brooks and Kameelah L. Martin, 144–54. New York: Routledge.

Hall, Z. 2017. "The Shrews Are Drunk in Love." *Popular Music and Society* 40, no. 2: 151–63.

Hansen, Kai Arne. 2017. "Empowered or Objectified? Personal Narrative and Audiovisual Aesthetics in Beyoncé's *Partition*." *Popular Music and Society* 40, no. 2: 164–80.

Harper, Paula. 2019. "*Beyoncé*: Viral Techniques and the Visual Album." *Popular Music and Society* 41, no 2: 61–81.

Harris-Perry, Melissa. 2015. "Foreword." In *Black Female Sexualities*, edited by Trimiko Melancon and Joanne M. Braxton, vii–xi. New Brunswick: Rutgers University Press.

Harris, Tamara Winfrey. 2019. "Interlude F: 'Formation' and the Black-Ass Truth about Beyoncé and Capitalism." In *The Lemonade Reader*, edited by Kinitra D. Brooks and Kameelah L. Martin, 155–57. New York: Routledge.

Harvey, Eric. 2017. "Beyoncé's Digital Stardom." *Black Camera: An International Film Journal* 9, no. 1: 114–30.

Hatzipanagos, Rachel. 2020. "Royalty, Social Class Could Not Shield Meghan from Racism in Britain." *Washington Post,* January 16. https://www.washingtonpost.com/nation/2020/01/16/meghan-obama-class-race/.

Higginbotham, Evelyn Brooks. 1993. *Righteous Discontent: The Women's Movement in the Black Baptist Church, 1880–1920.* Cambridge, MA: Harvard University Press.

Highsmith, Lauren V. 2019. "'Beyoncé Reborn: *Lemonade* as Spiritual Enlightenment." In *The Lemonade Reader*, edited by Kinitra D. Brooks and Kameelah L. Martin, 133–43. New York: Routledge.

Hinks, Joseph. 2017. "Beyoncé Just Dropped a New Version of J. Balvin's 'Mi Gente' to Benefit Hurricane Victims." *Time*, September 29. https://time.com/4962254/beyonce-mi-gente-puerto-rico-mexico/.

Hobson, Janell. 2016. "Feminists Debate Beyoncé." In *The Beyoncé Effect: Essays on Sexuality, Race and Feminism*, edited by Adrienne Trier-Bieniek, 11–26. Jefferson, NC: McFarland.

———. 2020. "Oshun Energy in Beyoncé's 'Black Is King.'" *Ms.*, August 3. https://ms magazine.com/2020/08/03/oshun-energy-in-beyonces-black-is-king/.

Holtzman, Dinah. "As You Lick It: Bey and Jay Eat Cake." *Black Camera: An International Film Journal* 9, no. 1: 179–88.

hooks, bell. 2016. "Moving Beyond Pain." bell hooks Institute. May 9. http://www.bell hooksinstitute.com/blog/2016/5/9/moving-beyond-pain.

Hopkins, Susan. 2018. "Girl Power-Dressing: Fashion, Feminism and Neoliberalism with Beckham, Beyoncé and Trump." *Celebrity Studies* 9, no. 1: 99–104.

James, Robin. 2008. "'Robo-Diva R&B': Aesthetics, Politics, and Black Female Robots in Contemporary Popular Music." *Journal of Popular Music Studies* 20, no. 4: 402–23.

———. 2015. *Resilience and Melancholy: Pop Music, Feminism, and Neoliberalism.* New Alresford, UK: Zero Books.

———. 2019. "Interlude C: How Not to Listen to *Lemonade*: Music Criticism and Epistemic Violence." In *The Lemonade Reader*, edited by Kinitra D. Brooks and Kameelah L. Martin, 69–76. New York: Routledge.

Johnson, Birgitta J. 2019. "She Gave You *Lemonade*, Stop Trying to Say It's Tang: Calling Out How Race-Gender Bias Obscures Black Women's Achievements in Pop Music." In *The Lemonade Reader*, edited by Kinitra D. Brooks and Kameelah L. Martin, 234–45. New York: Routledge.

Jones, Melanie C. 2019. "The *Slay* Factor: Beyoncé Unleashing the Black Feminine Di-

vine in a Blaze of Glory." In *The Lemonade Reader*, edited by Kinitra D. Brooks and Kameelah L. Martin, 98–110. New York: Routledge.

Jones, Nicholas R. 2019. "Beyoncé's *Lemonade* Folklore: Feminine Reverberations of *Odú* and Afro-Cuban *Orisha* Iconography." In *The Lemonade Reader*, edited by Kinitra D. Brooks and Kameelah L. Martin, 88–97. New York: Routledge.

Kao, Jason, and Denise Lu. 2019. "How Trump's Policies Are Leaving Thousands of Asylum Seekers Waiting in Mexico." *New York Times*, August 18. https://www.nytimes.com /interactive/2019/08/18/us/mexico-immigration-asylum.html?searchResultPosition=1.

Kehrer, Lauron. 2019. "Who Slays? Queer Resonances in Beyoncé's *Lemonade*." *Popular Music and Society* 41, no 2: 82–98.

Keleta-Mae, Naila. 2017. "A Beyoncé Feminist." *Atlantis* 38, no. 1: 236–46.

Keyes, Cheryl L. 2000. "Empowering Self, Making Choices, Creating Spaces: Black Female Identity via Rap Music Performance." *Journal of American Folklore* 113, no. 449: 255–69.

Kohlman, Marla H. 2016. "Beyoncé as Intersectional Icon? Interrogating the Politics of Respectability." In *The Beyoncé Effect: Essays on Sexuality, Race and Feminism*, edited by Adrienne Trier-Bieniek, 27–39. Jefferson, NC: McFarland.

Kooijman, Jaap. 2014. "The True Voice of Whitney Houston: Commodification, Authenticity, and African American Superstardom." *Celebrity Studies* 5, no. 3: 305–20.

———. 2019. "Fierce, Fabulous, and In/Famous: Beyoncé as Black Diva." *Popular Music and Society* 41, no 2: 6–21.

Kumari, Ashanka. 2016. "'Yoü and I': Identity and the Performance of Self in Lady Gaga and Beyoncé." *Journal of Popular Culture* 49:403–16.

Li, Stephanie, ed. 2017a. *Close-Up: Beyoncé: Media and Cultural Icon. Black Camera: An International Film Journal* 9, no. 1.

———. 2017b. "Introduction: Who Is Beyoncé?" *Close-Up: Beyoncé: Media and Cultural Icon. Black Camera: An International Film Journal* 9, no. 1: 106–13.

Lieb, Kristin. 2016. "I'm Not Myself Lately: The Erosion of the Beyonce Brand." In *The Beyoncé Effect: Essays on Sexuality, Race and Feminism*, edited by Adrienne Trier-Bieniek, 75–93. Jefferson, NC: McFarland.

Lorde, Audre. 1993. "The Master's Tools Will Never Dismantle the Master's House." In *Feminist Frontiers* III, edited by Laurel Richardson and Verta Taylor, 10–11. New York: McGraw-Hill.

Lordi, Emily J. 2016. "Beyoncé's Other Women: Considering the Soul Muses of *Lemonade*." *Fader*, May 6.

———. 2017. "Surviving the Hustle: Beyoncé's Performance of Work." *Black Camera: An International Film Journal* 9, no. 1: 131–45.

Mahon, Maureen. 2011. "Listening for Willie Mae 'Big Mama' Thornton's Voice: The Sound of Race and Gender Transgressions in Rock and Roll." *Women and Music* 15:1–17.

Martínez Jiménez, Laura, Lina Gálvez Muñoz, and Ángela Solano Caballero. 2018. "Neo-

liberalism Goes Pop and Purple: Postfeminist Empowerment from Beyoncé to Mad Max." *Journal of Popular Culture* 51, no. 2: 399–420.

McGee, Kristin. 2019. "Biopolitics and Media Power in the Online Dance Remake: Remixing Beyoncé's "***Flawless" in the YouTube Archive." *Popular Music and Society* 41, no 2: 22–41.

McKittrick, Katherine. 2017. "Footnotes (Books and Papers Scattered About the Floor)." Keynote presentation at Berkeley Black Geographies. https://www.youtube.com /watch?v=J9u7fsUPFbM.

McRobbie, Angela. 2004. "Post-Feminism and Popular Culture." *Feminist Media Studies* 4, no. 3: 255–64.

Mercer, Kobena. 1986. "Monster Metaphors: Notes on Michael Jackson's 'thriller.'" *Screen* 27, no. 1: 26–43.

Miles, Corey. 2016. "Beyoncé's Lemonade: When Life Gave Us Lemons, We Saved the World." *Human and Society* 41: 136–38.

Mitchell, Anne M. 2016. "Beyoncé as Aggressive Black Femme and Informed Black Female Subject." In *The Beyoncé Effect: Essays on Sexuality, Race and Feminism*, edited by Adrienne Trier-Bieniek, 40–54. Jefferson, NC: McFarland.

Morgan, Joan. 2002. "The Bad Girls of Hip-Hop." In *Public Women, Public Words*, edited by Dawn Keetley and John Pettegrew, 426–27. Lanham, MD: Rowman & Littlefield.

Moss, Sonita R. 2016. "Beyoncé and Blue: Black Motherhood and the Binds of Racialized Sexism." In *The Beyoncé Effect: Essays on Sexuality, Race and Feminism*, edited by Adrienne Trier-Bieniek, 55–76. Jefferson, NC: : McFarland.

New School. 2014. "bell hooks: Are You Still a Slave? Liberating the Black Female Body." Filmed May 2014. YouTube video, 1:55:32. https://www.youtube.com/ watch?v=rJkohNROvzs.

Olutula, Sarah. 2019. "I Ain't Sorry: Serena Williams and Black Female Hierarchies in Beyoncé's *Lemonade*." *Popular Music and Society* 41, no 2: 99–117.

Oppel, Jr., Richard A., Robert Gebeloff, K. K. Rebecca Lai, Will Wright, and Mitch Smith. 2020. "The Fullest Look Yet at the Racial Inequity of Coronavirus." *New York Times*, July 5. https://www.nytimes.com/interactive/2020/07/05/us/coronavirus-latinos-african -americans-cdc-data.html.

Pareles, Jon. 2016. "Review: Beyoncé Makes 'Lemonade' Out of Marital Strife." *New York Times*, April 24. https://www.nytimes.com/2016/04/25/arts/music/beyonce-lemonade .html.

Peñate, Patricia Coloma. 2019. "Beyoncé's Diaspora Heritage and Ancestry in *Lemonade*." In *The Lemonade Reader*, edited by Kinitra D. Brooks and Kameelah L. Martin, 111–22. New York: Routledge.

Philp, David. 2014. "Get Classy: Comparing the Massive Marketing of *Anchorman 2* to the Non-marketing of Beyoncé's *Beyoncé* Album." *MEIEA Journal* 14: 219–49.

Pullen, Kirsten. 2011. "'If Ya Liked It, Then You Shoulda Made a Video': Beyoncé Knowles, YouTube and the Public Sphere of Images." *Performance Research: A Journal of the Performing Arts* 16, no. 2: 145–53.

Railton, Diane, and Paul Watson. 2005. "Naughty Girls and Red Blooded Women: Representations of Female Heterosexuality in Music Video." *Feminist Media Studies* 5, no. 1: 51–63.

Richards, Kimberley. "Beyoncé's New Song Inspires Celebratory #BrownSkinGirlChallenge on Twitter." *Huffpost*, July 23. https://www.huffingtonpost.ca/entry/brown-skin -girl-challenge-blue-ivy-beyonce_n_5d372809e4b0419fd3338f2a?ri18n=true.

Roberts, Dorothy E. 1999. *Killing the Black Body: Race, Reproduction, and the Meaning of Liberty*. New York: Vintage.

"The Royal Wedding: Bishop Michael Bruce Curry Gives a Powerful Sermon | Access." 2018. Uploaded May 19. YouTube video. https://www.youtube.com/watch?v=WtOYXtkilMk.

Sandberg, Sheryl. 2013. *Lean In: Women, Work and the Will to Lead*. New York: Knopf.

Sanneh, Kalefeh. 2004. "The Rap against Rockism." *New York Times*, October 31.

Saturday Night Live. 2016. "The Day Beyoncé Turned Black." February 14. YouTube video. https://www.youtube.com/watch?v=ociMBfkDG1w.

Shackleford, Ashleigh. 2019. "Interlude B: Bittersweet Like Me—When the Lemonade Ain't Made for Black Fat Femmes and Women." In *The Lemonade Reader*, edited by Kinitra D. Brooks and Kameelah L. Martin, 9–14. New York: Routledge.

Simmons, LaKisha M. 2019. "Pull the Sorrow from Between My Legs: *Lemonade* as Rumination on Reproduction and Loss." In *The Lemonade Reader*, edited by Kinitra D. Brooks and Kameelah L. Martin, 42–54. New York: Routledge.

Smith, Marquita R. 2017. "*Beyoncé*: Hip Hop Feminism and the Embodiment of Black Femininity." In *The Routledge Research Companion to Popular Music and Gender*, edited by Stan Hawkins, 229–41. New York: Routledge.

Smith, Marquita, Christina Baade, and Kristin McGee. 2019. *Beyoncé*. *Popular Music and Society* 41, no 2.

Stewart, Lindsey. 2019. "Something Akin to Freedom: Sexual Love, Political Agency, and *Lemonade*." In *The Lemonade Reader*, edited by Kinitra D. Brooks and Kameelah L. Martin, 19–30. New York: Routledge.

Tinsley, Omise'eke. 2019. *Beyoncé in Formation: Remixing Black Feminism*. Austin: University of Texas Press.

Trier-Bieniek, Adrienne, ed. 2016. *The Beyoncé Effect: Essays of Sexuality, Race and Feminism*. Jefferson, NC: McFarland.

Truth and Reconciliation Commission of Canada. 2015. "Honoring the Truth, Reconciling for the Future: Summary of the Final Report of the Truth and Reconciliation Commission of Canada." http://www.trc.ca/websites/trcinstitution/File/2015/Honouring _the_Truth_Reconciling_for_the_Future_July_23_2015.pdf.

Truth, Sojourner. 1851. "Ain't I a Woman?" In *The Sojourner Truth Project*, edited by Leslie Podell. Accessed December 20, 2018, at https://www.thesojournertruthproject.com.

Tsang, Martin A. 2019. "The Magnetic and Poetic Magic of Oshún as Reflected in Beyoncé's *Lemonade*." In *The Lemonade Reader*, edited by Kinitra D. Brooks and Kameelah L. Martin, 133–32. New York: Routledge.

Utley, Ebony A. 2017. "What Does Beyoncé Mean to Young Girls?" *Journal of Popular Music Studies* 29:1–12.

Vernallis, Carol. 2013. *Unruly Media: YouTube, Music Video, and the New Digital Cinema.* New York: Oxford University Press.

———. 2016a. "Beyoncé's Lemonade, Avant-Garde Aesthetics, and Music Video: "The Past and Future Merge to Meet Us Here." *Film Criticism* 40, no. 3: 1–5.

———. 2016b. "Beyoncé's Lemonade: She Dreams in Both Worlds." *Film International*, June 2.

———. 2017. "Beyoncé's Overwhelming Opus; or, the Past and Future of Music Video." *Film Criticism* 41; no. 1: 1–31.

Walker, Alice. 1967/1983. *In Search of Our Mother's Gardens: Womanist Prose*. Orlando, FL: Harcourt.

Wallace, Alicia. 2017. "A Critical View of Beyoncé's 'Formation.'" *Black Camera: An International Film Journal* 9, no. 1: 189–96.

Ward, Mako Fitts. "Queen Bey and the New N*****ati: Ethics of Individualism in the Appropriation of Black Radicalism." *Black Camera: An International Film Journal* 9, no. 1: 146–63.

Warwick, Jacqueline. 2007. *Girl Groups, Girl Culture: Popular Music and Identity in the 1960s*. New York: Routledge.

Weidhase, Nathalie. 2015. "'Beyoncé Feminism' and the Contestation of the Black Feminist Body." *Celebrity Studies* 6, no. 1: 128–31.

Weisbard, Eric. 2014. In *Top 40 Democracy: The Rival Mainstreams of American Music*. Chicago: University of Chicago Press.

Wells, Ida B. 1892. *Southern Horrors: Lynch Law in All Its Phases*. Available on *Project Gutenberg*, posted 2005. http://www.gutenberg.org/ebooks/14975.

Whiteley, Sheila, ed. 1997. *Sexing the Groove: Popular Music and Gender*. New York: Routledge.

Whitaker, Isabel González. 2019. "Finding *La Reina* in Queen Bey." In *Queen Bey: A Celebration of the Power and Creativity of Beyoncé Knowles-Carter*, edited by Veronica Chambers, 149–58. New York: St. Martin's Press.

PART ONE

"Diva"
Black Feminist Genealogies

Our book opens with H. Zahra Caldwell's essay on how the tradition of Black women's cool has shaped both Beyoncé's *Lemonade* and Solange Knowles's *A Seat at the Table*. In Chapter 1, Caldwell examines the ways in which this tradition has historically been appraised as valuable and then appropriated by white culture, but she also traces a lineage of Black women performers, like Bessie Smith and Abby Lincoln, who have expressed coolness in their work, building on this history to draw out the Black feminist themes in the 2016 albums by the Knowles sisters. The recognition that untangling lineages and relationality between creative Black women can help reveal Black feminist themes also shapes Chapter 2, in which Cienna Davis examines the much-remarked connections between Julie Dash's 1991 independent film, *Daughters of the Dust*, and *Lemonade*. While many have commented on the ways in which *Lemonade* borrows visually from Dash's film, especially in "Reformation," Davis uses the connection to examine the difficult topic of colorism, especially the ways in which light skin has been associated with privilege but also, historically, with sexual exploitation, sex work, and a betrayal of respectability politics. Davis examines how *Lemonade* works through the traumatic legacies of slavery and ongoing racial violence, as well as how it enacts and calls for healing and hope for the future.

H. ZAHRA CALDWELL

1. "I Came to Slay"
The Knowles Sisters, Black Feminism, and the Lineage of Black Female Cool

"Mother dearest, let me inherit the earth."

Warsan Shire, Lemonade

(Knowles 2016)

Borrowing from Black queer culture, Beyoncé makes reference to the "slay" at several points in her 2016 sonic and visual album, *Lemonade*. "To slay" is to embody excellence, to perform a feat so well that it diminishes all other endeavors. It is an example to be emulated. For Black women, the act of slaying has built into itself contestation, resistance, healing, and remaking. Something more whole rises in the place of that which has been slayed. In her song "Formation," Beyoncé tells her listener, "slay trick or you get eliminated" (2016). Eschewing the misogyny attached to *trick* and using a seemingly third-person voice, she uses the moniker to place emphasis on the derisive treatment of Black women in America. Beyoncé understands that America's constructions of Black women most often stand outside and apart from the constructions that they hold of themselves. She implores these women to constantly "slay" for survival or "get eliminated." How do they function in a society in which they are perpetually treated as subhuman? They slay. In other words, they construct their own self-worth as a counternarrative to the larger dehumanizing society. Sociologist Patricia Hill Collins might describe this act of self-definition as a primary foundation of Black feminist thought. In her seminal text, *Black Feminist Thought: Knowledge, Consciousness, and the Politics of Empowerment*, she points to a fully realized standpoint that is occupied by Black women and affords them a distinctive "Black feminist consciousness"

(Collins 2000, 98). Their resistance lies within the establishment of selfhood, particularly self-definition and self-determination. This is in defiance of their denigration within the larger society. All of this can be seen in the act of slaying.

The slay is one of the several mechanisms of Black female cool. It resonates with Black feminism and, akin to Black cool, springs from ancient traditions and yet is shaped by a modern Black present. Black feminism surfaces as an articulation of lineage and is often used as a strategy for survival. Both Black feminism and the slay are necessarily transgressive and embody community, balance, reformation, and aspiration. Neither is meant to invite in the uninitiated, and both exist as a result of the Black woman's peculiar history, worldview, and ability to survive and thrive in a hostile environment. Despite this (or because of it), Black female cool stands at the forefront of a constant reimagining that is consumed by the larger American culture. Much of this owes its due to "the slay." In her essay, "The Slay Factor: Beyoncé Unleashing the Black Feminine Divine in a Blaze of Glory," scholar Melanie C. Jones writes, "The slay factor that [Beyoncé] unleashes bears power that is recognizable to cis-queer-trans Black women alike, and is akin to the mystery of the sacred—its witness cannot be wholly explained, but Black women *know what it is and what it ain't*" (Jones 2019, 98–99). The elusiveness and chasing of the slay within the larger culture often lead to the misuse and abuse of Black female cool in popular culture.

Margo Jefferson famously wrote in her 1973 article about rock and roll, "Ripping Off Black Music,"

> I dreamed this was the latest step in a plot being designed to eliminate blacks from Rock music. . . . Future generations, my dream ran, will be taught that while rock may have had its beginnings among blacks, it had its true flowering among whites. The best black artists will thus be studied as remarkable primitives who unconsciously foreshadowed future developments. (1973, 45)

It seems her dream was not far-fetched. This treatment was and continues to be assigned to Black female cool in spite of the strong contradiction of ubiquitous Black female cool throughout the history of American music, including rock and roll. Pop music fixtures such as Miley Cyrus, Katy Perry, and Taylor Swift, all white women, have built careers through the periodic co-opting of Black cool, from Cyrus's bizarre twerk-based 2013 Video Music Awards (VMA) performance to Perry's revolving door of cultural appropriation, including her regular appearance in cornrows. Perhaps one of the more memorable uses of

Black female cool in recent years was Swift's 2014 "Shake It Off" video, in which she crawls between the legs of a line of Black women as they twerk and smirk. Their bodies are objectified and fragmented, and their collective appearance serves as cultural fodder to heighten the popularity of white artists, many of whom have deservedly been critiqued for their use of Black creative modes and Black bodies as adornments to heighten their cool factor (Mechanic 2017; Williams 2017; Zoladz 2017). Their appropriation of culture propels their careers while leaving the ill association of "ratchetness" with Black culture even as Black women continue to slay through co-opted innovation.

Beyoncé's *Lemonade* (2016) and Solange's *A Seat at the Table* (2016) resist this misuse and remind us of the contributions and practices of the slay, Black female cool, and Black feminism. Their reifying of a Black women–focused cultural counternarrative belongs in a long historical lineage of Black female cool. *Lemonade* was Beyoncé's sixth album, released in April 2016. It had two components: traditional audio tracks and an accompanying sixty-five-minute visual album. As a whole, it is an acutely interior and exigent national conversation about race, class, gender, and Blackness. *Lemonade*'s view into very personal struggles around infidelity, self-worth, and reclamation can also be understood as a metaphor for African American women's complicated relationship with America. The album allows these women to express a full gamut of emotion and responses to their oppressed conditions. Solange's third studio album, *A Seat at the Table,* released in September 2016, aligns with many of the concerns of *Lemonade.* These range from Black female interiority to critiques of American oppression. Unlike her sister, who has said that she prefers to speak mostly through her music, Solange has been outspoken offstage and as an artist. Within her album, she immerses listeners in an interior conversation in which Black women are presumed competent and function as witnesses and guardians of the Black community. This album provides a potent critique of American democracy and inserts itself into a very current conversation about race, gender, power, disenfranchisement, and struggle.

In the essay, "'All That You Can't Leave Behind': Black Female Soul Singing and the Politics of Surrogation in the Age of Catastrophe," Daphne Brooks examines the political impact of Black women's popular music in the midst of the 2005 Gulf Coast hurricane (2008). She provides an important lens through which to view Beyoncé's and Solange's 2016 albums as well as their other creative production. Brooks specifically describes Beyoncé's second album, *B'Day*, as creating a "kind of black feminist surrogation . . . an embodied cultural act that articulates

black women's distinct forms of palpable sociopolitical loss and grief as well as spirited dissent and dissonance" (2008, 183). Drawing from Brooks, I argue that Black women's artistic creation often acts as a conduit for their collective personal and public struggles. Through their artistic performances, Beyoncé, Solange, and those who came before them speak to Black women and for Black women. Again, their creative work operates as a place of safety for these women. Given the consistent negotiation of such themes and the persistent address to Black women's culture, I assert that the Knowles sisters belong within this lineage and extend the tradition of Black female cool. This is simultaneously their extension of this cool and their original contributions to it.

In this chapter, I first examine Black female cool in contrasting eras as articulated and expanded by six of its key architects: Bessie Smith, Big Mama Thornton, Abbey Lincoln, Nina Simone, Aretha Franklin, and Labelle—to establish it as a lineage. As a frame, I consider four major characteristics of this lineage: the ways in which Black female cool performs Black feminist surrogacy, how it values Black female aesthetic labor, Black female cool's dialectic conversation with the sociopolitical realities of its moment, and its reliance on creative innovation and musical interventions. The second half of the chapter offers a close reading of Beyoncé and Solange's recent landmark albums, respectively, *Lemonade* and a *Seat at the Table*, in which I connect the sisters to and aver their modern expansions of the long lineage of Black female cool.

THE COOL

Historian Robert Farris Thompson's 2011 collection, *Aesthetic of the Cool: Afro-Atlantic Art and Music*, features on its cover an African woman caught in a close-up in mid-dance. Her head is turned a bit to the side and slightly cocked down, her eyes half-lidded glance downward, mouth set as she moves to the rhythm. Her expression is transcendent and self-possessed, less about the fire than it is the ice. She is so confident in her movement, style, and swagger that she is beyond bravado and settling into knowing. This look can be seen in any African or diasporic Black community on the globe. You might suddenly see it at a club, in a Black church, or passing on the street. It *is*. This is Black cool. Black women alone do not hold a patent on this cool, but because of their historical positioning, they are often progenitors of it and deploy it as a survival strategy. Thompson discusses the African origins of the cool: "To be cool means to become composed in a sharing sense, to remember the way one ought to be. Intensity can

be matched with ecstasy, a fixed expression with solemnity of mien, opposing immobile face with the pulsations of the body. Cool is also, a sign of positive transition to ideal worlds" (2011, 5–6).

Thus, the cool, like the slay, is transgressive and exists on many planes at once. It is a physical, emotional, and spiritual state of being. Endemic to the "philosophy of the cool, is the belief that the purer, the cooler a person becomes the more ancestral she becomes. He or she becomes self-possessed and undistracted." Thompson contends, "She can concentrate upon truly important matters of social balance and aesthetic substance" (2011, 16–18). Writer Helena Andrews adds that Black cool is "always looking ahead, up and over, not really at some-thing" (quoted in Walker 2012, 35). When seated within a female body, Black cool takes on added dimensions. It isn't that Black female cool is not both ancestral and present, but to be sustaining, it must anticipate and respond to the vicis-situdes of its community. Thompson and Andrews's descriptions of Black cool align well with the current evolutions of sisters Solange and Beyoncé. Although they are very different women and types of artists, their latest projects see them pressing on the boundaries of popular culture, each reflecting aspirations to "self-possession," "social balance and aesthetic substance" (2011, 16-18). In their work, they use these tools to imagine an empowered Black female present and future. This is but one of their contributions to Black female cool.

Soyica Diggs Colbert explains that "[Black] aesthetics ability to engage with the impossible and unreasonable also allows the artist to illuminate the cross purposes of desire and outcomes that perpetuate, crystalize, and transform racial categories . . . expressing innovation and pragmatism, they often appear to be on the 'threshold of revelation'" (2017, 16). These are the locations from which both Beyoncé and Solange align with Black female cool and the slay, as well as push it forward. They use the current conditions of African American women as a space from which to reach those things that are seemingly impossible like sociopolitical equity and personal freedom. This exploration is a significant ad-dition to the flurry of discussion currently surrounding the cultural production of Beyoncé and Solange.

FIGURE 1.1 Big Mama Thornton, *Big Mama Thornton with the Muddy Waters Blues Band 1966* (Arhoolie Records, 1966). This now-classic album was released thirteen years after "Hound Dog." However, Thornton's musical contributions continued to be underappreciated in the musical mainstream.

THE LINEAGE

"Your mother is a woman and women like her cannot be contained."

Warsan Shire, quoted in Lemonade

In 1956 Elvis Presley's cover of Big Mama Thornton's "You Ain't Nothin' But a Hound Dog" sat atop the US charts for eleven weeks in multiple genres, including R&B and pop (Figure 1.1). In 2004, *Rolling Stone* identified it as among the five hundred greatest songs of all time ("500 Greatest" 2004). Many have cited Elvis's performance of this song on *The Ed Sullivan Show* as a marker for the genesis of modern American cool. What is often lacking in such discussions, however, is a gendered recognition of this particular now-iconic version. In fact, it wasn't so much that Elvis emulated Black male cool as he did Black *female* cool, as his performance riffed on Thornton's nervy, aggressive, sensual performance. When blues woman Big Mama Thornton released her version in 1953, it quickly rose to the number one song on *Billboard*'s R&B chart for seven weeks and remained exceedingly popular in African American communities ("Thornton, Willie Mae 'Big Mama'" 2008). There were many differences between Presley's and Thornton's versions. Thornton's, grittier and rawer than Presley's revision, celebrated Black female sexuality and liberation. His centered on whiteness, masculinity, and male desire. Through her recording and live performances, she authored a superior cultural product that was then commodified and adopted into the American mainstream. Unfortunately, her contributions to music and, specifically, rock and roll history have been obscured.

Historian Maureen Mahon has described how Thornton "tapped into a liberated black femininity through which she freed herself from many of the expectations of musical, lyrical, physical, and sartorial practice for black women" (2011, 1). Her cool rejected the limiting definitions of American femininity. Although not every Black woman performer can be described as having Black feminist tendencies, there is a strong argument to be made that many, such as Thornton, had to channel them in order to secure their places in the American cultural spotlight. For example, in a highly complex and sometimes coded manner, Thornton incorporated the specific poetics of a longer tradition of Black female performers. She transmitted the sexual innuendo of Ma Rainey and Dinah Washington and the defiance of Nina Simone and Esther Phillips. She embodied the values and performance ethics of many other African American women singers who came before and after her.

By discussing women who are engaged in this cultural work, I hope to reinforce the idea, discussed by scholar and activist Angela Davis, that there are multiple and enduring Black feminist traditions and that these practices continue to evolve and blossom (Davis 1999, xix). One site where we can see that evolution is within the lineage of Black female cool. The modern cultural productions of Beyoncé, Solange, and their foremothers expand our theoretical frame and defining practices in order to interrogate and honor all the expressions of Black feminist labor. The list of mothers and foremothers of Black female cool is long. My goal here is not to provide an exhaustive overview of African American women artists who propagated and propagate Black female cool (there are many) but to highlight a few of those who were elemental in its development.

No interrogation of Black cool would be complete without a discussion of Bessie Smith, whose influence on Black cool was foundational in the early twentieth century. Smith's career and influence also parallel Beyoncé in significant ways. This does not intentionally ignore the influence or impact of so many others, such as Ma Rainey or Mamie Smith. As a Black woman and using the stage as "a privileged site," Smith ushered in a national blues era and helped initiate the ensuing jazz age (Carby 1987, 8).[1] In her short career, she released over 160 recordings that shaped popular blues music and imprinted American music into the twenty-first century. National popular entertainment was merely a fledgling industry in early twentieth-century America. In spite of this, Smith was so popular that she sold over a million records in the 1920s, a feat that helped save Columbia Records from bankruptcy (Albertson 2003, 56). Smith's popularity and economic success greatly resemble the millions of dollars Beyoncé would

generate for the same label almost a century later. Whole industries, such as fashion and music, have thrived with the labor of Black women and through the aesthetics of Black female cool.

In addition to her national musical impact, Smith's indelible place within early Black touring entertainment should be noted. Because of her successful recording career, she became one of the most popular touring entertainers. Like Beyoncé, Smith was a hard-working performer and show woman, as well as a formidable businesswoman who was known for her extravagant performances and self-marketing.[2] She sold her records and ephemera at her stage shows and managed her transportation by purchasing her own custom-built train car. Due to her popular positioning, she attained a greater level of control over her career than most other Black performers, male or female, did. She was the rare Black woman in charge of her brand. Smith set a precedent for Beyoncé's command over her music and merchandising, but more important, her performances drew on the powerful tradition of the Black female cool that Smith embodied.

Like many other Black theatrical performers, Smith attained work through the Theatre Owners Booking Association (TOBA), a booking agent for Black vaudeville artists. And also like other performers on the circuit, Smith's shows might consist of several acts and treat audiences to several hours of entertainment. Still, her stage shows, relying on creative innovation, were legendary for their elaborateness and opulence, as are Beyoncé's 2018 On the Run Tour II, the most recent of this writing, On the Run Tour II, stretched three hours, included several acts, featured scores of performers and musicians, and sold nearly 3 million tickets). Attendees would wait in lines that circled blocks for Smith. By centering her performances on a Black woman's body, she brought glamour and modernity to small towns and segregated cities on the Chitlin' Circuit, a series of designated venues in which African American performers could perform during segregation. One fellow musician, Danny Barker, recalled that Smith's shows were electric and entrancing. It was as if "she could bring about mass hypnotism" (Scott 2005, 125). In short, she engineered the cool that was to be emulated and brought the slay. All of this still says little to nothing of the tremendous impact she had on American culture writ large. Nearly a century later, Beyoncé has captured this spirit in her shows.

Semi-embedding herself in 2013's Mrs. Carter's World Tour, writer and cultural critic Rachel Kaadzi Ghansah noted the connection that Beyoncé has with her audience—or, rather, the connection that her audience has with her. Although Beyoncé's audiences are mixed in gender, women dominate. Ghansah observed "literally swarms, of women . . . by this I mean every kind of woman you can

imagine, they come invincible." One member of security she interviewed admitted that the audience was sundry but "the Black girls though?" He exclaimed, "They take it *seriously*." Smith had a similar effect on female audiences, perhaps because, as Ghansah points out, "there are so few black icons who speak to the realities of black life" (2014). Undoubtedly, this is what Smith's audience valued about her presentation and cultural production. They spoke, and still speak, directly to the authentic experiences of Black women. Both Smith and Beyoncé performed the work of Black icons. They represent an aspirational cool but seem home girl accessible. This is what Beyoncé taps into, and it is the governing ethos of *Lemonade*. The audience's adoration for Smith and Beyoncé is anchored in many characteristics of the Black female cool lineage. In concert, they became/become surrogates for Black women, particularly their interiority. They also present Black female aesthetics and creative innovations that feel familiar to this community. Despite this, or maybe because of these two Black women's willingness to allow others into an intracommunity conversation, they became an underacknowledged model for twentieth- and twenty-first-century American cool.

Another location of pivotal Black female cool is the mid-twentieth century. The rise of avant-garde jazz brought with it a reimagined African and African American–driven music and aesthetic. The female embodiment of this innovation and extension of jazz was Abbey Lincoln, who had come to prominence as a nightclub performer who sang standards. However, her immersion into the avant-garde jazz scene significantly changed the trajectory of her career. The albums that followed her 1957 release, *Abbey Lincoln's Affair... A Story of a Girl in Love*, were increasingly focused on avant-garde jazz and experimentation. She came to see herself in the singing tradition of Billie Holiday, Sarah Vaughan, and Dinah Washington and credited them with "teaching her how to sing with conviction." She explained, "I came from all of them" (*Jazz Profile* 2018). By emphasizing this, she connects herself directly to the musical lineage of Black female cool. She also focused more on Black female interiority as well as social issues and movements. She released trailblazing albums in the late 1950s that were unrivaled by most other solo Black woman artists. These included 1959's *Abbey Is Blue* and 1961's remarkable *Straight Ahead* (Figure 1.2). In the liner notes to the latter album, jazz writer and critic Nat Hentoff remarked, "This is a woman singing, and more specifically, it is a Negro woman, because part of the striking liberation of Abbey's singing has come from a renewed and urgent pride in herself as a Negro" (Hentoff 1961). *Straight Ahead* moves Black women's concerns to the middle of the political debate. That would not be her only contribution.

ABBEY LINCOLN STRAIGHT AHEAD

MAX ROACH · COLEMAN HAWKINS · ERIC DOLPHY · MAL WALDRON
BOOKER LITTLE · JULIAN PRIESTER · ART DAVIS · WALTER BENTON
CANDID

FIGURE 1.2 Abbey Lincoln, *Straight Ahead* (Candid Records, 1961). Many consider this one of Lincoln's greatest recordings. It is even more significant for the way in which it centers Black women's concerns and is a marker within the lineage of Black female cool.

Because of Lincoln as an antecedent, women artists such as Beyoncé and Solange can also be inspired to push music to its experimental limits, as well as boldly shape Black-based female aesthetics. Evolution and experimentation in creative production were traditionally the purview of men, white or Black.

Of her many recordings, Lincoln may have garnered the widest public attention for her performance with drummer and then husband Max Roach on the *We Insist! Freedom Now Suite* in 1960. The music on the album was in direct conversation with the concerns of the Black audience in this period of civil unrest and transformation. The modern civil rights movement, hopeful international freedom struggles, and the affirmation of Blackness were all inspirations for the suite. The live performances of the songs from this album in the United States, and later in Europe, modernized and expanded the palette of performance tropes contained within Black female cool in the early 1960s. Lincoln was reflective of a flourishing embrace of Black beauty. She had become associated with the Harlem-based African Jazz-Art Society & Studios (AJASS), which, among other events, hosted fashion shows that featured clothing with African motifs and models with elaborate natural hairstyles. These models, monikered Grandassa, and the shows became well known within the nascent Black Is Beautiful movement. The first of these shows in 1962 was headlined by Lincoln and Roach (Laneri 2018; Ford 2015, 57).

In her live music performances, Lincoln stood center stage and exhibited an image that pulled from an African aesthetic (Feldstein 2013, 35). She wore regal African dresses with her natural hair coiffed in an Afro, colorful beaded braids,

and elegant updos. She stands within the vanguard of Black female cool in the late 1950s and early 1960s. The African-inspired aesthetic and natural hair styles that she helped pioneer later became the standard of Black American cool and heavily influenced American cool in the 1960s and 1970s. Black female cool values both Black female beauty and Black female aesthetic labor.

The spiritual sister and contemporary of Abbey Lincoln was Nina Simone, who has been much discussed but yet not sufficiently credited for her vast contributions to Black female cool (Figure 3). She was a changeling at the start of her career, and Black and white audiences alike did not know what to make of her, which was probably for the best. This indefinable categorization left her free to be the kind of artist very few men or women were and are allowed to be in the commercial music industry. No genre could contain her musical output, and her, evolving, unrepentant African aesthetic, akin to Lincoln, helped to shape the ensuing Black power era. That would be a powerful site of Black feminist consciousness and Black female cool. Historian Ruth Feldstein has discussed at length in her work, the activist and cultural contributions of Simone and her accompanying performer peer group, including Lincoln and South African singer Miriam Makeba, in the late 1950s and early 1960s. Feldstein explains that few movement narratives and music histories include Simone as an activist. She identifies this as arising from a discomfort with "certain kinds of cultural productions and particular expressions of female sexuality [that] have often been placed beyond the parameters of African American political history" (Feldstein 2005, 1351). This description must include the slay and Black female cool.

There is often a historical blind spot in regard to the activism of women in any form, particularly as connected to cultural production. This also represents an erasure of Black female cool as many music and movement historians had been unable to locate Simone within one particular activist or musical genre and were uncomfortable with her overtly racialized protest. What we should ask in retrospect is, "How did her activism inform her cool?" It, in fact, formed its base. Simone's irreverence, movement politics, and embrace of Black cultural symbols were all reasons that she is a model of Black female cool. This cool composition was in a symbiotic relationship nationally and globally. Simone both reflected a global Black culture and produced it in the 1960s and 1970s. We should be asking the same questions of Beyoncé and Solange. Their current intermixture of social concerns, aesthetics, and art in *Lemonade* and *A Seat at the Table*, respectively, as well as their production of a deliberate Black female cool, inserts them within this long activist cultural line.

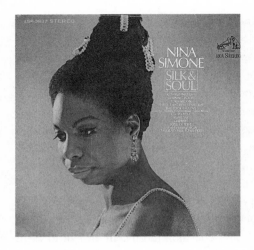

FIGURE 1.3 Nina Simone, *Silk & Soul* (RCA Victor, 1967). The cover art for this album points to Simone's embrace of political movements and African culture during the 1960s. It includes the civil rights anthem, "I Wish I Knew How It Would Feel to Be Free."

Historically, Black female cool has played a role in the expansion of the national understanding of Black women's positioning and standpoints. In addition to the blues, soul music is one of the most prolific musical genres within the lineage of Black female cool. It is a genre in which women often aligned with patriarchal notions while singing about lost loves and proclaiming in song their efforts to be a "good woman." Conversely, soul is also a space of resistance and challenge. In 1967, Aretha Franklin covered Otis Redding's 1965 hit "Respect." His original version placed emphasis on masculinity and the subservience of women. Respect became a euphemism for sexual attention in the male version. Franklin reworked the song into a feminist anthem. She revised the lyrics and melody slightly, coming up with a song that insisted on a man's respect for his woman, turning the original intent completely on its head. Her version spelled out the word, R-E-S-P-E-C-T, foregrounding women's work and demanding, well, respect. She insists, "Sock it to me, sock it to me, sock it to me." Redding told an audience at the Monterey Jazz Festival that same year, "This is a song that a girl took away from me. But I'm still going to sing it anyway" (Gould 2017, 7).

A singer as superb and lauded as Franklin stands at the nexus of the cool for many reasons, including the characteristics of lineage, valuing Black female aesthetics, her dialogue with Black sociopolitical concerns, and her creative innovations and musical interventions. However, here I want to emphasize her literal personification of Black female cool. Today in historical accounts, Franklin's "Respect" has been positioned as an anthem in the midst of the bourgeoning white feminist movement, which it, unintentionally, was. Yet without

the overlap of race and gender, "Respect" would be a different song. Franklin acts as a Black feminist surrogate in her iteration of the song. She is speaking with a Black woman's sensibility and understanding of the world around her. Women generally related to the song, but Black women saw her performance as original to their communities and the women who live in them. It also acknowledged their crushing intersectional experiences with racism and gender and underscores Black women's involvement in a women's movement of their own. Franklin's interpretation of respect is marked with a duality: it speaks to both Black women's marginalized relationship to men as well as within the larger nation. I am pointing to the importance of Franklin's powerful performance as I see the themes presented within *Lemonade* and *A Seat at the Table* as speaking to Black women in analogous ways.

The evidence of the symbiotic influence of Black feminism and Black female cool can be seen in blues, jazz, soul, and the genre-bending funk of the 1970s. At a panel discussion shortly after Prince's death, music journalist Carol Cooper remarked that she had not seen an audience aesthetically reflecting an artist the way that Prince's did since the vocal group Labelle. She cited their 1974 "Wear Something Silver" concert, which was the first appearance of a Black pop group at New York City's Metropolitan Opera House (Cooper 2016; see Figure 1.4). Labelle, formerly known as the Bluebells, had incubated their new look and image in Europe. Their former persona was that of a more soulful Motown-style girl group, which originally included Cindy Birdsong, who left to join the Supremes,

FIGURE 1.4 Labelle, *Something Silver* (Warner Bros, 2011). This compilation is an ode to the music released by Labelle during the "Something Silver" period, between 1971 and 1974. The cover photograph is an overwhelming example of their femme Afrofuturism.

as well as Patti Labelle, Nona Gaye, and Sarah Dash. In their performative and sartorial style, they had stayed securely in the boundaries of American femininity. Their new incarnation, however, was a response to changing times and shredded those boundaries. Labelle pioneered a feminist Afrofuturism. The vocalists were sensually clad in outrageous outfits that spanned leather to chain mail to feathers. They helped to shepherd in an era of female empowerment music. Their cultural productions showed value for Black women's aesthetic labor. Contemplating this as well as their sound and image, Labelle centered women and women's issues in a way that had not been done before. This was their endowment to Black female cool, and, in short order, American cool.

Their performances exerted a defining influence on their multicultural, multigenerational, and multigendered fans. Nona Gaye, daughter of Marvin Gaye and a Labelle fan, described the audience as a motley crew of "Bloomingdale's blacks, lots of gay people, young college hippie freaks, some Spanish-speaking people and even some old people like our parents" (Davis 1974). They showed up and mixed with the buttoned-up Met crowd in midtown New York wearing all shades of chromium. Silver-sprayed hair, chunky silver boots, even silver fur could be spied in the monochromatic audience. This appearance was only two years from Labelle's apex. They disbanded in 1976 (Rockwell 1974). The contours that they gave to seventies music and Black female cool across several genres generally remain unidentified beyond mention by a few music journalists and historians. In a similar treatment, the avant-garde funkster Betty Davis, a musical contemporary of Labelle, has only recently been recovered. Both Davis and Labelle, like many other Black woman artists before them, suffered from the extreme expectations of femininity and the fallout of the politics of respectability. Nonetheless, they carried on Black feminist surrogacy for a diverse population of Black women. Because of the third space that African American women often occupy in American society, they can deploy cultural products and engage in sociopolitical activism in unexpected and unconventional forms. Artists in the lineage of Black female cool, such as Beyoncé and Solange, reside at the intersection of gender, race, cultural production, and sometimes the activism of political and cultural movements.

SITES OF BLACK FEMINISM IN THE CULTURAL
PRODUCTION OF BEYONCÉ AND SOLANGE KNOWLES

"The past and the future meet us here."

Warsan Shire, quoted in Lemonade

Static definitions of feminism, Black feminism, and womanism are imperfect when detailing the Black woman's long history of centering and advocating for women as whole, worthy, and equal people in the world. All of this practiced within particular, and often intersectionally oppressive, historical circumstances requires malleability. In *Feminism Is for Everybody*, bell hooks reiterates her succinct definition of feminism as "a movement to end sexism, sexist exploitation, and oppression" (2000a, ix). She implores men and women to "come closer" to feminism and to exchange sexist thought for feminist thought and action (2000a). In her much-discussed May 2016 blog post, "Moving beyond Pain," she critiques *Lemonade* for what she sees as antifeminist capitalist commodification of the Black female body and Black female pain (hooks 2016). Despite this assessment, many other Black feminists saw the albums (visual and sonic) as contributing to a "movement to end sexism" and occupying a space within the long processes of replacing sexist thought with "feminist thought and action."

Brittney Cooper, for example, counters hooks's assessment. She insists that "feminism needed Beyoncé." Cooper sees her as being a more honest example of how "hard it is for Black women to get on the same page than any . . . professional feminists." She adds, "After Beyoncé feminism was no longer something reserved for Black girls with college degrees and PhDs . . . this Black girl who'd built a singing career . . . could be a feminist. And she would use her considerable cultural power to spread the gospel of feminism to the masses" (Cooper 2017, 30–31).

In *Beyoncé in Formation: Remixing Black Feminism*, scholar Omise'eke Natasha Tinsley also questions the limiting of Black feminism. She writes, "Black feminism isn't a dogma with tenets every good feminist has to adhere to on pain of expulsion. There are as many ways to be a black feminist as to be a person, and the fact other black feminists disagree with some of Beyoncé's positions demonstrates how rich black feminism is" (2018, 8).

Whatever her brand, Beyoncé's Black feminism speaks to a wide base of Black women and rests heavily on her embodiment of Black female cool. Like women in the lineage of Black cool before them, both Beyoncé and Solange Knowles have used their albums and the accompanying stages as locations of Black women's

agency as connected to sexuality, expression, commerce, and self-definition. These albums also speak to the ways in which feminism is complicated by Blackness and reoriented by Black modes of feminism. Each sister walks in the line of women who employed Black feminism as, again, an organic survival and activist strategy and a natural extension of their experiences and worldview.

Beyoncé

As sometimes portrayed in the national press as Black-girl-next-door-meets-vixen, Beyoncé's creative production shows her to be much more nuanced. In 2008, she discussed her employment of an alter ego, Sasha Fierce, through which she channels her larger-than-life onstage persona. The same year, during an interview with Oprah Winfrey, she explained that her newly released two-disc album, *I Am . . . Sasha Fierce* reflected two sides of herself, with the first disc, *I am*, being closer to her authentic self and, the second disc, *Sasha*, as her onstage musical persona (Oprah 2008). She explained further that Sasha "takes over when it's time for me to work and when I'm on stage; this alter ego that I've created that kind of protects me and who I really am" (du Lac 2008). Sasha is the executor of the slay.

This was a rare glimpse into Beyoncé's view of her personas. Normally, the use of a stage persona is common among performers. However, in his article, "The Impersona of Lena Horne" (2008), cultural studies scholar Shane Vogel discussed how African American women performers have used personas simultaneously as sites of endurance and power. Beyoncé's clarity on her split personas shows that she has an appreciation of the costs of assertiveness, sensuality, and acts of self-definition for women in her community. For an African American female performer who has reached the heights of celebrity that Beyoncé has or that Horne had, it takes on additional significance. Knowingly or not, Beyoncé carries, as a surrogate, a shield for Black women. In her cultural production, they are awarded humanity and multiplicity. This complex discourse did not begin with *Lemonade*. It only represents a more pointed and timely conversation about Black female exteriority and interiority. Its candid rawness aligns historically with Black female cool.

In the following close readings, I interrogate the ways in which *Lemonade* and *A Seat at the Table* function as Black feminist cultural texts that center Black women and Black womanhood.

LEMONADE

"If we're going to heal let it be glorious / One thousand girls
raise their arms."

Warsan Shire, quoted in Lemonade

In 1972 Esther Phillips entered Rockefeller Plaza where her record label was headquartered. She wore a full-length mink coat that concealed a bat because she was on a mission to be paid money she was owed from her recordings.[3] She approached the secretary demanding payment and after being put off threatened to "break up the place." She continued, "I pay the rent on this fuckin' office, bitch. My records pay your wages . . . and I'm not leavin' 'til I get a goddam check!" She left shortly after with a check in hand (Nathan 1999, 101–2). This scene has a sister in the visual accompaniment to Beyoncé's "Hold Up" on *Lemonade*. The sensibility is the same. "Hold Up" represents the Black female character coming to grips with her mate's infidelity. She wields a bat as she struts down the street breaking car windows as onlookers witness her abandon. Both episodes evoke Black women's irreverent self-definition and self-determination. The violent possibilities of a bat are off-putting. However, the rage at the all-encompassing systems of oppression facing Black women can be understood.

Real-life Phillips and the character Beyoncé embodies are shaping their own realities and futures in their unswerving actions. They get results—one a check for her labor, the other a venting of Black woman's anger so often demonized by white society. Doing so while decked out in a luxurious mink and a yellow Roberto Cavalli dress, respectively, emphasizes their control over their own unapologetic self-defining (Figure 1.5).

Collins explains that society often discounts the ability of Black women to clearly see their own oppression and be advocates for their own humanity and worth (Collins 1989, 746). This is clearly not the fate of Phillips and Beyoncé's characters. These scenes prove the power of the slay in Black female cool. Through their mastery of the slay, they position themselves as inimitable cultural producers; then they wield it as an instrument to get what they desire and need.

A walk-through of both visual and sonic *Lemonade* educes the centrality of a Black feminist consciousness and the honoring of the stores of knowledge from which it arises. During the song "Freedom" and near the close of the visual *Lemonade* album, a group of African American women cook together, set the table,

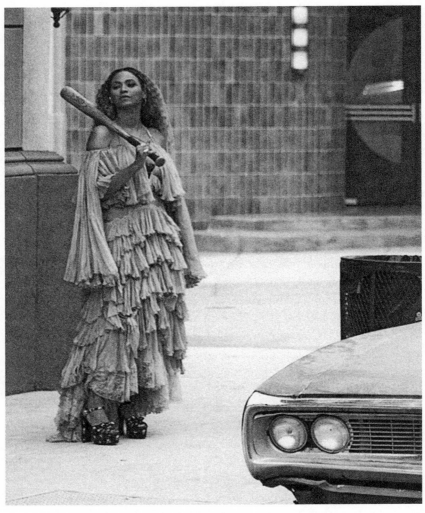

FIGURE 1.5 Beyoncé in her video for "Hold Up" (2016) wearing a yellow
Robert Cavalli dress, wielding a bat, and demonstrating the Black feminist traits
of self-determination and self-definition.

and sit down to eat. Beyoncé and her collaborators literally and figuratively give Black women a seat at the table. In conversation with author dream hampton, Regina Bradley reflects how she was moved by Black women "having a seat at the table that [they] have been preparing for others" (2016). This is one place in which Beyoncé is in conversation with Solange's album of the same name. Read as a text, Beyoncé's album calls America to account for its treatment of Black people in general and Black women in particular. It also reminds Black women that they can always find the healing they need within the circle of Black womanhood.

In relationship to this consciousness, *Lemonade*'s cool is female and ancestral. It traces its backward path through the South and to Africa. It is bone Black. One writer noted that it is not just "a curation of the blues woman aesthetic but an active reckoning with it as manifested in southern spaces" (Bradley 2016). Beyoncé wants viewers to take in Black Southern beauty in its fullness rather than ignore or deride it in the way of American culture. Beyond visual aesthetics Beyoncé borrows from Southern blues women, such as Memphis Minnie, to construct her sound. Led Zeppelin's 1971 remake of Minnie's early hit, "When the Levee Breaks," is sampled in *Lemonade*'s "Don't Hurt Yourself." This sample works on many levels as the original composition referenced the Great Mississippi Flood of 1927 that badly damaged Louisiana, as Hurricane Katrina would in 2005 (Garon and Garon 1992, 39). Katrina and its devastation are purposefully referenced many times throughout the album, visually and sonically. The inclusion of this sample also acknowledges the stature of Memphis Minnie, an admired blues guitar innovator whose talents superseded gender and her place in the canon of Black female cool. There is little doubt that Beyoncé recognized herself in this Southern blues woman in both the geographical and popular spaces she occupied.

Throughout *Lemonade,* Beyoncé, like her sister, centers Black women's interior intracommunal conversation as a resistance to white hegemonic dominance and repression. The film uses different vantage points and sifts through generations, centuries, economic classes, locales, and geographical landscapes, calling up an array of emotions and truths for African American women. It is a healing space that stretches far beyond romantic relationships. The album is formed around eleven stages of recovery for Beyoncé's character who has experienced infidelity: intuition, denial, anger, apathy, emptiness, accountability, reformation, forgiveness, resurrection, hope, and redemption. There is also a twelfth stage, formation.

Formation calls on Black women, and Black people, to "get in formation" for the work to come. One form of the therapy used in "Formation" is the reliance on

Black female cool, which can be seen throughout the video. Directed by Melina Matsoukas, it has pointed messages about women and their power. Beyoncé sings, "I see it, I want it, I stunt, yellow bone it / I dream it, I work hard, I grind 'til I own it / I twirl on them haters" ("Formation" 2016). An army of women fills the scenes. Some are Beyoncé's all-female dance troupe, others everyday Black women in New Orleans. The message is about what these women can achieve, what they desire, and that they are the locus of influence and authority. Cultural critic Jenna Worthman described "Formation" as "a dab in a video form, playing on a loop" (Caramanica, Morris, and Worthman 2016). She is referring to a dance move out of Black Atlanta in which dancers suddenly bow their head into their elbow in a show of confidence and cool.

The ending of the video also nods affirmatively to Black female cool. Matsoukas says that the final scene was originally going to be the one in which Beyoncé sinks into the water atop a New Orleans police car. The director wanted to end it showing how the police and other governmental apparatuses had not "shown up for us." After reviewing the film, Beyoncé wanted to end with something more empowering and uplifting, and so Matsoukas incorporated a "'black-girl air grab,' an incisive gesture made with your forearm upright as your fingers stretch to toward the ceiling and close in a fist" (Okeowo 2017). The subtext of this final act of cool denotes the Black women's ultimate power to change their own circumstances and that of their community. Again, and again, Black women and their agency are the center of the narrative in *Lemonade* as is their cool.

Solange

On August 27, 2008, during her tour for her second album, *Sol-Angel and the Hadley St. Dreams*, Solange confronted two Fox News reporters for making remarks about her brother-in-law, Jay-Z, at the top of her interview. The Black female interviewer insisted that the comments were spoken off camera. In response to the clapback, a white male anchor closed the segment by intentionally mispronouncing Solange's name and saying, "She was promoting her new album, whatever it's called, nobody cares, and it's going to be in stores, not that any of you care. What a little brat!" ("Behind the Music" 2008). This harsh rebuke seemed to be acceptable for the show, network, and interviewer as they uncomfortably laugh and move on to the next topic. One can only imagine that the interviewing of celebrities often involves all kinds of unpredictable reactions to questions asked. However, Solange's treatment, in what she saw as a defense of herself and

her family, is handled with exception and met with anger and palpable disdain in a white hegemonic society. She is too often seen in the media as simply Beyoncé's sister; however, as an artist, Solange has been creating distinctive music and aesthetics as a part of an interchange with the discussed lineage. Much of her work has been independent and free of the confinement of major labels. Even a quick review of her bourgeoning catalog demonstrates her engagement with many of the themes that arise in *A Seat at the Table*, as well as the contours of Black female cool. This album takes it further.

A SEAT AT THE TABLE

Solange's album, *A Seat at the Table*, is a result of both the evolution of Black cool and later experimentations within this aesthetic (Figure 1.6). More important, Solange's work incorporates the ancestral and sociopolitical outlook of her foremothers.

Solange converses directly with an avant-garde Black female cool with mid-twentieth-century roots. In various interviews, she has disclosed that one of her inspirations was another beacon in the lineage of Black female cool, harpist Alice Coltrane. Solange explained to one interviewer, "I kind of wanted to channel her transcendence to some of those frequencies that really puncture you and give release" (Hrishikesh 2016). The correlation to the serenity, spirituality, and resonating musicianship of Coltrane is evident in *A Seat at the Table*.

Solange's sociopolitical concerns, as well as musical interventions within Black female cool, mirror those of Abbey Lincoln. Like *Straight Ahead*, *A Seat at the Table* is textured and experimental but also devoid of the seemingly mod-

FIGURE 1.6 Solange, *A Seat at the Table* (Saint Records and Columbia Records, 2016). The cover of Solange's third album reflects her experimental Black female cool aesthetic.

ern popular music tendency for overproduction. The twenty-one-track album contains songs interlaced with interviews. The intent of the project is seen in her track list beginning with "Rise" and ending with "Scales." The song list and interludes form an arc that explores Black life. Songs such as, "Don't Touch My Hair," "Mad," and "F.U.B.U." (For Us by Us) explicitly communicate a response to white supremacy and its fallout for African Americans. She uses the album and its connected soundscape and aesthetics as a site of contestation and resistance to larger systems of white supremacy and patriarchy (Knowles 2016). Solange saw the album as "a project on identity, empowerment, independence, grief and healing." In short, this project was a continuing of the "slay" as in breaking down and remaking (Hirway 2016).

Solange has described this album as a response to the racial oppression that violently weighs on Black America. This violence takes many forms as expressed in her work. The very concept of the album was in part a reaction to the marginalization of Black female cool by white cultural critics. In January 2013, Solange wrote about her love and appreciation of the 1990s R&B singer Brandy and reacted to the many negative remarks of the so-called Indie white guys by imploring music blogs to hire writers who "REALLY understand the culture of R & B." An encounter with music writer Jon Caramanica reinforced this for her. Soon after the Twitter storm, she was asked to be part of a podcast panel that she saw as steeped in "cultural tourism." She declined. When the podcast aired, Caramanica commented that in his experience, much of Solange's concert audience was white, and he advised, "I'd be careful not to bite the hand that feeds me." Solange responded in a podcast with cultural critic Helga Davis by saying, "That was kind of the turning point in the transition for me writing the album that is now 'A Seat at the Table.' . . . it haunted me . . . and also the racial subtleties—are not so subtle—of what that encompasses when you say that to a Black woman. Then you connect it by saying 'Do you know who's buying your records?' So, I was essentially being told to shut up" (Davis 2017). Solange is referring to the support of hegemony by white music critics who are participating in the practice, hundreds of years old, of policing Black women's bodies and resistance. These critics remain attached to power structures that enable the ultimate evaluation and control of modes of production and reception contexts that seek to keep Black women beholden to the drives of white institutional markets.

The song on the album that responds to this episode is "Don't You Wait." She sings, "Now, I don't want to bite the hand that'll show me the other side, no / But I didn't want to build the land that has fed you your whole life, no / Don't

you find it funny?" (Solange 2016). She gives credit to Black people for building the country through enslaved, uncompensated labor and performatively upends the false power relationship implied by the white reviewer. As Hill Collins points out, Black women's viewpoint of reality is based on their intersectional positioning. Her sociopolitical line of sight is broader and more critical (2000). As such, in her song, Solange raises the specter of Black contribution, Black labor, and the many unacknowledged ways that white America benefits from them. Black female cool is only one overlooked form of labor and contribution by Black women. From his location, the white reviewer has limitations in his understanding of this. Solange remedies that.

In response to her outspokenness and cultural activism, one reporter labeled Solange "the patron saint of black women" (Valdes 2017). They surely are in need of one. The treatment of Sandra Bland and, more recently, Chikesia Clemons represents the extent of America's animosity toward and discomfort with the Black woman's body. Sandra Bland was pulled over in Waller County, Texas, in 2015 by a police officer for failure to signal a lane change. His already overly aggressive interaction with her was heightened by her own assertion of her rights. Bland was violently removed from her car, thrown to the ground, and arrested. Throughout the arrest, Bland voiced her protest and repeated her rights. She was booked and jailed. She died in custody three days later (Montgomery 2015).

Chikesia Clemons also had a confrontation with police when she went with friends to eat at a Saraland, Alabama, Waffle House. After complaining to servers about the charge for take-away plastic utensils, an argument ensued and the police were called. She, like Bland, protested and asserted her rights. This seemingly low-level incident escalated to Clemons's violent arrest. Her halter dress was stripped from her, she was pushed face down and topless as she was handcuffed, and then was taken away (Horton 2017). Both women can be heard asking, "What did I do?" This is a question that should be asked of the larger society. What could they have done to receive such treatment? How do they survive in a hostile environment such as this? Herein lies the importance of *A Seat at the Table* and *Lemonade*—for that matter, a place that is dedicated to the veneration of Black women. As these two cases demonstrate, as do so many others, it is no small thing to venerate Black women and for them to self-venerate.

Solange's album confronts this directly. She explains:

I started to see the . . . black artists who made work about blackness and what it felt like to feel this black body and occupy space in a country that still does

not value our black bodies at the level and place that they should be. That people . . . can be comfortable with you telling your stories through your art . . . but really uncomfortable with you talking about it outside of that context.

She points out how she began to be targeted once she became more vocal about the social conditions that African Americans experience (Davis 2016). As she crosshatches Black female cool with an activist Black feminism, she is perceived as a threat to the status quo. The work of claiming a seat at the table is meaningful. The allegory of "a seat at the table" is apropos for the legacy of Black female cool as well. It operates from the same locations of self-definition and self-determination. It has forced the spotlight on African American women's contributions even as they were quickly subsumed and minimized. By enlisting and connecting with the legacy of feminist cool, Black women force America to acknowledge the important cultural, social, and political spaces that they fill.

Of the twenty tracks on the album, Solange has described "Cranes in the Sky" as directly pointing to the overarching weight of racial oppression. The lyrics insist, "It's like cranes in the sky / sometimes I don't wanna feel those metal clouds." The oppression is hard to evade. She lists the ways in which she attempts to lessen the burden: "I tried to drink it away / I tried to put one in the air / I tried to dance it away." Her breakdown of the meaning of the lyrics also points to the crucial role of protector that African American women play for each other and their community. The end of the song says, "I tried . . . write it away or cry it away." There is a response: "(don't you cry it baby)" (Solange 2016). Solange describes this lyric as relating a "sense of community," a community of supportive Black women. She explains that this specifically represented her mother and aunts "in three-part harmony" as they encouraged her to push past pain and disappointment. This was also encouragement to "get your ass up!" Interestingly, she adds that her repetition of the phrase "away, away, away, away, away" near the end of the song was intended to feel like "a group of women relating this awayness" (Hirway 2017). In addition to its formidable musical interventions and accompanying innovative aesthetics, "Cranes in the Sky" becomes a medium for Black feminist consciousness and posits Black female cool as fundamental to liberation.

CONCLUSION: THIS *IS* BLACK FEMALE COOL

"I just might get your song played on the radio station."

Beyoncé, "Formation"

Beyoncé won the award for best urban contemporary album at the 2017 Grammys for *Lemonade*. In her acceptance speech, she explained, "My intention for the film and album was to create a body of work that would give a voice to our pain, our struggles, our darkness and our history" (Horvitz 2017). She speaks bluntly to Black America, and even more directly to Black women. Her album, and her sister's album, communicate what so many forget about them: that they have Black Southern roots and were nurtured by Black women in their immediate family and in their modes of artistry. Each has spoken about this repeatedly in interviews. Coupled with this is their reliance on family with a focus on motherhood, as daughters to their mother, Tina Knowles, and in their own roles as mothers to their children, as well as commitments to sisterhood, as seen in their close relationship to each other and other Black women. They have also repeatedly acknowledged their connections to their musical women forebears. This is no overstatement. From Beyoncé's controversial homage to Josephine Baker at the 2006 Fashion Rocks show to Solange's homages to Alice Coltrane, they make us aware of their creative antecedents. More than anyone else, the sisters posit themselves as part of a lineage of Black feminist cool. Both *Lemonade* and *A Seat at the Table* attest to this. Because of these associations, both albums visually and sonically operate as sites of Black feminism and Black feminist consciousness. These productions are overwhelmed with illustrations of both.

Beyoncé's 2018 performance as the first Black women to headline the Coachella Festival was likely moored in Black female cool. This lauded annual music festival is often wrought with racial insensitivity and cultural appropriation. To it, Beyoncé brought an unprecedented Black pageant. Paid for out of her own budget, her over-the-top production included over one hundred Black performers in marching band military formation. The singer was inspired by the elaborate half-time shows found at historically Black colleges and universities (Penrice 2018). She explained, "I wanted a Black orchestra. I wanted the steppers. I needed the vocalists. . . . I wanted different characters. I didn't want us all doing the same thing . . . the amount of swag is just limitless . . . so much damn swag" (*Homecoming* 2018). I think *slay* can be emphasized and read here as well.

She begins the show by entering the stage wearing an Egyptian crown, flanked

by dozens of female dancers in bodysuits emblazoned with the image of King Tut. She connected Ancient African Blackness to modern African American Blackness, and it only gets Blacker from there. The interweaving of speeches by Malcolm X and Nina Simone, as well as the singing of the Black national anthem, "Lift Every Voice and Sing," signaled Beyoncé's efforts to send a message to African Americans about their rich history and momentous cultural contributions. A dance break with her sister, Solange, included a Black girl game of patty cake and reminded us of Black feminism and the centrality of sisterhood (both literal and figurative). The two-hour show included Black cultural hallmarks that many audience members may have missed. Surely it mystified some watchers with its unfettered reliance on Black female cool. Beyoncé's show acknowledges that the cool is complicated and reoriented by the experience of slavery and dispersal, yet despite this, it survives. It continues to act, beyond aesthetic expression, as a place of shelter for Black people within the diasporas. Both *Lemonade* and *A Seat at the Table* emanate from this view of reality; both act as forms of resistance, and both engage with a Black feminist consciousness. The sisters confront a set of Black realities and layer contemporary interpretations onto the foundations of Black feminism and Black female cool. The forms of oppression and the exclusionary cultural norms that they call attention to are much the same, as experienced by Black women.

Recalling Helena Andrews's insistence that Black cool is "always looking forward" (in Walker 2012, 35), we can discern the urgency of the current cool expression in both Solange and Beyoncé's albums, aesthetic productions, and political interrogations. They unabashedly imbue their art with a Black woman's ethos and are looking to the future. Within their social awareness and artistic evolutions, we can see the push to hold America accountable and remind Black people of who they are as a historical and contemporary people. This may place Beyoncé and Solange in the lineage of Black cool even more than their other previously established linkages. With their feminist Black cool musical and aesthetic strategies and their brands of slay, the Knowles sisters just might get your record played on the radio station.

NOTES

1. Hazel V. Carby's "'It Jus Be's Dat Way Sometime': The Sexual Politics of Women's Blues" (1987) is an essential exploration of women in blues. Another pivotal contribution to the Black feminist literature of Blues women is *Black Pearls: Blues Queens of the*

1920's by Daphne Harrison (1988). She examines many unsung Blues women and their tremendous contributions to Blues music and the social and political backdrops they find themselves.

2. An exemplar of Beyoncé's hard work, in the spirit of Smith, was in the production of her fifth album, *Beyoncé*, and its accompanying seventeen-part visual album, all made in the midst of her 132-day Mrs. Carter World Tour in 2013 Remarkably, this was all done through her own Parkwood Entertainment Company. This is discussed in Rachel Kaadzi Ghansah's article, "How Sweet It Is to Be Loved by You: The Beyhive" (2014).

3. Phillips's contributions to Black female cool were respected by her peers in the music industry. They saw her as a singer to be revered. This was so much the case that Aretha Franklin, the anointed queen of soul, ceded her 1974 Grammy to Phillips, believing that her album, *From a Whisper to a Scream*, was more deserving of album of the year than her own.

REFERENCES

Albertson, Chris. 2003. *Bessie*. Rev. and expanded ed. New Haven: Yale University Press.

"Behind the Music." 2008. In *More Las Vegas*. Las Vegas: Fox News Network, August 27.

Beyoncé. 2016. *Lemonade*. Parkwood, Columbia.

———. 2017. "Solange." *Interview Magazine*, January 10. https://www.interviewmagazine.com/music/solange.

———. 2019. *Homecoming: A Film by Beyoncé*. Parkwood Entertainment.

Bradley, Regina, and Dream Hampton. 2016. "Close to Home: A Conversation about Beyoncé's *Lemonade*." *Record*, April 26. https://www.npr.org/sections/therecord/2016/04/26/475629479/close-to-home-a-conversation-about-beyonc-s-lemonade.

Brooks, Daphne A. 2008. "'All That You Can't Leave Behind': Black Female Soul Singing and the Politics of Surrogation in the Age of Catastrophe." *Meridians* 8, no. 1: 180–204.

Caramanica, Jon, Wesley Morris, and Jenna Wortham. 2016. "Beyoncé in 'Formation': Entertainer, Activist, Both?" *New York Times*, February 6. https://www.nytimes.com/2016/02/07/arts/music/beyonce-formation-super-bowl-video.html.

Carby, Hazel V. 1987. "'It Jus Be's Dat Way Sometime': The Sexual Politics of Women's Blues." *Radical America* 20, no. 4: 8.

Colbert, Soyica Diggs. 2017. *Black Movements: Performance and Cultural Politics*. New Brunswick, NJ: Rutgers University Press.

Collins, Patricia Hill. 2000. *Black Feminist Thought: Knowledge, Consciousness, and the Politics of Empowerment*. Rev. 10th anniversary ed. New York: Routledge.

———. 1989. "The Social Construction of Black Feminist Thought." *Signs* 14, no. 4: 745–73.

Cooper, Brittney C. 2018. *Eloquent Rage: A Black Feminist Discovers Her Superpower*. New York: St. Martin's Press.

Cooper, Carol. 2016. "Remembering Prince: Reflections on the Life and Legacy of a Musical Genius." Paper presented at Remembering Prince: Reflections on the Life and Legacy of a Musical Genius, New York, April 29.

Davis, Angela Y. 1999. *Blues Legacies and Black Feminism: Gertrude "Ma" Rainey, Bessie Smith and Billie Holiday*. New York: Vintage.

Davis, Curt. 1974. "Rock N' Soulers Labelle Play the Met, Yet." *People*. https://people.com /archive/rock-n-soulers-labelle-play-the-met-yet-vol-2-no-17/.

Davis, Helga. 2016. "Solange, Cranes in the Sky." *Song Exploder*. Podcast audio, December 5. https://www.newsounds.org/story/singer-solange/.

du Lac, Freedom. 2008. "Beyonce's I Am . . . Sasha Fierce." *Washington Post*, November 17. http://www.washingtonpost.com/wp-dyn/content/article/2008/11/17 /AR2008111703099.html?noredirect=on.

Feldstein, Ruth. 2005. "'I Don't Trust You Anymore': Nina Simone, Culture, and Black Activism in the 1960's." *Journal of American History* 91, no. 4: 1349–79.

———. 2013. *How It Feels to Be Free: Black Women Entertainers and the Civil Rights Movement*. New York: Oxford University Press.

"The 500 Greatest Songs of All Time." 2004. *Rolling Stone*, December 9.

Ford, Tanisha C. 2015. *Liberated Threads: Black Women, Style, and the Global Politics of Soul*. Chapel Hill: University of North Carolina Press.

Garon, Paul, and Beth Garon. 1992. *Woman with Guitar: Memphis Minnie's Blues*. Boston: Da Capo Press.

Ghansah, Rachel Kaadzi. 2014. "How Sweet It Is to Be Loved by You: The Beyhive." *Record*, March 17. https://www.npr.org/sections/therecord/2014/03/17/258155902/how-sweet -it-is-to-be-loved-by-you-the-beyhive.

Gould, Jonathan. 2017. *Otis Redding: An Unfinished Life*. New York: Crown.

Harrison, Daphne Duval. 1988. *Black Pearls: Blues Queens of the 1920s*. New Brunswick, NJ: Rutgers University Press.

Hentoff, Nat. 1961. Liner notes to *Straight Ahead*, edited by Abbey Lincoln. New York: Candid.

Hirway, Hrishikesh. 2017. "Solange." *Song Exploder*. Podcast audio, October 26. https:// soundcloud.com/hrishihirway/song-exploder-solange.

hooks, bell. 2000a. *Feminism Is for Everybody: Passionate Politics*. Boston: South End Press.

———. 2000b. *Feminist Theory: From Margin to Center*, 2nd ed. Boston: South End Press.

———. 2016. "Moving Beyond Pain." Bell Hooks Institute, March 16. http://www.bell hooksinstitute.com/blog/2016/5/9/moving-beyond-pain.

Horton, Alex. 2017. "A Woman Was Tackled by Officers at an Alabama Waffle House. Police Are Defending the Arrest." *Washington Post*, April 24. https://www.washing tonpost.com/news/business/wp/2018/04/23/police-wrestled-a-black-woman-to-the

-ground-exposing-her-breasts-in-restaurant-video-shows/?noredirect=on&utm
_term=.91cfb3d985f0.

Horvitz, Louis. 2017. "59th Annual Grammy Awards." Directed by Louis Horvitz. CBS. February 12.

"Jazz Profile: Abbey Lincoln." 2010. *Jazz Profiles*. NPR. August 17. https://www.npr.org /programs/jazzprofiles/archive/lincoln.html.

Jefferson, Margo. 1973. "Ripping Off Black Music." *Harper's Magazine* (January), 40–45.

Jones, Melanie C. 2019. "The *slay* Factor: Beyoncé Unleashing the Black Feminine Divine in a Blaze of Glory." In *The Lemonade Reader*, edited by Kinitra D. Brooks and Kameelah L. Martin, 98–110. New York: Routledge.

Knowles, Beyoncé, Asheton Hogan, Michael Williams, and Khalif Brown. 2016. "Formation." In *Lemonade*. Parkwood Entertainment, Columbia Records.

Knowles, Solange. 2016. *A Seat at the Table*. Saint Records, Columbia Columbia Records..

Knowles, Solange, and Raphael Saadiq. 2016. "Cranes in the Sky." In *A Seat at the Table*, Saint Records, Columbia Records.

Knowles, Solange, Sampha Sisay, and Adelekan Olugbenga. 2016. "Don't Wait." In *A Seat at the Table*. Saint Records, Columbia Records.

Laneri, Raquel. 2018. "How a Harlem Fashion Show Started the 'Black Is Beautiful' Movement." *New York Post*, February 5. https://nypost.com/2018/02/05/how-a-harlem -fashion-show-started-the-black-is-beautiful-movement/.

Lincoln, Abbey. 1961. *Straight Ahead*. Jazzman, gistributed by First American Records. Sound recording, JAZ 5043 Jazz Man.

Mahon, Maureen. 2011. "Listening for Willie Mae `Big Mama' Thornton's Voice: The Sound of Race and Gender Transgressions in Rock and Roll." *Women and Music: A Journal of Gender and Culture* 15:1–17.

Mechanic, Jesse. 2017. "Katy Perry's Cultural Appropriation Meat Grinder." *HuffPost*, May 23. https://www.huffingtonpost.com/entry/examining-katy-perrys-cultural-appropria tion-meat_us_592464ebe4b0e8f558bb2a3a.

Montgomery, David. 2015. "New Details Released on Sandra Bland's Death in Texas Jail." *New York Times*, July 20. https://www.nytimes.com/2015/07/21/us/new-details-released -in-sandra-blands-death-in-texas-jail.html?smid=fb-nytimes&smtyp=cur.

Nathan, David. 1999. *The Soulful Divas: Personal Portraits of over a Dozen Divine Divas, from Nina Simone, Aretha Franklin and Diana Ross to Patti Labelle, Whitney Houston and Janet Jackson*. New York: Billboard Books.

Okeowo, Alexis. 2017. "The Provocateur behind Beyoncé, Rihanna, and Issa Rae: How the Director Melina Matsoukas Helps Female Artists Reinvent Themselves." *New Yorker*, March 6. https://www.newyorker.com/magazine/2017/03/06/the-provocateur-behind -beyonce-rihanna-and-issa-rae.

Penrice, Ronda. 2018. "Beyonce's Coachella Was an Unprecedented Black Cultural Influence in America." *NBC News*, April 16. https://www.nbcnews.com/think/opinion /beyonc-s-coachella-performance-was-unprecedented-celebration-black-cultural -influence-ncna866326.

Rockwell, John. 1974. "The Pop Life." *New York Times*, October 11.

Scott, Michelle R. 2005. *Blues Empress in Black Chattanooga: Bessie Smith and the Emerging Urban South*. Urbana: University of Illinois Pres.

Thompson, Robert Farris. 2011. *Aesthetic of the Cool: Afro-Atlantic Art and Music*. New York: Periscope Publishing.

"Thornton, Willie Mae 'Big Mama.'" 2008. In *the New Encyclopedia of Southern Culture*, edited by Bill C. Malone, 370. Chapel Hill: University of North Carolina Press.

Tinsley, Omise'eke Natasha. 2018. *Beyoncé in Formation: Remixing Black Feminism*. Austin: University of Texas Press.

Valdes, Mimi. 2017. "Solange Knowles Shows Us All What Can Happen When a Woman Finds Her Purpose." *Glamour* (December).

Vogel, Shane. 2008. "Lena Horne's Impersona." *Camera Obscura* 67:11–44.

Walker, Rebecca, and Henry Louis Gates. 2012. *Black Cool: One Thousand Streams of Blackness*. Berkeley: Soft Skull Press.

Williams, Sherley Anne. 1991. "Returning to the Blues: Esther Phillips and Contemporary Blues Culture." *Callaloo* 14, no. 4: 816–28.

Williams, Stereo. 2017. "Miley Cyrus' Gross Racial Tourism." *Daily Beast*, May 17. https:// www.thedailybeast.com/miley-cyrus-gross-racial-tourism.

Winfrey, Oprah. 2008. "The Oprah Winfrey Show." In *Beyoncé*, 60 minutes, November 18.

Zoladz, Lindsay. 2017. "Taylor Swift Stakes Her 'Reputation' on Big Sounds and Petty Grievances." *Ringer*, November 10. https://www.theringer.com/music/2017/11/10/16633196 /taylor-swift-reputation-review.

CIENNA DAVIS

2. From Colorism to Conjurings
Tracing the Dust in Beyoncé's *Lemonade*

Beyoncé represents a controversial, popular figure of gender, sexual, racial, and skin color politics. As one of the most successful recording artists of the twenty-first century, her work engages with themes of female empowerment, financial independence, and sisterhood. Her musical and visual catalog evokes her Southern upbringing and dedication to Black culture, but many critics cite her lack of direct engagement with racial politics, her expressed Creole heritage, light skin, and mainstream appeal to call Beyoncé's Black feminist credentials into question. During Black History Month in February 2016, however, the release of Beyoncé's provocative single, "Formation," which evoked Hurricane Katrina to articulate a desire for Black women to "get in formation" against the extrajudicial killings of Black Americans, and her subsequent Super Bowl performance, with its unmistakable homage to the Black Panther Party and Malcolm X, reopened debates about her politics. Praise amassed for Beyoncé's surprisingly direct and confrontational pro-Black, pro-woman message alongside harsher criticisms—some of which decried the pop star as a Black capitalist conveniently appropriating Black suffering for commercial gain (Harris 2016; Lewis 2016; London 2016; Guo 2016; Ball 2016). It is within this context that Beyoncé's sixth studio album and second visual album, *Lemonade* (2016), was released. Drawing comparison to Julie Dash's film *Daughters of the Dust* (1991), this chapter engages conflicting reactions between the "Formation" music video and *Lemonade* visual album, as well as some of Beyoncé's earlier work, to consider the continued role of colorism as it intersects with racism and sexism and to construct exclusionary notions of Blackness that attempt to restrict the expressivity of those considered outside Blackness.

I begin by briefly introducing Black feminism as the theoretical standpoint that guides my research. Considering the significance of *Lemonade* and *Daughters of the Dust* as important Black feminist projects, I draw a parallel between Beyoncé and *Daughters'* most contentious character, Yellow Mary Peazant, to consider the role of complexion in Beyoncé's successful career and in criticisms of "Formation." Finally, using the notion of diasporic melancholia, which scholar Sarah Clark Kaplan (2007) employs to negotiate the scapegoating of skin color against the traumas of slavery, I conclude by affirming Beyoncé's Blackness and her capacity for creating critical and political dialogue in her work, past and present, to acknowledge the significance of both *Lemonade* and "Formation" in Afro-diasporic genealogies of Black womanhood.

BLACK FEMINIST THEORY

Contemporary Black feminist theory emerged out of the failures of the women's movement, the Black liberation movement, and anticapitalist movements to incorporate the perspectives of those with the least political power within the movements, particularly that of Black women living simultaneously under gender, racial, sexual, and class oppression. Black feminism demands an intersectional approach to activism and outreach that acknowledges the interlocking ways in which race, class, gender, and sexuality affect the life outcomes of Black women (Collins 2000, 12, 18, 22). Because Black women cannot rely on the power of whiteness, patriarchy, or generational wealth to elevate their humanity, the revolutionary force behind Black feminism is its necessary impulse to end all forms of oppression (Combahee River Collective 2003).

Daughters and *Lemonade* represent Black feminist approaches to film-making that lovingly elevate the particularity of the Black female experiences in the Southern United States on both systematic and interpersonal levels crossing sexual, class, and skin color lines. Black feminism offers a useful theoretical framework to approach these two projects because it not only affirms the personal narratives and experiences of Black women as valuable and relevant starting points for assessing inequality in the United States but also because its emphasis on intersectionality enables consideration of the impact of colorism on the lives of Black women.

Colorism is often understood to be a highly contentious topic for Black Americans, with many downplaying its social and political impact for the sake of feigning communal harmony. Others fear that the discussion of color prejudice only

magnifies Black America's dirty laundry for further scrutiny (Wilder 2015, 25). Though well intentioned, these efforts leave the real impact of colorism unaddressed. They also silence the experiences of Black women under intracommunal color hierarchies and limit the possibility for intervention. Black feminist theory is an analytic that doesn't accept the redistribution of the "master's tools," or colonial mechanisms of domination, to certain members of oppressed groups that would, for example, enable lighter-skinned Black Americans greater access to the socioeconomic privileges of whiteness at the expense of darker-skinned Black Americans (Lorde 1984). Black feminist theory provides space broad enough for thorough consideration of the differences within the Black community that delimit the potential of all Black subjects. In using this theoretical framework, my research gives attention to multiple levels of oppression relating to sexuality, class, and gender while focusing most closely on the topic of colorism in relation to Beyoncé's performances of racial and gender politics.

LEMONADE AND *DAUGHTERS OF THE DUST*

On April 23, 2016, Beyoncé released her sixth solo album and second visual album, *Lemonade*. It quickly took the world by storm and was met with enthusiastic, shallow, confused, and enraged reviews. On the surface, most mainstream media outlets praised the project as an unmatched musical and cinematic feat, but they anxiously overreported speculations of infidelity surrounding Beyoncé's hip-hop mogul husband, Jay-Z. The Internet obsessed over who "Becky with the good hair" was, while many outside the Black community debated what "good hair" meant (Beyoncé 2016, "Sorry"; Edwards 2016). Sketch comedy show *Saturday Night Live* even spoofed the discomfort of Beyoncé's white fans witnessing their postracial pop queen "turning Black" (SNL 2016; Cashmore 2010). Conservatives raged that Beyoncé's militaristic performances were race baiting, while others jumped to erroneously adopt "Becky" as a racial slur (Suen 2016; Weiss 2016). Even police departments across the United States responded with threats to boycott security work at her concerts (Associated Press 2016).

Meanwhile, Black Twitter exploded in praise of Beyoncé's transition from hip-hop diva to Queen Bey (Rodriguez 2016). Article after article excavated the gems of Black gold buried within Beyoncé's seminal work—from allusions to voodoo, Santeria, Candomblé, orisha, and Egyptian royalty; to the fusion of Victorian and antebellum Southern style with bold Ankara prints and sacred Yoruba body painting; to the wide catalog of Black music forms that Knowles

evoked, including country, Caribbean, rock, and gospel (Evelyn from The Internets 2016; Bale 2016). Among the praise, it was easy to forget the controversy and skepticism surrounding "Formation" just two months earlier, where line-by-line and scene-by-scene dissections positioned Beyoncé as a Black capitalist, appropriating the suffering of Black working-class victims of Hurricane Katrina and Black queer bodies and voices with a convenient and opportunistic pro-Black message (London 2016; Lewis 2016; Rad Fag 2016; Blay 2016). There was a palpable sense that many Black Americans were having difficulty accepting that an attractive, wealthy, light-skinned, Black woman of Creole descent who wears long, blonde weaves could truly comprehend the trauma and suffering of the Black diaspora. While many critiques provided valid insights, underneath the surface of some of these well-meaning critiques were the lingering traces of a long-standing tradition within the United States to delimit not only Black women's potential for self-determination, agency, and transformation but also their capacity to be multidimensional, feeling human beings living through histories of racist and sexist oppression. It is within this intracommunal conflict that I find a compelling connection between *Lemonade* and Julie Dash's ground-breaking film, *Daughters of the Dust.*

Unlike "Formation," *Lemonade* was quickly praised as a modern representation of Black feminism within popular culture. Beyond the raw and revelatory narrative of heartbreak, anger, denial, reconciliation, forgiveness, and transformation, one of *Lemonade*'s most remarkable features is its blatant allusions and even replication of motifs within *Daughters of the Dust*. *Daughters of the Dust* revised the cinematic iconography of Black women of the diaspora as the first film by an African American woman with a theatrical release (Machiorlatti 2005). Twenty-five years later, the seeds of Dash's subversive cinematic feat blossomed into a lemon tree, bearing fruit that Beyoncé's production company, Parkwood Entertainment, squeezed into a refreshing glass of *Lemonade*. The shared setting, narrative content, and styling; the purposeful continuation of African spiritual tradition and cultural forces in the diaspora; and the intense focus on the Black female experience create an unbreakable connection between the two projects that even prompted the digital restoration and theatrical re-release of *Daughters* in 2017 (Murphy 2016). Building on Dash's legacy, Knowles carries *Daughters'* Black feminist message to a new generation of Black women seeking redefinition while simultaneously transporting her massive global audience into the largely uncharted territories of multidimensional Black womanhood.

Daughters of the Dust follows the women of the Peazant family living on Ibo

Landing, a sea island off the Georgia–South Carolina coast. The film's narrative takes place on the eve of the family's departure from the secluded southern islands to the northern states for greater opportunities in the thriving social, cultural, and economic life that was advertised in the emergent twentieth-century United States. During the film, lyrical vignettes portray scenes of preparation for the family's final supper together: the play of the youngest Peazant children along the waves of the ever-present sea that frames their lives; intimate conversations and gossip among women, husband and wife, matriarch and ancestral spirits, unborn child and living family are gracefully strung between composed portraits documenting the family's life before their grand migration to the mainland. While the Peazants enjoy their final hours together on Ibo Landing, the family's matriarch, Nana Peazant, works to ensure her departing family's retention of their spiritual and cultural connection to their African ancestors. Using magic, conjuring, and charms, Nana Peazant ensures the safe arrival of her unborn great-grandchild into the world and creates an eternal connection between her spirit and her descendants.

The film memorably portrays the significance of Black women as the con- veyors, or griots, of ancestral wisdom and familial unity, but relations between the women of the Peazant family are far from harmonious. Conflict emerges at several points throughout the film, but the source of persisting controversy is the return of Yellow Mary Peazant from the mainland to Ibo Landing. On one hand, Yellow Mary "embodies an unashamed black female sexuality that encompasses both exploitation and agency" that the Peazant women struggle to accept despite pleas from the family matriarch (Kaplan 2007). On the other hand, Yellow Mary is marginalized within her family because of her light complexion and the perceived misuse of its endowed privileges. These critical points connect Yellow Mary, the prodigal child, and Beyoncé, the licentious pop star embodying America's post- racial era (Cashmore 2010, 136). I argue that while *Lemonade* may not present the same critique of exclusionary Black womanhood present within *Daughters of the Dust*, disparate reactions to Beyoncé's visual album and the "Formation" music video inadvertently demonstrate the longevity of harmful colorist prejudices that disparage the agency and self-determination of Black women. To absolve this tendency to disregard the relevancy of racial and gender oppression within the lives of lighter-skinned Black women, I employ the framework of diasporic melancholia to forge a new relationship between traumas of the past and the struggles of the present to articulate grievances and express desires for improved Black futures. Through a barrage of Black feminist conjurings, *Lemonade* draws

on the legacy of *Daughters of the Dust* to break through barriers still placed on multihued Black female bodies.

COLOR NAMES AND COLOR NOTIONS

Sociologist JeffriAnne Wilder defines colorism as "the unequal treatment and discrimination of individuals *belonging to the same racial or ethnic minority group* (e.g. African Americans) based upon difference in physical features—most notably skin complexion (color), but also facial features and hair texture" (Wilder 2015, 6). The roots of colorism in the African American community can be traced directly to slavery when designations were made between darker-skinned slaves ("field negroes"), who performed the harshest physical labor in the fields, and lighter-skinned slaves ("house negroes"), who performed domestic labor. Although the "one-drop rule" ensured that mixed-race children of enslaved Black women and white male sexual predators would be racially classified as Black, mixed-race slaves were afforded opportunities not available to those of a darker complexion, including access to their freedom, education, and property. In Louisiana and some other Southern states, those racially mixed individuals with African, European, and Native American ancestry were even able to establish their own communities, which came to constitute a new mixed-race "Creole" class that was viewed as superior to less racially ambiguous Blacks (*Too White* 2007). The continued significance of these demarcations is apparent in the color names Black Americans today use and the notions that we associate with them (Wilder 2015).

In 1946, sociologist Charles Parrish published *Color Names and Color Notions*, a study that explored the names African Americans used to describe their varying complexions. Sixty years later, when executing a similar task with her Black female research subjects, Wilder found that between the two studies, nine color names for light, medium, and dark brown skin tones remained in common use today, including "high yellow," "bright," "light," and "yellow" (Wilder 2015, 69–70). So while *colorism* is a term that has yet to be fully incorporated into everyday Black American language and culture, the color names and notions preserved in the Black community since slavery constitute a commonsense knowledge of color that continues a divisive and psychologically damaging intracommunal regime of color hierarchy (Wilder 2015, 6–7). Wilder's research also reveals how gendered colorism creates an especially unrelenting strain in the lives of Black

women who are crudely sorted within hierarchies of both beauty and Blackness that work to undermine their self-conception and sense of worth.

When asked to share their associations with different terms relating to skin color, Wilder's (2015, 75) research participants confirmed that "blue-black," "purple," "burnt," and other terms associated with darker skin tones were largely attached to negative connotations like "suspicious," "loud," "ghetto," "less intelligent," and "unattractive." In comparison, common terms for lighter skin tones like "redbone" and "high yellow" connoted attractiveness, amiability, and trustworthiness (Wilder 2015, 70). But beyond confirming the continuation of positive and negative attributes with lightness and darkness, respectively, Wilder's discussions (73, 75) demonstrated that darker skin tones were also linked positively with African ancestry and Black pride, while lighter-skinned participants reported a need to overcompensate in order to prove their Blackness. Despite their privileges, lighter-skinned participants shared feelings of constraint, subjection to stereotyping, questions of their identity, and perceptions that they never experienced racial discrimination (Wilder 2015, 73). What became apparent was that only medium-toned Black (or "brown") women were protected within discourses of colorism from the overdetermined expectations and prejudices uniquely reserved for darker- and lighter-skinned Black women (Wilder 2015, 81). To examine color prejudice against lighter-skinned Black women, we return to *Daughters of the Dust*.

The historical prevalence of color names is made apparent through Yellow Mary Peazant in *Daughters*, where "yellow" serves as the verbal pronouncement of the visual difference we see between Mary and her darker-skinned relatives on Ibo Landing. From the moment she appears in the film, Dash decisively portrays Yellow Mary's complexion as a point of contention among the other Peazant women. Almost immediately, Yellow Mary is taunted because of her complexion by her cousin Viola Peazant who, after glancing at Mary's even lighter-skinned companion, Trula, spitefully japes, "Of course, compared to some people, Yellow Mary isn't all that light-skinned." Viola's remark not only comments on the precarious presence of Trula but highlights how color names can be used within Black families as artillery to target phenotypic difference. Acknowledging the women's varying skin tones, Viola's comment attempts to level Mary's otherwise privileged social position by placing Trula, an even lighter woman, at a remote distance from the Peazant family (Cucinella and Curry 2001, 207). In response to this slight, Yellow Mary and Trula conceitedly laugh when Viola tries to engage

them in further conversation. We see, as Viola makes fun of the women's lighter complexions to break through an anticipated superiority complex, the women respond by embracing the stereotype of conceit associated with Black women of lighter complexions (Wilder 2015, 65).

Setting foot on the island, Yellow Mary is met with scornful glances and mocking tones from the Peazant women, who appear fearful, fascinated, and disgusted by her return (Streeter 2004, 777). Color and sexuality are portrayed as interlocking points of ostracism and ridicule among the women of the family. At the sight of Mary, one of the Peazant women reminds the family that "Yellow Mary went off and got ruint." Before the women are sure of the lesbian relationship between Mary and Trula or certain of the women's professions as prostitutes, Mary is immediately placed in the category of a "ruined woman" because of the sexual transgression previously enacted on her by her white employer in Cuba (Streeter 2004, 772). In addition, the skin tone of the two women provides further evidence of a history of sexual violence enacted on their mothers by white men. The sexual transgressions of others are thus contorted to define the character of the women themselves and the view that they have been "contaminated" by their proximity to whiteness (Streeter 2004, 772, 780).

At a later point in the film when Yellow Mary's back is turned, Viola snidely remarks, "All that yellow wasted." It remains unclear in the statement if Viola is referring to Mary's failure to adhere to norms of heterosexuality, her ruination by sexual assault, or her career as a prostitute. Within the remark, however, it remains clear that there is something valuable to be gained by virtue of one's "yellow" hue. As such, all of these perceived transgressions are further exacerbated by the expectations placed on her skin tone. After being exiled within her home, expectations of racial uplift placed on her hue provide an additional level of color prejudice that attempts to stifle the agency of Yellow Mary's individual development and personal ambitions (Cucinella and Curry 2001, 197).

With their glowing skin and long, thick hair, Yellow Mary and Trula's appearances visually counter the world of Ibo Landing. Their wealth and fine clothing when compared even to Viola, a missionary also living on the mainland, speak to their greater access to socioeconomic success in the burgeoning United States. While it remains evident that darker-skinned Black women endure more widespread and measurable social disadvantages when it comes to employment, education, relationships, and psychological development, the phenotypic features that privilege lighter-skinned women do not shield them from white racism or racialized sexual violence (Hunter 2002). It also makes them targets of disdain

and prejudice within their race. Stigmas of contamination and sexual ruination, as well as expectations of unconstrained social advancement, stifle Mary's relationship with many of the darker-skinned women in her family. In response to the callousness, Mary performs conceit, appropriating colorist stereotypes to protect against the taboos associated with her skin color, sexuality, and profession. As Wilder's research demonstrates, the dynamic of cross-color disparagement present in the fictional Peazant family persists in the present day, often preventing those on opposite ends of the color spectrum from finding common ground.

BEYONCÉ'S COLOR CONTROVERSY

Like most other Black Americans, Beyoncé Knowles is of mixed ethnic heritage. She was raised in a middle-class suburb of Houston, Texas, by her African American father, Mathew Knowles, and her Louisiana Creole-descended mother, Tina Lawson. Both grandparents on her mother's side were mixed-raced Creoles of African, French, and Native American heritage who married in Louisiana (Griffin 2011, 137). Although Tina Lawson distanced herself from her Creole roots during the era of Black Pride, Beyoncé has embraced her Creole heritage (Blay 2016; Kwaiyimey 2008; Stodghill 2012).

In Black America, the word *Creole* can trigger negative connotations closely tied to the traumas of slavery. Professor, scholar of skin color politics, and *Colorlines* contributor Yaba Blay took particular issue with the lyrics of "Formation" where Beyoncé proclaims, "You mix that Negro with that Creole make a Texas bama," asserting that for "those of us who are not Creole and whose skin is dark brown, the claiming of a Creole identity is read as rejection," adding that "much of the investment in Creole identity is predicated on a vehement rejection of Blackness" (Blay 2016; Beyoncé 2016). Though distinct in its reflection on the history of Creole identity, this critique speaks to established criticisms that Beyoncé's signature blonde weaves are proof that she rejects her African American heritage.

There is, of course, evidence that distance from Blackness is an asset for popular Black female performers. Considering the top three Black female performing artists of the moment—Beyoncé, Rihanna, and Nicki Minaj—it is without doubt that phenotypically common African features (wide nose, full lips, dark skin, and kinky hair) carry little esteem within mainstream American culture—unless those features are linked to sexuality, particularly the rear end. In recognizing her mixed-race identity, Farah Jasmine Griffin argues that Beyoncé purposefully builds on the fantasy of the "mulatta temptress," citing the "fancy girl" imagery

of her 2006 album, *B'Day* (Griffin 2011, 139–40). Viewed as beautiful through their proximity to whiteness and licentious through their Blackness, fancy girls were mixed-race women of Louisiana who were sold alongside laboring African slaves as sexual concubines. When slavery ended and it was no longer acceptable for white men to have Black mistresses, the institutionalized devaluation of Black woman created the conditions for all Black women to be regarded as whores or prostitutes (hooks 1981, 62). It is under such circumstances that Yellow Mary was raped while serving as a wet nurse for a wealthy white family in Cuba, perhaps the catalyst for her foray into sex work. Despite the fancy girl's ability to escape labor in the field, the devaluation of Black women into sexual objects of white male fantasy reflects a shared history of racialized sexualization.

In keeping with the discussion of colorism and sexuality, Caroline Streeter's analysis of mulatto characters in African American literature demonstrates how these figures often represent access to class mobility and escape from the stigmas of Blackness while simultaneously symbolizing the traumatic history of enslavement and sexual violence (Streeter 2004, 768). In her analysis of *Daughters,* Streeter explains how the vilification of Trula and Yellow Mary by the Peazant women represents a form of "moral scapegoat[ing]" whereby "making the mulatta the abject symbol of painful histories" is used to distance themselves from the sexual trauma of slavery (772). Dash problematizes these desperate efforts to reclaim an imagined "black female purity" through Eula Peazant, Nana Peazant's granddaughter-in-law who is unsure of the paternity of her unborn child after being raped by a white landowner (Kaplan 2007, 521). In her final emotional appeal, Eula reminds the women:

> As far as this placed is concerned, we never enjoyed our womanhood. . . . Deep inside, we believed that they ruined our mothers, and their mothers before them. And we live our lives always expecting the worst because we feel we don't deserve any better. Deep inside we believe that even God can't heal the wounds of our past or protect us from the world that put shackles on our feet.

Streeter persuasively argues that *Daughters* offers a "critique of 'race pride' which relies upon stable categories and normative behaviors" (Streeter 2004, 783). Though I would argue that legal intermarriage and reproduction between Black people of various hues have made it such that light skin today does not immediately represent a "visible scar of slavery and rape" as it did at the turn of the twentieth century, it is important to acknowledge the historical continuity

of these ideas, as well as how the oppositional knowledge established during the era of Black Power that inspired Black racial pride also established exclusionary definitions of Blackness—one that excluded Black queer identities, condemned Black female strength and sexual agency, dictated Black hair and aesthetic styling, and marginalized mixed-race identities (Streeter 2004, 777). When we try to escape past traumas by constructing ideas of Black pride that rely on methods of exclusion and scapegoating to promote an imagined Black female sexual purity, we lose track of the continued persistence of the one-drop rule in shaping perceptions of Black female sexuality.

Like the fancy girls of the early twentieth century, lighter-skinned Black women have a greater ability to exploit and profit from the fetishization of their Blackness while maintaining access to ideals and protections of beauty and womanhood within white heteropatriarchy not afforded to darker-skinned Black women, who are extremely delimited by stereotypes of the hypersexual Jezebel and the angry, harsh Sapphire (hooks 1981, 85–86; Railton and Watson 2005, 62). Beyoncé's capacity to be viewed as pleasing by the dominant beauty standards of Western society with the added bonus of the embodied sexuality associated with Blackness has enabled her to move beyond the urban market and become a verifiable global pop superstar with immeasurable mainstream appeal (Cashmore 2010, 140). Given this, it is interesting that in the earlier parts of her career, while still under the management of her father and before publicly proclaiming her feminism, Beyoncé adopted methods of compartmentalization to separate her respectable, conservative side from her more sexually adventurous alter ego, Sasha Fierce, suggesting that regardless of the hue of her skin, "black women have yet to be granted the full privilege of expressing their sexual agency without paying the price" (Griffin 2001, 138; Weidhase 2015, 129).

The same cannot be said of numerous white and non-Black female performing artists like Kylie Minogue, Christina Aguilera, and Jennifer Lopez, whose displays of sexuality have not defined their music careers, limited their success, or discredited their ability to be viewed as role models (Railton and Watson 2005, 51; Hobson 2003, 97–98). Despite the clear inequity within the color hierarchy that garners many lighter-hued Black women continued commercial appeal alongside critiques of their supposed "hypersexuality," it remains evident that Black female sexuality is always embodied and fixed to the flesh of Black women regardless of hue in a way that is not attached to white female performers.

This returns us to the problem many African Americans find with Creole self-identification. For many, Beyoncé's embrace of her mixed heritage may be

a reminder of the difference between herself and the broader Black American community and her improved access to success within mainstream society, but it obscures the dilemma of those like Beyoncé's own mother, Tina, who felt compelled to reject her Creole heritage and prioritize her Black identity to quell the exclusionary pro-Black mentality of the 1960s. To criticize Beyoncé's embrace of her mixed-race heritage lands us in the same exclusionary traps of race pride that prioritize the trauma of slavery and its created color hierarchies over the multiplicity, fragmentation, and dynamism of the Black experience in the United States. The same unattainable image of Black female purity that haunts Yellow Mary is also held over Beyoncé, but the expectation for Beyoncé to neglect her own family history, her class privilege, and her racial heritage only attempts to satisfy a sense of Black female and racial purity that does not exist in the United States. The divisiveness of such criticism, while important for demonstrating the continuation of color hierarchies in the Black community, also runs the risk of marginalizing large segments of the Black community rather than opening the space for the multiplicity of Black experiences (Cucinella and Curry 2001, 207).

LEMONADE AS A PRACTICE
OF DIASPORIC MELANCHOLIA

In Freudian terms, melancholia is understood as the effect of failed mourning for the loss of that which cannot be fully known. Many contemporary psychologists have individualized and pathologized melancholia as an unproductive and paralyzing psychic conflict. Scholar Sara Clarke Kaplan uses her analysis of *Daughters of the Dust* to reject the notion that the work of mourning must come to an end, particularly for the tragedies endured during the African diaspora (Kaplan 2007, 513). She argues instead that the mourning of these tragedies should not be read as a "regressive attachment to the past" but rather a "militant refusal" (Kaplan 2007, 514). She defines *diasporic melancholia* as "an embodied individual and collective psychic practice with the political potential to transform grief into the articulation of grievance that traverse continents and cross time" (513).

Given this, Kaplan reads *Daughters* as a diasporic ceremony—"a spatio-temporal nexus that collocates the past, the present, and the future; the living, the dead, and the unborn; Africa, the Americas, and the Middle Passage," whereby diasporic religious practices perform the transmission of collective histories, memories, and forms of knowledge that maintain connections to African spiritual traditions (Kaplan 2007, 516–17). In *Daughters*, this is apparent through the

permeating presence of white clothing typically worn by initiates of voodoo, Santeria, and Candomblé, West African spiritual traditions maintained by diasporic subjects in the Americas. In the director's cut of the film, Dash even refers explicitly to the orishas, the goddesses of Yoruba culture, that the film's main female characters embody, with Yellow Mary representing the West African Yoruba deity Yemoja – the primordial orisha and mother of all living things (Falola and Otero 2014, xix; Washington 2014, 257). And though it is mocked as "hoodoo mess," Nana Peazant passes down the tradition of collecting "scraps of memories" to her grandchildren that connect them to their personal history and their ancestry (Dash 1991). *Daughters* unquestionably reveres West African spiritual traditions and mythologies.

The folkloric story behind Ibo Landing's name shared by the family reveals the mass suicide of the Igbo people to mourn the tragic genocide of the Middle Passage and honor those who chose death over bondage. It also reminds the family that despite past tragedies, they are the descendants of those who chose to survive. Their ancestors possessed strategies that guided their survival, providing their descendants with the opportunity for eventual socioeconomic progress through migration. Here, the politics of diasporic melancholia acknowledge past tragedies to offer strategies for navigating the present and guiding the future.

Lemonade's own diasporic ceremonial sequence, "Reformation," begins with Beyoncé garbed in white. Long white dresses are seen adorning the bodies of Black women who wade through the ocean water, staring out into the horizon with their arms locked and raised, reminiscent of Nana Peazant's submersion in *Daughters,* the initiation ceremonies of Santeria in Cuba and Candomblé in Brazil, while also conjuring up an Afro Atlantic vision of Yemoja's aquatic penchant (Otero and Falola 2014, xix). This sequence reimagines the myth of Ibo Landing as an act of collective resistance against the chains of enslavement that pull against Beyoncé's waist as she appears stranded along the beach. During "Reformation," we are even momentarily granted access to the performance of what would appear to be a sacred ritual of witches or what scholar Janell Hobson might identify as a "conjure women" (Hobson 2016). The short and indistinct clip reflects the true secrecy and inaccessibility of certain ceremonies for those who have not undergone initiation into these diasporic traditions. The invented ceremonial ritual between Black women along the swampy shores and beachfront demonstrates a deep investment in resistive Afro-diasporic spirituality.

Adding a greater touch of authentic Afro-diasporic spirituality, Nigerian visual artist Laolu Senbanjo's Yoruba-inspired "Sacred Art of Ori" is featured

prominently in *Lemonade*. Senbanjo uses white ink to trace the essence of individuals on their skin as a means of worshipping the orishas (Tan 2016). Diasporic religious practices such as these act "as living 'repertoire,' capable of producing and transmitting collective histories, memories, and forms of knowledge that must be addressed, but which the written archive cannot-or will not-contain" (Kaplan 2007, 516).

In Haitian and Louisiana tradition, voodoo Mama Brigitte is a spirit believed to be guardian of the souls of the dead who favors obscenities (e.g., middle finger up, "when he fuck me good . . .") and drinks rum with hot peppers (e.g., "hot sauce in my bag") (Hobson 2016; Beyoncé 2016). Citing the connections in "Formation," Hobson repositions Beyoncé as the figure of the conjure woman, who sits at the crossroads "between the living and the dead, between the feminine and the masculine, between the heteronormative and the queer, between the sacred and the profane" (Hobson 2016). Her conjuring begins with the aural resurrection of New Orleans comedian Messy Mya, the twenty-two-year-old who was shot and killed under mysterious circumstances in 2010 and can be heard in the first seconds of the video asking, "What happened at the New Wildin's?"—also heard as "New Orleans" (Prakash 2016). This resurrected sample not only highlights the unsolved murder of the queer Black artist but asserts the failed response of the Federal Emergency Management Agency (FEMA) and the ensuing chaos of medical maltreatment, violence, and police corruption of post-Katrina New Orleans.

The notion of Beyoncé as a conjure woman is made more explicit by the co-directorial presence of Kahlil Joseph whom filmmaker and cultural critic dream hampton describes as a modern-day visual folklorist (Bradley and hampton 2016). In previous work, Joseph positioned the artist Flying Lotus as Elegba, the Yoruba trickster deity and messenger between the spirit world and the living who collects the dancing soul of a murdered Black man and carries him to the afterlife in his Cadillac (Bradley and hampton 2016; Flying Lotus 2012). Reimagined in "Formation," a young Black boy in a hooded sweatshirt dances before a row of white police officers with their hands up. This poignant visual image performs a conjuring of the unarmed seventeen-year-old Trayvon Martin, murdered by a white vigilante while walking through his own neighborhood wearing a hooded sweatshirt, and twelve-year-old Tamir Rice, who was murdered while playing with a toy gun in the park by the Ohio police within seconds of their arrival at the scene. This conjuring is reenacted in *Lemonade* where the "Mothers of the Black Lives Matter Movement" are seen holding photographs of their slain sons, including the mothers of Trayvon Martin, Eric Garner, and Mike Brown.

One prominent critique by scholar Maris Jones took issue with Beyoncé's evocations of Hurricane Katrina in "Formation," stating, "Our trauma is not an accessory to put on when you decide to openly claim your Louisiana heritage . . . the trauma is not yours to appropriate or perform" (Jones 2016). Jones's criticism of "Formation" calls out the opportunistic emulations of Southern Black life in Louisiana, the reasonable sense that Beyoncé could not possibly relate to the suffering of working-class Black Americans affected by the devastation of Hurricane Katrina, and feelings that the visual message of the music video did not match its lyrical content. Opportunism and exploitation are sound concerns when one can assume disinterest in Black suffering by a Black woman, but Beyoncé's body of work and her charitable donations have demonstrated a high regard for Blackness and the specificity of the Black female experience. In addition, the trauma of Hurricane Katrina speaks not just to the experience of those directly affected by the flooding but to the repetitious nature of Black unfreedom and devaluation. In choosing to recreate the flooding of Hurricane Katrina ten years after its initial devastation and marrying it with contemporary images of state violence, "Formation" demonstrates the continuity of trauma and violence against Black bodies across time and space, thus enacting the politics of diasporic melancholia.

It is important to also note that Beyoncé's visual evocation of Louisiana and Southern bayou culture in the aftermath of Katrina is not without precedent. Eight years prior to the release of "Formation," scholar Daphne Brooks argued that it was possible to listen to Beyoncé's album *B'Day* (2006), released on the one-year anniversary of Katrina, "on another frequency so as to hear the register of post-Katrina discontent in pop music . . . and the ways in which Knowles reconfigures a sort of dissent as fleet, urgent desire, and aspiration" (Brooks 2008, 192). The visual markers of Southern bayou culture in *B'Day*'s marketing, as well as the apparent plantation setting and the ornate Victorian design present in the album's single, "Déjà vu," mirrors much of the design within the entire visual album. It is almost unnerving how Brooks's assessment of *B'Day* speaks directly to *Lemonade* while simultaneously responding to Jones's view of the lyrical superficiality of "Formation":

Although the album returns time and again to conflicts between love and money, the material on *B'Day* examines an ever-sophisticated range of emotions tied to black women's personal and spiritual discontent, satiation, self-worth, and agency. . . . Consider shrewd and complicated articulation of rage,

"resentment" (closing track), desperation, and aspiration that Beyoncé's album charts at a time when public and sociopolitical voices of black female discontent remain muted, mediated, circumscribed, and misappropriated. (Brooks 2008, 184)

Brooks's analysis engages directly with the devastation of Hurricane Katrina while also, at a rather early point in Beyoncé's solo career, creating an analytical space that respects Beyoncé's Blackness and her capacity to be a voice of Black female discontentment in pop music. And with the growing popularity of social media in helping the Black community become more alert, aware, and vocal about the systematic impact of anti-Black racism in the United States, the atmosphere was ripe for the reimagining of earlier works with a more explicit political message in its unequivocal reverence for the resiliency of Black womanhood. Beyoncé's *Lemonade* conjures the anguish of historical trauma, and in refusing to allow the devastation of Katrina to remain in the past, she creates a historical continuum to express contemporary grievances.

With explicit imagery, past traumas collide with the present as Beyoncé sinks into the Louisiana floodwaters atop a police car. This provocative re-creation of Hurricane Katrina's devastation alongside the conjurings of murdered Black men and boys works to unite the contemporary devaluation of Black life under the US justice system and the suffocating forces of white supremacy to the exercised agency of the Africans crossing the Middle Passage who chose suicide over life as a slave. Projecting colorist assumptions onto Beyoncé's work in ways that attempt to reserve the traumas of Hurricane Katrina and police brutality to "authentic" and local Black folks prevents us from recognizing the politics of diasporic melancholia in her work. In conjuring these historical and present traumas, Beyoncé concludes "Formation" by making her demand explicit: "Stop shooting us."

Many elements of *Lemonade* perform diasporic ceremonies like those in *Daughters of the Dust*, but the pervasiveness of colorism has made it difficult for some critiques to assess Beyoncé's work within lineages of the African diaspora, Black womanhood, and Black feminist filmmaking. When one can take Beyoncé's Blackness and her capacity and openness for creating critical and political dialogue in her work seriously, it is possible to assess her evocation of past and present traumas of the Black diaspora through the politics of diasporic melancholia and to acknowledge her deep investment in diasporic ceremony and lineages of Black womanhood.

CONCLUSION

Beyoncé is a fascinating case in the discussion of colorism because her long career expresses a rich intimacy to Southern Black culture and female empowerment while also playing into tropes of the mulatto "fancy girl," a life experienced by Yellow Mary Peazant, whose relative proximity to whiteness adhered social value within mainstream culture. For those unable to traverse between Blackness and whiteness with the same ease, Beyoncé's acceptance of her Creole lineage can be read as a rejection of Blackness, making her evocations of Black suffering and Blackness in general appear disingenuous. But at what point do we accept that Blackness as an apparently coherent race is not a biological fact or cultural predisposition, but rather emerges from the doubleness of being both inside and outside modern conventions, assumptions, and aesthetic values (Gilroy 1993, 77)? The dispersal of the African diaspora across the West into social worlds that continually bar those with even one drop of "black blood" from full access to whiteness is the point from which Black expressive cultures emerge—in response to the perpetual state of double consciousness. And despite the relative ease with which Beyoncé has managed to climb the ladder of popular culture compared to darker-skinned Black female performers, it does not detract from her investment in the matrilineal transmission of collective histories, memories, and knowledge that are sacred to Black feminine consciousness—such as the heritable skill to take lemons and turn them into lemonade.

While diasporic melancholia refuses to let go of racism's irrevocable damages, its true political potential rests in the inclination toward transforming grievances into expressions of political desires that travel across space and time (Kaplan 2007, 514). Color hierarchies under diasporic melancholia are not to be dismissed as a mere historical occurrence but demand acknowledgment of its continued impacts. To stagnate in this trauma, however, does not productively transform grief into political desires. Black Americans must question whether the desire to discredit someone's position within genealogies of the Black diaspora comes from an attempt to prioritize their own trauma under colonial regimes of colorism and whether this prioritization risks cross-color solidarity against white supremacist racial oppression. For Beyoncé to evade colorist preconceptions and use her fame, wealth, and visibility to demonstrate the continuity of racial trauma and violence against Black bodies across time and space in the most popular Black feminist musical film project of recent history not only asserts the relevance of Blackness for those on the lighter end

of the color spectrum but also uses her platform to express the militancy and demands of a new generation of Black activists.

ACKNOWLEDGMENTS

An earlier version of this chapter was published in *Taboo: The Journal of Culture and Education* 16, no. 2 (2017). My thanks to Caddo Gap Press, which has granted permission for republication.

REFERENCES

Associated Press. 2016. "More Police Unions Call for Beyoncé Boycott." *Billboard*, February 19. https://www.billboard.com/articles/columns/pop/6882806/beyonce-more-police-unions-call-for-boycott.

Bale, Miriam. 2016. "Beyonce's 'Lemonade' Is a Revolutionary Work of Black Feminism: Critic's Notebook." *Billboard*, April 25. http://www.billboard.com/articles/news/7341839/beyonce-lemonade-black-feminism.

Ball, Charing. 2016. "Beyoncé's Formation and the Failed Strategy of Black Capitalism." *Madam Noire*, February 8. https://madamenoire.com/613117/beyonces-formation-and-the-failed-strategy-of-black-capitalism/.

Beyoncé. 2016. *Lemonade*. Parkwood Entertainment.

Blay, Yaba. 2016. "On 'Jackson Five Nostrils,' Creole vs. 'Negro' and Beefing over Beyoncé's 'Formation.'" *Colorlines*, February 8. http://www.colorlines.com/articles/jackson-five-nostrils-creole-vs-negro-and-beefing-over-beyonc%C3%A9s-formation.

Bradley, Regina, and dream hampton. 2016. "Close to Home: A Conversation about Beyoncé's 'Lemonade.'" *NPR Music: The Record*, April 26. http://www.npr.org/sections/therecord/2016/04/26/475629479/close-to-home-a-conversation-about-beyonc-s-lemonade.

Brooks, Daphne. A. 2008. "'All That You Can't Leave Behind': Black Female Soul Singing and the Politics of Surrogation in the Age of Catastrophe." *Meridians* 8, no. 1: 180–204. http://www.jstor.org/stable/40338916.

Cashmore, Ellis. 2010. "Buying Beyoncé." *Celebrity Studies* 1, no. 2: 135–50. https://doi.org/10.1080/19392397.2010.482262.

Collins, Patricia Hill. 2000. *Black Feminist Thought: Knowledge, Consciousness, and the Politics of Empowerment*, 2nd ed. New York: Routledge.

Combahee River Collective. 2003. "A Black Feminist Statement." In *The Feminist Theory Reader*, edited by Carole R. McCann and Seung-Kyung Kim, 164–71. New York: Routledge.

Cucinella, Catherine, and Renee R. Curry. 2001. "Exiled at Home: *Daughters of the Dust* and the Many Post-Colonial Conditions." *Melus* 26, no. 4: 197–221. http://www.jstor.org/stable/3185547.

Dash, Julie, dir. 1991. *Daughters of the Dust.* Kino International. Film.

Edwards, Jessica. 2016. "The BeyHive Gets the Wrong Becky and Comes for Rachael Ray #Lemonade." *Blavity News and Politics.* April 24. https://blavity.com/wrong-becky-hive.

Evelyn from The Internets. 2016. "Beyonce Said Drink This #Lemonade, Heaux!! | VEDA Day 24 of 30 @EVEEEEZY." Video file. April 24. https://youtu.be/3NI3ZjcLbe8.

Falola, Toyin, and Solimar Otero. 2014. "Introduction: Introducing Yemoja." In *Yemoja: Gender, Sexuality, and Creativity in the Latina/o and Afro-Atlantic Diasporas*, edited by Toyin Falola and Solimar Otero, xvii–xxiv. Albany: SUNY Press.

Flying Lotus. 2012. "Until the Quiet Comes." Vimeo video. August 30. https://vimeo.com/48551671.

Gilroy, Paul. 1993. *The Black Atlantic: Modernity and Double Consciousness.* London: Verso.

Griffin, Farrah. J. 2011. "At Last ...?: Michelle Obama, Beyoncé, Race and History." *Daedalus* 140, no. 1: 131–41. https://doi.org/10.1162/DAED_a_00065.

Guo, Jeff. 2016. "The Strange Contradiction in Beyoncé's New Song 'Formation.'" *Independent*, February 10. https://www.independent.co.uk/arts-entertainment/music/beyonce-formation-video-song-super-bowl-a6864551.html.

Harris, Brandon. 2016. "Here's the Problem with Beyoncé's 'Formation' Video." *Indie Wire*, February 13. https://www.indiewire.com/2016/02/heres-the-problem-with-beyonces-formation-video-22050/.

Hobson, Janell. 2003. "The 'Batty' Politic: Toward an Aesthetics of the Black Female Body." *Hypatia* 18, no. 4: 87–105. https://doi.org/10.1353/hyp.2003.0079.

———. 2016. "Beyoncé as Conjure Woman: Reclaiming the Magic of Black Lives (That) Matter." *Ms.*, February 8. http://msmagazine.com/blog/2016/02/08/beyonce-as-conjure-woman-reclaiming-the-magic-of-black-lives-that-matter/.

hooks, bell. 1981. *Ain't I a Woman: Black Women and Feminism.* Boston: South End Press.

Hunter, Margaret. L. 2002. "'If You're Light, You're Alright': Light Skin Color as Social Capital for Women of Color." *Gender and Society* 16, no. 2: 175–93. http://www.jstor.org/stable/3081860.

Jones, Maris. 2016. "Dear Beyoncé, Katrina Is Not Your Story." *Black Girl Dangerous*, February 10. http://www.blackgirldangerous.org/2016/02/dear-beyonce-katrina-is-not-your-story/.

Kaplan, Sara Clarke. 2007. "Souls at the Crossroads, Africans on the Water: The Politics of Diasporic Melancholia." *Callaloo* 30, no. 2: 511–26. ttps://muse.jhu.edu/article/222803.

Kwaiyimey. 2008. "Beyoncé Speaks Creole." Video file. August 28. https://www.youtube.com/watch?v=wiDuAbDonxQ.

Lewis, Shantrelle. 2016. "Beyoncé's 'Formation' Exploits New Orleans' Trauma." *Slate,*

February 10. http://www.slate.com/articles/double_x/doublex/2016/02/beyonc_s
_formation_exploits_new_orleans_trauma.html.

London, Dianca. 2016. "Beyoncé's Capitalism Masquerading as Radical Change." *Death and Taxes*, February 9. http://www.deathandtaxesmag.com/280129/beyonce-capitalism
-black-activism/.

Lorde, Audre. 1984. *Sister/Outsider: Essays and Speeches*. New York: Crossing Press.

Machiorlatti, Jennifer. 2005. "Revisiting Julie Dash's 'Daughters of the Dust': Black Feminist Narrative and Diasporic Recollection." *South Atlantic Review* 70, no. 1: 97–116. https://www.jstor.org/stable/20462733.

Martinez, Maurice M., dir. 2007. *Too White to Be Black, Too Black to Be White: The New Orleans Creole*. Wilmington, NC: Door Knob Films.

Murphy, Mekado. 2016. "'Daughters of the Dust,' a Seeming Inspiration for 'Lemonade,' Is Restored." *New York Times*, April 27. http://www.nytimes.com/2016/04/28/movies
/daughters-of-the-dust-restoration-beyonce-lemonade.html.

Parrish, Charles H. 1946. "Color Names and Color Notions." *Journal of Negro Education* 15, no. 1: 13–20. doi:10.2307/2966307.

Prakash, Neha. 2016. "How Beyoncé's 'Formation' Video Highlights Black Artist's Murder." *Fusion*, February 10. http://fusion.net/story/266893/beyonce-formation-superbowl-
messy-mya-new-orleans/.

Rad Fag. 2016. "My (Apparently) Obligatory Response to 'Formation': In List Form." *Radical Faggot*, February 10. https://radfag.com/2016/02/10/my-apparently-obligatory-
response-to-formation-in-list-form/.

Railton, Diane, and Paul Watson. 2005. "Naughty Girls and Red Blooded Women: Representations of Female Heterosexuality in Music Video." *Feminist Media Studies* 5, no. 1: 51–63. https://doi.org/10.1080/14680770500058207.

Rodriguez, Mathew. 2016. "Beyoncé's 'Lemonade' Literally Broke the Entire Internet." *Mic*, April 23. https://mic.com/articles/141645/beyonc-s-lemonade-literally-broke
-the-entire-internet#.URCMvjO8u.

SNL. 2016. "The Day Beyoncé Turned Black." *YouTube video*. February 14. https://youtu.
be/ociMBfkDG1w.

Stodghill, Alexis. 2012. "Beyoncé L'Oréal Ad Controversy Inspires Black Community Backlash." *Grio*, February 10. http://thegrio.com/2012/02/10/beyonce-describes-herself
-as-african-american-native-american-french-in-new-loreal-ad/#beyonce-true-
match-loreal-adjpg.

Streeter, Caroline. 2004. "Was Your Mama Mulatto? Notes Toward a Theory of Racialized Sexuality in Gayl Jones's 'Corregidora' and Julie Dash's 'Daughters of the Dust.'" *Callaloo* 27, no. 3: 768–87. https://www.jstor.org/stable/3300843.

Suen, Brennan. 2016. "Conservative Media Get Into 'Formation' to Attack Beyoncé's Super

Bowl Performance." *Media Matters for America*, February 8. https://www.mediamatters
.org/research/2016/02/08/conservative-media-get-into-formation-to-attack/208439.

Tan, Avianne. 2016. "Meet the Nigerian Artist behind the Yoruba Body Art in Beyoncé's
'Lemonade.'" *ABC News*, April 26. http://abcnews.go.com/Entertainment/meet-nigerian
-artist-yoruba-body-art-beyoncs-lemonade/story?id=38678748.

Washington, Teresa N. 2014. "Introduction: Introducing Yemoja." In *Yemoja: Gender,
Sexuality, and Creativity in the Latina/o and Afro-Atlantic Diasporas*, edited by Toyin
Falola and Solimar Otero, 215–66. Albany: SUNY Press.

Weidhase, Natalie. 2015. "'Beyoncé Feminism' and the Contestation of the Black Feminist
Body." *Celebrity Studies* 6, no. 1: 128–31. https://doi.org/10.1080/19392397.2015.1005389.

Weiss, Suzannah. 2016. "Is 'Becky' Really a Racist Stereotype against White Women?"
Complex, April 28. https://www.complex.com/life/2016/04/beyonce-lemonade-becky.

Wilder, JeffriAnne. 2015. *Color Stories: Black Women and Colorism in the 21st Century*.
Santa Barbara, CA: Praeger.

PART TWO

"Formation"
A Southern Turn

Extending from Cienna Davis's discussion of colorism in Chapter 2, Riché Richardson takes up another marker in Chapter 3 that some commentators have treated as a problem for Beyoncé's relationship to Blackness: her blonde hair. Placing Beyoncé in relation to her creativity and her tresses, Richardson points to longer histories of Southern—specifically, Texas—glamour, going back to Farah Fawcett's feathered locks on *Charlie's Angels,* and how this mode of femininity was repurposed in Destiny's Child's "Independent Women, Part I," the theme for the movie remake of the show. Richardson shows that the Southern turn in "Formation," which is continued in *Homecoming*, had deep roots in Beyoncé's work. In Chapter 4, J. Brendan Shaw examines *Lemonade*'s vivid use of plantation settings—sites that remain imbricated with our understandings of both the US South and the global South. He examines how the film engages with Black feminist thought about utopianism and temporality and how it transforms the plantation into a paradoxical site for Black women's healing and world making.

RICHÉ RICHARDSON

3. Beyoncé's South and a "Formation" Nation

From her emergence in her native Houston, Texas, in the late 1990s as the lead singer of the award-winning group Destiny's Child, and rise to fame alongside Kelly Rowland and Michelle Williams, Beyoncé's trajectory to international superstardom and a successful career as a solo singer, actress, clothing designer, and entrepreneur holds important implications for critical discourses on the US South as a geography.[1] It provides a poignant illustration in popular culture of the region's recurring impact on the nationalization and globalization of Black femininity in popular and political contexts. Themes related to Beyoncé's intersectional identity as a model of Black and Southern womanhood have recurred in her song lyrics, performances, and visual representations. Her performance at the 2009 inauguration of Barack Obama as the nation's forty-fourth president provided a platform for her to reflect on this aspect of her background with even more focus by acknowledging the experiences of her parents, Mathew Knowles and Tina Knowles Lawson in the segregated South, Black civil rights struggles in the region, and the new day signaled by this historic election.[2]

This chapter throws into relief Beyoncé's earlier engagements in discourses related to the US South, which have typically been overlooked in contemporary critical discussions of her artistry. It also addresses the ways in which she has disrupted conventional purist narratives of American selfhood premised on Black exclusion and abjection that romanticize Southern white womanhood. In the video "Independent Women, Part I," a paean to the hit 1970s television show *Charlie's Angels*, Beyoncé's stylization is partly inspired by the iconic Texas actress Farrah Fawcett. Reflecting on this performance can help us gain a deeper and more complex understanding of the role that Southern epistemologies played

in shaping Beyoncé's popular image during the early stages of her career, as well as her long-standing engagement with discourses related to the US South. Doing so will also provide contexts and foundations for thinking about her more recent work. To this end, I also consider "Formation" and the film *Homecoming*, both of which center Black culture in the US South, while also evoking histories of slavery and persisting forms of racism and injustice (Beyoncé 2016a, 2019). These monumental projects showcase Beyoncé's commitment to reflecting on her identity as a Black woman from the South while saliently registering her concerns as an activist committed to social justice issues such as racial profiling and anti-Black police violence.

I begin with an overview of some of the key critical and theoretical perspectives that ground the discussion. In this chapter, my uses of the term "US South" as an adjectival qualifier draw on critical methods situated at the intersection of American studies and Southern studies that decenter North America and disrupt its persistent ubiquity and univocality in defining and signifying "Southern" as a concept, which has been conditioned within regimes of slavery, imperialism, and colonialism. Critical analyses of the global and hemispheric South are the basis on which the US South comes into geographical relief as one of multiple Souths in the Western Hemisphere and as a region inescapably shaped dialectically within the vast complex of plantation architectures iterated across its geographies, a critical approach that promotes interdisciplinary and comparative study of the region.

The rooting of my work on the US South in such understandings accords with "the new Southern studies," a concept that Houston A. Baker Jr. and Dana D. Nelson introduced in 2001 in a special issue of the journal *American Literature*, which they coedited. Entitled "Violence, the Body and 'The South,'" they pondered how American studies texts were increasingly "reconfigure[ing] our familiar notions of Good (or desperately bad) Old Southern White Men telling stories on the porch, protecting white women, and being friends to the Negro" (2001, 231).[3] "The new Southern studies" was also the critical frame for the University of Georgia Press book series New Southern Studies, for which I became coeditor with Jon Smith in 2005 and have served as the editor since 2018. The original mission statement for the series acknowledged that

the South has emerged as central to debates about America's identity historically and culturally, in fields such as American studies, African American studies, cultural studies, and postcolonial theory. Engaged with these debates from the outset, this series analyzes and assesses the South afresh; its chief aim is a floor-

to-ceiling rethinking of some of the central ideas of critical theory as it relates to the region and its various cultural identities: objecthood, identity, space, nation, region, abjection, the body, empire (University of Georgia Press 2005).

My own research project in the field has been grounded in questions related to the status of the US South in shaping formations related to gender, race, and sexuality in the United States; shaping categories such as the American and the African American; and nationalizing constructions of Black masculinity and Black femininity.

The new Southern studies has posed the most consistent and sustained challenge to traditional Southernist scholarship since the beginning of the new millennium. Its critical and theoretical methodologies facilitate the acknowledgment and embrace of a migratory Southern subject as opposed to thinking of the Southern region in conventional literal and essentialist ways (i.e., below the Mason Dixon line), while expanding and broadening archives for critical study in the field and conceptualizing textuality in a broad way (see Smith and Cohn 2004). These critical contexts facilitated my research on the dirty South rap movement at the beginning stages of my career and at this point provide valuable critical foundations for me to examine the song lyricism and performance practices of Beyoncé as a Black woman artist in the US South.

It is useful to study Beyoncé through the lens of the new Southern studies because she has staged one of the most dramatic "Southern turns" that we have witnessed in recent years (Richardson 2003; Baker 2001). Moreover, given her self-naming as "Texas 'Bama" in "Formation," she embodies and articulates new notions of Southern subjectivity that were inconceivable and illegible in the past. The new Southern studies' insurgent, unconventional thinking about questions of geography and identity embraces such fluid framings of regional identity that are premised on regional, racial, and cultural hybridity and intermixtures.[4] Beyoncé's original and insurgent intersectional identity, which she affirms in "Formation" by citing her parents' origins in Texas and Alabama, invokes internal patterns of Black migration in the South and belies conventional notions of Southern identity that have been premised on geographical fixity. I also draw on Africana studies, focusing on the Africana South and Southwest in particular.[5]

Beyoncé's invocation of contemporary activist movements, from Black Lives Matter to #TakeAKnee, affirms Southern connections to civil rights histories, along with newer Black political movements, while acknowledging afterlives and continuing traumas related to slavery and Jim Crow. Her reminder in "For-

mation" of the continuing significance of the tragedy of Hurricane Katrina and the devastation that it wrought for predominantly Black communities in New Orleans and the Gulf regions of Louisiana and Mississippi was coupled with the centering of Black women's political agency in the US South. Examples of this agency range from Stacey Abrams's inspiring run for the Georgia governorship in 2018 to Bree Newsome's courageous removal of the Confederate flag from the state house in Charleston, South Carolina, in June 2015, in the wake of the horrific tragedy at Mother Emanuel African Methodist Episcopal Church in which a white supremacist murdered nine parishioners during Bible study, including the Rev. Clementa Pinckney. That the political climate in the US South has remained at the forefront in advancing some of the nation's most regressive and reactionary policies on issues such as immigration and voting rights since the election of Donald Trump as president in 2016 underscores why it remains a battleground on which to fight for freedom and civil rights to help bring about social and political change.

TEXAS FEMININITY AND THE FARRAH FAWCETT FACTOR IN FASHIONING BEYONCÉ

In my scholarship, I have argued that the US South has played a long-standing constitutive role in nationalizing ideologies of race, gender, and sexuality with profound impacts on representations of Black masculinity and Black femininity, including their routinized stereotyping.[6] Gender ideologies of Southern origins, from the Black male as an "Uncle Tom" and rapist and the Black female as mammy, to the white male as a "Southern gentleman" and the white female as the "Southern lady" and "Southern belle," have helped to constitute the dominant heteronormative national discourses on masculinity and femininity since the nineteenth century, premised on Black abjection. In the new millennium, the rise of a Black and Southern woman such as Beyoncé as a popular superstar and national icon is fascinating to me for deviating from the typical abject narratives of Black femininity that have circulated in the United States, alongside scripts that have invested high symbolic capital in idealized white femininity.

The prioritization of white womanhood in constituting national identity in the United States is shadowed by white supremacy and notions of Black women's racial inferiority and otherness. For example, in early Hollywood cinema, white Southern womanhood was recurrently invoked as a national ideal, as illustrated in the portrayal of Lillian Gish in D. W. Griffith's epic propaganda film, *The*

Birth of a Nation (1915), which romanticized the Ku Klux Klan. Significantly, the film frames the "North" and "South" as symbolic brothers through its primary male heroic figures, who were separated by the tragedy of the Civil War, while presenting Black people as being responsible for dividing the Union, a national family they did not belong to and in which they occupied a position of inferiority. Within its historical racialist ideology of white supremacy, the us South typically exalted white Southern womanhood as a symbol of the region's purity, premised on an essentialist and naturalized view of Southern women as an extension of the region's landscape, in some cases drawing on the pastoral (Yaeger 2009).[7] As a Black woman from the South who emerged as "America's sweetheart" in the new millennium, Beyoncé is significant for disrupting the conventional white significations attached to the region in the cultural imagination. It is therefore useful to reflect on how her roots in the us South, and Texas specifically, shaped her development into a national icon.

While Obama's historic inauguration as president may have been a pivotal political and professional moment in Beyoncé's development, it was not the first time she had performed at a us presidential inauguration. Notably, prior to her solo career, Beyoncé had performed with Destiny's Child, along with other pop artists, on January 19, 2001, on the eve of fellow Texan George W. Bush's inauguration. As she commented, "I never thought that I would meet—let alone perform for—the president of our country" (Arenofsky 2009, 35).

Her appearance at Bush's inauguration concert came in the wake of the widespread exposure that Destiny's Child had received after the release of the song "Independent Women, Part I" as part of the soundtrack for the first *Charlie's Angels* film, which starred Lucy Liu, Drew Barrymore, and Cameron Diaz. Directed by McG, the 2000 film was based on the hit television series that ran from 1976 to 1981, which was produced by Aaron Spelling and starred Farrah Fawcett, Kate Jackson, and Jaclyn Smith as former police officers who were employed in Los Angeles as detectives at the private detective agency of the millionaire Charlie Townsend. As Elana Levine reveals in *Wallowing in Sex: The New Sexual Culture of 1970s American Television, Charlie's Angels* (2007), alongside shows such as *Wonder Woman* and *Three's Company*, was part of a wave of productions that cast women in leading roles as symbols of sex and beauty, even as they simultaneously pushed sexual boundaries, grappled with tough questions related to gender, and promoted notions of women's empowerment.

The video for "Independent Women, Part I" also emphasizes themes of women's empowerment.[8] It features the members of Destiny's Child at a boot camp

for angels, screening scenes from the film, training, and then trying out stunts, including fighting, skydiving, and riding motorbikes. One of the final shots in the video highlights the trio in the personae of "angels" as they stand posed against a fiery backdrop in the black silhouettes iconically associated with the original TV angels.[9] The image not only referenced the 1970s triumvirate but also helped stitch together and immortalize the three-woman version of Destiny's Child after the departure of Farrah Franklin, who, due to illness and missed performances, had been dismissed in 2000 after six months with the group.[10]

The members of Destiny's Child did not appear in the 2000 film, but the final shot in the music video of the trio being greeted "good morning" by the unseen Charlie (whose was memorably voiced by John Forsythe in the television series) creates the effect of a cameo appearance for them. Whereas the angels in the film remained white, with the exception of Lucy Liu, the video staged a bold vision of Black angels, along with other angels of color, in Charlie's detective world, breaking its tacit color barrier. The famous *Charlie's Angels* triumvirate, whose focal point had been Fawcett, was recast with the blonde Beyoncé flanked by her fellow Destiny's Child members, the dark-haired Rowland and Williams. The video's iconography foregrounding Black women as angels was significant, too, because angels, much like the famous James "Bond Girls," until Halle Berry broke the tacit color barrier by portraying Bond's love interest in the film *Die Another Day* in 2002, had been primarily depicted as white women. While the angels remained white in the film, the video, at least at an imaginative level, staged a bold vision of Black angels, along with other angels of color, in Charlie's detective world.

Farrah Fawcett's influence was evident in Beyoncé's styling in the video, most notably when she appears with the blonde flipped and winged hairstyle associated with Fawcett, the most famous original "angel" and another Texas native. This hairstyle choice referenced Beyoncé's trademark long, blonde hairstyle, which had marked her typical center position during performances by Destiny's Child. Beyoncé's association with Fawcett, an "all-American" beauty symbol, I suggest, established the groundwork for Beyoncé's emergence as a premier icon of femininity in US and global contexts.

A native of Corpus Christie, Texas, Fawcett's starring role on *Charlie's Angels* consolidated her status as an internationally famous American icon in the mid-1970s. In the months before she landed her job on the television series, the release of a poster by Pro Arts, featuring her with a winged and curled hairstyle, a bright, sparkling smile, and wearing a red bathing suit, catapulted her to superstardom.

As Levine illustrates, Fawcett's image was ubiquitous on products ranging from dolls to lunch boxes as she emerged as the reigning sex symbol in US popular culture during the 1970s (Levine 2007; Nelson 2009). Indeed, Hugh Hefner, the founder of *Playboy* magazine, asserted that "Farrah Fawcett defined what one thinks of as the All-American girl" and that "she was the Marilyn Monroe of the 1970s" (Hefner 2009). To be sure, the immortalization of Fawcett's famous face in two 1980 portraits by pop artist Andy Warhol, known for his paintings of everyday commercial items and iconic figures such as Marilyn Monroe, bespoke Fawcett's celebrity all the more.[11] The bathing suit that Fawcett wore on the best-selling poster of all time, at 12 million copies sold, was donated by her estate to the permanent collection in the Smithsonian National Museum of American History in 2011. As Levine acknowledges, in the mid-1970s, Fawcett was the top choice of young girls when they were polled and asked who else they would most want to be (Levine 2007, 123).

Fawcett is indispensable for thinking about the impact of the South on Beyoncé's fashioning and mediated her emergence as "America's sweetheart." As Jody Rosen points out in a June 3, 2014, *New York Times* article, "Beyoncé: The Woman on Top of the World," this status has often eluded Black women, in spite of the dominant positions that some have occupied in American music.[12] The status of being "America's sweetheart" has more frequently been linked to white Southern women such as Fawcett, Julia Roberts, and Reese Witherspoon but rarely, if ever, been invoked in relation to Black womanhood prior to Beyoncé. Though she shares common ground with the litany of Southern women who have emerged as models of national beauty and femininity, I suggest that Beyoncé is exceptional for broadening and expanding this concept by disrupting its conventional white-centered significations. Such representations of American womanhood make sense if we recognize the long-standing role that the US South has played in constituting scripts of femininity that become national and gain popularity.

As Elizabeth Bronwyn Boyd notes in her book, *Southern Beauty: Performing Femininity in an American Region* (2000), the US South cultivates distinct feminine aesthetics. It is important to recognize the region as a backdrop from which Fawcett emerged as the premier icon of American feminine beauty during the 1970s.[13] More to the point, the distinct, hyperfeminine beauty aesthetics frequently linked to femininity in Texas, as described in Deborah Rodriguez's 2007 memoir, *Kabul Beauty School*, also arguably played a role in helping to popularize native Texan women from Fawcett to Beyoncé in the national context. As Rodriguez points out, Texas's aesthetics are often even more pronounced,

hyperbolic, and stylized: she describes "Texas ladies," also billed the "Texas dolls," "who breezed through the gate with the biggest bouffant hairdos, the most extravagantly applied perfume, and the glossiest nails, as well as faces made up as if they were stars in a daytime soap opera" (43). It is important to think about the imprint of such Texas roots in establishing foundations for Fawcett's larger-than-life hairstyle and blond iconicity, significations that have been similarly foundational in shaping Beyoncé's signature lengthy, bold, blonde hairstyle fashioned within a distinctly Black aesthetic and hair culture. Beyoncé's signature hairstyle is a by-product of her mother's artistry and design at their family's Headliners Hair Salon based in Houston, Texas, an enterprise that made the family millionaires.[14] Fawcett and Beyoncé's shared origins in Texas with its distinct aesthetics in feminine fashioning, I suggest, established foundations for their popularization and nationalization, respectively, during the bicentennial year and at the dawn of the millennium.

This comparative lens I employ to discuss Fawcett and Beyoncé also draws on discourses of the Black/Africana South and Southwest.[15] This concept deconstructs and disavows conventional geographical boundaries within Southern studies by exploring how subject positionings at the intersection of the South and American West and near borderlands reshape Blackness. I acknowledge this rubric in the process of pondering the significance of Beyoncé and Fawcett's mutual ties to Texas in relation to their feminine fashioning and construction as ideal models of American womanhood.

Like Fawcett, Beyoncé's hairstyle has grounded her iconicity and shaped her association with beauty and glamour in the national imaginary. Her blonde hair color and long extensions have also been central in constructing her image in popular culture (see Richardson 2017). This signature hairstyle recalls the marketing of Tina Turner during the 1970s, whose styling bell hooks has critiqued for its appropriation and reinforcement of Eurocentric beauty aesthetics and linkage to animal imagery: "Always fascinated with wigs and long hair, she created the blond lioness mane to appear all the more savage and animalistic. Blondeness links her to jungle imagery even as it serves as an endorsement of a racist aesthetics which sees blonde hair as the epitome of beauty" (hooks 1992, 68).

As Aisha Durham has pointed out, Beyoncé successfully performs a range of Black femininities (2011). Yet it is useful to recognize how other feminine formations, such as Fawcett's, have contributed to Beyoncé's popular construction, to understand how her strategic appropriations of blondness unsettle and expand the aesthetics of Black womanhood while disrupting conventional white

supremacist aesthetics. Recognizing this connection enables us to think with more complexity and depth about the Southern and Texan impact on Beyoncé's representation and to recognize how multifaceted, sustained, and long-standing it has been, while pointing to the contradictions in Beyoncé's discourse related to scripts of race and gender, including notions of beauty.

Beyoncé's trajectory from Houston to worldwide phenomenon is reminiscent of Fawcett's path to stardom in the 1970s. Her singing career and other ventures, including celebrity endorsements for companies such as Pepsi, L'Oréal, H&M, and Walmart, have made her a multimillionaire. Named by *People* magazine in 2012 as the "Most Beautiful Woman in the World," Beyoncé has emerged as a top beauty symbol in American culture and inherited the status as an iconic American beauty that was associated with Fawcett at the peak of her career during the 1970s, in spite of Black women's alienation and exclusion from the nation's dominant beauty standards and devaluation of Black women's bodies.[16] Beyoncé's breakthroughs at this level show Black women's capacity to interrupt and unsettle the prevailing, white-centered narratives of American identity. It is noteworthy that her currency as a brand was initially advanced through advertising campaigns in cosmetics emphasizing her "mixed" and "Creole" heritage and downplaying Blackness, which were tacitly premised on notions of the postracial and post-Blackness. These early representations run counter to the assertive epistemology of Blackness that she scripts through song lyrics and visuals in more recent work such as "Formation."

Acknowledging this earlier cultural moment of "Independent Women, Part I," which juxtaposed Beyoncé with Fawcett's blonde iconicity and Texas femininity, provides valuable contexts and foundations for tracing the singer's evolution toward the radical raced, sexed, and gendered aesthetics of self-fashioning in the video for "Formation," which frame Beyoncé in relation to her family history and Black Southern roots (Destiny's Child 2000; Beyoncé 2016a). Moreover, it provides additional frameworks for thinking about how and why the singer has become a national and global icon in her own right and on her own terms, a woman that many other women and girls aspire to be—notwithstanding Black women's long-standing devaluation and stereotyping in popular culture and media that have typically favored women who look like Fawcett, as Beyoncé acknowledges in her reference to "Becky with the 'good' hair" in the song "Sorry" from *Lemonade* (Beyoncé 2016b). Ironically, she has been at the forefront in helping to expand the nation's narrow beauty standards that so long focused on white womanhood while devaluing Black women and other women of color.

"BEYONCÉ IS BOTH OLD SOUTH AND NEW SOUTH"

While Southern regional themes were evident in Beyoncé's artistry from her days in Destiny's Child, they erupted in full force with "Formation," the first hit single released from the *Lemonade* album. In this project, she positions Southern identity as being core to her identity as a raced and gendered subject, drawing on it to challenge narrow and exclusionary notions of American self-hood. In "Formation," profuse invocations of Black Southern identity assert a narrative of Beyoncé's background that centers Blackness, which complicated, and to some extent contradicted, the color-blind narratives of her history previously circulated in the media. "Formation" shaped a subversive and inclusive notion of Blackness that Beyoncé boldly showcased in the video and during her performance before a national audience at the 2016 Super Bowl halftime show, heralding her activism related to issues such as racial profiling and police violence against Blacks. At the same time, it established foundations for her increasing commitment to showcasing Black community traditions and institutions evident in more recent projects such as her *Homecoming* show at the Coachella music festival in 2018.

The release of the "Formation" video on the eve of the Super Bowl 50 halftime show heralded a radical turn within Beyoncé's repertoire and a more assertive engagement with the US South than had been evident in the past. Its lyrics most saliently invoke the region by framing Beyoncé's identity in relation to her Creole mother's roots in Louisiana and her "Negro" father's in Alabama, autobiographically positioning Beyoncé as a by-product of this geographical and genetic fusion that she terms "Texas 'Bama" (Beyoncé 2016a). As Jenna Wortham notes in the dialogue on "Formation" in the *New York Times*, this neologism is all the more significant because it unsettles uses of the term *'Bama* as a "lethal insult" (Caramanica, Morris, and Wortham, 2016). Most typically, this term has been used in Black urban contexts as an epithet to make fun of people regarded as tacky and "country," as illustrated in several scenes in Spike Lee's 1987 film *School Daze*.

The setting of the video "Formation" in New Orleans and its featuring of the singer lying atop a police car that sinks as the video ends critiques the neglect of the city after it was hit by Hurricane Katrina, had its levees break, and flooded in 2005. It is significant that Beyoncé's "Formation" revisited this tragedy over a decade later, at a point when it was increasingly receding in memory. Hurricane Katrina and the horrific losses of life that followed in its wake are invoked by a line at the beginning of the song, sampled from the late gender–nonconform-

ing local commentator Messy Mya. The assertive voice that follows belongs to the Black queer hip-hop and bounce musician Big Freedia, also a New Orleans native, who establishes a tone of empowerment in the song, paradoxically by underscoring Beyoncé's fierceness among "bitches" and arrival to "slay." Such terms further link the song's message to Black queerness linguistically and signal Beyoncé's embrace of Black queer and trans communities, while Big Freedia's voiceover invocations of soul foods such as "cornbread" and "collard greens" root it in the South as a region (Beyoncé 2016a).[17]

Beyoncé's acknowledgment of the "hot sauce in my bag" and assertion that she has remained "country" in spite of her money also play up Southern themes. However, the visual dimensions of the video play a critical role in rendering Louisiana as a place that is both visceral for viewers in the new millennium and a site of lingering trauma. Images of a Black college marching band and Black churches emphasize Southern heritage as the camera pans through the areas of New Orleans that were most devastated by Hurricane Katrina and have yet to recover, underscoring the storm's continuing impact on the landscape. History is brought to life as well in Beyoncé's multilayered portraits of Black women and girls dressed in white that recall antebellum styles and traditions associated with Black Creole women, as well as embodiments of Black womanhood compellingly visualized by Julie Dash's film *Daughters of the Dust* (1991). Plantation-style settings, such as the Fenyes Mansion in Pasadena, California, also invoke this history (see McInnis 2019).[18] As Jon Caramanica suggests, "Beyoncé is both old South and new South" (Caramanica et al. 2016).

Simultaneously, the "Formation" video indicts the pervasive killings in the contemporary era of African Americans at the hands of law enforcement, which have typically gone unpunished. The culmination of "Formation" brings these themes full circle with images of the police car sinking with Beyoncé atop it, a youth to whom officers raise their hands in surrender, and a wall that shows the words "Stop Killing Us" written in graffiti (Beyoncé 2016a). This bold theme fueled a backlash against the singer that resulted in the police boycotting several of her performances in cities such as Miami, Florida, and her hometown, Houston. In an April 2016 interview with *Elle* magazine, Beyoncé addressed such protests by commenting, "I'm an artist and I think the most powerful art is usually misunderstood." She went on to say that

anyone who perceives my message as anti-police is completely mistaken. I have so much admiration and respect for officers and the families of the officers

who sacrifice themselves to keep us safe. But let's be clear: I am against police brutality and injustice. Those are two separate things. If celebrating my roots and culture during Black History Month made anyone uncomfortable, those feelings were there long before a video and long before me. I'm proud of what we created and I'm proud to be part of a conversation that is pushing things forward in a positive way. (Gottesman 2016)

The provocative contours of the "Formation" video were the backdrop for Beyoncé's performance at Super Bowl 50, which, in a game at Levi's Stadium in the San Francisco Bay Area, paid tribute to the Black Panther Party on the fiftieth anniversary of its founding in Oakland, California. In the halftime show, performances by Cold Play and Bruno Mars set the stage for Beyoncé's segment, which began when she entreated her fellow women dancers to "get in formation." The dancers' styling in Black leather bodysuits and berets directly referenced the Black Panthers, whose leather jackets and berets became iconic in photography and television during the late 1960s. Their Afros also referenced this period, when the Black Power movement had helped popularize natural Afro hairstyles and emphasize Black beauty, while also visually building on Beyoncé's assertion of her adoration for her daughter Blue Ivy's Afro hair in the song's lyrics. Notably, Beyoncé and her dancers configured their bodies to form an "X," which paid tribute to the Black Muslim leader Malcolm X, who played a key role in inspiring Huey P. Newton and Bobby Seale to found the Black Panthers in 1966. The dancers' "formation" both enacted Beyoncé's opening entreaty and, together with the song's lyrics, echoed the militaristic formations in which the organization's members drilled to learn armed self-defense. Their nearly unison choreography was punctuated at the beginning by a raised fist. This moment arguably rests in the continuum with John Carlos and Tommie Smith's famous salute to Black Power during the national anthem at the 1968 Olympics, and it anticipated the incendiary critiques of police violence staged later in 2016 by Jesse Williams and Colin Kaepernick. The culmination of the performance against the backdrop of a video that included Black singers who had starred in earlier Super Bowl halftime shows, such as James Brown, Stevie Wonder, Whitney Houston, Prince, and Michael Jackson, saliently invoked the themes of Black History Month, when Super Bowl 50 took place.

Both the "Formation" video and the song's performance at the Super Bowl as a paean to the Black Panthers underlined the long history of Black resistance to anti-Black violence in policing. It connected the Black Panthers' founding to

abusive policing in Black communities and its long-standing critique of police brutality with the work of political groups such as Black Lives Matter and #SayHerName in protesting contemporary police abuses. (Indeed, the latter hashtag echoes the popular song by Destiny's Child, "Say My Name," one of its anthems for women's empowerment.) Beyoncé's use of Black Panther Party iconography in her performance lies in a continuum with its citations within Black popular culture, from Tupac Shakur's video "California Love" to musical performances and scenes in the television drama *Empire*. The roots of this organization in Alabama's Black Belt and the impact of the Lowndes County Freedom Organization, founded by Stokely Carmichael in 1965 to support Black voter registration, on its emergence link it organically to the South and in this sense also reinforce the Southern epistemology invoked within "Formation."

In "Formation," the South's ongoing traumas of slavery and Jim Crow are recollected in atrocities such as anti-Black police violence in the contemporary era. The song depicts not simply a Black Southern history, but American history itself, in which Beyoncé scripts herself as a symbolic subject who has reached the pinnacle of success. She accomplishes the task of embodying national selfhood by remaining grounded in her "Texas 'Bama" identity, staying closely moored to her family of origin, and continuing to honor and pay tribute to Southern legacies while also claiming new dimensions of her identity as a wife and mother.

In the "Formation" video and Super Bowl performance, Beyoncé underscores the utility of embracing alternative and hidden histories and challenges her audiences to envision the United States as a nation where white subjectivity is not always centering its definitions of national selfhood. Beyoncé's epistemology on the South has become increasingly central to her artistry and aesthetics, presenting a counternarrative to purist, nativist, white-centered notions of American identity. She reinforced and reiterated these Southern thematics in her compelling performances at the 2018 Coachella Festival in California, as the first Black woman ever to headline the festival. Dubbed "Beychella," the multifaceted show incorporated step, marching band, dance, and gospel choir performances associated with Southern culture, as well as appearances by Destiny's Child, Solange, and Jay-Z. These elements recollect and build on the dynamism of "Formation" in performances widely hailed by critics as a further testament to her unbounded artistic genius, superstardom, national significance, and even as a harbinger of further national honors and distinctions to come.

The Beychella performances reached a wider audience in the documentary and concert film, *Homecoming*, released by Netflix in 2019. Like "Formation" and the

Lemonade visual album, *Homecoming* created another deep and dynamic engagement with Black Southern contexts (Beyoncé 2016a, 2016b, 2019). It showcased time-honored traditions linked to historically Black colleges and universities (HBCUs) predominantly located in the region, from collegiate marching bands and drumlines to Black fraternity and sorority step shows—practices anticipated in the "Formation" video's footage of a Black marching band and highlighting of Black women dancers. By invoking these traditions generally and not promoting any specific HBCUs or Black Greek organizations, *Homecoming* provides a panoramic view of these institutions and celebrates their shared history and values.

Calling the film "Homecoming" signals the role of HBCUs as premier institutional sites for grounding the history and culture of Black communities in the US South; replacing the "e" in "Homecoming" with the Greek letter sigma (Σ) positions Greek organizations at the center of those traditions. At Black colleges, homecoming is a cherished celebration that draws many graduates back to their undergraduate campuses annually. Homecoming is the primary event that builds and sustains connections and networks among Black college graduates. Its events, which can play out for days, often include lavish gala balls and receptions, pageants, parades, street vending, tailgating, concerts featuring celebrities, Greek step shows, and parties. Homecoming culminates in a football game, the highlight of which is a halftime show featuring marching bands, dance ensembles, and drum majors. Alumni often don the paraphernalia of their college, fraternity, or sorority at the game. In addition to reconnecting alumni to their alma maters, homecoming celebrations raise vital funds for the university and promote alumni giving. Beyoncé's *Homecoming* highlights the distinct manifestations of homecoming in Black collegiate settings, recapturing their energy and dynamics.[19]

To develop the drumline and band featured in Beychella (and *Homecoming*), Beyoncé worked with Don P. Roberts and his Drumline Live company.[20] They brought together some of the most talented and skilled band members from across the country to develop the landmark concert. In *Homecoming*, which featured over two hundred performers, the drumline percussion, whistle blowing, and musicianship of the marching band and orchestra ground the concert with sounds typically unheard in popular music performances. Positioned on bleachers, the dancing and movement of the band and orchestra members serve as a dynamic visual backdrop for Beyoncé and other performers at the front of the stage. Together with the meticulously choreographed and timed routines by male and female step and dance groups, they frame the concert as being collective

rather than individual, a collectivity that also reflects the investments of Black colleges in their local, predominantly Black communities. In the documentary, Beyoncé reflects on the development of the concert: "I wanted a Black orchestra. I wanted the steppers. I needed the vocalists. I wanted different characters; I didn't want us all doing the same thing. And the amount of swag is just limitless. Like, the things that these young people can do with their bodies and the music they can play. The drum rolls and the haircuts and the bodies ... it's just not right. It's just so much damn swag" (Beyoncé 2019).

Beyoncé offers a glimpse into the Black college experience at institutions that few in the American mainstream have experienced or encountered. She uses her platform to share knowledge about HBCUs, whose rich history as sites for educating and uplifting former Black slaves goes back to the antebellum era. With few exceptions beyond films like *Drum Line* (2002) and *Stomp the Yard* (2007), which dramatized the competitive dimensions of HBCU marching bands and Black Greek step shows, respectively, as well as Spike Lee's *School Daze* (1987), which is set at the fictive Mission College in Atlanta, Georgia, or the NBC television show *A Different World* (1987–1993), HBCUs have seldom been depicted in the popular mainstream. By placing the band and orchestra onstage, Beyoncé's Coachella performance situated the predominantly white audience as a stand-in for the crowds at Black homecoming events, and educated them about Black cultural traditions.

Beyoncé's solo performance of the first verse of "Lift Every Voice and Sing," known as the Black national anthem, also staged a salient and dynamic celebration of Black identity in *Homecoming* (Perry 2018). Written by Harlem Renaissance author and NAACP leader James Weldon Johnson and composed by his brother, J. Rosamond Johnson, both from Jacksonville, Florida, the song is intimately linked to celebrations of Black history and culture, including HBCUs. Moreover, as a classic church hymn, "Lift Every Voice and Sing" is related to sermonic and song traditions within the Black church. While Beychella invited its audience to experience performance practices and traditions associated with Black Southern colleges, Beyoncé's stylization in the concert also invoked the aesthetics of Southern culture familiar in the white mainstream, in much the same way that her hairstyle in "Independent Women, Part I," referenced Farrah Fawcett. These style elements included cutoff denim shorts, which were originally popularized by the character Daisy Duke on the popular television show *The Dukes of Hazzard* (1979–1985), and helped make the actress Catherine Bach a sex symbol. Beyoncé also wore white fringed boots, which subtly referenced country

western style and her home state of Texas. Her claiming of these elements was balanced by her more textured, curly hairstyle, which affirmed hair aesthetics of the contemporary natural hair movement among Black women.

Homecoming innovatively reframes many of the music tracks and themes that centered women in *Lemonade* and incorporates a compelling performance of "Formation." It emphasizes themes of women's empowerment, invokes feminism, centers and foregrounds women as dancers and performers, and sometimes specifically addresses "ladies" in the audience. These dimensions reach their height when Kelly Rowland and Michelle Williams, to whom Beyoncé refers as her "best friends," perform a medley of Destiny's Child's most popular songs, including "Say My Name," as well as in a dance duet between Beyoncé and her sister, Solange.

It is also important to note that this landmark concert project complements Beyoncé's committed outreach to Black colleges and support of them in her HBCU Homecoming Scholars Program, which she established in 2017 as the Lemonade Scholars Program (Reed 2018). Her philanthropic contributions to Black colleges, like the work of Oprah Winfrey and Robert Smith, have placed her at the vanguard among Black leaders and celebrities dedicated to investing in and promoting Black institutions, which helps to free them from the constraints of white donors, who sometimes limited their vision and development. Beyoncé's sustained public outreach to Black colleges not only builds on her activist work but also mirrors, reinforces, and extends the best practices of community engagement that have been encouraged among faculty, staff, and students within institutions of higher learning, which have also been a tradition of HBCUs.

Beyoncé's artistry has been profoundly shaped by her backgrounds in the US South. A nuanced examination of such themes within her work can help us appreciate the foundations on which her engagements with the region have developed and how they have evolved and expanded over time. The linkages to Farrah Fawcett that I have examined clarify how Beyoncé's stylization evoked this iconic model of Southern femininity, while disrupting its long-standing racialist politics in scripting American womanhood as white. Such insights also provide valuable background for thinking about Beyoncé's recent engagements with the US South in works such as "Formation" and *Homecoming*. Not only do these insights help throw into relief the ways in which these works are more assertive and radical; they also help us recognize how much they have displaced previous color-blind representations of Beyoncé. Beyoncé richly demonstrates the potential for Black women to embody national models of femininity in the United States while making legible new Black Southern diasporas and identi-

ties. Of course, invoking the US South as an essential home in the project of constructing Blackness, including Black femininity, can risk replaying nostalgic and romantic formulations of Black identity that obscure how the region also remains a site of continuing trauma and entrenched racial and social inequalities. Nevertheless, the latest Southern turns in Beyoncé's work are perhaps the greatest yet, in acknowledging the region's regressive racialist politics from slavery to Jim Crow while also paving the way toward a new, more inclusive politics of race, sexuality, gender, and nation formation, in which Beyoncé, and we, too, can sing "America," in the sense that the poet Langston Hughes dreamed.

NOTES

1. For biographical discussions of Beyoncé, see Eslea 2011, Arenofsky 2009, and Taraborrelli 2016.

2. Beyoncé links her parents' backgrounds in the segregated South to the significance of the inauguration in a 2011 interview with Piers Morgan. For the full transcript, see Morgan 2011. Daryl Eslea comments on the impact of segregation on Mathew Knowles: "A true product of the American South, he saw at first hand segregation and the hatred from whites in a changing, troubled America. In his youth, the country was a cauldron of uncertainty and change, yet outwardly, it was almost impossible to notice. The world image of the country was one of a happy, smiling, white suburbia" (2011, 1). Knowles also discusses the pain of experiencing Jim Crow in his memoir (2017).

3. Baker's work, like my own and that of newer scholars, has also advanced critical reflection on Black Southerners. For example, see Robinson 2014.

4. Indeed, in their signal essay, Baker and Nelson remind us of Malcolm X's famous "summation of U.S. regionalism" that identified Mississippi as "anywhere in the United States south of the Canadian border," suggesting the openness of the new field to embracing this radical cartography for mapping the South in this nation (2001, 231).

5. Africana studies is an interdisciplinary field invested in comparative methods and foregrounds an examination of Africa and its diasporas, including the United States and the Caribbean. My earliest conversations in Southern studies offered critical perspectives and insights less derived from American studies than rooted in Africana studies and focused on the Black Atlantic, Black British cultural studies, and Caribbean studies. The contributions of such areas in the development of Southern studies, including discourses on the global and hemispheric South, have been obscured and seldom mentioned.

6. My study from Duke University Press, *Emancipation's Daughters: Re-Imagining Black Femininity and the National Body* (2021), acknowledges the US South's impact in stereotyping Black women. See also Richardson 2007, 2011.

7. Tara McPherson's study, *Reconstructing Dixie: Race, Gender, and Nostalgia in the Imagined South* (2003), critiques representations of the US South that obscure the region's interfacings across racial categories, including between Blacks and whites, and that are premised on the racialized fantasy of a monolithically white South.

8. The song appears on the group's third album, *Survivor* (2001), which celebrated empowerment themes, especially in the title track that became closely associated with Destiny's Child and, later, with Beyoncé as a solo artist.

9. Interestingly, this signal moment in the group's history is represented in the cover design for Mathew Knowles's 2019 biography of the group.

10. The Destiny's Child fashion doll sets produced by Hasbro in 2002 and Mattel in 2005 further enshrined this triangulated version of the group.

11. The Black actress Stacey Dash ironically registered Fawcett's status in the nation's popular imaginary and linkage to notions of American beauty in endorsing President Obama's Republican opponent, Mitt Romney, in the presidential election in 2012 when she released a photo of herself on Twitter that re-created Fawcett's image from the poster wearing a red bathing suit, smiling and in profile, but featuring an American flag instead of the multicolored, striped backdrop in Fawcett's photo.

12. Rosen (2014) notes, "Beyoncé has become something more than just a superstar. She is a kind of national figurehead, an Entertainer in Chief; she is Americana."

13. The December 6, 1976, cover feature in *People* magazine on the actresses in *Charlie's Angels*, "How Three Sweet Southern Girls Became TV's Hit Team," registered the national impact of the stars as Southern women.

14. I thank Mathew Knowles for sharing some reflections with me on this business enterprise and related publishing projects in November 2018. I also had the opportunity to interview Knowles at Cornell University alongside Harvard University scholar Marla Frederick in "A Conversation with Dr. Mathew Knowles" on September 27, 2018.

15. I first heard of the concept in Liverpool, England, in 1997 at the Mapping African America conference sponsored by the Collegium for African American Research, an organization designed to take African American studies into European contexts. As a graduate student, I learned about it while participating on a panel on the Black South alongside Karen Kossie and Veronica Toombs. They were also graduate students and emerging scholars deeply invested in Southern studies and were reading and studying critiques by Paul Gilroy and Carole Boyce-Davies on the problem of American-centered discourses of Blackness. Because they were living and studying in Texas, a place geographically categorized as being both Southern *and* Western and characterized by interethnic and linguistic flows and exchanges and intermixtures, they had been drawn to analyze the "Black South and Southwest" specifically. It is therefore significant and most fitting that Tyina Steptoe reads Beyoncé through this "South western" lens in her essay in *The Lemonade Reader*, entitled "Beyoncé's Western South Serenade" (Steptoe 2019).

16. Beyoncé seems to occupy the space as a popular icon in the global arena once held by Michael Jackson, who was known to his fans worldwide as the king of pop. Indeed, the news of Jackson's sudden death on June 23, 2009, eclipsed the sad news from earlier in the day of Fawcett's passing after struggling with cancer for several years.

17. Scholars working in queer and trans studies have been vital in advancing the field's epistemologies on Beyoncé while shaping emerging areas such as Beyoncé studies. A host of Black queer and trans women, including impersonators and activists such as Riley Knoxx and Miss Shalae (also known as Michell'e Michaels), have played a salient role in helping to popularize Beyoncé. Miss Shalae starred in a 2016 remake of *Lemonade* by a collective of trans women known as the Glass Wing Group in a 2016 video, "Lemonade Served Bitter Sweet" (see Chapter 9, this volume). Beyoncé has done outreach and collaborations with Black queer and trans women, as illustrated in her work with Laverne Cox, the award-winning Alabama actress and activist who serves as the face of Ivy Park, the active clothing brand cofounded by Beyoncé. Finally, Janet Mock (2014) has played a key role in expanding and nuancing the analysis of Beyoncé within Black feminist discourses.

18. The song "Irreplaceable," on Beyoncé's 2006 *B'Day* album, anticipates some of the strategies that she deploys years later in "Formation" in its mansion setting and positioning of women performers in the background.

19. Indeed, in the eyes of many critics, Taylor Swift's use of a marching band in her 2019 Billboard Music Awards performance of her song, "Me!" riffed on Beyoncé's *Homecoming* and represented a gross cultural appropriation that devalued and obscured the linkages of such performance practices to Black communities. See, for example, Grant 2019.

20. Don P. Roberts trained the band featured in the popular 2002 film *Drumline*.

REFERENCES

Arenofsky, Janice. 2009. *Beyoncé Knowles*. Westport, CT: Greenwood Press.

Baker, Jr., Houston A. 2001. *Turning South Again: Re-Thinking Modernism/Re-Reading Booker T.* Durham: Duke University Press.

Baker, Jr., Houston, and Dana D. Nelson. 2001. "Preface: Violence, the Body and the South." *American Literature* 73, no. 2: 231–44.

Beyoncé. 2006. *B'Day*. Sony Urban Music, Columbia.

———. 2016a. "Formation." Filmed summer and fall 2015. YouTube video, 4:47. Posted by beyonceVEVO, December 9, 2016. https://www.youtube.com/watch?v=WDZJPJV__bQ.

———. 2016b. *Lemonade*. Parkwood, Columbia.

———. 2019. *Homecoming: A Film by Beyoncé*. Parkwood Entertainment.

Boyd, Elizabeth Bronwyn. 2000. *Southern Beauty: Performing Femininity in an American Region*. Austin: University of Texas.

Caramanica, Jon, Wesley Morris, and Jenna Wortham. 2016. "Beyoncé in 'Formation': Entertainer, Activist, Both?" *New York Times*, February 8.

Dash, Julie, dir. 1991. *Daughters of the Dust*. Kino International. Film.

Destiny's Child. 2001. "Independent Women, Pt. 1." YouTube video, 3:56. Posted by Destiny's Child, November 24, 2009. https://www.youtube.com/watch?v=olPQZni7I18.

Durham, Aisha. 2011. "Check On It: Beyoncé, Southern Booty, and Black Femininities in Music Video." *Feminist Media Studies* 12, no. 1: 35–49.

Eslea, Daryl. 2011. *Beyoncé: Crazy in Love: The Beyoncé Knowles Biography*. London: Omnibus Press.

Gottesman, Tamar. 2016. "Beyoncé Wants to Change the Conversation." *Elle* (April).

Grant, Shawn. "Fans Name Taylor Swift's #BBMA Opening Performance #Mayochella after Seemingly Ripping Off Beyoncé's 'Homecoming' Theme." *Source*, May 2.

Hefner, Hugh. 2009. "The Sex Symbol." In "Remembering Farrah: Her Life in Pictures." *People Tribute* (October), 28.

hooks, bell. 1992. *Black Looks: Race and Representation*. Boston: South End Press.

Knowles, Mathew. 2017. *Racism from the Eyes of a Child*. Houston: Music World Publishing.

———. 2019. *Destiny's Child: The Untold Story*. Houston: Music World.

Levine, Elana. 2007. *Wallowing in Sex: The New Sexual Culture of 1970s American Television*. Durham: Duke University Press.

McG, dir. 2000. *Charlie's Angels*. Columbia Pictures. Film.

McInnis, Jarvis C. 2019. "Black Women's Geographies and the Afterlives of the Sugar Plantation." *American Literary History* 31, no. 4: 741–74.

McPherson, Tara. 2003. *Reconstructing Dixie: Race, Gender, and Nostalgia in the Imagined South*. Durham: Duke University Press.

Mock, Janet. 2014. "My Feminist Awakening and the Influence of Beyoncé's Pop Culture Declaration," September 3. https://janetmock.com/2014/09/03/beyonce-feminist-mtv-vmas/.

Morgan, Piers. 2011. "Interview with Beyoncé," *Piers Morgan Tonight*, June 27. http://transcripts.cnn.com/TRANSCRIPTS/1106/27/pmt.01.html.

Nelson, Valerie, J. 2009. "Farrah Fawcett Dies at 62; Actress Soared with, Then Went Beyond, 'Charlie's Angels.'" *Los Angeles Times*, June 26. http://www.latimes.com/news/obituaries/la-me-farrah-fawcett26-2009jun26,0,4388762.story.

Perry, Imani. 2018. *May We Forever Stand: A History of the Black National Anthem*. Chapel Hill: University of North Carolina Press.

Reed, Ryan. 2018. "Beyoncé Expands HBCU Scholarship Program in Second Year." *Rolling Stone*, April 16.

Richardson, Riché. 2003. "Southern Turns." *Mississippi Quarterly* 56: 555–77.

———. 2007. *Black Masculinity and the U.S. South: From Uncle Tom to Gangsta*. Athens: University of Georgia Press.

———. 2011. "Mammy's 'Mules' and the Rules of Marriage in *Gone with the Wind.*" In *American Cinema and the Southern Imaginary,* edited by Deborah Barker and Kathryn McKee, 52–78. Athens: University of Georgia Press.

———. 2017. "Forgetting Farrah." *HuffPost,* December 31. https://www.huffingtonpost .com/entry/forgetting-farrah_us_5a497203e4b06cd2bd03e12c.

———. 2021. *Emancipation's Daughters: Re-Imagining Black Femininity and the National Body.* Durham. NC: Duke University Press.

Robinson, Zandria. 2014. *This Ain't Chicago: Race, Class and Regional Identity in the Post-Soul South.* Chapel Hill: University of North Carolina Press.

Rodriguez, Deborah. 2007. *Kabul Beauty School.* New York: Random House.

Rosen, Jody. 2014. "Beyoncé: The Woman on Top of the World." *New York Times,* June 3.

Smith, Jon, and Deborah Cohn, eds. 2004. *Look Away!: The U.S. South in New World Studies.* Durham: Duke University Press.

Steptoe, Tyina. 2019. "Beyoncé's Western South Serenade." In *The Lemonade Reader,* edited by Kinitra D. Brooks and Kameelah L. Martin, 183–91. New York: Routledge.

Taraborrelli, J. Randy. 2016. *Becoming Beyoncé: The Untold Story.* New York: Grand Central.

University of Georgia Press. 2005. New Southern Studies Series. https://ugapress.org /series/new-southern-studies/.

Yaeger, Patricia. 2009. *Dirt and Desire: Reconstructing Southern Women's Writing, 1930–1990.* Chicago: University of Chicago Press.

J. BRENDAN SHAW

4. Merging Past and Present in *Lemonade*'s Black Feminist Utopia

The past and the present merge to meet us here.

Warsan Shire, quoted in Beyoncé's Lemonade *(2016)*

Black women relax in the stillness of a hot and sticky Southern afternoon, lazing on rocking chairs or sprawled across trees thick with moss. The screams and giggles of excited little Black girls break into the quiet of the day as they rush across a field of green, eager to see what the day holds. Black women gather vegetables from a lush garden and prepare a communal dinner eaten outside. Black singer Beyoncé's visual album *Lemonade* (2016) asks the viewer to spend time with these women and girls and displays a utopia grounded in their quotidian moments of connection. *Lemonade* presents a Black feminist utopia in contrast to the mainstream Western conception of a utopia as a world that has solved the fundamental ills of our contemporary moment through the radical reshaping of political and social life. Instead of presenting a nation reconstituted from the top down, *Lemonade* shows the possibilities for difference in small moments of connection between Black people.

Black feminist thinking reconsiders not just the scale of utopian thinking but also the historical limitations on *who* is centered in a utopia. Within political thought and creative works, the discussion of what constitutes a utopia has a long history, but as Avery Gordon argues, the "Western historiography of utopian thought and practice and the contemporary field known as utopian studies is a decidedly Eurocentric and racially exclusive construct" (2018, 35). Novelist Toni Morrison criticizes Western utopian thought for imagining "an impossible future, an irretrievable and probably nonexistent Eden" (1998, 3) and argues that

too often utopianism gets expressed through a "pathetic yearning and futile desire" for a world without race (4). In contrast to European utopian traditions, Gordon describes "the other utopian," which is "characterized by both direct action against and nonparticipation in liberal democratic state politics, by various forms of refusal, including the boycott and the occupation without demands. This other utopianism, audacious in its assertions, gestures towards an alternate universe or civilization, long in the making, emerging out of and receding back into the shadows as needed, sometimes linking its varied traditions and strands in solidarity and fellowship, sometimes badly internally broken" (2018, viii). In her description of "the other utopian," Gordon links a vision of elsewhere with an existing tradition of marginalized communities resisting and refusing normative logics of identity and nation. Utopianism in the tradition Gordon describes is understood through individual and collective action instead of governmental decisions made by those in power.

Reading *Lemonade* through the lens of utopianism requires not simply shifting our understanding of the utopian but also reckoning with the increasingly cynical view taken of imagining otherwise in contemporary American society. Calling something "utopian" has become a way of dismissing a dream of possibility or reducing it to an unachievable fairy tale.[1] Responding to critics who call utopian thought "naïve, escapist, and dangerous," Jayna Brown argues "that struggles against oppression would not exist if there were not some shared sense that other states of being were possible, where collective lives of abundance and happiness could be realized" (2010, 128). In this chapter, I focus specifically on the Black feminist utopian vision imagined in *Lemonade*, considering the utopian as not a childish fantasy but instead a necessary political tool. I develop a theory of Black feminist utopianism that connects with the alternative futures imagined and enacted within Black women's communities and artistic creations.

My analysis starts by thinking broadly about the concept of the utopian and futurity within Black feminist and queer theory before examining the complicated politics of Beyoncé's artistic work. *Lemonade* offers a potential visual and sonic present and future centered on Black women's community and the sharing of labor and intimacy. The film uses the iconography of the plantation to offer a route to the utopian built out of the past and never forgetting the dark histories that inform the present moment. In contrast to the large-scale dark utopias that dominate popular culture, the utopian presented here is one that exists on a smaller, more quotidian level and is made up of personal interactions.[2] Black feminist scholars have written about the radical potential of homemaking for

African Americans as a site for attempting to escape the vagaries of a white supremacist culture (Davis 1995; Gumbs 2017; hooks 2015; Isoke 2011). I argue for the radical potential of remaking the domestic space and finding power in claiming the former slaves' quarter along with the master's house. The plantation has a particularly dark history for Black women, but I draw on Katherine McKittrick's concept of "plantation futures" to theorize how *Lemonade* finds hopeful futurity in this site of violence and death (2013). Plantations were not only the site of deep sadness, but also form part of the ongoing history of Black radical resistance through joy and pleasure in the face of oppression. Black women return to the plantation in *Lemonade* to build intimate ties that offer a vision of a different future and inveigh against a cynical defeatism.

BLACK FEMINIST UTOPIANISM

Before turning to my analysis of *Lemonade*, I first contextualize this work within broader histories and theories of Black feminist and queer theorizations of the utopian. A utopic future appears in the final lines of Helen Cade Brehon's essay in the 1970 anthology *The Black Woman*. Brehon (the mother of the collection's editor, Toni Cade Bambara) writes of a future revolution: "Looking back—no more! To what shall I look forward? Chaos, revolution, more love, hate, fulfillment, need, pride, embarrassment? After the 'Great Day' I do hope I'll be able just to hail a cab—Utopia!" (Brehon 2005 [1970], 296).[3] Brehon's facetious comment about the aftermath of revolution in the form of the mundane moment of catching a taxi reflects a utopic vision that sees the everyday experiences of racism (and interlocking sexism and heteropatriarchy) resolved in small moments of interaction. Racist practice is a series of everyday occurrences that together form the elaborate systems that activists continue to protest and seek to overthrow. Mingling affective experiences with the upheaval of revolution and its attendant chaos, Brehon grounds a notion of what I would call Black feminist utopianism in her dream of a fleeting moment (catching a cab) no longer tethered to the unpleasant prejudice of others.

Many of the authors in Bambara's groundbreaking collection, the first exclusively focusing on Black women, pair a critique of contemporary culture with a call for revolutionary change to actually meet the needs of the citizenry. A revolution, these women contend, cannot simply approach one axis of oppression, for it will have not done anything revolutionary simply in undoing one layer of injustice. Bambara writes that those seeking change must "fashion revolution-

ary selves, revolutionary lives, [and] revolutionary relationships" (2005 [1970], 134). This intersectional revolutionary approach remains fundamental to Black feminist theories of the future. Jayna Brown writes that despite institutional attempts to hollow out the radicalism of Black feminisms, by returning to the artistic output of Black women writers and artists in the 1970s and 1980s, we can trace "an anarchistic impulse in black radical feminist art and activism that refuses to be subsumed within neoliberal market feminism" (2018, 582).

The utopianism of revolution must occur as part of the everyday. For example, Brown describes the radical feminist film *Born in Flames* (1983) as inciting viewers to "make revolution real, to make it our daily practice" (2018, 596). In applying a Black feminist utopian analytic in this chapter, I am arguing for a quotidian (and domestic) understanding of imagining the future. Tina Campt defines the quotidian as a practice "honed by the dispossessed in the struggle to create possibility within the constraints of everyday life" (2017, 4). These moments of possibility allow for a reading of the utopian found in moments like Brehon's desire to easily catch a cab or the shared intimacy of the community of women in *Lemonade*. The ideas presented in *The Black Woman* echo the writing of other Black radical feminists, writers, and thinkers whose work forms the basis for Jennifer C. Nash's theory of Black feminist love politics (2013; 2019). Nash describes a politic that disavows "attachment to the present"; instead, "love-politics practitioners dream of a yet unwritten future; they imagine a world ordered by love, by a radical embrace of difference, by a set of subjects who work on/against themselves to work for each other" (2013, 18). Black feminism in this tradition moves beyond a political approach based in a desire for institutional recognition and instead follows José Esteban Muñoz's vision of queerness (2009). Queer utopianism in Muñoz's formulation describes "a modality of critique that speaks to quotidian gestures as laden with potentiality" (91). Nash and the writers in *The Black Woman* similarly approach utopianism through "quotidian gestures" and other small moments of intimacy that offer forms of redress outside the state's response to harms, thus performing "a critique of the state and its capacity (or incapacity) to ever adequately remedy injuries" (Nash 2013, 16).

Unlike the mainstream Eurocentric utopian visions of popular culture, Black feminist imaginings of a different world are grounded in both present-day realities and the absolute necessity for social change. Brittney C. Cooper argues that "Black women's visionary pragmatism always encoded a view of Black people as a people of the future" (2015, 15). Her "visionary pragmatism" phrase encapsulates the complexity of Black feminist utopian thinking—one that blends the

necessity and pleasure of imagining a future with a realist grounding far different from the traditional Western utopian imaginary. *Lemonade*'s visual and aural invocations of the Black Lives Matter movement, police brutality, and Hurricane Katrina demonstrate the urgency so often embedded in art that imagines a Black feminist utopia. Tina Campt writes, "The grammar of black feminist futurity is a performance of a future that hasn't yet happened but must" (2017, 15). Her work focuses on photography and locates the realization of this Black feminist future not simply in political resistance but also in the "everyday imaging practices of black communities past, present, and future" (17). Black feminism has long understood theory and world making as not limited to confines of academia but occurring within artistic production and intimate connections in a variety of spaces.

I read *Lemonade* as part of a broader set of ongoing work by Black women artists and cultural producers that blend visionary pragmatism and necessity with creative expression. Susana M. Morris argues Black women's "futurist imaginings of art, literature, film, and music are often ignored, dismissed or diminished, but nevertheless remain fundamental to any complete understanding of futurity" (2016, 33). Since 2015, the Black Lives Matter Organization has celebrated February's Black History Month as Black Futures Month, aiming to imagine a "liberated future" and using art as a way "to imagine utopia, to dream, to unhinge the chains that bind us" (Black Lives Matter 2017). Each day of February, the Black Lives Matter website showcases a different piece of visual art offering a window into a potential future, frequently seeking to expand the lens of liberation to include marginalized groups within the Black community such as trans individuals or the elderly, or to think creatively about what a future can look like. The turn to the future through art by the Black Lives Matter movement, which has Black queer women at its center, makes sense given the history of Black feminism as a utopianist project. This yearly project echoes Morris's claim that "to be black and not only envision yourself in the future but at the center of the future . . . is an act of resistance and liberation, particularly in a present plagued by white supremacy and imperialism" (2016, 33). Black feminist utopian thinking can also be seen in the viral popularity of the hashtag #Blackgirlsarefromthefuture, started by scholar Renina Jarmon in 2010. Jarmon describes her motivation for creating the hashtag: "If Black girls occupy one of the lowest rungs on the social hierarchy, when I turn around and contend that Black girls are from the future, I have momentarily turned the social order on its head" (2013, 84). The art curated by the Black Lives Matter organization, Jarmon's popular hashtag, and the

cross-genre work in *The Black Woman* collection all serve as examples of a Black feminist utopianism rooted in the fabric of the everyday. One last example, a comedic one, can be seen in the title selection from Black poet Nikki Giovanni's 2013 collection, *Chasing Utopia*. The "Utopia" of the title is not an ephemeral place or a feeling but rather a specialty beer crafted by beer brand Samuel Adams. Giovanni describes turning to this beer after the death of multiple family members who were beer drinkers. Giovanni's piece demonstrates the vision of Black feminist utopia I am describing in *Lemonade*—one that is quotidian, affective, and built with an eye toward the past.

THE CONTENTIOUS POLITICS OF BEYONCÉ

Upon its release, *Lemonade* was swiftly deemed Beyoncé's most progressive, most personal, most creative, and most politically Black artistic production. While my focus in this chapter is on *Lemonade*, the visual album cannot be disentangled from her broader presence in American popular culture. As one of the most successful Black American entertainers in history, Beyoncé's relationship to Black feminist and progressive political action has been contentious. Initially, both as part of the group Destiny's Child and in her own solo career, the singer chose to be somewhat circumspect about her own political views.[4] With her visual albums *Beyoncé* (2013) and *Lemonade*, Beyoncé shifted her public image to openly engage with issues of gender and racial inequities in American society. Eric Harvey demonstrates the way in which the singer has used the accelerating significance of digital social media platforms to change her star image and merge her progressive politics with her creative output (2017). Beyoncé's choice to highlight grassroots struggles like Black Lives Matter in her work has drawn widely divergent responses from Black feminist critics. Mako Fitts Ward argues, "Beyoncé's fetishized Black feminist radicalism has transformed the politics of social movements into a set of commodities that ultimately sustain her personal empire" (2017, 148). Ward reads the investment in antiracist and feminist politics evinced in the singer's recent work as simply performative, an appropriation of radical politics as glamorous twenty-first-century chic lacking any links to actual substantive change.

Perhaps the most widely discussed criticisms of Beyoncé have come from celebrated Black feminist writer bell hooks, who generated a lot of buzz for calling the singer a "terrorist" for her participation in capitalist visions of femininity (Coker 2014). In her critique of *Lemonade*, hooks echoes Ward in calling out the

film for its failure to effect social change (2016). While she celebrates the images of Black womanhood, hooks considers the film to be ultimately a fantasy that retrenches sexist and racist systems. I agree with a wariness about looking to capitalist production as the ultimate solution to interlocking oppressive regimes, yet I still believe we can read cultural productions as eliciting affective responses and offering visions of the future. *Lemonade* is a corporate production, but the film can also speak differently to specific audiences—especially Black women—who are rarely spoken to on such a broad and mainstream scale. Black women are not a monolithic bloc, of course, and response to Beyoncé reflects both excitement about being represented and questions about which bodies and experiences are centered in this vision of Black womanhood (see Kai 2019; Shackelford 2019).

The criticism of the singer's failure to incite societal change places a lot of responsibility on an artist who also takes on risk in engaging so directly with political movements many Americans (and even the federal government) see as threatening.[5] I follow Daphne Brooks in arguing that part of the political potential in Beyoncé's work comes from her insistence that audiences "passionately engage and grapple with pop spectacle" (2016). Brooks does not deny the capitalist underpinnings of the singer's work, calling her a conundrum, yet she also argues Beyoncé "shows how popular music culture—and especially black women's popular culture—can awaken, acknowledge and articulate the pleasures and distastes of those in the margins." Brooks and Harvey highlight the ways in which *Lemonade* and Beyoncé's recent creative output more broadly have allowed Black feminist writers to drive critical conversation in a sphere—popular music—that remains dominated by white men's voices. My analysis of *Lemonade* draws in part from the rich amount of scholarly and popular texts responding to the film written by a multitude of Black feminist thinkers and artists.[6]

WATCHING (AND LISTENING TO) *LEMONADE*

As a text, *Lemonade* exceeds conventional boundaries of genre and media. Initially the visual album aired as a one-hour special on HBO before being available exclusively through Tidal and then later available for purchase through more traditional means (iTunes and, finally, a physical CD). Unlike her previous visual album, *Beyoncé* (2013), *Lemonade* is not simply a set of music videos that run consecutively; rather, the film presents a set of linked vignettes following a fictionalized Beyoncé as she navigates the despair and anger of discovering her partner's infidelity, ultimately reconciling with him after connecting with a

strong Black women's community. The film moves among roughly parallel narrative threads that occasionally intersect: highly metaphorical fantasy sequences like the now iconic sequence in which Beyoncé, dressed in a yellow designer dress, gleefully smashes car windows with a baseball bat as spectators rejoice; footage of middle- and lower-class New Orleans residents presented in super-saturated colors, which suggest documentary realness; and, most important for my analysis, sequences set on a large Southern plantation. *Lemonade*'s visuals draw clear inspiration from a rich set of Black cultural artifacts including Carrie Mae Weems's black-and-white photographs of Black men and women and Julie Dash's groundbreaking narrative film, *Daughters of the Dust* (1991).[7]

Lemonade's visuals are constantly interacting with the music, which is at times differently mixed in the film (most noticeably in the reduction of men's voices on all three tracks that feature male artists) and includes additional aural components not found on the music album. In the film scene for "Don't Hurt Yourself," for example, the song is interrupted by audio of the 1962 Malcolm X speech in which he avers that Black women are the most disrespected and vulnerable people in America.[8] Threaded throughout the visual album are audio clips of Beyoncé reading poems by Somali-British poet Warsan Shire, who became famous by sharing her writing on social media platforms including Twitter and Tumblr. As Robin James argues, no analysis of *Lemonade*'s music can be divorced from the visual components, and a true attendance to Black feminist musical analysis requires understanding music as entrenched in the visual and cultural components of lived experience (2019).[9] Where the visuals conjure up a host of literary and visual references, the music is similarly dense with allusion and references, including a broad array of musical samples and interpolations, along with movement across multiple musical genres, including New Orleans jazz, rap, R&B, and alternative rock.[10] As this brief discussion of the visual and aural components suggests, *Lemonade* is a dense artifact enmeshed in a long Black cultural tradition.

The affective trajectory of *Lemonade* draws on the viewer's knowledge of Beyoncé and her husband, rapper Jay-Z, as arguably two of the most visible Black Americans in the world. Watching social media responses to the HBO airing of the visual album reveals a clear reading of the narrative of betrayal and reconciliation as being about this very public marriage. The emotional journey of the film is signaled by chapter titles that move from "Denial" and "Anger," through "Accountability" and "Loss," to "Hope" and "Redemption." As is frequently the case with our most beloved celebrities, many read the public persona and art

as an articulation of Beyoncé's private affairs, a missive from an icon known for keeping a tight control on her image. I argue instead that *Lemonade* presents an aestheticized version of her life—one that mixes actual footage of her family (including her parents, her daughter, and her husband's grandmother speaking at her ninety-first birthday party) with evocative fantasies and set pieces. Furthermore, the movement of the album (both visually and aurally) is from a narrative of personal hurt to a shared need for revolutionary freedom and the finding of solace among a larger community. Beyoncé's marriage is not entirely absent from the film's concluding section—her union with Jay-Z is celebrated in the closing section of the film alongside footage of other couples (including interracial and same-sex pairings). The film "draws the throughline between personal and historical injury" and "takes a story of personal betrayal as an opportunity to sing the blues for so many ways Black women are vulnerable to hurt" (Brooks 2019, 162; Tinsley 2018, 29).

Treva Lindsey writes, "*Lemonade* wasn't just a visual album about cheating; it was a visual album about the power of black women's kinship across generations. It shows our communal spaces as healing, loving, and necessary" (2016). I follow Lindsey's call to read the broader narrative of Black women forging communal and utopian spaces for healing. My argument for the envisioning of a Black feminist future in *Lemonade*, one visualized as a Black woman's space, does not read the album as crafting an explicitly queer or separatist space, but rather one expansive to multiple forms of healing intimacy.[11]

SEARCHING FOR A HOME IN A RACIST, SEXIST WORLD

From its opening sequences, *Lemonade* establishes the importance of home spaces for Black women and shows that a lack of physical grounding can reflect a lack of emotional stability. The film's first chapter, "Intuition," foregrounds the Southern plantation home as a space of stillness and waiting. In these first shots, the camera tracks along the various buildings on a plantation—the large main house, the slave quarters—and shoots up toward the sky through large trees thick with moss. The shots are black and white with only the sounds of nature. Black women dressed in all white are shown throughout this plantation landscape, waiting.

By the film's end, the plantation space is filled with women working together in the act of homemaking, an act of political resistance. Describing the practice of what she calls "creating living room," Alexis Pauline Gumbs writes, "In the

current moment, our [Black] communities are continuing to do what we have done for generations, creating housing, spiritual space to breathe and collective space to gather, without permission" (2017). Since slavery, the building of home places by Black women has been an inherently radical and political act of survival and nurturance (hooks 2015; Isoke 2011). Homes offer space for Black people to briefly escape the forces of white supremacy, even when Black community members do not own the physical dwellings.

The plantation spaces, where women wait expectantly, contrast with the sites of placelessness that the singer visits in the first half of the film. A lack of a grounding in a home echoes the emotional turmoil of Beyoncé's heartbreak and anger. The stillness of the plantation in the opening section contrasts with the film's catalyzing movement of Beyoncé jumping off a high-rise building, presumably distraught by her husband's betrayal. After her dive off the building, the singer finds herself in a surreal underwater bedroom, facing her own double. The action in this underwater sequence appears often to speed up as Beyoncé recites a Warsan Shire poem in which the female body is used to defile sacred objects. While the scene establishes a narrative of female empowerment, the physical space feels gothic and unwelcoming to the protagonist.

Writers have shown the way in which this sequence—Beyoncé's apparent suicide turning into a rebirth from water—draws from a rich tradition of African mythology.[12] Within this narrative, the underwater space is liminal, representing a space between life and death. From here, the singer is reborn in a vibrant yellow dress, and viewers watch her gleefully stroll down a street smashing the windows of cars and shops with a bat. The urban scene of "Hold Up" is clearly artificial and serves to allow the singer to play out this revenge fantasy without any repercussions. Beyoncé continues to move between transient sites with the use of a parking garage setting for her aggressive rock track, "Don't Hurt Yourself." While the visuals for the song "Sorry" feature extended sequences of the singer and tennis player Serena Williams inside the plantation's main house, the elaborate dance numbers in this section are set on and around a bus, which is literally a site of transience.

In the video for "6 Inch," Beyoncé watches desolate nighttime street scenes from the comfort of a car. Intercut are scenes of her dancing for an unseen audience and later causing a claustrophobic hallway to start on fire. Here the interior spaces are uneasy and dark, alluding to places where some women transact sex work. There is also a section set in a plantation house with Beyoncé dressed in a Victorian costume, swinging a lightbulb and illuminating a circle of women.

As with the rest of "6 Inch," this setting is unnerving, but it also highlights the slowly gathering women's community and the ways that the plantation space will come to be central to the healing second half of *Lemonade*. In the closing scene of this chapter, the singer stands in front of a burning plantation house flanked by men, defiantly facing the camera "as an antebellum horror-movie fire-starter" (Lordi 2016). Emily Lordi argues that Beyoncé's repeated singing of "Come back" at the end of the song can be heard as a call to women in the "backrooms of slave plantations. *To come back and do what?* One answer: help the community heal. Another is, help burn shit down. These are not necessarily different" (2016). Lordi's analysis shows the ways in which "6 Inch" bridges the placelessness of the film's first half and the plantation homecoming of the second half. While the image of the burning plantation provides catharsis, the return of these buildings in the next chapters demonstrates their key role in building a Black feminist utopia.

The second half of *Lemonade* shows a Black feminist utopian space crafted by Black women reclaiming and remaking the plantation environment as a site of resistance through communion. Turning to the plantation as a site of home-making initially seems like an odd choice since this was a landmark constructed to dehumanize African Americans. The plantation household was a political and economic space in which crafting private space was nearly impossible for enslaved peoples (Glymph 2003). American chattel slavery worked by constructing a space in which enslavement was naturalized as the right of white men and women, and this space retains the histories of brutality required to maintain this world order. The plantation was instrumental in establishing American racial hierarchies, serving as the center of the slave trade and working to erase a Black sense of place for enslaved peoples (McKittrick 2011, 2013). The plantation buildings and grounds shown in *Lemonade* are all actual sites in New Orleans.

In her stunning essay on the film, LaKisha Michelle Simmons describes the history of slavery and slave rebellions: "Dismembered and displaced bodies are haunting the landscape of *Lemonade*'s past and present" (Simmons 2016). Plantations linger in the public consciousness as markers of racist pasts, continuing to circulate through "slavery's profound extensions" into the present through a variety of visual content ranging from historical photographs and historical films to plantations claimed as tourist sites and venues for social events (Brown 2017, 121). Writing about Steve McQueen's film *12 Years a Slave* (2013), Kimberly Juanita Brown asks, "How cleanly . . . can we separate plantations as built environments from the enslaved workers who built them?" (2017, 127). Brown's question reveals

the ways in which plantation spaces are not simply a remnant of a barbaric system but also the literal product of that system, built from the forced labor of the enslaved. Beyoncé's choice to set much of *Lemonade* on plantation grounds draws on this living history—one that continues to linger in this space—signaling a claiming of this history for Black women, who are often figured as the most vulnerable and violated in the popular narrative of slavery.[13]

PLANTATION FUTURES (AND PASTS)

The past and present are linked through geography, argues Katherine McKittrick (2011, 2013), a claim echoed in the Warsan Shire poetry line in the chapter epigraph: "The past and present merge to meet us here." Through its use in *Lemonade*, the "here" in the quote becomes the physical space of the Southern plantation. If the plantation land and buildings are used in *Lemonade* to evoke the difficult histories of American chattel slavery, this history must be remembered as also holding the tools of decolonial resistance. Describing the plantation's role in crafting the "racial contours of uneven geographies" undergirding the current racial system, McKittrick asks, "What kind of future can the plantation give us?" (2013, 12). She argues that the otherness and abjection of the Black body that occurred on plantations need not be its only contribution to our understanding of future possibility. McKittrick's idea of "plantation futures" (2011, 2013) reclaims these historical spaces from their commonsense equation with simply the horrors of slavery. Returning to the plantation echoes Jennifer C. Nash's argument that "freedom and radical black feminist politics can be rooted in myriad sites, including spaces that have been rife with our own subordination" such as spaces "historically constructed to secure our status as property" (2019, 130). Instead of ceding to a logic of the Black subject as consigned to death, theorists might return to the plantation and see how it also houses the potential for life, creativity, and resistance. "The Southern Plantation has yet to be acknowledged as the birthplace for a community and a culture that has changed the world," writes food historian Michael Twitty (2013). He adds, "Our aesthetics–our foodways–our music–our spirituality–our everything—owes a great deal to the civilization in chains" (Twitty 2013).

LaKisha Michelle Simmons's essay on *Lemonade* (2016) centers on the ways that plantations, specifically those used as settings for the film, were historical sites of rebellion and resistance. One approach to fighting back against the past can be seen in the elemental destruction wrought by Beyoncé in the angry first

half of *Lemonade*. The singer rises from the water to wreak havoc with her bat in "Hold Up," and "Don't Hurt Yourself" and "6 Inch" feature fires that are both chaotic and cleansing. A more settled version of engaging with the past can be seen in the engagement with the built environment and natural surroundings of the plantation in the second half of the film. Black women sprawl across trees, sit among flowers, and walk through the shallow waters along the low beach of the bayou. These women choose to return to this space on their own terms to build community and heal.

The idea of a Black female community turning to the plantation as the site for building a future in *Lemonade* presents a Black feminist utopia within the domestic space of the home. While the home in American culture has often been doubly constricting for Black women as a nexus of gendered and racial oppressions, it can also serve as a site of resistance through community. The lofty imaginary utopias often seen in Western white cultural texts are "never home," Toni Morrison writes (1998, 11), and *Lemonade* presents a return to the plantation as a homecoming. Morrison calls for an investment in the more quotidian metaphor of the home as a place for remaking social life. Turning to the domestic sphere "moves the job of unmattering race away from pathetic yearning and futile desire; away from an impossible future, an irretrievable and probably nonexistent Eden to a manageable, doable, modern human activity" (Morrison 1998, 3–4). Morrison's argument about the failures of utopian thinking and her call to take "what is articulated as an elusive race-free paradise and domesticate it" complement the broad Black feminist investment in a futurity that seeks change not simply at the level of policy but also in smaller, everyday affective moments (1998, 8). For my purposes, Morrison's emphasis on the metaphor of the home and McKittrick's reconceptualization of the plantation provide ways in which Beyoncé reacquaints viewers with the history and geography of slavery.

Recasting the conventional narrative of the plantation as a site of pain and sadness, *Lemonade* presents this historical space as one of rebirth and Black feminist communion. With the chapter "Accountability," the film shifts to the plantation as its central setting and sets about crafting the building and environs as a welcoming racial home. Black women waiting on the plantation are intercut with the more urban and fantastical sequences in the first half of the film. In the affective arc of *Lemonade*, the move to the plantation coincides with the movement from anger and apathy to the forgiveness, redemption, and hopefulness of the album's concluding half. "Accountability" opens with little Black girls breaking into the stillness and waiting quiet of the plantation space with

their joy at playing with dolls and jumping on a bed. In another scene, a little girl watches Beyoncé tie up her hair. Children embody the hopeful futurity of plantation futures, and Black children remind viewers that Black women "have lost their children past and present" (Simmons 2016). The future possibilities inherent in children are reinforced by documentary footage of a Black man explaining that he lives for his children, seeking to emulate former President Barack Obama. "Accountability" includes the song "Daddy Lessons," in which the speaker details her father's warnings about romantic partners and describes how her father taught her to use a gun for self-protection. Among the images shown during the song is footage of Beyoncé as a little girl playing with her father. This section of the film—and later footage of Jay-Z playing with their daughter, Blue Ivy—celebrate the potential of Black fatherhood; however, the plantation space in the film remains almost entirely populated by Black women, presenting the healing potential of this utopian space as explicitly feminine.

While I understand *Lemonade* as offering a Black feminist utopia, this does not mean that the film obscures the presence of Black death. I have discussed the ways in which the setting invokes the violent history of slavery, but the film also highlights the continued history of racist violence, especially deaths of Black boys and men at the hands of the police. Tina Campt argues that within Black feminist theory "the question of futurity is inextricably bound up in the conundrum of being captured by and accountable to the historical impact of the Atlantic slave trade on the meaning of Black womanhood in the Americas" (2017, 15). The future imagined by Black feminist thinkers does not erase the past but reckons with its continuing stain on American social life, drawing attention to how this history lives on in the continued murders of Black men, women, and trans individuals by the state. *Lemonade* juxtaposes the presence of Black girls playing on the plantation with an intense sequence in the chapter "Resurrection" highlighting the deaths of Michael Brown, Eric Garner, and Trayvon Martin. The mothers of these boys and men, dressed in regal finery, sit enthroned and hold photographs of their dead sons, one unable to make it through the shoot without crying. The murders of all three boys and men served as flashpoints in the ongoing struggle for Black lives led by the Black Lives Matter movement.

In drawing on the iconicity of Black *men*'s death, the film risks participating in the effacement of the death of Black women and Black trans or gender noncon-forming individuals. Jennifer C. Nash notes that even in the discussion around #BlackLivesMatter, a "pervasive racial iconography" has become naturalized, one in which "black women are represented as witnesses of violence and black men

are represented as victims of violence, where black women raise the dead and black men are the dead" (2016, 752). Treva Lindsey calls on those documenting the current antiracist movement to not relegate "Black women and girls, queer people, and trans* people to the margins" (2015, 236). Given the disproportionate number of Black trans women murdered in the United States, Omise'eke Tinsley describes her thirst for "images reflecting black trans* women's complex, carefree, and careful lives" (2018, 146). She draws attention to the absence of Black trans women in *Lemonade* and hopes that in a future Beyoncé project, there will be a "black woman power anthem" featuring an "out black transwoman dancing beside her, slaying all day" (158).[14]

I want to hold the concerns raised by Nash, Lindsey, and Tinsley in tension with the moving spectacle of the mothers of the movement holding the photographs of their dead sons in a musical album/television special released by a mainstream musical artist.[15] I find the choice to include these women and their grief exceptionally powerful even while it may narrow the parameters of the Black Lives Matter movement's aims. While the space of the mothers could be read as reifying the gender binary Nash describes, *Lemonade* can also be read as placing them within a space of healing across generations of Black women. On the plantation, these mothers are offered not simplistic promises of redemption but the potential for utopian futures.

THE TEMPORALITY OF FREEDOM

The spaces shown in *Lemonade* with only Black women operate in the utopian temporality Kara Keeling calls "poetry from the future," sitting outside normative attempts to fix subjects in a specific time and place (2019, 81–105). *New York Times* writer Wesley Morris describes how *Lemonade* conflates "300 years ago and right now" (Caramanica et al. 2016). Historical markers are in flux, with the women wearing contemporary designer clothes alongside Victorian-influenced attire. In the chapter "Reformation," a brief clip shows a Black woman with a buzzed head in nineteenth-century costuming looking down on the playing field in a modern stadium. A longer scene in "Resurrection" highlights the film's temporal slippage: a crowd of Black women dressed in white dresses come together outside for a group portrait taken with an old-fashioned plate camera. The scene recreates pivotal moments from Julie Dash's *Daughters of the Dust* (1991), a film about the Peazants, a family of Gullah heritage living on an island off the South Carolina coast. In the film, a Northern photographer documents the family's last days in

the Low Country. Unlike in *Daughters*, however, the photograph in *Lemonade* captures women united by space and experience instead of strict family ties, and instead of a man, teen actress Amandla Stenberg plays the role of photographer. Stenberg's inclusion in this role draws on her visibility as both an actress and a vocal Internet personality invested in raising awareness about feminism, queer identities, and gender fluidity.[16] Stenberg's queer nonbinary identity paired with her Blackness and her youth informs her positioning as the photographer; the scene shows the past bleeding into the present with her twenty-first-century celebrity persona paired with the presence of the anachronistic photography equipment.

The Black women come together in the space of the plantation, which is out of time and across time. As a utopian space, this is one marked by stillness and nature instead of the harsh technological futures frequently figured in contemporary popular culture.[17] Utopian gestures are domestic and quotidian, found in intimate connections and bonds forged as Black women are shown growing food, cooking, and eating together. In the closing song, "All Night," which plays over the "Redemption" chapter, Beyoncé sings about love as a "weapon" and a site of "salvation." The invocation of love "all night long" clearly reads as sexual, and yet this could also describe the alternate future *Lemonade* envisions separate from Beyoncé's interactions with her actual family. This dreamy Southern home space suggests that shared domestic tasks and breaking bread together can offer redress to the harms of racism, sexism, and state violence. Choosing to perform these tasks on the sites where Black women were once compelled to by violence offers a quiet resistance through "visual reclamation" and an example of what Sara Ahmed refers to as "feminist housework" (Maner 2018, 195; Ahmed 2017, 7). Ahmed argues that a movement for change "needs to take somewhere," and a movement often itself serves as a kind of shelter for those involved in struggle (2017, 3). She writes, "Feminist housework aims to transform the house, to rebuild the master's residence" (7). While Ahmed may understand "housework" as a metaphor, in *Lemonade* Black women in communion find true transformation of the space through their labor.

Musically, the trajectory of the album is toward Beyoncé's reconciliation with her partner, but in these scenes of Black women coming together, we see the shared community providing a different kind of healing that seems beyond simply the rekindling of heterosexual romance. The later chapters of the film do emphasize visually Beyoncé and Jay-Z's marriage with home video clips. At the same time, this narrative is kept separate from the plantation setting of the Black

women's community, suggesting a second reading of healing from the onslaught of misogynoir that permeates American society. Drawing from the writings of Toni Cade Bambara, Avery Gordon stresses the need for community as part of a healing process, writing, "The community must be present because without it, you've got no place to go when you're better" (2018, 48). Gordon's framing presents an idea of healing that is both personal and communal; this divide can be seen in the film's presentation of multiple scenes of Beyoncé alone facing her own demons but also her role as part of the Black women's plantation home.

Jennifer C. Nash reads Black feminist love politics as an affective project that "reformulates public culture and organizes it around affect and new conceptions of redress" and reorients public culture toward "a different sense of temporality" that allows for the dream of a "yet unwritten future" (2013, 16, 18). This unwritten future—this plantation future—is presented most fully in the last chapter of the film, visually cued by a switch to filming the plantation space in color instead of black and white. Black women move through the space in brightly colored clothes with the images supersaturated to heighten the brilliance. Black women pick vegetables in a garden and prepare foods in the kitchen of an old slaves' quarter and then sit in stillness together on a front porch. These women include Stenberg, teen actress Zendaya, sister singers Chloe and Halle, and Oscar-nominated child actress Quvenzhané Wallis—all figures who have faced scrutiny for their raced and gendered bodies in the public sphere. The utopian space of the front porch, the garden, and the dinner table are not free from the contemporary and past moments. These other temporalities are not intrusions but instead fertile ground for building community.

The freedom offered in *Lemonade* is one that is ephemeral and a work in progress. Beyoncé sings the song "Freedom" to a tent revival made up of Black women; the chorus oscillates between lines about being unable to "move" and a need to "keep running." "Freedom" in this song is not an arrived at state of being but something constantly sought through continual physical and spiritual movement against the confines of society. The line "I can't move" echoes "I can't breathe," the chilling words of Eric Garner before he died in a police chokehold in 2014. Instead of offering the tent revival a song about Christian salvation, Beyoncé performs a song about "Freedom" as a constant "struggle" (Davis 2016), reflecting the ongoing antiracist work of Black feminist thinkers. Avery Gordon argues, "is an uneven process, not very linear, always looping around, catching us at different moments. . . . [Freedom is] the process by which we do the work of making revolution irresistible, making it something we cannot live without"

(2018, 49). The temporality of freedom is not a straight line but rather a constant working through, a negotiation between stillness and frenetic movement, like the aesthetic movements seen across *Lemonade*. Jayna Brown similarly describes utopia as "a process, an ongoing activity, a continual reaching forward that can help spur revolutionary action" (2010, 128). The pleasures and joys of freedom, articulated in the rich and dense aesthetic project of *Lemonade*, offer an affective move toward some other way of being, different ways of knowing time and history. By making revolution irresistible, Gordon writes, "We make the best history we can now, which is only ever when we have a chance" (2018, 205). Returning to the plantation, Beyoncé reclaims this home as a site of rebellion and joy instead of simply death and defeat. The Black feminist utopia I have described here is not one that institutes change from the top down but rather one in which little moments of communion offer a path to a necessary future.

ACKNOWLEDGMENTS

My thanks to the original readers of this chapter (in much different form in a dissertation): my committee of Joe Ponce, Debra Moddelmog, and Andreá Williams and my dissertation writing group Toni Calbert, Tiffany Salter, and Krupal Amin. I have discussed the ideas in this chapter at length with Michael Harwick and Andrea Breau. My linguist crew—Katie Carmichael, Cindy Johnson, and Marivic Lesho—provided on-demand editing assistance and told me when my sentences needed some TLC. Sonnet Gabbard and Taneem Husain offered help in a myriad of ways. This chapter wouldn't exist without the pathbreaking and necessary work done by so many Black feminist scholars and writers, many cited here. *Lemonade* has led to many exceptional pieces of writing, and I am grateful for these authors' incisive analysis, as well as my own personal corner of social media where I engaged in debates with friends near and far (especially Jacinta Yanders and Alex Harlig). I have tried to faithfully cite and shout out all the amazing writing on this film that informed this piece. My thanks to this book's editors and to Marquita Smith for her insightful and helpful feedback on this chapter.

NOTES

1. In Avery Gordon's essay on police and prison abolition and the art of Glenn Ligon, she discusses the way that "utopian" has become understood as worthless fantasy (2017).

She writes, "To view [the demand for the abolition of police power] as a political exigency and not 'merely utopian' in the dismissive sense is exactly the kind of utopianism that radical abolitionists have historically modeled" (2017, 200). This chapter does not take up directly the fight for abolitionism but follows Gordon in understanding utopianism as holding the seeds of true change, not simply foolhardy thinking.

2. Examples of popular dark utopias include *The Purge* film series (2013–) (in which crime is nearly nonexistent because of a yearly day in which any and all violence is socially allowed), *The Hunger Games* film series (2012–2015) (in which a highly stratified society forces citizens to compete for survival), and *The Handmaid's Tale* TV series (2017–present) (in which reproduction is controlled by the state).

3. Toni Cade Bambara published as Toni Cade when *The Black Woman* was released; however, in this chapter, I use the name she adopted later. The bulk of her work was published under this name.

4. The discussion that follows about Beyoncé's political stances should be understood as commenting on both her explicitly stated personal politics and the visible performance of progressive politics in her audio and visual art. I am conscious of Samantha Pinto's recent argument (2020) that reading later work by Beyoncé as "political" reinforces a notion of the political in art as opposed to the popular, drawing on high art/avant-garde aesthetics, and referencing Black nationalism. Pinto offers a reading of the singer's earlier work as not simply "escapist fantasy" but engaging with a long history of Black women playing with surface pleasures to enact a "politics of the possible" (523).

5. In a polarized political climate, especially in the wake of the 2016 presidential election, there has been an increased call for musical artists to take political positions. Even before this moment, however, certain artists have always been expected to more clearly take on political positions (especially those openly LGBT identified and/or nonwhite). Furthermore, once an artist expresses some political beliefs through their art (as with Beyoncé's display of the word *feminist* onstage at the MTV Video Music Awards show in 2014), critics place ever greater weight on their art. This entire chapter relies on reading *Lemonade* through a political lens, but I am cautious about the expectations placed on any artist—especially a Black woman—to perform politics in a way that is as explicit and "right" as desired by observers. White pop singer Taylor Swift's initial refusal to disavow Trump or give more than a tepid denouncement of her white supremacist following was called cowardly yet did not lead to the same call for explicit political content in her music. By not engaging at all with politics, Swift avoided being judged by the politics she chose (not) to sing about.

6. I draw on articles I found in the initial critical response to *Lemonade* via social media (especially the Facebook feed of my colleague Jacinta Yanders) as well as Janell Hobson and Jessica Marie Johnson's exhaustive bibliography, "#Lemonade: A Black Feminist Resource List" (2016). More recent articles (and revised versions of some pieces initially

published online) can be found in *The Lemonade Reader* (2019), edited by Kinitra D. Brooks and Kameelah L. Martin, and *Queen Bey* (2019), edited by Veronica Chambers.

7. Janell Hobson (2016) draws parallels between Carrie Mae Weems's series, The Louisiana Project, and the imagery of the Southern plantation space reclaimed by the Black female body. In the segment "Hold Up," the yellow designer dress Beyoncé wears, along with her emergence from water, draws on the imagery of the Afro Latinx goddess Oshun. The figure of Oshun recurs in *Black is King* (2020). The visual references to African deities further align *Lemonade* with a queer temporality moving among the past, present, and future. For more on *Lemonade*'s intertextual references, see Hobson's "Lemonade: Beyoncé's Redemption Song." Hobson and Treva Lindsey (2016) both also draw attention to the many Black feminist literary references in *Lemonade*.

8. The full audio clip features Malcolm X saying, "The most disrespected person in America is the black woman. The most unprotected person in America is the black woman. The most neglected person in America is the black woman."

9. James's analysis focuses on reviews of *Lemonade* that attempt to separate the music from the visuals in a move that, she argues, severs the music from a Black feminist practice. She contrasts these reviews with the multiple reviews and essays penned by Black women, noting that when these women write about how *Lemonade* makes them feel, "what affects and knowledges and emotions it communicates, *they are talking about the music*—they [Black feminist writers] just work in a tradition that understands music as something other than 'the music itself' (that is, they don't think music is abstracted away from visual and cultural elements, from structures of feeling common to black women with shared histories and phenomenological life-worlds)" (original emphasis, 2019, 74).

10. Beyoncé has cultivated an image of intense control over her creative output and executive-produced both the music and visual albums. I see her work with musical artists across genres and the broad array of samples (including Led Zeppelin, Andy Williams, field recordings by Alan Lomax, and the Southern rap duo Outkast) as part of her investment in the type of densely intertextual work frequent in Black cultural production. The dizzying number of writers credited for many of her songs has also led to a series of Internet memes lambasting her for her lack of creativity, frequently contrasting the number of writers credited on her albums with the small number on either the work of recent white rock artists (especially the alternative rock singer Beck) or with older classic rock artists (such as Queen). The latter comparison completely ignores the change in copyright law since the 1990s because of sampling. For more on this debate over creative control (and the race and gender bias against Black women), see "She Gave You *Lemonade*, Stop Trying to Say It's Tang" by Birgitta J. Johnson in *The Lemonade Reader* (Brooks and Martin 2019).

11. Omise'eke Tinsley's *Beyoncé in Formation* (2018) provides a compelling examination of the singer's relationship to queer identities and desires through a mix of theoretical and personal exploration.

12. Janell Hobson describes the scene's use of African mythology: "There is La Sirene, underwater, in the realm of the other world, asleep before slowly awakening to her resurrection in the here and now, becoming Oshun, fertility goddess bedecked in her trademark yellow with gushing waters accompanying her entrance" (2016). For more on the use of Afrodiasporic imagery, see the chapter in the section "Of Her Spiritual Strivings" in *The Lemonade Reader* (Brooks and Martin 2019).

13. The use of existing plantations in filming *Lemonade* points to the way in which historical plantation sites now operate as tourist attractions, museums, and sets for various creative projects. Along with *Lemonade*, other recent texts that have centered on the plantation include the films *12 Years a Slave* (2013), *The Beguiled* (2017), *Antebellum* (2020), and the television series *Underground* (2016–2017). Some of these plantations have been used in multiple productions.

14. Black queer Bounce singer Big Freedia and New Orleans performer Messy Mya are featured on the audio for "Formation" but do not appear in the film. Beyoncé's more recent films—the concert film *Homecoming* (2019) and the visual album *Black is King* (2020) also lack any explicit representation of trans or gender nonconforming individuals.

15. In discussing *Lemonade*, a colleague noted that in removing Kendrick Lamar's rap from the film's mix of the song "Freedom," the song removes a Black male voice. The use of rap on a song focusing on revolution draws on a history of hip-hop as the provenance of Black rebellion; his absence from the film simultaneously reinforces a logic of Black male scarcity while crafting a space that is only feminine.

16. Stenberg first gained broad notice for her role in the film adaptation of the popular young adult novel *The Hunger Games*, a role that received considerable fan backlash because many readers had failed to realize her character Rue was described as not white. Stenberg has become a highly visible presence on social media as she works to educate fans about cultural appropriation and queer genders and sexual identities. Over 2 million viewers have watched her YouTube film, "Don't Cash Crop on My Cornrows." Omise'eke Tinsley describes Stenberg's cameo as "electric with queer subtext" (2018, 139).

17. For more on the use of stillness in *Lemonade* and its relationship to Black female interiority and resistance, see Sequoia Maner's essay, "Where Do You Go When You Go Quiet?" (2018). Maner also links Beyoncé to the lineage of Zora Neale Hurston and Alice Walker.

REFERENCES

Ahmed, Sara. 2017. *Living a Feminist Life*. Durham, NC: Duke University Press.

Bambara, Toni Cade, 2005 [1970]. "On the Issue of Roles." In *The Black Woman: An Anthology*, edited by Toni Cade Bambara, 123–35. New York: Washington Square Press.

Beyoncé. 2016. *Lemonade*. Parkwood Entertainment. DVD.

Black Lives Matter. 2017. "Black Futures Month." January 25. https://blacklivesmatter.com/programs/black-futures-month/.

Brehon, Helen Cade. 2005 [1970]. "Looking Back." In *The Black Woman: An Anthology*, edited by Toni Cade Bambara, 287–96. New York: Washington Square Press.

Brooks, Daphne A. 2016. "How #BlackLivesMatter Started a Musical Revolution." *Guardian*, March 13. https://www.theguardian.com/us-news/2016/mar/13/black-lives-matter-beyonce-kendrick-lamar-protest.

———. 2019. "The Lady Sings Her Legacy: Introduction." In *The Lemonade Reader*, edited by Kinitra D. Brooks and Kameelah L. Martin, 161–65. New York: Routledge.

Brown, Jayna. 2010. "Buzz and Rumble: Global Pop Music and Utopian Impulse." *Social Text* 28, no 1: 125–46. https://doi.org/10.1215/01642472-2009-063.

———. 2018. "A World on Fire: Radical Black Feminism in a Dystopian Age." *South Atlantic Quarterly* 117, no 3: 581–97. https://doi.org/10.1215/00382876-6942171.

Brown, Kimberly Juanita. 2017. "At the Center of the Periphery: Gender, Landscape, and Architecture in *12 Years a Slave.*" *Global South* 11, no. 1: 121–35. https://doi.org/:10.2979/globalsouth.11.1.07.

Campt, Tina M. 2017. *Listening to Images*. Durham, NC: Duke University Press.

Caramanica, Jon, Nikole Hannah-Jones, Wesley Morris, and Jenna Wortham. 2016. "Beyoncé's 'Lemonade' Makes a Statement. Discuss." *New York Times: Music*, April 27. https://www.nytimes.com/2016/04/28/arts/music/beyonce-lemonade-discussion.html.

Coker, Hillary Crosley. 2014. "What bell hooks Really Means When She Calls Beyoncé a 'Terrorist.'" *Jezebel*, May 9. https://jezebel.com/what-bell-hooks-really-means-when-she-calls-beyonce-a-t-1573991834.

Cooper, Brittney C. 2015. "Love No Limit: Towards a Black Feminist Future (in Theory)." *Black Scholar* 45, no. 4: 7–21. https://doi.org/10.1080/00064246.2015.1080912.

Dash, Julie. 1991. *Daughters of the Dust*. Kino International. Film.

Davis, Angela. 1995. "Reflections on the Black Woman's Role in the Community of Slaves." In *Words of Fire: An Anthology of African-American Feminist Thought*, edited by Beverly Guy-Sheftall, 200–18. New York: New Press.

———. 2016. *Freedom Is a Constant Struggle: Ferguson, Palestine, and the Foundations of a Movement*. Chicago: Haymarket Books.

Giovanni, Nikki. 2013. *Chasing Utopia*. New York: HarperCollins.

Glymph, Thavolia. 2003. *Out of the House of Bondage: The Transformation of the Plantation Household*. Cambridge: Cambridge University Press.

Gordon, Avery. 2018. *The Hawthorn Archive: Letters from the Utopian Margins*. New York: Fordham University Press.

Gumbs, Alexis Pauline. 2017. "Make Our Way Home: Radical Legacies of a Black Feminist Living Room." *Huffington Post*, February 4. https://www.huffingtonpost.com/entry/radical-legacies-black-feminist-living-room_us_58949e91e4b0c1284f25734c.

Harvey, Eric. 2017. "Beyoncé's Digital Stardom." *Black Camera: An International Film Journal* 9, no. 1: 114–30. https://doi.org/10.2979/blackcamera.9.1.07.

Hobson, Janell. 2016. "Lemonade: Beyoncé's Redemption Song." *Ms. Magazine* (blog), April 29. http://msmagazine.com/blog/2016/04/29/lemonade-beyonces-redemption -song.

hooks, bell. 2016. "Moving Beyond Pain." *The bell hooks Institute* (blog), May 9. http:// www.bellhooksinstitute.com/blog/2016/5/9/moving-beyond-pain.

——. 2015. *Yearning: Race, Gender, and Cultural Politics.* New York: Routledge.

Isoke, Zenzele. 2011. "The Politics of Homemaking: Black Feminist Transformations of a Cityscape." *Transforming Anthropology* 19, no. 2: 117–30. https://doi.org/10.1111 /j.15487466.2011.01136.x.

James, Robin. 2019. "How Not to Listen to Lemonade: Music Criticism and Epistemic Violence." In *The Lemonade Reader*, edited by Kinitra D. Brooks and Kameelah L. Martin, 69–76. New York: Routledge.

Jarmon, Renina. 2013. *Black Girls Are from the Future: Essays on Race, Digital Creativity and Pop Culture.* Washington DC: Jarmon Media.

Johnson, Birgitta J. 2019. "She Gave You Lemonade, Stop Trying to Say It's Tang: Calling Out How Race-Gender Bias Obscures Black Women's Achievements in Pop Music." In *The Lemonade Reader*, edited by Kinitra D. Brooks and Kameelah L. Martin, 234–45. New York: Routledge.

Kai, Maiysha. 2019. "Interlude A: What Do We Want from Beyoncé?" In *The Lemonade Reader*, edited by Kinitra D. Brooks and Kameelah L. Martin, 5–9. New York: Routledge.

Keeling, Kara. 2019. *Queer Times, Black Futures.* New York: NYU Press.

Lindsey, Treva B. 2015. "Post Ferguson: A 'Herstorical' Approach to Black Violability." *Feminist Studies* 41, no. 1: 232–37. https://doi.org/10.15767/feministstudies.41.1.232.

——. 2016. "Beyoncé's *Lemonade* Isn't Just about Cheating, It's about Black Sisterhood." *Cosmopolitan*, April 27. https://www.cosmopolitan.com/entertainment/music/a57592 /beyonce-lemonade-about-black-sisterhood.

Lordi, Emily J. 2016. "Beyoncé's Other Women: Considering the Soul Muses of *Lemonade*." *Fader*, May 6. http://www.thefader.com/2016/05/06/beyonce-lemonade-women-soul -muses.

Maner, Sequoia. 2018. "'Where Do You Go When You Go Quiet?' The Ethics of Interiority in the Fiction of Zora Neale Hurston, Alice Walker, and Beyoncé." *Meridians* 17, no. 1: 184–204. doi:10.1215/15366936-6955164.

McKittrick, Katherine. 2011. "On Plantations, Prisons, and a Black Sense of Place." *Social and Cultural Geography* 12, no. 8: 947–63. https://doi.org/10.1080/14649365.2011.624280.

——. 2013. "Plantation Futures." *Small Axe* 17, no. 3: 1–15. https://doi.org/10.1215/07990537 -2378892.

Morris, Susana M. 2016. "More Than Human: Black Feminisms of the Future in Jewelle Gomez's *The Gilda Stories*." *Black Scholar* 46, no. 2: 33–45. http://doi.org/10.1080/000 64246.2016.1147991.

Morrison, Toni. 1998. "Home." In *The House That Race Built*, edited by Wahneema Lubiano, 3–12. New York: Vintage Books.

Muñoz, Josè Esteban. 2009. *Cruising Utopia: The Then and There of Queer Futurity*. New York: NYU Press.

Nash, Jennifer. 2013. "Practicing Love: Black Feminism, Love-Politics, and Post-Intersectionality." *Meridians* 11, no 2: 1–24. https://doi.org/10.2979/meridians.11.2.1.

———. 2016. "Unwidowing: Rachel Jeantel, Black Death, and the 'Problem' of Black Intimacy." *Signs* 41, no. 4: 751–74. https://doi.org/10.1086/685114.

———. 2019. *Black Feminism Reimagined: After Intersectionality*. Durham: Duke University Press.

Pinto, Samantha. 2020. "'I Love to Love You Baby': Beyoncé, Disco Aesthetics, and Black Feminist Politics." *Theory and Event* 23, no. 3: 512–43. https://muse.jhu.edu/article /760430.

Quan, H. L. T. 2017. "'It's Hard to Stop Rebels That Time Travel': Democratic Living and the Radical Reimaging of Old Worlds." In *Futures of Black Radicalism*, edited by Gaye Theresa Johnson and Alex Lubin, 173–93. London: Verso.

Shackleford, Ashleigh. 2019. "Interlude B: Bittersweet like Me—When the Lemonade Ain't Made for Black Fat Femmes and Women." In *The Lemonade Reader*, edited by Kinitra D. Brooks and Kameelah L. Martin, 9–14. New York: Routledge.

Simmons, LaKisha Michelle. 2016. "Landscapes, Memories, and History in Beyoncé's Lemonade." *UNC Press* (blog), April 28. https://uncpressblog.com/2016/04/28/lakisha -simmons-beyonces-lemonade.

Tinsley, Omise'eke. 2018. *Beyoncé in Formation: Remixing Black Feminism*. Austin: University of Texas Press.

Twitty, Michael W. 2013. "Ani DiFranco: She Ain't Whistling Dixie." *Afroculinaria* (blog), December 30. https://afroculinaria.com/2013/12/30/ani-difranco-she-aint-whistling -dixie.

Ward, Mako Fitts. 2017. "Bey and the New N*****ati: Ethics of Individualism in the Appropriation of Black Radicalism." *Black Camera* 9, no. 1: 146–63, https://doi.org/10.2979 /blackcamera.9.1.09.

PART THREE

"XO"
Faith and Fandom

In Part 3, Birgitta Johnson and Rebecca Sheehan examine how gospel music performers and Beyoncé fans have responded to the artist's recent visual albums. In Chapter 5, Johnson investigates musicians who have engaged with Beyoncé's music by performing and sharing gospel music covers of her explicit love songs, "Drunk in Love" and "Partition." Through web ethnography and interviews with this community of YouTubers, Johnson offers rich, complex insights into the discussions of respectability politics, spirituality, and empowerment that have long taken place in response to Beyoncé. Johnson situates the practice both within the tradition of interchange between Black gospel and popular music, as well as within Beyoncé's music itself, a discussion that makes the Beyoncé Mass she discusses in her conclusion seem commonsense rather than counterintuitive. In Chapter 6, Sheehan focuses on Beyoncé fans outside the United States. Her survey builds on classic work in feminist popular culture and popular music studies that takes seriously the voices and perspectives of fans—work that challenges the tendency to speculate about the opinions and motivations of a diverse range of people. Surprisingly, despite the Beyhive's legendary status and the fluidity with which some observers have moved between social media, think pieces, and even scholarship, this sort of research into ordinary Beyoncé fans has been extremely limited (Utley's focus groups with teenaged girls is a notable exception [2017]). Sheehan's study reveals her respondents to be self-reflexive about their fandom, finding inspiration in Beyoncé without necessarily swallowing the consumerist and other neoliberal messages that also find their way into her work.

REFERENCE

Utley, Ebony A. 2017. "What Does Beyoncé Mean to Young Girls? *Journal of Popular Music Studies* 29: 1–12.

BIRGITTA J. JOHNSON

5. At the Digital Cross(roads) with Beyoncé
Gospel Covers That Remix the Risqué into the Religious

After the surprise release of *Beyoncé* in December 2013, fans and amateur musicians rushed to YouTube.com to share remixes of the album's most popular tunes. However, some of them forwent covering the standard love songs for the very sexually suggestive hits, such as "Drunk in Love" and "Partition," and gave them full, Christian-themed makeovers. From rewriting most, if not all, of the original lyrics to reworking the melody through gospel vocal performance aesthetics, some of the YouTube responses to *Beyoncé* conceptually "took it to church," offering praise around homemade digital altars. After interviewing some of the gospel remix creators, I found that they were inspired less by "Beyhive" levels of fandom, or a concern with cleaning up or cooling down racy lyrics than by an interest in creatively expressing religious devotion and personal spiritual challenges. The remixes have remained meaningful to viewers: some of them still garnered online feedback years after the initial blogosphere and urban radio coverage of them declined.

Within the African American gospel tradition, covers of secular hits are not new. Traditionally, the lyrical conversion from a worldly perspective into a pious one occurs within the safe boundaries of switching a romantic love song into a song expressing love for God. Today, however, some amateur gospel covers draw on a broader range of material, including sexually explicit songs, which require a much longer leap to become spiritually uplifting. Furthermore, young Christian-identified pop fans have more access to user-friendly recording equipment and social media platforms. Thus, they can produce and disseminate their own religious covers of secular hits relatively unhindered. Scholars who research

new media and digital communities such as Henry Jenkins and Trevor Blank see these online spaces as fertile ground for ethnographic research in popular culture and how it is consumed globally and reproduced in digital spaces.

Using digital ethnography, interviews, lyrical analysis, and convergence culture theories of consumption and fandom in the social media age, this chapter delineates how recent gospel covers of overtly erotic songs from *Beyoncé* exemplify this pronounced and controversial shift in the gospel tradition. The gospel covers examined here represent three trajectories from which to engage young millennials' willingness to use technology to merge their musical tastes as consumers with individual creative expression. This combination allows for the performance of spiritual beliefs outside the traditional contexts of the church or gospel music concerts. Their refashioning of Beyoncé's sonic performance elements and lyrical content in order to express personal spiritual challenges points toward a type of empowerment and risk taking that undergirds much of Beyoncé's oeuvre, including *Lemonade*, as I discuss in the conclusion.

BEYONCÉ BREAKS THE INTERNET

On December 13, 2013, just after midnight and without a promotional campaign or lead single in radio rotation, Beyoncé Knowles Carter released her self-titled album, *Beyoncé*, on iTunes. It was her fifth studio album and included fourteen audio tracks and a visual tour de force of seventeen music videos recorded in various locations around the world. Even with the delayed release of the physical album, *Beyoncé* broke digital sales records by becoming the fastest-selling digital album of all time, with over 800,000 copies sold worldwide within the first three days of its release. In online parlance, Beyoncé "broke the Internet," and fans worldwide gathered immediately on social media to share their responses to the new project. Major news outlets also grappled with the surprise release of an entire visual album. For many, the project was a drastic departure for the R&B-rooted, Houston-born pop star. Fans and mainstream media alike either celebrated or viciously maligned the content and visual images from the album, which presented Beyoncé not only as a globally recognized entertainer but also as a Black woman exploring themes related to sensuality, pleasure, her postpregnancy body, her career, and aspects of her intimate relationships with her husband and family in ways she had never disclosed before in interviews or in her music.

Almost immediately, and through much assistance from US pop and urban

radio stations, "Drunk in Love" emerged as the album's first hit song, despite being the album's second officially released single in the United States. The amount of Urban Dictionary defying sexual innuendo and double entendre was matched with a music video of Beyoncé and her husband, hip-hop mogul Jay-Z, performing the song to each other on a moonlit beach. By February 2014, the third released single, "Partition," upped the ante with more provocative components, such as shadowy burlesque dance sequences, illusion lingerie, and even more explicit sexual references than heard in "Drunk in Love." While there were other singles from the album, some of which became hits internationally, "Drunk in Love" and "Partition" dominated the US market in 2014 and became inescapable on radio, television, major award shows (the Grammy Awards and the MTV Music Video Awards), and online, especially through amateur cover videos and comedic parody videos. These amateur videos contribute to what communications scholar Henry Jenkins describes as "convergence culture" across today's new media landscapes with consumers voicing their likes and dislikes in highly participatory ways—reinventing, remixing, and expanding the entertainment products they consume or are exposed to in society.

During the first three months of *Beyoncé*'s release, fans and amateur comedians in particular used YouTube.com and Facebook to share homemade covers and remixes of "Drunk in Love" and "Partition," often outpacing the responses of professional comedians on daytime talk shows, late-night television, and variety shows such as *Ellen*, *The Late Late Show with James Cordon*, and *Saturday Night Live*. In addition to the response videos, remixes, and parodies, scholars, journalists, and cultural critics drove up the Internet traffic around Beyoncé the artist and *Beyoncé* the album with reviews, critiques, and questions that tapped the familiar and complex wells of commercialism, capitalism, Black feminism, authenticity, sexism, agency, and morality.

This was the popular culture landscape in which three gospel remixes by LaThelma Armstrong, Jill Lindsey Adkins and Dameka Rochelle, and Shenina Williams arrived.[1] Just as *Beyoncé* drew a range of responses and critiques, these gospel remixes of "Drunk in Love" (by Armstrong, and Adkins and Rochelle) and "Partition" (by Williams) created a stir in their online communities and even in non-Internet spaces, such as urban radio and local church events. Although the sacred orientation of the songs distinguished them from other *Beyoncé* remixes, they represented a continuation of the gospel music tradition in which secular, pop music hits were refashioned into sacred musical expression.

WORRYING THE LINES BETWEEN
THE SACRED AND SECULAR

African American gospel music is loosely defined as a "confluence of sacred hymns, spirituals, shouts, jubilee quartet songs, and black devotional songs with noticeable blues and jazz rhythmic and harmonic influences" (Johnson 2017). Its roots inherently blur many philosophical lines between sacred and secular, even though its guiding principle is to spread "the good news" of the Christian faith. During gospel music's emergence in the 1920s, pioneers of the genre battled naysayers and church leaders who opposed the blues and jazz sonic elements that supported the religious lyrical content. As the genre developed its own distinctive sonic markers and harmonic elements during the golden age of gospel between the 1940s and 1960s, gospel music dug deeper lyrically, using well-known Negro spirituals, hymns, Bible verses, and overt references to God, Jesus, and other biblical figures to assure casual listeners that the genre was indeed a sacred music form. However, with the rise of modern gospel and contemporary gospel in the mid- to late 1960s, gospel music artists once again pushed boundaries and worried the sacred-secular lines much like blues singers bending pitches and manipulating time to tell the stories of everyday people dealing with the troubles and joys of the world. Many songwriters and singers brought in arrangement and rhythmic elements from soul and funk music but maintained gospel music's dedication to sacred lyricism and the pious aspects of the Christian experience.

On a few occasions, professional gospel artists have made cover versions of well-known secular songs. For example, the late James Cleveland, king of gospel music and pioneer of modern gospel, retooled Gladys Knight and the Pips' 1973 hit, "You're the Best Thing That Ever Happened to Me," into, "Jesus, You're the Best Thing That Ever Happened to Me," on the debut album of the Charles Fold Singers of Cincinnati, Ohio, in 1975. Even in the live performance on the recording, Cleveland mentions before the first chorus, "Now I don't know who Gladys Knight was talking about but Jesus is the best thing that ever happened to me" (Cleveland and Fold 1975). He also references the song's secular music origins earlier in recording. Regardless of these literal and lyrical references to a soul music hit, it went on to become one of Cleveland's most popular songs and helped launch the gospel careers of the Charles Fold Singers beyond the Midwest.

In 1984, BeBe & CeCe Winans, who would become the most celebrated as well as controversial gospel duo by the end of the decade, included a cover of

Joe Cocker and Jennifer Warnes's soft rock hit "Up Where We Belong" from 1982's *An Officer and a Gentleman* soundtrack on their debut album, *Lord Lift Us Up*.[2] Twenty years later, in 2002, the all-female contemporary gospel group, Trin-i-tee 5:7, covered R&B/soul singer Musiq Soulchild's massive hit "Love" from his debut album in 2000. Their cover's brief stint on urban radio was not as successful as Cleveland's church choir hit or BeBe & CeCe's entry into the lyrically nebulous "inspirational gospel" subgenre, but it followed the practice of covering a secular song with generic, love-oriented lyrics that could be easily converted to reflect a religious or sacred theme. Negative responses to these novelty covers and reworked arrangements were relatively minimal. Cleveland's song is still a standard on classic gospel radio today, and Trin-i-tee 5:7's "Lord" inspired other amateur covers of their remake on YouTube, years after the group disbanded in 2013.[3]

Gospel covers of secular hits in the twenty-first century, while still not as common as they were in the 1970s, exist in a more diverse and diffuse sonic landscape than that of James Cleveland's generation. By the turn of the century, the use of secular music production techniques and styles from hip-hop, house music, jazz, funk, and rock had become commonplace among contemporary and urban contemporary gospel artists. However, the use of secular songs by gospel artists—beyond sampling a phrase or part of an instrumental track—is still somewhat taboo. The most commercially successful exceptions are MaryMary and Kirk Franklin, who has made it one of his primary production approaches.[4] Franklin and the Campbell sisters of MaryMary still receive pushback for their styles of gospel music, but their overwhelming success on secular radio and among nonchurchgoing audiences still makes them mainstays in the gospel music industry; they are among the very few gospel artists today who have also achieved mainstream notoriety. Younger gospel artists who push sonic and genre boundaries to a greater degree than Franklin and MaryMary face greater struggles; some, like Tonéx/B. Slade, Lecrae, and Mali Music, have abandoned being labeled as gospel artists altogether.[5]

The walls around the taboo of covering secular songs are being lowered in the era of new media and greater access to high-quality audiovisual technology. By 2010, with video file sharing sites such as YouTube and VIMEO and social media sites with video-sharing capabilities like Facebook, Instagram, and Twitter, amateur performers of gospel covers had far more access to audiences. Young amateur and semiprofessional users can avoid the dissenting deacon, the stern-faced church mother, or even possible ridicule from family in order to

post homemade but near-studio-quality gospel covers and remixes to the Web for free. In the description of his 2012 book, *Folk Culture in the Digital Age: The Emergent Dynamics of Human Interaction*, Trevor Blank describes the impact of new media on vernacular expressions and folkloric forms online and in the real world:

> New media is changing the ways in which people learn, share, participate, and engage with others as they adopt technologies to complement and supplement traditional means of vernacular expression. But behavioral and structural overlap in many folkloric forms exists between on- and offline, and emerging patterns in digital rhetoric mimic the dynamics of previously documented folkloric forms, invoking familiar social or behavior customs, linguistic inflections, and symbolic gestures. (Blank 2012)

I suggest that the gospel remixes of some of Beyoncé's more provocative songs are examples of young African American Christians' engagements with new media, which gives them space and manageable platforms to perform and engage directly with their peers and others via social media. The gospel remixes I describe here exemplify how young people are able to sidestep the outright rejection and censorship that they might encounter in formal church settings from church leaders or other believers who may not share their open affinity for secular pop. In online spaces, they are more likely to find other believers like themselves who are less hindered by gospel music's sonic taboos. In these spaces, they can engage in traditional forms of gospel music creation and performance in order to express a variety of Christian concerns through the appropriation of nongospel music. In practices similar to testimonial-styled gospel music, millennial users get to center the originality of lyrical content more than melodic familiarity in order to capture and communicate life experiences as Christian people of color. Their themes of devotion, worship, praise, salvation, evangelism, grace, and mercy are foundational Christian messages and go beyond the general expressions of love for God that were the focus of many gospel covers in the past. Just as Beyoncé's album project bucked traditional music industry marketing methods and revealed new creative areas in her evolution as an artist, the young women who created the gospel covers for "Drunk in Love" and "Partition" used technology and participatory culture to refashion an important Black vernacular music tradition as a means of spiritual self-expression.

FRUITS OF A FAST

LaThelma Armstrong's "Beyoncé Drunk in Love: Gospel Remix" was one of the first gospel covers to emerge after the release of *Beyoncé*.[6] In addition to giving an excellent vocal performance that sonically matched Beyoncé's rendition of "Drunk in Love," Armstrong's gospel remix became a conduit for her to transmit entirely new meanings and spiritual perspectives through a song whose focus on earthly pleasures and sexual desire is very apparent. These two aspects of the remix contributed to its popularity, and infamy, across several media platforms in 2014. Moreover, virtual communities that enjoyed or supported her cover continued a longer engagement with it, and her remix even inspired its own cover—a true demonstration of the memetic and participatory nature of convergence culture today.

LaThelma Armstrong wrote her cover days after the release of *Beyoncé* in 2013 while on a semester break in her hometown of Chicago. She posted it to YouTube in January 2014 after friends suggested that she make a video of her unique take on the risqué hit. Armstrong's version is a full structural cover of the original. She rewrote nearly all of the lyrical content of "Drunk in Love," but in her video performance, the twenty-two-year-old seminary student recreated a great deal of the song's melody and Beyoncé's vocal aesthetic, including inflections, accents, melisma, and articulation. Unlike many covers and remixes of *Beyoncé* content, Armstrong performed her version a cappella. The setting of her video performance is inside the empty sanctuary of Miller Chapel at Princeton University.

While the original lyrics of Beyoncé's "Drunk in Love" are a revelry of alcohol-fueled lust, double entendre, bedroom braggadocio, and subtle references to the wealth of the Knowles-Carter household, the lyrics of Armstrong's cover diverge from nearly all semblance of the original lyrical content's themes. Key lyrical phrases of the verses, such as, "I've been thinking, I've been thinking," appear only once in Armstrong's version, while Beyoncé's raspy declaration, "We woke up in the kitchen," from the prechorus is transformed into, "We woke up out of Eden." What keeps some listeners intrigued, however, is how Armstrong uses literary and timbral assonance to reference the sounds of the original lyrics while delivering a totally different narrative. For example, "I've been drinking, I've been drinking," in the introduction becomes, "I've been praying, I've been praying," and "Cigars on ice, cigars on ice," in the first verse becomes, "See God on High, God on High," while Armstrong's vocal delivery closely mimic's Beyoncé's

pitch, timbre, enunciation, and timing. When I asked her about this aspect of her remix, she spoke of the importance of making sure her cover was recognizable and sounded like the original song. However, the great degree to which her vocals capture the nuances of Beyoncé's original vocal performance can also be attributed to her talent and past experience as a church worship leader, as well as the voice lessons she took during her undergraduate studies at Scripps College.[7] The inescapable popularity of the song, even in her own home, was another factor that contributed to her absorption of its sonic aesthetics. Armstrong also believed that modeling her vocal delivery closely after Beyoncé's would draw listeners to her modified lyrics. In summer 2015, she noted in an interview with me, "That's what mattered the most to me . . . for me it was . . . content. Like, 'We need you. Jesus, we need you.' That's what I felt at that moment." By performing her cover without any musical accompaniment, audiences can hear both the popular melody of "Drunk in Love" and the changed lyrical content of the gospel cover.

The initial lyrical focus for Armstrong's "Gospel Remix" is contemplative and devotional. It presents a believer speaking directly to God on behalf of other believers. Lyrics such as, "Why can't your people see they need you, Jesus?," "Feeling like a stranger in the absence of your presence," and "Jesus, we need you—yeah, yeah" all echo the prayers for divine assistance heard in the prayer hymns and praise songs of newly independent African American churches of early-twentieth-century Jim Crow America. In the first two verses, Armstrong describes a distance between believers and Jesus but also notes how the Christian savior has not given up on believers, singing at the end of the verses and prechorus, "Yet, You chose to love." This sentiment then becomes the remix's main chorus:

> Even when we're not right, you love, love.
> Even when we're not right, you love, love. (Armstrong 2014)

During the second full verse when Beyoncé delivers the lyrics in a rhythmic, half-rapped cadence, LaThelma duplicates her vocal technique and shifts the lyrical focus of the song to praise, rejoicing, direct biblical references, and popular Christian theology:

> Even when we're not right, you make everything alright.
> No complaints for my life, so fluorescent under God's light.
> Y'all I'm praising! Jeremiah 29 and 11,
> I'm speaking it, living it—If you scared, call that reverend. (Armstrong 2014)

In addition to citing Jeremiah 29:11, celebrating the new life and grace and mercy available to believers "even when we're not right," Armstrong also borrows the use of "flashing lights" in the original song. In the remix, the flashing paparazzi camera lights of the original become light of a divine origin. The praise and celebratory nature of the second verse also represents when the lyrics transition into a first-person, individualized point of view. The praise mode of this verse can also be viewed as having a testimonial theme. In addition to speaking about God's light, Armstrong mentions a popular verse from the Book of Jeremiah that references God's plans of "peace and not evil" to give believers "a future and a hope" (King James Version). Because of the popularity of Jeremiah 29:11 within Christian spaces, Armstrong's mere mention of it frees up the verse from any direct quoting of the scripture, thus giving more time to praise, testimony, and professions of Christian devoutness.

The exuberance in the cover's second verse is amplified by how Armstrong uses colloquialisms such as "y'all," "get my mind right," and "grind," as well as reappropriating the double entendre of the original song. Where Beyoncé's version of the song references phallic symbols, such as a microphone and surfboard, which she sings on until hoarse or swerves on in a bathtub, Armstrong changes these sexual references to messages of praise and enthusiastic Christian devotion:

Y'all, I'm praising, I'm singing—this truth till my voice hoarse.
God, fill me up all the way, then use me for your purpose—
Purpose, purpose. Studying your word, study, studying your word.
I'm swerving on that, swervin', swerving on them curses.
I been trusting in you, trusting, it's working for my good, good.
 (Armstrong 2014)

Armstrong's reuse of *hoarse, swerving,* and *good, good* are beyond surface-level reappropriations. The allusions to Christian doctrine in this part of the verse are subtler than the nod to the Old Testament's Jeremiah 29:11 at the beginning of the verse. Some listeners can recognize coded references to the New Testament verse Romans 8:28 when Armstrong repeats the words *purpose* and *good*. The transformation of a verse about sexual positions into one that affirms religious devotion occurs via signifying on the Bible verse: "And we know that all things work together for good to them that love God, to them who are the called according to his purpose" (King James Version). These two verses are often paired in preached sermons, and they are also regularly used together in gospel song

lyrics, improvised vamps, impromptu gospel sermonettes, and congregational worship contexts. By the end of the second verse, the remix has more in common lyrically with several Black sacred music genres than anything in contemporary commercial popular music.

The third verse of the remix repeats the pleas for Jesus's presence from the first two verses and the second verse's themes of devoutness and dedication, but this time it also addresses another aspect of the trinity, the Holy Spirit. Armstrong mostly addresses Jesus and the Holy Spirit in the third verse, except for two lines in the middle, where, for the first time, she addresses listeners directly. Much like some hip-hop artists or spoken word poets exhort their listeners, Armstrong notes:

> I meant to spill this spirit all up on your conscious,
> I've been thinking, holiness. (Armstrong 2014)

After this brief aside, Armstrong once directs her address to Jesus, asking for his presence in the lives of believers but this time in an even more fervent tone:

> We need your presence right here,
> Jesus, we need you, right now.
> Can't kept these tears from falling,
> Jesus, we need you. (Armstrong 2014)

Of all the gospel covers of songs from *Beyoncé* posted in 2014, this remix was the most widely viewed and disseminated. Compiling the number of views from Armstrong's YouTube channel, as well as those of other users who reposted the video, the remix received approximately 405,000 views across several user accounts as of December 2017. By the time I interviewed Armstrong in June 2015, her video had received 14,000 likes, 388 dislikes, and 1,475 comments on her personal YouTube account, and she had done several interviews about her remix on a few local radio shows. It was also renamed "Beyoncé Drunk in Love! (Church Rendition)" and reposted in March 2014 by the tabloid media site World Star Hip Hop, where it received 159,856 views.

Not all those who reposted the video approved of it. In March 2014, Charing Ball critiqued the remix on the blog, *Madame Noire*, in a piece entitled, "Drunk in Love with Jesus? The Peculiarity of Freak Song Getting Gospel Remixes," which garnered about 47 main comments and dozens of subthread comment responses between readers. The comments on Ball's article included the usual denouncements of how "the secular" cannot be remade into a sacred expression and how

the remix was corny because of the explicitness of the original; however, some were positive about the remix. Typically the favorable responses focused on the lyrical content and how Armstrong made certain phrases "catchy" or relatable to Christian beliefs and experiences. One commenter noted, "I enjoyed the song! The lyrics are dope, she flipped a song used to sell sex to glorify God's love. In my head I'm singing, 'yet you chose to love' . . . it's stuck in my head. Props to her!" (Ball 2014). Others pointed out the double standard against people making gospel remixes out of secular songs when other, non-gospel-affiliated artists or individuals remix songs all the time. Referencing a viral YouTuber known for purposefully making poorly sung remixes, one commenter observed, "It's funny how people can listen and make a big deal out of JJ Ice Fish remixing and ruining songs but when [Armstrong] does it, it's unacceptable. Really? She has a beautiful voice that is being used to build the kingdom of God" (Ball 2014).

Such comments expressed a more accepting view of Armstrong's gospel remix, but they also involved critiquing Ball and anti-remix commenters. In particular, there were several exchanges between readers and Ball in the comments section, where readers chide the author for transcribing the lyrics incorrectly and for her unfamiliarity with the biblical passages on which Armstrong signified. One commenter noted:

> I personally love her remix. Some of you missed it, including the author, and that is o.k. The point of re-making any hip hop song is to reach the people who love gospel and love the beat/melody of a secular song but can't fully enjoy the original song. . . . Songs like this help to glorify while you get the same bounce. Both songs are o.k. and both are used for different purposes. Congratulate the girl! Great voice and great message hun! (Ball 2014)

These responses on social media and in online communities often take place without the participation of the artists and individuals who have inspired all of the discussion. It is unlikely that Beyoncé uses a ghost account to jump into every debate about her music online, and in our interview, Armstrong mentioned engaging only some of the commenters on her YouTube channel about her cover. However, the participatory nature of convergence culture is not limited to reactionary responses in comment sections. Viewers who consume Beyoncé's original music and the covers of her music can continue the feedback loop of independent cultural production by creating their own responses. For example, in March 2014, while some radio stations and bloggers were criticizing Armstrong's gospel cover of "Drunk in Love," Tommy Thompson, an

American Sign Language (ASL) artist who had learned to sign from his deaf parents, posted his own cover of Armstrong's remix to YouTube.[8] In the video, he signed Armstrong's lyrics along with the audio from her remix. Thompson gave Armstrong song writing credit in his video's description and even used her gospel cover's title as a part of his sign language cover's title: "Sign Language Beyoncé Drunk in Love: Gospel Remix by Tommy Thompson." What is significant about Thompson's ASL cover is that for viewers who are deaf or hearing impaired, the musical hooks of Beyoncé's original hit become less relevant, while Armstrong's significant lyrical rewrites are emphasized to the point that Beyoncé and Jay-Z's lyrical imprint is nearly erased. This kind of independent engagement in digital spaces away from corporate projections and marketing campaigns is why Jenkins notes:

> In this emerging media system, what might traditionally be understood as media producers and consumers are transformed into participants who are expected to interact with each other according to a new set of rules which none of us fully understands. Convergence does not occur through media appliances—however sophisticated they may become. Convergence occurs within the brains of individual consumers. Yet, each of us constructs our own personal mythology from bits and fragments of information we have extracted from the ongoing flow of media around us and transformed into resources through which we make sense of our everyday lives. (Jenkins 2006)

As a self-proclaimed ASL artist, Thompson took inspiration not from Beyoncé's original but from Armstrong's gospel remix. But what convergences inspired Armstrong to create her gospel remix in the first place?

I interviewed Armstrong via FaceTime in June 2015, over a year after her remix caught the attention of media outlets and social media sites. She had finished her third year of the master's of divinity program at Princeton Theological Seminary and was in the midst of a pastoral internship at the renowned Shin Yang Presbyterian Church in Seoul, South Korea. At the time of our interview, her YouTube presence was still minimal: her profile listed her status as a seminary student but provided little additional information. Moreover, although talented singers commonly post multiple videos of both formal and informal performances, the only original video posted on Armstrong's YouTube channel was of the Beyoncé cover.

In discussing her initial inspiration for the gospel remix, Armstrong shared that she had been in a period of fasting in December 2013 just as "Drunk in Love"

was released and took over both the airwaves and the halls of her Chicago home, where her sister was playing the song repeatedly. Armstrong reminisced about her desire to focus on prayer, meditation, and fasting during the winter break in order to prepare for her second semester in seminary and how she decided to rewrite the song rather than incite an argument with her sister by asking her to turn the song off. In only a few hours, she completed her gospel remix of "Drunk in Love." She reflected in our interview:

> I was in a moment of . . . fasting, I was needing something from God. So my lyrics kind of exuded where I was at that time. And it just so happened that it fell on a Beyoncé beat because at that moment I was fasting and needing something from God and then Beyoncé was playing so like these two things—my environment produced this. And that was interesting.

When I asked her how so much of the song could be rewritten in a few hours, she replied, "My heart was ready—to do that."

Armstrong did not immediately post her remix to YouTube. It was only after she returned to Princeton Theological Seminary in January that her classmates encouraged her to share her gospel remix on social media. They not only suggested that she post her remix to YouTube; they also suggested that she record herself singing the song in the school's chapel. Her classmate, Derrick Harris, filmed the video, and it was posted online in January 2014.

The nature of positive responses Armstrong received in person and via social media is another remarkable aspect of how different audiences are receiving gospel covers of secular music. Speaking about her immediate family and friends, Armstrong noted, "My community liked it. . . .They liked the attention it was garnering." In one case, a stranger attending her grandmother's funeral approached her and mentioned recognizing her from the remix video, while a coworker of her brother told her that she listened to the song every day. Armstrong had even received Facebook Messenger requests from people all over the world asking for prayer and guidance. She noted being surprised by how open people were with her online, but also how, ironically, these interactions aligned with her pastoral calling and goals. Armstrong is a gifted worship leader and singer, but her aspirations in ministry are not to be a gospel artist or music minister. Thus, these responses to her remix in the areas of virtual lay ministry became a source of encouragement in her ministry vocational goals. She observed, "People really felt 'me,' I'm a true-authentic worshiper."

ANSWERING THE CALL TO COVER A HIT

Jill Lindsey Adkins and Dameka Rochelle's February 2014 cover of "Drunk in Love" is another example of a secular-to-gospel cover born out of divine inspiration, not impressionable fandom.[9] Their acoustic guitar-based duet, "Beyoncé's 'Drunk in Love' spiritual remix (cover)," was initially posted on their individual Facebook pages and then to YouTube a week later on February 23. In an interview, Adkins recalled thinking about doing a cover of "Drunk in Love" because of its popularity, the catchiness of the song, and the many other covers flooding social media at the time. But she abandoned the idea and decided not to record a cover as she had done in the past for other songs on her YouTube channel. One night, however, she recollects, "I went to the restroom . . . and literally it was like God said, 'I want you to do this song. I want you to do the cover. . . . And I want you to do it with Dameka.'" The Chattanooga native said she could hear the voice clearly and could tell it wasn't her imagination.

At the time, Dameka Rochelle was a distant acquaintance. Adkins knew of her only as a high school classmate of her husband. They had not spoken or even communicated by text, but Adkins overcame the awkwardness of her spiritual directive and reached out to Rochelle using Facebook Messenger to get her telephone number. Adkins cautiously texted Rochelle and relayed what God had told her to do with the "Drunk in Love" cover and that he also wanted Rochelle to join the process. Adkins described waiting nervously as the "message bubbles" signaling Rochelle's incoming response appeared on her phone. And just as quickly as she reached out, the local singer and MC had agreed to join the project. Adkins also remembered the lyrics coming very quickly:

> I texted her about . . . 10 o'clock and by 10:05, I had my whole verse written. Like God was just like flowing through me. It wasn't what I wanted to say. It wasn't anything that I was feeling in that moment. It was what God wanted me to say. . . . Then . . . I sent it to Dameka, and just like that *snaps finger* she had her verse. It wasn't even a second thought. We didn't have to walk around and think about it. It just happened and it was so awesome how it happened.

The women met in Rochelle's home and recorded their cover on Adkin's cell phone. Rochelle's husband, James, activated the acoustic guitar track from a laptop and the record function of the phone, just out of view of the camera. They perfected their cover in just three takes and uploaded it to Facebook from their phones. When looking back on that moment a year later in our interview

in 2015, Adkins confirmed where the inspiration came from, even when the song and its modified format were not what she had in mind initially: "And I think God was using me to minister to other people because when I look back and hear the song, I'm like, 'I wasn't even going through nothing!'—the way that I sang the song but people were like, 'Oh, I love it. It was exactly what I needed.' And I'm [thinking], 'Dang, that's crazy!'"

Adkins and Rochelle's take on "Drunk in Love" departs significantly from the five-verse structure of Beyoncé and Jay-Z's original hit. They created a shorter, two-verse version that incorporates Adkins's alto range and smooth, sung vocals along with Rochelle's rap-sung lyrical delivery. Sounding like a Southern version of Floetry, the English soul duo, Jill and Dameka's performance is supported by an acoustic guitar instrumental cover of "Drunk in Love," performed by Lea Beiley, an artist Adkins found using Google search. Not only did Adkins and Rochelle create a shorter version of the song, but they also significantly modified how the duet is performed between the two vocalists. After a sung verse and prechorus by Adkins and one rapped verse by Rochelle, the balance of the remix features the two trading phrases or lines of the chorus—first as singer versus rapper, then as singer versus singer, and ending with them harmonizing the chorus together.

Adkins's nonallegiance to the song's original structure and most of its lyrical content can be attributed not only to the divine prompting she received but also to her limited familiarity with the song's lyrics. She admitted that she did not know all of the lyrics or all of their double meanings, but she was certain that musically, "Drunk in Love" was a good song. From her background singing in church, studying music at an arts high school in Chattanooga, and experience as a choral major in college, Adkins said she was most impressed and attracted to how Beyoncé presented the song vocally. It was the sound of Beyoncé's vocal performance that influenced her approach to and intentions for the remix:

The thing with the song is that it was so popular because it's catchy-realistically. It's a catchy song and. . . . A lot of times when people hear music they can hear the music for the lyrics, and I don't know if it's just because I can play the piano and I love music so much but when I heard it, like I didn't hear what Beyoncé was saying. . . . I could *hear* what she was saying to a certain extent but it was just the *overall sound* of the song is what caught my attention. A lot of it I still don't understand . . . but *the way* that she presented it in the song, it was attractive, you know what I mean? And that could be a good thing and a bad thing, especially in music all together because you're hearing it and you're not even

realizing what you're feeding your spirit and that's where it stopped for me. I was like this song *is* good, so let's not lie and pretend it's not good. It is a good song and I don't want to change the song so much that it is unrecognizable but I want to be able to share it with people [who] maybe don't want to listen to "surfboard" or whatever. They still get to hear the song because it's a good song but from a different standpoint.

On the surface, Adkins and Rochelle's remix seems to be focused on seeking God's presence or assistance, like many prayer-oriented gospel and sacred songs. However, underneath, the lyrics communicate messages of transformation and gratitude from both of the lyricists—changing Beyoncé's boisterous "we be all night, love" in the choruses into a worshipful "you saved my life, love" and "he can change your life with love." In Adkins's first and only verse, she mimics the repetition and alliteration of Beyoncé's first verse, "I've been drinking, I've been drinking" and "I've been thinking, I've been thinking," by singing, "I've been praying, I've been praying" and "I've been changing, I've been changing." She cites personal challenges in between these lines with "feels like the enemy trying to bring me down" and "Every time I try to stand, I fall down to the ground." Adkins uses lyrics with similar vowel sounds to sonically reference the original, but the lyrical departure is clear when she smoothly intones, "Oh Jesus, I need you right now. . . . Show me love." The prechorus makes a reference to standing in a kitchen, as in the original; however, the point of view is that of a believer reaching out in need and in prayer, not someone recovering from a blackout:

Oooh, I'm standing in the kitchen and I got my hands lifted,
I need you to—save me and show me love.
Been up all night
And all I've been doing is crying and praying cause I've had enough.
Please show me love. (Adkins and Rochelle 2014)

Dameka Rochelle's half-sung, half-rapped verse follows next instead of the full chorus of the original. Like a true MC, Rochelle provides her own stylistically distinct verse. She does not sonically or rhythmically reference Jay-Z's performance from the original; rather, she shapes her flow and timbre with subtle nods to lyrics sung during Beyoncé's second verse. It is during Rochelle's verse that the theme of transformation and gratitude takes over the remix:

And everthang's all right, long as God is on my side.
No complaints cause nothing's perfect but I keep a smile.

Lord I thank you for staying by me.
You never left me.
I'm counting all, I'm counting all, I'm counting all my blessings.
Lord I thank you.
Been praying right, stomping on the devil.
He tried to bring me down, I ain't gone let 'em, I'm too clever.
Lord I thank you. So sanging, recording til my voice's hoarse
Everyday a blessing, I wake up and I say thank you Lord.
Thank you Lord, thank you Lord
For loving me when I didn't need;
I'm still standing tall still singing thank you Lord, thank you Lord,
 thank you Lord
Praising Him feels good, good. (Adkins and Rochelle 2014)

From this verse forward, both Adkins and Rochelle's sung and half-sung ad-libs on the chorus's melody are built around communicating the salvific nature of God's love. They move from trading verses to trading phrases until they end up singing the last chorus in harmony together with further modified lyrics:

But You changed my life with
Love
You changed my life
Love, with love
He can change your life with love,
Love
Jesus Christ
Love, love. (Adkins and Rochelle 2014)

In line with the live performance tradition of gospel music, Adkins and Rochelle switch to the second person to address both God and their listeners. They testify to the life-changing power of Jesus in their own experience and also communicate to listeners that they too can receive access to that power. While not an explicit or direct appeal to nonbelievers or those who have gone astray, this subtle change at the end of the remix further grounds Adkins and Rochelle's cover within typical gospel music performance and ministry practice.

The online responses to "Beyoncé's 'Drunk in Love' spiritual remix (cover)" are harder to quantify because they initially posted the video to their personal Facebook pages. Very quickly, other users started to share Adkins and Rochelle's

cover, both within and outside the Facebook platform. Rochelle estimated that there had been fifty thousand Facebook views by the time they opted to post the video to their respective YouTube channels the following week in February 2014 (interview with Adkins, 2015). As of December 2017, their YouTube views totaled around a combined thirty thousand, and most of the feedback in the comments was very positive, praising the quality of both the singers' voices and the song's flow. Their family, friends, and church communities loved the song, and the two women were invited a few times to perform it at churches around Chattanooga, Adkins told me in our 2015 interview. They were even approached by J. Long, formerly of the R&B boy band Pretty Ricky, about a collaboration, although this project never materialized.

Adkins and Rochelle continued to get positive feedback about the cover as the months passed. However, they never reunited to perform another gospel cover.[10] Adkins had recorded other cover songs and posted them to her YouTube channel. In 2017, she and her husband started a family vlog series on YouTube, "Happily Ever Adkins." Dameka Rochelle's aspirations as an independent artist continued to blossom after the cover made the rounds in social media. In addition to recording music videos and releasing her own albums, in 2015 Rochelle produced her own autobiographical mini-documentary that explores how she survived domestic violence in high school as a teen mother and then revived her dreams to pursue music. She uses the documentary to promote her own women-centered initiative, CurV (Celebrate Unseen Real Value). Currently, she's one of Chattanooga's key figures in the independent music scene, splitting time between the city and Atlanta ("Live @ Power 94").

Adkins and Rochelle are not Beyoncé stans, although Adkins noted that she does respect Beyoncé's work ethic and career. Rochelle is a preacher's daughter who grew up singing in church and counts Erykah Badu, Lauryn Hill, and Drake as her musical influences. Thus, the impetus for their remix pulls more strongly from a spiritual perspective than from their fascination with Beyoncé, although to make a gospel cover of a sexually provocative popular song may open one to criticism. However, the way in which Adkins articulates her doubts about the possible reception of her remix reflects a more assertive attitude toward creative expressions of faith found among millennials and young Gen X-ers in the twenty-first century. She explains:

> I was scared at first because [I thought] people are going to be like, "You don't take a song like that and put God's name on it." But I was like, you don't tell me

what I do and what I don't do, 'cause you don't know the God that I know. And in this day and age now, sometimes you have to tweak it so that people my age— we're the next generation . . .—will be attracted to it. . . . Somebody needed to hear that song and they may not have listened unless they saw Beyoncé "Drunk in Love" on it. So, I just felt like I had . . . to do it. (Adkins interview, 2015)

In this explanation, Adkins also acknowledges that Beyoncé's notoriety and the popularity of "Drunk in Love" may have helped attract listeners, enabling them to hear the message in Rochelle's and her remix.

How Adkins and Rochelle tweaked an already good and popular song for an alternative spiritual use is what makes their remix successful. As with other positive responses to gospel remixes, listeners frequently commented about "needing to hear that song" or the song "speaking to them" during a tough time. These responses counter the assumptions by critics of gospel remixes that listeners are incapable of separating the sacred intent of the remix from its more sinful or flesh-centered origins. However, no matter how much traditionalists rail against gospel remixes, they continue to be created and distributed on social media sites, circulating outside the traditional channels of the gospel music industry.

MEETING JESUS AT THE PARTITION

In many amateur gospel covers and remixes, the evangelistic aspect of gospel music is a key feature; indeed, it is often what motivates the songwriter to make the secular-to-sacred adaptation in the first place. Gospel covers and remixes that explicitly focus on winning Christian converts are more often found in informal, local, or community spaces. For example, it is not uncommon for a choir soloist or praise team leader to spontaneously reference a popular secular song during a church service. Today, YouTube videos of these more evangelistically oriented covers by individuals and small vocal groups are common, and they can be just as contentious among some gospel music audiences as non-convert-oriented gospel remixes. Evangelical remixes may strike younger listeners as "corny" or "trying too hard" to get their attention by co-opting a top secular artist's work, such as the videos featuring gospel covers of Prince songs that were posted during the week after his death in 2016. For some older listeners, the practice violates the mandate that Christians be "in the world but not of the world"; the main critique of most secular-to-gospel remixes is that they conform to "worldly" tastes and standards. Certainly old beliefs about nonsacred genres of music being

"the devil's music" persist even in today's Black Christian musical landscape in which contemporary and urban contemporary gospel is dominant. When one adds the aura of Beyoncé, a Christian-identified, Black female pop superstar with roots in the Black church, praise and condemnation of gospel remixes take on additional layers of meaning.

On April 7, 2014, Florida-based singer Shenina Williams posted her "Partition-Beyoncé: Gospel Remake " video to YouTube over a month after Beyoncé's "Partition" was officially released as a single. Out of all the gospel covers of songs from *Beyoncé*, this is the only one to remake "Partition," one of the most explicit and sexually suggestive songs from the album project. Like Adkins and Rochelle's remix, Williams sets the lyrics from the perspective of a believer directly addressing God. However, nearly all of Williams's lyrics reflect a Christian in crisis and in need of immediate divine assistance. Performed over an instrumental track of "Partition," Williams's cover is an up-tempo plea for help to survive life challenges, worldly temptations, gossipers, and staying steadfast in the faith.

A professional singer and psalmist for Christian events and church services, Williams used her vocal and performance talents to personalize her cover, departing further from the sonic and lyrical elements of the original than the gospel remixes already discussed. Williams sings her remix in a higher key than Beyoncé's original, and beyond the monosyllabic delivery of the verses, she does not attempt to recreate its timbres and inflections. However, her performance of the chorus does adopt the pleading and devotional sentiments of the original—but with Jesus, not a lustful romantic partner, as the intended audience. Instead of a request made to an unknown limousine driver, Williams implores, "Jesus come and see about me please. Jesus come and see about me please; can't you see I'm down here on my knees." From there, the first verse delivers a litany of life and spiritual challenges that morph a semipublic backseat romp into a cry for immediate divine aid:

> Took 45 minutes to get all dressed up,
> And Lord, I really need to make it to this church.
> I just thought about my life, now I'm in here crying.
> Gotta get myself together, Lord I'm really trying.
> Temptation out here in this world so real,
> Trying to eat me up like a Happy Meal.
> Leaning on Him before I hit the ground.
> Oh Jesus, Jesus help me slow it down.

Took 45 minutes to get all dressed up,
Lord, I really need to make it to this church. (Williams 2014)

In both verses, Williams explores the theme of a Christian desperately trying to get to church to find solutions to life's problems. In the first verse, the lyrics speak to the idea of being overwhelmed by temptations and struggles in life. In the second verse, Williams intensifies her plea to Jesus and gets even more specific, citing the impact of gossipers in her life:

Jesus, come and see about me fast—
Jesus, come and see about me fast,
Can't keep my name out their mouth, puttin' me on blast
Talking 'bout stuff I did in my past.
I really don't know how much longer I can last. (Williams 2014)

The rest of the second verse explains how she is trying to maintain a focus on Jesus in the midst of other distractions, using familiar literary characters to illustrate the unsteadiness of her spiritual walk:

Trying to live holy and be bonafide,
But the Devil got me feeling all Jekyll and Hyde.
Feel like Smokie Norful, "Lord I need you now,"
Lead me and guide me and show me how. (Williams 2014)

In the last two lines before the prechorus, Williams signifies on "I Need You Now," Smokie Norful's award-winning gospel ballad from 2002. The urgency of Norful's lyrics, "not a second, or another minute, not an hour or another day, but at this moment . . . I need you to make way," are echoed in the overall sentiment of Williams's "Partition" remake, as well as her performance of it on camera. Sonically, she uses inflections, an overtly nasal tone, and bent notes to convey pleading and vulnerability rather than Beyoncé's breathy and raspy delivery in the original. Visually, she uses body language to reinforce the mood and meanings of the remix's lyrics, pantomiming most of the lyrics from her chair. For example, she subtly bows while singing, "Lord I need you now"; often lifts one or both of her hands in prayer, professed devotion, or praise during the choruses; and often looks upward or up over her shoulder to signify a presence above her.

Williams's remake also references a distinctive sociocultural aspect of many African American churches. The reoccurring prechorus, "Took 45 minutes to

get all dressed up, Lord, I really need to make it to this church," highlights the continued importance of being well dressed in many churches, despite many "come as you are" and "casual Sunday" efforts. Putting on one's "Sunday's best" or "Sunday come to meeting" clothes is a tradition in African American churches that goes back to the late nineteenth century when most African Americans had limited resources for non-work-related clothing but still wanted to honor the sacredness of communal worship. For generations, care, time, and whatever little disposable income was available were devoted to acquiring one set of "church clothes," which was reserved for weekly worship and kept in impeccable shape by mothers, grandmothers, or aunts. In the post–World War II economic boom, when the financial status of many African Americans improved, the sartorial choices for Sunday morning were not only enhanced but expanded to the degree that church attire became an important visual signifier of Black church worship alongside pressed choir robes and church mothers dressed all in white for communion Sunday. As the legendary fashion editor André Leon Talley and theologian Eboni Marshall Turman explain, "In the South, going to church was the most important thing in life. And it was a fashion show" (Novak 2018). Taking considerable time to "get all dressed up" for church, as Williams describes in her gospel remake, is still an important ritual, even for many millennials.

The most distinctive aspect of Williams's "Partition" remake is the explicit evangelistic message in the spoken interlude. Whereas Beyoncé's original version includes a spoken interpolation of a scene about female sexuality from the French-language version of the 1998 film *The Big Lebowski*, Williams addresses viewers directly:

Do you know Jesus? Huh?
Yeah, Jesus. The one who died for your sins. Christ!
Do you know Him? If you died today, where would you go?
Think about it. Submit your life to Him.
He loves you. (Williams 2014)

This appeal includes phrases and questions that often are deployed in formal invitations to Christian conversion and discipleship during church services, revivals, crusades, and some religious concerts. From storefront preachers to globally broadcasted televangelists, this appeal to follow Jesus and join the Christian faith is a key feature of the religion, and Williams breaks the fourth wall in an intentional way by addressing viewers about their salvation status. The invitation also reifies the overall message of the remake, as exemplified in its chorus:

Take all of me.

I just wanna give You my whole life,

Give you my whole life.

Jesus, take all of me.

I just wanna give You my whole life,

So that I can be what You want me to be, what You want me to be.

 (Williams 2014)

The themes of maintaining connection and being a devout Christian, as well as spreading the message of salvation through Jesus, situate this remake in the long tradition of gospel music that frequently blurs and mixes secular and sacred music influences to reach wider audiences through personalized accounts and artistic expressions. After Williams delivers the appeal for discipleship (or conversion), she returns to the chorus with a highly stylized and gospel-influenced vocal delivery—full of melismas, leaps, and soulful ad-libs. By the end of the remix, Beyoncé's "Partition" is present only via the audio track, supporting Williams's gospel singing virtuosity.

CONCLUSION

In the gospel remixes of the most sexually explicit songs from *Beyoncé*, the move from secular lyrical content to sacred- and worship-oriented lyrics required more from their creators than traditional gospel covers of well-known secular songs. Instead of changing a word or phrase or two, these remixes represent substantial reworkings of the lyrics of "Drunk in Love" and "Partition" in order to firmly reframe the songs around themes of praise, testimony, devotion, supplication, evangelism, and modern Black church culture. The leap from the erotic (and, some may even say, sinful) to the spiritually uplifting is largely built on each remix's ability to thoroughly explore Christian religious themes from the perspective of a devout but flawed believer. Whether audiences accepted or rejected these remixes often had less to do with how they felt about Beyoncé than about their attitudes regarding the practice of changing secular songs into sacred ones or their evaluation of the remixes' distinctness from their sexually explicit roots.

These remixes can also be viewed as examples of how Beyoncé's music resonates not only with Black women but with many people of color and marginalized groups. This became even more apparent in 2016, when Beyoncé's record-breaking visual album release, *Lemonade*, became a global cultural phenomenon.

Lemonade reading groups, free digital syllabi, and several college courses were developed to examine the themes of Black womanhood, empowerment, healing, and survival from the album. The visual album even inspired a sacred service known as "Beyoncé Mass."[11]

In April 2018, the Vine SF, a ministry at San Francisco's Grace Cathedral, held the first "Beyoncé Mass," where attendees were invited to "sing your Beyoncé favorites and discover how her art opens a window into the lives the marginalized and forgotten—particularly black women."[12] The mass was inspired by a course, Beyoncé and the Hebrew Bible, created by assistant professor and Reverend Yolanda Norton and offered at San Francisco Theological Seminary. Featuring a live band and singers, the mass used songs from *Lemonade*, along with some of Beyoncé's earlier solo repertory (e.g., "Flaws and All" and "I Was Here") and the Destiny's Child hit "Survivor," in order to amplify messages of empowerment, Black female spirituality, disrupting (religious) bondage, and intersectional feminism. The event drew approximately nine hundred people, who enthusiastically joined in singing and dancing to Beyoncé's songs, which were woven into the structure of a Catholic mass with its mix of sung liturgy, responsorial singing and readings, and a homily Norton delivered.

In May 2018 the mass became the subject of a VICE Selects episode, "Finding God at a Beyoncé Mass," which has been viewed nearly 20 million times on the VICE Selects website alone.[13] While many news outlets framed the story of the Beyoncé Mass in a negative or blasphemous light, the comment sections for many of the posts and repostings of the VICE Selects episode were more complex. The voices for and against the mass echoed how viewers had critiqued or applauded the gospel remixes of "Drunk in Love" and "Partition" years earlier on YouTube, Facebook, gossip blogs, and urban radio shows.

What is perhaps most striking about the gospel remixes by Armstrong, Adkins and Rochelle, and Williams is not only that they preceded events like the Beyoncé Mass[14] and the various revisionings of *Lemonade* in higher education and popular culture, but that they also anticipated Beyoncé's own more explicit engagement with religious iconography and sacred imagery. From the surprise release of *Lemonade* via HBO broadcast to Beyoncé's massive stagings of its music at awards shows, the Formation tour, and even the publicity photographs of her pregnancy, Beyoncé regularly used and mixed religious icons and sacred symbols to address issues of infidelity, family, healing, Black women's liberation, and empowerment. Fans and scholars quickly noted her use of Yoruba-based, West African, and Afro Caribbean deities, such as Oshun and Oya; Catholicism's

Madonna; Southern voodoo; the religious-tinged poetry of Warsan Shire; and various Christian-oriented spoken word segments (M. Jones 2019; N. Jones 2019). Beyoncé's increased and more pronounced exploration of sacred themes, messages, and imagery at this point in her career may represent another fold in her overall artistry, but it also affirms some listeners' abilities to find and even mold very personal, sacred meanings in all of her work, regardless of its club banging or worldly status.

NOTES

1. Since the time these remixes were posted in 2014, LaThelma Armstrong has married and now goes by her married name, LaThelma A. Yenn-Batah. Jill Lindsey did not include her married surname, Adkins, when posting her cover on YouTube in 2014 but does use her married name in interviews and later videos. During the course of this project, Shenina Williams changed her professional name to Nina Skyy and performs under that moniker. Many of her videos using Shenina Williams as an identifier have been removed from YouTube since the mid-2010s.

2. BeBe and CeCe's 1984 gospel cover was largely overshadowed by subsequent original songs, like "Lost without You" and "Heaven," which purists criticized for the absence of references to God or Jesus in lyrics sung over quiet storm R&B- and dance R&B-flavored production.

3. Another successful gospel cover in the twenty-first century was when contemporary gospel legend Karen Clark-Sheard teamed up with her teenage daughter, Kierra "Kiki" Sheard, on "You Loved Me" in 2003. The live recording received gospel and urban radio airplay and was a veritable gospel vocal tutorial of Jill Scott's signature song, "He Loves Me (Lyzel in E Flat)" released on her debut album *Who Is Jill Scott? Words and Sounds Vol. 1* in 2000. KiKi Sheard's feature on the gospel cover set her up for a successful recording career outside the large shadow of her famous gospel music family.

4. In 2005, Kirk Franklin broke into the US Billboard Hot 100 (#61), peaked at number 5 on the US *Billboard* Hot R&B/Hip-Hop Songs chart, and dominated the top spot on the Hot Gospel Songs chart with "Looking for You" from his album *Hero*. The song samples and loops the instrumental track of the chorus and verses of Patrice Rushen's jazz disco hit, "Haven't You Heard," from her *Pizzazz* album (1979).

5. For accounts of these artists' changing attitudes about being known as gospel artists, see McIntyre 2017, Patrick 2013, Associated Press 2014, Sanneh 2010, and Wade-O 2013.

6. See the video at https://www.youtube.com/watch?v=T9tzU5quHhc (Armstrong 2014).

7. Armstrong's natural singing gifts are further grounded by two years of voice lessons

in high school in Chicago and four years of voice lesson while at Scripps College. Although she was not a music major, she did lead musical worship and directed church choirs while in college. She was also raised in an independent African Methodist Episcopal church in Chicago and considers herself "culturally A.M.E.," although she was a graduate of a Presbyterian seminary school. She was seeking ordination in the Presbyterian Church at the time of our interview in 2015.

8. See the video at https://www.youtube.com/watch?v=zBRKFFjah5I (Thompson 2014).

9. See the video at https://www.youtube.com/watch?v=insVcWqMr5A (Adkins and Rochelle 2014).

10. They did collaborate on an acoustic cover of UK garage hit "La La La" by British producer Naughty Boy featuring Sam Smith in June 2014.

11. As early as four months after the album's release, *Lemonade*-inspired college courses were offered in fall 2016 at the University of Texas, San Antonio (Black Women, Beyoncé, and Popular Culture, by Kinitra Brooks), the University of South Carolina (Lemonade: A Survey of Black Women's Agency and Community Building through Music and Performance, by Birgitta Johnson), and Arizona State University (*Lemonade:* Beyoncé and Black Feminism, by Rachel Fedock). While these were not the first college courses related to Beyoncé or a Black feminist readings of her works, they represent the fast-paced engagement of Black feminist scholars in bringing contemporary pop culture to university campuses and curriculum spaces.

12. A description of the Beyoncé Mass can be seen at http://www.gracecathedral.org/events/about-our-beyonce-mass/ (Grace Cathedral 2018).

13. To view "Finding God at a Beyoncé Mass," see https://www.facebook.com/VICE/videos/867076020147056/.

14. At the time of this writing, two more Beyoncé Mass services were held in New York City at the First Presbyterian Church of Brooklyn and St. James Presbyterian Church in Harlem on October 23 and 24, 2019, respectively. The event now has its own informational website at https://www.beyoncemass.com/.

REFERENCES

Adkins, Jill Lindsey, and Dameka Rochelle. 2014. "Beyoncé's 'Drunk in Love' Spiritual Remix (cover)." February 23. https://www.youtube.com/watch?v=insVcWqMr5A.

Armstrong, LaThelma. 2014. "Beyoncé Drunk in Love: Gospel Remix." February 20. https://www.youtube.com/watch?v=T9tzU5quHhc.

Associated Press. 2014. "Rapper Lacrae Doesn't Want to Be Limited by Christian Label." *SFGate,* October 6. https://www.sfgate.com/entertainment/article/Rapper-Lecrae-doesn-t-want-to-be-limited-by-5805446.php.

Ball, Charring. 2014. "Drunk in Love with Jesus? The Peculiarity of Freak Song Getting

Gospel Remixes." *Madame Noire*, March 18. https://madamenoire.com/411214/drunk
-in-love-with-jesus-the-peculiarity-of-freak-songs-getting-gospel-remixes/.

Blank, Trevor. 2012. *Folk Culture in the Digital Age: The Emergent Dynamics of Human Interactions*. Boulder, CO: Utah State University Press.

Cleveland, James, and Charles Fold. 1975. "You're the Best Thing That Ever Happened to Me." *Rev. James Cleveland and the Charles Fold Singers—Jesus Is the Best Thing That Ever Happened to Me*. Savoy Records. DBL 7005.

Grace Cathedral. 2018. "About Our Beyoncé Mass." http://www.gracecathedral.org/events/about-our-beyonce-mass/.

Jenkins, Henry. 2006. "Welcome to Convergence Culture." *Confessions of an ACA-FAN*, June 19. http://henryjenkins.org/blog/2006/06/welcome_to_convergence_culture.html.

———. 2008. *Convergence Culture: Where Old and New Media Collide*. New York: New York University Press.

Johnson, Birgitta. 2017. "Gospel Music." In *Oxford Bibliographies in African American Studies Online*. New York: Oxford University Press.

Jones, Melanie C. 2019. "The *Slay* Factor: Beyoncé Unleashing the Black Feminine Divine in a Blaze of Glory." In *The Lemonade Reader*, edited by Kinitra D. Brooks and Kameelah L. Martin, 98–110. New York: Routledge.

Jones, Nicholas R. 2019. "Beyoncé's *Lemonade* Folklore: Feminine Reverberations of *Odú* and Afro-Cuban *Orisha* Iconography." In *The Lemonade Reader*, edited by Kinitra D. Brooks and Kameelah L. Martin, 88–97. New York: Routledge.

Knowles, Beyoncé, Noel Fisher, Shawn Carter, Andre Eric Proctor, Rasool Diaz, Jordan Asher, Brian Soko, Timothy Mosley, and Jermone Harmon. 2013. "Drunk in Love." *Beyoncé*. Columbia Records and Parkwood Entertainment.

Knowles, Beyoncé, Terius Nash, Demitri Jay, Justin Timberlake, Timothy Mosely, Jerome Harmon, Dwane Weir, and Mike Dean. 2013. "Partition." *Beyoncé*. Columbia Records and Parkwood Entertainment.

"Live @ Power 94 Radio Station Interview Chattanooga TN." 2014. December 6. https://www.youtube.com/watch?v=Q-TeRxVRRIU.

McIntyre, Hugh. 2017. "Lacrae Talks His New Album and Moving beyond Christian Music." Forbes.com, July 10. https://www.forbes.com/sites/hughmcintyre/2017/07/10/lecrae-talks-his-new-album-and-moving-beyond-christian-music/3/#5861c6665624.

Novak, Kate. 2018. *The Gospel According to André*. Magnolia Pictures.

Patrick, Kris. 2013. "Boycott of TONEX's Gospel Comeback Concert Gaining Supporters." *PATH Megazine*, September 11. http://pathmegazine.com/news/gospel/boycott-of-tonex-gospel-comeback-concert-gaining-supporters/.

Sanneh, Kelefa. 2010. "Revelations: A Gospel Singer Comes Out." *New Yorker*, February 8. https://www.newyorker.com/magazine/2010/02/08/revelations-3.

Thompson, Tommy. 2014. "Sign Language: Beyoncé Drunk in Love: Gospel Remix by Tommy Thompson." March 20. https://www.youtube.com/watch?v=zBRKFFjah5I.

Vice. 2018. "Finding God at a Beyoncé Mass." May 17. https://www.facebook.com/VICE /videos/867076020147056/.

Wade-O, DJ. 2013. "Mali Music Explains His Shift from Gospel Music to Mainstream Music." *Wade-O Radio*. October 8. http://wadeoradio.com/mali-music-explains-shift -gospel-music-mainstream-music/.

Williams, Shenina. 2014. "Partition-Beyonce: Gospel Remake-Shenina Williams." April 7. https://www.youtube.com/watch?v=7EoefSxjgwQ [site discontinued].

REBECCA J. SHEEHAN

6. "She Made Me Understand"
How *Lemonade* Raised the Intersectional Consciousness of Beyoncé's International Fans

In April 2016, with limited advance notice, Beyoncé released her sixth solo and second visual album, *Lemonade*, online. As with *Beyoncé*, her 2013 album, *Lemonade* did not appear with heavy promotion but relied instead on the social media interest generated among fans in response to the sudden release of a new album. Beyoncé's fan base, the most dedicated of whom are known as the Beyhive, did not disappoint expectations (Bereznak 2016). On Twitter alone, they produced 4.1 million tweets about *Lemonade* in less than two days, nearly four times the number they produced for *Beyoncé* (Lipshutz 2013; Getz 2016; Avdeeff 2016). Working outside the established and more traditional networks of the music industry, these fans' active online engagement helped push both albums to the top of the album charts and therefore demonstrated their considerable power (Harper 2019).

Despite this power, journalists who readily recognize Beyoncé's cultural force rarely discuss her fans—or popular music fans more generally—with any positivity. A *Guardian* article that applauded Beyoncé's new release strategy as a "masterclass" on how to reinvent the music industry dismissed the "fans who went into meltdown and . . . shifted 430,000 copies of *Beyoncé* in one day." It described hardcore fan bases as "grotesque" and discussed the "putrefaction of fan communities" (Robinson 2014). Those same fans who did the bulk of the labor in marketing Beyoncé's two surprise albums were depicted as "hilarious, honest, and hysterical," "a moving, breathing, shrieking mass of . . . fangirls" (Cills 2013).[1]

Such characterizations of fans as unhinged, pathological girls have a long history. They accompanied the rise of celebrity in the twentieth century and,

as Norma Coates has argued, became entrenched in popular music discourse in the 1960s when male rock music producers, described as authentic, came to be defined in relation to and against female pop music consumers, who were described as inauthentic (Coates 2003). This identity construction, which works in part by shaming fans, and often on the basis of their femininity, continues despite the music industry's awareness of the crucial role fans play in marketing and supporting artists—and in the music industry's very existence (Sheehan 2010; Zubernis and Larsen 2012, 228). In fact, the way in which mainstream media journalists and many music publications obscure and devalue fans and the free labor they provide acts as a form of disciplining intended to stratify and regulate how fans contribute to this structure with the aim of maintaining the industry's economic dominance. In this schema, fans occupy a subordinate position to stars and the industries that produce them (Fenn 2002; Terranova 2000; Fuchs 2016). Fans are both exploited by and help to fuel neoliberal capitalism, a free market economic system in which individuals seek to acquire profit and its related power. Positioned as uncritical consumers, fans are easily disparaged and dismissed. Indeed, as Bertha Chin and Lori Hitchcock Morimoto have argued, "Fandoms that evince no explicit oppositionality . . . are left open to critique primarily on the basis of their perceived complicity with hegemonic state and corporate institutions" (2013, 95). For these reasons, fans are marginalized and silenced outside social media and fan sites.

When substantive Beyoncé fan voices do appear in respected media forums, including newspapers, magazines, and books, they tend to be those of scholars, public intellectuals, and professional writers who are also fans. Roxane Gay, Melissa Harris-Perry, Brittney Cooper, and Michael Arceneaux are among the high-profile fans who have spoken or written about Beyoncé, her work, and their Beyoncé fandom (Lee 2016; Harris-Perry 2016; Cooper 2018; Arceneaux 2018). Their professional standing as analysts of race, gender, sexuality, Black feminism, and popular culture gives credibility to their commentary on Beyoncé. Similarly, scholar-fans who use Beyoncé for pedagogical purposes bring the cachet of academic framing to their work. Candice Benbow's "Lemonade Syllabus" is an online study guide designed to help everyday people analyze *Lemonade* and bring visibility to Black women, their analysis, and their writing. Introduced on social media as #LemonadeSyllabus, it was downloaded more than forty thousand times in its first week online (Benbow 2016). Kevin Allred's and Omise'eke Natasha Tinsley's different college courses about Beyoncé have received international attention, and material from those classes has taken shape in books (Tinsley

2018; Allred 2019). These analyses have been critical to shaping everyday fans' understanding of Beyoncé (Patrick 2019), yet we do not know much about what that understanding is.

Scholarship about Beyoncé has largely replicated the omission of ordinary fans from its analysis. Ebony A. Utley has written about Beyoncé's significance to girls aged eleven to sixteen (2017), and Aria S. Halliday and Nadia E. Brown have used data from focus groups of Black millennial female college students to understand how their identities are influenced and empowered by Beyoncé and Nicki Minaj's performances (2018). But to date, no scholarly study exists of self-identified Beyoncé fans and how they understand and respond to her. By foregrounding Beyoncé's everyday fans (or fandom), this chapter aims to correct this omission. It focuses on a specific group of Beyoncé fans: those who live outside the United States. My exploration of this particular group draws inspiration from one of the major themes of *Lemonade* and Beyoncé-related scholarship since that album was released: the specificity of Beyoncé's identity and experience as a Black American woman (Finley and Willis 2019; Tinsley 2018; Yeboah 2016; McFadden 2016). The chapter's animating question departs from a seeming paradox. Beyoncé's *Lemonade* has been celebrated as "a love letter from a southern Black woman to other southern Black women" (Bradley, 250) and for what Inna Arzumanova (2016) refers to as its "proprietary blackness"—a presentation of African American racial identity not open for broad identification, interpretation, or co-optation by white consumers. Yet the album has also been an international success among racially diverse audiences, and Beyoncé continues to reign as a global cultural icon.

How, then, do Beyoncé's racial identity and the *Lemonade* album translate into connection and popularity outside the United States? In order to answer that question, this chapter analyzes the ways that Beyoncé's non-American fans understand, identify with, and make sense of her identity. It draws its evidence and main arguments from both online ethnographic research (online surveys) and analyses of fandom through individual cases. I begin with a discussion of the methodology used for data collection from fans and the body of theory that informs my analysis of the data. The chapter then analyzes the three major themes that emerged from the surveys. First, it examines *Lemonade's* particular importance in raising fans' intersectional consciousness. Second, it explores Beyoncé's engagement with and rejection of respectability politics, an African American strategy developed to survive and challenge anti-Black racism by performing identity according to white expectations. Finally, the chapter looks

at the potential of hard work as a tool of self-determination within neoliberal capitalism.

The chapter argues that beyond the United States and across borders of identity and geography, Beyoncé has forged a transnational community of fans who are bonded by a shared love of her and an associated intersectional consciousness. This consciousness has been raised the most by what these fans see as Beyoncé's embodiment of and lessons in understanding her identity as intersectional—both in individual terms of multiple and overlapping social identity categories and in structural terms, shaped by power formations including racism and sexism (Crenshaw 1991; Cooper 2015). As a result, fans better understand the particular oppressions Black American women suffer. They are also able to apply inter-sectional thinking to understanding their own identity-based struggles with racist, sexist, homophobic, and white heteronormative structures. To these fans, Beyoncé provides a model of resistance to such oppressions through her self-love and hard work. The transformative potential of their fandom is present in their resulting desire to survive and thrive on their own terms too.

METHOD

I draw on a broad range of fan responses to Beyoncé collected in an online survey I distributed in April 2018 over Facebook, Twitter, and Instagram.[2] Some Beyoncé-dedicated Facebook pages and Twitter fan sites posted the survey link in response to my request, and people in my social networks reposted or retweeted the link before it began to move more organically. Most of the respondents had completed the survey prior to Beyoncé's first Coachella performance on April 14, and the remainder completed the survey in response to a final push for respondents sent out on April 20, ahead of her second Coachella appearance.

The survey, available in English only, asked specifically for Australian and other Beyoncé fans outside the United States in order to understand how Beyoncé translates in and into different national contexts. It was completed by 102 people ranging in age from sixteen to forty-five, with seventy-one of the respondents clustered between the ages of sixteen and twenty-five (respondents had to be at least sixteen years old to meet the mandated ethical requirements of the survey). The highest number of responses were from eighteen- and nineteen-year-olds (twelve each), and then from seventeen-year-olds (ten). Sixty-four percent of participants were in Australia, and 76 percent of all participants had completed some or all of a university education. These high percentages likely reflect my

own geographic and institutional location at a university in Australia and my associated social media networks. The 37 percent of participants outside Australia came from Argentina, Brazil, Canada, Denmark, England, Gibraltar, Greece, Italy, Jamaica, Malaysia, New Zealand, Nicaragua, the Netherlands, Norway, France, the Philippines, Saudi Arabia, Scotland, South Africa, and Trinidad and Tobago. Seventy-six percent of respondents identified as female, 22 percent were male, and two identified as nonbinary. Fifty-eight percent identified as straight, and 39 percent identified as lesbian, gay, bisexual, queer, pansexual, and asexual. Of the ninety-five respondents who indicated their race, more than half identified as white or Caucasian. Thirty-seven respondents identified as of color. The majority of survey respondents, 57 percent, identified as having no religion; 26 percent were Christian and 9 percent Muslim.

I recognize that in their self-selection and willingness to complete a thirty-question survey that required relatively long answers, the participants may not be representative of the majority of Beyoncé's fans. The survey participants also may be more self-conscious and self-reflexive and may exhibit higher education levels on average than other Beyoncé fans. Their understandings of Beyoncé are likely informed by writers, scholars, and other professionals who have parsed *Lemonade* in the mainstream media and so reflect communities of knowledge and understanding rather than the sole production of Beyoncé-as-individual. Furthermore, these fan responses may be performative in presenting their "best" or "ideal selves" (Dever, Vickery, and Newman 2009, 49).

Of the thirty questions in the survey, nine were demographic ones about age, location, occupation, and identity. Of the remaining twenty-one questions, thirteen were open-ended, and eight gave participants standardized choices from a menu of options that always included "other" and space to explain what that was. In order to decrease the likelihood of leading participants to give answers based on the content of the questions or the standardized list options, the survey began with a number of open-ended questions. Participant responses to these questions prefigured topics that appeared later in the survey in the option-based questions, including independence, hard work, racial and gender pride, and sexual empowerment, and made clear that fans were thinking about these topics prior to completing the survey. One option-based question asked participants to indicate the five most important topics with which Beyoncé deals. The option list for that question consisted of recurring themes I identified in *Lemonade* and in scholarship about Beyoncé: self-esteem, hard work, getting rich, pride in female sexual desire, and racial pride. The question that immediately followed

was open-ended and asked fans to identify and explain which two of the five were the most important topics to them.

Open-ended questions in the survey design allowed fan responses, rather than my preconceptions, to determine the themes of this chapter. In particular, the survey did not use the word *intersectional* and even tended to separate race from gender until a question toward the end of the survey asked fans whether Beyoncé's Black female identity was relevant to them. Furthermore, although I had some sense of how fans might respond, I did not anticipate that for the majority of them, hard work would almost rival racial pride as the most important of Beyoncé's topics or that the two topics were related for many fans. Although I quote fans verbatim, I have edited spelling and some grammar for clarity. Because the survey was anonymous, each respondent's comments are recorded against a unique number and that number is cited with associated quotations.

Three broad themes emerged from survey responses. First, many fans identified *Lemonade* as a turning point in Beyoncé's oeuvre for the attention it paid to forms of oppression of Black women. For example, respondents respected Beyoncé's willingness to use her public platform for social commentary. From this platform, they learned about racism in the United States, which raised their consciousness of racism more broadly. Moreover, especially for fans who identified as marginalized people themselves, and regardless of their national context, they engaged with and in many cases identified with Beyoncé's intersectional identity, including her Black American femaleness and the associated ways in which her sexuality has been historically pathologized by white culture. Second, fans interpreted Beyoncé's engagement with femininity, marriage, motherhood, and sexuality through an intersectional frame. As a result, fans witnessed and understood that Beyoncé rejected respectability politics and instead proudly owned her Black femininity and sexuality. Third, fans identified racial pride and hard work as the most important topics that Beyoncé performed and addressed. Here, they recognized tensions in the way that she combines political pop with profit making. A minority criticized Beyoncé for her wealth and perceived commodification of Black identity politics, but many fans read *Lemonade* and Beyoncé's success dialogically too, in conversation with the longer history of Black slavery and the still-present structural problems it embedded in capitalism, and so as a form of restorative justice (Lipsitz 1990; Durham, Cooper, and Morris 2013; Winfrey Harris 2019).

The strong themes in the responses—particularly in understanding Beyoncé's status as a Black woman—crossed age, location, education level, identity, and

national context. For that reason, although this chapter puts Australian fan re-
sponses in the context of Australia's racial politics, I also quote fans from differ-
ent countries to illustrate commonalities across national borders. While further
research could yield a more comprehensive explanation of these commonalities,
the responses speak to Beyoncé's ability to communicate the particularities of her
intersectionality transnationally, across difference, and to the ways in which fans
around the world relate to her across difference through their own experiences
of identity-based oppressions.

In listening to fans' voices and taking them seriously as agents in the process
of interpretation and meaning making, my analysis is informed by scholarship in
sociology, the politics of listening, audience reception theory, fan studies, femi-
nist and Black feminist theory, and Black queer theory (Cinque and Redmond
2016;, Jenkins and Shresthova 2011; Radway 1983; Gorton 2009). In different
ways, scholars including Cathy J. Cohen, Susan Bickford, and Leah Bassel have
argued that by listening to marginal groups and taking seriously the voices of
those who are made inaudible, we can disrupt existing power hierarchies and
reveal alternative forms of community and community building, politics, and
resistance (Cohen 2004, 33; Bickford 1996, 96; Bassel 2017, 3).

LEMONADE AS TURNING POINT: POLITICAL POP, CONSCIOUSNESS RAISING, AND INTERSECTIONAL IDENTIFICATION

The first question on the survey asked respondents when they had first become
Beyoncé fans and why. Many had been preteenagers and initially were drawn to
Beyoncé's talent, beauty, infectious music, and the associated fun and pleasure
she inspired. "'Crazy in Love' is the song of a generation," one fan wrote. "I'm the
star at every wedding when it comes on. People make room for me on the dance
floor" (#40). When asked if there was an iconic Beyoncé moment, more than
a third of survey respondents—including among those who had been fans for
years previously—chose *Lemonade* for the way it centered her identity as a Black
woman and incorporated personal themes of infidelity and betrayal, as well as
political themes regarding women's and racial empowerment (#41, #50, #51, #56).

Indeed, Beyoncé's willingness to use her music and celebrity status for political
purposes, including providing a global platform for American racial politics, the
Black Lives Matter movement, and the relationship between identity and power,
inspired and educated many fans (#16, #19, #37). One fan's comment is testa-

ment to the impact of such work in the popular cultural realm: "I am a woman of colour in politics and her lyrics give me life, grounding and a framework that is accessible to the masses" (#99). For many fans, *Lemonade* is educational: it heightens awareness about Black life in the United States and raises consciousness more broadly about race, gender, and sexuality. In this way, *Lemonade* pushes back against what Patricia Hill Collins calls the "matrix of domination" that suppresses subordinate group knowledge (Collins 1991, 226, 229; Sowards and Renegar 2004). As one fan wrote "[Beyoncé] uses her platform, as a black woman, to inspire and educate other black women, or other minorities, that they are beautiful and powerful and unstoppable no matter what kind of life they live" (#71).

A significant number of fans, including those from Australia, Malaysia, New Zealand, Greece, and Saudi Arabia, described how *Lemonade* taught them about the particularity of Black women's experiences and the severity of the "racial divide" in the United States (#13, #9, #77, #37). One wrote, "Living in Australia, being so far removed, you don't really and can never really understand or empathise fully with the experience of being black in America. [But] I think Beyoncé allows the world to gain a glimpse or understanding of what that might encompass" (#39). White Australia too has a long history of systemic oppression, such as the colonial genocidal practices that reduced the Indigenous population to 3 percent, restrictive immigration policies in place up until the 1970s known colloquially as the "White Australia Policy" for the kind of population they curated, a detention system that imprisons asylum seekers primarily from the Arab world for years in "offshore processing" facilities, and a continued government refusal to make any formal treaty with Aboriginal and Torres Strait Islanders. Despite this history, broad-based and popular conversations about race and related forms of oppression are both minimal and minimized within the public sphere. Indeed, in a newspaper article that argued Australia would not embrace a home-grown artist of color who spoke out about racism and sexism, several Aboriginal Australian women identified Australia's low tolerance for antiracist dialogue and activism in the mainstream. From their perspective, an Aboriginal Australian musician could not comment on the intersections of racism and sexism in the way that Beyoncé has and still expect and enjoy any significant success (Clarke 2016). Certainly Beyoncé's distance, combined with her power as an American in relation to the economically, politically, and culturally subordinate Australia, affords her a public voice not available to marginalized Australians.

Beyoncé's political pop, then, creates an important consciousness-raising

platform for examining race both within and outside the United States. Furthermore, it seems that rather than exclude audiences, *Lemonade*'s "proprietary blackness" inspires self-consciousness about whiteness, its privilege, and its associated power. For example, Beyoncé fan and dance instructor Liz Calahan opened a school in Melbourne, Australia using crowd-funded money from other Beyoncé fans to teach them how to dance like Beyoncé and foster associated body positivity. But post-*Lemonade*, Liz Calahan said she was less comfortable with the school because it "felt wrong for me to be claiming [the experiences of Black women as] a white Anglo-Celtic woman in Australia" (Fuss 2018).

Yet fan responses also show identification with Beyoncé's multiple and intersecting identities. This reflects the effectiveness of what Marla H. Kohlman argues is Beyoncé's deliberate strategy to exploit her status as an "intersectional icon" in order to engage different audiences with her racial, gender, and sexual identity (2016, 36). Although Beyoncé does not separate these identities from one another, fans may identify with her on the basis of race or gender or some combination of identities, and they may also generally identify with her status as a marginal person without sharing its specific composition. Beyoncé's intersectional identity also helps to explain how the experiences of a Southern Black American woman connect with people of different identities in different geographical locations. For non-American Black fans, non-Black fans of color, and people who belong to racialized subcultures within majority Anglo societies, the identification with Beyoncé is particularly meaningful. A Nigerian Australian female wrote, "I am black and I grew up with a limited amount of people who looked like me and were proud to be black. So, my positive association with my colour has to some extent been effected by her popularity and presence in our pop culture narrative" (#52). Similarly, a London-based twenty-year-old who identified as gay and as Black Caribbean wrote, "She is a black woman just like me and she makes me feel proud of that. . . . It's empowering to see her be so talented and so successful. It's beautiful that she embraces her identities and it encourages me and others to do the same. Beyoncé helps me feel loved in a world that doesn't love black women" (#84).

People of color who are not part of an African diaspora also identify with Beyoncé. They see themselves as racial "others" and note the particular effect *Lemonade* has had on their greater racial pride. Many were also queer identified, indicating an additional affinity with Beyoncé's sexuality: despite her heterosexuality, her Black female sexuality has historically been demonized. A nonbinary gay Lebanese Australian wrote, "It can be hard to feel important or

understood as a nonwhite person . . . [and *Lemonade*] was my baby step into black art and how important black art is in feeling racial pride" (#56). An East Indian Canadian woman wrote, "Seeing her, another woman of colour, succeed and be at the top of her industry inspires me. Her race and gender didn't stop her from accomplishing all that she's accomplished and it won't stop me" (#74). A gay Malaysian male wrote, "For . . . centuries, people of colour were often . . . seen as parasites, weak and so on to colonizers. To see Beyoncé as a proud black woman in *Lemonade* was very inspiring as I, myself [am a person] of colour." His identification with Beyoncé on the basis of race and a feeling of marginalization was shared by a gay Brazilian male and a bisexual Saudi Arabian male (#60; #87). These fan comments point to the way in which success functions not to transcend identity but to empower the individual to transcend identity's socially imposed limits. Such a response raises the question of the extent to which Beyoncé and her fans engage with the politics of respectability. A frequent topic in these debates revolves around ascertaining the extent to which she conforms to or resists these politics.

RESPECTABILITY POLITICS AND
AN INTERSECTIONAL FRAMEWORK

Respectability politics emerged in the late nineteenth century to challenge harmful Black stereotypes and still has currency as a means to promote racial assimilation and uplift. In this schema, white myths about Black Americans as lazy, hypersexual, and angry could be challenged if Black Americans pursued and embodied the opposite qualities: hard work, wealth, education, restraint, and manners, including—especially for women—in the realm of sexual behavior (Higginbotham 1993; Carby 1998; Cooper 2017). Some critics and fans read Beyoncé as playing into and reinforcing respectability politics through her message of hard work by presenting herself as "Mrs. Carter" and singing her most sexually explicit songs about sex *within* marriage, and in her beatific representations of herself as a mother. To add to this reading of Beyoncé as conforming to dominant cultural expectations, some charge Beyoncé with fueling its worst and most damaging impulses, including "neoliberal feminism, hegemonic femininity and monetised motherhood" (Hopkins 2017, 100). In one Sydney R&B club, where I observed "Single Ladies" deployed as a mating call—the (presumably) single ladies put their hands up on the song's command and triggered a palpable energy rise in the room—I wondered about the extent to which Beyoncé reinforces

conservative heterosexual gender dynamics while raising expectations of female beauty and sexual availability. Indeed, one gay fan found Beyoncé's

> constant reinforcement of her heterosexuality . . . a little overbearing. Though I understand this as her being strategic in her display of sexuality (i.e. "look I'm pole dancing, but it's okay because only my husband is in the audience"). Her constant reference to being a wife and mother . . . seem[s] to reinforce her "good woman" status, and I don't enjoy that. My cynical take is that it's not to ostracise her many religious fans, and to soften the impact of her (sexual and racial) politics for those who can't handle it. I imagine she would appeal to conservatives also. (#92)

It is true that Beyoncé emphasizes hard work, parades her marriage and status as a mother, and repeatedly draws attention to her heterosexuality. For some audiences who reject neoliberal messages of individual self-improvement or who do not conform to cisgender and heteronormative expressions of identity, love, family, and desire, these aspects of Beyoncé may be distancing at the least. But these criticisms should not obscure the ways in which Beyoncé's identity as a Black woman modifies the meaning of her performances. The way that Beyoncé performs work and sex, for example, has a very different meaning than if a white woman were to perform these in the same way.

Indeed, the majority of survey respondents recognize Beyoncé's multiple overlapping identities—63 percent acknowledged Beyoncé's specific identity as a Black American female—and therefore interpret her engagement with neoliberalism and normative behavior very differently. By viewing her engagement with respectability politics through an intersectional framework, many fans think Beyoncé rejects respectability. Instead, they see a woman of color self-consciously and intentionally making a "political statement about the treatment of people of colour," purposefully taking pride in her Black identity and Black family, refusing to play to white expectations, and celebrating and flaunting her sexuality, her own body, and her independent womanhood (#5). While fan responses show that Beyoncé has clear appeal beyond those who share her particular racial identity, they recognize and applaud her refusal to "shrink blackness," a refusal that Myles E. Johnson argued was on display at her historic Coachella performance (Johnson 2018). One fan wrote, "She's black and proud, as she should be" (#31).

Fans see that as a mother, a Black woman, and a woman, Beyoncé takes back her sexuality from those who sought to colonize and control it (#23). Instead of presenting herself as demure in an attempt to counter racialized stereotypes

of Black sexuality, Beyoncé deploys the trope of Black female hypersexuality, the Jezebel, to rework its representation on her own terms (Miller-Young 2014, 9; Collins 1991, 77). Through her performances, lyrics, and vocals, Beyoncé communicates that she has ownership of and takes pride and pleasure in her sexual, Black, female body. In doing so, she claims what Mireille Miller-Young calls "erotic sovereignty" (2014, 16). For Indigenous Australian actor Madeleine Madden, Beyoncé's message of erotic sovereignty is welcome because of the similarities between African American women and "what Aboriginal women endure and encounter. I love how she celebrates a black woman's sexuality. Our bodies have been taboo and sexualised for all the wrong reasons for too long" (Clarke 2016; Conor 2016).

Beyoncé's empowered sexuality models a path to "love of self" and offers a liberating vision for many of her fans whose sexual expression is continually subjected to external surveillance, representation, and controls—women, mothers, queer-identified people, and members of conservative religions—across racial difference and sexual preference (#74, #41, #17). Comments from such fans demonstrate the limits of the supposedly liberated contemporary sexual culture and the extent to which they view Beyoncé's messages as oppositional. One nineteen-year-old woman wrote, Beyoncé "taught me that I have the freedom to express myself however I like . . . that it's not only okay for men to express their sexuality[;] women can do it too" (#24). For some, Beyoncé ventriloquizes their desire. A twenty-eight-year-old who identified as Christian and Black African wrote, "It's still somewhat a taboo of sorts to express your sexual desires as a woman, [but] her songs give me the freedom to sing all the things I couldn't say on this topic" (#63). A biracial Chinese and White Australian wrote, "As a gay man, I find a sympatico with certain aspects of female sexuality that are not portrayed in male sexualities in pop culture. Intimacy, complexity, respect. [Beyoncé] reflects how I feel more about sexuality, and it's really enriching" (#23). That same fan learned not to feel guilty about his own sexuality from Beyoncé, and his "self-esteem has grown" as the result. Indeed, Beyoncé's LGBTQ recognition, as expressed, for example, through the inclusion of gay nonbinary bounce musician Big Freedia in the music video for "Formation," gives some fans the sense that she is a staunch ally (Wong 2014; Smith 2017; Tinsley 2018). Expressing a view shared by several gay male respondents, one wrote that her allyship "help[s] me accept who I am and feel proud for it" (#78). Such responses stand in contrast to Mako Fitts Ward's criticism that Beyoncé appropriates "genderqueer Black aesthetics" in order to assert her own heteronormative and cisgender subjectivity (Ward 2017, 154–55).

In making *Lemonade* an album about rage and grief over marital infidelity that can also be read as a parable of the mistreatment of Black women, Beyoncé demonstrated a willingness to engage with feelings and displays of anger, jealousy, and a loss of control (Allred 2019). These emotions are not part of a catalog of respectability, but rather fit the stereotype of the angry Black woman, the Sapphire, and are emotions that are often used to characterize, negatively, unwelcome female emotions and behavior (Harris-Perry 2011). But Beyoncé refuses to be shamed. By sharing her feelings and vulnerabilities, she also refuses the stereotype of the Black superwoman who is strong and tough and suppresses her feelings (Wallace 1999, 107). As the result, a number of fans recognize Beyoncé's complex humanity and see her persona and message as genuine, not constructed.

WOKE CAPITALIST OR HARDWORKING FREEDOM FIGHTER? FINDING AUTHENTICITY AND ENACTING RESISTANCE IN NEOLIBERAL CAPITALISM

Still, some critics question and challenge Beyoncé's authenticity as an artist and a political actor, posing the implicit question: If you sell empowerment through capitalism, is the empowerment real? Beyoncé's embrace of neoliberal capitalism—a free market economic system in which individual profit is the end goal and agency is achievable through hard work and consumption—is a key theme for her critics. In 2017, Beyoncé's net worth was estimated at $350 million, a fortune amassed from selling music and merchandise, acting in Hollywood feature films, and developing and selling product lines, including her Ivy Park fashion label and her perfume (Greenburg 2017). She launched the Ivy Park label one week before *Lemonade*, and the line—and her entire franchise—greatly benefited from the associated publicity. The single magazine interview she did at that time with *Elle* magazine featured her on the cover with the caption: "Beyoncé talks freedom, feminism and how her new fashion line helps women love their bodies" (Gottesman 2016). In the final lyric of "Formation," Beyoncé sings, "Your best revenge is your paper" (for those not familiar with American Southern Black vernacular, the accompanying visual in the music video of her rubbing her thumb and fingers together makes clear that "paper" means money).

How do fans understand and make sense of the way Beyoncé links freedom to work and money? Some embrace her accumulation of wealth unproblematically. One fan wrote, "She is an independent woman who doesn't need a man to define who she is, [and] she has created an empire in her own name. Which is also

an empowering message to the consumer" (#50). For others, hard work is the means to self-determination. While 65 percent of respondents recognize wealth as one of Beyoncé's main characteristics, only 5 percent thought that "getting rich" was among the most important topics she addressed. Indeed, for 68 percent of survey respondents, Beyoncé's thematic engagement with and modeling of hard work was far more important than money—almost equally as important as her thematic engagement with racial pride (chosen as most important by 69 percent). Fan comments about these topics reflect their belief in Beyoncé's narrative of hard work enabling individuals to transcend the structural limits imposed on marginal identities. A twenty-two-year-old gay man of color in Brazil reflected the sentiments of many other fans in writing, "Independence and hard work [are] what I believe the world needs and she believes in this too. . . . People who believe in themselves, wake up and do the things to make your dreams come true. If you, mainly black, woman and LGBT+ don't work more than the others, you . . . will not win anything, that's the point" (#60). This comment also recognizes the reality that people from marginalized groups do have to work harder than those from dominant groups for opportunity and recognition.

Many of these fans used the vernacular phrase "she owns it" to describe Beyoncé, a phrase that conflates the language of private property with individual accomplishment. Still, such fans are motivated by Beyoncé's work ethic and link it to greater self-esteem, personal integrity, and independence rather than the accumulation of economic capital. One fan wrote, "Beyoncé's work ethic and her ability to tell people what she wants and being a BOSS inspires me every day. I strive to work hard in everything I do because I wanna be as bad of a bitch as her. And I want to be independent—a man ain't gonna be there forever for me but I sure am gonna be here for myself! I gotta take care of my damn self no matter what" (#33).

Another fan reflected on how her own single mother worked hard and raised four daughters but appeared to lose her sense of self in the process. Like Beyoncé, this fan hopes to achieve her dreams through hard work while maintaining her "personality and not conform[ing] to other ideals" (#66). These fans believe that self-esteem must be coupled with hard work for individuals to reach their potential (#69).

Beyoncé's "I grind till I own it" story, identified by so many of her fans, fits what Robin James (2015) identifies as one of the tenets of the neoliberal resilience paradigm within the pop music industry: it requires everyone to work hard but

admits only a few very select winners. "I grind till I own it" is also a story of the triumph of the self over structures of inequality. Sujatha Fernandes has identified this kind of "curated story" as a tool of neoliberalism that "produc[es] subjects who are guided by . . . principles of upward mobility, entrepreneurship, and self-reliance" (2017, 2–3). Such stories shift the burden of change to the individual and "help to defuse the confrontational politics of social movements" (11). Certainly, released in the context of the Black Lives Matter movement's rise, *Lemonade* can be read similarly because its story focuses on one woman's coming to terms with betrayal within her marriage. Although the album's visual depictions of many different Black women move beyond a purely individual concern to represent and engage with a community, bell hooks argues that these visuals cannot be transformative because they commodify the Black body not for social change but for profit. hooks writes, "Commodities . . . are made, produced and marketed to entice any and all consumers. Beyoncé's audience is the world, and that world of business and money-making has no color" (hooks 2017; Hopkins 2017). To Rev. Osagyefo Sekou, Beyoncé is a proponent of neoliberalism, capitalism, and their attendant features: rampant individualism at the cost of seeking or supporting the need for structural change (Sekou 2014). To him, Beyoncé wants only to survive in and dominate the existing system. Such criticisms of Beyoncé as capitalist, postfeminist, or consumer feminist undermine her viability or credibility as a political actor (Chatman 2015; Hickey-Moody 2017).

A handful of fans who participated in the survey shared similar criticisms. They expressed irritation with Beyoncé either "bragging about money" or avoiding discussing her wealth altogether and the way she "sells empowerment through capitalism" (#83, #85, #100). One described Beyoncé's efforts as "Woke capitalism," explaining that phrase in this way: "I think every single issue Bey sings/speaks about is carefully considered zeitgeist shit. I don't think she has any real sense of what it means to be black or a woman. I think she thinks she does, because she is essentially these things, but goddamn she is a capitalist first, and her identity politics spread from there" (#43).

The majority of fan comments, however, understand Beyoncé—and themselves—not as tools of neoliberalism but as survivors within it. Considered from the point of view of a dialogical politics of revenge and reclamation, which converse not only with the neoliberal present but with an ever-resonating past of exploitation, Beyoncé's emphasis on her hard work acquires a different meaning for some of her fans. They read Beyoncé's combination of Black identity politics and capitalism as risky because of its potential to turn off some audiences. By

this logic, Beyoncé would enjoy even greater profits if she avoided addressing racialized politics; therefore, making money is not her sole motive.

These fans can see that Beyoncé's Black capitalism—her "best revenge"—resists and protests the traditional power hierarchy of what Cedric Robinson called racial capitalism, a modern economic system built on white racial and colonial dominance, dispossession, and violence (#80, #90; Robinson 2019; Kelley 2017; Johnson 2018).[3] Put simply, Beyoncé succeeds in a system that has historically denied her financial success. In recognizing the extent to which the music industry has been built on the unpaid labor of Black women and Beyoncé's rebuke to that, one biracial fan wrote,: "She is someone dominating a capitalist system that has always failed women of colour. It's not only a nice `fuck you' to the patriarchy, but it's also a nod to the women of colour who have contributed to the success and annals of music and culture in America" (#23). A Black South African woman wrote, "Whether people will admit it or not Black women are the least respected across all fields. The pay gap is a typical example. In music Black women are seen as a tool and are barely given the respect they deserve. . . . But I love that Beyoncé has crossed over [to] fans everywhere" (#63). In an interview with the *Sydney Morning Herald*, Indigenous rights scholar and activist Marcia Langton, who is Aboriginal Australian, shared similar sentiments. To Langton, "Black women are prisoners of the worst kind of patriarchy," and Beyoncé "is the heroine of the black is beautiful movement for women. The thing about Beyoncé is, is that she's a brilliant businesswoman, here she is making her own money and singing about it. It's stunning" (Clarke 2016).

Finally, Beyoncé's insistence on the visibility and importance of her own labor refuses the historical and ongoing invisibility and exploitation of Black women's labor (Brooks 2008). As Jon Caramanica wrote of her Coachella performance on April 14, 2018, which was streamed live online to an audience of almost half a million people around the world, "Some superstars prize effortlessness, but Beyoncé shows her work—the cameras captured the force and determination in her dancing, and also her sweat" (Caramanica 2018). Fans appreciate that she recognizes the reality of hard work and "doesn't hide [the] effort she puts in" (#101). Beyoncé rejects the theft of Black women's labor through insisting on being paid in full (Kelley 1997, 43–77; Moller 2017; Tudor 2017; Fuss 2018), which she does, as one fan put it, through "control of her IP [intellectual property], image and musical output." Beyoncé's emphasis on her hard work and resulting profit thus becomes an important corrective to what this same fan recognized as "historically [not] an option for Black women" (#26).

CONCLUSION

As these many comments from non-US fans suggest, Beyoncé, particularly through *Lemonade*, has taught her fans to think intersectionally, to see how a Black American woman and her community suffer from intersecting power structures that shape experiences rooted in identity. Fans then extrapolate from Beyoncé's model to better understand identity-based oppression that they or others have experienced. As the result, they demonstrate a transnational, intersectional consciousness. In cheering Beyoncé's survival and success, fans see themselves as participants in processes of resistance and survival. It is true, in a limited and immediate sense, that the agency fans find in Beyoncé's work is the kind encouraged by neoliberalism, focused on individual hard work rather than structural transformation. However, Beyoncé's specific identity as a Black American woman, and the history imbued in that identity, encourages fans to think dialogically too. As the result, fans are not overdetermined by the neoliberal context but see Beyoncé in conversation with historically entrenched power structures.

Beyoncé inspires transformation of the self through personal pride. She offers fans the strength to imagine their lives differently. In a time of gross inequality, especially for people with marginalized identities, individual transformation—and the hope of it—matters. In such a context, as Audre Lorde argued, a focus on caring for the self is an act of resistance (1988, 131). To dismiss such focus as a pandering solely to neoliberalism is shortsighted and gives neoliberalism unwarranted power. As Sara Ahmed has argued, "Neoliberalism sweeps up too much when all forms of self-care become symptoms of it" (2014). Furthermore, the concern with the self does not necessarily preclude a simultaneous sense of community or its well-being. Many fans wrote that in addition to building their self-esteem, Beyoncé fandom has helped them to feel a sense of belonging, community, connectedness, and friendship with other fans, a feeling that they are "part of something" (#34). The fans' ability to embrace intersecting identities, the past and present, and individuality and community resists fragmentation in a dehumanizing world. If we listen to their voices, Beyoncé fans can teach us how to sit with complexity and bring together, rather than compartmentalize, our pleasure and politics, our multiple selves. The result is potentially generative. As one fan wrote of what they get from loving Beyoncé, "I feel whole" (#33).

ACKNOWLEDGMENTS

To the Beyoncé fans who completed a long online survey, shared their insights, and made this chapter possible: thank you. Thank you to Christina Baade and Kristin McGee for their phenomenal, incisive readings and suggestions. This chapter began life in conversation with Taylor Fox-Smith, who contributed to the preliminary research, project conceptualization, and the questions included on the survey—I am grateful for all her labor and input. Thank you to the Alchemists, Chin Jou, Norbert Ebert, Alice Gifford, Justine Lloyd, Peter Rogers, and David Smith for their help, support, and critical comments, and to Beverley Wang for a serendipitous conversation about race and identity. Special thanks to Olivia Banner, to whom I owe at least a limb. I dedicate this article to Rosalie, my mother, the child of multiple colonial projects, whose mixed-race identity excluded her from many kinds of belonging but who found meaning and joy in music and gave that gift to me.

NOTES

1. Media coverage of the Beyhive often disparages its members as extreme by focusing on their vengeful rage (see, for example, Chapin 2016; Croffey 2018).

2. I was inspired to conduct an online survey by Toija Cinque and Sean Redmond's online survey of David Bowie fans (2016). I was also inspired by Anwen Crawford's discussion with fans in her book about Hole (2015).

3. For an analysis of how Madam C. J. Walker and A'Lelia Walker worked with and changed ideas about Black women's labor, beauty, consumption, and respectability, and so were forbears of Beyoncé, see Dossett (2009).

REFERENCES

Ahmed, Sara. 2014. "Selfcare as Warfare." *feministkilljoys*, August 25. https://feministkill joys.com/2014/08/25/selfcare-as-warfare/.

Allred, Kevin. 2019. *Ain't I a Diva? Beyoncé and the Power of Pop Culture Pedagogy*. New York: Feminist Press.

Arceneaux, Michael. 2018. *I Can't Date Jesus: Love, Sex, Family, Race, and Other Reasons I've Put My Faith in Beyoncé*. New York: Atria.

Arzumanova, Inna. 2016. "The Culture Industry and Beyoncé's Proprietary Blackness." *Celebrity Studies*, 7, no. 3: 421–24. https://doi.org/10.1080/19392397.2016.1203613.

Avdeeff, Melissa. 2016. "Beyoncé and Social Media: Authenticity and the Presentation of Self." In *The Beyoncé Effect: Essays on Sexuality, Race and Feminism*, edited by Adrienne Trier-Bieniek, 109–23. Jefferson, NC: McFarland.

Bassel, Leah. 2017. *The Politics of Listening: Possibilities and Challenges for Democratic Life*. London: Palgrave Macmillan.

Benbow, Candice Marie. "Lemonade Syllabus." May 6. http://www.candicebenbow.com /lemonadesyllabus/.

Bereznak, Alyssa. 2016. "Inside the BeyHive." *Ringer*, June 3. https://www.theringer .com/2016/6/3/16042806/Beyoncé-beyhive-online-fan-forum-b7c7226ac16d.

Bickford, Susan. 1996. *The Dissonance of Democracy: Listening, Conflict, and Citizenship*. Ithaca, NY: Cornell University Press.

Bradley, Regina N. 2018. "Afterword." In *The Lemonade Reader*, edited by Kinitra D. Brooks and Kameelah L. Martin, 250–52. New York: Routledge.

Brooks, Daphne A. 2008. "All That You Can't Leave Behind": Black Female Soul Singing and the Politics of Surrogation in the Age of Catastrophe." *Meridians: Feminism, Race, Transnationalism* 8, no. 1: 180–204.

Caramanica, Jon. 2018. "Review: Beyoncé Is Bigger Than Coachella," *New York Times*, April 15. https://www.nytimes.com/2018/04/15/arts/music/Beyoncé-coachella-review.html.

Carby, Hazel. 1998. *Race Men*. Cambridge, MA: Harvard University Press.

Chapin, Angelina. 2016. "The Wrath of Beyoncé's Beyhive: How Fans Have Lost the Plot." *Guardian*. May 1. https://www.theguardian.com/music/2016/apr/30/Beyoncé-beyhive -fans-rachel-roy-lemonade.

Chatman, Dayna. 2015. "Pregnancy, Then It's "Back to Business": Beyoncé, Black Femininity, and the Politics of a Post-Feminist Gender Regime." *Feminist Media Studies* 15, no. 6: 926–41.

Chin, Bertha, and Lori Hitchcock Morimoto. 2013. "Towards a Theory of Transcultural Fandom." *Participations: Journal of Audience and Reception Studies* 10, no. 1: 92–108.

Cills, Hazel. 2013. "'Beyoncé' Made the Internet Explode Today." *Rolling Stone*, December 13. https://www.rollingstone.com/music/news/beyonce-made-the-internet-explode -today-20131213.

Cinque, Toija, and Sean Redmond. 2016. "Lazarus Rises: Storytelling the Self in the Migrant Fandom of David Bowie." *iaspm@journal* 6, no. 1: 7–24. https://doi.org/10.5429/2079 -3871(2016)v6i1.2en.

Clarke, Jenna. 2016. "What If Jessica Mauboy Pulled a Beyoncé?" *Sydney Morning Herald*, May 1. https://www.smh.com.au/entertainment/celebrity/what-if-jessica-mauboy -pulled-a-Beyoncé-20160429-goiext.html.

Coates, Norma. 2003. "Teenyboppers, Groupies, and Other Grotesques: Girls and Women and Rock Culture in the 1960s and Early 1970s." *Journal of Popular Music Studies* 15, no. 1: 65–94.

Cohen, Cathy J. 2004. "Deviance as Resistance: A New Research Agenda for the Study of Black Politics." *Du Bois Review* 1, no. 1: 27–45. https://doi.org/10.1017/S1742058X04040044.

Collins, Patricia Hill. 1991. *Black Feminist Thought: Knowledge, Consciousness, and the Politics of Empowerment*. New York: Routledge.

Cooper, Brittney C. 2015. "Intersectionality." In *The Oxford Handbook of Feminist Theory*, edited by Jane Disch and M. E. Hawkesworth. New York: Oxford University Press.

———. 2017. *Beyond Respectability: The Intellectual Thought of Race Women*. Urbana: University of Illinois Press.

———. 2018. *Eloquent Rage: A Black Feminist Discovers Her Superpower*. New York: St. Martin's Press.

Conor, Liz. 2016. *Skin Deep: Settler Impressions of Aboriginal Women*. Crawley, Western Australia: UWA Publishing.

Crafts, Susan D., Daniel Cavicchi, Charles Keil, and the Music in Daily Life Project. 1993. *My Music: Explorations of Music in Daily Life*. Hanover, NH: University Press of New England.

Crawford, Anwen. 2015. *Live through This*. New York: Bloomsbury.

Crenshaw, Kimberlé. 1991. "Mapping the Margins: Intersectionality, Identity Politics and Violence against Women of Color." *Stanford Law Review* 43, no. 6: 1241–99.

Croffey, Amy. 2018. "Beyoncé Being Bitten by Unnamed Actress Sends Beyhive into Frenzy." *Sydney Morning Herald*, March 27. https://www.smh.com.au/entertainment/music /Beyoncé-being-bitten-by-unnamed-actress-sends-beyhive-into-frenzy-20180327 -p4z6gy.html

Dever, Maryanne, Ann Vickery, and Sally Newman. 2009. *The Intimate Archive: Journeys through Private Papers*. Canberra: National Library of Australia.

Dossett, Kate. 2009. "'I Try to Live Somewhat in Keeping with My Reputation as a Wealthy Woman': A'Lelia Walker and the Madam C. J. Walker Manufacturing Company." *Journal of Women's History* 21, no. 2: 90–114.

Durham, Aisha. 2012. "Check On It." *Feminist Media Studies* 12, no. 1: 35–49. https://doi.org /10.1080/14680777.2011.558346.

Durham, Aisha, Brittney C. Cooper, and Susana M. Morris. 2013. "The Stage Hip Hop Feminism Built." *Signs* 38, no. 3: 721–37.

Fenn, Kathryn Kerr. 2002. "Daughters of the Revolution, Mothers of the Counterculture: Rock and Roll Groupies in the 1960s and 1970s." PhD diss., Duke University.

Fernandes, Sujatha. 2017. *Curated Stories: The Uses and Misuses of Storytelling*. New York: Oxford University Press.

Finley, Cheryl, and Deborah Willis. 2019. "Some Shit Is Just for Us." In *The Lemonade Reader*, edited by Kinitra D. Brooks and Kameelah L. Martin, 17–18. New York: Routledge.

Fuchs, Christian. 2016. "Digital Labor and Imperialism." *Monthly Review*, January 1. https://monthlyreview.org/2016/01/01/digital-labor-and-imperialism/.

Fuss, Eloise. 2018. "Beyoncé Orders Australian 'Bey Dance' Fan School to 'Cease and Desist.'" *ABC News*, March 2. http://www.abc.net.au/news/2018-03-02/Beyoncé-orders -australian-fan-school-to-cease-and-desist/9484520.

Getz, Dana. 2016. "Beyoncé's Lemonade: Twitter Data Shows 4.1 Million Tweets in under 48 Hours." *Entertainment Weekly*, April 25. http://ew.com/article/2016/04/25/beyonce -lemonade-twitter-stats/.

Gorton, Kristyn. 2009. *Media Audiences: Television, Meaning and Emotion*. Edinburgh: Edinburgh University Press.

Gottesman, Tamar. 2016. "Beyoncé Wants to Change the Conversation." *Elle*, April 4.

Greenburg, Zack O'Malley. 2017. "Beyoncé's Net Worth: $350 Million in 2017." *Forbes*, June 6. https://www.forbes.com/sites/zackomalleygreenburg/2017/06/06/beyonces -net-worth-350-million-in-2017/#68880a466e80.

Halliday, Aria S., and Nadia E. Brown. 2018. "The Power of Black Girl Magic Anthems: Nicki Minaj, Beyoncé, and 'Feeling Myself' as Political Empowerment." *Souls* 20, no. 2: 222–38.

Harper, Paula. 2019. "*Beyoncé*: Viral Techniques and the Visual Album." *Popular Music and Society* 42, no. 1: 68–81.

Harris-Perry, Melissa V. 2011. *Sister Citizen: Shame, Stereotypes, and Black Women in America*. New Haven: Yale University Press.

———. 2016. "A Call and Response with Melissa Harris-Perry: The Pain and the Power of 'Lemonade.'" *Elle*, April 26. https://www.elle.com/culture/music/a35903/lemonade-call -and-response/

Hickey-Moody, Anna. 2017. "Join the Uprising." *Elle*, April 30. https://customreport. mediaportal.com/#/articlepresenter/a77ead13b5cbc0d862862f1d257babc4/262827223 /840527658?_k=rkoyys.

Higginbotham, Evelyn. 1993. *Righteous Discontent: The Women's Movement in the Black Baptist Church, 1880–1920*. Cambridge, MA: Harvard University Press.

hooks, bell. 2016. "Beyoncé's Lemonade Is Capitalist Money-Making at Its Best." *Guardian*, May 12. https://www.theguardian.com/music/2016/may/11/capitalism-of-beyonce -lemonade-album.

Hopkins, Susan. 2017. "Girl Power-Dressing: Fashion, Feminism and Neoliberalism with Beckham, Beyoncé and Trump." *Celebrity Studies* 9, no. 1: 99–104. https://doi.org/10 .1080/19392397.2017.1346052.

James, Robin. 2015. *Resilience and Melancholy: Pop Music, Feminism, Neoliberalism*. Lanham, MD: John Hunt Publishing.

Jenkins, Henry, and Sangita Shresthova. 2011. "Up, Up, and Away! The Power and Potential of Fan Activism." *Transformative Works and Cultures*, no. 10. http://dx.doi .org/10.3983/twc.2012.0435.

Johnson, Myles E. 2018. "Beyoncé and the End of Respectability Politics." *New York Times*, April 16. https://www.nytimes.com/2018/04/16/opinion/Beyoncé-coachella-blackness.html.

Johnson, Walter. 2018. "To Remake the World: Slavery, Racial Capitalism, and Justice." *Boston Review*, February 20. http://bostonreview.net/forum/walter-johnson-to-remake -the-world.

Kelley, Robin D. G. 2017. "What Did Cedric Robinson Mean by Racial Capitalism?" *Boston Review*, January 12. http://bostonreview.net/race/robin-d-g-kelley-what-did-cedric -robinson-mean-racial-capitalism.

Kelley, Robin D. G. 1997. *Yo' Mama's Disfunktional!: Fighting the Culture Wars in Urban America*. Boston: Beacon Press.

Kohlman, Marla H. 2016. "Beyoncé as Intersectional Icon? Interrogating the Politics of Respectability." In *The Beyoncé Effect: Essays on Sexuality, Race and Feminism*, edited by Adrienne Trier-Bieniek, 27–39. Jefferson: McFarland Books.

Korosec, Kirsten. 2018. "How Beyoncé's Coachella Performance Broke Records." *Fortune*. April 17. http://fortune.com/2018/04/17/beyonce-coachella-youtube-performance /#ob-player.

Lee, Nicole. 2016. "Roxane Gay on Lemonade: 'By the Power of Beyoncé, I'll Overcome My Fear.'" *Guardian*, May 3. https://www.theguardian.com/books/2016/may/02/roxane -gay-beyonce-lemonade-women-writers-pen-festival

Lipshutz, Jason. 2013. "Beyoncé's Surprise Album: 20 Tweets from Mind-Blown Musicians." *Billboard*, December 13. https://www.billboard.com/articles/news/5839698 /beyonces-surprise-album-20-tweets-from-mind-blown-musicians.

Lipsitz, George. 1990. *Time Passages: Collective Memory and American Popular Culture*. Minneapolis: University of Minnesota Press.

Lorde, Audre. 1988. *A Burst of Light*. Ithaca, NY: Firebrand Books.

McFadden, Syreeta. 2016. "Beyoncé's Formation Reclaims Black America's Narrative from the Margins." *Guardian*, February 8. https://www.theguardian.com/comment- isfree/2016/feb/08/Beyoncé-formation-black-american-narrative-the-margins.

Miller-Young, Mireille. 2014. *A Taste for Brown Sugar: Black Women in Pornography*. Durham: Duke University Press.

Moller, Kenza. 2017. "What Does It Mean That Rumi & Sir Are Trademarked? Beyoncé's Twins Have Names Now." *Romper*, July 1. https://www.romper.com/p/what-does-it -mean-that-rumi-sir-are-trademarked-beyonces-twins-have-names-now-67856.

Patrick, Stephanie. 2019. "Becky with the Twitter: *Lemonade*, Social Media, and Embodied Academic Fandom." *Celebrity Studies* 10:191-207.

Radway, Janice A. 1983. "Women Read the Romance: The Interaction of Text and Context." *Feminist Studies* 9, no. 1: 53–78. https://doi.org/10.2307/3177683.

Robinson, Cedric J. 2019. *On Racial Capitalism, Black Internationalism, and Cultures of Resistance*, edited by H. L. T. Quan. London: Pluto Press.

Robinson, Peter. 2014. "Beyoncé Has Reinvented How to Release an Album. Over to

You, Adele." *Guardian*, January 2. https://www.theguardian.com/music/2014/jan/01/beyonce-redefined-release-album-adele

Sekou, Rev. Osagyefo. 2014. "The Master's House Is Burning: bell hooks, Cornel West and the Tyranny of Neoliberalism." *Truthout*, May 19. http://www.truth-out.org/opinion/item/23792-the-masters-house-is-burning-bell-hooks-cornel-west-and-the-tyranny-of-neoliberalism.

Sheehan, Rebecca J. 2010. "Liberation and Redemption in 1970s Rock Music." In *The Shock of the Global: The 1970s in Perspective*, edited by Niall Ferguson, Charles R. Maier, Erez Manela, and Daniel Sargent, 294–305. Cambridge, MA: Belknap Press of Harvard University Press.

Smith, Da'Shan. 2017. "5 Times Beyoncé Showed LGBTQ Inclusively in Her Artistry." *Billboard*, September 15. https://www.billboard.com/articles/news/pride/7941076/beyonce-lgbtq-support-songs-videos-interviews.

Sowards, Stacey K., and Valerie R. Renegar. 2004. "The Rhetorical Functions of Consciousness-Raising in Third Wave Feminism." *Communication Studies*, 55, no. 4: 535–52.

Terranova, Tiziana. 2000. "Free Labor: Producing Culture for the Digital Economy." *Social Text* 18, no. 2: 33–58.

Tinsley, Omise'eke. 2018. *Beyoncé in Formation: Remixing Black Feminism*. Austin: University of Texas Press.

Tudor, Stephanie. 2017. "Beyoncé's Legal Team Sends Cease-and-Desist to Brooklyn Tribute Bar." *New York Eater*, December 18. https://ny.eater.com/2017/12/18/16791426/leyenda-sleyenda-Beyoncé-cease-desist-brooklyn

Utley, Ebony A. 2017. "What Does Beyoncé Mean to Young Girls?" *Journal of Popular Music Studies* 29, no. 2. https://doi.org/10.1111/jpms.12212.

Wallace, Michele. 1999. *Black Macho and the Myth of the Superwoman*. New York: Verso.

Ward, Mako Fitts. 2017. "Queen Bey and the New N*****ati: Ethics of Individualism in the Appropriation of Black Radicalism." *Black Camera* 9, no. 1: 146–63.

Winfrey Harris, Tamara. "Interlude F. Formation and the Black-Ass Truth about Beyoncé and Capitalism." In *The Lemonade Reader*, edited by Kinitra D. Brooks and Kameelah L. Martin, 155–57. New York: Routledge.

Wong, Curtis M. 2014. "Why Big Freedia Doesn't Want You to Put Her in a Category When It Comes to Gender." *Huffington Post Australia*, July 1. https://www.huffingtonpost.com.au/entry/big-freedia-gender-identity-_n_5544730.

Yeboah, Amy. 2016. "What Beyoncé Teaches Us about the African Diaspora in *Lemonade*." PBS, News Hour, April 29. https://www.pbs.org/newshour/arts/what-beyonce-teaches-us-about-the-african-diaspora-in-lemonade.

Zubernis, Lynn, and Katherine Larsen. 2012. *Fandom at the Crossroads*. Newcastle upon Tyne: Cambridge Scholars Publishing.

PART FOUR

"Worldwide Woman"
Beyoncé's Reception beyond the United States

Part 4 continues the focus on Beyoncé's international reception in Chapter 6. While Beyoncé's identity as a Black woman is important to many of her fans and critics—both within the United States and internationally—understandings of this global pop star and her performances of gender, sexuality, race, and privilege differ greatly depending on the national and geographical context. Here, we have two very different but both highly illuminating case studies. In Chapter 7, Simone Pereira de Sá and Thiago Soares examine Beyoncé's status in Brazil, a country that has figured in documentaries about fans (e.g., *Waiting for B* by Paulo Cesar Toledo and Abigail Spindel, 2015) and Beyoncé's videos (e.g., "Blue"). They move beyond cultural imperialist models of musical consumption to focus on how Brazilian performers have drawn on Beyoncé's image to develop more cosmopolitan personae. Analyzing the "performative scripts" of the funk carioca singer Ludmilla and the tecnobrega singer Gaby Amarantos, they show the strategic ways the singers moved from regionally, ethnically, and generically marginalized positions to reach wider audiences in Brazil and beyond. Elena Herrera Quintana explores in Chapter 8 Beyoncé's reception by Spanish feminists, particularly the ways in which some have criticized her for being hypersexualized and hypercapitalist. Quintana examines not only the limited reach of intersectional feminism in Spain, but also the ways in which discussions of race and racism are limited by the nation's failure to contend with its colonial past and its current politics around immigration. She argues that for Spanish feminists, recognizing Beyoncé as an intersectional figure, is bound up with the struggle against anti-Black racism.

SIMONE PEREIRA DE SÁ AND THIAGO SOARES

7. The Performative Negotiation of Beyoncé in Brazilian Bodies and the Construction of the Pop Diva in Ludmilla's Funk Carioca and Gaby Amarantos's Tecnobrega

Onstage are the image, the singer, the voice, the dance, and the biography. A singer is a kind of shadow and echo of countless other singers—an image that stands on other bodies, their grimaces, looks, hair styles, and other clichés. There was something of Billie Holiday in Amy Winehouse, of Madonna in Britney Spears, and of Rihanna in Miley Cyrus. A face that is another. A body in perspective. Acts, gestures, expressions that we have already seen and still find seductive. We delight in repetition.

In this chapter, we expand on Edgar Morin's (1989) perspective, which advocates for extratextual analytical forms within pop culture such as cultivating an emphatic relationship to movie star bodies, and especially to the star's face. For him, the celebrity faces of, for example, Marilyn Monroe, Greta Garbo, and Marlene Dietrich act as a privileged place from which to influence the cinematic experience. With this emphasis on the face, it is natural that Morin highlights this perspective when dealing with film. However, when we talk about music, the face is not enough. The body-sound of the singer is her face, her voice, the expressions that expand muscles at the height of the song, but it is mainly her musical body: the hands that gesture or hold the microphone with more or less vehemence; the shoulders that protrude before a sigh, a breath, or a dramatic moment; the hips that concentrate a certain eroticism in the act of moving that circumscribes attraction or estrangement; the legs, in their game of reveal-hide, a poetic epicenter of haughtiness, the high heels. The body-sound of the singer

projects a sense of musicality and movement for the images. Unlike the static face of the movie star, for the pop star's body, the idea of motion is always present.

It is in the displacement of the perspective of the face, which strongly emphasizes Morin's argument, for a materialization on the body, here called body-sound, that we call on to posit the centrality of performance to work through the analysis in making connections between two Brazilian singers and Beyoncé. *Performance* is thus a keyword for our discussion. Understood as "a communicative process anchored in corporeality" (Frith 1996) and, further, as a way to produce meaning and negotiate positions (Taylor 2013), it helps us to focus on the role of the body in the construction of the pop diva character.

It is from this portrait of dynamic images that the power of clichés emerges. It is the potential place of the utopian body, idealized, but built by media images, movie scenes, concerts, and live performance acts. Images of the singers who "haunt" other singers are a space to summon the performances through repetition or "acts of transference" (Schechner 1988). Beyoncé is an image/sound projected onto other singers, other subjects, as a species not only of a singer model in pop culture but also her reenactment within other singers, mainly from peripheral countries of the Global South, singers who seem to negotiate with local and regional cultures through the images projected by global entertainment culture.

In this chapter, we discuss the presence and "restoration" of Beyoncé's within the performances of two Black Brazilian female artists—funk carioca singer Ludmilla and tecnobrega singer Gaby Amarantos.[1] Here, we conceptualize Beyoncé as catalyst of a Black pop diva corporeality within peripheral landscapes. Ludmilla began her career calling herself MC Beyoncé. However, after gaining broader media visibility in 2013, she took back her own name— Ludmilla—leaving behind the pseudonym and signing a contract with a major label, Warner Music Brasil. In a similar process, tecnobrega singer Gaby Amarantos first presented herself as "Beyoncé do Pará" ("Beyoncé from Pará," referring to the northern Brazilian state, Pará, where she comes from) and recorded a Portuguese version for "Single Ladies" called "Hoje Eu Tô Solteira" ("Tonight I'm Single"), again leaving behind the pseudonym after becoming well known in the Brazilian media landscape. Significantly, in the case of both singers, the association with Beyoncé was established early in their careers, when they still needed to negotiate with certain media frames.

In this context, our main objective is to analyze the trajectory and performance of these two female singers, Ludmilla and Gaby Amarantos, who have

both acquired high media visibility in the Brazilian musical landscape, taking Beyoncé as an aesthetic epicenter to discuss a hegemonic corporality circulating in the entertainment industry and political sphere. With our analysis, we highlight zones of tension around intense processes of commodification of these assemblages in peripheral territories. As a second objective, we underline the construction of the "pop diva" character—understood as part of the global imaginary that Arjun Appadurai (1996) recognizes as "the mediascape of modernity," identifying the points of dialogue and rupture between this global imaginary and the local context of the Brazilian singers.

With this starting point, we are not postulating that Brazilian singers only imitate Beyoncé and use the US pop singer as a moment in their career. But we do think that by reenacting Beyoncé in their bodies, such singers respond to the expectations of larger audiences—those connected with global circuits of entertainment—while also uncovering ways that peripheral subjects respond to the cravings for participating in modernity. In short, we are not proposing the global hegemony thesis, which views imitation as a form of oppression by the global pop culture upon its subjects; rather, we reverse this formulation and try to amplify the different ways in which Beyoncé is used as a means by which Brazilian singers of peripheral musical genres respond to the demands of the public *and* the market, from the intensification of this connection, especially within digital social networks.

These local-global relations are animated through movements, responses, and rearticulations and have been productively discussed more broadly in the field of popular music by Motti Regev (2007). Regev's notion of aesthetic cosmopolitanism in late modernity, which he understood not necessarily at the individual level but at the structural and collective level, acts as a cultural condition that is inextricable from current forms of ethnonational uniqueness. Put differently, Regev wants to suggest that aesthetic cosmopolitanism comes into being not only through consumption of artworks and cultural products from the "wider shores of cultural experience," but also, and more intensively, through the creation and consumption of much of the locally produced contemporary art and culture believed to express forms of ethnonational uniqueness.

Aesthetic cosmopolitanism is the condition in which the representation and performance of ethnonational cultural uniqueness are largely based on art forms created by contemporary technologies of expression and whose expressive forms include stylistic elements knowingly drawn from sources exterior to indigenous traditions. As such, aesthetic cosmopolitanism is not the exception in contem-

porary cultural practices but, rather, the normal and the routine (Regev 2007, 126). Regev discusses how cultural singularities are articulated and not erased in global processes of circulation of consumer goods and images. Cultural practices of negotiation between the local and the global are constant, contested, and full of possibilities, engendering performance road maps to be put into perspective. According to Regev, if aesthetic cosmopolitanism begins with a taste for cultures of countries, nations, and ethnicities different from one's own, then at the level of production, local cultural producers who have developed tastes for goods from cultures other than their own become inspired and influenced in their own work by elements from these other cultures. As Regev argues, "Cultural elements from alien cultures are thus inserted, integrated and absorbed into the producer's own ethno-national culture" (2007, 127). Taking Regev's discussion as a frame to deal with global-local movements in music, we explore in this chapter various ways in which two Brazilian singers—Ludmilla and Gaby Amarantos—use Beyoncé's images to embody the concept of aesthetic cosmopolitism. Moreover, we examine what it is about Beyoncé's pop diva identity that might make her an especially appealing reference in the Brazilian context.

The restoration of Beyoncé in the bodies of Gaby Amarantos and Ludmilla therefore deals with performative negotiations that occur in the micropolitics of bodies, gestures, and actions incorporated in media environments and can promote the understanding of political relations through sounds and images present in global pop culture. We investigate the "scripts" that Gaby Amarantos and Ludmilla stage using Beyoncé as the scenic epicenter through photographs, video clips, and fragments of participation in television programs in Brazil. Beyoncé highlights the power of pop culture in peripheral contexts of Latin America. Even before the worldwide consecration of the album *Lemonade*, which punctuated the singer's career in the intersectional debate between race and gender, Beyoncé was present in the pop imaginary of Brazilian singers as a model of Black femininity worthy of being imitated.

Before proceeding with the analysis of how Beyoncé is incorporated into the performance of Ludmilla and Gaby Amarantos, we need to understand how the corporality of the pop diva is a performance—from the review of performance notions within media and performance studies. Next, we examine and provide a theoretical frame for understanding the concept of performance, uncovering the negotiation required in the arrangement between "archive" and "repertoire" present in the reenactment processes. As Diana Taylor maintains, it is from the negotiation between memory and presentiment of embodied actions that anchors

the theatricality of "performance roadmaps" (Taylor 2013). Therefore, our interpretations of the various media objects employed by singers Gaby Amarantos and Ludmilla, such as photographs, online music videos, and live performance acts, connect them to Beyoncé and construct two performance road maps: (1) the moment when the Brazilian singers "act" Beyoncé in their artistic careers and (2) when they abandon any relationship with Beyoncé and even deny any relationship with this singer's aesthetics.

PERFORMANCE AS NEGOTIATION

In discussing the notion of musical performance, Simon Frith highlights the role of the body not only in the way music is updated by musicians themselves at each performance but also in the way the audience receives it (Frith 1996, 211). The performance is thus a communicative process anchored in corporeity and at the same time an experience of sociability because it supposes rules and conventions negotiated within communities of taste (203). At the same time, however codified the performance is, it also assumes an element of risk, danger, or misunderstanding, since the carefully produced character is surrounded by a "real body": a body that is unbalanced and falls, produces sweat, and doesn't always obey what was defined by the script. It is thus a situation where thinking and doing are together, combining in the same scene the gesture of spontaneity and staging of a social role.

In this context, following Diana Taylor (2013), we propose to think of the performance "as an episteme, a way of knowing," not only but also as an object of analysis. As Taylor states, "We learn, we transmit knowledge through the incorporated action, the cultural agency and the choices that are made" (17). She seems to draw methodological drafts to demarcate the performance as an epistemological phenomenon: "By placing myself as another social actor in the scripts I analyze, I hope to position my personal and theoretical investment in the argument, not covering the differences of tone but putting in theoretical and empirical dialogue" what is shown, as it turns out, what one sees and how one sees it (17). Taylor's premise seems to understand performance as an interweaving between languages and their scenarios, the situations and contexts of apparitions, and the dynamics of visuality and enjoyment. By claiming performance as a "way of knowing," and therefore a field of knowledge, Taylor recognizes that "the openness and multivocality of Performance Studies are an administrative challenge" as disciplinary boundaries are constantly stressed and revised, limited and expanded (17).

The idea of performance therefore overlaps and is informed by traditions of anthropology, performing arts, visual arts, and linguistics, among others, and we propose here an approach connected to the field of communication through two of its thematic objects in which we focus most, music and social networking sites, and in the articulation between both. The heart of the debate around performance in the field of communication is the idea of incorporation, repetition, reiteration. Gestures inhabit bodies, trigger memories, put experiences into perspective. What does the body make visible?

Taylor calls attention to the notion of "embedded performance," which would be "the tangible dimension of acts that play a key role in memory conservation and the consolidation of identities in literate, semi-literate and digital societies" (2013, 21). The performances would thus be vital "acts of transference," allowing the co-construction of knowledge, memory, and a sense of social identity (Schechner 1988). Joseph Roach recognizes the mimetic and mnemonic character of performances, but, almost in a twist to psychoanalysis, he writes, "The genealogies of performance bring with them the idea of expressive movements as mnemonic reserves, including standardized movements made and remembered by bodies, residual movements implicitly stored in images or words (and in the silences between them) and imaginary movements dreamed in minds, not before language, but as constituent parts of it" (1996, 26).

We call attention to the fact that investigating performances demands not only a close look at the field of the symbolic but how performative acts want to propose a "production of meaning" while also offering something of a nonhermeneutic order, which involves the interrelationships of bodies and objects that affect and produce presence (Gumbrecht 2004). Although such a presence can be "occupied" and bodily and mediated, gaining new layers, the understanding is that it is a process that is always unfinished, under construction. Although certain performative acts and their records—such as music shows and theatrical presentations—can bring an idea of their conclusion, they do not close in on themselves but, rather, cause affectations, reverberations, and reelaborations, even after their supposed end and that certainly begin before its beginning. The motor of life, and the performance, does not cease.

What emerges in our argument, therefore, is one of the main questions about what we call analytic "performance road maps" to address the incorporation of Beyoncé's corporality into the performances of peripheral pop divas. Instead of privileging texts and narratives, we take the performance road map adopted by the singers as a space in which positions are taken, from the subjective,

social, and cultural to the market position. Here we reveal strategies that can be read as decisions in discursive and cultural environments. What we propose is a methodology of performance analysis via the notion of script, in Taylor's (2013) perspective—not only as a succession of positions but as an environment in which social actors are organized by innumerable contingencies that make them demarcate points of view about their trajectories. In the pop music field as treated in this chapter, it is understood that the performative script is a horizon of possibility in which subjects are deeply empowered by a variety of forces from the market in the attempt of public expansion and partnerships and by various manners of consecrating relationships within the music field.

In short, we view performances as staged and theatricality driven arrangements that reinsert the political and cultural hierarchies (high/low, center/margin, outside/within, North/South) within meaning-making processes through which heterogeneous places of identification and cultural negotiation are placed. The idea of performance disrupts the arbitrary closure of identities in the hierarchy of authority discourses, since cultural identities would always be called into question from various performance actions. For this analysis, we propose the idea of *performative negotiations*, emerging from the possible articulations and cultural practices that, when interfaced by the continuous traces of the "other" through images, sounds, representations, and corporalities, resist totalizations and destabilize discursive coherence, processes of ambivalence where the aesthetic and the political adhere and refuse images from (un)identifications and strategies of individual and collective subjectivities.

POP DIVA CORPOREALITY

The word *diva*, originally from the Latin *divus*, which means goddess or divinity, first appears in music linked to the great opera female singers, the celebrated prima donnas. The term was extended throughout the twentieth century to refer not only to the cultural icons of cinema, music, and entertainment culture, but more recently to any powerful, spectacular, glamorous, and, sometimes "unreasonable," woman. Exploring the relationship between gay culture and the cult of divas in the opera environment, Craig Jennex highlights the clichés, the artifice, and the exaggeration of the representation of heterosexual love as elements of operatic performance: "Combining conventional elements of spoken theater (costumes, elaborate sets, props, and staging) with music (usually an orchestra and often a large chorus), opera is, arguably, one of the most ostentatious art

forms in the Western classical music tradition. In opera, emotions and plots are, Bronski argues, exaggerated to the point of absurdity" (2013, 352). In this cultural environment where fans worship the singers—especially female singers—the acting ability and musicianship of a diva are central elements of her persona but also crucial to her success in garnering a community of opera queens as fans.

In pop music, the term *diva* has gained common ground to highlight the lineage of transnational singers and performers that emphasizes the visual spectacle, the scenic presence, the choreography, and the development of dramatic personae. Madonna, Britney Spears, Rihanna, Lady Gaga, and Beyoncé can be seen from the same lineage of women staging ways of being in the world "for the idea of empowered femininity, body awareness, entertainment and political aspects related to women and homosexuals" (Xavier, Evangelista, and Soares 2016, 96). The label also has a negative connotation when used to criticize a female star as "unreasonable, unpredictable and likely unhinged" and as someone "whose financial success has yielded excess" (Springer 2007, 257; Kooijman 2019, 2). Discussing the "dual nature of divadom," Kooijman observes, "Although diva has been applied to female stars of various ethnicities, there is a specific connection between the diva and Black female performers, based both on the positive connotations of strength and survival within a white-dominated entertainment industry as well as on the negative connotations of excessive and unruly behavior, often based on racial stereotypes" (2).

Kooijman's article focuses on Beyoncé's performance as a Black diva, proposing that Beyoncé's star image dialogically interacts with a larger tradition of Black female superstardom, such as Tina Turner and Diana Ross, among others. His premise is that although Beyoncé pays tribute to her Black diva lineage, she also redefines the concept while also revealing the contradictions of the label: "Divas both challenge and reinforce dominant ideologies; divas are both commodities to be sold to large audiences and potentially critical figures of strength and inspiration" (Kooijman 2019, 3).

It is necessary to emphasize the importance of the racial component in the debate about the diva and the processes of restoration of Black diva corporality, as Kooijman points out, in contexts outside the United States. Although Beyoncé is the performance negotiation "apparatus" of Gaby Amarantos and Ludmilla, it is possible to think about the absence of Black divas in Brazilian pop music and also in the presence of the Black female singers associated with musical genres such as samba. Brazil is a country historically marked by *mestiçagem* (miscegenation): of the 205.5 million Brazilians (2016 census), only 8.2 percent declare

themselves Black, according to the Brazilian Institute of Geography and Statistics.

The absence of a Black self-identification is a necessary component to understand the wide existence of Brazilian pop singers who identify as "brunettes," such as Ivete Sangalo and Anitta or blondes like Paula Toller and Cláudia Leitte. In this context, Beyoncé's role as the emblematic figure of the Black diva in the pop music world can be seen as a way in which Brazilian pop music producers and singers search for references of Black female divas in a self-reflexive dynamic capable of democratizing the media imaginaries in Brazil.

Next, we offer close readings in order to analyze the performative road maps, first of Gaby Amarantos and then of Ludmilla, in their restorations of Beyoncé. We have divided the analyses into two parts: the moment of appearance and disappearance of Beyoncé references within the careers of these two Brazilian artists.

GABY AMARANTO'S PERFORMANCE: CARNIVALIZING POP DIVA

Gaby Amarantos became popular on the Brazilian music scene in 2012 when she released her album, *Treme*, which featured the song "Ex Mai Love," the opening theme of the soap opera *Cheias de Charme*. It was nominated for a Latin Grammy, and she became one of the most played artists on the Brazilian music charts that year. Before this national success, however, as a leader of tecnobrega groups, the singer already had fifteen years performing experience in the city of Belém do Pará, located in the north of Brazil, near the Amazon region. It is necessary to realize these two moments in Gaby Amarantos's career—first as a local singer in Pará music market and then as a singer of national scale in Brazil—to recognize how Beyoncé's corporality is triggered as a form of negotiation among broader audiences, especially those more pop and global oriented, while also maintaining the "myth of origin" of the artist, which attributes significant charges of authenticity.

In 2010, even before becoming a national singer, Gaby Amarantos received an invitation to perform at the Rec Beat festival in the Carnival of Recife in northeastern Brazil, and, as divulged by presenter Fausto Silva, in the TV program *Domingão do Faustão*, in Rede Globo, she was "afraid" of being rejected by the public of the event, since it was a "festival of independent music and indie rock."[2] In Brazil, there is a tension involving artists from the outskirts of big cities, linked to musical genres such as funk carioca, tecnobrega, brega, and, in general, genres popular with economically disadvantaged listeners, whose

performers ascend to celebrity status singing songs of strong popular appeal. It is the movement to enter in a musical space linked to musical genres such as rock and indie rock that Gaby Amarantos triggered Beyoncé. "I was dressed in a black swimsuit and two dancers [were] on stage, so I walked in, people started yelling 'Beyoncé! Beyoncé! Diva! Diva!'" recalled the singer on the occasion of her second appearance on TV program *Domingão do Faustão* in Rede Globo. At the Rec Beat festival, in addition to her songs, Gaby Amarantos planned to sing "Hoje Eu Tô Solteira" ("Today I'm Single"), a version of "Single Ladies" made by the Brothers band from Belém do Pará.

In order to highlight the performative road maps of Gaby Amarantos's performance, we posit that the enunciative context in which the singer first evokes the us pop diva occurs within Carnival, the biggest Brazilian popular party. We therefore introduce the idea of carnivalization as a discursive artifact that will guide performance (Bakhtin 1993) and then the negotiation (affirmation and later denial of the singer Beyoncé) of her trajectory in media, which highlights a type of performance that triggered associations with a strong global and cosmopolitan accent in tension with her origin. It coincided with the moment at which she reached her first big commercial success in Brazil, with the release of the track "Ex Mai Love," which was also the occasion in which she sought to erase the reference of Beyoncé in her career, as proclaimed in an interview with G1 news portal, which proclaimed, "Beyoncé of Pará was a phase, [which] is over, now meet Gaby Amarantos" ("A fase de Beyoncé do Pará já passou' afirma Gaby Amarantos" 2012).

Gaby's Fantasy of Beyoncé

It was during Brazilian Carnival that Amarantos most forcefully incorporated Beyoncé into her performance—that is, the context of Amarantos's positioning herself as "being seen" as Beyoncé at a popular party, in which there was a suspension of codes and standards of behavioral norms, coupled with precepts of liberation, abolition of hierarchies, and the consolidation of freedom and happiness. Given the context in which her performance takes place, dressing in her black bathing suit and posing as "Beyoncé do Pará" at the Rec Beat festival, Gaby Amarantos was, in essence, costumed by Beyoncé. It is important to note that in classifying Gaby's performance as a "Beyoncé fantasy," we are complicating the act of fantasizing, from the premise of Mikhail Bakhtin that being fantasized

incorporates the "dreamlike desires of another place and time, utopia" but also from the idea that the Other is chosen as fantasy (Bahktin 1993, 78; Da Matta 1973, 18). It is from this premise that we highlight the issue of appearance as central to the perception of how Beyoncé's fantasy rests on Gaby's body. Between 2010 and 2012, in which the singer called herself "Beyoncé do Pará," Gaby did a series of photographic essays in which she reenacted Beyoncé's famous poses, such as the one where she leans on her knees while holding the high heel of a platform shoe, which resembles the photograph used in the material for the album *I Am Sasha Fierce*, released by Beyoncé in November 2008.

What seems central to Gaby Amarantos's staging of Beyoncé was the need for a slim, athletic body, a presumed requirement for all US pop divas. For this reason, the Brazilian singer started giving interviews to celebrity magazines and gossip sites in which she commented on the need to diet and maintain balanced eating patterns. To the news website O Dia, Gaby testified that she "wants to reach 40 years healed" and that she had to resort to *Medida Certa*, a TV reality show, to lose fifteen pounds (Areias 2014). The need for the athletic body to better enact the Beyoncé fantasy happened because of the dress that Gaby chose for her appearances. In Carnival and in several media stages, Gaby appeared with the black swimsuit that Beyoncé consecrated in the "Single Ladies" music video.

However, the similarities with the "Single Ladies" music video ended in the swimsuit. In several other Gaby appearances, she performed alone, without the two female dancers. Moreover, she did not follow the difficult choreography presented in the video. The prospect of Beyoncé's "appearance" in a fantasy for Gaby Amarantos evokes the debate over the duration of the performance—or how a "carnival" play lasted for two years in various media appearances and arrangements. Although "Beyoncé do Pará" was "born" during a carnival party, we noticed that Gaby Amarantos overlapped with other performances by wearing other costumes—not only the "Beyoncé do Pará," but also head ornaments referring to native Amazonian Indians, colorful swimsuits, and feathers. These costumes are common in tecnobrega concerts in Pará.

"Beyoncé do Pará" Funeral

We even tried a strategy [where we were] going to make a joke,
a kind of "Beyoncé do Pará" funeral. It would be really funny. But then
the title went away in a quiet way. After the success of the song at the soap
opera *Cheias de Charme* ("Full of Charm"), the release of the album,
[and the] video clip, was a bombardment of Gaby Amarantos
and "Beyoncé do Pará" was saying goodbye.

Gaby Amarantos

The disappearance of Beyoncé in Gaby Amarantos's career was, as she herself says, "strategic." There seems to be in Gaby's speech an attempt to move through a performance road map toward a pop song canon by enacting a regional and carnivalized reading of the pop diva early in her career. From the moment she was consecrated in the music market, Beyoncé was also discarded. We noticed in the performative script of Beyoncé's disappearance that Gaby's strategy was confined to the Brazilian market; for the international market, approaching Beyoncé was a way to mark the singer as an exponent of a peripheral Brazilian music scene.

So even after her success in Brazil, which occurred in 2012, Gaby Amarantos continued to be revered no more as "Beyoncé do Pará" but as "Beyoncé do Brasil," as was exposed in the July 23, 2013, edition of the *Guardian*. In the article, published a year after her success in Brazil—and when she was no longer referred to as "Beyoncé do Pará"—Gaby appears in the same pose referring to *I Am . . . Sasha Fierce*. The disappearance of Beyoncé in Gaby Amarantos corporality was a well-timed strategy that did not materialize in the performative script of the singer because the pop diva was constantly activated and still remembered before the apparitions of Gaby, especially within the international market.

LUDMILLA'S PERFORMANCE: FROM FUNK TO POP DIVA

In Ludmilla's case, her trajectory relates to her childhood in the Duque de Caxias suburb, a municipality located on the outskirts of Rio de Janeiro. Here, she developed the precocious talent for music by participating in family parties where she added vocals to her stepfather's pagoda (samba) group; posted amateur videos on YouTube; and cultivated a close relationship with the funk music business through her uncle, with whom she recorded "Fala Mal de Mim" ("Bad

Things about Me"), whose music video was produced under the stage name MC Beyoncé, a singer she has idolized since the age of twelve (Almeida 2017). This early video reached more than 15 million views and also drew the attention of Warner in 2012. A recording contract with the label followed in 2013; when she released her first album soon afterward, she dropped the Beyoncé moniker to retake her baptismal name, Ludmilla.

In Ludmilla's performance, we chose to observe the presence and absence of the Beyoncé spectrum through a set of music videos. The first is the one that gave her visibility in 2012, at that time under the name MC Beyoncé.[3] Ludmilla independently produced the massively popular music video "Fala Mal de Mim" ("Bad Things about Me"), an important catalyst for her media visibility and attracting the interest of Warner (MC Beyoncé [Ludmilla] 2012). Directed by Ciclone/Perna's Video and produced with modest technical resources, it mixes scenes of animation with locations on a music stage—simulating a funk ballroom (*baile funk*)—and street scenes. The costumes and choreography are those of an ordinary girl who could be found dancing at any funk ball in the city of Rio de Janeiro: short jeans, cropped top, sneakers, sunglasses, long curly hair dyed laurel, and a thick, pasted golden necklace with the letter B.

The song "Fala Mal de Mim" is recorded only with the singer's voice over the electronic funk carioca beat, with no other accompaniment or arrangement. The lyrics deal with a very present theme in this generation of composers and singers: the dispute with envious women, the *recalcadas* (who envy the beauty of those who are successful), and is peppered with expressions and popular slang, such as *bonde* (tram, referring to a group of friends), *caozada* (to lie), and *rata molhada* (wet rat, referring to the envious enemy). That is, in this video, the set of references from the universe of funk carioca—in terms of the sonority and vocal performance, as well as costume, ambience, and choreography—is explicit. It is thus a music video for a funk singer whose entrepreneurship and ingenuity also arose from this musical environment. As an "ordinary girl," Ludmilla is as talented as many others found singing and dancing on YouTube in search of professional opportunities.

Ludmilla incorporated Beyoncé within the spectrum of the funk carioca musical genre, dressing like a *funkeira* (funk carioca girl), calling herself MC Beyoncé, and causing the pop diva to "inhabit" the physical and lyrical universe of funk carioca in Rio de Janeiro through her presence. It is a different relationship from that proposed by Gaby Amarantos, who seemed to want to erase the vestiges of the technobrega musical genre (extravagant, with ultracolored costumes) and

present herself as a sober and thin performer with straight hair and high heels, wearing a black swimsuit like Beyoncé wore in "Single Ladies." In Ludmilla's case, we have the staging of a *Beyoncé funkeira* (Beyoncé from funk carioca), with shades of this peripheral musical genre in her way of dressing and in performing on the stage in a more stripped-down style. The particular Beyoncé funkeira that Ludmilla staged at the beginning of her career crystallizes as a performance in potential, to the point that when Beyoncé performed in Rio de Janeiro during Rock in Rio in 2013, Beyoncé inserted herself, in the encore of the show, into a moment in which she staged as a funkeira ("Beyoncé Rock in Rio" 2016). On the sound of MC Federated and the Leleks, journalist Monica Parreira pointed out how Beyoncé, who was wearing short jeans and a white shirt, with loose hair, "made a point of dancing a very carioca style. Even the costumes were capriciously embedded in the context" (2013). She continued, "The singer, who during the show changed her clothes almost ten times, wore a traditional pair of jeans with a white blouse to pack the `steering wheel.' Beyoncé rocked the funk and drew more applause from the audience before finalizing the show, which lasted about an hour and a half." This example highlights our main thesis, showing how these performance road maps are fluid and how local-global relations are animated through movements, responses, and rearticulations. Thus, if Ludmilla embodied Beyoncé, Beyoncé also embodied funk carioca in an exchange rather than one-way movement.

In 2013, the same year that Gaby Amarantos was mentioned in the *Guardian*, Ludmilla signed a contract with Warner, a record label through which she released two albums—*Hoje* ("Today," 2014) and *A Danada Sou Sou* ("Damn It's Me," 2016). It was the breakup with the former entrepreneur that caused Ludmilla to abandon her Beyoncé nickname, retaking her baptismal name as her stage name. Equally instrumental in this change were the various legal ramifications surrounding the use of artists' names in their careers and growing speculation about restrictions within the music market. In Ludmilla's new phase, she appeared with new physical features, including a modified nose and a curvier and more sensual body acquired through plastic surgery. These features were accentuated by costumes and wigs that more explicitly triggered the model of global pop divas, especially Beyoncé. Throughout this period, she released a set of videos in which these references were reinforced.

The first video, "Sem Querer" ("Unintentionally"), was released in January 2014 of Ludmilla's new period. In a publicity appearance discussing the video, she claimed this song was "for those who do not want to know about marriage,

do not want to know about commitment" (Ludmilla 2014b). The song, composed when she was fifteen, was inspired by experiences with her passionate boyfriend who wanted a stable relationship, while she chose to spend the nights dancing away. The lyrics of the song underscore this independent woman who tells her boyfriend to find another woman because she does not like commitment and prefers to dance and drink beer throughout the night. Communicating this idea, the scenario is set in an alley near an open shed and wire fence. She performs inside and outside the shed, enacting choreographed steps, sometimes accompanied by dancers. The video was shot at night, and the lights, barrels, and metallic objects reinforce the music video's futuristic industrial aesthetic. The costumes are also in line with the environment: an urban image is presented, which references international fashion trends, consisting of shorts, leggings, and tops, with a predominance of black, purple, and metallic glitter. Ludmilla displays blonde hair, sometimes curly, sometimes smooth, and wears dramatic evening makeup. Finally, in rhythmic and technical terms, the music departs from the sound of funk carioca and approaches pop with strong hooks and repetitive refrains while the modern pop choreographies also trigger references closer to street dance and hip-hop more than funk carioca. In the first frame of the video, Ludmilla is again using a thick gold necklace, but no longer with the letter B. Now she adorns the letters MC Ludmilla.[4]

A second music video that launches the same futuristic street aesthetic is "Bom" ("Good"), released in 2016 (Ludmilla 2016a). In it, Ludmilla appears to be singing a song depicting an evening of sexual pleasure and develops an elaborate choreography of marked steps accompanied by dancers in a dark setting, also dominated by a shed that seems abandoned. The spectator sees scaffolding and stairs, as well as a vintage model car. Just as in the previous clip, the styles consist of shorts, hot pants, and black or metallic swimsuits, which come with boots up to the thigh, leather coats, black socks, and black or purple flat wigs—which reinforce the urban and cosmopolitan aesthetics that circulate in the globalized fashion market.

Thus, Ludmilla makes a move similar to that of Gaby Amarantos; she seems to want to erase the traces of funk carioca in order to move toward a more pop and global spectrum. In the "Sem Querer" and "Bom" music videos, the references of pop culture divas are present in the discourse of women's empowerment and independence, the street-retro-futuristic aesthetic that resists identifying this particular Brazilian place, or the sonority and performance styles that remain close to pop aesthetics. We see an intertextual dialogue especially with Beyoncé's

videos such as "Diva" and "Crazy in Love," whose scenarios also trigger the same retro-futuristic aesthetic in their depiction of sheds, scaffolding, abandoned cars, and wire fences that point to a global periphery, a nonplace of difficult geographical identification. Other timely details, such as the presence of mannequins in concert with singers, reinforce the dialogue between the music videos of these two female singers.

The reference to the "Diva" video clip has special meaning for our discussion because Kooijman (2019) analyzes Beyoncé's performance in this video as a moment when she redefines the Black diva label, literally exploding the scenario by the end of the video clip. According to Kooijman, "This tension between respectability and sexual provocativeness is also visible in the 'Diva' music video, as the dictionary-style lemma of the opening shot presents two definitions of the 'respectable' diva that subsequently are challenged by Beyoncé's 'aggressive femme' performance" (2019). Koijmann cites Griffin (2011) to point out that by using the Sasha Fierce alter ego, Beyoncé plays both roles. Unlike the Black divas who came before her, Beyoncé "has not been forced to choose between 'respectable lady' [like Diana Ross] and 'bombshell' [like Tina Turner]" (Kooijman 2019, 3).

In contrast to this video's preferred nocturnal aesthetics, the initial scene of the "Sou Eu" ("It's Me") music video is set in a river, where Ludmilla and a group of dancers appear in swimsuits and shorts (2016b). The setting in some ways resembles or pays tribute to Destiny's Child's "Survivor" music video, in which Beyoncé, Kelly Rowland, and Michelle Williams appear dancing on a beach "somewhere in the South Pacific," as identified within the legend of the first frame. In both videos, the choreography alternates between scenes from the open space of the banks of the sea/river with others in a more densely configured space of the jungle, where there is an arena/dance floor that seems abandoned and is occupied by singers/dancers. It is again these nonplaces where we are no longer certain if the scenes are temporarily located in the past, present, or future. "Somewhere in the South Pacific," or, perhaps, a river within a rain forest, are both inspired by clichés reproduced in numerous films while also evoking a timeless retro-futuristic aesthetic of mythical warrior women who survived some shipwreck or destruction. The costumes—shorts, swimsuits, short skirts, some curly ruffled cloths, one-shoulder tops, high heels, and bare bellies—also reinforce the association of video clips with feminine myths of strong , sexy, self-sufficient women. They handle these adversities with ease.

Finally, it is worth mentioning some similarities between the music video "Hoje" ("Today") by Ludmilla (2014a) and "Independent Woman, Part I," one

of the most emblematic videos by Destiny's Child. In both videos, the script is set in a futurist environment—a boot camp in the case of Destiny's Child and a factory in Ludmilla's video. Although the lyrics address different topics, the atmospheres of both videos—with cartoonish neon colors, touches of humor, and singers dressed as students—suggest that the "Independent Woman" video was an inspiration for Ludmilla's video.

CONCLUSION

Performance studies approaches complicate standard claims in the classic texts of Latin American cultural studies to reveal that not all forms of hegemonic absorption by the subaltern are a sign of submission, and not all refusals are a sign of resistance. When we locate the analysis through the investigation of corporalities, scenarios, and performance road maps, we materialize hypotheses around the possible plays in the relations between transnational pop culture and subaltern subjects. Artists like Gaby Amarantos and Ludmilla, when activating Beyoncé, negotiate hegemonic performance standards but also destabilize this model, opening possibilities for "bastard stagings" that respond to regulatory principles that are not clearly defined.

If we now return to our first set of assertions, about the ways in which Beyoncé is embodied and updated in the performances of these two Brazilian singers, we can see that the performance road maps of both trigger the presence of Beyoncé in order to broaden their audience and engage dialogically with a wider global market. This process allows the basis for the recognition of Black divas in Brazilian pop music. This is followed by a second break, when these performers excise Beyoncé's explicit presence, which seems to be an impediment to the development of their respective careers.

We recognize that in this second moment, the spectrum of Beyoncé remains modulated within the performance of both, since they continue to guide their careers in the model of the pop spectacle that has Beyoncé as one of its current references. Thus, Beyoncé and her model of stardom and celebrity continue to mediate aspects of their corporality—be it in the pose of Gaby Amarantos when presenting herself to the international market or in the set of Ludmilla's music videos where we see inspiration and dialogue with videos from various stages of Beyoncé's career—as a way to erase the traces of musical genres of local origin toward a more pop, deterritorialized, yet global spectrum.

A second question is why, of all the international pop divas, Ludmilla and

Gaby Amarantos chose to model themselves after Beyoncé and not, for instance, Lady Gaga or Madonna. Here, it is important to recall the discussion about Beyoncé as a Black diva. If we think that through the incorporation of Beyoncé, Gaby Amarantos and Ludmilla would symbolize and inhabit the Black divas of Brazilian pop music, what do they bring and negotiate in terms of aesthetic cosmopolitanism? The singularity of the two female singers is to bring to the Brazilian peripheral musical genres, funk carioca and tecnobrega, the incorporation of an imaginary that brings together the racial foundations including the power, attitude, and glamour of Black American culture. Faced with a performance that demonstrates and proudly highlights the hips and buttocks with a dance that reminds us of twerking (in Brazil popularly called *quadradinho*), it is argued that to trigger Beyoncé is also a way to demarginalize the figure of the Black woman in Brazilian musical genres. The image of Beyoncé, as "incorporated" in Gaby Amarantos and Ludmilla, helps to break with the stigma of Black women historically subjugated in Brazilian society, pointing to new pedagogies of Blackness for women in contemporary Brazil.

NOTES

1. Funk carioca—or simply "funk" in Brazil—is a dance music style different from what "funk" means in the rest of the world, since Brazilian funk has its origins in Miami Bass. Also, in Brazil there is a specific name for the parties where people go to dance funk carioca, the so-called *baile funk*. Finally, the word *carioca* refers to people born in Rio de Janeiro; it is also used to mark the birthplace of Brazilian funk music. Tecnobrega (also known as tecno melody) is a popular musical genre that emerged in Belém do Pará in the 2000s. The genre goes from traditional brega, calypso, forró, bolero, merengue, and carimbó to electronic music and samba. The greater predecessor of tecnobrega was the group Banda Tecno Show, at the time led by Gaby Amarantos. In the early 2000s, they began mixing guitar riffs from traditional hardcore music with electronic beats and arrangements created by computer programs, which was seen as a break in the music market of Pará at the time (Melo and Castro 2011).

2. To watch (in Portuguese), see "Beyoncé do Pará (Gaby Amarantos)—1° VEZ NO FAUSTÃO" (2010), https://www.youtube.com/watch?v=g2b2i0G8vJs.

3. The term "MC" refers to the figure of the ceremonial master, who conducts the show in funk carioca dance balls. In funk carioca, the term became popular and synonymous with *singer*; therefore, numerous funk carioca singers perform under the nickname of MC, as did Ludmilla, who called herself MC Beyoncé.

4. Later, the singer removes "MC" from her name, recognizing the stigma that this

acronym carries in Brazil because it is associated with the musical genres that circulate in favelas and peripheries, such as funk and hip hop.

REFERENCES

Almeida, Francisco. 2017. "Fã da Beyoncé, Ludmilla conta o que falaria em um encontro com ela." *TV Foco*, February 10. https://www.otvfoco.com.br/fa-da-beyonce-ludmilla-conta-o-que-falaria-em-um-encontro-com-ela/.

Appadurai, Arjun. 1996. *Modernity at Large: Cultural Dimensions of Globalization*. Minneapolis: University of Minnesota Press.

Areias, Karilayn. 2014. "Gaby Amarantos: 'Quero chegar aos 40 gata e Sarada como a Angélica.'" *O Dia*, February 18. https://odia.ig.com.br/_conteudo/diversao/celebridades/2014-02-18/gaby-amarantos-quero-chegar-aos-40-gata-e-sarada-como-a-angelica.html.

Bakhtin, Mikhail. 1993. *A cultura popular na Idade Média e no Renascimento*. São Paulo/ Brasília: Hucitec.

"Brazil's Music Revolution: The New Stars Remaking a Nation's Future." 2013. *Guardian*, July 24. https://www.theguardian.com/music/2013/jul/23/brazil-music-revolution-new-stars.

Da Matta, Roberto. 1973. "O carnaval como um rito de passagem." In *Ensaios de antropologia estrutural*, 121–68. Petrópolis, Vozes.

"'A fase de Beyoncé do Pará já passou' afirma Gaby Amarantos." 2012. *G1*, April 20. http://g1.globo.com/ceara/noticia/2012/04/fase-de-beyonce-do-para-ja-passou-afirma-gaby-amarantos.html.

Frith, Simon. 1996. *Performing Rites: On the Value of Popular Music*. Cambridge, MA: Harvard University Press.

Griffin, Farah Jasmine. 2011. "At Last . . . ?: Michelle Obama, Beyoncé, Race and History." *Daedalus* 140, no. 1: 131–41.

Gumbrecht, Hans Ulrich. 2004. *Produção de Presença: O que o Sentido não Consegue Transmitir*. Rio de Janeiro: Contraponto/ Editora PUC Rio.

Jennex, Craig. 2013. "Diva Worship and the Sonic Search for Queer Utopia." *Popular Music and Society* 36, no. 3: 343–59.

Kooijman, Jaap. 2019. "Fierce, Fabulous, and In/Famous: Beyoncé as Black Diva." *Popular Music and Society* 41, no 2: 6–21.

Lockridge, Aisha Damali. 2012. *Tipping on a Tight Rope: Divas in African American Literature*. New York: Peter Lang.

Mask, Mia. 2009. *Divas on Screen: Black Women in American Film*. Urbana: University of Illinois Press.

Melo, Olívia Bandeira, and Oona Castro. 2011. "Castro Apropriação de tecnologias e

produção cultural: inovações em cenas musicais da Região Norte." In *Nas bordas e fora do Novas tendências da música independente no início do século XXI*, edited by Micael Herschman, 185–208. São Paulo: Estação das Letras e Cores.

Morin, Edgar. 1989. *Estrelas—Mito e Sedução no Cinema*. Rio de Janeiro: Rocco.

Parreira, Monica. 2013. "Beyonce causa alvorço ao dançar funk no Rock in Rio, assista." *A Redação*, September 14. http://aredacao.com.br/cultura/33348/beyonce-causa-alvo-roco-ao-dancar-funk-no-rock-in-rio-assista.

Regev, Motti. 2007. "Cultural Uniqueness and Aesthetic Cosmopolitanism." *European Journal of Social Theory* 10:123–38.

———. 2013. *Pop-Rock Music: Aesthetic Cosmopolitanism in Late Modernity*. Cambridge: Polity Press.

Roach, Joseph. 1996. *Cities of the Dead: Circum-Atlantic Performance*. New York: Columbia University Press.

Rogers, Mary. 1999. *Barbie Culture*. London: Sage.

Schechner, Richard. 1988. *Performance Theory*. London: Routledge.

Springer, Kimberly. 2007. "Divas, Evil Black Bitches, and Bitter Black Women: African American Women in Postfeminist and Post-Civil-Rights Popular Culture." In *Interrogating Postfeminism: Gender and the Politics of Popular Culture*, edited by Yvonne Tasker and Diane Negra, 249–76. Durham: Duke University Press.

Taylor, Diana. 2013. *O Arquivo e o Repertório*. Belo Horizonte: Editora da UFMG.

Xavier, Luciana, Simone Evangelista, and Thiago Soares. 2016. "Performatividade de gênero na música popular periférica." In *Música, Som e Cultura Digital: Perspectivas comunicacionais brasileiras*, edited by Simone Pereira de Sá, Beatriz Polivanov, and Simone Evangelista. Rio de Janeiro, E-Papers.

VIDEOGRAPHY

Beyoncé. 2009. "Diva." Melina Matsoukas, dir.

Beyoncé, feat. Jay-Z. 2003. "Crazy in Love." Jake Nava, dir.

"Beyoncé do Pará (Gaby Amarantos)—1° VEZ NO FAUSTÃO." 2010. uploaded on May 3, 2010 by CANALINNOVE. YouTube. https://www.youtube.com/watch?v=g2b2ioG8vJs.

"Beyoncé Rock in Rio." 2016. Uploaded on January 9, 2016, by Raffa Sousaj. YouTube. https://www.youtube.com/watch?v=GoRaunkYiDw.

Destiny's Child. 2000. "Independent Women." Francis Lawrence, dir.

———. 2001. "Survivor." Darren Grant, dir.

Ludmilla. 2014a. "Hoje (Today)." Rafael Kent, dir. YouTube. https://www.youtube.com/watch?v=Rvq7R9dwJ3U.

———. 2014b. "Sem querer (Inintentionally)." Thiago Calvin, dir. YouTube. https://www.youtube.com/watch?v=gqFDr_jzo9I.

———. 2016a. "Bom (Good)." Felipe Sassi, dir. YouTube. https://www.youtube.com/watch?v=UUueHQ4bNfo.

———. 2016b. "Sou Eu (It's Me)." Fabio Ladeluca, dir. YouTube. https://www.youtube.com/watch?v=8aQTjEotXVw.

MC Beyoncé [Ludmilla]. 2012. "Fala Mal de Mim (Bad Things About Me)." Ciclone/Perna's YouTube video. https://www.youtube.com/watch?v=-mkCbfHrUwo.

ELENA HERRERA QUINTANA

8. A Critical Analysis of White Ignorance Within Beyoncé's Online Reception in the Spanish Context

Since 2014, Beyoncé's performances and interactions have elicited considerable critical feminist and race-based reactions in Spain. The events that motivated such strong reactions included the sampling of Chimamanda Ngozi Adichie's speech in her 2013 "***Flawless" recording and subsequent video, as well as her self-identification as a feminist during the MTV Video Music Awards in 2014. In 2016, on the release of her second visual album, *Lemonade*, many argued that this work exhibited a strong antiracist message, with many feminist overtones and African American cultural and political references, such as to Malcolm X, the Black Panthers, and the Black Lives Matter movement. This chapter examines the reception of Beyoncé's work within the Spanish national context, paying special attention to her last two visual albums, *Beyoncé* and *Lemonade*. In particular, it queries how and why a critical dimension of her work's cultural message and visual references remains unacknowledged or misunderstand due to the lack of reflection regarding racial and ethnic identity dynamics at the crossroad of gender.

To uncover the mechanisms leading to such oversights, the chapter considers several sources circulated in mainstream Spanish media since the first visual album release in 2013. These include references to Beyoncé's albums, *Beyoncé* and *Lemonade*, as well as her performances and recordings, in *El País* (a national newspaper), *Pikara Magazine* and *Tribuna Feminista* (both feminist online magazines), and *Afroféminas* (online media focused on race and gender in Spain). The articles selected for analysis consist mostly of online versions of journals and magazines, which allows them to be shared and commented on by Spanish

readers. I have selected representative articles that expose reiterative ideas and discourses about Beyoncé in the Spanish media and broader cultural context.

In general, from these sources, there are three main debates surrounding the reception of Beyoncé's activism. One is related to whether her sexualized performances are incompatible with feminism. The second focuses on the social and class context in which Beyoncé is perceived, depicting it as either too rich, as conditioned by neoliberalism, or as too popular and mainstream to enable her reception as an authentic feminist icon. The third debate relates to the reception of her raced body as well as various racist conceptions and interpretations of her performing body. This chapter focuses mainly on the third debate because the discourse contained within it represents the strongest differences when compared with North American contexts. There is a gap between Beyoncé's North American and Spanish receptions, with particular values and interpretations that are acknowledged in the North American context but go unnoticed in the Spanish context. Nevertheless, estimations of sexuality, the body as an object, and class-related issues always remain in the background. This chapter examines the lack of a critical reflection on intersectionality in Beyoncé-related Spanish media discourse, focusing in particular on the online journalistic field and centering the analysis in terms of the racial blindness and "white ignorance" (Mills 2007) inherent in the Spanish context.

I begin by analyzing historical contexts within Spain that exclude recognizing race as a social dimension with significant consequences for Beyoncé's reception in these online contexts. Second, I interrogate the concept of "white ignorance" as a critical category from which to situate these debates. To highlight their practical mechanisms, I describe some cases related to Afro activism in this landscape of white ignorance, such as the racist response experienced by the Spanish Afro community when they denounced discriminatory practices in the academic field or online racist harassment, such as that enacted on Desirée Bela-Lobedde. Third, I offer an overview of the Afro community in Spain and its development in a historical context. Finally, thus positioned, this analysis examines a discursive gap in relation to Beyoncé's intersectionality in both the Spanish media and Spanish academic research. Ultimately, I argue that without a contextualized understanding of Black/Afro and ethnic identity within Spain or elsewhere, it is impossible, at the crossroads of gender, class, and other social categories, to understand Beyoncé's work in its full complexity.

INTERSECTIONALITY AND THE
AFRO COMMUNITY IN SPAIN

Two prominent debates related to Beyoncé's sexuality and class, her sexualized performances and her status as a neoliberal icon, are evident in North American and Spanish media. The third context, however, relating to her raced body, is perceived differently in Spain owing to the racial specificities and colonial past of this nation. Concerns regarding the representation of race and racism are difficult to locate, with the exception of a few sources, whereas questions and assessments of her social class and the uses and representations of the female body prevail in relation to marketplace capitalism. These race-based critiques in particular generate controversy. Also, the limited theoretical corpus within Spanish scholarship on pop culture, feminism, and race impedes a full and nuanced understanding of Beyoncé's reception in the Spanish context.

One of the most respected and widely read Spanish feminist publication is *Pikara Magazine*, an online magazine focusing on social and cultural issues from a feminist perspective. *Pikara* has won more than twenty journalism awards in the past seven years. In 2014, it published an article on Beyoncé entitled "Is Beyoncé Feminist?" In fact, we can find this question surrounding Beyoncé in several contexts and places around the world, suggesting that one of the main debates within contemporary feminism considers the feminist authenticity of current media celebrities and icons.

María Luisa Latorre, a feminist activist who also publishes in *Tribuna Feminista* (Feminist Tribune), writes, "Beyoncé is not subversive. . . . Beyoncé also enjoys the privileges. Neither machismo nor racism affect her as the rest of the mortals. It is the effect of being enormously rich" (Latorre, 2014). The overestimation of class oppression as a source of discrimination has a long tradition in Spain due to the strong Marxist influence in left-wing thinking. The consequence is a lack of intersectional analysis to incorporate race and ethnicity into the equation. It is a problem not solely in Spain; it also affects broader left-wing thinking throughout Europe (Eddo-Lodge 2017, 102).

The problem arises because race and racism remain relatively unknown for the majority of Spaniards. Reflecting on this fact, Google Translate, with its algorithms based on statistical use, does not translate the word *race* as the Spanish word *raza*, but instead as *carrera*, which means sports competition. Perhaps this is funny, but it is also clarifying. In Spain, there remains a lack of knowledge about the ethnic and racial characteristics of our population. We white Spaniards

remain ignorant about the structures of and the functioning of intersectional forms of exclusion. For example, we do not have an institutional census about the Black and Afro-descended population in Spain. As the historian Antumi Toasijé (2010) says, "Almost no scientific attempt has been made to quantify the number of people that are Afro descendants, African and black, residing in the Spanish territory." In recent years, the Afro activist community has increasingly underlined this problematic situation (Sánchez, 2020; Gerehou, 2020).

Toasijé (2010) explains that the Afro Spanish community is made up of five groups: migrants from Africa; Afro Latin people; Afro-descended migrant people from Europe, the United States, and Asia; Spanish-born children and grandchildren related to each group; and slave-descended people. These populations emerge from the unique historical circumstances of Spain, resulting in a heterogeneous population. Yet this population is little recognized, let alone understood, in terms of race identity and the politics of representation. Toasijé explains that one of the problems in the foundation of an institutional census in Spain is known as *colorism* (color scale), wherein a number of people who are recognized as Black by white people reject their Black heritage and define themselves closer to a white color scale as a way of avoiding social stigma, so we have a specific group that does not self-identify as Black and is therefore difficult to include in this hypothetical institutional census.

Toasijé points out several reasons why an institutional census is needed: to visualize and verify that Spanish society is not just white, to ensure the recognition and self-recognition of this Black/Afro-descended community, and to offer a visualization and confirmation of common life experiences relating to racism, and not exclusively in relation to class and gender. This institutional census would also aid in the search for representation in spheres of power. Finally, such a census would recognize the first ethnic minority to exist within modern Spanish society and whether it outnumbers the Roma population.

The active color blindness in Spain arises from several factors. First, there is a lack of recognition of our past as a slaveholding country (Piqueras 2017). In general terms, we do not know about and are not taught at school about the prominence of the Spanish Crown in the global slave trade and trafficking in the sixteenth and seventeenth centuries and, later, through the liberalization of the slave traffic during the eighteenth century. In an interview hosted by *Casa America*, the author of "La Corona Española y el tráfico de negros: Del monopolio al libre comercio," Reyes Fernández Durán, points out: "In Spain this is not talked about, it is like the slaves were just in Saxon America, like *Uncle Tom's Cabin*, we

did not have anything to do with it. . . . The people have to be conscious that we simply did" (Fernández Durán 2012). According to García Barranco and Martín Casares, Spain was the country with more slaves from sub-Saharan Africa than any other European country (García Barranco and Martin Casares 2010, 1). Also, we were the last country to abolish slavery in overseas territories such as Cuba and Puerto Rico in 1886. The practice of slavery guaranteed the Spanish colonial success in America: "For four centuries, the supply of black slaves to Europe and America was a great commercial company for the Crown" (Barbolla Mate 2013, 13–14).

Second, Spain is very close to Africa, and it was a colonial country with several African colonies in the past. Two Spanish cities, Ceuta and Melilla, are still located in Africa, and Spain also controls the Canary Islands. Today, Spain has administrative control over the western Sahara. Indeed, "Africa begins in the Pyrenees" is a common phrase in Europe, where it is meant as an insult and also experienced as one (Toasijé 2009). Acording to Toasijé,"There has been a definite intention, on several levels, to destroy all facts regarding Africa in relation to Spain" (349). One of the targets for these intentions was when Spain entered the European Common Market and the European Union in 2002. This "Europeanization" meant at the same time a "de-Africanization" of the country to ensure the "advanced" guidelines of the European Union (Toasijé 2009, 350). It involved making Spain's inmigrant policy tougher, circulating criminalizing discourses against inmmigrants, especially Black people. Toasijé wrote that "the European Union seeks to push Spain to demonstrate its Europeanity by closing the gates to the millenarian African immigration, and Spain will not be careless in this dangerous task, to the extent of killing disarmed people, to 'be as European as possible'" (350).

In this social climate of race-based animosities and our related perceived ethnic identity, the reception of Beyoncé as a Black woman is especially difficult to understand in Spain, or even to imagine. Therefore, the neoliberal and class dimensions of her figure remain the privileged considerations of larger debates.

A recent example of this often overemphasized classist and economic perspective can be found in the blog account *Demonio Blanco,* which has more than 62,000 likes on Facebook. This blog focuses on political and social issues from a left-wing perspective. The entry recirculated a *Huffington Post* article (Shank and Bedat 2016) about Beyoncé's clothing brand, Ivy Park, and the exploitation of a female workforce in its factories. In the post's comments section, someone responded, "The rules of capitalism do not change, be it man or woman. Gender

issues will only make the right of one gender or the other prevail, but those below will continue to be the ones below" (Demonio Blanco Facebook, 2016). In the Spanish articles I have analyzed, it seems the economic and class dimensions are understood as the main source of discrimination, cancelling out or minimizing the effect of other variables—mainly race and ethnicity—and therefore preventing Beyoncé from (successfully) portraying a political message of subalternity. She is too rich and neoliberal, not subordinate at all, even if she is a Black woman in post-Trump's United States.

For this reason, Charles Mills's analysis of race and racism is instructive here. In "White Ignorance," Mills claims, "in the left tradition, this was precisely the classic thesis: (class) domination and exploitation were the foundation of the social order" (Mills 2007, 34). In general terms, left-leaning political analyses in Spain center on socioeconomic class dimensions, resulting in the elision of race as a factor and even contributing to racist and "color-blind" perceptions. In this reasoning, the racial subordination affecting every individual who does not fit into the white norm is not understood, nor are the racist consequences of these views. The "white blindness" (Mills 2007, 19), or, in Eduardo Bonilla's (2006) words, the "color blindness" of Spanish society forgets race and ethnicity as relevant categories.

This dynamic remains in our so-called postracial society, although in Spain postracialism is relatively unknown because we do not consider our racial heritage in general terms. The term *postracial* seems to be an effect of this color blindness and white ignorance. The resulting white ignorance is a cognitive phenomenon that erases the cultural differences related to race as a social construct—one that establishes a white normativity and white group as a reference group (Mills 2007, 25). Yet it does not exclusively affect white people. The collective amnesia produced by white ignorance creates a space where race is not understood to be a discriminatory variable, a situation enabled by the forgetting of its structural relation to institutions of power and access to wealth. In this social climate, those who insist that race is an issue are viewed as the real racists because they do not want to forget and enter into this kind of "epistemology of ignorance" (28). Crystal Fleming (2017, 2018) used the term *anti-racialism* to depict this phenomenon, one often witnessed in other European countries, including France.

WHITE IGNORANCE IN PRACTICE:
AFRO ACTIVISM AND RACISM

Two recent cases illustrate how white ignorance operates in the Spanish context. The first case involved online racism and misogny directed at the Black feminist blogger Desirée Bela-Lobedde, who focuses on racist representations and Afrobody politics and who founded her site Negra Flor (Black Flower). Like other political and social speakers, Bela-Lobedde offered paid workshops and talks. An online debate started in June 2017 about whether activism should be a paid activity, focusing on her workshops, which cost 19 euros per person. The issue rapidly became a trending topic in Spain, with two main positions represented: activism, in the form of workshops and talks, is an altruistic task, not a job, and activism should be a paid activity because it requires effort and time, accrues derivative costs from renting office space, and entails administrative costs for organizing events.

Why did this debate about the nature of activism start with the case of a Black Spanish woman? It seems there were racist motivations behind some of the comments. For example, the Twitter debate became centered on Bela Lobedde herself, who received so much harassment that she canceled her workshop and closed her Twitter account. Although some people supported Lobedde with the hashtag #YoApoyoaNegraFlor (#ISupportBlackFlower), which was based on her pseudonym as a blogger, the case gained little media attention, with just a few online articles denouncing the racist motivations behind the criticism (Mohorte 2017; Vírseda 2017). Moha Gerehou, an antiracist journalist who writes in *El Diario* about racism in Spanish society and the ex-president of sos Racismo Madrid (sos Racism Madrid), wrote on Twitter, "I insist: we have the same right to be on Twitter, to get paid for talks and do the same things as you at the same requirement level. End of story" (Gerehoy 2017).

The second case involved the relatively new, left-wing political party Podemos, which advocates for deep political changes in the Spanish political sphere. In 2018, Podemos organized several seminar sessions, Feminism and Hegemony, in the Faculty of Philosophy at the Complutense Univsersity of Madrid, one of the main universities in Spain. The first poster circulated featured an Angela Davis photo, apparently whitewashed and retouched with a pop art filter; however, they did not include her work in the main bibliography or invite any speaker focused on forms of racial hegemony or on Davis's work, let alone Davis herself. The first reactions on Twitter soon materialized, especially from several Afro

activists. They included Bela-Lobedde, Gerehou, and Esther (Mayoko) Ortega, an antiracist feminist thinker and cofounder of Afroconciencia o El espacio antes conocido como Afroconciencia, usually Conciencia Afro.[1]

These Afro activists pointed out the clear whitewashing of Angela Davis's photo, even if the original photo was already "too white," as some people commented in an attempt to deny the obvious racism. Others commented on the makeup of the seminar. Ortega (2018) responded in her Twitter account, "Among the reference authors in that pseudo-seminar there is not one non-white feminist. In fact, just three Feminists among the rest of the authors: Butler, Irigaray and Despentes." Bela-Lobedde, along with others, observed that the common phenomenon of whitewashing demonstrated how white people *love* Black culture without Black people: "It seems to me the highest hypocritical thing using Davis as an attraction when there is not a racialized woman speaker. Shame on you" (Bela-Lobedde 2018). Irantzú Varela, a white feminist activist who usually contributes humorous feminist videos to *Pikara Magazine*'s website, emphasized the serious dimension of this case and lobbied for real intersectional feminism: "Black feminism changes my life because it changes my perspective about my privileges, but in political practice the *little white [payablanca]* inside us appears too easily" (Varela 2018).[2] In response, Bela-Lobedde called out these dynamics between loving Black culture but remaining aloof to real Black people's lives: "Everything black changes your lives: black feminism, traveling to Africa . . . but not black people. . . . Talk with your white 'sisters' and tell them it is enough of this desdain" (Bela-Lobedde 2018).

Clara Serra, a congresswoman in the Assembly of Madrid, a regional political body, and the main coordinator of Podemos's seminar, posted a response to these critiques on her Facebook page. Her post did little to acknowledge that Podemos's failure to include any Black or intersectional feminist speakers, list any Black feminist author in the recommended bibliography, or consider any race issue during any session of a Feminism and Hegemony course represented an instance of white ignorance. Rather, Podemos's press release read: "I am concerned about the aggresiveness in social media debates, often with manners that do not help to persuade and to convince each other in the promotion of our communal goals" (Serra 2018). The response participated in a long tradition of white women accusing Black women of being too agressive or rude, drawing on the so-called angry Black woman stereotype. This is not a trivial point: it is at the core of the racist representations of Black womanhood. More alarming was the reference to persuasion, which suggested that the issue of race and racism is

a question of argument and rhetoric rather than of social justice and a need for reparation. Indeed, nowhere in the press release did Serra mention racism or discriminatory actions; instead, she focused on responding to criticisms about the number of male speakers who argued that feminism is not just a female issue.

Throughout this social media debate, several people explored their inner racism and the mechanisms working behind it. At the same time, many others failed to see the point, unable to experience any destabilization in their privileges as white feminists or white people. Alba Pez, representative of the State Equality Area in Podemos, wondered, "Is it not a victory of black feminism that a feminist like Angela Davis is recognized as an icon for all feminists?"[3] Indeed, there is no victory if we use Angela Davis as an icon without taking on her work and perspective; in that case it is just white appropriation.

THE AFRO COMMUNITY AND AFRO FEMINISM IN SPAIN

Let's go back to 1978, the period in Spain after the fall of fascism and the rise of democracy, when the immigrant population rapidly increased. Newly arrived immigrants came from other European and Asian countries, which were presumably richer than Spain, and from African and Latin American countries, which were considered poorer than Spain. This was the perfect terrain to create two different moral categories of immigrants: the rich and good "Europeans" and the poor and criminal immigrants "from abroad" (Toasijé 2010). This social stratification was openly discriminatory, as was clear in the implementation of immigrant policies, which were more liberal with European immigrants and more restrictive and punitive to those arriving from countries outside the European Union. In this situation, some immigrant groups started to organize and promote collective action in an effort to improve their social conditions and access to basic human rights (Toasijé 2010).

At the same time, a young generation of Black people who were born in Spain and had full citizenship were looking to reinforce their Black and Spanish identity by fighting against institutionalized and daily racism, such as violent street harassment from young far-right collectives (Toasijé 2010). Both collectives—people with citizenship and without—shared solidarity links. In the late 1990s, they formed associations like Frente Organizado de Juventud Africana (African Youth Organized Front) and Asociación Panteras Negras (Black Panthers Association).

In 1992, the first racist crime with media repercussions occurred in the Span-

ish democracy (Toasijé 2010). The background was the Los Angeles riots after the police acquittals of the Rodney King case. Lucrecia Perez, an Afro Dominican Black woman, was murdered by an off-duty police officer, who acted with three minors linked to neo-Nazi groups. Only a year earlier, a group formed by Afro Guinean women, *E'waiso Ipola*, which means "Woman, wake up," in the *bubi* language, had become one of the first Afro feminist collectives founded in our country. In an interview with Esther (Mayoko) Ortega, the group's cofounder, Remei Sipi, explained that in the early 1990s, the main struggles that African and immigrant women had to confront in the Spanish context were their own citizenship rights, unsupportive partners, rampant ethnocentrism in school books, and the stigmatization of migrant and Black people in the media (Ortega, 2018).

Ortega understands that the Afro feminist movement in Spain is still pursuing many of the same goals that E'waiso Ipola worked for in the 1990s. Nonetheless, there are differences. As one of the cofounders of the Afro feminist space within Afroconciencia/Conciencia Afro, Ortega explained that the migrant issue in this organization has become less central, maybe due to the fact that more members of the Afroconciencia/Conciencia Afro collective were born in Spain. Another difference is the understanding of gender as a nonbinary question, centered on efforts to recognize a racialized sexual diversity and point out the racist practices within the left wing LGTBIQ+ Spanish movement. However, other collectives are focusing on the migrant issue, such as the collective Migrantes Transgresorxs (Transgressive Migrants), which was founded in 2009 and focuses on Spain's restrictive and racist migrant policies.[4] Also labor organizations representing home and care workers, such as SEDOAC, have highlighted the difficult situation of migrant women in this sector.

According to Ortega, questions about representation are still important, especially in terms of how the media and institutions represent Black women and how Black women represent themselves. In Spain, Black women are generally pigeonholed into two main forms of representations: hypersexualization and invisibility. Ortega says, "Black women in the public space have few possibilities to not be read as sexual workers" (Ortega 2018). In this sense, as in Anglo American contexts, Black womanhood is represented in hypersexualized terms, and Black women are read and misrecognized as easily accessible sexual bodies. On the opposite pole, as Ortega pointed out, there are the dynamics of invisibility, where Black women do not even exist, resulting in a lack of representation of Afro women as diverse social subjects.

BEYONCÉ'S RECEPTION IN SPANISH MEDIA: POLICING BLACK WOMEN'S BODIES

Considering this social climate, the discomfort and controversy generated in Spain by Beyoncé's sexualized performances is not surprising. For example, the Plataforma Anti Patriarcado Facebook site, a radical feminism platform sometimes accused of trans-exclusionary radical feminist politics, critiqued the article "Beyoncé Ends Up with Machismo in Two Hours" (Kovacsics 2016), published in the right-wing newspaper *El Español*. In the comments section, a reader declared, "It sounds to me that her way of self-presentation does nothing but objectify women. . . . She continues to present herself as a `sexual icon.' While sexualizing every inch of our female body, sexy clothing, will not be a viable way to fight machismo" (Plataforma Anti Patriarcado 2016).

Meanwhile, in a *Pikara Magazine* article, María Luisa Latorre doubted Beyoncé's ability to become an empowering feminist icon: "I do not know exactly how a singer will empower women if she represents the patriarchal beauty standards, when she makes sexualized videos" (Latorre 2014). These ideas are the product of a white ignorance that intersects with racist representations of Black womanhood in Spain. How could a Black woman represent beauty ideals when the standards are based on whiteness within our racist society? More than a denouncement of unfair beauty standards, these ideas represent a lack of reflection on the racism behind both race and beauty. Also, it is a traditional patriarchal mechanism to view and to analyze women—celebrities in particular—in terms of their bodies: pretty, ugly, too fat or too slim, too Black, too masculine, too old, too bitchy, too naive. In prioritizing superficial body characteristics, more serious estimations about an artist's ideas or actions are avoided.

In 2014, the Spanish newspaper *El Pais*, founded as a left-wing publication but eventually turned more conservative, published an article, "Is Beyoncé Feminist?" penned by María Angelés Cabré, who had founded the Cultural Observatory of Gender in 2013 (2014). Most striking, Cabré concludes by referring to Beyoncé's body performance: "Is it complacent or subversive to claim the body and sexuality? . . . Can a cleavage be ironic? Those of us who believe in seduction as art think so, although we prefer by far the subtle sensuality of a Juliette Binoche or the British elegance of a Tilda Swinton to Queen Bey's vulgar hip game" (Cabré 2014).

Akeia A. F. Benard argues that "the body is an appropriate cultural symbol to explore the links between colonialism and patriarchal capitalism" (Benard 2016, 2). Why is Beyoncé's body read in terms of vulgarity? Is it not a reformulation of

racist visions about racialized bodies, appealing to particularly hegemonic and colonial aesthetic tastes? The seduction that Juliette Binoche can offer relates especially to her particular class, race, and culture, whose intersections privilege certain forms of sex and erotica while deeming others as pornographic or vulgar. Is Beyoncé guilty of having hips, and how do we determine if a hip game is vulgar or seductive? If we understand white ignorance and *whiteness* "as a political construct rather than simply an ethnic category . . . a cognitive model" (Alcoff 2007, 49), are these ideas not ultimately the bourgeois class ideals of a white European culture? Are they not related to specifically white forms of upholding and judging women characters and celebrities?

In the comments section of Cabré's article, a reader posted: "Beyoncé, no matter how good her intentions are, objectifies women because she turns them into just bodies more than minds, just attractive and beautiful bodies. The message is: success lies in being a bombshell . . . the referents for girls today are women that exploit their bodies. . . . I do not think this is a good way to reinforce female roles. For this I cannot share the idea that Beyoncé is feminist."

Unfortunately, it is difficult to find counterdebates within Spanish academic scholarship that highlight Beyoncé as an African American woman; relate her work with racial representations of Black women in the music industry, from Josephine Baker to current hip-hop feminism perspectives; or contextualize her in relation to the broader US historical tradition in which Black women are represented in racist, hypersexual ways. Because the Spanish analysis mostly overlooks this background, interpretations tend to focus solely on Beyoncé's sexual performances as being "without value beyond male titillation" (Winfrey 2013) and conclude that her feminist message is contradictory. Also, as Robin James pointed out in her contributions to the recent *Lemonade Reader*, with the divorce between the musical elements from the visual work on *Lemonade*, the Spanish analyses reinforce the invisibility of Black female narratives interspersed within the album, positioning criticism toward limited sections of the piece, avoiding others where Black cultural theory is necessary (James 2019, 72–74).

A special case in this regard is Afroféminas (Afrowomen), a Spanish website centered around these issues with an antiracist perspective, founded by Afro feminist activist Antoinette Torres Soler.[5] Mariana Olisa, an Afro feminist activist and cofounder of Black Barcelona, an Afro collective born in Catalonia, published an article on Afroféminas in 2014 about Beyoncé's song, "Single Ladies (Put a Ring on It)." Most Spanish feminists understood the song in the context of white norms, as if Beyoncé were simply talking about getting married. However, Olisa's

analysis focused on a Black feminist reading, exploring especially the "loneliness of the Black woman" in, for example, the marriage and dating market. The hypersexualization of Black womanhood reinforces the idea of the Black woman as a lover but not as a formal partner (Olisa 2016). The white feminist reading focused on the conservative feature behind the idea of marriage, whereas the Black feminist reading understood the personal experiences of Black women in terms of access to marriage and partnerships in a racist system that sees them too frequently as just the other woman.

In 2016, an article about Beyoncé's work published by Afroféminas elicited a discussion about race-based and women's issues (Herrera Quintana 2016a.) The debate focused on her body modifications, including skin treatments, hair coloring, and hair weaves. Some commenters considered these controversial practices to be a means of control over the Black female body, blaming the subjects rather than condemning the broader racist and sexist system. Others saw them as a kind of racial rejection in Beyoncé's bodily performance, such as this comment: "It seems hypocritical for her to talk about her black pride . . . then why does she lighten her skin, why does she straighten her hair, even go blond, and also, she had nose surgery to have it made longer. . . . If she really wants to help end racism in the United States she should stop manipulating the beauty standards and be an example" (Afroféminas 2016).

In the same thread, another person answered: "Well now, as it turns out, to feel Black you have to wear your Afro," criticizing the link between hair and Black identity. Another wrote: "She, like most women in the public eye in the United States, is under incredible pressure to correspond to a more European version of themselves" (Afroféminas 2016). In this statement, Europe is understood as a white society, reducing and simplifying the multiethnic diversity of the population to one ethnic group when this is not the reality of the European population.

In the unsigned article, "Las contradicciones de Beyoncé en la Superbowl" ("The Contradictions of Beyoncé at the Super Bowl") published in the Spanish left-wing national newspaper *El Diario* following Beyoncé's Black Panther tribute at the 2016 Super Bowl halftime show, the title already implied a perceived "inauthenticity" in Beyoncé's work (2016). Birgitta J. Johnson points out the traditional treatment of Black female pop stars as "robots" in a totally controlled industry, where they lack any agency; to the contrary, male singers, Black or white, are considered "disciplined geniuses" (Johnson 2019, 239). The content of *El Diario*'s article is full of references to her corporal modifications more than to her political discourses, focusing attention on her body more than her words.

One commenter wrote, "Why does the black girl play white? There is nothing more shameful than rejecting her own condition. A monkey in silk is a monkey nonetheless" (comments section, *El Diario cultura* 2016). The accusation of racial rejection by Beyoncé is part of historically entrenched racism; by using the reference to a monkey, these words draw directly on racist biological narratives of slavery and colonialism.

Kaila Story explains, "The idea of blackness as a color was already outlined within Christianity and symbolized inherent evilness, libidinousness and disgrace. It was in this context that Africans were compared to apes—with the same animalistic childishness, savageness, bestiality, sexuality and lack of intellectual capacity. . . . Female bodies were regarded with similar types of measurement" (Story 2010, 27). Thus, the ape references associated with Black people have a long history in the racist imaginary as a dehumanizing mechanism (Atiba Goff et al. 2008), including in the Spanish and European context. We can see this metaphor alive in European soccer game contexts; there are several cases in which Black soccer players, such as the Afro Italian player Mario Balotelli, were harassed, called a "monkey," or were tossed bananas from the stands. It is therefore not by chance that the use of the "Negro-ape metaphor" (Atiba Goff et al. 2008, 292) appears even in left-wing commentary and in the reception of Beyoncé: it reanimates the oldest and most explicit form of racism.

The anonymous author of "The Contradictions of Beyoncé at the Super Bowl" reduces Beyoncé to superficial visual racial typologies: "White, black, dyed blonde" (*El Diario cultura,* 2016). "White" refers to the practice of skin lightening, while "dyed blonde" refers to Beyoncé's unusual blonde hair, as if a Black person cannot have or use blonde hair. In Hazel Carby's words, it seems as if Beyoncé's physical changes are viewed in terms of some "moral panic" by part of the audience: "as a social and political problem, a problem that had to be rectified in order to restore a moral social order" (Carby 1992, 739–40). In the white ignorance cognitive model, there is little space for multiple ways of being Black; Blackness is shaped with a limited number of representations. In this example, Black people are not blonde, so if they are blonde (whether dyed or natural), they are assumed to be inauthentic. Paradoxically, when a white pop star changes her hair color, there is no racial meaning attached to it; it is understood as an aesthetic matter, an issue of the pop industry. White ignorance forgets and disavows the violent and oppressive history conditioning Black racial categories, as well as the range of laws and attempts to regulate and police Black bodies.

THE RECEPTION OF BEYONCÉ'S FEMINIST ACTIVISM
WITHIN SPANISH ACADEMIC RESEARCH

In 2017, *Investigaciones Feministas* (*Feminist Research*), a scholarly feminist publication from Complutense University of Madrid, published an article centered on Beyoncé: "El feminismo como producto mediático: la paradoja Beyoncé" ("Feminism as a Media Product: The Beyoncé Paradox"; Fernández Hernández 2018). In this publication, the Anglo American context seems to predominate because Beyoncé is indissolubly linked with the "postfeminist sensibility" (Gill 2007) or the new "postfeminist neoliberal mystique" (Martínez 2017). In a recent article, Fernández argued, "In this frame, Beyoncé not only performs the postfeminist agenda in global media but also the postracial agenda, confirming capitalist privilege, the achievement of the American dream, which erases any particularism related to race" (Fernández Hernández 2018, 467). I think it is impossible to support this affirmation after *Lemonade*, where we found an explicit attempt to oppose claims of a supposed postracial society through references to existing forms of racism. If we understand Beyoncé's full antiracist message and conversation, such as references to Malcolm X's speech about the status of Black women, the institutional police answer to her supposedly antipolice message in her videos, the presence of the Black Lives Matter's mothers, and the #StopShootingUs issue, it is difficult to conclude that there is any presence of postracial agenda in her work. It may not be the most radical message, but in the context of pop music, its mere inclusion is a radical departure from the aesthetics of popular music performances where performers are expected to sing, dance, and entertain without conveying a political message.

Fernández, referring to Gill's ideas on postfeminism, points out: "The feminist performance which seems embodied by Beyoncé, fits in this media postfeminism. . . . This postfeminism erases political issues related with the distribution of power, simulating a certain illusion of equality, as it does an identical operation with the race and class factors" (Fernández Hernández 2018, 467). However, it seems problematic to reduce Beyoncé to her social class and understand her message just in terms of a "rich bitch" model, forgetting her activism, which highlights particular forms of Afro American discrimination. Indeed, Beyoncé in *Lemonade* is arguably claiming a form of solidarity as a Black woman, engaging with this subaltern position.

Nonetheless, Fernández also recognizes how Beyoncé's audiovisual performances have had a positive impact, inspiring Spanish celebrities to take feminist

positions (Fernández Hernández 2018, 468–69). For example, in 2015, the actress Inma Cuesta denounced *El País* for retouching her body in postproduction, making it appear "more slim" (*El País* 2015). Michelle Jenner, also an actress, published a critique in her Instagram account about the oppressive weight of modern beauty standards (*El País*, 2016). Ylenia, a reality TV celebrity known for her appearances in *Gandia Shore,* the Spanish version of *Jersey Shore* (which is usually discredited as being too "chav" or too "ratchet,"[6]) initiated a conversation about feminist authenticity when she started to republish feminist quotes in her Twitter account (Serrano, 2017). According to Fernández, these celebrities' actions found an opening into the dominant order for modest subversive acts, and they stimulated new conversations in fields far removed from popular culture: "The conversation initiated by a celebrity in mass media continues in other spaces online where the interactions, by pure accumulation, can leave the frames proposed in the first instance" (Fernández Hernández 2018, 468–69).

A similar critique of Beyoncé as an epitome of "neoliberal postfeminism" can be found in an article by Spanish scholars Laura Martínez Jiménez, Lina Gálvez Muñoz, and Ángela Solano Caballero (2018), published in the North American *Journal of Popular Culture.* In the article, "Neoliberalism Goes Pop and Purple: Postfeminist Empowerment from Beyoncé to Mad Max," the authors discuss the "new mystique of neoliberal postfeminist," which they define as "the proclamation of a fake and perverse equality that connects women to the standard of neoliberal masculinity, while at the same time glamorizing a sexualized and liberating neo-traditionalism" (402). In this logic, Beyoncé represents a sort of new meritocracy: a sexualized neoliberal female empowerment product.

The authors recognize the racist ways in which Black women are represented in popular culture as hypersexualized subjects, and they note that for that reason, Black women "are traditionally expected to assume attitudes and identities that are deeply marked by modesty, chastity, and self-control and that will guarantee not only their public respectability but also their safety as a resistance strategy against racist abuse and disciplining" (Martínez Jiménez et al. 2018, 407). For the authors, taking into account these historic representations and expectations could explain Beyoncé's posfeminist success as "convenient, enjoyable, and empowering—though in ambivalent terms—for a multitude of young Black women" (407).

Understanding the history of Black women's representations enables an alternative and more nuanced reading of women's hypersexualized bodies. It is only by keeping the history of representations in mind that we can fully under-

stand Beyoncé's work. If these expectations about the displays of sexuality of Black women are linked so tightly to "respectability politics" (Higginbotham 1992; Collins 2004; Kehrer 2017), it is easy to understand the liberating effect for young Black women (as well as for others). As Sarah Jackson asserts, "The idea that Beyoncé being sexy is only her performing for male viewers assumes that embracing sexuality isn't also for women" (Jackson 2013). In her article on twerking and YouTube videos, Kyra D. Gaunt adopts Dan Miller's concept of "auto-sexuality" as a form of erotic display—and a mostly feminine one, where one isn't necessarily seeking the attention of a male gaze or male interactions or necessarily participating in lesbianism (Gaunt 2015, 249). Maybe we could explore this concept of auto-sexuality rather than just viewing sexualized performances as acts of satisfying a heterosexual male audience.

Another dimension of this debate is rooted in the common objectification of bodies in the representational ecosystem. Usually the reference is white, thin, and able-bodied, and the analysis provided is extended to other bodies. But some bodies are not represented in media culture at all. One can think of the fat bodies and the traditional representations of them from the mid-twentieth century in media culture: often invisible, sick bodies, nondesiring and undesirable bodies. Fat bodies are read "as a site of moral and physical decay" (Murray 2005). To sexualize these types of bodies, then, such as showing them in a positive sexual light, elicits a different meaning and offers a political potential that we should not underestimate. In the same way, sexualizing functionally diverse bodies could be a political mechanism to fight against hegemonic sexual forms of exclusion, as the Spanish documentary *Yes, We Fuck* reveals (Centeno and de la Morena 2015). We must be careful not to extend the analysis of certain bodies or cultural products to the whole representational reality, avoiding reductionist approaches.

Referring to the postfeminist question, Fernández asserts, "The postfeminist formulations in mass media always seem addressed to the same privileged white woman, just subaltern by her own decision" (Fernández Hernández, 2018, 467). We cannot fall into the mistake of simplifying the diversity of subjectivities behind the category "privileged white woman." However, the problem may not be in the object of the postfeminist formulations but the fact that the readings are always done by the same "privileged white woman" perspective, which works to privilege this specific class and ethnic narrative, overlooking the possibility of readings from other, subaltern positions.

The readings that reinforce only the neoliberal aspects of Beyoncé's work, then, often simplify and underestimate the importance of her racial identity

and political references, as a reading—once again—from a perspective of white ignorance. The importance of being and being perceived as a Black woman is at the core of Beyoncé's two visual albums, *Beyoncé* and *Lemonade*. Therefore, it is necessary that a real intersectional feminism is engaged with in order to fully understand the multiple experiences explored in these albums. It is possible to recognize the neoliberal features of Beyoncé's work without underestimating the racial discussion initiated by her work. Feminist cultural researchers have to avoid reading Beyoncé's work as another pop music product, keeping in mind that her Black body has meanings rooted in slavery and in the successive representations of Black female bodies since then within the culture industry. As Johnson asserts, Beyoncé has served real *Lemonade*, not an "artificially flavored Tang" (Johnson 2019, 235).

CONCLUSION

To understand Beyoncé's work, it is necessary to take into account every dimension of her audiovisual output as well as the broader reception of this product. If we omit the racial and racist history behind the representation of Black women's bodies next to the everyday forms of exclusion and racism that they are forced to confront, it is impossible to recognize the full significance of Beyoncé's discursive and performative politics. To be a Black or Afro woman in Spain's contemporary society means much more than making reference to a few stereotypes perceived within Beyoncé's work, which more often pigeonhole all Black women. One of Beyoncé's main points is to reveal the multiple dimensions of being a Black woman at the present moment. Her performances have actively altered the representational narratives of beauty, breaking the racist idea that beauty is synonymous with white.

The first time that political institutions, such as the Spanish Parliament and Assembly of Madrid, publicly condemned racism was in 1992, with the murder of Lucrecia Perez (Toasije 2010). Spain's past as a colonial country demands the difficult task of working to better understand the diversity of Spanish race and ethnicity, recognizing structural racism, and examining mediated representations of racial identity. We live in an era where such epistemologies of ignorance are actively reproduced. Spain has to conduct a reparations process that involves the recognition of our colonial and slaveholding past. In the Spanish context, some of the race-based performance aesthetic and critiques of white beauty ideals in Beyoncé's work are missed or not understood in their full complexity because

of the invisibility and active inattention of the race/ethnicity experience and of pervasive racism.

A modern intersectional feminism in Spain, as elsewhere, has to fully account for the intersections of race, class, and sexuality in a forward-looking and rigorous manner, not just as a way to look cool or modern on some occasions. We also have to develop new ways to confront music and popular culture. Beyoncé represents a strategic location for cultural studies, comprising several contemporary debates about gender, race, and capitalism, and we must not miss the chance to put these issues on the table. As Angela McRobbie pointed out in "Postmodernism and Popular Culture," "Glamour, glitter and gloss should not so easily be relegated to the insistently apolitical" (McRobbie 2005, 19).

NOTES

1. Afro Consciousness, or the space formerly known as Afro Consciousness/Consciousness Afro. In Spain, the term *Afroconciencia* (Afro Consciousness) is copyrighted. The antiracist political collective Afroconciencia/Conciencia Afro received a legal complaint accusing it of misappropriating a commercial brand (Afroconciencia & afroportunidades S.L) and requiring it to change its name. Now the group normally uses "The space formerly known as Afro Consciousness" or "Consciousness Afro." In a press note, the group declared their sadness and rage about this situation and "with this colonial logics and control from the Spanish state."

2. Inratzú Varela said the word *payablanca,* which refers to white feminist women. *Paya* is the name that Roma people use to refer white people; *paya* is feminine, and *payo* is masculine. *Payablanca* means not Roma and not Black. I choose to use the phrase "little white," referring to "hidden white privilege."

3. This was on Alba Pez's personal Facebook site, @AlbaPez, on January 26, 2018.

4. In Spanish, the letter X is used to mean gender-inclusive language.

5. This site is essentially the only website covering these topics, although there is also EFAE (Empoderamiento Femenino Afrodescendiente en España [Afrodescent Feminine Empowerment in Spain]), a blog that has exhibited little online presence in the past year.

6. As Owen Jones (2011) explains in "The Demonization of the Working Class," *chav* is the derogatory term usually employed to refer to members of the working class. According to the analysis of Heidi Lewis (2013) and the Crunk Feminist Collective (2012), *ratchet* is a term used especially against black women "to describe women that are unintelligent, loud, classless, tacky, and hypersexual, among other things" (Lewis 2013). In Spain the term *choni* is often used in a similar vein, especially against white women.

REFERENCES

Afroféminas. 2016. Facebook, February 11 [post taken down].

Alcoff, Linda Martin. 2007. "Epistemologies of Ignorance, Three Types." In *Race and Epistemologies of Ignorance*, edited by Shannon Sullivan and Nancy Tuana, 39–57. Albany: State University of New York Press.

Atiba Goff, Phillip, Jennifer L. Eberhardt, Melissa J. Williams, and Matthew Christian Jackson. 2008. "Not Yet Human: Implicit Knowledge, Historical Dehumanization, and Contemporary Consequences." *Journal of Personality and Social Psychology* 94, no. 2: 292–306.

Barbolla Mate, Domitila. 2013. "La esclavitud negroafricana en España: una historia silenciada." *Africa Fundación.*

Bela-Lobedde, Desirée (@desiree_bela). 2018. Twitter, January 26.

Benard, Akeia A. F. 2016. "Colonizing Black Female Bodies within Patriarchal Capitalism: Feminist and Human Rights Perspectives." *Sexualization, Media, and Society* 2, no. 4: 1–11.

Bonilla-Silva, Eduardo. 2006. *Racism without Racists: Color-Blind Racism and the Persistence of Racial Inequality in America.* Lanham, MD: Rowman & Littlefield.

Cabré, María Ángeles. 2014 "¿Es feminista Beyoncé?" *El País*, September 1.

Carby, Hazel. 1992. "Policing the Black Woman's Body in an Urban Context." *Critical Inquiry* 18, no. 4: 738–55.

Centeno, Antonio and Raúl de la Morena, dir. 2015. *Yes, We Fuck!* Independent film.

Collins, Patricia Hill. 2004. *Black Sexual Politics: African Americans, Gender and New Racism.* New York: Routledge.

Crunk Feminist Collective. 2012. "(Un)Clutching My Mother's Pearls, or Ratchetness and the Residue of Respectability." Crunk Feminist Collective, December, 31. http://www.crunkfeministcollective.com/2012/12/31/unclutching-my-mothers-pearls-or-ratchetness-and-the-residue-of-respectability/.

El Diario cultura. 2016. "Las contradicciones de Beyoncé en la Superbowl." *El Diario cultura*, February 8.

El País 2015."Inma Cuesta denuncia los retoques de Photoshop en una de sus fotos." *El País*, October 14.

———. 2016. "Michelle Jenner critica la idea de la mujer perfecta." *El País*, January 27.

Eddo-Lodge, Reni. 2017. *Why I'm No Longer Talking to White People about Race.* London: Bloomsbury, 2017.

Fernández Durán, Reyes. 2011. "La Corona Española y el tráfico de negros: Del monopolio al libre comercio." *Ecobook*, Madrid, 2011.

———. 2012. "Un libro sobre lo que nunca se ha hablado antes en España." Interview with Casa America, Madrid, March 7.

Fernández Hernández Z, Lola. 2018. "El feminismo como producto mediático: la paradoja Beyoncé." *Revista de Investigaciones Feministas* 8, no. 2: 457–74.

Fleming, Crystal Marie. 2017. *Resurrecting Slavery: Racial Legacies and White Supremacy in France*. Philadelphia: Temple University Press.

———. 2018. *How to Be Less Stupid about Race: On Racism, White Supremacy and the Racial Divide*. Boston: Beacon Press.

García Barranco, Margarita, and Aurelia Martín Casares. 2010. "La esclavitud negroafricana en la historia de España—Siglos XVI y XVII." *Comares*, Granada.

Gaunt, Kyra D. 2015. "YouTube, Twerking and You: Context Collapse and the Handheld Co-Presence of Black Girls and Miley Cyrus." *Journal of Popular Music Studies* 27, no. 3: 244–73.

Gerehou, Moha (@mohagerehou). 2012. "Qué puede hacer un partido político para ser antirracista" *El Diario*, July 26.

——— . 2017. Twitter, June 6.

Gill, Rosalind. 2007. "Postfeminist Media Culture: Elements of a Sensibility." *European Journal of Cultural Studies* 10, no. 2: 147–66.

Herrera Quintana, Elena. 2016a. "Black Panther Beyoncé." *Afroféminas*, February 11.

———. 2016b. "¿Qué lleva la limonada de Beyoncé?" *Afroféminas*, April 28.

Higginbotham, Evelyn Brooks. 1992. "African-American Women's History and the Meta-language of Race." *Signs* 17, no. 2: 251–74.

James, Robin. 2019. "Interlude C: How Not to Listen to Lemonade: Music Criticism and Epistemic Violence." In *The Lemonade Reader*, edited by Kinitra D. Brooks and Kameelah L. Martin, 69–76. New York: Routledge.

Johnson, Birgitta J. 2019. "She Gave You Lemonade, Stop Trying to Say It's Tang. Calling Out How Race-Gender Bias Obscures Black Women's Achievements in Pop Music." In *The Lemonade Reader*, edited by Kinitra D. Brooks y Kameelah L. Martin, 234–45. New York: Routledge.

Kehrer, Lauron. 2017. "Beyond Beyoncé: Intersections of Race, Gender, and Sexuality in Contemporary American Hip-Hop." PhD diss., University of Rochester.

Kovacsics, Violeta. 2016. "Beyoncé acaba con el machismo en dos horas." *El Español*, August 4.

LaTorre, María Luisa. 2014. "¿Es Beyoncé feminista?" *Pikara Magazine*, February 3.

Lewis, Heidi R. 2013. "Exhuming the Ratchet before It's Buried" *Feminist Wire*, January 7.

Martínez Jiménez, Laura. 2017. "Women Are Strong as Hell! Empowerment and Micro-Sexism in Post-Crisis Popular Culture of Neoliberal." In *La desigualdad de género invisibilizada en la comunicación. Aportaciones al III Congreso Internacional de Comunicación y Género y al I Congreso Internacional de Micromachismos en la Comunicación*, edited by Luis Alfonso Guadarrama, Jannet Valero, Paola Panarese, and Juan Carlos Suárez, 652–56. Madrid: Dykinson.

Martínez Jiménez, Laura, Lina Gálvez Muñoz, and Ángela Solano Caballero. 2018. "Neo-liberalism Goes Pop and Purple: Postfeminist Empowerment from Beyoncé to Mad Max." *Journal of Popular Culture* 51, no. 2: 399–420.

McRobbie, Angela. 2005. *Postmodernism and Popular Culture*. New York: Routledge.

Mills, Charles W. 2007. "White Ignorance." In *Race and Epistemologies of Ignorance*, edited by Shannon Sullivan and Nancy Tuana, 13–38. Albany: State University of New York Press.

Mohorte. 2017. "NegraFlor: cuando un debate sobre las buenas prácticas del activismo torna en acoso en Twitter." *Magnet*, June 7.

Murray, Samantha. 2005. "Doing Politics or Selling Out? Living the Fat." *Women's Studies* 34, no. 3/4: 265–77.

Olisa, Mariana. 2016. "La solitud de la mujer negra." *Afroféminas*, July 4.

Ortega, Esther (Mayoko) 2018. Twitter, January 26.

———. 2018. "Prácticas Feministas Decoloniales." Instituto de Migraciones of Granada University, March 5.

Owen, Jones. 2011. *Chavs: The Demonization of the Working Class*. London: Verso

Piqueras, José Antonio. *La esclavitud en las Españas. Un lazo transatlántico*. Madrid: Catarata, 2017.

Plataforma Anti Patriarcado. 2016. Facebook, August 6.

Ruiz, Patricia, and Gabriela Sánchez. "Claves para entender la realidad de los CIE en España." *El Diario*, October 16.

Sánchez, Gabriela. 2020. "Recopilar datos oficiales étnico-raciales para medir el racismo: un debate estancado en España que gana fuerza en Europa." *El Diario*, June 29.

Serra, Clara. 2018. Facebook, January 26.

Serrano, Beatríz. "Todo lo que te molesta de que Ylenia sea feminista es todo lo que está haciendo bien." *BuzzFeed*, May 25.

Shank, Michael, and Maxine Bedat. 2016. "How Beyoncé's 'Ivy Park' Label Should Solve Sweatshop Scandal: Switch Suppliers." *Huffington Post*, May 25.

Story, Kaila Adia. 2010. "Racing Sex—Sexing Race: The Invention of the Black Feminine Body." In *Imagining the Black Female Body: Reconciling Image in Print and Visual Culture*, edited by Carol E. Henderson, 23–43. New York: Palgrave Macmillan.

Toasijé, Antumi. 2009. "The Africanity of Spain: Identity and Problematization." *Journal of Black Studies* 39, no. 3: 348–55.

———. 2010. "La memoria y el reconocimiento de la comunidad africana y africano-descendiente negra: en España: El papel de la vanguardia panafricanista." *Nómadas. Critical Journal of Social and Juridical Sciences* 28, no. 4. https://www.redalyc.org/pdf/181/18118913014.pdf.

Varela, Irantzu (@IrantzuVarela). 2018. Twitter, January 26.

Víseda, Henar. 2017. "El Caso NegraFlor: La afrofeminista a la que el acoso le llevó a renunciar al activismo." *Notodo*, June 20.

Winfrey Harris, Tamara. 2013. "All Hail the Queen? What Do Our Perceptions of Beyoncé's Feminism Say about Us?" *Bitch Magazine*, May 20.

Zas Marcos, Mónica. 2016. "Dejemos de criticar a Beyoncé por su activismo." *El Diario*, August 29.

"Hold Up"
Performing Femme Affinity and Dissent

A crucial theme running through this book is that the performative is political. In Part 5, Jared Mackley-Crump and Kirsten Zemke examine the politics of Beyoncé tribute performances by trans women of color, while Byron Craig and Stephen Rahko address the politics of one of the most-watched performances ever: Beyoncé's performance of "Formation" at Super Bowl 50 in 2016. Mackley-Crump and Zemke explore in Chapter 9 how some trans femmes of color have responded to *Lemonade*. While they acknowledge the ways in which Beyoncé has been criticized for appropriating queer and trans subcultural expression without always giving credit or political support in return, they also attend closely to the words and performative responses of trans women of color in two case studies. First, they offer fresh insights into the much-discussed debate among bell hooks, Laverne Cox, and Janet Mock by centering the voices of the trans women in the conversation. They then examine a *Lemonade* tribute by the Glass Wing Collective featuring Michell'e Michaels, which claims connection to Beyoncé, her "Fierce Queen Diva Femme" persona, and a fairy-tale fantasy that challenges those who would distinguish between cis and trans women. Craig and Rahko take on another contentious issue in Chapter 10: the charge that Beyoncé has appropriated the style of Black resistance from both the Black Lives Matter movement, as well as the Black Panthers. Drawing on theories of celebrity and branding, along with an analysis of the "Formation" video and Beyoncé's Super Bowl 50 performance, Craig and Rahko argue for a more pre-

cise understanding of what Beyoncé is doing. She is not resistant (they reserve that category for explicit political protest), but neither is she compliant: she is engaging in celebrity dissent and drawing on the tradition of protest pop—actions that contribute in important ways to challenging structural inequality and contemporary white supremacy.

JARED MACKLEY-CRUMP AND KIRSTEN ZEMKE

9. Six-Inch Heels and Queer Black Femmes
Beyoncé and Black Trans Women

In this chapter, we explore the concept of femme in relation to Beyoncé's performance of gender, sexuality, and race in *Lemonade* as a gender muse for trans women of color. In *Lemonade*, Beyoncé's particular femme performance is grounded in African American history, resists white patriarchal norms, and was developed in dialogue between Black women and queer folks of color. Femme is an empowering gender aesthetic illustrated by tropes of diva and queen, and emerging from struggle is fierce, a quality derived from the survival techniques and artistry of the Black queer femme community. *Lemonade*'s queer resonances and Beyoncé's pro-Black feminism are empowering for femmes of color regardless of biology, and this includes trans women, drag queens, femme lesbians, and sissy boys. Beyoncé's sexualized femme performance has brought her power in a racist society, which then bolsters and empowers those who identify as femme, subverting heteronormative hierarchies.

The diva, the queen, and fierceness inform our exploration of Beyoncé's hyper-femme presentation in *Lemonade*, which, centering on a Black female experience, offers strategies of resilience and power for Black femme trans women. Bey's fierce queen diva persona is a reworking of racist tropes, able to affirm feminist politics while presenting as hyper-femme. We focus on activist/author Janet Mock and activist/actor Laverne Cox, who have spoken about their visceral responses to Beyoncé's presentation as strong, Black, and femme. Their adoration of Beyoncé provides a counter-discourse to the feminist problematics of Beyoncé highlighted by bell hooks. We examine an eleven-minute visual reaction to *Lemonade* by the Glass Wing Group collective, where the central performer negotiates her own intersections of gender, feminism, and Black femininities via Beyoncé.

This fan-generated video offers a trans lens of the Black femme as presented by Beyoncé. For these subjects, the adoption of an empowering femme identity is a survival tactic, the promise of a fairy-tale ending, from trauma, to hope, to resilience—one of the dominant themes of *Lemonade*. Survival in Beyoncé's case can be tainted by entanglement in market capitalism, as well as accusations of queer appropriation, which are addressed as caveats. However, the Black trans femme voices offered here welcome Beyoncé's marketable and visible celebration of the Black femme; for them, it reconciles the problematics of race, sexuality, gender, and politics often attached to femme presentations.

THE QUEEN DIVA

Beyoncé revisits and provides reversions of historical Black femininities, which have long been subject to racist tropes rooted in history and slavery. The Jezebel, the Sapphire, and the "Black superwoman" are particularly relevant to Beyoncé, women in hip-hop, and femme-presenting drag queens and queers. The nod to queer bounce artists on "Formation" opens a space for the discussion of the diva, the queen, and the shape-shifting "Queen B(?)" (Horton-Stallings 2007) as femme tropes with queer resonances that Beyoncé wears with ferocity. Beyoncé both becomes and begets these tropes, entrenching her position as an integral broker in the mutual conversation and creativity between the Black straight femme community and Black femme queers.

The Jezebel trope centers on Black women as seductive, cunning, and exotic temptresses who use sex to manipulate men (Ladson-Billings 2009). The legacy of this Jezebel presents a quandary for Black musicians who want to emphasize and celebrate their sexuality, especially as it raises the debate as to whether Beyoncé and her contemporaries are asserting sexual agency or reifying racist stereotypes. Another racist trope is the Sapphire, the angry Black woman, derived from the notion that Black women did not satisfy patriarchal expectations of docility and fragility (West 2012). Originating in the minstrelsy-derived *Amos 'n' Andy* radio and television series of the 1940s and 1950s, she is a loud, nagging, hostile woman who takes pleasure in emasculating men (West 2012). Another cast for Black women is the Black superwoman.

These tropes lurk within pop culture consciousness to the degree that African American women (and queers) continually feel the specter of such stereotypes and twist and transgress them to craft Black femme performances. Much of *Lemonade* is an angry response to the marital infidelity of Beyoncé's husband,

but she translates this into a rich exploration of creativity, including a parallel metaphor of anger at white racism in America. Indeed, the whole framework of *Lemonade*, the survival and resilience of the Black woman, is an example of the Black superwoman, where a famous Black woman's life narrative reinforces the fictional images of Black women who have the infinite capacity to get past formidable obstacles. This takes on special significance when considering our trans subjects' use of femme identities as a literal survival mechanism.

By including two queer Black femme voices on *Lemonade*, Beyoncé allies with the New Orleans queer community and embraces it as an integral part of the city's identity:

> "What happened at the New Wildins? [New Orleans]. . . . Bitch, I'm back. By popular demand." (Messy Mya)
> "I did not come to play with you hoes, I came to slay, bitch." (Big Freedia)

The opening lines of "Formation" come from Messy Mya and are lifted from Messy's YouTube videos, "Booking the Hoes of New Wildings" and "A 27 Piece Huh" (Mya 2010a, 2010b). Messy was a distinctly New Orleans personality who twerked, rapped, and offered "shady" commentary. They had an unashamedly local accent combined with various hues of dyed hair, cheek piercings, and impertinent humor. Sources speculated about Messy's sexuality, and both *he* and *she* pronouns were applied. With Messy's connection to the bounce subculture, with rapping and twerking, as well as queer slang, gender-bending presentation, and popularity with the local gay community, their presence in "Formation" can be seen as an acknowledgment and celebration of intersectional empowerment. Messy Mya's inclusion is also a reminder of gun violence, as Mya was shot and killed in 2010, at age twenty-two.

The second New Orleans queer voice on "Formation" comes from bounce music star Big Freedia. Bounce is a type of vigorous Southern hip-hop that emerged in New Orleans in the late 1980s. While its earliest pioneers were not gay, the style was taken up in some gay clubs, and queer rappers began to perform and create tracks in this style. Due to its queer connections, bounce was at one time called "sissy bounce." Big Freedia is one of the best known of the queer bounce artists, and her music bears the hallmarks of the genre: specific beats and samples, call and response, instructions to dance, and a frenetic energy. Like Mya, her presence in "Formation" can be read as an inclusion of Black Southern queerness. In her contribution, Freedia evokes both queerness (by employing Black drag

queen slang like *slay* and *bitch*) and the American South (by referencing food staples cornbread and collard greens). Freedia uses the words *queen* and *diva* to identify herself.

That Big Freedia self-identifies as "queen diva" is relevant here: *queen* is a term often applied to Beyoncé. With obvious connotations of royalty and status, the word also has queer and Black relevance. Leola A. Johnson shows how *queen* was applied to Aretha Franklin, as the queen of soul, and Bessie Smith, as empress of the blues. She argues that these women, who "reigned over popular culture," are the "aristocrats of the street" and defy the sexual and political conventions of white capitalist male supremacy (Johnson 2003, 154). In exploring rapper Queen Latifah, Johnson further suggests that adopting "queen" was connected not to European monarchies but to Afrocentricity; the term calls to African queens like Nefertiti and Numidia and celebrates African civilization and history.

LaMonda Horton-Stallings has further introduced the concept of the Queen B(?) (2007). She is the femme version of the masculine literary Black trickster figure and encompasses the predatory queen bee (who kills and eats her mate after copulation), the queen bitch (who steps outside constructs of respectable Western femininity), and the queen bulldagger (the butch lesbian). This shape-shifting figure—switching persona at will to suit her desired outcome—is a particularly Black femme gender performance that encompasses distinctly Black femininities. Horton-Stallings's Queen B(?) offers fluid possibilities for distinctively African American "female" genders and sexualities, femininities derived from African stories and literature (2007, 180). The Queen B(?) uses sexuality to obtain material and ideological needs, similar to Beyoncé's sexualized performance style that transgresses society's limitations and suppressions of female desires. The Queen B(?) plays with but also subverts prescribed racialized and gendered roles and tropes; she relies on and manipulates the threat of female sexual desire to her advantage. While some may see Beyoncé's hypersexual performances as reproducing women in popular culture as sexual objects for the male gaze, the Queen B(?) abrogates the binary canons that divide sexuality in terms of homosexual/heterosexual, good/evil, sacred/profane: "The Queen B(?) folk myth presents female omnipotence through sexual desire, sexual freedom and independence, and violence carried out by deception and trickery" (Horton-Stallings 2007, 172). Queen Bee Beyoncé's hyper-femme, hyper-hetero, cis presentation is Black, wealthy, and proud, transgressing and mocking racist patriarchal prescriptions. Her insertion of Black and queer activisms and celebrations into mainstream white America is a subversive act. Her sexualized femme performance gives her

power in popular culture, which she uses to celebrate and inspire Black femmes of all shades.

Beyoncé and Freedia also play with the identity of diva, another term with relevance for gay and Black cultures. Linda Lister (2001) argues that the diva is rooted in the Western European opera tradition and portrays a woman of great talent and respect, beloved and deified by their fans. This trope experienced a revival in the 1990s, with the label applied predominantly to African American singers (e.g., Whitney Houston, Mary J. Blige). The diva, with her extreme talent, selfishness, and failures, has been empowering for gay men, who find a "uniquely queer strength" in fandom of divas and queens. Craig Jennex (2013), for example, found that for some gay men, diva fandom offered an element of identity and community. The diva's triumphs over personal adversity helped gay men cope with their own personal difficulties: coming out, family rejection, addiction (Draper 2017).

In addition to queen and diva, there is fierceness, a particularly Black queer aesthetic. The concept of fierceness is an important factor in understanding the salience of Beyoncé's hyper-femme persona for queers of color. *Fierce* is an example of words and characteristics that over time have moved from the Black female community into the Black drag community, wider gay community, and, finally, broader popular culture (Johnson 2004; Román 1993). Beyoncé's fierceness is both a refusal and an owning of the Sapphire trope. By naming her studio album *I Am . . . Sacha Fierce* (2008), Beyoncé articulated a fierce alter ego. She later "killed off" Sacha Fierce, stating that she was no longer necessary (Crosley 2010). The former teen pop star exploring fierceness through an alter ego was now ready to consume the fictive and emerge fully formed, a move perhaps fully realized in her powerfully symbolic and much-discussed "feminist" performance at the 2014 MTV Video Awards. Since then, she has employed fierceness to challenge a status quo interpretation of conventional female popstar sexuality; she is happy to marry her hyper-femme (hetero)sexuality with her own feminist politics and deny the existence of a paradox between the two. It is this femme-feminist intersection that, we argue, becomes important in understanding a trans reading of Beyoncé and of *Lemonade*, but it does not come without its caveats.

Beyoncé's co-optation of queerness has been critiqued by both the queer and academic communities. The inclusion of Messy Mya and Big Freedia on "Formation" has been criticized as superficial nods to queerness. Andreana Clay (2016) points out that both are visually absent and posits that the song's call to stand together and organize implies that a movement is yet to be established, thus

erasing the Black queer women already heavily involved with Black Lives Matter (2016). Shantrelle Lewis (2016) asserts that Messy Mya is decontextualized and dehumanized; there was no mention of their life, murder, or meaning for New Orleans. In this view, "Formation" becomes not advocacy but a co-optation of trauma—Black tragedy as a prop. The inclusion of Messy "disturb[s] the grave," using the "voice of a queer and deceased Black man" as marketing for her next world tour (Lewis 2016). Messy's presence is further convoluted by the fact that their sister is suing because Mya's voice was sampled without remuneration, with Beyoncé's management countering that they fall under fair use provisions (Cullins 2017). Lauren Kehrer offers a more favorable read, noting that while Beyoncé's queer co-optations are "unacknowledged," "uncompensated," and "complicated," their inclusion shows at least some diversity and representation (2019, 95).

The nods toward Southern Black queerness in "Formation" are not the first time that Beyoncé's mining of this particular heritage has resulted in controversy. Consider when Beyoncé incorporated J-setting, a dance style associated with Black Southern gay men who maintained the competitive aspects and line formations of its HBCU (historically Black colleges and universities) marching bands lineage but moved it into the club, into two of her music videos, "Single Ladies" (2008) and "Diva" (2008), and, in doing so, thrust the style into the mainstream. Lamont Loyd-Sims (2014) argues that J-setting is an alternative form of knowledge for a community of Black gay men who perform in a femme style. It is a vehicle of self-celebration, a strategy for survival against racism and hetero-centrism, and a safe space for men to embrace femininity and affirm themselves as feminine men. While Beyoncé's inclusion of J-setting may be seen as a nod to and acceptance of queer folk, Loyd-Sims is worried about the erasure of the dance's roots and the potential for loss of the culture's queer activism and transgressive articulations, especially in a hetero-monogamous song, "Single Ladies" (see Gaunt 2015).

The notion of appropriation leads to the most substantial critique: that of Beyoncé as commodity, conforming to and profiting from white capitalist agendas. Max S. Gordon (2017) presents a stinging critique of Beyoncé and Jay-Z, whom, he charges, are disconnected from and exploitative of the Black community and its legacy of struggle. He is perturbed by their lack of humility and billionaire status and Beyoncé's profiteering from representations of whiteness. Neither Beyoncé nor Jay-Z critiques capitalism; in fact, they operate in the opposite direction. Their Midas touch, like the original gold-transforming king, kills what it touches—in their case, the underground political Black artistes they co-opt in

their work. That the *Lemonade* project was used to promote Beyoncé's clothing line, Ivy Park, which was exposed for exploiting Sri Lankan female sweatshop workers (Mills 2016), is an apt illustration of this critique.

Janet Mock (2016), however, defends Beyoncé's capitalism as a necessary means of survival, a case of "girls getting their money straight," which even Beyoncé critic bell hooks herself implores Black women to do (hooks 2016). Similarly, Ann Werner (2001) has noted the ingenuity of African Americans having been able to recognize and market their specialized and highly desired cultural goods. With the many accounts of Black contributors to popular music dying penniless (Billie Holiday or Bessie Smith are examples), Beyoncé has converted the salience of her femme Blackness into capital, denting the white domination of the music industry. Trans-ness and queerness can also have commodifiable purchase in popular culture, which can open important spaces for trans and queer voices to be heard. The mere possibility of a so-called trans moment has been a vital impetus for trans women of color. The Black trans femme subjects explored here reflect on this dilemma as it relates to both Beyoncé and trans projects.

LAVERNE COX AND JANET MOCK: FIERCE, BLACK, FEMME, AND TRANS

It is against this understanding of Beyoncé's femme gender performance—her reappropriation and refusal of racist tropes, her fierce queen diva persona—that we situate our high-profile trans Black femme subjects and their responses to Beyoncé and *Lemonade*. That we are even able to discuss the influence of Beyoncé on high-profile trans personalities reflects one of the more profound recent cultural shifts: the so-called trans moment. Although it is nearly impossible to trace a (subjectively attributed) watershed moment, several significant examples have nonetheless coalesced around a concentrated period of time. These include high-profile public transitions, like Chaz Bono and Caitlyn Jenner; prominent representation in the media of trans people and characters, such as Laverne Cox in *Orange Is the New Black* and the films *Dallas Buyer's Club* and *Tangerine*; and politically, former Army-private-turned-Wikileaker Chelsea Manning, who came out as trans in 2013. President Obama also oversaw changes to federal employment discrimination legislation that added protections for trans people, and in 2015, he became the first US president to say the word *transgender* in a State of the Union address (Griggs 2015). Social media also provide trans people with platforms to mobilize and build communities. The hashtag, #transtakeover,

which went viral in 2016, is one example of trans people using social media as an act of collective defiance (Karlan 2016). There is also a spatial concentration at play, centered in the United States, but either way, the trans moment has started to attract scholarly attention (Jackson, Bailey, and Foucault Welles 2017; Lovelock 2017).

The words of actor/activist Laverne Cox and writer/activist Janet Mock as self-confessed Beyoncé fans provide a rich analytical field that illustrates the singer's position as an empowering symbol for trans women of color. Both women have spoken about their visceral responses to Beyoncé's presentation as a fierce, Black, hyper-femme diva and of the centering of the Black female experience in *Lemonade*.

Cox's relationship with Beyoncé dates to the emergence of Destiny's Child, which achieved commercial success as she began transitioning (Essence 2015). That Beyoncé is her idol is obvious. In 2016, for example, she transformed into Beyoncé's "Single Ladies" look for a *Cosmopolitan* magazine spread (Seemayer 2016). She also appeared on the TV show *Lip Sync Battle*, performing "Lose My Breath." The admiration has become somewhat mutual, with Beyoncé hiring Cox to model and appear in publicity material for her Ivy Park sportswear in 2017 (Moniuszko 2017). Most intriguing, Cox revealed that she was approached to appear in the *Lemonade* track "Sorry." Although not publicly confirmed by Beyoncé, Cox has spoken of it repeatedly (Harnick 2017), and it adds to the notion that elements of *Lemonade* were designed to contain specific queer referents.

Cox has made little substantive comment about *Lemonade*. After its premiere, she simply tweeted, "I was served lemons but I made #Lemonade. Just tears, so many tears." However, in talking about the development of her own feminist politics and gender identity, Beyoncé's influence is clear.

In 2014, Cox participated in a public dialogue with bell hooks that canvassed the intersection of feminism and femininity (New School 2014). It provides a fascinating demonstration of the tension between feminism that critiques stereotypical femininity as a function of the male gaze and feminism that seeks to be both feminist and reclaim feminine aesthetics. hooks asked Cox to explain her adoption of a stereotypical femme presentation, noting that for many feminists, an issue with trans women was the sense that a traditional femininity was being celebrated when a central tenet of feminism had been to move away from this very position. Cox asserted that while some of her presentation reflected her career in show business, "some of it is about what I find aesthetically pleasing for myself." She continued by noting, "I've gone through lots of phases where I've

had braids, and where I've been . . . very androgynous [but] this is where I feel empowered, ironically, and comfortable." While it would be easy to dismiss this as resulting from an acquiescence with a patriarchal conception of womanhood, her subsequent musings were particularly insightful:

> It is something that I wrestle with, having an understanding of your [hooks's] work and an understanding of patriarchy, am I feeding into the patriarchal gaze when I'm in my blonde wigs? . . . I think the really honest answer is that I've constructed myself in a way so that I don't, I don't want to disappear. . . . There is an erasure of certain bodies and certain identities, and I have not ever been interested in being invisible and being erased. So, a lot of how I am negotiating these systems of oppression, in trying not to be erased, is perhaps buying into some of these ideas of the patriarchal gaze of white supremacists.

At this point hooks interrupts:

> The desire to be seen and to be visible is a desire we have to recognize, and we have to continually critique the fact that Laverne Cox, Beyoncé . . . the long blonde, or near blonde locks, speak to a larger audience. I mean, would white people be following after Beyoncé if she was up there bouncing with her nappy locs, her short afro or what have you? We can't dismiss how certain representations allow us greater visibility.

Cox continued:

> I don't make these choices uncritically. . . . It's not like I'm blindly thinking that any of this is apolitical. In a white supremacy, in a patriarchal culture, it's all political and it's complicated. . . . But I don't think that this presentation makes me any less aligned with feminist politics, with anti-white supremacist politics, with wanting to create spaces of freedom. Because I love natural hair and I love underneath my lace wig I don't relax my hair, and I love my corn rows, and I'm learning to embrace and love this. It's just not something I choose to show the world (New School 2014).

This exchange highlights that Cox's femme presentation clearly provides both empowerment and aesthetic pleasure. Crucially, though, Cox is not uncritical. She recognizes that her femme presentation adheres somewhat to Western beauty

standards and that this has granted her a certain degree of social mobility and access. Her assertion that underneath the facade, she does not relax her hair, loves her cornrows, but chooses not to show them publicly, can be read in two ways. It can be said that Cox is acknowledging the price she pays for this access through a denial of her natural hair. However, in a similar way, the hijab, often positioned as patriarchically oppressive, can also be framed as liberating, allowing Muslim women control over their public and private self-presentations (Anderson Droogsma 2007). Cox strategically presents a public persona that allows her the access she needs to further her career and advocacy, while reserving her less constructed self for private spaces. Either way, while acknowledging this tension, Cox refuses to concede that her femme presentation does not create an unresolvable binary opposition to feminist and trans activist politics. Indeed, an added complication of personal safety comes into play, as she commented elsewhere: "Being able to walk down the street and not having strangers recognize you as trans is about survival. We become targets for violence. . . . It is revolutionary for any trans person to choose to be seen and visible in a world that tells us we should not exist" (Jones 2014)

In this sense, not only is Cox reckoning with the politics of identity but doing so in an environment where trans women, especially of color, often bear the brunt of transphobic violence. Here, appropriating stereotypical notions of feminine beauty in order to be "passable" takes on a graver meaning than conforming to a feminism that seeks to deny the patriarchal gaze, which can literally be deadly. Drawing strength from and emulating a Black woman who is defiantly fierce, femme, and commercially successful becomes a potent symbol of survival and of overcoming significant barriers to break new ground in trans visibility. By drawing on Beyoncé, Cox finds an equivalence in refusing to accept that selling a particular Black femininity does not preclude one from engaging in gender activism and race politics. Indeed, it is in emulating Beyoncé's fierce, Black femininity that Cox negotiates the tricky domains of visibility and erasure.

The apparent femme/feminist contradiction has long been discussed with regard to Beyoncé (e.g., Trier-Bieniek 2016) and, indeed, to many other female musicians who have traversed this tricky plane. hooks's widely disseminated 2014 claim who Beyoncé was a "terrorist" for her collusion with the perpetuation of unrealistic female beauty standards set off an ongoing, public disagreement with Janet Mock. Mock's position is similar to Cox's: a femme presentation does not negate advocating feminist politics. The debate was brought back into the public domain in the aftermath of *Lemonade*.

Although acknowledging its radical centering of Black female bodies, hooks asserted that *Lemonade* nonetheless commodified them and thus failed to "truly overshadow or change conventional sexist constructions" of said bodies (hooks 2016). To her suggestion that Lemonade represented "utterly-aestheticized . . . fashion plate fantasy," Mock responded that this "reek[ed of] judgment of glamour, femininity & femme presentations" (Mock 2016). On social media, she continued, "This echoes dismissal of femmes as less serious, colluding w[ith] patriarchy, merely using our bodies rather than our brains to sell. . . . Femme feminists/writers/thinkers/artists/ are consistently dismissed, pressured to transcend presentation in order to prove wokeability. Our 'dressed up' bodies and 'big hair' do not make us any less serious. Our presentations are not measurements of our credibility." Here Mock asserts that a femme presentation or identity can be woke (politically aware), serious, "credible," and feminist.

LEMONADE AND THE BLACK GIRL FAIRY TALE

Mock's own reaction to *Lemonade* was visceral. After sitting with it for a couple of days, she published an essay response. In it, she states that "I often dream about what 'happily ever after' looks like for the Black girl" and notes that Black women have rarely been offered fairy tales that center them and their experiences (Mock 2016). She invokes the story of canonic Black literary figure Janie Crawford, from Zora Neale Hurston's *Their Eyes Were Watching God* (1937), a woman who lived and loved, was struck and betrayed, but who survived to tell her story. For Mock, "it is in the telling where the fairy-tale begins": "Living and loving, hurting and surviving is not enough. Being able to give testimony to the burden, to 'spin gold out of this hard life' and 'conjure beauty from the things left behind,' is the fairy-tale for the Black woman. . . . We refuse the sentencing of silence by giving testimony" (Mock 2016).

This is *Lemonade*'s significance for Mock: a work of testimony that is a contemporary fairy tale for Black women. She is suggesting, then, a construct radically different from the familiar Disneyfied fairy tales. In this world, with a direct lineage to the European literary tradition, fairy tales end with "happily ever after": the female protagonist finds her prince and secures the protection of marriage, thus fulfilling her role as mother and wife. This "happily ever after" is the reward for virtuous, honorable women only; the nondeserving become spinsters and witches (McKay et al. 2014). Rebecca Wanzo provides a fascinating critique of this tradition, showing both the futility of applying fairy-tale tropes to

the embodied Black experience and also how attempts to create Black princess narratives are fraught with paradox (2011). The glorification of Michelle and Barack Obama as a modern Black fairy-tale romance provides a real-life example of this aspirational fiction. Outlining that which Michelle gave up to allow her husband's career to flourish, as well as the extraordinary nature of the White House–era Obamas, Wanzo quotes Michelle, who suggested that the notion of a fairy-tale marriage was "unfair to the institution of marriage, and it's unfair for young people who are trying to build something, to project this perfection that doesn't exist" (quoted in Wanzo 2011, 13).

Indeed, the intersectional realities of Black love prove to be far more complex. In an interesting review of academic literature, multimedia, and literary forms, Katrina Billingsley (2016) shows Black love to be something represented as both stereotypically dysfunctional but also as working against oppressive racist tropes. In this reading, Black love, and the possibility of a Black fairy-tale construct, are forced to reckon with uniquely Black characteristics. Author Susan Taylor eloquently notes, Black love flourishes despite histories of oppression because "partnerships are our strength, the glue that holds families and communities together. ... All the mighty forces arrayed against us would be rendered powerless in the face of mutual Black love" (quoted in Billingsley 2016, 22). Thus, there is an incommensurability with an assumption that Eurocentric conceptions of love and "happily ever after" can simply be applied to Black contexts (Wanzo 2011). To construct a realistic Black girl fairy tale requires a nuanced and inherently intersectional approach. Certainly it cannot be meaningfully achieved without considering the multiple other culturally specific forces that act on these constructs, such as race and gender but also sexuality and ableism (Schalk 2016).

In this light, Mock's reading of *Lemonade* is instructive. Radically diverging from the European tradition, this fairy tale draws strength from pain, burden and adversity, and challenging erasure. In both the Black cis- and trans-female experience, this is a powerful narrative, and one that Mock gave voice to when she married in 2016. In realizing her own *Lemonade*, Mock gave testimony to her own unique Black trans fairy tale. She described a fairy-tale wedding as something she never thought feasible, noting, "The men who love [us], the partners who are with [us] or desire [our] bodies . . . are shamed, because we are told that we are not real women, that we do not belong in these spaces, that we do not even belong in spaces like bathrooms" (WNYC 2016).

Thus, the act of getting married, of stepping "into a space where you look like the living embodiment of these fantasies that we are fed," but a space in which

trans women are never centered, becomes a radical act (WNYC 2016). This is the overcoming of adversity that realizes Mock's Black-girl fairy tale and the denial of forces that would seek to render her invisible. In defiance of criticisms of patriarchal acquiescence, Mock had a simple response: "Great if you enjoy it, but I'm not doing this for your cis-, white, heterosexual, patriarchal gaze. I'm doing this because there's certain girls that need to know that, here's a mirror that reflects you more fully" (WNYC 2016). As with Cox, here we see evidence of the empowerment that Mock draws from Beyoncé, her Black femininity, and, especially, *Lemonade*. Beyoncé's powerful testimony to burden and survival as a Black woman becomes Mock's powerful tool to make the metaphorical lemonade from the lemons served to her as a Black trans woman. In doing so, Mock denies the erasure of herself and other Black trans women, to refuse acts of silencing; *Lemonade* becomes the fairy tale that "[gives] us a blueprint to better live, struggle, and dream" (Mock 2016).

(RE)SERVING *LEMONADE* BITTERSWEET

The fan response video has become a contemporary marker of fandom (Pullen 2011). These videos come in many forms: the lyric video, the dance video, the direct-to-camera cover, the tutorial, the parody, and the user-illustrated video (Liikkanen and Salovaara 2015). A simple search on YouTube returns digital reams of such material produced in response to *Lemonade*, and indeed to Beyoncé's wider catalog. Interestingly, in a recent analysis of fan-generated responses to Beyoncé, Ann Werner (2014) found that the majority attempted to achieve a physical resemblance to the star and were most often made by fans read as African American women. Werner concludes that these videos indicated a clear "search for authenticity," and where a factor appeared disruptive—whether through whiteness, maleness, Asianness, or even poor dancing—viewers and users alike received the video as "slightly wrong" and criticized it accordingly (Werner 2014, 192–93). Similarly, if the video was read as slightly wrong by the creator, and likeness in looks or dance moves was not achieved, a justification or explanation of its "wrongness" was offered.

This search for authenticity clearly informs the trans collective Glass Wing Group's *Lemonade Served Bittersweet* (2016). Released first on Facebook in July 2016, it features Beyoncé impersonator Miss Shalae (Michell'e Michaels), who, alongside collaborators Q Buedette and Adisa Gooding, recreates aspects of the *Lemonade* tracks "Hold Up," "Freedom," "Sorry," and "6 Inch" (Glass Wing

Group 2016). The video was shot across a tiny sixteen-hour window and completed within three months of *Lemonade*'s release. While there is an obvious gulf between the resourcing of *Lemonade* and *Lemonade Served Bittersweet*, Glass Wing Group managed to faithfully recreate some of the now iconic moments, costuming, choreography, and visual aesthetics. For example, in the video for "Hold Up," Miss Shalae initially emerges from a watery prison wearing a version of Beyoncé's iconic yellow dress and releasing her aggression with the infamous "hot sauce" baseball bat. Similarly, Glass Wing's "Freedom" and "Sorry" recreate key aesthetics: the direct-to-camera, black-and-white address in "Freedom," complemented by solo dancer, and both choreography and body suits echoing Laolu Senbanjo's body art for the backup dancers in "Sorry."

The group's "6 Inch" is especially successful, pulling off an effective re-creation of the original's dark, red-infused lighting aesthetic. A wide-brim-hatted Beyoncé/Michelle, being driven around at night, through an active urban red-light district and passing the "same" Wall Street location, is intercut with Michelle and the other dancers imitating Beyoncé's look and choreography. It closes with Michelle, dressed in a form-fitting black gown and bathed in dark red lighting, swinging a lightbulb around her head like a lasso—a striking image taken from the latter half of the original. *Lemonade Served Bittersweet* does not attempt a shot-by-shot remake. Insurmountable limitations have instead unleashed Glass Wing Group's own creativity in order to faithfully recreate aspects of the original, while allowing *Lemonade* to act as inspiration for filling the gaps in between.

Echoing Werner's (2014) findings, many comments made on Miss Shalae's Facebook page by Black-presenting viewers of Glass Wing Group's video, whether trans or cis-gendered women and men (queer or otherwise not obviously identified), reflect a judgment based on their presentation of authenticity. Frequently these comments center on Michelle's likeness to Beyoncé and the faithful re-creation of the *Lemonade* original. For example, one viewer posted, "At first I was like, I'm liking it she looking just like Beyoncé, then I'm like, wait, this six inches better than Beyoncé." Other commenters expressed similar sentiments: "Your [sic] a Star Ms.Lady! Your presence is like Ms.Bey herself" and "In a couple of these angles she looked more like Beyoncé than Beyoncé does." Another individual focused on the quality of the re-creation, exclaiming, "The Freedom and 6 Inch sequence snatched my existence!" Others echoed this sentiment: "This is extraordinary work. Amazingly well shot and the choreography is exemplary. Bravo!"; "Your 6 Inch version get to be better than the original. Love everything about [it]"; "Video is better than her real video congrats." Still other viewers

illustrated their pleasure by expressing hope that Beyoncé would see the video (and presumably respond publicly): "OMG Beyoncé NEEDS TO SEE THIS!! Absolutely amazing"; "I really hope Beyoncé gets to see this. I'm speechless right now. All of you ladies did a great job."

Some viewers, employing terms derived from queer Black culture, pointed to the overall impact. Typical of these was this succinct and humorous comment: "What will you say at my funeral now that you've killed me!! Yasss." Others were similarly affected: "She Slayed THAT! THE END!" and "Yaaaaas hunty I am here for this slayage." Some commenters pointed to *Bittersweet*'s life-giving properties: "Amazing! You gave me my life! Yaass ms may God continue to bless you! Ok have to watch it again! #slaaayy" and "I just received every ounce of my life at 3am." One post summed up the video as simply "beautiful Black girl magic!"

Finally, another common theme expressed in the comments related to the video's innate trans politics. As one viewer wrote, "I gagged the whole time im buzzing been waiting for summat like this to come out.these trans women are beautiful!!!" while another posted, "wow this is amazing!!! Yes thats what our people give back so much talent!" One commenter noted that although she was not a Beyoncé fan, it was "nice to see trans people coming together." In a particularly personal reference to a deceased member of the trans community, another wrote, "Barbie would be so Phuking proud of you Miss_Shalae . . . BRAVO."

Taken together, these comments on Miss Shalae's Facebook page demonstrate an overwhelmingly positive reaction to Glass Wing Group's *Lemonade Served Bittersweet* and to the collective's efforts to achieve likeness and authenticity. Likeness was achieved at the same time as their trans-ness was centered. Many viewers celebrated Michell'e's embodiment of Beyoncé and the group's re-creation of *Lemonade* visuals. In asserting this, it would be a grave error to simply conflate this more in-group, trans-affirming reception with universal approval. Popular website Bossip (2016) was just one among many media sites to post the video on its release; the presumably less moderated comments posted in response were overwhelmingly negative and transphobic in their assessment of the video's authenticity and the bodies of the collective's members.

The video quickly went viral, thanks in part to the range of blogs and mainstream media outlets that picked it up as a story (e.g., Nichols 2016). With this, Michell'e was given a platform to comment publicly and used the opportunity to explain how the work came about, its inspiration, and what she hoped it might achieve more broadly. The original inspiration came after Beyoncé's Super Bowl performance of her single "Formation." Michell'e intended to rework this and,

rather than addressing #blacklivesmatter, address the #translivesmatter movement, given the high number of trans women of color who are murdered every year (Tiven 2016). When *Lemonade* was released, "speaking to Black Lives Matter and women coming together and uniting," Michell'e felt it was a more manageable work to imitate because its enactment could be achieved without relying on a large number of other participants (Tiven 2016). Speaking to *Black Hollywood Lives*, she explained that when *Lemonade* was released, "I was just completely moved by the whole thing . . . it made me remember things I went through in my life" (2016). The songs chosen for *Bittersweet* "particularly spoke to me, and I was moved when I saw the visuals." Elsewhere she noted that Beyoncé is "an all round true inspiration": "I resemble her and love everything she does as an artist" (Bryant 2016). Michell'e also believes Beyoncé to be an outspoken feminist, something she aspires to be on behalf of the trans community (Tiven 2016). These statements recall Rasmussen Pennington (2016), who demonstrates how fans are driven to create their own videos as emotional, personal responses to the work of their idols. Here, Beyoncé as a musical idol and inspiration to Michell'e is made explicitly clear, but so too is Beyoncé's role of modeling a strong Black femme feminist woman. In addition, Michell'e stated her belief that Beyoncé is a strong, vocal supporter of the queer community: "She's not afraid to speak out, and she's not afraid to lose followers . . . with other [artists], a lot of their fans are the LGBTQ community, and they overlook that" (Tiven 2016).

In terms of affect, Michell'e has clearly stated the politics behind the aesthetics. She hoped that the work would inspire the trans community and eliminate barriers between cis and trans women (Bryant 2016). She noted issues of violence and discrimination against trans women and tied these into her hope that the video (and her subsequent work) could achieve positive change: "I want more than anything to inspire trans women, especially young trans women because . . . being transgender is not something to be celebrated. It's a very negative culture here, so I wanted to showcase a trans group doing positive things" (Tiven 2016). But she also hoped that positive change would be achieved more broadly, that people would become more educated about trans issues and start to question (and change) the treatment of trans people (Bryant 2016). And while trans issues were not addressed directly in *Lemonade Served Bittersweet*, Michell'e stated that she wanted to continue using the platform given to her to speak out about the issues (Tiven 2016), something she continues to do intermittently through her various social media platforms.

In her own words, the songs chosen for *Lemonade Served Bittersweet* were

those that resonated most with Michell'e, and it is notable that three of the four come from the first half of *Lemonade*, the space in which Beyoncé works through her deeply personal trauma before turning to hope and eventual redemption. "Hold Up," "Sorry," and "Freedom" are defiant songs of personal and collective empowerment with the rallying cry of the latter being, "a winner doesn't quit on herself." Given the affective intention of the video, the choice of these songs is clear: Michell'e is asserting her own personal empowerment while seeking to empower her fellow Black trans women. With visuals centered on nighttime economies, the video's finale, "6 Inch," is a none-too-subtle anthem to working women, including sex workers. Beyoncé's protagonist grinds day and night, from Monday to Friday and from Friday to Sunday, and she's worth every dollar, every minute. The song is a defiant snub to a politics of respectability that would deny Black women agency to seek self-empowerment and mobility through such forms of employment. Here, though, its inclusion becomes doubly symbolic. As a Beyoncé impersonator, Michell'e is implicated in nighttime entertainment economies, with their underground, quasi-legal, possibly illicit, and erotic under-tones. (Harley 2002 discusses how marginalized Black women have historically used such economic means as survival mechanisms.) Furthermore, if engaging in particular forms of sexualized nighttime economies falls outside the accepted norms of Black respectability, then doing so as a queer subject pushes her further into the margins, rendering her ever more invisible and written out of acceptable forms of Blackness (McBride 1998). The positioning of "6 Inch" as the video's climax confronts this head-on, defiantly repositioning Michell'e's illicit, queer, Black female body at the center of the viewer's desire and gaze and as in control. If *Lemonade* is a testimony to survival, the Black-girl fairy tale, then *Lemonade Served Bittersweet* reimagines this through a Black trans lens that speaks person-ally to and of Michell'e Michaels. Through *Lemonade Served Bittersweet*, Michell'e has been inspired to express, adopting Mock's phraseology, her own Black-girl fairy tale; it is a testimony to her own burden, struggle, and ultimate survival as a trans Black woman, Beyoncé impersonator, and entertainer.

CONCLUSION

This chapter has offered a small glimpse of *Lemonade* through a trans lens as part of a dialogue around femme as a gender construct that provides inspiration, and even survival, for Black trans and queer folks. It complements the recent analysis of feminist, lesbian scholar Omise'eke Tinsley, who calls *Lemonade* a

"Femme-onade mixtape" for the way it unashamedly embraces the femme in feminism and centers Blackness within this femme-inism (2018). Where it may appear that a femme performance or identity is derived from a stifling traditional gender binary, we argue it has had a different trajectory. Beyoncé's high-femme is not grounded in historic white femininities but rooted in Black history and culture, negotiated with Black queer culture, and it offers a rejoinder and rebuttal of stereotypes. It embodies some of the core tropes of Black femininities: the queen, the diva, the Queen B(?), being fierce, and the Black-girl fairy tale. Beyoncé's presentation of an empowered Black feminist highlights the tensions within feminism over femme presentations, tensions of which our trans subjects are keenly aware. Trans-femme adoptions of hyper-femme presentations can be seen as reveling in oppressive and racist representations of womanhood; however, we assert that Beyoncé's fierce, hyper-femme Blackness provides a promise of empowerment for queer Black femmes because of its axis of survival, resilience, Black struggle, and nods to Black queerness.

Janet Mock and Glass Wing Group's Michell'e Michaels both connect with the fairy-tale elements of *Lemonade*. For Mock the project offered a "blueprint" for those femmes who act not for the white patriarchal gaze but as promise of a happy ending for the burden, struggle, and survival as a femme-presenting trans Black woman. Michell'e's *Lemonade Served Bittersweet* expresses her own Black-girl fairy tale, seeing no distance between her *Lemonade* and Beyoncé's, collapsing barriers between cis and trans women. The Internet provided a space for a trans-fan response video, as well as multiple voices of appreciation and gratitude from the community it reached.

Cox and Mock relate to the weight of power and visibility that Beyoncé has. They acknowledge that their presentation as "passing" as cis has gained them acceptance with mainstream audiences so they endeavor to use their positions to further the change they desire: greater visibility and acceptance for all trans people. Both admire how Beyoncé's capitalist power is used to pursue a political message: Black femme power. On the subject of Beyoncé's growing feminism, for example, Mock reflects that "she [Beyoncé] could have just as easily sold concerts and sold records and not made a message with her work" (WNYC 2016). Cox, Mock, and even hooks are "trying to sell books and get speaking engagements; Beyoncé is trying to do all of that at the same time" (WNYC 2016). This economic survival is only one element for trans femmes of color, who face everyday threats to their literal survival; thus, the fairy-tale blueprint becomes strategy.

The fierce queen diva femme is a gender aesthetic, which can accentuate,

exaggerate, or flout one's gender identity. It is defined by its own practitioners and anyone can perform them. As Judith Butler has reflected, gender can be a "domain of pleasure" for those who "really love the gender that they have claimed for themselves" (Williams 2014). Here, femme is the fairy-tale heroine who rebels against antiquated, patriarchically defined femininity, embracing and creating a gendered performance that defies hierarchies and boundaries. Femme is neither queer nor straight; it was created by the discourse between communities, particularly straight and queer communities of color. Femme does not reify historic notions of femininity; rather, it interrogates and re-visions through the art, voices, and activism of practitioners themselves. Femme is a space for play and survival for Black femmes who have long faced violence and marginalization. Beyoncé's celebration and performance of a hyper-femme identity in *Lemonade* offer a tool of empowerment for Black trans women and embodies our notion of Femme.

REFERENCES

Anderson Droogsma, Rachel. 2007. "Redefining Hijab: American Muslim Women's Standpoints on Veiling." *Journal of Applied Communication Research* 35, no. 3: 294–319.

Billingsley, Katrina. 2016. "Love Jones: A Phenomenological Study of Diverse Black Romantic Love Relationships." PhD diss., North Carolina State University.

Black Hollywood Lives. 2016. "Black Hollywood Lives' Conversations: Michelle Michaels." July 31. https://www.youtube.com/watch?v=jIfhyyvFbPc.

Bryant, Miranda. 2016. "'She Is an Inspiration': Transgender Women Recreate Beyoncé's Stunning Lemonade Video in a Bid to Inspire Other Trans People to 'Follow Their Hearts and Dreams.'" *Daily Mail*, July 16. http://www.dailymail.co.uk/femail /article-3692724/She-inspiration-Transgender-women-recreate-Beyoncé-s-stunning -Lemonade-video-bid-inspire-trans-people-follow-hearts-dreams.html.

Clay, Andreana. 2016. "Slay Trick: Queer Solidarity (?) in Formation." *Queer Black Feminist*, February 11. http://queerblackfeminist.blogspot.co.nz/2016/02/slay-trick-queer-solidarity-in-formation.html.

Crosley, Hillary. 2010. "Beyoncé Says She 'Killed' Sacha Fierce." *MTV*, February 26. http:// www.mtv.com/news/1632774/Beyoncé-says-she-killed-sasha-fierce/.

Cullins, Ashley. 2017. "Beyoncé Can't Dodge 'Formation' Copyright Lawsuit." *Hollywood Reporter*, July 6. https://www.hollywoodreporter.com/thr-esq/Beyoncé-cant-dodge -formation-copyright-lawsuit-1024671.

Draper, Jimmy. 2017. "'What Has She Actually Done??!': Gay Men, Diva Worship, and the Paratextualization of Gay-Rights Support." *Critical Studies in Media Communication* 34, no. 2: 130–37.

Essence. 2015. "Laverne Cox's Love of Beyoncé." February 20. https://www.youtube.com/watch?v=jBqnEeVsakw.

Gaunt, Kyra. D. 2016. "YouTube, Twerking, and You: Context Collapse and the Handheld Copresence of Black Girls and Miley Cyrus." In *Voicing Girlhood in Popular Music*, edited by Jacqueline Warwick and Allison Adrian, 218–42. New York: Routledge.

Glass Wing Group. 2016. *Lemonade Served Bittersweet*. Facebook, July 12. https://www.facebook.com/miss.shalae.michaels/videos/204341396629398/.

Gordon, Max S. 2017. "Family Feud: Jay-Z, Beyoncé, and the Desecration of Black Art." *Medium*, January 7. https://medium.com/@maxgordon19/family-feud-jay-z-beyonc%C3%A9-and-the-desecration-of-black-art-24d483f1fc88.

Griggs, Brandon. 2015. "America's Transgender Moment." *CNN*, June 1. https://edition.cnn.com/2015/04/23/living/transgender-moment-jenner-feat/index.html.

Harley, Sharon. 2002. "'Working for Nothing But a Living': Black Women in the Underground Economy." In *Sister Circle: Black Women and Work*, edited by Sharon Harley and the Black Women and Work Collective, 48–66. New Brunswick: Rutgers University Press.

Harnick, Chris. 2017. "Just the Thought of Meeting Beyoncé at the 2017 Grammys Made Laverne Cox Burst into Tears." *Eonline*, February 12. http://www.eonline.com/news/828735/just-the-thought-of-meeting-Beyoncé-at-the-2017-grammys-made-laverne-cox-burst-into-tears.

hooks, bell. 2016. "Moving beyond Pain." bell hooks Institute, May 9. http://www.bellhooksinstitute.com/blog/2016/5/9/moving-beyond-pain.

Horton-Stallings, LaMonda. 2007. *Mutha' Is Half a Word: Intersections of Folklore, Vernacular, Myth, and Queerness in Black Female Culture*. Columbus: Ohio State University Press.

Jackson, Sarah J., Moya Bailey, and Brooke Foucault Welles. 2017. "#GirlsLikeUs: Trans Advocacy and Community Building Online." *New Media and Society* 20, no. 5: 1868–88. https://doi.org/10.1177/1461444817709276.

Jennex, Craig. 2013. "Diva Worship and the Sonic Search for Queer Utopia." *Popular Music and Society* 36, no. 3: 343–59.

Johnson, E. Patrick. 2004. "Mother Knows Best: Black Gay Vernacular and Transgressive Space." In *Speaking in Queer Tongues: Globalization and Gay Language*, edited by William L. Leap and Tom Boellstorff, 251–78. Champaign: University of Illinois Press.

Johnson, Leola A. 2003. "The Spirit Is Willing and So Is the Flesh: The Queen in Hip Hop Culture." In *Noise and Spirit: The Religious and Spiritual Sensibilities of Rap Music*, edited by Anthony B. Pinn, 154–70. New York: New York University Press.

Jones, Saeed. 2014. "Laverne Cox Is the Woman We've Been Waiting For." *BuzzFeed*, March 16. https://www.buzzfeed.com/saeedjones/laverne-cox-is-the-woman-weve-been-waiting-for?utm_term=.hqp8qLo8Z#.ofoD6y1DL.

Karlan, Sarah. 2016. "Trans People Are Sharing Selfies on Twitter with #TransTakeover to Spread Love." *BuzzFeed*, September 30. https://www.buzzfeed.com/skarlan/the -trans-community-is-celebrating-themselves-with-a-twitter?utm_term=.cgNKJRqK9 #.krqDbX7Dn.

Kehrer, Lauren. 2019. "Who Slays? Queer Resonances in Beyoncé's Lemonade." *Popular Music and Society* 42, no. 1: 82–98.

Ladson-Billings, Gloria. 2009. "'Who You Callin' Nappy-Headed?' A Critical Race Theory Look at the Construction of Black Women." *Race Ethnicity and Education* 12, no. 1: 87–99.

Lewis, Shantrelle. 2016. "'Formation' Exploits New Orleans' Trauma." *Slate*, February 10. http:// www.slate.com/articles/double_x/doublex/2016/02/beyonc_s_formation_exploits _new_orleans_trauma.html.

Liikkanen, Lassi, and Antti Salovaara. 2015. "Music on YouTube: User Engagement with Traditional, User-Appropriated and Derivative Videos." *Computers in Human Behavior* 50: 108–24.

Lister, Linda. 2001. "Divafication: The Deification of Modern Female Pop Stars." *Popular Music and Society* 25, no. 3–4: 1–10.

Lovelock, Michael. 2017. "Call Me Caitlyn: Making and Making Over the 'Authentic' Transgender Body in Anglo-American Popular Culture." *Journal of Gender Studies* 26, no. 6: 675–87. https://doi.org/10.1080/09589236.2016.1155978.

Loyd-Sims, Lamont. 2014. "J-Setting in Public: Black Queer Desires and Worldmaking." Master's thesis, Georgia State University. http://scholarworks.gsu.edu/wsi_theses/37.

McKay, Kathy, Tinashe Dune, Catherine MacPhail, Virginia Mapedzahama, and Myfanwy Maple. 2014. "Fairytales, Folklore and Femininity: Making Sense of the (Un)Sexed Female Body across Time and Space." In *Exploring Bodies in Time and Space*, edited by Loyola McLean, Lisa Stafford, and Mark Weeks, 15–26. Oxford: Inter-Disciplinary Press.

Mills, James. 2016. "Exposed: Sweatshop 'Slaves' Earning Just 44p an Hour Making 'Empowering' Beyoncé Clobber." *Sun*, May 7. https://www.thesun.co.uk/archives/news /1176905/exposed-sweatshop-slaves-earning-just-44p-an-hour-making-empowering -Beyoncé-clobber/.

Mock, Janet. 2016. "'Lemonade' Is Beyoncé's Testimony of Being Black, Beautiful and Burdened." https://janetmock.com/2016/04/26/Beyoncé-lemonade-testimony-black -women-burden/.

———. 2016. Facebook. 2016. May 9. Accessed November 26, 2018. https://www.facebook .com/janetmock/posts/10154228113096522.

Moniuszko, Sara. 2017. "Laverne Cox Stuns as Model for Beyoncé's Ivy Park Fitness Line." *USA Today*, September 6. https://www.usatoday.com/story/life/entertainthis /2017/09/06/laverne-cox-stuns-model-Beyoncés-ivy-park-fitness-line/638421001/.

Mya, Messy. 2010a. "Booking the Hoes from New Wildin." Posted August 20, 2010, by TheeHHGz. YouTube video 5:14. https://www.youtube.com/watch?v=daKqgdcyp TE&t=183s.

———. 2010b. "A 27 Piece Huh." Posted September 5, 2010, by TheeHHGz. YouTube video 1: 53. https://www.youtube.com/watch?v=zsYOnx2xJuY.

New School. 2014. "bell hooks: Are You Still a Slave? Liberating the Black Female Body." Filmed YouTube video 1:55:32. https://www.youtube.com/watch?v=rJkohNROvzs.

Nichols, James. 2016. "These Trans Women Just Epically Remade Beyoncé's 'Lemonade.'" *Huffington Post*, July 25. https://www.huffingtonpost.com/entry/transgender-collective-Beyoncé-lemonade_us_579101bbe4b0bdddc4d38721.

Pullen, Kirsten. 2011. "If Ya Liked It, Then You Shoulda Made a Video: Beyoncé Knowles, YouTube and the Public Sphere of Images." *Performance Research* 16, no. 2: 145–53. https://doi.org/10.1080/13528165.2011.578846.

Rasmussen Pennington, Diane. 2016. "'The Most Passionate Cover I've Seen': Emotional Information in Fan-Created U2 Music Videos." *Journal of Documentation* 72, no. 3: 569–90.

Regester, Charlene. 2000. "The Construction of an Image and the Deconstruction of a Star: Josephine Baker Racialized, Sexualized, and Politicized in the African-American Press, the Mainstream Press, and FBI files." *Popular Music and Society* 24, no.1: 31–84.

Román, David. 1993. "Fierce Love and Fierce Response: Intervening in the Cultural Politics of Race, Sexuality, and AIDS." *Journal of Homosexuality* 26, no. 2–3: 195–220.

Schalk, Sami. 2016. "Happily Ever After for Whom? Blackness and Disability in Romance Narratives." *Journal of Popular Culture* 49, no. 6: 1241–60.

Seemayer, Zach. 2016. "Laverne Cox Transforms into Beyoncé and Tina Turner in Stunning New Photospread." *Entertainment Tonight*, September 6. http://www.etonline.com/news/197370_laverne_cox_transforms_into_Beyoncé_and_tina_turner_stunning_new_photospread.

Tinsley, Omise'eke. 2018. *Beyoncé in Formation: Remixing Black Feminism*. Austin: University of Texas Press.

Tiven, Lucy. 2016. "These Transgender Artists Found a Way to Make 'Lemonade' Even More Empowering." *attn.*, July 19. https://archive.attn.com/stories/10056/transgender-remake-of-beyonce-lemonade.

"The Transgender Version of Beyoncé's Lemonade Service Bittersweet Video." 2016. *Bossip*, July 14. https://bossip.com/1333036/the-transgender-version-of-beyonces-lemonade-served-bitter-sweet-video/.

Trier-Bieniek, Adrienne, ed. 2016. *The Beyoncé Effect: Essays on Sexuality, Race and Feminism*. Jefferson, NC: McFarland.

Wanzo, Rebecca. 2011. "Black Love Is Not a Fairytale." *Poroi: An Interdisciplinary Journal of Rhetorical Analysis and Invention* 7, no. 2: 1–18.

Werner, Ann. 2014. "Getting Bodied with Beyoncé on YouTube." In *Mediated Youth Cultures: The Internet, Belonging, and New Cultural Configurations*, edited by Andy Bennett and Brady Robards, 192–96. London: Palgrave Macmillan.

West, Carolyn M. 2012. "Mammy, Jezebel, Sapphire, and Their Homegirls: Developing an 'Oppositional Gaze' toward the Images of Black Women." In *Lectures on the Psychology of Women*, edited by J. C. Chrisler, C. Golden, and P. D. Rozee, 286–99. Long Grove, IL: Waveland Press.

Williams, Cristan. 2014. "Gender Performance: The TransAdvocate interviews Judith Butler." *TransAdvocate*, March 7. http://transadvocate.com/gender-performance-the-transadvocate-interviews-judith-butler_n_13652.htm.

WNYC. 2016. "Sooo Many White Guys: #3 Phoebe and Janet Mock Make Lemonade." *WNYC*, July 26. https://www.wnycstudios.org/story/3-phoebe-and-janet-mock-make-lemonade.

BYRON B CRAIG AND STEPHEN E. RAHKO

10. From "Say My Name" to "Texas Bamma"
Transgressive Topoi, Oppositional Optics, and Sonic Subversion in Beyoncé's "Formation"

Scholars of popular music across the fields of musicology, cultural studies, rhetorical studies, and Black studies have long been invested in the question of the relationship between popular music and the symbolic and cultural power dynamics of (late) modernity. At stake in this debate has always been the politics of commodified aesthetic expression, specifically, the question of whether the consumption of popular music and celebrity brands within capitalist consumer culture activates or contains political and civic consciousness. In this chapter, we begin from the premise that popular music and celebrity culture can be political, and we seek to contribute to this long-standing debate through a visual, lyrical, and musical analysis of Beyoncé's popular and controversial song "Formation," which we argue represents a strategic, symbolic intervention against the American fantasy of color blindness.

"Formation," in terms of its overarching aesthetic and especially the cultural context of its reception, represents an important cultural artifact that should encourage scholars to rethink the parameters of the debate over the politics of the American culture industries, particularly with regard to matters of consumption practices, celebrity, popular music, and the rhetorical politics of race. We understand "Formation" as a protest song deeply rooted within what Shana L. Redmond (2013) has called the Black diasporic "sound franchise," and we argue that Beyoncé represents the critical dimensions of Black celebrity in an era marked by intensifying racial polarization and white resentment. "Formation" is a musical form indicative of a popular trend in American public culture that challenges systemic racism: a celebrity discourse of politics that can potentially

serve to symbolically coordinate American audiences to constitute forms of critical race consciousness toward developing an oppositional politics against the dehumanizing conditions with which people of color live. "Formation," we will argue, advances a visual and lyrical rhetoric of race that can be read by audiences of color and their white allies as a call for a new type of Black oppositional politics in a culture that increasingly identifies itself as postracial.

BEYONCÉ, COLOR BLINDNESS, AND THE (POST)RACIAL POLITICS OF CELEBRITY IN THE ERAS OF OBAMA AND TRUMP

In February 2016, Beyoncé took many Americans, particularly those who self-identify as white, by surprise with the release of "Formation," a protest song against systemic racism and Black socioeconomic plight. The release came during a turbulent period of social unrest and protest over the enduring legacy of racism and the disposability of Black life that was catalyzed by a noxious series of incidents involving rampant racist police brutality and the shootings of unarmed Black citizens. Protests against the murder of Trayvon Martin by wannabe cop George Zimmerman in 2012 and the murder of Michael Brown by officer Darren Wilson in 2014 gave birth to and galvanized Black Lives Matter, the social movement that calls for a grassroots, democratic response to the crises of mass incarceration, police brutality, urban divestment, and Black underemployment. "Formation" was warmly received, but it quickly became a target for a combative and caustic wave of white resentment that found refuge in the vulgar, and frequently violent, campaign rallies of presidential candidate Donald Trump. To be sure, *Saturday Night Live*'s clever and satirical skit, "The Day Beyoncé Turned Black," captured the awkward unease and discomfort that marked the white reception of a music video that the alt-right website Breitbart called a "big wet kiss to Black Lives Matters" meant to evoke "anti-police sentiment" among communities of color (Hudson 2016a, 2016c).

The response to the release of "Formation" offers an important moment for revisiting the way scholars have addressed the politics of popular culture. Indeed, theoretical interest in the politics of consumption and popular music has stemmed from a long-standing concern about the effects of popular culture and whether consumers can exercise oppositional and political interpretations by positing their own meanings onto it. This question has informed much of the contemporary scholarship of the politics of popular music and popular culture.

Stan Hawkins (2016), Lori Burns and Melisse Lafrance (2002), Natalie Weidhase (2015), Marquita R. Smith (2017), and Aisha S. Durham (2014), among many others, have advanced important interpretations of popular music that have emphasized its opposition to dominant political attitudes. By contrast, Lawrence Grossberg has raised doubts about the critical potentialities of popular music and has argued that far from a subversive force in American culture, popular music and its constitutive practices have become so commodified that it is, in his words, "depoliticized" (Grossberg 1997, 120–21; see also Grossberg 1992, 1–30).

The debate over politics, consumption, and popular music has been transformed by the way scholars have increasingly come to account for the way celebrity and the culture industries (popular music, professional sport, Hollywood cinema) inform popular discourses about race in the United States. To frame our analysis, we pose four questions to guide how to understand and critique our current cultural condition with respect to the American rhetorical politics of race:

1. How has the politics of race in the post–civil rights era been transformed by the growing popular visibility of Blackness in American popular and public culture?

2. With regard to race and the increased visibility of Blackness, to what extent has the commodification of race and gender come to facilitate and reinforce a condition that scholars and political pundits have called "postracial"?

3. How has the ideology of "post-race" shrunk space for public critique and debate about the ongoing legacy of systemic racial inequality and injustice at a time when white resentment and white supremacy movements are intensifying?

4. How have social movements such as Black Lives Matter and celebrity performances such as Beyoncé's "Formation" responded to the ideology of post-race through strategic symbolic political dissent?

The discourse on post-race has emerged slowly but surely since the end of the 1960s and announced that race relations have arrived at, or have at least approached, a moment in American history when the state and the law are no longer required to ensure racial equality.[1]

With the election of Barack Obama as president in 2008 and 2012, this postracial consensus rapidly congealed and solidified across many areas of American political culture. The *Wall Street Journal*, for example, responded to Obama's victory by proposing that "perhaps we can put to rest the myth of racism as a barrier to achievement in this splendid country" (2008). According to this postracial

consensus, racial discrimination can no longer be declared systematic in a way that warrants the state to intervene. Grounded in an ideological investment in the normative value of being color-blind, the postracial consensus proposes that rather than seeing and acknowledging racial difference, we should instead not see race at all (Bonilla-Silva 2014, 73–122). Thus, criticisms over racial disparities in criminal justice, health care access, unemployment, housing, equal access to education, or even equal access to voting are, in the parlance of our postracial times, merely a cynical strategy of playing the race card or disingenuous political correctness. Policies seeking to correct the historical legacy of racial discrimination, moreover, are framed by the postracial consensus as illegitimate on racial grounds since such policies are said to perpetuate the race problem by creating new victims through purported reverse racism.

What caused the rise of postracial political attitudes? Many scholars have argued that an important component in the cultural shifts of racial attitudes and in racial politics over the past sixty years has been the advent of highly visible Black and ethnic minority entertainers, celebrities, and public figures (Gray 1995; Denzin 2001; Neal 2002). The advent of Black and ethnic minority celebrities such as Oprah Winfrey, Michael Jordan, and President Obama has transformed American racial politics since their public visibility has come to represent a post–civil rights symbolic threshold for meritocracy on racial grounds. This postracial mystique, as Catherine R. Squires puts it, emphasizes neoliberal orthodoxies of market individualism within a "celebration" for multicultural difference and diversity (2014, 7). Racialized celebrities have reinforced this mystique to the extent that their strategies for personalized racial identity intersect with the exigencies involved in the strategic management of their public personas and celebrity brands. Many racialized crossover celebrities are forced to walk a fine line between the authenticity of their own racial self-identity and self-expression and the branding prerogatives of appealing to as broad an audience as possible without offending the racial self-identities of mainstream, and mostly white, consumers.

For our purposes, the sincerity or authenticity of the desire of some racialized celebrities to transcend or minimize their race is unimportant; what is important is that this identity strategy has a clear branding effect from which scholars can draw conclusions. Industry research suggests that, among white teenagers, crossover stars such as Jennifer Lopez, Halle Berry, and Michael Jordan are not perceived so much as minorities but as "a different kind of White person" (Hall 2002, A2). In this vein, many scholars, such as Ellis Cashmore, have argued that

racialized celebrities reinforce the depoliticizing effects of color-blind or post-racial ideologies since, as he puts it, "ethnic minority celebrities" are "an expression of a world in which racism [is] supposedly going or gone" since "celebrities comfort rather than challenge" because "that's what they're for" (2006, 121, 139).

In this context, Beyoncé has frequently emerged as a key figure in debates among scholars over the politics of race and gender in late modernity. Cashmore, for example, has described Beyoncé as the ultimate postracial symbol who, in his words, "perhaps more than any other individual, [has] convinced us that racism [is] outdated" (2006, 135; see also Cashmore 2010). Among feminists, she has been a polarizing figure. Feminists critical of Beyoncé, such as bell hooks, have argued that she advances a faux feminism by claiming the term for herself while reinforcing age-old tropes about Black women as hypersexual (Sieczkowski 2014). Echoing Cashmore, hooks has critiqued Beyoncé's visual album *Lemonade*, arguing that it fails as a form of authentic political agency because, as she puts it, "commodities, irrespective of their subject matter, are made, produced, and marketed to entice any and all consumers. Beyoncé's audience is the world and that world of business and money-making has no color" (2016). Aisha S. Durham and Marquita R. Smith, however, have defended Beyoncé as an embodiment of "hip hop feminism," because her "curves" both contest and redefine the normative aesthetics and discourses of beauty that have been historically associated with whiteness (Durham 2014, 81–99; Smith 2017). Lindsey Stewart has responded to hooks's criticisms, arguing that her sense of political agency overlooks the way *Lemonade* evokes Black spiritual traditions of self-definition that are necessary for the development of political protest (Stewart 2019, 27–28).

We enter these debates from two directions. First, we agree that the debates over Beyoncé, celebrity, and the politics of race cannot be divided from deeper concerns and questions about the politics of popular visibility and political advocacy within the space of late-capitalist culture. We find Roopali Mukherjee's concept of "bio-branding" useful toward interrogating the possibilities and limitations of political agency when it is mediated by commodified forms of sociality. Drawing from Michel Foucault, Mukherjee argues that branding strategies must be understood as part of a larger expression and technique of biopolitical governance that, in her words, "assesses whole populations in order to foster and promote life, to improve its chances and compensate for its failings as well as to mark some populations as 'inferior' [and] as harmful to the larger body of the nation" (2016b, 6). In a cultural context where "the vocabularies and logics of the market appear to be decisively redefining our experience of citizenship,

community, [and] our sense of self," we must recognize the inherent tensions that constitute the political discourses and advocacy of celebrities like Beyoncé because their discursive strategies must always negotiate their market position (Mukherjee 2016b, 2). To be sure, critics of celebrity branding, consumption, and popular music pose a series of important questions that we cannot avoid. What does it mean for celebrities to be political advocates? Where does advocacy begin and branding end? Because celebrities are always and already marked as commodified signs of public culture, are their political interventions already blunted from the beginning, or are there special rules of engagement for their ability to do politics? In short, what are the limits of celebrity advocacy if their advocacy cannot be separated from brand exposure?[2]

The biopolitical control of celebrity branding strategies, however, is never absolute, and forms of celebrity advocacy and cultural production can serve important liminal outcomes. As Kendall R. Phillips has argued, Foucault recognized "spaces of dissension," or moments and "places where the incoherence and contingency of [a] discourse is experienced directly and, therefore, the production of dissenting discourse becomes possible for those who have momentarily recognized the instability" (2002, 334). Cultural fissures of this sort produce the basis for what Phillips has called "spaces of invention," or "spaces within which the possibility of new actions (or utterances or selves) can be imagined" and when "the invention of new discourses" becomes possible (2002, 332, 334). Our relationship to commercial space is fluid, and celebrities who enact political gestures and discourses can create cultural fissures through dissent. When popular musicians or professional athletes engage in political speech acts of protest, they disrupt, even if only momentarily, the space of commodified relationships. Disruptions to commodified space in the form of such political symbolism can be understood as a strategic form of culture jamming because they intend to reorient the gaze of the consumer by challenging what is expected, anticipated, or desired from commodified relationships predicated on entertainment (Harold 2007, xxiv–xxx). To be clear, we are less inclined to claim that celebrity advocacy and protest are acts of resistance; rather, we prefer to reserve this term for understanding and describing practices and strategies that replace commodified relationships with democratic sociality and participation. That said, forms of celebrity dissent can be deeply transgressive and can create discursive effects that activists and social movements such as Black Lives Matter can exploit. The fact that police unions called for a boycott of Beyoncé's "Formation" tour is a testament to the transgressive and disruptive dynamics that are possible (Chokshi 2016b).

For these reasons it is vital that the branding strategies as well as the musical and performative aesthetics of celebrities such as Beyoncé be interpreted and understood within the political context in which they are culturally produced. Despite the hegemony of color blindness as a dominant rhetoric of race, there can be no doubt that the political climate of the United States has been increasingly marked by an intensifying racial polarization. The toxic combination of stagnant incomes, rising mortality rates, and gradual demographic eclipse among self-identified "whites" has transformed the political and cultural landscape of late capitalism in the United States and aggravated the ugly sinews of America's legacy of systemic racism. Accordingly, we seek to contribute to the debate on the politics of consumption, celebrity, and popular music by locating Beyoncé within the current political climate of racial polarization that began to boil in the United States during the Obama presidency and has only intensified with the candidacy and election of reality television star and real estate mogul Donald Trump.[3]

Indeed, we argue that the current political climate of racial polarization forces a rethinking of the symbolic and affective politics of consumption, popular music, and celebrity branding. At the very least, Beyoncé represents a musical artist and celebrity brand navigating a culture of deep political polarization, where branding in the era of Trump is marked by, in Arun Kundrani's (2016) words, a "new racial identity politics" predicated on intense white resentment.[4] Scholarly criticisms of Beyoncé should understand her art and celebrity branding within a late-capitalist context where white anger is strategically and consciously stroked as a way of courting conservative taste cultures, be it by NASCAR, Papa John's Pizza, country music, the National Rifle Association, Islamophobic and homophobic "family values" or "faith-based" bookstores and media corporations, or alt-right and conservative media outlets like *Fox News* and *Breitbart*. Contrary to critics such as Grossberg and Cashmore, it is hard to conclude that Beyoncé is "comforting" as a celebrity or that her music is "depoliticizing" when *Breitbart* and *Fox News* have strategically used her celebrity brand and music as symbolic instruments to arouse the white anger and resentment that drives conservative self-identity and political mobilization (Hudson 2016b). To be sure, it is not a surprise to see that even as president, Donald Trump has continued to use Twitter and hold rallies for the purpose of attacking racialized celebrities in order to strategically energize his base of largely white male voters (e.g., Graham 2017).

Second, we argue that Beyoncé's music video "Formation" represents an important shift in the rhetorical politics of race in American political culture. We argue that Beyoncé's "Formation" should be understood as part of a new

resurgence in what we call "protest pop." Celebrity entertainers such as Beyoncé, Kendrick Lamar, Common, Janelle Monáe, Childish Gambino, Chance the Rapper, Prophets of Rage, a Tribe Called Quest, and the late great Prince have clearly responded to the Black Lives Matter movement and the pillaging that communities of color have continued to suffer since the Great Recession. We define protest songs as those that identify social problems and call for action in response to such problems. As Allan Moore observes, a protest song expresses "opposition to a hegemonic [formation]" with the intention of, as Jonathan C. Friedman notes, changing public opinion and attracting "people to movements and promot[ing] group solidarity" (Moore 2013, 387; Friedman 2013, xvi).

Indeed, in this chapter we seek to advance a rhetorical theory of cultural musicology that is predicated on the way public cultures are constituted by the lyrical, visual, and sonic dynamics of popular music as a cultural formation. We understand protest songs such as Beyoncé's "Formation" and Janelle Monáe's "Hell You Talmbout" as constitutive of what Shana L. Redmond has called the Black diasporic "sound franchise," which she defines as an "organized melodic challenge utilized by the African descended to announce their collectivity and to what political ends they would be mobilized" (2013, 4). Sound franchises, she notes, are "composed of a series of alternative performance practices developed and executed to counteract the violent exclusions and techniques of silencing contained within the governing structures of white supremacy" and produce "sound-politics" that can constitute "musico-political counterpublics" that mobilize toward political ends (Redmond 2013, 9). As we will demonstrate, Beyoncé's "Formation" is a sonic and symbolic subversion of the hegemony of color blindness, and its public and digital circulation as a cultural form has the capacity to mobilize "communal engagements that speak to misrecognition, false histories, violence, and radical exclusion" while also creating space for insurgent representations of race that can carry "alternative theorizations and practices of blackness" (Redmond 2013, 2).

A crucial part of contemporary popular music is the way beats and lyrics are accompanied by visual rhetoric in the form of music videos as well as other televised performances. We argue that late-modern protest pop is distinctive from other eras of protest music by the way the performer crafts what we call an oppositional optic: a consciously crafted visual strategy meant to deconstruct and subvert normalized forms of popular representations and imagery, or what we have elsewhere called "vernacular visuality" (Craig and Rahko 2016, 287–89). Crucial to this process is the way the performer advances transgressive visual

topoi, or visual imagery that transgress and counter the visual commonplaces of representation that are often the source for public oral and visual argument and ultimately inform public political doxa. In the case of Beyoncé's "Formation," we seek to demonstrate how the music video and public performance of the song advance oppositional optics and transgressive topoi that respond to the racial politics of the United States by strategically subverting this culture's hegemonic visuality of race.

THE POLITICS OF BEYONCE'S "FORMATION"

Beyoncé's Celebration of the Black Body and Quotidian Blackness

The context of historical and contemporary representations of Blackness allows us to appreciate Beyoncé's strategic use of visual and lyrical rhetoric in "Formation." "Formation" is a visual montage of images of everyday Blackness and of Black people in their own spaces on their own terms that takes control of Black imagery and narrative from white gazes and postmodern racism. Her strategic visual display of her own body and celebration of the Black male body self-consciously subvert the symbolic violence of hegemonic visual forms.

Visually and lyrically, "Formation" advances a critique of interracial politics predicated on celebrating the Black body. Beyoncé self-consciously revels in the elements of the Black physique that have been condemned under white gazes as carnivalesque, savage, and generally associated with ugliness. Historically, peoples of African descent have been hypersexualized since the auction blocks of slavery while also rendered inferior on purportedly scientific grounds with eugenics and other power/knowledge assemblages that have sought to prove their inferiority based on social Darwinist and craniofacial differences with whites of European descent. The historical legacy of these discourses has come to mark the Black body as, ironically, simultaneously physically undesirable and aesthetically abhorrent yet also hypersexualized.

Indeed, historians and cultural critics have long demonstrated that a litany of stereotypical stock images of the Black body have been crafted to delight and sanction the prejudices and exploitative practices of white audiences from slavery, through Jim Crow, and now into the post–civil rights era. Black feminist scholars like Patricia Hill Collins (2008), for example, have documented and critiqued the historical origins and residual legacies of stock representations of Black women as lascivious and hypersexual (Jezebel); crude, sassy, and emotionally

cantankerous (Sapphire); overweight with noticeable gluteal qualities (Hottentot Venus or Sarah Baartman); as well as incompetent and hopelessly dependent on white paternalism (Mammy). Critics such as Ronald L. Jackson II, moreover, have documented and critiqued stock figures of Black men such as the "brute" or "buck." As a minstrel character, the brute was "almost always a tall, dark-skinned, muscular, and athletically built character" and always scripted, notes Jackson, to be "nothing less than an indiscrete, devious, irresponsible, and sexually pernicious beast" (2006, 41–44). The carnal elements of Blackness—body size, dark skin pigmentation, broad thickness of nose and lips, and rotund face—have been used to underpin white gazes and fears in order to render Blackness as threatening and, as we have argued elsewhere, to aestheticize Blackness as *anti*-iconic (Craig and Rahko 2016, 289). The symbolic and affective investment whites make in Black anti-iconicity is psychologically and spiritually rooted in white self-loathing, for as James Baldwin (1962) observed, "White people will have quite enough to do in learning how to accept and love themselves and each other, and when they have achieved this—which will not be tomorrow and may very well be never—the Negro problem will no longer exist, for it will no longer be needed."

The symbolic violence inflicted on the Black body takes no prisoners and touches Blackness marked by celebrity and quotidian alike. Among Black men, public figures such as scholar Henry Louis Gates Jr. and professional athlete James Blake have been imagined as "brutes" and "bucks" and subjected to the same forms of police suspicion, violence, and brutality that led to the tragic fatalities of Philando Castile and Eric Garner. Among Black women, Venus and Serena Williams, Aiyana Jones, Rekia Boyd, Rachel Jantel, and Sandra Bland have been symbolically and even fatally disfigured for their body types and perceived temperaments.

Yet race relations and racial events in the United States are marked increasingly by their postgeographic orientation in the sense that they are increasingly experienced affectively and materially within digital networks. As Safiya Umoja Noble has argued in *Algorithms of Oppression: How Search Engines Reinforce Racism*, in the digital era of platform capitalism, these symbolic and material forms of racial stereotypes and profiling have come to shape what she calls practices of "technological redlining" and "algorithmic oppression" (2018, 1–5). In crafting the digital architecture of the Internet, the dynamos of platform capitalism and so-called big data such as Google, Amazon, and Facebook have reinforced a neoliberal culture where "identity markers are for sale in the commodified web to the highest bidder" and digital representations of race and gender represent a

new form of capital to be coded, algorithmically classified, and ranked on behalf of clients (Noble 2018, 91). The result has been the digital reification of racist and misogynist stock representations of Blackness, which has only summoned a new digital materiality of racism, be it through the ranking of search results, algorithmic discrimination, anonymous racial and gendered cyber-bullying, or digital blackface (Noble 2018, 25; Badger 2016).

In Figures 10.1 to 10.3 we can see how "Formation" visually protests the stock imagery of racist misogyny and the norms of white bourgeois femininity. As in many of her performances, "Formation" transgresses white bourgeois conceptions of beauty as it features Beyoncé dancing in a body suit that asserts the presence of her curvy thighs and thicker body type (Figure 10.1). Yet "Formation" also contests the normativity of white bourgeois fashion through its display of quotidian Black femininity, be it Black women dancing in the street in the summer (figure 10.2) or creatively inventing new norms of style (Figure 10.3). As Durham notes, "Black women often exist as visible nonspeakers who garner attention as sexual spectacles in the public imagination" (2014, 7). Through these quotidian images, "Formation" disrupts the norm of Black invisibility while creating affective and symbolic space for Black women and girls to unapologetically celebrate their bodies.

FIGURE 10.1 Beyoncé dancing in a body suit. Screenshot
from "Formation" video (*Lemonade* 2016b).

270 *"Hold Up"*

FIGURE 10.2 Black women dancing in the street. Screenshot from "Formation" video (*Lemonade* 2016b).

FIGURE 10.3 Black women in a wig shop. Screenshot from "Formation" video (*Lemonade* 2016b).

Lyrically, Beyoncé affirms the aesthetic beauty of Black masculinity when she sings, "I like my negro nose with Jackson Five nostrils" (Beyoncé 2016a). Like other prominent Black artists, such as Toni Morrison, Alice Walker, Audre Lorde, and Zora Neal Hurston, who have rewritten the Black body, redeeming it in the face of racist tropes imposed on it, Beyoncé's celebration of the Black body can be understood as a reinscription of it as a site for personal expression, style, solidarity, and confident identity formation. Toward these ends, "Formation" performs an oppositional optic against the dominant ideological discourses of race that take visual forms in late capitalism. Her lyrics and visual strategies echo Baldwin's observation: "I do not know many Negroes who are eager to be 'accepted' by white people, still less to be loved by them; they, the blacks, simply don't wish to be beaten over the head by the whites every instant of our brief passage on this planet" (1962).

Beyoncé's Call for Intersectionality and Critique of Black Bourgeois Respectability Politics

As the Black body has been marked as anti-iconic, it has also been psychologized and pathologized as socially and criminally deviant, as well as lacking proper bourgeois values and mores necessary for success. As Brittney C. Cooper has demonstrated, class politics has always been endemic to the African American experience but became particularly pronounced as Black people entered the professions and found prosperity after slavery (2017, 19–25). A crucial historical factor in this dynamic is what we have elsewhere called "white decorum and bourgeois sentimentality," for the Black bourgeoisie has strategically used aesthetic elegance to counter popular representations of Blackness as savage (Craig and Rahko 2016, 293). The burden of white gazes and the threat of their disapproval, however, soon began to aggravate social tensions between the Black elite and the Black lower class, whose dress and social etiquette have been "marked by social verve, resistance to convention, and a willingness to experiment" (Dyson 2005, 42–43). Unnerved by what they perceived to be boorish social mores and customs that threatened their own fragile bourgeois status, Black elites began carrying "out a program of moral rebuke disguised as social uplift" that has become ritualized through lecturing and cajoling the Black poor for how they dress, behave, and speak (Dyson 2005, 110). Black respectability politics has found contemporary proponents in Bill Cosby and President Obama, who have lectured poor Blacks

about their parenting, styles of dress, diets, and broader social habits (Dyson 2005, 1–33, 2016, 200).

In "Formation," Beyoncé's celebration of quotidian Blackness represents a rebuke of the Black bourgeoisie's politics of respectability. Contrary to Cashmore's claims discussed above, Beyoncé conspicuously stylizes herself through what Dyson has called an identity strategy of "intentional blackness" (2005, 42–43). Her intentions are clear in her lyrics and visual imagery from the very beginning: the music video opens with a close-up shot of a computer screen that reads "parental advisory" and "explicit lyrics" (Beyoncé 2016b). These words can be understood as a critique of the legacy of C. Delores Tucker, who was a Black bourgeois icon of the post–civil rights era. She (in)famously crusaded against rap music by condemning it as toxic for poor Black youth and called for parental advisory ratings legislation. Indeed, rather than valorizing and embracing the safe imagery of the Huxtables on *The Cosby Show*, *Black-ish*, or other popular commodified representations of bourgeois Black life that takes place in the posh suburbs, "Formation" embraces and redeems the everyday life of the Black South and the Black working class.

"Formation" visually defies the expectations of respectability politics through images of Black working-class people. We see Black women and girls being themselves: dancing in the street, hanging out in wig shops and experimentally wearing blue hair. We see Black men dancing, eating crawfish, playing basketball, playing in a marching band, and even in cowboy hats, riding horses through working-class urban neighborhoods. When Beyoncé sings, "Earned all this money but they never take the country out me," and when she tells her listeners, "My daddy Alabama, Momma Louisiana / You mix that Negro with that Creole make a Texas Bama," she subverts the normativity of Black bourgeois respectability in the vernacular language of the Black working class (2016b). Her embrace of the term *bama* is especially telling, for it was originally Black slang to name the Black working class arriving in the North from the South during the Great Migration. A racist and classist term, the word was reserved to describe someone who didn't know how to behave "properly" and was not presentable according to white sensibilities. Toward this end, she can be understood to be advancing what José Esteban Muñoz has called "disidentification," which explicitly and strategically refuses modes of conventional politics (1999, 1–25). Her lyrical protest pushes against the boundaries of respectability by embracing Blackness that historically has been rendered unpleasant and undesirable.[5]

Indeed, Beyoncé lyrically, visually, and musically advances a distinctive articulation of Black authenticity. From her hair, to her choice of clothes, to her use and absence of makeup, Beyoncé frequently presents herself in an unglamorous and raw fashion in the image of everyday working-class life. Such grittiness, for example, is reflected in the use of a home video camcorder visual aesthetic. Her visual display deconstructs a politics of purity to the extent that the imagery of "Formation" collapses clear distinctions between vernacularized Black bodies and celebrity bodies demarcated as agents of cultural production valued by consuming audiences. The authenticity of "Formation" is sonically reinforced by selective moments that lack studio flourish. A prime example is the song's introduction, which features Beyoncé's untreated spoken-word vocals against a minimalist backdrop of a single synthesizer phrase. Her musical identification with Southern traditions, from her sampling of New Orleans rappers and use of Southern "trap"-style production (i.e., the prominent use of complex hi-hat beats and booming bass from drum machines, mainly the Roland-TR 808), underscores this ethos. Indeed, through these sonic strategies, she is able to orchestrate the diasporic sound franchise in ways that craft fugitive space for insurgency within the Black public sphere.

Yet the vision of Black authenticity proposed here moves beyond style itself and reaches deep into the tensions of the political. Historically, appeals to an "authentic" politics of Blackness—be they via nostalgia for Afrocentricity, the Black church, or the Nation of Islam—have succumbed to misogynistic and homophobic attitudes that have reinforced a gendered and queer divide. Through inclusive visual images of queer Black men in gay bars and samples of queer rapper Big Freedia, "Formation" unapologetically proposes a form of protest politics predicated on intersectional solidarity that, as Marquis Bey has put it, "exceeds the borders of Black normality" (2017, 165). Through raw sonic disruption and transgressive visual topoi, "Formation" reimagines protest under a sign of Blackness that is creatively unfinished and celebrates Blackness without reifying essentialist conceptions of identity.

Beyoncé's Celebration of Black Political Mobilization and Struggle against Injustice

In "Formation" Beyoncé does not merely settle for redeeming quotidian Blackness and proposing an insurgent intersectional coalition. Rather, when Beyoncé (2016b) says, "Okay, ladies, now let's get into formation," she makes a call for

action that celebrates the tradition of Black political defiance against injustice. With these lyrics, she reminds us of the crucial role that collective organizing by Black women—be it Ida B. Wells, Sojourner Truth, and countless others—has played in the history of American social justice movements.

This is significant because the castigation of the Black poor by the Black elite does not occur in a political vacuum. As Dyson observes, these ritualized condemnations "bolster the belief that less money, political action and societal intervention—and more hard work and personal responsibility—are the key to black success" (2005, 37). Indeed, the obsession with poor citizens of color and their shortcomings has been accompanied during the post–civil rights era by the emergence of new and insidious theories of racial hierarchy and pathology. Aside from Daniel Patrick Moynihan's infamous 1965 report that described the Black family as a "tangle of pathology" marked by high illegitimacy rates, non-existent fathers, and female-headed households, the period between the 1970s and 1990s witnessed the rise of texts such as Edward Osborne Wilson's *The New Synthesis* and *The Bell Curve* by Charles Murray and Richard J. Herrnstein that explained urban crime, welfare recipients, and single-parent households in terms of intersections between race, psychology, intelligence, biology, and genetics (Kendi 2016, 391, 431–32, 458–59).

The popular circulation of these ideas has informed a series of policy interventions since the 1980s and 1990s predicated on what Joe Soss, Richard C. Fording, and Sanford F. Schram have called "neoliberal paternalism." Neoliberal paternalism, they argue, presumes that after 1945, American social welfare policy began facilitating an erosion of social order and morality among the poor, which has necessitated the state to impose new forms of discipline and authority for what the policy sees as "the poor's own good." Thus, the perceived social disorder arising from the poor's affliction with teen pregnancy, single motherhood, criminality, and nonwork has been met with poverty governance policies that prioritize work compliance, more documentation of their behavior, intensified and increased surveillance and policing of their communities, and more incarceration (Soss, Fording, and Schram 2011, 24–27). The result of these policies has been a criminal justice crisis, which Michelle Alexander has aptly called the "new Jim Crow," marked by record incarceration rates and countless tragedies of unarmed citizens of color murdered by police (2010, 1–20).

Despite the emergence of "color blindness" in the wake of the Obama presidency, the living conditions for communities of color are a cruel reminder of the systemic racism that permeates American social life. The Great Recession

FIGURE 10.4 Beyoncé on top of a New Orleans police cruiser submerged
in floodwater with flooded homes in the background. Screenshot
from "Formation" video (*Lemonade* 2016b).

decimated the Black middle class and, as many have argued, came at a moment
when America's first Black president was largely reluctant to talk about race until
the combination of recurring tragic police shootings and white terrorism at the
Emanuel African Methodist Episcopal Church in Charleston, South Carolina,
gave him no choice.[6] Despite his efforts to reform health care and the criminal
justice system, an enduring irony of the Obama era will undoubtedly be that
during America's first Black presidency, a movement called "Black Lives Matter"
forcefully assumed America's conscience in an era of intensifying inequality and
white nationalism.

It is against these developments that "Formation" offers a forceful and unapolo-
getic response. Released only months after the tenth anniversary of Hurricane
Katrina, "Formation" makes several references to both New Orleans and polic-
ing. In Figure 10.4, we can see references to both as Beyoncé positions herself
on top of a New Orleans police cruiser submerged in floodwater with flooded
homes in the background. The image at once draws critical attention to the crisis
of overpolicing and the denial of Black humanity, but also harshly critiques the
pillaging and disposability of Black communities mired in what Naomi Klein

has called "disaster capitalism" (2007, 5–8, 406–38). Beyoncé's (2016a) lyrical reference to "albino alligators" can be understood as an admonishment about the dangers of white predatory capitalists who lurk to financially exploit Black suffering, be it through environmental racism, real estate and gentrification, or the unjust financial appropriation of Black musical and artistic styles by the culture industries. Beyoncé's (2016b) strategic use of visual imagery, through her position on the police car, her use of the middle finger, and her visual references to Dr. Martin Luther King Jr., symbolizes and celebrates the tradition of Black defiance against injustice.

The pathos and ethos of defiance is reinforced by "Formation's" mesmerizing sonic force. There is nothing soft about "Formation"; the 808 bassline is aggressive and tonally hard edged, and the use of horns in the choruses lends to the power of the song's bold critique. Musically, the song's production features a repeating tritone in the choruses and postchoruses, and this use of dissonance emphasizes her defiance through musical gesture. Compositionally, "Formation" uses an unconventional song structure and undermines what consumers have come to expect of Beyoncé's style. It resists catchy tunes and predictability, keeping the listener off-guard. By undermining common conventions of pop music, the song's structure reinforces the song's potent protest against our troubled times. "Formation" marks the political coming of age of one of the world's most powerful and publicly visible pop stars, who is willing to subvert the expectations of her own established reputation and celebrity brand in order to expand her creative boundaries for a higher calling.

The "Formation" music video ends with a panning shot of graffiti that reads, "stop shooting us," which is followed by an image of Beyoncé and the police cruiser completely submerged under the floodwater. This sequence of images visually illustrates Baldwin's warning at the end of *The Fire Next Time*, when he writes:

> If we—and now I mean the relatively conscious whites and the relatively conscious blacks, who must, like lovers, insist on, or create, the consciousness of the others—do not falter in our duty now, we may be able, handful that we are, to end the racial nightmare, and achieve our country, and change the history of the world. If we do not now dare everything, the fulfillment of that prophecy, re-created from the Bible in song by a slave, is upon us: *God gave Noah the rainbow sign, No more water, the fire next time!* (1993, 105–6)

In bold visual terms "Formation" ends by offering the following chastisement: if white Americans cannot confront their complicity in the unjust suffering of

FIGURE 10.5 Beyoncé and her dance troupe make
the Black Power salute during Super Bowl 50 (NFL 2016).

people of color, then the nation's racial history and its accumulated tensions
will destroy it and bring everyone down with it, and there will be no survivors.

CONCLUSION

Beyoncé's performance of "Formation" during the Super Bowl 50 halftime show
exemplifies what is possible when celebrities of conscience choose to strategically
leverage their symbolic power to protest social injustices. Adorned in the iconic
style of the Black Panthers and armed with the sonic force of the diasporic sound
franchise, Beyoncé and her dance troupe subverted the commodified gazes of
one of the largest mass media spectacles of late-modern culture. In Figure 10.5,
we see can how their performance symbolically channeled the Black Power salute
in tribute, not only to the legacy of Malcolm X and grassroots Black political
mobilization, but also to the Black Lives Matter movement. Beyoncé's dancers,
for example, used the occasion to call for justice for Mario Woods, a twenty-
six-year-old Black man killed by Bay Area police two months before the Super
Bowl (see Figure 10.6). Their transgressive act clearly unsettled the expectations
of many white consumers, prompting Republican congressman Peter King and
former New York City mayor Rudy Giuliani to claim that Beyoncé's performance
was "outrageous" and "anti-police" (Chokshi 2016a).

The consumption of politically charged popular music alone cannot resolve
complex social and political struggles because social change also depends on

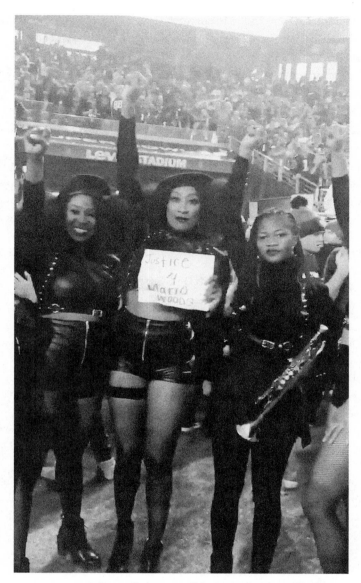

FIGURE 10.6 Beyoncé's dancers call for justice for Mario Woods, a twenty-six-year-old Black man killed by Bay Area police two months before Super Bowl 50 (BLM Bay area 2016).

democratic innovations and redesigns to the institutions of American neoliberalism. Indeed, the consumption of politicized celebrity brands and popular music represents only one dimension of the complex responsibilities involved with democratic citizenship. Nonetheless, in our troubled era of intensifying racial polarization and social inequality, it is a dimension of consumer citizenship that should not be discounted by scholars and should be actively leveraged by advocates for new and substantive forms of equality, cooperative self-determination, and democratic forms of sociality and associated living. The protest music of the diasporic sound franchise has and will continue to give birth to counterpublics that can help build a more just world, for the musical and the political cannot be divided. As Plato long ago observed, "Musical innovation is full of danger to the whole State. . . . When modes of music change, the fundamental laws of the State always change with them" (2008, 424b–424c).

NOTES

1. For an excellent account of the rise of "post-race" as a political signifier in the American post–civil rights era, see Roopali Mukherjee (2016a).

2. Mukherjee's argument on bio-branding is extended in her forthcoming book *The Blacking Factory: Brand Cultures and the Technologies of the Racial Self.*

3. The racial attitudes of self-identified "White" Americans is well documented (see Dionne, Ornstein, and Mann 2017, 119–71). The structures of systemic racism are also well documented (see Bonilla-Silva 2014, 25–72).

4. For an excellent genealogy of resentment as a significant emotion in the rhetoric of American politics see Jeremy Engels (2015). For an excellent account of the politics of white resentment, see Carol Anderson (2016) and Jonathan M. Metzl (2019).

5. For an excellent analysis of how Beyoncé's music videos call attention to the intersections of sexuality, race, class, and gender in the performance of Black womanhood, see Durham (2017). For an excellent extended analysis of Beyoncé's celebration of her own heritage and the regional aesthetics of East Texas/western Louisiana culture in "Formation," see Tanisha C. Ford (2019).

6. Both Dyson and Bonilla-Silva have made this argument (Dyson 2016, 154–225, 255–271; Bonilla-Silva 2014, 255–283).

REFERENCES

Alexander, Michelle. 2010. *The New Jim Crow: Mass Incarceration in the Age of Colorblindness*. New York: New Press.

Anderson, Carol. 2016. *White Rage: The Unspoken Truth of Our Racial Divide*. New York: Bloomsbury.

Badger, Emily. 2016. "How Airbnb Plans to Fix Its Racial-Bias Problem." *Washington Post*, September 8. https://www.washingtonpost.com/news/wonk/wp/2016/09/08 /how-airbnb-plans-to-fix-its-racial-bias-problem/?utm_term=.66b574d97c23.

Baldwin, James. 1962. "Letter from a Region in My Mind." *New Yorker*, November 17. https://www.newyorker.com/magazine/1962/11/17/letter-from-a-region-in-my-mind.

———. 1993. *The Fire Next Time*. New York: Vintage International.

Bey, Marquis. 2017. "Close-Up: Beyoncé: Media and Cultural Icon: Beyoncé's Black (Ab) Normal: Baad Insurgency and the Queerness of Slaying." *Black Camera: An International Film Journal* 9, no. 1: 164–78.

Beyoncé. 2016a. "Formation." *Lemonade*. Columbia, 2016, MP3.

———. 2016b. "Formation." YouTube video, 4:47. Posted by beyonceVEVO December 9, 2016. https://www.youtube.com/watch?v=WDZJPJV__bQ.

BLM Bay area [BLMBAYAREA]. 2016. @Beyoncé's Dancers and Band Want #JusticeMario Woods #Last3Percent #SB50 [Tweet], February 7.

Bonilla-Silva, Eduardo. 2014. *Racism without Racists: Color-Blind Racism and the Persistence of Racial Inequality in America*, 4th ed. Lanham, MD: Rowman & Littlefield.

Burns, Lori, and Melisse Lafrance. 2002. *Disruptive Divas: Feminism, Identity and Popular Music*. New York: Routledge.

Cashmore, Ellis. 2006. *Celebrity/Culture*. London: Routledge.

———. 2010. "Buying Beyoncé." *Celebrity Studies* 1, no. 2: 135–50.

Chokshi, Niraj. 2016a. "Rudy Giuliani: Beyoncé's Halftime Show Was an 'Outrageous' Affront to Police." *Washington Post*, February 8. https://www.washingtonpost.com/news /arts-and-entertainment/wp/2016/02/08/rudy-giuliani-beyonces-half-time-show-was -an-outrageous-affront-to-police/?utm_term=.fb1390c2dd1d

———. 2016b. "Boycott Beyoncé's 'Formation' Tour, Police Union Urges." *Washington Post*, February 19. https://www.washingtonpost.com/news/post-nation/wp/2016/02/19/boycott -beyonces-formation-world-tour-police-union-urges/?utm_term=.e97757591e1a.

Collins, Patricia Hill. 2008. *Black Feminist Thought: Knowledge, Consciousness, and the Politics of Empowerment*. New York: Routledge.

Cooper, Brittney C. 2017. *Beyond Respectability: The Intellectual Thought of Race Women*. Urbana: University of Illinois Press.

Craig, Byron B, and Stephen E. Rahko. 2016. "Visual Profiling as Biopolitics: Or, Notes on Policing in Post-Racial #AmeriKKKa." *Cultural Studies, Critical Methodologies* 16, no. 3: 287–95.

Denzin, Norman K. 2001. "Representing Michael." In *Michael Jordan, Inc.: Corporate Sport, Media Culture, and Late Modern America*, edited by David L. Andrews, 3–14. Albany: SUNY Press.

Dionne, Jr., E. J., Norman J. Ornstein, and Thomas E. Mann. 2017. *One Nation after Trump: A Guide for the Perplexed, the Disillusioned, the Desperate, and the Not-Yet Deported.* New York: St. Martin's Press.

Durham, Aisha S. 2014. *Home with Hip Hop Feminism: Performances in Communication and Culture.* New York: Peter Lang.

———. 2017. "Class Formation: Beyoncé in Music Video Production." *Black Camera* 9, no. 1: 197–204.

Dyson, Michael Eric. 2005. *Is Bill Cosby Right? Or Has the Black Middle Class Lost Its Mind?* New York: Basic Books.

———. 2016. *The Black Presidency: Barack Obama and the Politics of Race in America.* Boston: Houghton Mifflin Harcourt.

Engels, Jeremy. 2015. *The Politics of Resentment: A Genealogy.* University Park: Pennsylvania State University Press.

Ford, Tanisha C. 2019. "Beysthetics: 'Formation' and the Politics of Style." In *The Lemonade Reader*, edited by Kinitra D. Brooks and Kameelah L. Martin, 192–201. New York: Routledge.

Friedman, Jonathan C. 2013. "Introduction: What Is Social Protest Music? One Historian's Perspective." In *The Routledge History of Social Protest in Music*, edited by Jonathan C. Friedman, xiv–xvii. New York: Routledge.

Graham, Bryan Armen. "Donald Trump Blasts NFL Anthem Protesters: 'Get That Son of a Bitch off the Field.'" *Guardian*, September 23. https://www.theguardian.com/sport/2017/sep/22/donald-trump-nfl-national-anthem-protests.

Gray, Herman. *Watching Race: Television and the Struggle for Blackness.* Minneapolis: University of Minnesota Press, 1995.

Grossberg, Lawrence. 1992. *We Gotta Get Out of This Place: Popular Conservatism and Postmodern Culture.* New York: Routledge.

———. 1997. *Dancing In Spite of Myself: Essays on Popular Culture.* Durham: Duke University Press.

Hall, Wiley A. 2002. "Urban Rhythms: Hooray! Halle Berry Is a 'Bond girl' Now." *Afro-American Red Star* 111, no. 16.

Harold, Christine. 2007. *Our Space: Resisting the Corporate Control of Culture.* Minneapolis: University of Minnesota Press.

Hawkins, Stan. 2016. *Queerness in Pop Music: Aesthetics, Gender Norms, and Temporality.* New York: Routledge.

hooks, bell. 2016. "Moving beyond Pain." May 9. bell hooks Institute. http://www.bellhooksinstitute.com/blog/2016/5/9/moving-beyond-pain.

Hudson, Jerome. 2016a. "Beyoncé's Song 'Formation' a Big Wet Kiss to Black Lives Matter." *Breitbart*, February 6. https://www.breitbart.com/big-hollywood/2016/02/06/2961178/.

———. 2016b. "'Lemonade': Beyoncé Drops Album Full of Feminist, Black Lives Mat-

ter Propaganda in HBO Special." *Breitbart*, April 24. http://www.breitbart.com/big-hollywood/2016/04/24/beyonces-hbo-special-lemonade-nauseating-display-black-feminist-propaganda/.

———. 2016c. "Beyoncé Has Spent Years Stoking Anti-Police Sentiment." *Breitbart*, July 8. https://www.breitbart.com/big-hollywood/2016/07/08/texas-bama-beyonce-spent-years-stoking-anti-police-sentiment/.

Jackson II, Ronald L. 2006. *Scripting the Black Masculine Body: Identity, Discourse, and Racial Politics in Popular Media*. Albany: SUNY Press.

Kendi, Ibram X. 2016. *Stamped from the Beginning: The Definitive History of Racist Ideas in America*. New York: Nation Books.

Klein, Naomi. 2007. *The Shock Doctrine: The Rise of Disaster Capitalism*. New York: Metropolitan Books.

Kundnani, Arun. 2016. "Recharging the Batteries of Whiteness: Trump's New Racial Identity Politics." *Truthout*, December 13. http://www.truthout.org/news/item/38704-recharging-the-batteries-of-whiteness-trump-s-new-racial-identity politics.

Metzl, Jonathan M. 2019. *Dying of Whiteness: How the Politics of Racial Resentment Is Killing America's Heartland*. New York: Basic Books.

Moore, Allan. 2013 "Conclusion: A Hermeneutics of Protest Music." In *The Routledge History of Social Protest in Music*, edited by Jonathan C. Friedman, 387–99. New York: Routledge.

Mukherjee, Roopali. 2016a. "Antiracism Limited: A Pre-History of Post-Race." *Cultural Studies* 30, no. 1: 47–77.

———. 2016b. "Bio-Brand in the Blacking Factory: Material Cultures and the Technologies of the Racial Self." Keynote address presented at Digesting Discourses: Taste, Appetite, and Consumption Conference, Indiana University–Bloomington, Bloomington, March 4.

———. Forthcoming. *The Blacking Factory: Brand Cultures and the Technologies of the Racial Self*. Minneapolis: University of Minnesota Press.

Muñoz, José Esteban. 1999. *Disidentifications: Queers of Color and the Performance of Politics*. Minneapolis: University of Minnesota Press.

Neal, Mark Anthony. 1999. *Soul Babies: Black Popular Culture and the Post-Soul Aesthetic*. New York: Routledge.

NFL. 2016. "Coldplay's FULL Pepsi Super Bowl 50 Halftime Show feat. Beyoncé & Bruno Mars!" YouTube video, 13:11. Posted by NFL February 11. https://www.youtube.com/watch?v=c9cUytejf1k.

Noble, Safiya Umoja. 2018. *Algorithms of Oppression: How Search Engines Reinforce Racism*. New York: New York University Press.

Phillips, Kendall R. 2002. "Spaces of Invention: Dissension, Freedom, and Thought in Foucault." *Philosophy and Rhetoric* 35, no. 4: 328–44.

Plato. 2008. *The Republic*. Translated by Benjamin Jowett. New York: Cosimo Classics.

Redmond, Shana L. 2013. *Anthem: Social Movements and the Sound of Solidarity in the African Diaspora*. New York: New York University Press.

Sieczkowski, Cavan. 2014. "Feminist Activist Says Beyoncé Is Partly 'Anti-Feminist' and 'Terrorist.'" *Huffington Post*, May 9. https://www.huffingtonpost.com/2014/05/09/beyonce-anti-feminist_n_5295891.html.

Smith, Marquita R. 2017. "Beyoncé: Hip Hop Feminism and the Embodiment of Black Femininity." In *The Routledge Research Companion to Popular Music and Gender*, edited by Stan Hawkins, 229–41. London: Routledge.

Soss, Joe, Richard C. Fording, and Sanford F. Schram. 2011. *Disciplining the Poor: Neoliberal Paternalism and the Persistent Power of Race*. Chicago: University of Chicago Press.

Squires, Catherine R. 2014. *The Post-Racial Mystique: Media and Race in the Twenty-First Century*. New York: New York University Press.

Stewart, Lindsey. 2019. "Something Akin to Freedom: Sexual Love, Political Agency, and *Lemonade*." In *The Lemonade Reader*, edited by Kinitra D. Brooks and Kameelah L. Martin, 19–30. New York: Routledge.

Wall Street Journal. 2008. "President-Elect Obama: The Voters Rebuke Republicans for Economic Failure." *Wall Street Journal*, November 5. https://www.wsj.com/articles/SB122586244657800863.

Weidhase, Natalie. 2015. "'Beyoncé Feminism' and the Contestation of the Black Feminist Body." *Celebrity Studies* 6, no. 4: 128–31.

PART SIX

"Freedom"
Sounding Protest,
Hearing Politics

Like Byron Craig and Stephen Rahko in Chapter 10, Annelot Prins and Taylor Myers examine Beyoncé's 2016 Super Bowl performance of "Formation," as well as her performance of "Freedom" at the 2016 BET Awards. In Chapter 11, they explore themes of protest expressed musically in these songs, arguing that part of their power is rooted in how they call on earlier traditions of Black political song, especially music related to the US civil rights movement. Their musicological analysis highlights the interconnections of the music recording, its production, and its particular song forms to make connections to the political potential of performances presented within Beyoncé's live performances and music videos. In Chapter 12, Rebekah Hutten and Lori Burns also engage in close musical analysis through what they call "multimodal intertextual analysis" that examines the musical, visual, and narrative aspects of "Sorry." Their analysis takes the creative work seriously, showing how the different elements reinforce themes of intersectional feminism.

11. Musical Form in Beyoncé's Protest Music

Although much scholarly and public attention focuses on the activism in Beyoncé's lyrics, visuals, and interviews, there has been comparatively little engagement with activism in her music. Likewise, studies of her music have not satisfactorily interacted with her celebrity status and extramusical politics. Her music and stardom are nevertheless thoroughly entwined. In this chapter, we shed light on how Beyoncé creates musical structures that underline the political messages central to the cultivation of her star text. Our understanding of star texts is informed by Richard Dyer's definition of the concept. Dyer argues that star texts consist of all publicly available material related to a celebrity, making them always extensive, multimedia, and intertextual (1998, 2003, 3). He claims that through the study of star texts, we are able to analyze how stars live out and expose the tensions within accepted ideological constructions in society (2003, 7). A star text is never able to reach a stable point of meaning because of its complicated relation to the society in which it exists. In this chapter, we analyze Beyoncé's star text, including her music, to gain an understanding of the evolving relationship between her persona and the political debates resonating in US society.

Beyoncé's star text has never been apolitical. Daphne Brooks and Alicia Durham have pointed out that articulations of Black femininity, which can be read as political in and of themselves in their US context, have always been present in Beyoncé's oeuvre (Brooks 2008; Durham 2012). However, these musical politics were expressed differently earlier in her career, illustrative of older post–civil rights culture, and focused on wrapping political messages in subtlety. In the mid- to late 2010s, Beyoncé's musical politics were rearticulated in much more explicit detail. Star texts, because of their inherently unstable nature, constantly

react and rearticulate according to the changing contexts in which they exist. Beyoncé's star text underwent a transformation over time as music evolved with the sociopolitical history of the United States, which resonates in her use of musical form and sonic references. Beyoncé's relationship between musician and intended audience has matured as US culture has polarized around issues such as Black Lives Matter.

Specifically, we contend that in her most explicitly political songs, Beyoncé moves toward forms favored in Black musical genres, as demonstrated in two songs from *Lemonade* (2016). On the track "Formation," Beyoncé deviates from certain organized phrase forms and standard verse/chorus forms, on which modern pop listeners are dependent. In "Freedom," she disrupts mainstream conventions in order to make sonic references to Black musical cultures that enhance her musical form and strengthen the activist elements in her star text. These two musical strategies have two effects. First, the lack of a familiar form makes listeners strain, causing them to listen more carefully and hear the political message presented. Second, the references to Black musical genre tropes provide the possibility of a reading that grounds Beyoncé in a long lineage of protest music and firmly positions her in a politicized Black Southern context. Ultimately, the use of particular song forms as political strategy is mirrored by the ascent of her celebrity activism in the feminist and Black Lives Matter movements. They co-construct and strengthen each other.

In this chapter, we analyze how both strategies are employed differently in televised performances and recordings. We show how Beyoncé's televised performances musically foreground these strategies even more than the album versions, using the performance of "Formation" during the Super Bowl halftime show (2016) and the performance of "Freedom" during the Black Entertainment Television Awards (BET) in 2016. These performances, because they were televised live, have added elements of choreography and fashion that help Beyoncé project protest narratives. Both songs come from Beyoncé's 2016 album, *Lemonade*, which relies on long-form narrative to tell multiple stories simultaneously, whereas the televised performances rely on short, singular narratives.

Lemonade, as a long-form cultural product, uses the double-voiced utterance to lament struggles with infidelity in personal relationships, as well as provide narratives that discuss gendered, racialized, and sexualized inequalities in US society both visually and lyrically. The double-voiced utterance allows a specific word or phrase to take on two meanings simultaneously, playing into Black as well as white discourses (Gates 1988, 50–51). The double-voiced utterance is a form of

signifyin(g)[1] in which a layer of implied meanings in a specific cultural product becomes accessible for specific members of the African American community, who are more likely to have the knowledge about Black popular culture necessary to understand the tropes and references used (Gates 1988; Brackett 1995).[2]

Lemonade relates a personal story of a woman scorned as it simultaneously tells a grand American story about histories of inequality and their lasting effects. As we noted, the double-voiced utterance has a long tradition in African American literature and music. We, however, argue that two specific performances of "Formation" and "Freedom" privilege a politicized reading over a personalized reading, almost doing away with the layered meanings altogether, or perhaps reducing them to an aesthetic musical functionality embedding the songs in Black musical history in favor of the anthemic potential of the songs in their context of global pop-cultural consumption. In her book, *Anthem: Social Movements and the Sound of Solidarity in the African Diaspora* (2014), Shana L. Redmond discusses how coded language, musical form, and performance culture are embedded in a long history of music making in racial communities (2014, 11). For the anthems she analyzes in her work, she discusses their sonic regimes but also their pedagogical and organizational importance: these are songs for mobilization. In order to inform and mobilize, these songs have to be able to allow "outsiders" to "connect with populations beyond their immediate reach" (9). Redmond argues that this interplay among artists, audiences, and publics enables anthems to be both result and creator of historical momentum.

The televised performances of "Formation" and "Freedom" discussed in this chapter foreground the narrative that focuses on gendered, racialized, and sexualized inequalities in the United States while the attention to infidelity and personal relationships is set aside. On the visual album *Lemonade*, both narratives are present, their duality strengthened by poetry, visuals, and other contextual elements. By presenting both songs as protest music anthems, their televised performances foreground the politicization of Beyoncé's star text.

THE POLITICAL FUNCTIONS OF BEYONCÉ'S MUSICAL FORM

A piece's musical form dictates how sections are organized and into what categories those sections could fall. We will be using the section roles as defined by Trevor Declercq: verse, chorus, refrain, bridge, solo, prechorus, and link (2012). Within a song, these roles perform different duties. For our purposes, we will be

investigating the role of verse, chorus, and bridge most closely. The verse typically moves a story forward and is repeated with different lyrics each time (Covach 2009). For example, the lyrics in Beyoncé's "Crazy in Love" (2003) describe an attraction that becomes increasingly serious for the protagonist. The chorus, the most memorable section of a piece's form, usually contains the titular lyric and has a "fixed text of several lines" (Covach 2009; Stephenson 2002, 234). In "Crazy in Love," this is clearly delineated by the climax of timbral intensity and the repetition of the line, "Got me looking so crazy right now." The bridge is a section of timbral, harmonic, and melodic contrast, usually iterated only once after all other sections have been stated. It is usually followed by more occurrences of the chorus. It can be used to alter the intensity of the preceding material, either to intensify or deescalate the energy of the song. In "Crazy in Love," this is the section after the rap verse. "Crazy in Love" also features a rap verse between a chorus and the bridge.[3]

We use "Crazy in Love" as a base for Beyoncé's standard form because it materializes in Beyoncé's biggest hits, such as "Baby Boy" (2003), "Irreplaceable" (2006), "Halo" (2008), "Single Ladies" (2008), and "If I Were a Boy" (2008), with occasional variety in the presence of rap verses or extended bridges.[4] This collaboration with Jay-Z, whom she later married, functioned as a springboard for Beyoncé's solo career. Despite rearticulating Beyoncé's star text as independent from Destiny's Child, "Crazy in Love" does nothing revolutionary in terms of form, which makes it a fitting song to introduce the normative form on which our examples rely. Two separate instrumentations in the chorus and the verse are constant throughout the song. The bridge is a combination of chorus and verse material, and Beyoncé's call of "uh-oh" over the verse material serves as a link between sections. Jay-Z's prolonged rap verse was not common at the time, but is a slight variation of the verse/chorus form and perhaps hinted at the young couple's romantic entangling. This is the outline of the form for "Crazy in Love":[5]

Intro (0:00–0:29)
Verse 1 (0:29–0:48)
Chorus (0:48–1:08)
Verse 2 (1:08–1:37)
Chorus (1:37–2:00)
Rap Verse (2:00–2:45)
Bridge (2:45–2:59)
Chorus (3:00–3:55)

The use of conventional and familiar forms makes hearing this music comfortable and accessible. Dating back hundreds of years, forms of repetition have been privileged in common practice, as exemplified by repeat signs, sonata recapitulations, and da capo aria form. Repetition is privileged at every level in music like Beyoncé's, from surface rhythms to repeated chord progressions and recurring sections. The model is typical with good reason: listeners should be familiar with the piece, getting it stuck in their head, in order to buy it. Repeated choruses and even verse melodies help guide this aim. Beyoncé's "Crazy in Love" is a representative and convincing example of this type of repetition.

In 2013, Beyoncé began hybridizing form in political songs to force listeners to hear a deeper message. For example, "***Flawless" from 2013's *Beyoncé* combines angst music, hip-hop braggadocio, and a long sample of Nigerian author Chimamanda Ngozi Adichie's TED Talk on feminism. The sampled voice of Adichie discusses female ambition and sexual freedom and ends with the dictionary definition of *feminism* that states a feminist is "a person who believes in the social, political, and economic equality of the sexes" ("***Flawless" 2013).

It is no surprise that the musical form of "***Flawless" is in itself unconventional: it is meant to grab the listener's attention. The song begins rather predictably, with two verses of the same melodic content. Typically, a prechorus functions to build up anticipation for a chorus. Here, the prechorus also builds up the song. The repeated phrase, "Bow down, bitches," the increasingly aggressive vocal strain, the rising volume of the synth, and finally the heightened surface rhythm of the drum track all are anticipatory in nature. However, while an experienced listener might expect a beat drop to follow with a dynamic chorus, it is instead followed by introductory material. This deception is occasionally used in this genre to return to the verse and leads into the chorus only the second time around, but in "***Flawless," the chorus to this prechorus never arrives. It is deceptively followed by Adichie's extended sample over the new sparse accompaniment of plucked strings and Beyoncé's ethereal head voice, with drum hits sporadically added. This sample is so long—lasting nearly one minute—that it almost erases the previous content from the listener's memory.[6]

It is perhaps by design, then, that after the Adichie sample, "***Flawless" has changed melody, harmony, lyric content, and other elements to create the new verse beginning, "I wake up (flawless) post up (flawless)." The new verse uses the same instrumentation as Adichie's sample. Because it is timbrally different from the first half, one could easily confuse it with a bridge, although its functions and properties in context are much more like a verse. However, this is followed by

the only thing one could consider a chorus in this song: "I woke up like this" and "I look so good tonight." We are calling this a chorus only because of its rate of repetition in the song in its entirety. Not much about the instrumentation changes in this section: it adds only a few extra drum hits or Beyoncé's voice, which adds some background doublings,. The intensity of this chorus builds through accelerated surface rhythms in the drum hits and culminates with Beyoncé's rap verse with new instrumentation. The end of the rap verse overlaps with the subtler, less intense new verse and chorus repeat, distinguishing them from the larger texture and thicker accompaniment of the rap verse. This transition gives the listener little time to acclimate to the new patterns, because this section is just two minutes of the total 4 minute, 16 second song. The disparate content before and after the sample could be considered as two separate songs, resulting in a feeling of unsettled discomfort:

Intro (0:22–0:31)
Verse (0:31–0:58)
Prechorus (0:58–1:11)
Intro (1:11–1:27)
Spoken (1:27–2:21)
New Verse (2:22–2:35)
Chorus (2:35–3:03)
Rap Verse (3:03–3:11)
Chorus (3:11–3:53)[7]

This is striking compared to other songs on the *Beyoncé* album, which addressed fewer social issues. "Drunk in Love," featuring Jay-Z, was the biggest hit of the album. This song follows a relatively standard form in which even the forays away from the verse melody have appropriately similar accompaniment. As in "Crazy in Love," Jay-Z performs a lengthy rap verse, but the accompaniment remains the same throughout, so the change is less noticeable.[8] This return to a standard song construction for Beyoncé, in her lyrics, their message, and the broader form, reinforces that Beyoncé's ability or desire to produce a conventional form has not been compromised.

The structural decisions made on *Lemonade*, as well as *Beyoncé*, indicate that political songs have political forms, urging the audience to listen to their message, while classically novel yet predictable songs represent a more digestible entertainment format. This dualism is visible in Beyoncé's star text as well: she

allows for a reading of her image as activist as much as she provides the opportunity of a reading of her as a captivating entertainer. Unlike Nina Simone, whose political messages about racism and sexism led to fewer performance invitations in the mid-1960s, Beyoncé has not been coerced into rejecting either aspect of her star text to date.

The form of "Formation" (2016), written by Swae Lee and Beyoncé and produced by Mike WiLL Made It, is nothing like that of "Crazy in Love" (see Table 11.1). Whereas "Crazy in Love" follows a pattern set by Beyoncé and her contemporaries, "Formation" keeps listeners guessing. The first two minutes proceed in a categorizable and expected structure. The verse, prechorus, and chorus are clearly delineated and perform their functions as anticipated, including a beat drop at the end of the prechorus that leads into the chorus (unlike in "***Flawless"). The verse is repeated verbatim with identical lyrics, which is uncommon for this genre but not unheard of. Overall, these two minutes are standard.

The disruption of the form begins at 2:00. After being lulled into the verse/chorus pattern, Beyoncé sings a bridge (2:00–2:17, "I see it, I want it"). It sounds like a bridge because it has capitalized on the buildup of intensity that has been stewing, with impressive drum hooks and a full marching band backing Beyoncé's new lyrics. The plucked minor-third hook that was present throughout even the spoken samples in the first half is now exchanged for big synth sounds. However, this is followed by a less intense new section (2:17–2:41, "I go hard / I slay"), which uses accompanying material from the original verse but contains new vocal phrases and lyrics, constituting what could be called a second bridge. This accompaniment is then topped with more new material and a mimicked electronic key change at 2:41. Here, Beyoncé finally sings the titular word, *formation*, and is joined by backing vocals. In retrospect, although it takes nearly three minutes to achieve, there is finally a better contender for the role of chorus. When a fourth consecutive section of new material arrives, it is now easier to perceive this as a bridge because it follows some clear chorus material. This is the last portion of new material, and the last minute repeats the same confusing structure of the second minute. Although the basic hook of a minor third is present and salient throughout the majority of the song, Beyoncé's varied melodic lines and phrase structures make each section distinct and not easily categorizable.

It is important to note that no vocal material from the first two minutes is repeated anywhere in the second half, making the large-scale structure of "Formation" identical to that of "***Flawless"—the song in which Beyoncé claimed the feminist label and in that way explicitly politicized her star text.[9] "Formation"

TABLE 11.1 Form of "Formation" on Lemonade Album (2016)
and as Performed at Super Bowl 50

FORMATION (*Album Version*)	FORMATION (*Super Bowl Version*)
Intro (Link Material) (0:05–0:21)	Chorus 2 (4:08–4:24)
Verse/Link (0:21–0:37) [Y'all haters corny]	Outro (chorus 2) (4:24–)[1]
Prechorus (0:37–0:45) [My Daddy Alabama]	Chorus 2 (0:07–0:23)
	Prechorus (0:26–0:35)
Chorus (0:45–1:01) [I like my baby heir]	Chorus (0:35–0:49)
Link Mat. (1:01–1:22)	*Bridge (0:49–1:05)*
Verse/Link (1:22–1:38) [Y'all haters corny]	Bridge 2 (1:05–1:27) (overlaid
Prechorus (1:38–1:45) [My Daddy Alabama]	with bridge music)
	Chorus 2 (1:27–Dance-off)
Chorus (1:45–2:00) [I like my baby heir]	
Bridge (2:00–2:17) [I see it]	
Bridge 2 (2:17–2:41) [I go hard/I slay]	
Chorus 2 (2:41–2:57) [Ok ladies]	
Bridge 3 (2:57–3:13) [When he]	
Bridge 4 (3:13–3:27) [I might get your song played]	
Bridge (3:27–3:44) [I see it]	
Bridge 2 (3:44–4:08)	

1. These formal sections have been very liberally codified. In order to substantially describe a form like this or "***Flawless," we might turn to Brad Osborn's work on post-millennial progressive rock through composition. Despite the obvious genre differences between his corpus and ours, the terminology "section group" and referring to sections by letter number as opposed to function are tempting in our work. However, Beyoncé's music is not through-composed, and the sections do often evoke a specific function. If one were to use Osborn's terminology, the first two minutes would constitute section group I, and the last two would be section group II.

rejects the norms of predictability by favoring short, surprising new sections. Each section takes only a few seconds before proceeding to more new material. The average section is only about fifteen seconds, nearly half of "Crazy in Love"'s thirty seconds per section. The shorter section length leaves less time to become acclimated to the section's patterns: harmonic hooks, melodic content, and drum rhythms. Combined with the fact that these sections are not fully repeated, the

form of the song seems to work deliberately to discomfort listeners. There is no concerted effort to get this song stuck in the listener's ear. In this song, Beyoncé is not interested in making her audience feel comfortable: she has a message to project.

Lyrically, "Formation" can be read as a Black feminist call to arms, as well as a pledge of allegiance to the Black community. Beyoncé centralizes her own genealogy in her lyrics, singing, "My daddy Alabama, momma Louisiana, you mix that negro with that Creole make a Texas bamma." She situates herself specifically in Black Southern American culture. With "earned all this money but they never take the country out me," she emphasizes her devotion to her roots and a moment before fame, a well-known strategy that celebrities use to authenticate their stardom.[10] Beyoncé reminds her audience that however global her outreach might be, she first and foremost remains a Black woman from the South. Her stance is strengthened by the intertwinement of her star text and lived and embodied experiences: the lyrics cause a collapse between the person Beyoncé and the persona of Beyoncé. This fusion supports the performance's authentic feel. It provides audiences, especially a generation of Black women and girls, with ample opportunity for reparative readings as described by Omise'eke Tinsley in her book *Beyoncé in Formation: Remixing Black Feminism* (2018, 12).[11]

THE SUPER BOWL HALFTIME SHOW PERFORMANCE OF "FORMATION"

The day after the online release of "Formation," Beyoncé performed the song during the Super Bowl 50 halftime show (2016). Although the show was headlined by Coldplay and also featured Bruno Mars, its most discussed moment came from Beyoncé.[12] In her performance, the form of the song was heavily altered, but not in the interest of making viewers more comfortable (see Table 11.1).

In the 1 minute, 26 seconds during which Beyoncé occupies the full stage, she does not repeat a vocal melodic section. The instrumentation from the bridge returns in the second bridge but works with the original music from that section, so it does not provide the stable predictability to which viewers are accustomed. For comparison, within the first 1 minute, 30 seconds of Coldplay's performance, they repeat one of the only two sections they have performed so far. The band consistently repeats sections throughout their performance, despite reproducing abridged versions of each song. Beyoncé's formal disruption is thus intensified

in the televised performance in the song itself as well and through her position between two artists who typically rely on traditional forms.

The form is not the only object musically altered. Beyoncé combines two sections to sing: "Okay ladies, now let's get in formation / Prove to me you got some coordination. / You might just be a Black Bill Gates in the making." By combining these lines, she is not only speaking directly and solely to Black women, but she urges them to take coordinated control and claim success. As one might expect, this alienated a large percentage of the viewership of the Super Bowl halftime show, which did not expect its entertainment to be so explicitly mixed with politics. Moreover, it disrupted the maleness of the event: with its male sportsmen and the performances of Coldplay and Bruno Mars before hers, Beyoncé, with her own presence as well as lyrically, inserted and centralized Black women into the event.

While Coldplay and Bruno Mars made as much contact with the cameras recording the performance as with the live audience in the stadium, Beyoncé's sole focus was on the cameras, seemingly looking right at the viewers watching the screens on which she was visible, in both the stadium as well as in the houses of those watching at home. Her interaction with the camera was void of intruders. For example, no audience reactions were visible during her performance. We understand this as a deliberate decision, since visible audiences are often used to shape the public opinion of a performance (Marshall 1997, 63). By not including the audience's reaction to the performance, Beyoncé not only remained the focal point of the performance but also disrupted the guided and comfortable experience of the show and encouraged a reading of her performance as different from the rest of the show.

Her looks into the camera, direct references to Black women, and apparent aim to make white viewers uncomfortable might also be read as a performance of the Brechtian V-effect or process of defamiliarization (Willett 1964). The V-effect is used to estrange an audience from a performance. It breaks the fourth wall that allows audiences to be absorbed by what they see and underscores the artificiality of the performance being consumed. According to Brecht, who first used the term in 1936, the V-effect makes it difficult for audiences to simply identify themselves with a performer. It forces audiences to consciously, rather than unconsciously, consider the performer's actions and utterances. In other words, the V-effect encourages audience members to consume a performance actively rather than passively.

Beyoncé also uses her choreography and fashion to communicate her message

of Black pride and emancipation to the audience. Whereas Bruno Mars and his dance crew focused mostly on entertaining the audience with their dance moves, Beyoncé's dance moves referred to histories of antiracism and Black culture. She and her dancers took to the stage accompanied by militaristic drums and dressed in outfits referencing the Black Panthers, which celebrated its fiftieth anniversary that year. Within seconds, she and her dancers gave the well-known Black power salute. All of this helped to make the performance into a media event, a cultural moment, remixing the aesthetics and sensibilities of a Black protest culture yet never explicitly specifying the current political context of protest.

Beyoncé, wearing a leather jacket referencing Michael Jackson's iconic 1992 Super Bowl halftime show, smiled defiantly into the camera, directly meeting our gaze. In what followed, she choreographically positions herself as the driving force of the movement she is creating. For example, her dancers formed a V-formation behind her, an arrangement reinforcing the image of an army of women rallying behind their leader. The V is in itself a powerful historical symbol that was used during and after World War II to highlight victory over both the fascism abroad and racism at home. When they subsequently form a human arrow that flows toward and away from Beyoncé, a reading of Beyoncé as Black activist leader was again visually enforced. Much of the choreography referenced the drum and bugle moves of Southern dance crews, many of them highly competitive and well known for their creative formations. The performance presented Beyoncé, at the center of political engagement, as a driving force for social change. Later, the dancers created an X out of their bodies, filmed from above, referencing Malcolm X. In this performance, the music, lyrics, outfits, and choreography all came together to articulate a political statement while simultaneously creating a cultural moment and reinforcing a reading of Beyoncé's star text as both celebrity and activist.

The televised performance seemed to provide a clear message about antiracism and its relation to US history. As Michael R. Real argues, the Super Bowl "reveals specific cultural values proper to American institutions and ideology" (1975, 31). Although Real mostly implies values such as competitiveness and ambition, we could just as well argue that the appropriation of protest in this halftime show incorporates another set of self-claimed and often mythologized American values, mainly freedom of speech and, by extension, the freedom to dissent or protest.

Media events like the Super Bowl are constructions rather than reflections of the social order. Nick Couldry argues these events are "processes which construct

not only our sense of a social 'centre,' but also the media's privileged relation to that 'centre'" (2003, 56). This is important to consider because Beyoncé's performance during the halftime show was a planned and meticulously designed performance. It was a scheduled disruption, one that was premeditated in its incorporation into the event. Moreover, the Super Bowl is a hypercapitalist event. The winning teams win an incredible sum of money, the commercials cost a fortune to air, and the halftime show performers are the highest-earning artists of the United States.

The Super Bowl halftime show performance can arguably be read as the ultimate appropriation and usurpation of Beyoncé's radical potential precisely because she was incorporated into a Coldplay and Bruno Mars show. Mako Fitts Ward argues that Beyoncé glamorizes radicalism but never gets to its actual implementation. She concludes, "While there is deep cultural longing for what she represents to thrive amidst a mediascape that historically has demonized Black women, Beyoncé's fetishized Black feminist radicalism has transformed the politics of social movements into a set of commodities that ultimately sustain her personal empire" (2017, 148).[13] It could be argued that her brief performance became just another form of entertainment as much as it became a cultural moment or media event. The performance of radicalism became rearticulated as just another aspect of US culture and therefore integrated into the fold of mass entertainment in this highly symbolic yet conventional setting.[14]

REFERENCING BLACK MUSICAL HISTORIES

Another formative protest song from Beyoncé's *Lemonade* is "Freedom," a traditional soul anthem featuring rapper Kendrick Lamar.[15] Its distinctive sound relies on a sample of the organ in Puerto Rican band Kaleidoscope's song "Let Me Try" (1969). It also features a sample of a field recording of Reverend R. C. Crenshaw's "Collection Speech/Unidentified Lining Hymn" (1959), recorded by Alan Lomax, and a sample of the African American spiritual "Stewball," here using a recording of Prisoner 22 at Mississippi State Penitentiary (1947).

Nuanced differences make "Freedom" a very different kind of protest song from "Formation." The two songs contrast in function and therefore in musical elements. On its surface, "Formation" functions as a dance hit, akin to "Baby Boy" or "Single Ladies." This is indicated by the synth beat and the beat drops. In the second half of the song, each subsequent section raises the intensity of the energy. "Formation" would fit well in the dance scene, which values compelling

beats and repetitive hooks over interesting harmonic progressions or impressive vocality. The function of "Freedom" is much different. Although the syncopated drums still indicate a dancing rhythm, the focus on Beyoncé's prodigy as a singer and the narrative storyline place this in a category more akin to the R&B ballad. Another indication that this song aims beyond being a dance hall hit is the prominence of the pitched instruments (gospel choir, bass, organ), whose timbre is more salient in this song.

Aside from these sonic differences, "Formation" explicitly speaks to Black culture in its lyrics, referencing genealogy, hot sauce, natural textured hair, "Jackson 5 nostrils," and other culturally specific Black expressions and experiences. It is addressed to Black women, approaching something like a call to arms. "Freedom" is much subtler in its references, producing a replication of the Black zeitgeist of the social consciousness of the 1960s that could be understood only by those aware of the musical history of the Black liberation struggle. In her book on anthems, Redmond describes how Black anthems exist in this interaction specifically, building on the music and movements before them: "Politically, socially, and culturally they expanded previous paradigms and tactics, sometimes offering correctives to the preceding anthems" (2014, 15). Rather than a call to arms, this song focuses on the ongoing nature of the battle against racial inequality perpetuated for centuries.

Particular metaphors, including wading through the waters,[16] raining and thunder, and the constant references to God allude to a Black culture passed down through spirituals and informed by American Southern church culture. The mixture between the sacred and secular in Black popular musical traditions has been much discussed.[17] This subtlety is specifically reminiscent of R&B conventions that mix sacred styles and tropes with semisecular love songs, adding to a Black politics of pride and solidarity (Smethurst 2013, 110).

The song also contains more obvious references, for example, to marching in streets and breaking chains. The lyrics connect to the civil rights message of the early 1960s R&B and soul music, in which the singer/speaker is placed at the center of the action ("I break chains all by myself") and in extension becomes the focal point for the collective "we." David Brackett calls this narratological strategy the "hyperbolic glorification of the self" and terms the conflation between narrator and hero the "Intrusive I" (1995, 123–24). The Intrusive I in "Freedom" lyrically presents Beyoncé as a surrogate for African Americans and their struggle against oppression. This is nothing new; Daphne Brooks's (2011) work on Beyoncé shows how this strategy has often been employed throughout the singer's career.

It is not only the lyrics that incorporate Blackness into the song. The sparse

accompaniment of the drum during the verse, the heavy use of the blues scale, and the gospel choir and organ during the chorus are all crucial elements of popular music taken from African, early Black American, and soul music traditions. Portions of "Freedom" refer directly to "Think" by Aretha Franklin (1968). In this song, Franklin seemingly confronts a lover to reconsider her feelings, pleading that they stay together, citing the fact that they are stronger together. One lyric in "Think" stands out but does not function within the narrative: "Let your mind go, let yourself be free." It is from this line that Franklin draws the climactic though out-of-place bridge to the song: a fifteen-second foray from A major under the repeated word *freedom*. Harmonically, this section makes little conventional sense, moving between A, C, and D major chords. The upward-moving steps create a tension that is not altogether resolved in the final, climactic A major chord, though it does segue into a new key, a half-step higher than the original for the next verse.

This section imbues Franklin's song with civil rights clout and reframes the rest of the song from the position of the wronged lover to wronged Black American citizen. This relates to the tradition of the double-voiced utterance and use of "coding" or "signifyin(g)" in African American music history. Adam Gussow, writing specifically on the blues, argues, for example, that "the 'loss' half of the love-and-loss dialectic articulated by blues song is a way of transcoding such tribulations and torments: the bluesman sings of romantic mistreatment as a way of signifying on and mourning the 'sadder blues' of racial mistreatment" (2002, 56). Although "Think" cannot be called a blues song—most of Franklin's work is a mix of gospel and soul—a reading of her songs as coded is encouraged by Franklin's activism in the civil rights era. Her cover of Otis Redding's "Respect" is an example of her skillful transformative powers, which endowed songs that seemingly discussed love relationships with a new purpose as songs that encouraged and celebrated Black female empowerment (Smethurst 2013, 118). This is a narrative echoed throughout Beyoncé's *Lemonade*.

To highlight this comparison, the chorus of Beyoncé's "Freedom" follows the exact harmonic steps of "Think." At "I break chains all by myself" Beyoncé signifies breaking out by jolting the same surprising chromatic harmonic progression as Franklin. In "Freedom," the original key is D minor, but the F and G major chords during this break are in the same relationship to the tonic as Franklin's bridge in "Think." This correlation is not incidental: the concept of "Freedom" is a large part of both pieces.[18]

The form of "Freedom" falls into Beyoncé's standard form:

Intro (0:00–0:28)

Verse 1 (0:28–0:51)

Prechorus (0:51–1:01)

Chorus (1:02–1:24)

Link (1:24–1:47)

Verse 2 (1:47–2:10)

Prechorus (2:10–2:20)

Chorus (2:20–2:42)

Link (2:42–2:54)

Rap verse over verse and prechorus material (2:54–3:40)

Chorus (3:40–4:02)

Link (4:02–end)

But this section-within-section format found in the chorus is still unpredictable. The chorus has three parts: the titular call of "Freedom," the modulation step upward, and the final line, presented without accompaniment: "Imma keep running 'cause a winner don't quit on themselves." These three portions pass quickly and do not provide much continuity with each other.

This song does not need to defamiliarize or discomfort listeners with unpredictable musical forms because it is first and foremost directed toward the Black community with direct lyrical and musical links. Its political message is communicated through sonic references rather than processes of musical disruption. Beyoncé's performance enables the predictability of the song to drive the protest movement it invokes but still projects a sense of urgency with small minisections in the chorus. Here, she uses the predictable verse/chorus form to hearken back to an older Black protest tradition. As much as "Formation" forced people to listen, centralizing Beyoncé's Black feminist narrative within the structure of the formerly apolitical halftime show, "Freedom" anchors Beyoncé in a long lineage of civil rights music and thus functions differently. "Formation" takes up space where it is normally not granted, aimed at an etic audience that probably will contain many white people; "Freedom" speaks to an emic audience and a long cultural history of protest music.[19] This difference in targeted audiences is central to both the design of these performances and their evaluation.

The swelling harmony in the middle section of "Freedom's" chorus can be likened to electronic dance music (EDM) soars, as theorized by Robin James. James offers a convincing explanation for the popularity of soars in music, relating them to broader neoliberal regimes: "People find musical gestures like

EDM soars pleasurable because they perform the resilience we seek to embody" (James 2015, 5). This gesture of overcoming societal hardship through the use of intensified harmonic norms performatively relates racial injustice to resilience discourse. Damage gets recycled into more resources, which are here used to create a sellable track. James concludes that these incorporations of resilience in the sonic episteme ultimately do not fight the violence of what she calls "multiracial white supremacist patriarchy" but feed into it (James 2015, 11).

"FREEDOM" AT THE BLACK ENTERTAINMENT TELEVISION AWARDS

The annual BET Awards celebrates and honors the artistic accomplishments of Black and other minority artists in the entertainment industry. When Beyoncé performed "Freedom" at the opening of the 2016 award show, Black political activists, musicians, actors, artists, and politicians formed the audience. At the beginning of the ceremony, the camera panned over the crowd to reveal but a few white faces.[20] As mentioned in our analysis of "Formation," the visibility of an audience stimulates the public perception of a performance (Marshall 1997, 63). The shots of the audience emphasized that this was not the Super Bowl, whose larger audience meant more white viewers. Beyoncé was addressing an audience more likely to read her historical codes correctly.[21]

The BET Awards opened with the sound of military marching drums, similar to the beginning of the Super Bowl halftime performance of "Formation." Dr. Martin Luther King Jr.'s iconic "I Have a Dream" speech was amplified with drums while Beyoncé's dancers, dressed in white leather bondage harnesses and their bodies decorated with tribal patterns, marched toward the stage. King's voice was heard deliberating on the US Constitution and Declaration of Independence and the rights of life, liberty, and the pursuit of happiness. He said: "We refuse to believe that the bank of justice is bankrupt. And so, we've come to cash this check, a check that will give us upon demand the riches of freedom and the security of justice" (BET Awards 2016). Whereas Beyoncé compared herself to Bill Gates in the performance of "Formation," King's voice here speaks of a check, which needs to be cashed, that contains not financial rewards but social justice. As Dr. King's voice fades away, the pace of the drums stagnates.

Flickering lights in red and yellow intensify as Beyoncé and her dancers slowly walk through the pool of water onstage. The drums accompany Beyoncé when she sings that she's "tryna rain on the thunder / tell the storm I'm new"

(BET Awards 2016). Tempestuous imagery is used to put weight on the severity of the fight for social justice central to this performance. She continues, "I'ma walk, I'ma march on the regular, painting white flags blue." Beyoncé politicizes her star text when she sings that she will march and then points to the reason for her marching. While white flags are often used to signify peace, neutrality, or surrender, a blue flag symbolizes vigilance, perseverance, and justice. Within these lyrics, the well-known civil rights slogan, "no justice, no peace," echoes. The slogan can be related to Dr. Martin Luther King Jr.'s philosophy of nonviolent direct action (1963), but it also fits Malcolm X's "by any means necessary" (1964). Beyoncé creates an amalgamation of protest culture, with herself at the center, invoking several different traditions, most specifically in the Black protest music of the 1960s and 1970s.

Beyoncé's performance also visually conveys an apocalyptic aesthetic. The water on the stage references Katrina-struck New Orleans, which is also referenced in the music video for "Formation." This reference isn't surprising within a song about racial inequality: the response to Katrina became a focal point in discussions on current race relations in the United States. Many musical celebrities have participated in this discussion, most famously Kanye West, who was interrupted during NBC Universal's "A Concert for Hurricane Relief" after saying, "George Bush doesn't care about black people" (Strachan 2015). Beyoncé herself contributed to the founding of the Survivor Foundation, providing temporary housing to victims of the disaster.

The flooded stage also serves as an allusion to cultural flood myths. In these myths, natural disaster functions as a godly intervention that destroys civilization in an act of divine redistribution. Beyoncé is the primal focus of the performance, which positions her as the hero of the narrative and, perhaps, even as a savior of the people. The moment of crisis, emphasized by the water choreography, lyrics, and marching drums, is accentuated by red and yellow lighting, smoke machines, and pyrotechnics. The flooded stage presents the audience with an apocalyptic vision of America falling prey to its own race wars.

Throughout the choreography, Beyoncé and her dancers fight the water with their dancing, moving in ways that emphasize pain and strength at once. Halfway through the performance, the choreography climaxes in a step-style dance. The dancers and Beyoncé use their bodies and voices to add to the military drums of the song with stomps and screams, accentuated by the pyrotechnics rising when they scream. The violent gestures of the choreography epitomize their physical protest; the movements emphasize the physicality of oppression, endurance,

and resistance. It is interesting to note that the performance starts with only female dancers, who are later joined by male dancers positioned behind them. The presence of the male dancers shifts the song from a focus on Black female empowerment, as "Formation" does, to encompass Black liberation struggles more generally. Nevertheless, the choreography continues to situate Black women as the driving force of dissent.

When Kendrick Lamar's stage rises from the ground, his face is partly covered by a hoodie, which provokes a reference to Trayvon Martin. In combination with his literal rise from the ground, mirroring a rise from the grave, Lamar gives a nod to the long history of violence against Black men and women in the United States. Beyoncé herself famously marched after the death of Trayvon Martin and donated a large sum of money on what would have been Martin's twenty-first birthday. Moreover, the mothers of Michael Brown, Trayvon Martin, Oscar Grant, and Eric Garner were featured in the *Lemonade* film, holding pictures of their murdered children. They also appeared on the red carpet of the 2016 MTV Video Music Awards as Beyoncé's guests. These appearances raise difficult questions, such as whether the event organizers know they will co-opt the stage to disrupt entertainment with social and political commentary or if they book Beyoncé and Lamar knowing their politicized performances will provide great entertainment.

Lamar, who is also present on the album version of *Lemonade* yet absent from the film version of the song, here delivers an altered version of his recorded rap verse. During the BET Awards, he raps about the need for reparations and revolution, and emphasizes the formative role of television in creating awareness. His "40 acres, gimme mine" lyrics refer to the forty acres and a mule promised to every formerly enslaved African American during the Reconstruction. Lamar raps that reparations are still due; the finish line is not in sight yet. "Formation, exclamation, formation," he raps, referencing the song discussed earlier, calling for a broad movement to fight for racial justice.

In an article about Nina Simone, Tammy Kernodle analyzes how the protest song evolved alongside the civil rights movement in the 1960s. She describes how the music presents us with documentation of the articulations of changing political views in their times: "The consciousness reflected in their songs was not rooted in mainstream success or the idea of creating black music that would attract white audiences with messages that ignored social problems and racial identity—rather it was defined in a consciousness that sought to inspire, hope, faith, and perseverance in difficult times" (Kernodle 2008, 315).

We could say the same about Beyoncé's and Lamar's protest music: both are

deeply invested in messages of inspiration, hope, faith, and perseverance. But at the same time, we have to acknowledge that both artists are incredibly successful and attract mixed audiences while many of their songs still dialogically engage with social problems and representations of Blackness.

While such messages from the 1960s formed part of a countercultural voice, this message has been absorbed into popular culture in the contemporary neoliberal capitalist context of the United States. The virtues commonly associated with resistance and protest have become central elements of contemporary subjectivities: resilience, steadfastness, and a belief in the possibility of happiness form the cornerstones of our economic, social, and cultural selfhoods. They are the values that resonate and the values that sell. This brings us back to Mako Fitts Ward's argument that Beyoncé glamorizes radicalism but never gets to its actual implementation. Ward argues that Beyoncé has commodified the Black feminist radical tradition, transforming it into entertainment to be consumed by a broad audience (2017).

A different type of anticapitalist radicalism resonates in Gil Scott Heron's seminal 1971 song, "The Revolution Will Not Be Televised"—a claim that Lamar invalidates as he raps about a new era of Black protest in which the revolution *will* be televised. This could be interpreted as a claim on the possibility of radicalism from within capitalist structures. Beyoncé's manifestation of liberation could be read as an active opposition to Audre Lorde's often-repeated words, "The master's tools will never dismantle the master's house" (Lorde 1984, 110–13). bell hooks sided with Lorde in claiming that Beyoncé will never get "to destroy this imperialist, white supremacist, capitalist patriarchy by creating your own version of it. Even if it serves you to make lots and lots of money" (New School 2014).

Lamar refers to the constant making of lemonade, a metaphor for the struggles in African American history, and uses it to support Beyoncé's call to get in formation. In a way, the making of lemonade perhaps references the fact that both artists *are* invested in capitalism, making the most of the opportunities handed to them. Lamar later refers to the mass incarceration of Black people and speaks of his hopes for a better future, no matter the cost, echoing long histories of civil rights discourse without historicizing or contextualizing them.

The value of the collaboration between Lamar and Beyoncé is highly significant for the reading of this performance. Kendrick Lamar's album *To Pimp a Butterfly* (2015) was widely embraced for its highly political nature, and its most successful single, "Alright," quickly became the anthem for the Black Lives Matter movement. The star texts of Lamar and Beyoncé have both become ex-

plicitly connected to the antiracist struggle in the United States through their music, performances, interviews, and philanthropy. By combining them in one performance, the politicized aspects of both celebrities are mutually reinforced through their synchronized message. At the same time, critiques of the glamorization, spectacularization, and aestheticization of radicalism, proclaiming the emptying and decontextualizing of its contents for popular music, caution us from a purely celebratory view of these cultural products, especially as they remain aimed at mass consumption.

Halfway through their BET performance, the dancers fall to the ground, simulating corpses. When they rise to continue their militant choreography, their portrayal of resilience lays claim to the continued existence of African American history buried within, as well as living on US soil. During the climax of the performance, the dancers again lie on the ground while Beyoncé and Lamar dance face-to-face, synergizing their energetic movements and voices, portraying a shared battle in which their energies are synced for greater goals. The BET Awards bring Lamar and Beyoncé together as two of the most revered celebrity activists in contemporary music with a shared political message. After their performance, the audience reacts with raised fists that serve as the universal symbol for Black power.

CONCLUSION

Although Beyoncé was never apolitical, her politics were rearticulated in more explicit manners in her art from the mid- to late 2010s. During the Super Bowl halftime show performance of "Formation," this was done in a way that focused on histories of antiracist radicalism and a direct address to Black women that claimed the national stage of the NFL for its message. During the BET Awards, her performance of "Freedom" from a stage that celebrates Black culture in the United States put a message of Black liberation at its core. When her star text became increasingly politicized, most notably through her songs "***Flawless," "Formation," and "Freedom," a marked difference became apparent in the musical form of her pieces and their direct references to Black history. During her latest period, she has deemphasized the conventional song form in favor of a strong political message. In this way, Beyoncé consciously subverts the musical norms that rigidly dictate and restrict her musical messages. By not abiding by them, especially during televised performances of her songs, she creates media events and cultural moments that come into being through their politicized form

and message. Through transforming both the forms of the arrangements and the performative movements of her body and corporeal forms signifying Black dance, Beyoncé emphasizes her power to decide not just which messages leave her body but how they leave her body as well. The break from traditional song forms has an unsettling effect that forces audiences to pay attention and adds to an activist reading of her star text in its entirety.

Beyoncé's antiracist and feminist critiques emerge more powerfully, in a more creative fashion, and are more explicit than ever, even if the music is not as catchy or accessible. *Beyoncé* and *Lemonade*, seamlessly mixing new sounds with traditionally Black musical cultures through the double-voiced utterance, can be interpreted as much as high-quality entertainment as politicized manifestos. Ultimately, audiences do not necessarily need to take their pick between these options: the formal variations between Beyoncé's songs allow both readings to occur simultaneously. In this moment in US history, in which protest again forms a central element of American culture, Beyoncé positions herself as an entertainer and an activist, dispelling formal musical traditions to fill both roles while she continues to dominate the largest stages of the nation, and perhaps even the world.

ACKNOWLEDGMENTS

We extend our warmest thanks to all who helped this chapter along, especially our audiences at the Southwest Popular/American Culture Association 39th Annual Conference, the Popular Culture Association/American Culture Association 48th Annual Conference, and the Rutgers University Musicological Society, whose questions and feedback shaped this chapter and our ideas. Many thanks for the Feminist Theory and Music 13th Conference for creating an interdisciplinary network and encouraging young scholars to form these kinds of collaborations. Most important, we thank Marquita Smith and the editors of this book, Kristin McGee and Christina Baade, for all the time and effort they have invested in guiding this publication. Their encouragements, suggestions, and patience have been invaluable.

NOTES

1. Signifyin(g) is written with the "g" in parentheses because it shows what the concept does: it identifies a wordplay implying two meanings simultaneously. *Signifying* is the academic term, and *signifyin'* is the vernacular version. Because Henry Louis Gates Jr.,

whose book (1988) influences this chapter, spells it out, we do the same. Whenever we spell *signifyin(g)* in this manner, we thus refer to and borrow from Gates's scholarship.

2. We acknowledge the complexity of the concept of Black popular culture. As Stuart Hall argues, "American mainstream popular culture has always involved certain traditions that could only be attributed to black cultural vernacular traditions" (1993, 105). He explains that Black popular culture has always been hybrid and complex, since race itself is a social and cultural construct that cannot and should not be essentialized biologically. Moreover, Hall's conclusion about Black popular culture is important to keep in mind while reading this chapter: "Popular culture, commodified and stereotyped as it often is, is not at all, as we sometimes think of it, the arena where we find who we really are, the truth of our experience. It is an arena that is *profoundly* mythic. It is a theater of popular desires, a theater of popular fantasies" (Hall 1993, 113).

3. This can be aligned with DeClercq's (2012) "Solo" category.

4. This chapter makes no attempt to overstate the normalcy of Beyoncé's apolitical form process, and an extensive analysis of every Beyoncé song is beyond its scope.

5. This includes but does not visualize Declercq's (2012) "Link" section, which would be the repetition of the "Uh-oh, uh-oh" voice that connects the sections.

6. In his paper on the two-part complementary form, Stephen Graham discusses the way in which this form can be used to signal artistic maturity and gain critical credibility (2014, 471). Perhaps this is something that is also at play here, but for now, we focus on the effects of the two-part musical form on the communication of a politicized message.

7. This form chart excludes the pre- and post-song home video from Beyoncé's appearance on the television show *Star Search*.

8. The similarity of "Crazy in Love" (2003) and "Drunk in Love" (2013) further emphasizes the stability of the relationship of the two musicians over the past decade, something that was challenged and later reinstated with *Lemonade* (2016). "Drunk in Love" indicates a maturation of both Beyoncé's musicality and the relationship between the spouses.

9. Music composed by Beyoncé, Aaron Muka, Terius Nash, Chauncey Hollis, Raymond DeAndre Martin; produced by Hit-Boy, Hazebanga, Boots.

10. Jo Littler (2004) argues how such a reference to a moment before fame often legitimizes the meritocratic ideological framework of stardom.

11. See also *The Lemonade Reader* (Brooks and Martin 2019). Many of its chapter authors describe the ways in which Beyoncé's gendered, sexual, and racialized positioning offered hooks to Afrodiasporic audiences.

12. The NFL reported that Super Bowl 50, with 167 million viewers, was the most-watched program in TV history. The largest viewership was between 8:30 and 9:00 p.m. when the halftime show was performed (Pallotta and Stelter 2016). At 8:44, the most-Tweeted minute of the event collided with Beyoncé's performance: 162,000 Tweets were

sent at that specific moment, and 16.9 million Tweets were sent in total by 3.8 million authors (Nielsen 2016).

13. Ward's (1998) reading here differs from the arguments made by several chapter authors in *The Lemonade Reader*, as well as from Omise'eke Tinsley reading of Beyoncé. Tinsley would perhaps see Ward's argument as a paranoid reading in Sedgwickean terms. She writes that while paranoid readings try to keep a critical distance in their readings, she, with her reparative reading, "fights to extract sustenance from a popular culture largely uninterested in the survival of marginalized—including black and queer—communities" (Tinsley 2018, 12).

14. For a discussion of the reception of this performance, see Kokkonos (2017).

15. "Freedom" was written by Jonathan Coffer, Beyoncé, Carla Williams, Dean McIntosh (also known as Arrow Benjamin), Kendrick Lamar, Frank Tirado, Alan Lomax, and John Lomax Sr. The song is produced by Beyoncé, Just Blaze, and Jonny Coffer.

16. This is a direct reference to "Wade in the Water," a Negro spiritual that was said to contain information for enslaved Africans on how to reach the North without getting caught.

17. For a good overview, see Brackett 1995, (115–16). For a more recent discussion, focused on *Lemonade*, see Brooks and Martin (2019, 83–158).

18. The similarities don't stop there: the melodic line that follows scale degree 1; flat 3, 4 is also present throughout "Freedom." In addition, the rhythm with which each woman sings "Freedom" is exactly the same: eighth note (free), quarter note (dom). This syncopates the word, putting the emphasis on the second half of beat 1 in each case. In Beyoncé's case, this could be read as a sixteenth note, but the syncopation would still be created through offsetting the pick-up (free) to the first beat.

19. Wading through the water while singing also refers to Moses leading his people through hardship toward freedom while singing a song we could perhaps interpret as one of the first protest songs (Exodus 15). The hyperglorified self in "Freedom" invites a comparison between Moses and Beyoncé, articulating the music as a God-given and perhaps even divine song of freedom.

20. The audience watching at home was also likely skewed Black: Nielson (2011) shows BET programming accounts for three of Black Americans' twenty-most-watched programs and no white and "all" Americans' most-watched programs.

21. Nevertheless, we feel it is important to emphasize, in line with bell hooks (2016), that Beyoncé ultimately provides cultural products aimed at mass consumption in a capitalist society. This means her audience is always heterogeneous, which has an effect on the uses and functions of protest music. Tammy Kernodle (208), for example, concludes that the freedom songs of the civil rights movement played a central role in developing Northern, mostly white audiences' conception and understanding of the Black freedom movement

(298). Perhaps that holds true for Beyoncé's antiracist message as well. Audience research would however be indispensable in sustaining such a claim.

REFERENCES

Beyoncé. 2003. "Crazy in Love." *Dangerously in Love*. New York: Columbia.

——. 2013a. *Beyoncé*. New York: Parkwood and Columbia, 2013.

——. 2013b. "***Flawless ft Chimamanda Ngozi Adichie." *Beyoncé*. New York: Parkwood and Columbia, 2013.

——. 2016a. "Formation." *Lemonade*. New York: Parkwood and Columbia, 2016.

——. 2016b. "Freedom." *Lemonade*. New York: Parkwood and Columbia, 2016.

——. 2016c. *Lemonade*. Parkwood and Columbia.

"Beyoncé ft Kendrick – Freedom (BET Awards 2016)." 2016. Vimeo. https://vimeo
.com/173992190.

Brackett, David. 1995. *Interpreting Popular Music*. Berkeley: University of California Press.

Brooks, Daphne. 2008. "'All That You Can't Leave Behind': Black Female Soul Singing and the Politics of Surrogation in the Age of Catastrophe." *Meridians Feminism, Race, Transnationalism* 8, no. 1: 180–204.

Brooks, Kinitra D., and Kameelah L. Martin, eds. 2019. *The Lemonade Reader*. New York: Routledge.

"Coldplay's FULL Pepsi Super Bowl 50 Halftime Show feat. Beyoncé & Bruno Mars! | NFL." 2016. Uploaded by NFL. YouTube, February 11. https://www.youtube.com
/watch?v=c9cUytejfik.

Couldry, Nick. 2003. *Media Rituals: A Critical Approach*. London: Routledge.

Covach, John. 2009. *What's That Sound? An Introduction to Rock and Its History*. New York: Norton.

Crenshaw, R. C., Rev. 1959. "Peaching/Unidentified Lining Hymn." Shelby County: Alan Lomax Recordings. In the Alan Lomax Collection, Library of Congress.

Declercq, Trevor. 2012. "Sections and Successions in Successful Songs: A Prototype Approach to Form in Rock Music." PhD diss., Eastman School of Music.

Durham, Alicia. 2012. "'Check On It': Beyoncé, Southern Booty, and Black Femininities in Music Video." *Feminist Media Studies* 12, no. 1: 35–49.

Dyer, Richard. *Stars*. 1998 (1979). London: Palgrave Macmillan.

——. 2003 (1986). *Heavenly Bodies: Film Stars and Society*. London: Routledge.

"Exodus15." N.d. *Biblegateway*. Accessed December 13, 2018, at https://www.biblegateway
.com/passage/?search=Exodus+15&version=NIV.

Fitts Ward, Mako. 2017. "Queen Bey and the New N****rati: Ethics of Individualism in the Appropriation of Black Radicalism." *Black Camera* 9, no. 1: 146–63.

Franklin, Aretha. 1968. *Aretha Now*. New York: Atlantic.

Gates, Henry Louis, Jr. 1988. *The Signifying Monkey: A Theory of African-American Literary Criticism*. New York: Oxford University Press.

Graham, Stephen. 2014. "Justin Timberlake's Two-Part Complementary Forms: Groove, Extension, and Maturity in Twenty-First-Century Popular Music." *American Music* 32, no. 4: 448–74.

Gussow, Adam. 2002. *Seems Like Murder Here: Southern Violence and the Blues*. Chicago: University of Chicago Press.

Hall, Stuart. 1993. "What Is This 'Black' in Black Popular Culture?" *Social Justice* 20, no. 1/2: 104–14.

hooks, bell. 2016. "Moving beyond Pain." bell hooks Institute. http://www.bellhooksin stitute.com/blog/2016/5/9/moving-beyond-pain.

James, Robin. 2015. *Resilience and Melancholy: Pop Music, Feminism, Neoliberalism*. Hants.: Zero Books.

Kaleidoscope. 1969. "Let Me Try." *Kaleidoscope*. Berlin: Shadoks Music.

Kernodle, Tammy L. 2008. "'I Wish I Knew How It Would Feel to Be Free': Nina Simone and the Redefining of the Freedom Song of the 1960s." *Journal of the Society for American Music* 2, no. 3: 295–317.

King, Martin Luther Jr. 1963. "Letter from the Birmingham Jail." In *Why We Can't Wait*, edited by Martin Luther King Jr., 77–100. New York: Harper.

Kokkonos, Kristina. 2017. "'The Day Beyoncé Turned Black': An Analysis of Media Responses to Beyoncé's Super Bowl 50 Halftime Performance." Master's thesis, Wake Forest University.

Lamar, Kendrick. 2015. *To Pimp a Butterfly*. Santa Monica: Aftermath, Interscope, Top Dawg.

Littler, Jo. 2004. "Making Fame Ordinary: Intimacy, Reflexivity and 'Keeping It Real.'" *Mediactive* 2:8–25.

Lorde, Audre. 1984. *Sister Outsider*. Berkeley: Ten Speed Press.

Lavengood, Megan. 2017. "A New Approach to the Analysis of Timbre." PhD diss, City University of New York.

Malcolm X. 1970. *By Any Means Necessary: Speeches, Interviews, and a Letter by Malcolm X*. New York: Pathfinder Press.

Marshall, David P. 1997. *Celebrity and Power: Fame in Contemporary Culture*. Minneapolis: University of Minnesota Press.

Moore, Allan F. 2012. *Song Means: Analysing and Interpreting Recorded Popular Song*. London: Routledge.

New School. 2014. "bell hooks: Are You Still a Slave? Liberating the Black Female Body." Filmed in May. YouTube video, 1:55:32. https://www.youtube.com/watch?v=rJkoh NROvzs.

Nielsen. 2011. "U.S. TV Trends by Race and Ethnicity." Nielsen. https://www.nielsen

.com/content/dam/corporate/us/en/conference/Race%20and%20Ethnic%20TV%20 White%20Paper%20REPORT.pdf.

———. 2016. "Super Bowl 50 Draws 111.9 Million TV Viewers, 16.9 Million Tweets." Nielsen, February 8. https://www.nielsen.com/us/en/insights/news/2016/super-bowl-50 -draws-111-9-million-tv-viewers-and-16-9-million-tweets.html.

Osborn, Brad. 2011. "Understanding Through-Composition in Post-Rock, Math-Metal, and Other Post-Millennial Rock Genres." *Music Theory Online* 17, no. 3: 1–17.

Pallotta, Frank, and Brian Stelter. 2016. "Super Bowl 50 Audience Is Third Largest in TV History." *CNN*, February 8. https://money.cnn.com/2016/02/08/media/super-bowl -50-ratings/index.html.

Prisoner "22." 1947. "Stewball." Parchman Farm: Alan Lomax Recordings.

Real, Michael R. 1975. "Super Bowl: Mythic Spectacle." *Journal of Communication* 25, no.1: 31–43.

Redmond, Shana L. 2014. *Anthem: Social Movements and the Sound of Solidarity in the African Diaspora*. New York: New York University Press.

Scott-Heron, Gil. 1971. "The Revolution Will Not Be Televised." *Pieces of a Man*. New York: Flying Dutchman.

Smethurst, James. 2013. "A Soul Message: R&B, Soul, and the Black Freedom Struggle." In *The Routledge History of Social Protest in Popular Music*, edited by Jonathan C. Friedman. London: Routledge.

Strachan, Maxwell. 2015. "The Definitive History of 'George Bush Doesn't Care about Black People': The Story behind Kanye West's Most Famous Remarks." *Huffington Post*, September 9. https://www.huffingtonpost.com/entry/kanye-west-george-bush-black -people_us_55d67c12e4b020c386de2f5e.

Stephenson, Ken. 2002. *What to Listen for in Rock: A Stylistic Analysis*. New Haven: Yale University Press.

Tinsley, Omise'eke. 2018. *Beyoncé in Formation: Remixing Black Feminism*. Austin: University of Texas Press.

Ward, Brian. 1998. *Just My Soul Responding: Rhythm and Blues, Black Consciousness, and Race Relations*. Berkeley: University of California Press.

Willett, John. 1964. *Brecht on Theatre*. New York: Hill and Wang.

REBEKAH HUTTEN AND LORI BURNS

12. Beyoncé's Black Feminist Critique
Multimodal Intertextuality and Intersectionality in "Sorry"

With her path-breaking visual album, *Lemonade*,[1] Beyoncé embodies the values of intersectional feminism by saturating her work with cultural references that relate in meaningful ways to Black feminist thought.[2] By pursuing politically charged historical and cultural contexts within a multimodal work that operates through the expressive channels of words, music, and images, Beyoncé cultivates and invites a range of critical perspectives on intersecting axes of identity in contemporary Black America.[3]

For this chapter, we focus on the music video "Sorry," in part because it was one of the few videos from *Lemonade* that Beyoncé uploaded to YouTube, but also because the song, video, and accompanying poetry offer a sophisticated blending of intertextual content that is highly suggestive for intersectional reading.[4] We explore Beyoncé's treatment of the subject positions and identities of Black women that emerge in the music video and understand her assembly of cultural references to offer a commentary on the cultural history of Black women as she places her unique expression into dialogue with that history. We present our analytic framework as a tool for the interpretation of the messages about intersectional identities that emerge from Beyoncé's multilayered artistic work. To this end, we integrate intersectional feminist theory, drawing from the work of scholars in the fields of critical race theory and Black feminist thought (Crenshaw 1989, 1991; Collins 1990; Nash 2011; Carastathis 2016), with an understanding of intertextual analysis, drawing from the work of popular musicologists (Spicer 2009; Williams 2013; Burns, Woods, and Lafrance 2015; Burns and Lacasse 2018).[5]

In "Sorry," we find information in the textual, musical, and visual domains

that individually point to cultural signifiers and collectively contribute to a network of referential meanings, creating multiple levels of commentary, dialogue, and significance. The "cultural codes" (Frow 1990), "iterations" and "citations" (Derrida 1988; Brackett 2017), and "mosaic of quotations" (Kristeva 1980, 66) embedded within the music video comprise sampled music, genre signifiers, iconic visual references, quoted poetry, and speech. Such borrowings can be addressed by the theoretical concept of intertextuality, which grew out of literary studies (Kristeva 1980; Genette 1982; Hodges 2015) but is frequently applied to musical works (Klein 2005; Spicer 2009; Burns and Lacasse 2018), as well as to images (Jacobs 2011; Taban 2013) and film media (Iampolski 1998; Panigrahi 2013). It is challenging to address systematically the intertextual borrowings that occur across the multilayered expressive domains of a multimodal work. We find examples of such analyses in intertextual studies of lyrics and music in popular song (Williams 2013); however, it is rare to find intertextual analyses of the full multimodal expression of music video (McGee 2012; Hawkins 2013; Burns and Woods 2018). Indeed, Beyoncé's intertextual expression within a multimodal artistic platform poses a remarkable analytic challenge. As Panigrahi writes, "Every word in a text . . . is intertextual and so must be read not only in terms of a meaning presumed to exist within the text itself, but also in terms of meaningful relations stretching far outside the text into a host of cultural discourses. Intertextuality, in this sense, questions our apparently commonsensical notions of what is inside and what is outside the text, viewing meaning as something that can never be contained and constrained within the text itself" (2013, 2).

With our analysis, we illustrate Panigrahi's notion of an expansive web of relational meanings. One of our objectives therefore is to adopt a method that will allow the exploration of multiple chains of referential meaning, while maintaining a systematic approach to the analysis and interpretation of music video content.

ANALYTIC METHOD: MULTIMODAL INTERTEXTUALITY

Understanding intertextuality to comprise "the web of interrelated creative elements that link a text to other texts" (Burns, Woods, and Lafrance 2015, 4), we identify references that operate across a range of discursive registers. Through her iterations of specific and pointed cultural references, Beyoncé situates video scenes in places and spaces that are linked to significant cultural histories; she suggests particular bodies and identities by adorning the video performers in

specific clothing and makeup styles; she enacts gestures that cite cultural forms and historical situations; and she offers emotional expressions that conjure tropes of the human condition more broadly and her own experience more specifically. This list of discursive categories (places and spaces, bodies and identities, gestures, and emotional expressions) forms a valuable set of cross-cutting lenses through which we can examine the intertextual content in words, music, and images. The first step is to identify and contextualize the cultural references that emerge in the song and video. The second part of the interpretive process is to consider how the references are developed discursively to create perspectives on Black female subjectivity; more specifically, we ask how the gathering of references contributes to the representation of place and space, bodies and identities, gestures and emotional expression in ways that offer a multilayered cultural commentary on race, gender, and sexuality.

BLACK FEMINIST THOUGHT:
INTERSECTIONALITY AND TALKING BACK

In conjunction with the intertextual analysis, we engage with theories from Black feminism to interpret Beyoncé's messages as a form of cultural and musical disruption. Patricia Hill Collins writes, "If intersecting oppressions did not exist, Black feminist thought and similar oppositional knowledges would be unnecessary. As a critical social theory, Black feminist thought aims to empower African-American women within the context of social injustice sustained by intersecting oppressions" (Collins 1990, 22). Coined in the field of law by Kimberlé Crenshaw (1989, 1991) and characterized as an analytic framework, theory, and praxis, intersectionality is posited as an antidote to antidiscrimination law, which historically has favored unitary identities and social systems that portray the white heterosexual male experience as the neutral norm. Crenshaw develops a spatial metaphor to illustrate intersectionality, which we find pertinent to our analysis of "Sorry." Her notion of the traffic intersection demonstrates the function and experience of discrimination:

> Discrimination, like traffic through an intersection, may flow in one direction, and it may flow in another. If an accident happens in an intersection, it can be caused by cars travelling from any number of directions and, sometimes, from all of them. Similarly, if a Black woman is harmed because she is in an intersection, her injury could result from sex discrimination or race discrimina-

tion. . . . Sometimes the skid marks and the injuries simply indicate that they occurred simultaneously, frustrating efforts to determine which driver caused the harm. (Crenshaw 1989, 149)

Crenshaw's intersection has become extremely popular in feminist studies and within social media feminism—what some refer to as "fourth-wave feminism" (Rivers 2017).[6] She shows how Black women are not considered within the category of sex or race discrimination, a problem particularly explicit in the context of US law, which states that "discrimination proceeds from the identification of a class or category" (Crenshaw, quoted in Carastathis 2016, 82). Anna Carastathis writes that the potential of intersectionality exists "in its ability to reveal and transform relations of power, as these constitute the categories basic to our thinking, the conditions that structure our lives, and the identifications that enable our resistances" (2016, 238). For example, white women's gendered and raced experiences are often portrayed and treated as emblematic of all women's experiences. She writes that "white women's gendered experiences are no less racialized, and therefore no more generalizable than are Black women's; but this racialization is rendered invisible through the representational, territorializing claim to `women's' experiences that position white women as normative subjects of that category" (81). In her thorough exegesis of intertextuality, Brittney Cooper (2016) traces the genealogy, critiques of, and academic tensions surrounding the concept and concludes that it is "one of the most useful and expansive paradigms we have" in projects that examine how systematic power is structured. She writes:

What we must hold front and center is that in its relationship to dominant institutions (be they juridical, academic, or social), intersectionality has a teleological aim to expose and dismantle dominant systems of power, to promote the inclusion of black women and other women of color and to transform the epistemological grounds upon which these institutions conceive of and understand themselves. (22)

With "Sorry," Beyoncé injects a visually, textually, and musically diverse array of Black women's experiences into the genre of the hip-hop video, thus revealing her sensitivity to intersectional tensions and transforming the epistemological grounds of this dominant cultural form. Other authors have found an intersectional approach to be useful to the study of the visual album; Alexis McGee's reading of the visual album in *The Lemonade Reader* demonstrates how Beyoncé's

rhetorical strategies "[conjure] spaces for Black women's healing" by representing intersectional identities in Black public and private spaces (2019, 55–56).

The concept of talking back provides another valuable perspective on Beyoncé's portrayal of Black female subjectivities. bell hooks writes about the process of coming to voice as an "act of resistance, a political gesture that challenges politics of domination that would render us nameless and voiceless" (1989, 8). hooks writes: "Moving from silence into speech is for the oppressed, the colonized, the exploited, and those who stand and struggle side by side a gesture of defiance that heals, that makes new life and new growth possible. It is that act of speech, of 'talking back,' that is no mere gesture of empty words, that is the expression of our movement from object to subject—the liberated voice" (1989, 9).We understand talking back through music to comprise an artist's movement "from object to subject": employing vocal strategies, instrumental techniques, genre manipulations, or musical arrangements.[7]

"SORRY" AS MULTIMODAL INTERTEXT

The visual album *Lemonade* comprises twelve songs that are organized into chapters based on British-Somalian poet Warsan Shire's texts. Each chapter is introduced by a screen title, with Beyoncé delivering the poetry in voice-over while the video images and musical content emerge. The compact disc liner notes align the poetic chapter and song titles, using salient images from the visual album as the backdrop. The poetic chapter titles are single words that convey an emotive stance: Intuition, Denial, Anger, Apathy, Emptiness, Accountability, Reformation, Forgiveness, Resurrection, Hope, and Redemption. Although they may be interpreted as a reference to the stages one might pass through when experiencing marital infidelity, these terms can also be considered alongside the concept of talking back. As the protagonist of the album progresses through these emotional realms, she "move[s] from object to subject" (hooks 1989), responding to felt injustices that lead to hope and healing. The protagonist assumes subjectivity after experiencing the objectifying results of racism, sexism, and infidelity, by asserting these emotional stances (e.g., denial, anger, apathy) alongside varied representations of Black female identities.

"Sorry" (track 4) is integrated into the poetic chapter "Apathy," which offers a eulogy written for a female subject whose husband has betrayed her.[8] The passage ends with a biblical reference modified to fit with the theme of sexual betrayal: "Ashes to ashes, dust to *side chicks*." This song was received as a moment

of Beyoncé talking back to Jay-Z for his infidelity; however, we understand her message to be operating on a broader level about the role of women in hip-hop culture.[9] We begin with a discussion of selected cultural references in the poetry, lyrics, music, and images, followed by interpretive summaries based on the crosscutting discursive parameters.

CULTURAL REFERENCES AND CONTEXTS IN THE POETRY OF "SORRY"

Warsan Shire's poetry is written as an imagined obituary for a woman who was wronged by an unfaithful lover. The poetic language is characterized by weighty words that convey loss and damage: "killed me," "heart I broke," "gun to head," "living and dead." The passage adopts a religious tone with references to God and heaven, ending with "dust to sidechicks," a term from popular culture that connotes a mistress or "the other woman" in an adulterous affair (Shire 2016).[10]

CULTURAL REFERENCES AND CONTEXTS IN THE LYRICS OF "SORRY"

The lyrics of "Sorry" are characterized by slang expressions that create an image of a female subject who is defiantly enacting resistant behaviors to retaliate against the man who wronged her. One of the first cultural references emerging in the lyrics is the mention of D'Ussé, the brand of cognac that Jay-Z endorses (Bossart 2017). In a play on words, the D'Ussé cup quickly transitions to "deuces up," which eventually leads to the lyric "middle fingers up." These two expressions describe hand gestures that indicate a loss of patience, or anger, with another person. "Deuces up" has come to be known as an expression for a breakup, as captured in Chris Brown's hit song "Deuces," which was received as a commentary on his infamous breakup with Rihanna (Bain 2010; Rodriguez 2010). Similarly, Beyoncé's call for "middle fingers up" suggests a number of hip-hop tracks, but perhaps most pointed is Kanye West's "So Appalled" (featuring Jay-Z, among other artists); the rap lyrics to that track encourage listeners to put their hands (and middle fingers) in the air to demonstrate their indifference (West 2010).

We can view Beyoncé's movement from object to subject in a number of these moments as examples of talking back. She makes another direct reference to West's "So Appalled" when she declares, "Suck on my balls, pause," citing Jay-Z's expression in his featured verse in "So Appalled" ("I don't have to pause / All

of y'all can suck on my balls"). Beyoncé's comment, "pause," which follows the crude command, is commonly used by male rappers to indicate an insincerity of expression to avoid homosexual connotations, although Jay-Z insists that he doesn't "have to pause" because of his incredible rap prowess (West 2010).[11] In her adoption of this bawdy masculine trope, Beyoncé plays with gender roles, momentarily talking back with an assertive but farcical gender appropriation. In the short passage of lyrics delivered in the first verse and prechorus, Beyoncé has delivered several expressions that indicate resistance and talking back.[12]

In verse 2, Beyoncé proclaims several club activities ("wilding," "lying," and "grinding") that reverse the betrayal. In contrast, verse 3 reveals the subject's emotions on the nights when her lover abandoned her for the club circuit. With a statement of regret for putting on the symbolic ring of their relationship, Beyoncé points to her marriage as well as her hit single and video, "Single Ladies" (2008), in which she publicly flaunted her engagement ring. Traveling further into the feelings of regret, the final section of the song, the bridge, offers a few textual references that account for the impact of infidelity on her life. The reference to the "good life" is an ironic nod to the 2007 Kanye West song with that title that revels in sexual promiscuity (West 2007). A deeply personal context enters with the specific reference to her baby as she declares that mother and child will live their own good life, independent from her husband. The assertion of independence from men is a common thematic iteration across Beyoncé's discography; for instance, "Survivor" (2004), "Run the World (Girls)" (2011), and "Formation" (2016) have similar messages. The last few lines of the bridge call on Jay-Z ("big homie") to grow up, juxtaposing that reference with "boppers" who are "sneaking around" with her husband (Knowles-Carter 2016).[13]

The final line of the song ("You better call Becky with the good hair") is a powerful intertextual moment that received a great deal of press attention.[14] The reference to Becky can be traced back to Sir Mix-A-Lot's 1992 video, "Baby Got Back," which infamously opens with one white girl remarking to another white girl named Becky on the size of a Black woman's buttocks (Sir Mix-A-Lot 2010). Since that iconic video scene, the name Becky has evolved as a generic name for a white woman. In the Urban Dictionary, *Becky* is defined as "a basic bitch" or a "basic white girl" (Urban Dictionary 2016). The name even stands in for the concept of fellatio, for instance, in the rap song "Becky," by Plies (2009). Referring to "Becky" invites reflection on the role of white women in feminist movements across history: when Beyoncé "calls out" Becky for being part of the infidel betrayal, she might also be calling out white women whose efforts in antiracism often fail.[15]

CULTURAL REFERENCES AND CONTEXTS
IN THE MUSIC OF "SORRY"

"Sorry" opens with a musical quotation of Tchaikovsky's *Swan Lake*—the fourteenth song of act II, "Swan Theme; Moderato"—heard through the tinkling sounds of a music box as a background to the poetic recitation of Shire's ironic obituary passage. The story of *Swan Lake* follows Prince Siegfried, who falls in love with Princess Odette. The princess, however, has been placed under a curse by Von Rothbart: during the day she is a swan, and only by night is she in her true human form. The spell can be broken only if someone who has never been in love before makes an oath of true love and marries her. On the evening when Siegfried must choose a bride, Rothbart disguises his daughter Odile as Odette, and Siegfried chooses Odile as his wife, having been tricked into thinking he was choosing Odette. Odile and Siegfried dance the Black Swan pas de deux in the third act. Upon learning of Rothbart's trickery, Odette forgives Siegfried. At the end of the ballet, they die together. Interpretations vary, but it seems that either Rothbart kills them or the lovers choose to commit double suicide.

The story of *Swan Lake,* which sets the stage for Beyoncé's song, suggests some key thematic connotations: betrayal, desire for true love, competing female roles, being trapped because of men, and symbolic opposition between black and white.[16] We can also see Beyoncé in conversation with the female characters of the ballet, suggesting parallels between herself and both Odette (the betrayed) and Odile (the adulteress). Odile's identification is complex: she is characterized as the Black Swan, a tempestuous, evil seductress, yet she was forced into that position by her father. Neither Odette nor Odile has agency apart from the men in their lives; both are controlled by Rothbart, and both are destined to be married. This strategic reference to *Swan Lake* creatively critiques the surveillance of women's bodies and signifies (Gates 1988) on the construction and policing of Blackness as "evil."[17] Kyra Gaunt draws a further connection between Beyoncé and opera singer Elizabeth Taylor Greenfield, who was known as "The Black Swan" in England during the mid-nineteenth century (2019, 218).

At the end of the song intro, the music shifts from the tinkling music box to a hip-hop texture. While Beyoncé's music is typically heard within the broad category of R&B, this track offers a blend of dance hall signifiers (a genre related to reggae) with trap idioms (a style that cites the category of Southern hip-hop). The blend of trap–dance hall is evident not only in the backing track, which is characterized by the booming kick drum, elongated beats, fast trap-style high-

hats on the surface of the texture, and atmospheric synth layers adding depth to create a moody soundscape, but also in her vocal delivery, which features some of the "lazy" pronunciation (e.g., "sorr-eh"); rapid, choppy delivery (e.g., the "middle fingers up" section); and dance hall vocal responses and callouts.[18]

By mobilizing the stylistic strategies of trap (more generally) and trap–dance hall (quite specifically), Beyoncé builds a genre-based intertext to a number of hip-hop artists and songs—for instance, the work of Juicy J (e.g., "Bandz A Make Her Dance," 2012, and "Mansion," 2016), 50 Cent ("P.I.M.P" 2003), Migos ("One Time," 2015), and Future ("Trap N****s," 2015).[19] By drawing on elements of the trap genre, Beyoncé links her music to a style of expression featuring connotations of street life, as well as representations of Black masculinity within hip-hop.

In Beyoncé's response to these generic influences, she does not, however, present a consistent vocal style but rather offers striking changes throughout, demonstrating the virtuosic ease with which she can move in and out of a range of styles. In this regard, it is important to note that Beyoncé is credited with the vocal production for the track. She moves from an intimate and intense whisper ("what are you going to say at my funeral") [00:00], to an indifferent and lazy MC delivery ("I ain't sorr-eh") [1:23], to a reverberant and powerful appropriation of aggressive club activities ("suck on my balls, pause") [1:58], to the vocoder-inflected trap delivery ("middle fingers up") [2:07], to a seductive melodic style that invokes pentatonic tonality ("now you want to say you're sorry") [2:37], to a teasing and parodic spoken vocal ("he shoulda been home") [3:08], to a vulnerable, dreamy, and exposed vocal ("I left a note in the hallway") [3:21], and finally to a dark, dry, and grainy dismissal ("You better call Becky") [4:17]. These vocal strategies reflect the range of subject positions Beyoncé occupies as a strategy for talking back. She "talks back" not only in her use of vocal strategies but through the reference to *Swan Lake* and in her use of trap and trap–dance hall generic signifiers.

CULTURAL REFERENCES AND CONTEXTS IN THE IMAGES OF "SORRY"

"Sorry" offers a dense presentation of images that are rich for intertextual and intersectional analysis. First and foremost, the clip is shot entirely in black and white.[20] Film theorist James Snead (1994, 5) writes about the cinematic representations of white and black as an overdetermined representational strategy to mark good versus evil, and bell hooks writes that in media representations, "Blackness remains a primary sign of transgression" (hooks, 1997).

FIGURE 12.1 Four Scenes in "Sorry"

PLACES & SPACES

[0:07] [0:59] [2:28] [3:34]

BODIES & IDENTITIES

[0:15] [1:48] [2:46] [4:01]

GESTURES

[0:27] [1:26] [1:50] [2:19]

EMOTIONAL EXPRESSIONS

[0:01] [0:34] [0:37] [2:01]

In order to discuss the cultural references in the domain of images in a coherent way, we organize the contextual content here into four scenes: (1) the inside of an old bus; (2) the outer porch and interior hallway of a southern plantation mansion; (3) a dark, deserted road where the bus has stopped; and (4) a photography studio space (see Figure 12.1).

The Inside of an Old Bus

The first scene presents a strong web of intertextual meanings in Black American history as the site of racial tension and civil unrest. During the civil rights movement, public transportation often functioned as a site of resistance and activism. The "Apathy" scene in *Lemonade* calls on the public bus as a site of contention in American history. These activist moments include the Montgomery bus boycott following Rosa Parks's refusal to give up her seat to white bus riders. It also invokes the Freedom Riders movement; the Freedom Riders were civil rights activists who rode buses into segregated Southern states to protest the lack of enforcement of Supreme Court cases such as *Morgan v. Virginia* (1946) and *Browder v. Gayle* (1956), which ruled that segregation on buses in Alabama and Montgomery was unconstitutional. Beyoncé's video claims the historically racially segregated space of the bus as a place for a dozen women, seated along the side benches, wearing simple black clothing and adorned in West African (Yoruban) body paint. With this scene, the bus is converted into a moving club, complete with disco ball and potential for pole dancing, and the women fully occupy the space. Jay-Z plays a cameo role as the sole man who receives the finger-pointing, deuces-up, and middle-fingers-up gestures.

The bus in "Sorry" has also been viewed as a symbolic mode of transportation between life and death. Music critic Syreeta McFadden (2016) describes this scene, writing, "After the protagonist's spiritual death, the bus ride is a transitioning to an afterlife, a return to home and the source," and outside the bus, "Beyoncé, speckled with painted white dots, moves with a kind of warp-speed precision that seems beyond human." The bus, then, can also be interpreted as a transitory vessel, akin to the boat in Greek mythology, which transports newly deceased souls across the River Styx, dividing the living and dead. Interpreting the bus as transportation from life to death resonates with the poetry spoken during "Apathy," which explicitly deals with the death of the protagonist. LaKisha Simmons's analysis of this scene considers the bus not as a dividing force between the living and dead but rather as the connective space of a wake: "The school bus

is a portal, holding a dead mother and her dead and unborn children. All of the sounds and images conjure those children, infants, and unborn who have gone before us" (2019, 47). Simmons connects the grief communicated by the bus and its occupants to earlier references to miscarriage in *Lemonade*; Beyoncé herself has described her experience of miscarriage in her documentary *Life Is But a Dream* (2013) and, more recently, *Homecoming* (2020). In "Sorry," the atmosphere of grief is felt as a deeply personal communication of loss.

The body paint worn by the women on the bus amplifies that meaning. The artist Laolu Senbanjo, as a part of his project Sacred Art of the Ori, explains that in his native Yoruba language, "Ori" translates to the soul, essence, and destiny (Senbanjo n.d.). Yoruban body painting exists within the broader tradition of West African body painting, a tradition in which this painting can signify, as West African cultural specialist Gladys Freedman explains, "the temporary creation of a spiritual presence or efforts to communicate with beings outside of the real world" (1979, 40). The bus represents the past, the present, and the future as a metaphoric symbol of transition from one life to another. Obiechina (1975) writes that the past, present, and future are integral to Yoruba ideologies and spirituality; these three temporal spaces are "prominently conceived and woven into the Yoruba world-view." This ideology is evident in the very medium of a visual album. Carol Vernallis (2016) writes, "Two overlapping genres—music video and experimental film—provide *Lemonade* with a means to hold the past, present, and future together." In "Sorry," and indeed throughout the entire visual album, Beyoncé communicates nuanced messages about temporal space and the meanings inscribed on Black women's bodies. Near the beginning of *Lemonade*, she says, "The past, present, and future merge to meet us here. What luck. What a fucking curse."

Returning to the tradition of West African Yoruba body paint, it is important to consider the cultural purposes of this tradition. Yoruba people are an ethnic group in Yorubaland, in southwestern Nigeria and areas of Benin, West Africa. In an interview with the *New York Times*, the Nigerian American artist who painted the dancers in "Sorry," Laolou Senbanjo, declared, "I tell a lot of people 'your melanin is the paint.' When you look at the negative space and see what I do with it, what shines through is the darkness of your skin. It gives it the contrast" (Senbanjo, quoted in Best 2016). Tracie Utoh-Ezeajughi (2009) writes of Nigerian temporary body art called *Nzu*, which uses white chalk; several ethnic groups in Nigeria carry out this practice. For religious and spiritual purposes, the white chalk is painted on the face and ankles as a symbol of purification, a

form of cleansing that allows communication with spirits and as protection from "human and spirit enemies." Henry Drewal and John Mason (1997) write that Yoruba head and body painting works symbolically to "attract and encourage divine forces to occupy the bodies of the devout, who then literally *embody* sacred presences and powers." Fine arts scholar E. Ikoro writes that the main purpose of body painting in Nigerian societies is beautification, and often it is carried out during weddings or festivals (2013, 92). There are multiple traditions of body painting in previously British-colonized Nigeria,. and we can thus consider the Nigerian body painting reference in "Sorry" to be a diasporic one, which may not reference a specific society or tradition but draws from those traditions to create a multivalent expression of the Nigerian diaspora in America.[21]

The Outer Porch and the Interior Hallway of a Southern Plantation Mansion

Scene 2 was shot in both the Madewood Plantation House (inside the mansion) and the Destrehan Plantation of Louisiana (the outer porch) (LaBorde 2016). Outside the mansion, a walkway lined with fruit trees visually connects to text in the preceding chapter, "Anger," for which Shire's poetic text reads: "My father's hands around my mother's neck, fruit too ripe to eat" (Knowles-Carter 2016). The images of the fruit tree in "Sorry" connect to this poetic passage, but they also function as a cultural reference to the iconic song "Strange Fruit," famously performed by Billie Holiday. The lyrics of "Strange Fruit" comment on, describe, and protest lynching in the Southern United States. Thus, the fruit trees lining the entranceway to the plantation mansion function as a metaphor for Black victims of lynching, as well as the historic presence of Black lives and deaths on plantations. Shire's poetry can also be read as a reference to domestic abuse and violence against women of color and connects to the larger theme of death in the "Apathy" chapter.

Inside the plantation mansion, the ballet dancers seated on chairs against the walls mirror the visual setting of the women on the bus. An extravagant chandelier replaces the earlier disco ball as a visual focal point, moving the focus from light reflections to light refractions. Serena Williams descends an elegant staircase slowly and methodically, then follows the hallway until she reaches Beyoncé who is reclining in a throne-style chair. The setting of a mansion—adorned by dancing women, opulent lighting, elaborate staircases, and thrones—is a common image in hip-hop music videos. A glance at the 50 Cent

FIGURE 12.2 Hip Hop "mansion" in Beyoncé, "Sorry" (2016) and 50 Cent "P.I.M.P." (2003).

[1:48] [3:16]

video "P.I.M.P." (50 Cent 2003) illuminates this point immediately and clearly with its mansion setting (see Figure 12.2).

Such videos do not usually feature the powerful American athlete Serena Williams as the twerking dancer, nor do they feature Beyoncé as the MC. Beyoncé's recumbent position on the throne connects to a strong trope of the lounging MC in hip-hop videos and on hip-hop album covers (e.g., Queen Latifah, Outkast, and Snoop Dogg; Mlynar 2011), as well as to the mansion setting of "Formation," the first single from *Lemonade*. A more pointed reference to the Beyoncé video for "Déjà Vu" (2006) was identified by Omise'eke Natasha Tinsley, who writes that the video was filmed "at Louisiana's Oak Alley Plantation and [featured] Jay-Z sprawled in the great house in a similar high-backed chair, his left leg flung over the chair's arm as Beyoncé literally bends over backward dancing for him. But in 'Sorry,' Bey sits still as Serena twerks for *her*" (2018, 105–6).[22]

A Dark, Deserted Road
Where the Bus Has Stopped

Scene 3 seems to indicate an arrival point, which McFadden (2016) uses to signify an arrival in the journey between life and death. Beyoncé and a group of women stand on and around the bus, claiming the space as their own. In this scene, Beyoncé's long braids and face painting [2:47] are reminiscent of photographs of Fulani women of Nigeria, who practice body adornment rituals (Utoh-Ezeajugh 2009). Her hair and necklaces are similar to how she appears in a scene in the music video for "Formation"; also similar to the thematic content of that song, the women surrounding Beyoncé outside the bus are in formation.

A Photography Studio Space

The internal studio space in which Beyoncé—wearing metallic body paint and a braided hair crown that invokes the Egyptian queen Nefertiti—poses for a filmed sequence is not the only time her body is treated with metallic paint: In "Love Drought," the seventh track on *Lemonade,* she is painted in gold, surrounded by flowers, her hair loose and her movements fluid.[23] The contrasting styles of movement in "Sorry" and in "Love Drought" suggest different subject positions: in "Love Drought," she appears fertile, loving, generous, and forgiving, while in "Sorry," she is rigid, harsh, and accusatory.

The metallic body paint and the stylized display of Beyoncé's body in "Sorry" brings Rihanna's "Umbrella" to mind (not incidentally, a track featuring Jay-Z), which Stan Hawkins describes as an instance of "hyperembodiment, entailing a beautification process that takes the aesthetics of pop to an extreme" (Hawkins 2013, 478). The image also creates a visual intertext to Nefertiti, the Egyptian queen who was celebrated for her beauty. Beyoncé has developed links to Nefertiti in other music videos—for instance, in the closing sequence of her video for "7/11," in which she is sitting in a meditation pose, wearing a head crown in the classic Nefertiti shape.

INTERPRETING THE MULTIMODAL INTERTEXT OF "SORRY"

We can now put the discursive model into play, asking how the references in the multimodal channels intersect to create meaning.

Places and Spaces

Beyoncé juxtaposes a variety of physical spaces to offer a multidimensional commentary, not only on her personal situation but also on gender and race more broadly. From the opening poetic obituary, women are sent to their graves by the treatments that are enacted upon them. Against this backdrop of cruelty and even violence, the club scene, the hip-hop mansion, the Southern plantation, and the photography studio are all displayed as places in which Black women have had to negotiate their subjectivities. At the same time, these places and spaces are given deep historical roots as sites of African American oppression, where

women, in particular, experienced not only racial injustices but where gendered and sexualized inequities continue through cultural practices such as the hip-hop or dance hall representations of female bodies. By placing these spaces into immediate dialogue, Beyoncé asks us to consider the function of social space as a site of potential injustice.

Bodies and Identities

Within these spaces, Beyoncé also juxtaposes a range of female subjectivities: the poetic image of the corpse in the coffin as well as the "side chick" who was part of the adulterous affair; the "boppers" performing fellatio in the dark corners of the club, with "Becky" pointing to a white female identity for that role; the dozen Black women on the bus who wear Yoruban body paint, suggesting the Nigerian diaspora; the glamorous MC in the mansion, with Serena Williams as the "booty ho"; the nude model stylized as a Nefertiti figure, subjected to the male photographic gaze; and the rebellious street dancers in the deserted space outside the bus. By juxtaposing and intersecting these identities, Beyoncé refuses to adopt a single stable identity, imploring viewers to reflect on intersectional injuries.

Gestures

The video offers a rich commentary on female gestural agency across a range of cultural references. The opening poetic reference to a still female corpse is then juxtaposed with dance gestures from ballet (the seated version of the grand port de bras, with some contemporary features such as the chunky and irregular delivery of the circular movements), the club, the hip-hop mansion (middle fingers up, twerking, throne lounging), and the street (the setting of the bus; the isolated gestures of pop and lock dancing reminiscent of urban hip-hop street dancing). Throughout the video, Beyoncé's body language is interchangeably languid and aggressive, feminine and masculine. As Perrott, Rogers, and Vernallis (2016) write, "Arm, hand and finger gesticulations, head rolls, lunging and strutting all serve to parody many gangster rappers' expression of masculine power. . . . By re-performing these overtly masculine power-gestures as a strong woman oozing femininity, Beyoncé challenges the predominance of these gestures in popular music video, and thus engages in an act of detournement."

Re-performance is not only an act of hijack and challenge within the context of hip-hop music video; it also mocks the male character who is the subject of and

protagonist in the lyrics. Beyoncé sings about herself and a group of girlfriends going to the club, drinking, and proclaiming "boy, bye" while giving the middle finger and turning away from the camera.

Emotional Expressions

The emotional tone of the song is instantly established by the powerful words in Shire's poetry: ("killed me," "gun to head," "living and dead," "loneliness," "betrayal"). These words are received in the broader context of the chapter title, "Apathy," which connotes an absence of feeling, an emotional trait that would argue against the song title, "Sorry," and the suggestion of grief that should emerge through the form of the eulogy. The emotional stance of the poetic introduction is accordingly ambiguous and complicated, as the sentiment of loss competes with one of indifference. The lyrics in the verses and chorus portray a vindictive emotional state, one of carefree revenge, sometimes repurposing traditionally masculine hip-hop tropes. In both music and images, Beyoncé delivers an impressive range of emotional expressions that connote resignation, anger, loss, parody, insult, and vulnerability.

CONCLUSION

We close with a reflection on the development of intertextual and intersectional content in Beyoncé's "Sorry." While the work operates at the intersection of race and gender, its accessibility as a free YouTube video allows for such intersectional feminist messages to be communicated to a global audience. In the poetic, lyrical, musical, and visual realms, we have identified and interpreted a range of cultural references to places and spaces, bodies and identities, emotional expressions, and gestures that express significant aspects of what it means to be a Black woman in America. Beyoncé mobilizes her multimodal intertext to create a Black feminist critique of powerful cultural symbols: in the poetry, her obituary points out the hypocrisy of a marriage rooted in religion, marred by infidelity. Heaven, for her, is a "love without betrayal," a betrayal that is seen in both the infidelity of her husband and in the political and cultural betrayal that Black women experience. In the lyrics, she plays with gender, parodying hyper-masculine behaviors common in hip-hop, rap, and trap music videos; in the lyrics, Beyoncé "calls out" white women (represented by the "side chick," Becky), who too often have excluded Black women from feminist organizing. In the music, the genre refer-

ences to trap connect with Beyoncé's mockery of hyper-masculine music videos that represent Black women as objects. In addition, the scope of vocal techniques reflects a number of emotional subject positions, which may be autobiographical or representative of Black women's experiences more broadly. Finally, embedded in the images are cultural critiques embedded in the four settings—for example, the references to mansion plantations, the civil rights movement, a temporal space between life and death, and the gaze of the photographer. These cultural critiques are juxtaposed against one another and made cohesive in their casting in black-and-white film.

In this song about a woman who is not, in fact, sorry, Beyoncé's intertextual play articulates a progression from object to subject while the video images incite reflection on Black women's role in hip-hop music videos. We have identified moments in "Sorry" where Beyoncé talks back to systems of power: using a wide range of vocal strategies, she talks back to her husband, Jay-Z, about his presumed infidelity; in her appropriation of specific lyrical references, she mocks masculine tropes; and in the reworking of Tchaikovsky's *Swan Lake*, she defies the Western classical concept of Blackness as immoral or transgressive; by donning Yoruban body paint in the contested space of the public bus, she mobilizes traditional spiritualities against sites of civil policing.

Our aim with this analysis has been to demonstrate the rich potential of multimodal intertextuality, especially as it can be mobilized in connection with Black feminist theories such as intersectionality and talking back. In "Sorry," Beyoncé weaves together a wide range of cultural codes, creating a critical genealogy of her references but gesturing toward a world that departs from those contexts. This gesture is created by and for women who are on the margins, at the intersection of race and gender, and points to world making that goes beyond the acting out of diversity in its staunch critique of the consequences wrought by white supremacist histories.

NOTES

1. *Lemonade* has an extensive list of directorial and production credits, with Beyoncé identified as the executive producer of the album and with her name appearing first in the list of producers and directors. Throughout our analysis in this chapter, we implicitly and explicitly ascribe authorial credit to Beyoncé, although we recognize that it was a collaborative creative effort.

2. Although critics and scholars debate the degree to which Beyoncé presents her work in connection with feminist thought, we argue here for a feminist reading of "Sorry." Marquita Smith understands "Bey feminism" as "Hip hop feminism" and takes issue with writers who discredit the artist's feminist messages (2017, 239).

3. Simply defined, *multimodality* comprises the artistic integration of expressive semiotic modes (e.g., moving images, spoken language, sound) within the same media artifact. For multimodal analysis, see Burns (2017).

4. "Sorry," directed by Kahlil Joseph and Beyoncé, was released on HBO on April 23, 2016, and on VEVO June 22, 2016. It was the second single released (May 3, 2016).

5. As a theoretical approach, intertextuality has much in common with the concept of "signifyin(g)," a term that is mobilized in Black cultural studies to explore rhetorical strategies of social commentary through revision and play with language (Gates 1988; Floyd 1995).

6. Rivers's (2017) book on fourth-wave feminism describes a phenomenon on social media platforms in which women "call out" other people to "check your privilege" and practice intersectional feminism. There are both positive and negative effects of the popularity of intersectional feminism's promotion on social media: social media allows for many voices to be heard and expressed, whereas intersectionality is often communicated in ways that are reductive to its original meaning.

7. This notion of musical talking back can be connected to writings in the musicological literature about resistance, protest, or disruption. See Duval Harrison (1988), Davis (1998), Burns and Lafrance (2002), Ramsey (2004), Durham (2017), and Brooks (2018.

8. See www.genius.com/Beyoncé-sorry-lyrics for a transcript of the lyrics to "Sorry."

9. For media interpretation of "Sorry" as indicative of Jay-Z cheating on Beyoncé, see Feldman (2016), Levinson (2017), Menta (2016), Forrester (2016), Robinson (2016), and Rogers (2016). These are but a few of the hundreds of speculative journalistic and tabloid articles.

10. Robyn Boylorn (2014) has written about the glorification of the side chick for *Crunk Feminist Collective*. She argues that while white women who have relationships with married men are referred to as "mistress," women of color in the same situation are referred to as "side chick." She interrogates the language used to describe women in these positions with an intersectional framework that accounts for class and race. Seen in this way, Beyoncé seems to flip this narrative on its head by implying that her husband's side chick is in fact a white woman ("Becky with the good hair").

11. See the crowd-sourced Genius annotation for this lyric, as well as the Urban Dictionary entry on "Pause" (2004).

12. We connect this strategy of talking back to resistant modes of discourse. See Alexis McGee (2019), who has written about Black women's rhetorical and sociolinguistic techniques in *Lemonade*.

13. An annotation for the lyric "boppers" on Genius.com explains that it is "a term for a woman who chases men for their status—not necessarily trying to gain financially so much as socially" (Genius n.d.).

14. See note 10.

15. See Chapter 13, this volume, by Kristin Rowe.

16. As an example of how this story has been popularized in contemporary culture, the film *Black Swan* (2010) follows ballerina Nina who has been cast as the lead in *Swan Lake* in the dual roles of Black Swan and White Swan. The plot centers around Nina's mental illness, which leads to psychotic episodes in which she imagines her rival attacking her and stealing her part in the production. It is important to recognize the black/white tension on display in this story and to understand it at a symbolic level. To different degrees, depending on the representational strategies, the story of *Swan Lake* presents a diametric opposition between the White Swan as good and pure and the Black Swan as sensual and corrupt.

17. Later in the album, Sierra Leonean-American ballet dancer Michaela DePrince is featured in an extended dance sequence in the music video for "Freedom," explicitly demonstrating that Black women's cultural production is not limited to hip-hop and RandB cultures.

18. For an artist whose work is particularly emblematic of blending trap and dance hall, see Baker Steez, especially his video, "Topman" (2017).

19. Beyoncé began writing trap-influenced songs (e.g., "7/11" and "Flawless") on her *Beyoncé* album in 2013.

20. The black-and-white music video may also be interpreted as a reference to Beyoncé's opus of her own music videos, which were shot in black and white: "Freedom" (2016), "Flaws and All" (2009), "Single Ladies" (2008), "***Flawless" (2013), "Drunk in Love" (2013), and "Rocket" (2013), for example.

21. For those interested in a detailed visual analysis of *odú* Afro-Cuban Yoruban orisha traditions in *Lemonade*, refer to Jones (2019).

22. For readers interested in this reference, see the YouTube video for "Deja Vu" (2009) at time codes 0:12 and 2:36–2:45.

23. On goddess imagery in *Lemonade* and Beyoncé's subsequent 2017 Grammy Awards performance, see Melanie C. Jones's 2019 chapter in Brooks and Martin (2019).

REFERENCES

Bain, Becky. 2010. "Chris Brown Drops a 'Deuce' with Tyga." *Idolator: Buzz Media*, May 10. https://www.idolator.com/5502092/chris-brown-drops-a-deuce-with-tyga?safari=1.

Best, Tamara. 2016. "A Nigerian Artist Who Uses the Skin as His Canvas." *New York*

Times, November 30. https://www.nytimes.com/2016/11/30/arts/design/a-nigerian -artist-who-uses-the-skin-as-his canvas.html.

Bossart, Céline. 2017. "Inside the Extraordinary Cognac Brand Part-Owned by Jay-Z." *Billboard,* August 197. https://www.billboard.com/articles/news/lifestyle/8005621/inside -jay-z-cognac-brand-dusse-exclusive.

Boylorn, Robyn. 2014. "On the Glorification of the Side Chick." *Crunk Feminist Collective* (blog). http://www.crunkfeministcollective.com/2014/10/01/on-the-glorification-of-the -side-chick/.

Brackett, David. 2016. *Categorizing Sound: Genre and Twentieth-Century Popular Music.* Berkeley: University of California Press.

Brooks, Daphne. 2018. "Drenched in Glory: How Aretha Gave Voice to Embattled Black Women—and Transformed a Nation." *Guardian,* August 17. http://go.galegroup.com .proxy.bib.uottawa.ca/ps/i.do?id=GALE%7CA550517587andv=2.1andu=otta77973and it=randp=AONEandsw=w.

Burns, Lori. 2017. "Multimodal Analysis of Popular Music Video: Genre, Discourse, and Narrative in Steven Wilson's 'Drive Home.'" In *Coming of Age: Teaching and Learning Popular Music in Academia,* edited by Carolos Rodrigues, 81–110. Ann Arbor: University of Michigan Press.

Burns, Lori, and Serge Lacasse. 2018. *The Pop Palimpsest: Intertextuality in Recorded Popular Music.* Ann Arbor: University of Michigan Press.

Burns, Lori, and Alyssa Woods. 2018. "Rap Gods and Monsters: Words, Music, and Images in the Hip Hop Intertexts of Eminem, Jay-Z, and Kanye West." In *The Pop Palimpsest: Intertextuality in Recorded Popular Music,* edited by Lori Burns and Serge Lacasse, 215–51. Ann Arbor: University of Michigan Press.

Burns, Lori, Alyssa Woods, and Marc Lafrance. 2015. "The Genealogy of a Song: Lady Gaga's Intertexts on *The Fame Monster* (2009)." *Twentieth-Century Music* 12, no. 1: 3–35.

Carastathis, Anna. 2016. *Intersectionality: Origins, Contestations, Horizons.* Lincoln: University of Nebraska Press.

Crenshaw, Kimberlé. 1989. "Demarginalizing the Intersection of Race and Sex: A Black Feminist Critique of Antidiscrimination Doctrine, Feminist Theory and Antiracist Politics." *University of Chicago Legal Forum* 1, no. 8: 139–67.

———. 1991. "Mapping the Margins: Intersectionality, Identity Politics, and Violence against Women of Color." *Stanford Law Review* 43, no. 6: 1241–99.

Collins, Patricia Hill, and Sirma Bilge. 2016. *Intersectionality.* Cambridge: Polity Press.

Cooper, Brittney. 2016. "Intersectionality." In *The Oxford Handbook of Feminist Theory,* edited by Lisa Disch and Mary Hawkesworth, 1–25. London: Oxford University Press.

Davis, Angela. 1998. *Blues Legacies and Black Feminism: Gertrude Ma Rainey, Bessie Smith, and Billie Holiday.* New York: Vintage Books.

Derrida, Jacques. 1988. *Limited Inc.* Evanston, IL: Northwestern University Press.

Drewal, Henry John, and John Mason. 1997. "Ogun and Body/Mind Potentiality: Yoruba Scarification and Painting Traditions in Africa and the Americas." In *Africa's Ogun,* edited by Sandra Barnes, 332–52. Bloomington: Indiana University Press.

Durham, Aisha. 2017. "Class Formation: Beyoncé in Music Video Production." *Black Camera* 9, no. 1: 197–204.

Duval Harrison, Daphne. 1988. *Black Pearls: Blues Queens of the 1920s.* New Brunswick: Rutgers University Press.

Floyd, Samuel. 1995. *The Power of Black Music.* New York: Oxford University Press.

Forrester, Katy. 2016. "Who Is Becky with the Good Hair? All of the Theories over Jay-Z's 'Secret Mistress' after *Lemonade*." *Mirror,* April 26. https://www.mirror.co.uk/3am /celebrity-news/who-becky-good-hair-theories-7835398.

Freedman, Gladys. 1979. "Women as Artists and Artisans in West Africa: Special Reference tothe Akan." PhD diss., Union Institute and University.

Frow, John. 1990. "Intertextuality and Ontology." In *Intertextuality: Theories and Practices,* edited by Michael Worton and Judith Still, 45–55. Manchester: Manchester University Press.

Gajanan, Mahita. 2017. "Read Beyoncé's Powerful Acceptance Speech from the Grammy Awards." *Time,* February 13. http://time.com/4668482/grammys-2017-Beyoncé-speech/.

Gates, Henry Louis. 1988. *The Signifying Monkey: A Theory of African American Literary Criticism.* New York: Oxford University Press.

Gaunt, Kyra D. 2019. "Beyoncé's Lemonade and the Black Swan Effect." In *The Lemonade Reader: Beyoncé, Black Feminism and Spirituality,* edited by Kinitra D. Brooks and Kameelah L. Martin, 215–33. London: Routledge.

Genette, Gérard. 1982. *Figures of Literary Discourse.* New York: Columbia University Press.

Genius. N.d. "Beyoncé—SORRY Lyrics." *Genius.* Accessed September 27, 2018, at https:// genius.com/Beyonce-sorry-lyrics.

Hawkins, Stan. 2013. "Aesthetics and Hyperembodiment in Pop Videos: Rihanna's 'Umbrella.'" In *The Oxford Handbook of New Audiovisual Aesthetics,* edited by John Richardson, Claudia Gorbman, and Carol Vernallis, 466–82. Oxford: Oxford University Press.

Hodges, Adam. 2015. "Intertextuality in Discourse." In *The Handbook of Discourse Analysis,* edited by Deborah Tannen, Heidi Hamilton, and Deborah Schiffrin, 42–60. Hoboken NJ: Wiley.

hooks, bell. 1989. *Talking Back: Thinking Feminist, Thinking Black.* Boston: South End Press.

———. 2016. "Moving beyond Pain." bell hooks Institute (blog). May 9, 2016. http://www .bellhooksinstitute.com/blog/2016/5/9/moving-beyond-pain.

Iampolski, Mikhail. 1998. *The Memory of Tiresias: Intertextuality and Film.* Berkeley: University of California Press.

Ikoro, E. 2013. "Painting and Society in Modern Nigeria." *International Journal of Arts and Humanities* 3, no. 11: 87–93.

Jacobs, Karen, ed. 2011. *Poetics of the Iconotext*. Farnham: Ashgate Press.

Jones, Melanie C. 2019. "The Slay Factor: Beyoncé Unleashing the Black Feminine Divine in a Blaze of Glory." In *The Lemonade Reader: Beyoncé, Black Feminism and Spirituality*, edited by Kinitra D. Brooks and Kameelah L. Martin, 98–110. New York: Routledge.

Jones, Nicholas R. 2019. "Beyoncé's Lemonade Folklore: Feminine Reverberations of Odú and Afro-Cuban Orisha Iconography." In *The Lemonade Reader: Beyoncé, Black Feminism and Spirituality*, edited by Kinitra D. Brooks and Kameelah L. Martin, 88–97. New York: Routledge.

Klein, Michael. 2005. *Intertextuality in Western Art Music*. Bloomington: Indiana University Press.

Kristeva, Julia. 1967. "The Expansion of Semiotics." *Social Science Information* 6, no. 5: 169–81.

———. 1980. *Desire in Language: A Semiotic Approach to Literature and Art*. New York: Columbia University Press.

LaBorde, Lauren. 2016. "Mapping the Louisiana Locations in Beyoncé's 'Lemonade.'" *Vox Media*, June 3. https://nola.curbed.com/maps/Beyoncé-lemonade-louisiana-filming-locations.

Lacasse, Serge. 2007. "Intertextuality and Hypertextuality in Recorded Popular Music." *Critical Essays in Popular Music*, edited by Allan Moore, 147–70. Aldershot: Ashgate.

Levinson, Lauren. 2017. "Why 'Becky with the Good Hair' Has a More Powerful Meaning Than Infidelity." *PopSugar*, July 7. https://www.popsugar.com/beauty/What-Does-Becky-Good-Hair-Mean-41062522.

Marks, Anna. 2017. "Nike and Beyoncé Love This Nigerian Body Painting Artist." *Creators*, March 13. https://creators.vice.com/en_us/article/ypknbw/laolu-senbanjo-Beyoncé-nigerian-body-painting-artist.

McFadden, Syreeta. 2016. "Beyoncé's *Lemonade* is #blackgirlmagic At Its Most Potent." *Guardian*, April 24. https://www.theguardian.com/music/2016/apr/24/Beyoncé-lemonade-album-video-black-girl-magic-womanhood-america.

McGee, Alexis. 2019. "The Language of Lemonade: The Sociolinguistic and Rhetorical Strategies of Beyoncé's Lemonade." In *The Lemonade Reader: Beyoncé, Black Feminism and Spirituality*, edited by Kinitra D. Brooks and Kameelah L. Martin, 55–68. New York: Routledge.

McGee, Kristin. 2012. "Orientalism and Erotic Multiculturalism in Popular Culture: From Princess Rajah to the Pussycat Dolls." *Journal of Music, Sound, and Moving Image* 6, no. 2: 209–38.

Menta, Anna. 2016. "We Finally Know Who 'Becky with the Good Hair' Is in Beyoncé's

Song." *Elite Daily*, August 3. https://www.elitedaily.com/entertainment/Beyoncé-becky -with-good-hair-means/1571962.

Mlynar, Phillip. 2011. "Beyond Jay and Kanye's Throne: Ten More Regal Seats in Hip Hop." *Village Voice*, November 4. https://www.villagevoice.com/2011/11/04/beyond-jay-and -kanyes-throne-ten-more-regal-seats in-hip hop/.

Nash, Jennifer C. 2011. "Practicing Love: Black Feminism, Love Politics, and Post-Inter- sectionality." *Meridians* 11, no. 2: 1–24.

Obiechina, Emmanuel. 1975. *Culture, Society, and Tradition in the West African Novel*. Cambridge: Cambridge University Press.

Panigrahi, Debashish. 2013. "Intertextuality in Advertising." *Language in India* 13, no. 9: 251–63.

Perrott, Lisa, Holly Rogers, and Carol Vernallis. 2016. "Beyoncé's *Lemonade*: She Dreams in Both Worlds." *FilmINT*, June 2. http://filmint.nu/?p=18413.

Ramsey, Guthrie. 2004. *Race Music: Black Cultures from Bebop to Hip Hop*. Berkeley: University of California Press.

Rivers, Nicola. 2017. *Postfeminism(s) and the Arrival of the Fourth Wave: Turning Tides*. London: Palgrave Macmillan.

Roach, Joseph. 1992. "Mardi Gras Indians and Others: Genealogies of American Perfor- mance." *Theatre Journal* 44, no. 1: 461–83.

Robinson, Joanna. 2016. "Beyoncé Fans Target Rachel Roy as 'Becky with the Good Hair' in Great *Lemonade* Mystery." *Vanity Fair*, April 24. https://www.vanityfair.com /Culture/2016/04/rachel-roy-Beyoncé-jay-z-lemonade-becky-with-the-good-hair -solange-elevator.

Rodriguez, Jayson. 2010. "Chris Brown, Tyga Drop Fan of a Fan Mixtape." *MTV News*, May17. http://www.mtv.com/news/1639324/chris-brown-tyga-drop-fan-of-a-fan -mixtape/.

Rogers, Katie. 2016. "Beyoncé's 'Lemonade' Lyrics Entangle Two Rachels." *New York Times*, April 25. https://www.nytimes.com/2016/04/26/arts/music/Beyoncés- lemonade-lyrics-entangle-two-rachels.html.

Senbanjo, Laolu. "The Sacred Art of the Ori by Laolu Senbanjo." Laolu.NYC. http://www .laolu.nyc/ritual-face-art/.

Shire, Warsan. 2016. "Lemonade (Script) Beyoncé." *Genius*, April 23. https://genius.com /Beyoncé-lemonade-script-annotated.

Simmons, LaKisha. 2019. "Pull the Sorrow from between My Legs: Lemonade as Rumina- tion on Reproduction and Loss." In *The Lemonade Reader: Beyoncé, Black Feminism and Spirituality*, edited by Kinitra D. Brooks and Kameelah L. Martin, 42–54. New York: Routledge.

Smith, Marquita. 2017. "Hip Hop Feminism and the Embodiment of Black Femininity." In *The Routledge Research Companion to Popular Music and Gender*, edited by Stan Hawkins, 229–41. New York: Routledge.

Snead, James. 1994. *White Screens, Black Images: Hollywood from the Darkside*. New York: Routledge.

Spicer, Mark. 2009. "Strategic Intertextuality in Three of John Lennon's Late Beatles Songs." *Gamut* 2, no. 1: 347–76.

Taban, Carla. 2013. *Meta- and Inter-Images in Contemporary Visual Art and Culture*. Leuven: Leuven University Press.

Taraborrelli, J. Randy. 2015. *Becoming Beyoncé: The Untold Story*. New York: Grand Central Publishing.

Tinsley, Omise'eke Natasha. 2018. *Beyoncé in Formation: Remixing Black Feminism*. Austin: University of Texas Press.

Utoh Ezeajugh, Tracie. 2009. "Body Adornment Practises in Nigerian Culture: A Multi-Ethnic Investigation." *Creative Artist: A Journal of Theatre and Media Studies* 3, no.1: 117–32.

Vernallis, Carol. 2016. "Beyoncé's *Lemonade*, Avant-Garde Aesthetics, and Music Video: "The Past and Future Merge to Meet Us Here." *Film Criticism* 40, no. 3: 1–21.

Williams, Justin. 2013. *Rhymin' and Stealin': Musical Borrowing in Hip Hop*. Ann Arbor: University of Michigan Press.

SELECT DISCOGRAPHY

Beyoncé. 2016. *Lemonade*. Parkwood Entertainment and Columbia Records.

———. 2013. *Beyoncé*. Columbia Records.

———. 2011. *4*. Parkwood Entertainment and Columbia Records.

West, Kanye. 2007. *Graduation*. Def Jam Records and Roc-a-Fella.

———. 2010. *My Beautiful Dark Twisted Fantasy*. Def Jam and Roc-a-Fella.

SELECT VIDEOGRAPHY

50 Cent. 2003. "50 Cent–P.I.M.P. (Snoop Dog Remix) ft. Snoop Dog, G-Unit." YouTube video, 5:00. Published by "50 Cent," June. https://www.youtube.com/watch?v=UDApZhXTpH8.

Baker Steez. 2017. "BAKERSTEEZ–TOPMAN." YouTube video, 3:11. Published by BAKERSTEEZ OFFICIAL, March. https://www.youtube.com/watch?v=EqBM-7zPTw.

Beyoncé. 2014. "Beyoncé : Life Is But a Dream (Full Documentary)." YouTube video, 1:30:01. Published by "Mist," December. https://www.youtube.com/watch?v=VJizQTAySGQ.

———. 2009. "Beyoncé: Deja Vu (MTV Video Version) ft. Jay-Z." YouTube video, 4:01. Published by "Beyoncé," October. https://www.youtube.com/watch?v=RQ9BWndKEgs

Future. 2015. "Future: Trap Niggas [Prod by Southside]." YouTube video, 2:54. Published by Freebandz Films, March. https://www.youtube.com/watch?v=VjCJKS15W3k.

Juicy J. 2012. "Juicy J: Bandz A Make Her Dance (Explicit) ft. Lil' Wayne, 2 Chainz." *YouTube Video,* 4:40. Published by TheJuicyVEVO, September. https://www.youtube .com/watch?v=AIogk2KJeho.

——. 2016. "Juicy J 'Mansion' (WSHH Exclusive—Official Music Video)." YouTube video, 3:15. Published by WORLDSTARHIPHOP, July. https://www.youtube.com /watchv=beKnsP2qTgo.

Migos. 2015. "Migos' One Time." YouTube video, 4:40.

Published by Migos ATL, March. https://www.youtube.com/watch?v=RrI-3vt5VnE.

Plies. 2009. "Plies: Becky (Video)." YouTube video, 3:46. Published by PliesWorld, October. https://www.youtube.com/watch?v=JcKG4EJ6rsQ.

Rhianna. 2009. "Rhianna." Umbrella (Orange Version) ft. JAY-Z." YouTube video, 4:13. Published by Rhianna, December. https://www.youtube.com/watch?v=CvBfHwUxHIk.

Sir Mix-A-Lot. 1992. "Baby Got Back." YouTube video, 4:13. Published by Quantumofficial, February 2010/1992. https://www.youtube.com/watch?v=_JphDdGV2TUandlist=PLn _EVacHgb4rxom194X2ImwgwJTUe4qct.

PART SEVEN

"Pray You Catch Me"
Healing and Community

Like Burns and Hutten, Kristin Rowe, in Chapter 13, also examines "Sorry," ze-roing in on perhaps the most commented-on element of the song (and perhaps the entire album): the reference to "Becky with the good hair." Rowe moves her analysis far beyond the world of gossip to focus on the politics of hair, arguing that the song challenges Eurocentric beauty standards and makes space for valuing the diversity of Black women's beauty. Furthermore, she shows how the song and *Lemonade* as a whole make the case for the values of Black solidarity and interiority, the expression of complex personhood that is so often hidden as a protective measure in an anti-Black society. In Chapter 14, Mary Senyonga also responds to these themes of solidarity and validation, arguing that *Lemonade* offers space for Black women and femmes to come together to deal with the traumas of a violent culture and to heal. She underlines the ways in which *Lemonade* is both hopeful and acknowledging of trauma, thus offering an ap-propriate conclusion to our book.

KRISTIN DENISE ROWE

13. Beyond "Becky with the Good Hair"
Hair and Beauty in Beyoncé's "Sorry"

On April 23, 2016, world-renowned Black female, superstar, entertainer Beyoncé Giselle Knowles-Carter released *Lemonade*, an album and accompanying short film. *Billboard* magazine called the work "A Revolutionary Work of Black Feminism" because it featured and referenced Black women such as Nobel prize–winning novelist Toni Morrison, tennis legend Serena Williams, Somali poet Warsan Shire, directors Kasi Lemmons (*Eve's Bayou, 1997*) and Julie Dash (*Daughters of the Dust, 1991*), as well as the mothers of Michael Brown, Eric Gardner, and Trayvon Martin—three Black men murdered by the police (Bale 2016). In the *Lemonade* universe, Black women are also conjure women, dancers, cultural producers, goddesses, freedom fighters, and musicians. A core component of the album's Black feminism may be its ability to speak to the complexity, depth, and diversity of Black women's experiences.

Black women exist within a complex set of sociohistorical, structural, and affective body politics, particularly around concepts of beauty. Perhaps one of the best-known ways in which hegemonic beauty standards are mapped onto Black women's bodies is a long-held dichotomous understanding of "good hair" and "bad hair." "Good hair" is a term that has been ascribed to women of color whose hair most closely fits a Eurocentric standard of beauty—loosely curled, rather than kinky or coily. Indeed, as scholars Ayana D. Byrd and Lori L. Tharps remind us, "More than one hundred years after the terms 'good' and 'bad' hair became part of the Black American lexicon, the concept endures" (2014, 174). However, while Black women exist within a larger anti-Black context that has denigrated kinky textured hair as "bad hair," they are constantly acknowledging, critiquing, and negotiating this landscape. What might that kind of work

look like? How can we center Black women's voices while trying to understand these larger concepts of beauty standards? How do we begin to understand how Black women (re)negotiate, critique, and experience beauty through current representations of hair? I argue that one way to view this work is through a set of 2016 song lyrics by Beyoncé, as well as subsequent responses to these lyrics.

Enter "Becky with the Good Hair."

"Sorry" is a triumphant, first-person breakup track: the narrator experiences both strength and vulnerability by way of the chorus's repetition of "Sorry, ain't sorry." The track fits within a larger narrative that the album weaves together: the story of a Black woman discovering, experiencing, forgiving, and reflecting on her husband's infidelity. The final lines of "Sorry" now infamously state: "He only want me when I'm not there / He better call Becky with the good hair . . . / He better call Becky with the good hair" (Gordon, Knowles-Carter, and Melo-X 2016). Here, Beyoncé references her husband's mistress as "Becky," a slang term within the Black community for an average or unremarkable white woman. The term was popularized by the iconic 1992 single "Baby Got Back" by rapper Sir Mix-A-Lot.

In an album all about Black woman's power, Beyoncé lays bare and destabilizes long-standing assumptions around the meaning and currency of good hair. "Good hair" speaks to a hierarchy of hair texture that exists intraracially, but the ideology behind it stems from larger structures of colonialism, white supremacy, and (hetero)sexist beauty norms. In "Sorry," Beyoncé removes "good hair" from its pedestal, offering "Becky with the good hair" not as a shot or snub at white women, but as a cheeky critique of the ways Eurocentric beauty norms may have influenced her partner's choice of mistress.

Guided by Black feminist theory and cultural criticism, this chapter explores the sociohistorical context for Beyoncé's use of "Becky with the good hair," a textual analysis of the beauty and body politics surrounding "Sorry," and the mixed reception of the "Becky" lyrics from celebrities and consumers alike. I argue in this chapter that "Sorry," as well as the conversation around it, speaks to a particular kind of embodied interiority and agency of complex, flawed, Black women coming together, making meaning, and sharing experiencing through discourse around hair. These kinds of intimacies inform the larger project of *Lemonade* as a whole. In addition, the subsequent backlash and mocking of the lyrics by non-Black women suggest an immense value in Black women having safe spaces to negotiate body, beauty, and hair politics on their own terms, without fear of uninformed assumptions or surveillance.

BLACK HAIR AND BEAUTY STANDARDS

For decades, feminist scholars have written about the ways that narrow, hegemonic beauty ideals harm women and perpetuate sexism (Bartky 2013; Wolf 2002). Meanwhile, women of color have consistently complicated these notions of beauty culture further by pointing out the ways that limited notions of "beauty" and "perfection" are also indebted to racism and white supremacy. Literature on the ways that Eurocentric beauty norms or ideals map systemic white supremacy onto the physical body is extensive. Accordingly, mainstream beauty ideals have sociohistorically privileged features associated with whiteness: light skin, long and straighter hair, thin noses, and thin body frames (Byrd and Tharps 2014; Hunter 2005; Lake 2003).

Accordingly, features associated with Blackness—darker skin, wider noses, larger lips, and kinky hair textures—have consistently been denigrated and Othered socially. Although this chapter centers Blackness in a US context, Eurocentric beauty ideals have been documented across populations of people of color and across the African diaspora. Margaret Hunter argues in *Race, Gender, and the Politics of Skin Tone* (2005) that Eurocentric beauty standards are where racism and sexism intersect to serve the interest of two privileged social groups: whites and males. She notes, "Because race and gender can only be understood together, it follows that there must be a gender component to colorism itself. Light skin, in addition to being high status, is also regarded as more feminine, refined, or delicate" (3). In a world where qualities such as beauty, femininity, and delicacy are often lauded in women, these abstract and socially constructed standards of beauty ideals manifest themselves constantly.

These social standards are reflected in the fact that Black hair has been sociohistorically divided into categories of "good" and "bad" hair. This hierarchy is linked to European-centered standards of beauty because "good" hair is typically defined as hair with a wavier or loosely curled texture, while "bad" or "nappy" hair is kinkier and Afro textured (Banks 2000; Byrd and Tharps 2014; hooks, 2001; Jacobs-Huey 2006; Mercer 1994; Patton 2006; Rooks 1996; Robinson 2011). Black cultural studies scholar Kobena Mercer's piece, "Black Hair/Style Politics," states, "'Good' hair, when used to describe hair on a black person's head, means hair that looks European, straight, not too curly, not that kinky. And, more importantly, the given attributes of our hair are often referred to by descriptions such as 'woolly,' 'tough' or, more to the point, just plain old 'n****r hair'" (Mercer 1994, 101).

Historically, "tests" were done to determine if Black people's skin was light enough or their hair was "good" (wavy/loosely curly) enough to be accepted in certain social spaces. While tests like the "brown paper bag test" functioned to police skin tones, tests like the "comb test" concurrently policed hair textures (Byrd and Tharps 2014).[1] Scholar Obiagele Lake's *Blue Veins and Kinky Hair: Naming and Color Consciousness in African America* (2003) depicts advertisements for products as far back as the late 1800s that promised to make "kinky hair grow long and wavy" (54). The good hair/bad hair dichotomy is also linked to questions of maintenance because some Black women feel that "bad hair" needs to be straightened and styled, while "good hair" is more ready-to-wear (Robinson 2011).

Tracey Owens Patton notes that this hierarchy of hair textures "does not come solely from the African American community but also from the Euro American community, which promotes the acceptable standard of beauty" (Patton 2006, 39). She says that this standard of beauty privileges "very light skin," "blue or green eyes," and "long, straight or wavy hair" (39). Going further, Robinson's "Hair as Race: Why 'Good Hair' May Be Bad for Black Females" connects "good" and "bad" hair to the concept of colorism. Robinson defines colorism as "an intra-ethnic hierarchy that communicates light ethnic superiority" and as "a system of privileges, benefitting Blacks and other people of color with phenoltypical features commonly found among Whites, particularly lighter skin color and straighter hair textures" (Robinson 2011, 362). For Robinson, Patton, and others, colorism and hair hierarchies represent ways in which Western beauty standards are imposed on racialized people.

Relatedly, "good hair," as previously defined by loosely curly or wavy hair texture, is often attributed to biracial or multiracial ancestry (Bell 2010; Byrd and Tharps 2014; Lemieux 2014; Robinson 2011; Tate 2007). Here, beauty standards and colorism are mapped onto hair textures. While "good" hair is often conceptualized as a marker of biracial and multiracial identity, nappy Afro-textured hair is accordingly associated with people who are "fully" Black. Byrd and Tharps define the dichotomy by stating that during slavery, "Good hair was thought of as long and lacking in kink, tight curls, and frizz. And the straighter the better. Bad hair was the antithesis, namely African hair in its purest form" (2014, 18).

Despite this deeply and sociohistorically politicized context, Black women have always been creative, autonomous, and varied in terms of their hairstyles. Mercer notes, "On the political horizon of postmodern popular culture I think the *diversity* of contemporary Black hairstyles is something to be proud of . . . because this variousness testifies to an inventive, improvisational aesthetic"

(Mercer 1994, 128). Perhaps it is this autonomy, diversity, creativity, and inventiveness that has allowed the contemporary natural hair movement to flourish.

BEYONCÉ, AESTHETICS, AND BLACK FEMINISM

Scholarly and public interest in Beyoncé's art and stardom in terms of questions around gender, race, and sexuality has existed for at least a decade. Daphne A. Brooks's 2008 article argued that the work of Beyoncé's's 2006 album *B'Day* offers a kind of "black feminist surrogation," an "embodied performance that recycles palpable forms of black female sociopolitical grief and loss as well as spirited dissent and dissonance" (183). Ellis Cashmore's 2010 article unpacks Beyoncé as a "commodity," arguing at the time that her work sells a particular "dream" that "embodies a narrative, a living description of a culture in which race is a remnant of history and limitless consumer choice has become a substitute for equality" (135). Brooks's reading of Beyoncé's work through the lens of her feminist offerings and Cashmore's reading of her work through the lens of consumer-driven celebrity culture would come to predict two major strands of criticism of Beyoncé's work.

Some scholars have been receptive to the idea of Beyoncé as a feminist, often arguing that her art pushes us to imagine and grapple with new possibilities around how we understand Blackness, motherhood, sexual pleasure, entrepreneurship, and relationships with men. Janell Hobson's "Feminists Debate Beyoncé" ultimately lands favorably toward Beyoncé's feminism: "Beyoncé has most definitely changed the game in which black women can unhesitatingly embrace the 'feminist' label and bring to the table all of their sexiness and contradictory selves" (2016, 24). Brittany C. Cooper also wrote in support of Beyoncé's feminism: "We need to stop acting like radical feminism is the only kind of feminism" (2017, 228). Cooper also suggests that taking seriously a feminism like Beyoncé's's can detract from some of the elitism and exclusivity that happens within the movement. She states, "Time out for women-of-color feminist mean-girls shit. Sometimes folk just be hating. Real talk" (229). Ultimately, for Cooper, Beyoncé's feminism from her standpoint of an artist and entertainer provides something unique and unusual to the work, as Cooper notes: "Sometimes we take ourselves too seriously. If laughter and dancing ain't a part of this revolution we're building, then you can keep it" (229).

Other scholars and public figures have been more critical of Beyoncé's feminist politics.[2] Many of these arguments take Beyoncé's to task around issues of her in-

vestment in neoliberal capitalism, her reification of Eurocentric beauty standards, and her reiterating of well-worn sexual scripts. A widely discussed criticism of Beyoncé's feminism came from Black feminist and cultural critic bell hooks. At a 2014 panel discussion, "Are You Still a Slave? Liberating the Black Female Body," at New York City's New School, hooks argued that it is society's fascination with Beyoncé's's wealth within white supremacist capitalist patriarchy that undermines subversive possibility within her work (New School 2014). She stated:

> I think it's fantasy that we can recoup the violating image and use it. . . . You are not going to destroy this imperialist white supremacist capitalist patriarchy by creating your own version of it. . . . Even if it serves you to make you lots and lots of money. . . . Because . . . I've really been challenging people to think about, would we be at all interested in Beyoncé if she wasn't so rich? Because I don't think you can separate her class power and the wealth from people's fascination with her. (New School 2014)

Other panelists, including journalist/director/trans activist Janet Mock, pushed back on hooks's assertions, with Mock speaking to the ways that Beyoncé's's self-titled visual album, *Beyoncé*, particularly the song "Partition," has positively influenced her own understandings of Black women's sexuality and her own sensuality. Mock stated, "It's not that I don't see her without critique. . . . It was freeing to have Beyoncé showing her ass and . . . owning her body and claiming that space. That meant a lot to me, cuz it gave me the okay as someone who I looked up to since I was fifteen to have that" (New School 2014). In response, hooks made her now-infamous assertion that Beyoncé's is a "terrorist," maintaining that there is a part of her that is "antifeminist"—particularly her music and images' relationship to "young girls" (New School 2014). While hooks's comments about Beyoncé were surprising to some, they seem to fit squarely into hooks's longer intellectual trajectory.[3] For many critics, Beyoncé's commodification of sexuality is antithetical to more authentic forms of Black female sexual pleasure.

I am less interested in contributing directly to the debates on the merits of Beyoncé's feminism. These arguments have been rigorously unpacked for several years now, often ending up along a continuum of two places: (1) She is not or cannot be doing meaningful feminist work due to her investment in capitalism and wealth, normative beauty/femininity, and liberal individualism, or (2) We should take seriously the ways that her work is feminist—that is, it's complicating our ideas of Black femininity and sexuality and helping us view Black female

pleasure and joy (see also Hobson 2016; Weidhase 2015). Rather than commenting directly on Beyoncé's Black feminist identification, instead I investigate the "Becky with the good hair" line (and the album *Lemonade* more generally) as a discursively productive moment in that it reveals how Black women engage the particularities of the work. That is, Beyoncé's work is offering us feminist moments of exchange that seem to resonate and engender discourse among Black women in particular kinds of ways.

In addition to the question of her feminism, the question of Beyoncé's's relationship to beauty and ideas of femininity has also been contentious throughout her career. Those who critique Beyoncé pointed out her upholding Eurocentric beauty standards and limited ideals of femininity—particularly in the context of capitalist, racist, and patriarchal systems of oppression. Sarah Olutola's (2019) article asserts that the *Lemonade* era ultimately reifies a neoliberal, capitalist, patriarchal, white supremacist system. She argues this point through a close reading of Beyoncé's Super Bowl performance and "Sorry" video, arguing that in each of these spaces, Beyoncé (as the superstar "Queen B") actively elevates herself above the other (often dark-skinned) women she is surrounded by (Olutola 2019). We must acknowledge the ways in which Olutola's important work calls attention to how *Lemonade* reinscribes power dynamics, hierarchies of oppression, and capitalism to produce Beyoncé as a "star" who is put on pedestal above other Black women, particularly those with darker skin.

Janell Hobson also unpacked Beyoncé's relationship to notions of beauty, particularly in terms of various "hair moments" throughout her career. Hobson argues that Beyoncé's use of blonde weaves, as well as her blonde cornrows and braids throughout the visuals for *Lemonade*, "[disrupt] the beauty codes of whiteness while also upending the white supremacist definition of whiteness and blondeness with one that encompasses creolization and the African diaspora" (Hobson, 2019, 33). For Hobson, Beyoncé's career has been allowed room for her to reveal, disrupt, and play with notions of race, blondeness, and beauty ideals. Hobson also maintains that through the "Becky with the good hair line," Beyoncé "realigns her own body and self with other black women" (Hobson 2019, 33). In this way, Beyoncé implicitly speaks back to critics who have maintained that she is too blonde, too light skinned, too wealthy, and too in alignment with normative beauty ideals to represent or embody Black women more generally. My own analysis of Beyoncé's use of "Becky with the good hair," as well as the role of the body politic in the "Sorry" song and video more generally, is in conversation with Hobson's analysis.

On the topic of Beyoncé's situatedness in relationship to constructions of beauty, femininity, and Blackness, bell hooks critiqued her work again in 2016—this time in the context of the *Lemonade* era. In her essay, "Moving beyond Pain," hooks states that her first response to *Lemonade* was: "WOW—this is the business of capitalist money making at its best" (2016). In her review, she critiqued *Lemonade* for its "stylized, choreographed, fashion plate fantasy representations," glorification of violence, and fetishizing of Black female pain. hooks states, "*Lemonade* offers viewers a visual extravaganza—a display of black female bodies that transgresses all boundaries. It's all about the body, and the body as commodity. This is certainly not radical or revolutionary" (2016). As she had done during the 2014 "Are You Still a Slave?" conversation at The New School, Janet Mock once again responded to hooks's critiques of Beyoncé, this time in a series of tweets in May 2016 that read, in part:

> I hold bell hooks close. We are friends and have consistently disagreed privately and publicly about many topics like most friends do. ... "Utterly-aestheticized," "not dressed up bodies," "fashion plate fantasy" reeks judgment of glamour, femininity & femme presentations. This echoes dismissal of femmes as less serious, colluding w patriarchy, merely using our bodies rather than our brains to sell. Lets stop. ... Our "dressed up" bodies and "big hair" do not make us any less serious. Our presentations are not measurements of our credibility. These hierarchies of respectability that generations of feminists have internalized will not save us from patriarchy.

In terms of questions around beauty and body politics, hooks's critique and Mock's response reveal some of the major sites of contention at play. Mock and hooks's conversation personifies a push/pull between critiques of beauty and claims of femmephobia/judgment that have existed within feminism for decades.[4] hooks's critique of *Lemonade* forces us to reckon with the fact that the "beauty" presented in Beyoncé's work is rooted in complex power dynamics. Mock's response forces us to engage what it means to claim space in one's own body—particularly her own as a very femme-presenting Black trans woman who has grappled herself with the "pretty privilege" she has been afforded (see Mock 2017). I think that we can and should have nuanced conversations about the different kinds of work a project like *Lemonade* does—the ways that it maintains systems of oppression while perhaps also simultaneously subverting or revealing them as well. Although we must constantly be critical of "beauty," we must also recognize that it matters—as a site of pleasure, fun, self-expression, oppression,

pain, and more—to many Black women locally and globally. In a similar vein, we must constantly be critical of Beyoncé, while also recognizing that she matters a great deal to many Black women locally and globally. The analysis that follows suggests that while Beyoncé herself is complicit in mainstream beauty norms, she also has the agency to reveal and mock them in moments like the "Becky with the good hair" line.

ON "SORRY" AND THE RELEASE OF *LEMONADE*

The significance of the track "Sorry" and its engagement with Black hair politics must also be contextualized within both the cultural impact and the commercial and critical success of the album the song appears on: *Lemonade*. Released in April 2016, the visual album first aired on HBO, then on streaming service Tidal, and then on all other major streaming and music purchasing platforms. Like her previous, self-titled album, the actual release of the album was a surprise, and it was also a visual album, complete with a set of motion picture visuals that corresponded with all or part of each song. *Lemonade* was a commercial and critical success. The album charted at No. 1 on the Billboard 200, giving Beyoncé the sixth chart topper of her career, and on its release, *Lemonade* was the biggest album of 2016 (Caulfield 2016). Beyoncé's even made history by marking the first time a female act simultaneously charted twelve or more songs on Billboard's Hot 100 list because all twelve of *Lemonade*'s tracks made the list (Mendizabal 2016). The album was also a critical success: the review-curating website Metacritic gathered thirty-three reviews from major publications and noted that the album received nearly "universal claim," with a 92 percent "MetaScore" (Metacritic). Jonathan Bernstein of the *Telegraph* UK wrote, "*Lemonade* is by far Beyoncé's strongest album," while Greg Kot of the *Chicago Tribune* called the album "the singer's most fully realized music yet" (Bernstein, 2016; Kot, 2016).

"Sorry," the fourth track on the *Lemonade* visual album, fits within the album's larger narrative of a married Black woman experiencing various stages of her husband's infidelity. The song is an upbeat, first-person breakup track that juxtaposes vulnerability and strength. Beyoncé's calls for "middle fingers up" to her lover, and the chorus repeats, "Sorry, ain't sorry." The song was written and produced by the artists Melo-X, Diana Gordon (also known by her stage name, Wynter Gordon), and Beyoncé herself. Jon Pareles of the *New York Times* calls the track "a twitchy, flippant song that's by no means an apology. It's a combative, unglossy track on an album full of them" (2016). Beyoncé breathes the final, dis-

missive lyrics of the song barely over a whisper: "He only want me when I'm not there . . . / He better call Becky with the good hair." With these two lines, Beyoncé subverts hegemonic standards of beauty; evokes an embodied, sociohistorical construction of Black hair politics; and reveals a certain kind of intimacy shared between and among Black women.

ON BLACK FEMINISM AND INTERIORITY

Black feminist cultural criticism provides a way in for understanding the creation and reception of *Lemonade* more generally and "Sorry" more specifically. Within a longer tradition of Black feminist film criticism, Hobson also argues that art created by Black women that centers Black female experiences has the potential to subvert problematic or limited images of Black women (2005). She suggests that Black women's cultural production can recover or reframe embodied, racist, and sexist constructions of Black femininity that have historically been wrapped up in questions of beauty standards, sexuality, and fetishizing and colonial ideas of "the Other" (2005). The pursuit and manifestation of this kind of recovery create new spaces for constructing Black womanhood. Accordingly, Black female creators, directors, writers, artists, actresses, and producers have the ability to reimagine new and subversive representations of Black female subjectivity. This is not to suggest that every representation assembled by a Black woman will be inherently subversive or that it will represent all Black women's experiences. However, Black women have a particular ability to represent the nuances and complexities of their own lived experiences.

"Sorry" took on a particular significance within mainstream discourse, while holding—arguably more critical—interpretations for different audiences. Although *Lemonade* had never been confirmed as autobiographical at that time, many mainstream media publications became preoccupied with speculating on the "true" real-life identity of "Becky" and whether a "Becky" did indeed nearly destroy Jay-Z and Beyoncé's marital union.[5] Meanwhile, online, Black women actively critiqued, analyzed, and located various themes and references found within *Lemonade*, and "Sorry" in particular. They used Internet-based platforms such as microblogging site Twitter, social networking platform Facebook, blogs, and response videos on YouTube to unpack the various nuances of the work. Here, Black women's Internet use in part served as a space for what hooks might call "critical spectatorship," or what German philosopher/sociologist Jürgen Habermas might name a "counterpublic" or a "parallel discursive

arena"—a concept Graham and Smith (2016) use to describe "Black Twitter" as a discursive space.

I am also interested in framing these discourses through ideas of Black women's "interiority" and through a lens of "pleasure based consumption" (Nash 2012; Warner 2015). The recent turn in Black feminist cultural criticism toward pleasure-based media consumption forefronts the ways in which Black women find pleasure, often through identification, in media representations (Warner 2015). This attention to pleasure, in contrast to consumption, disrupts critics' (particularly Black feminists') historical preoccupation with determining where an image falls within the binary of a positive or negative representation of a Black women, as well as the historical tendency to seek out and point out "stereotypes" of Black women (the Jezebel or the Sapphire) found within representations. For me, both *Lemonade* and "Sorry" do this work of providing pleasure-based consumption that rejects binaries and boxes through their articulations of Black women's nuanced and layered experiences.

Lemonade and "Sorry" lay bare this nuance by making public what is often kept private: the embodied complexities, contradictions, and varied lived experiences of Black women's lives. In other words, Beyoncé's *Lemonade* reveals Black women's "inner lives," or their "interiority" (Robinson 2016). Scholars have theorized the concept of interiority in an attempt to articulate and uncover that which Black women (and, in some cases, Black people in general) have historically kept hidden in the interest of self-preservation and self-protection (Alexander 2004; Benjamin 2015; Hine 1989; Morgan 2015).

I understand Black women's interiority in part through their practicing of dissemblance, the term famously coined by historian Darlene Clarke Hine in her seminal 1989 piece, "Rape and the Inner Lives of Black Women in the Middle West." According to Hine, Black women "protect the sanctity of their inner lives" as a response to "the interplay of racial animosity, class tensions, gender role differentiation, and regional economic variations" (Hine 1989, 915). For Hine, "Black women as a rule developed a politics of silence, and adhered to a cult of secrecy . . . creating the appearance of disclosure, or openness about themselves and their feelings, while actually remaining enigmatic" (915). According to Hine, Black women's "inner lives"—their vulnerability, their complexity, their feelings—have historically been dissembled as a mode of protection from certain embodied forms of oppression inherent in Black female subjectivities. *Lemonade,* and "Sorry" in particular, make public some of these sites of complexity and vulnerability. I view the "Becky with the good hair" moment as a particular

point when that which is experienced and embodied privately in specific ways for and by Black women (hair, beauty standards, body politics) was made public and then interpreted publicly in various ways.

Elizabeth Alexander's 2004 work, *The Black Interior*, pushes us to consider the potentiality in revealing these interior moments, in "identifying complex and often unexplored interiority beyond the face of the social self" (4–5). She asks, "If black people in the mainstream imaginary exist as fixed properties deemed 'real,' what is possible in the space we might call surreal?" (5). It is this space of "possibility" through interiority that I am interested in. Alexander views Black artists as having the potential to do this work, noting, "I see [the black interior] as an inner space in which black artists have found selves that go far, far, beyond the limited expectations and definitions of what black is, isn't, or should be" (5). Like Alexander, I want my analysis to reveal spaces of potentiality when what is not public becomes public. Here, art/cultural production may reveal the complexities, vulnerabilities, intimacies, and embodied inner selves of Black women. For me, the taking up of "good hair" politics via the "Becky with the good hair" moment in "Sorry" opens up a space for possibility in terms of our conversations around hair politics, beauty culture, and the impact of systems of oppression on Black women's relationships to these constructs. How can we locate Black women's agency within these systems? And where is the radical potential in understanding Black women's reframing, renegotiating, vulnerability within, and experiencing of Eurocentric standards of beauty—rather than rendering them objects, victims, symbols, or models within that space?

Black feminist scholar Joan Morgan much more recently offered the notion of "Black female interiority" within her own work on Black women and pleasure, erotics, and sexuality. In part, Morgan's work on interiority speaks to Hine's groundwork on dissemblance, as she frames "interiority" as encompassing: "the quiet composite of mental, spiritual and psychological expression"; "the broad range of feelings, desires, yearning (erotic and otherwise) that were once deemed necessarily private by 'the politics of silence'"; and "the codicil to cultural dissemblance" (2015, 37). While Hine and Morgan are both largely referencing Black women's relationship to their sexuality, I maintain that hair/beauty and sexuality are linked because they are both embodied and felt in certain kinds of ways—a connection that is fully apparent in "Sorry."

"I AIN'T SORRY": RACE, GENDER, AND BEAUTY
IN *LEMONADE* AND "SORRY"

The song/music video "Sorry" appears as the "Apathy" stage of the larger breakup narrative of *Lemonade*. Before "Apathy" is "Anger," which is paired with the song "Don't Hurt Yourself (featuring Jack White)." Immediately preceding the "Anger" is a poem credited to Somali-British poet Warsan Shire. The passage involves the narrator offering to physically take and put on physical characteristics/body parts of "the other woman" in order to embody her and please the husband. In part, the passage reads:

> If it's what you truly want
> I can wear her skin over mine.
> Her hair over mine.
> Her hands as gloves.
> Her teeth as confetti.
> Her scalp, a cap.
> Her sternum, my bedazzled cane.
> We can pose for a photograph, all three of us.
> Immortalized ... you and your perfect girl.

Here, Shire/Beyoncé's work begins to link corporality, physical features, and beauty (via "perfection"). As later in the piece the "mistress" in the narrative is coded as non-Black, via the "Becky with the good hair" moment, Beyoncé's work implies early on with this poem that they are different and distinct corporeally. The violent and graphic nature of the poem stands in for the violence of beauty standards and body policing on Black women. The speaker is willing to wear the mistress's skin over her own—her scalp as a cap, her teeth as confetti, and her sternum as a cane. As Shirley Anne Tate argues, Black womanhood exists as "alter/native bodies," which are sites of negotiation both as bodies and within national bodies. Tate states:

> Enslavement, colonialism and settlement in the metropole constructed Black women's bodies as alter/native. As affective other/same, these bodies draw attention to the negotiations through which the semblance of consensus on the national body is created. At the same time they rupture this consensual, collective body formed through the (re)iteration, (re)interpretation and (re)

presentation of the meanings of muscle, bone, fat and skin—the materiality of the body itself. (Tate 2015, 8–9)

It follows that Beyoncé would early on establish the body as a site of struggle between the literal mistress of the story versus herself in a story where betrayal and infidelity also represent the oppression and denigration of Black women/Black womanhood. Beyoncé continues this metaphor with the use of the "Becky with the good hair" idea in the "Sorry" song. The video opens on a school bus where Beyoncé and several dancers are sitting together. The dancers, painted in Nigerian artist Laolu Senbanjo's Sacred Art of the Ori paint and traditional hairstyles, begin dancing on the bus. The video then cuts to a plantation house, the camera panning through the house past more dancers to tennis legend Serena Williams. Williams begins gyrating and twerking (a dance that involves bouncing one's bottom up and down to the beat) while in the house. The dancing is defiant yet playful as Williams returns the camera's gaze.

Throughout her lengthy career, Williams has been castigated and masculinized on and off the court for her physical strength and appearance, as well as her engagement with Black culture on the tennis court (e.g., "crip walking" after a win and wearing her hair in culturally specific styles). Indeed, when she and her sister were quite young, their hair was hyperscrutinized when they wore tiny braids with beads on the end. As Shirley Anne Tate argues, Serena Williams, Michelle Obama, and other Black women with muscles engender combinations of "fascination," "fear," and "disgust" within mainstream coverage. Tate reminds us, "These women carry the burden of the differential meaning of whiteness and femininity on their bodies and this is what we see being displayed in the media coverage" (2015, 117). Thus, Williams's dancing in this moment can be read as a kind of reclaiming of her body, beauty, and sexuality.

At the end of the video, Beyoncé is adorned in a sort of Queen Nefertiti–inspired outfit as she sings the final "Becky" lines, referencing her husband's mistress as Becky. Recall that "Becky" is a slang term used within Black communities for a nondescript, often young, white woman. The term was popularized by the iconic 1992 single "Baby Got Back" by rapper Sir Mix-A-Lot. In the 1992 music video for the song, two white women stare, mouths agape, at a Black woman's body. One says to the other in a "valley girl" tone, "Oh my god, Becky . . . *Look* at her butt . . . *It's just so. . . big*" (Sir Mix-a-Lot 1992). Here, Becky and her friend are represented as judgmental and ditzy, standing in complete opposition (literally, physically, and symbolically) to the Black woman in question

and her large "butt." In many ways, Becky sits in complete opposition to Black women, which speaks to the ways that the category of "woman" is defined in opposition to Black womanhood. As Hortense Spillers reminds us, "Woman—a universal and unmodified noun—does not mean *them*. 'Woman/women' belong to that cluster of nominatives that includes 'feminist,' 'lesbian,' even 'man,' that purport to define the essence of what they name, and such essence is inherently paradigmatic, or the standard from which deviation and variation are measured" (2003b, 159–60). Becky is the standard for womanhood, and the Black woman who's "got back" is "other-ed." As a non-Black woman, Becky is defined in opposition to Black womanhood, and each of them gains coherence from these oppositional definitions. Becky is everything a Black woman is not, especially in terms of her physicality—including, of course, her hair.

Over time, "Becky" became symbolic for all stereotypical, generic, or unremarkable young, white women. In "The Complete History of 'Becky with the Good Hair,' from the 1700s to 'Lemonade'" (2016), Jennifer Swann maps the evolution of the term, framing it in part through the lens of *Lemonade* and the question of sexuality. She cites Simone Drake, who links Becky to "Miss Ann"— coded language from the 1700s onward that Black enslaved women used to denote the white mistress of the household. Today, Swann defines Becky in this way: "Becky is white. Becky is basic [average, unremarkable]. Becky is bitchy. Nobody likes her" (2016). Becky may also be image obsessed, promiscuous, annoying, and—perhaps most pertinent—"never, ever" Black (Swann 2016). As Zeffie Gaines argues, "It's important to the narrative unfolding of Lemonade that the 'other woman' is somehow less black than Beyoncé, or not black at all. This is a vital part of understanding the symbolic logic" (2017, 108).

Beyoncé subverts the meaning of "good hair," removing "good hair" from its social pedestal within the hierarchy of hair textures, offering "Becky with the good hair" as a way to lay bare and critique how these hegemonic beauty standards may have affected her husband's attraction to his alleged mistress. Spillers states, "The subject is certainly seen, but she also sees. It is this return of the gaze that negotiates at every point a space for living, and it is the latter that we must willingly name the counter-power, the counter-mythology" (2003b, 163). The "Becky" moment is less about malice, spite, or bitterness, though—to be sure—there is some anger being (re)claimed there. It is more of an "I see you" moment, a kind of revealing and checking of assumptions that may be present in the literal (and metaphorical) crime of infidelity against the Black woman.

INTERIORITY, CRITICAL RESPONSES, AND THE SEARCH FOR "BECKY"

Black women's unique relationship to "Becky with the good hair" is in part high-lighted by the ways that mainstream media exhausted themselves in trying to uncover the identity of the "real" Becky. Many mainstream media publications became preoccupied with speculating on the "true" real-life identity of "Becky," and whether this "Becky" did indeed nearly destroy Jay-Z and Beyoncé's marital union. Rather than viewing "Becky" and her "good hair" as rhetorical, signal-ing Black women's relationships to beauty standards and non-Black women, mainstream media were incessant in this pursuit of this Becky's identity. The Internet swarmed with theories regarding the identity of the mistress of Beyoncé's husband, hip-hop icon Sean "Jay-Z" Carter. Major publications such as *People* magazine speculated on whether "Becky" was white, female, British pop singer Rita Ora, or half-Indian and half-Dutch fashion designer Rachel Roy, both of whom had been rumored to be linked to Jay-Z in the past (Mizoguchi 2016). According to writer Greg Tate (2016), the search for Becky after the release of *Lemonade* "broke the internet."

Zeffie Gaines notes, "Though much of the initial public attention focused on the question of infidelity in Beyoncé's high-profile marriage to Jay-Z, black women were quick to see that this album was about much more than a cheat-ing husband" (Gaines 2017, 103). Online, Black women critiqued, analyzed, and located various themes and references found within *Lemonade*, and "Sorry" in particular. They used social media platforms like Twitter, Facebook, blogs, and critical videos on YouTube to unpack the various nuances of the work.

Commentary from Black women suggested that *Lemonade* and "Sorry" laid bare what is often kept private: the embodied complexities, contradictions, and varied lived experiences of Black women's lives. Sociologist Zandria F. Robinson observed for *Rolling Stone* that Beyoncé's work reveals parts of Black women's "inner lives" (2016). Citing Darlene Clark Hine's "culture of dissemblance," Rob-inson stated, "Part of black women's magic, born of necessity, has been the ability to dissemble: to perform an outward forthrightness while protecting our inner, private lives and obscuring our full selves." Meanwhile Zeffies Gaines also argued that *Lemonade* gives voice to "a range of complicated experiences" and an "inte-rior landscape" that is "all too often elided in a culture that is mostly interested in demonizing and dismissing black femininity" (Gaines 2017, 101).

Lemonade, and "Sorry" in particular, make public some of these sites of com-

plexity and vulnerability. I view the "Becky with the good hair" moment as the point when that which is experienced and embodied privately in specific ways by Black women (hair, beauty standards, body politics) became public. Ultimately, Black female singer and songwriter Diana Gordon stated that indeed, "Becky" was never penned with the intention of referencing one specific person or incident. In an interview with *Entertainment Weekly*, Gordon stated, "The idea started in my mind but it's not mine anymore. It was very funny and amusing to me to watch it spread over the world. If it's not going to be me saying it, and the one person in the world who can say it is Beyoncé, I was f-ing happy" (Goodman 2016). Gordon said she "laughed" at people attempting to pin the designation on various female celebrities and thought to herself: "This is so silly. Where are we living? ... 'What day in age from that lyric do you get all of this information?" (Goodman 2016).

Predictably, the "Becky with the good hair" moment was not universally met with favor, particularly among non-Black women. An exemplar of this tension was a much-discussed Twitter thread written by popular Australian white female rap/pop artist Iggy Azalea. On the social media platform, Azalea critiqued the general use of "Becky" as a blanket name for white women, stating that it is equally as offensive to call a Black woman "Sha nay nay," a Black man "Deshawn," or an Asian woman "Ming Lee" (Davies 2016). As *US* magazine reported, the impetus for Azalea's commentary was a fan on Twitter referring to Azalea as a Becky, to which the recording artist replied with a series of tweets that stated in part:

> Don't ever call me a Becky. . . . WE ALL KNOW 'becky' started because you all think white girls just go around slobbing on everyones d--k. . . . Its in no way close to a slur, just rude to replace someones name with a generalized name representing their race. . . . No i dont think Beyonce is racist nor do i think calling someone "BECKY" is the same as a racial slur. I actually like her and the project. . . . BUT, no i dont think its great to use stereotypical names to describe ANY race. I think we can all agree on that. (Marquina, 2016)

Overall, Azalea's comments appear to have been taken with a grain of salt, likely due to her own history of being accused of cultural appropriation and racially insensitive lyrics.[6] The popular woman's celebrity website, Jezebel, cheekily titled one article, "Do Not Call Iggy Azalea a 'Becky' Even Though She's Acting Like One" (Davies 2016). Azalea is of course within her rights to find the idea of "Becky" offensive; however, the comparison of calling a Black woman "Sha nay nay" to calling a white woman "Becky" is a difficult one.

As Black female writer Kadia Blagrove maintains in *Huffington Post*, the use

of "Becky" in "Sorry" was less about the naming of individual white women and more about the critique of systems of oppression that often privilege them as a class. In making this point, Blagrove pushes back again Azalea's claims, stating:

> Aspiring rapper Iggy Azalea is fighting to end racism against white women by urging people to stop using the term "Becky." ... What a time to be alive. The "race card" is now being used by white people! "Becky" is not racist, but it is a term for "generic white girl." The moniker comes from a long history of frustration with white female supremacy in regards to femininity, beauty, and overall worthiness. Can it be seen as offensive? Sure, I guess. But it's not racist. (Blagrove 2016)

Like other Black female commenters, Blagrove was quick to articulate connections between Becky with the good hair, beauty, and Black women's specific subjectivities:

> The whole line refers to the very common insecurity many black women have had when being compared to or scrutinized against the often preferred eurocentric beauty standard. . . . She uses the "Becky" line in "Sorry" to illustrate the unique sting of colorism, racism, and misogyny hurled at black women by black men who prefer white (or just non-black) women over black women. (Blagrove 2016)

Indeed, alongside queries over "Becky's" identity and allegations of racism, some writers and cultural critics, many of them Black women, pointed to the ways that Beyoncé's lyrics can be read as subversive Black feminist commentary on hegemonic beauty standards rather than fodder for celebrity gossip. Black journalist Bené Viera wrote a Facebook post shortly after *Lemonade*'s release, stating toward the beginning of the post:

> Beyoncé made #Lemonade for Black women first, then Black people as a whole. Sure, others can enjoy it. But it's for us. Therefore, we really should be the ones writing about and dissecting it. If you didn't know what "call Becky with the good hair" meant without Googling, put your pen down. We don't want to read it. . . . It's heavily African influenced in every way imaginable. Then we have black feminist theory all up and through. (Viera 2016)

Here, Viera marks the "Becky with the good hair" line as the ultimate insider moment of *Lemonade*. If you had to actively Google that particular line because you were unsure of its meaning, that signals for Viera that perhaps *Lemonade*

wasn't written entirely for you. A lack of instant identification with the line indicates a lack of the embodied, lived, inner familiarity with the construct of "good hair" and what it means for women of color in relation to the "Beckys" of the world. In short, those who know, know. Black womanist writer, artist, and cultural critic Trudy of the website Gradient Lair also articulated the relationship between "Becky with the good hair" and Eurocentric beauty norms, tweeting: "'Becky' & 'good hair' comment. And the wearing 'her' skin/teeth etc. Like awareness of the *violence* of Eurocentric beauty norms" (Trudy). Here, the use of "wearing" and "violence" again speaks to the embodied nature—what is physically felt of Black women's experience of hegemonic beauty standards and white supremacist patriarchy more broadly.

Indeed, as this Black feminist cultural studies scholarship on interiority shows, the lyrics of "Sorry," and Lemonade more broadly, speak to specific embodied intimacies of Black womanhood. Hair aptly does this work because it is so embodied—it grows on the body, from the body, and is inscribed with sociohistorical meaning distinct to Black women's bodies alone.[7] The question of "good hair" versus "bad hair" stems from Black Americans' experiences during and after enslavement. Parallel language exists for Black women throughout the African diaspora, as the phrase "pelo malo" or "bad hair" is also used in Afro Latinx communities. However, the "good hair"/"bad hair" dichotomy remains rooted as an identifier of women of color's hair texture in a way that denotes a proximity to whiteness—whether as close in proximity to it ("good hair") or as antithetical to it ("bad" or "nappy" hair). Thus, Beyoncé's evoking of "Becky with the good hair" carries a specific and intimate rhetorical meaning for Black women in particular, who are often raised to have complex relationships with their own natural hair texture.

CONCLUDING THOUGHTS:
"BABY HEIR WITH BABY HAIRS"

Beyoncé evokes hair specifically, and beauty politics more broadly, in several other places throughout Lemonade—from her evoking of ancient queen Nefertiti with "crowned . . . braids [and] a bejeweled headdress" in the music video for "Sorry;" to her cornrows, head wraps, and box braids throughout the short film; to her featuring of young biracial actress Zendaya Coleman (an outspoken rising star who was publicly both praised and mocked for wearing faux dreadlocks at a red carpet event; Tinsley 2016). To discuss every "hair" moment in Lemonade

is beyond the scope of this chapter. However, a few lines from the lead single, "Formation," may be worth a concluding mention. Here, Beyoncé sings, "I like my baby heir with baby hairs and afros / I like my negro nose with Jackson Five nostrils" (Brown et al. 2016).

The moment is not only another nod to and subversion of Black women's specific experiencing of hegemonic, Eurocentric standards of beauty; it is also a direct "clapback" (retaliatory quip) at critics who lambasted Beyoncé for the appearance of the hair of her four-year-old daughter, Blue Ivy. In 2014, Beyoncé and husband, Jay-Z, were being criticized online for the appearance of Blue Ivy's hair, which often stuck straight out of her head in an Afro. Her critics would have preferred that Blue's hair was straightened, permed, smoothed down, plaited, or otherwise contained and made smaller. One woman went as far as to create a Change.org petition requesting that Blue Ivy's parents "properly" comb her hair. While likely created as a mean joke, the petition ultimately garnered over five thousand signatures (Moss 2016). As scholar Sonita R. Moss (2016) argues, the moment revealed the unique nature of racialized sexism and the ways in which even Beyoncé cannot escape the hyperscrutiny and demonization of "bad Black mothers" that Black women have faced for many years.

Beyoncé's mentioning of her "baby heir" daughter Blue Ivy's hair, alongside "Becky with the good hair," speaks to the ways that these politics are passed down intergenerationally and are very much rooted in Black women's girlhood. Zandria F. Robinson also observes, "*Lemonade* is Beyoncé's intimate look into the multigenerational making and magic of black womanhood" (2016). The nod to Blue Ivy speaks to additional intimacies of Black girlhood, which will ultimately evolve into Black womanhood. In order to garner the shared understanding of Black womanhood that is revealed through "Becky with the good hair," one must also experience "baby hair" with "baby hair" turned to "Afros."

Ultimately, Beyoncé's use of "Becky with the good hair" lays bare and subverts Eurocentric beauty standards while suggesting shared meaning and experiences regarding Black women's experiencing, negotiating, and critiquing these standards. The repetition of the two lines, and a charting of Black women's unique responses to them, suggests that many Black women instantly identified with the phrasing and thus "knew" the experience without needing it explained or named. The argument is not that Black women share a monolithic experience but that there are lived experiences that sometimes meet at similar intersections of Black cultural practices, gendered standards of beauty, and conversations around hair texture—partially produced by "intersecting" systems of oppres-

sions (Collins 2005). As women navigate these sometimes tumultuous terrains, they are able to both independently and collectively sing their experiences along with Beyoncé. Ultimately this is the work that *Lemonade* does. The crux of the album's Black feminism may be its ability to speak to the complexity, depth, and diversity of Black women's experiences. The implications of the lines, and the subsequent mixed reactions online, suggest an immense value in Black women having "intramural" (Spillers 2003a) spaces to negotiate body, beauty, and hair politics on their own terms—without fear of misinformed allegations of jealousy, racial bias, or surveillance.

In spite of the proliferation of the natural hair movement, Black women still grapple with Eurocentric beauty standards of their past and their present, and they will consistently face structures of sexism, racism, classism, heteronormativity, and more that will attempt to tell them exactly who and what they are. However, cultural productions like *Lemonade* at the very least open up a space, a step toward self-knowledge and ultimately self-acceptance through depictions of intimacy that Black women read, claim, and relate to in specific ways. The community of Beyoncé supporters and Lemonade fans is not a magically utopian, liberated, united, monolithic, group of "woke" "Black queens." Rather, its community comes from a revealing of the interiority and agency of complex, flawed, Black female human beings coming together, making meaning, and sharing experiencing through discourse.

NOTES

1. The "brown paper bag" tests allowed paper bags to serve as a benchmark for being "light enough" in skin tone intraracially. With "comb tests," hair that could easily be combed was privileged; kinkier, coily hair is thought to be more difficult to comb.

2. For example, white female singer/musician/songwriter/activist Annie Lennox called Beyoncé's feminism "tokenistic" and "feminism lite" in an interview (see Weidhase 2015).

3. hooks's 1992 chapter, "Selling Hot Pussy: Representations of Black Female Sexuality in the Cultural Marketplace," offers a reading of Black female sexuality rooted in questions of capital, exploitation, and classism. For hooks, the commodification of sexuality in virtually all of its forms undermines its potentiality to subvert. Her reading of Tina Turner's music video for "What's Love Got to Do with It" reflects this position. In the chapter, hooks states, "Contemporary black female sexuality is fictively constructed in popular rap and R&B songs solely as commodity—sexual service for money and power, pleasure is secondary" (69).

4. For a recent, comprehensive overview of this literature, see Elias, Gill, and Scharff (2017).

5. A year after the April 2016 release of *Lemonade*, Beyoncé's husband, Jay-Z, released an album, *4:44*, on June 30, 2017. His album explored themes of self-reflection, critiques of normative masculinity, maturity/growth, and Black entrepreneurship. On the track "4:44," he also speaks about his own infidelity in the form of a sort of apology letter, noting the physical and emotional toll the cheating took on Beyoncé herself. Finally, on June 16, 2018, the couple released their first joint album, *Everything Is Love*, under the name "The Carters"—a conclusion to what seemed to be a three-part album narrative. Here, the couple seems to have reconciled and moved forward. The album's themes revolve around their joint successes in terms of financial capital, cultural impact, romantic love, and the building of a Black pride-infused legacy.

6. Throughout her career as a rapper, Iggy Azalea has been accused of appropriating Black stylization, as well as African American vernacular English (see Cooper 2014). Early in her career, she also found racially charged controversy in referring to herself as a "runaway slave master" in her 2012 track "D.R.UG.S" (see Mossman 2014).

7. When I describe something as "embodied" or use the term *embodiment*, I am evoking it in ways similar to how philosopher Paul C. Taylor uses it in his book *Black Is Beautiful: A Philosophy of Black Aesthetics* (2016). Taylor references the tradition of Richard Shusterman's (2011) pioneering work on bodies and aesthetics. For Shusterman and Taylor, "embodiment" is interested in "the way the body is experienced, as it were, from the inside" (Taylor 2016, 107).

REFERENCES

Alexander, Elizabeth. 2004. *The Black Interior*. Saint Paul, MN: Graywolf.

Bale, Miriam. 2016. "Beyoncé's 'Lemonade' Is a Revolutionary Work of Black Feminism: Critic's Notebook." *Billboard*, April 25. http://www.billboard.com/articles/news/7341839/beyonce-lemonade-black-feminism.

Banks, Ingrid. 2000. *Hair Matters: Beauty, Power, and Black Women's Consciousness*. New York: New York University Press.

Bartky, Sandra Lee. 2013. "Foucault, Femininity and the Modernization of Patriarchal Powers." In *The Politics of Women's Bodies: Sexuality, Appearance, and Behavior*, 4th ed., edited by Rose Weitz and Samantha Kwan, 64–85. New York: Oxford University Press.

Bell, Monita Kaye. 2010. *Getting Hair "Fixed": Black Power, Transvaluation, and Hair Politics*. Saarbrücken: Lambert Academic Publishing.

Benjamin, Shanna Greene. 2015. "Pedagogy of the Post-Racial: The Texts, Textiles, and Teachings of African American Women." *Palimpsest: A Journal of Women, Gender, and the Black International* 4: 24–50. muse.jhu.edu/article/581326.

Bernstein, Jonathan. 2016. "Lemonade Is Beyoncé at Her Most Profane, Political and Personal: Review." *Telegraph,* April 24. http://www.telegraph.co.uk/music/what-to -listen-to/lemonade-is-beyonc-at-her-most-profane-political-and-personal/.

Bey, Jamila. 2011. "Going Natural' Requires Lots of Help." *New York Times,* April 10. http:// www.nytimes.com/2011/06/09/fashion/hair-care-for-african-americans.html?_r=0.

Blagrove, Kadia. 2016. "Five Things People Blew Out of Proportion about 'Lemonade.'" *Huffington Post,* April 29. https://www.huffingtonpost.com/kadia-blagrove-/5-things -people-blew-out-_b_9803692.html.

Bobo, Jacqueline. 1998. *Black Women Film and Video Artists.* New York: Routledge.

Brooks, Daphne A. 2008. "All That You Can't Leave Behind': Black Female Soul Singing and the Politics of Surrogation in the Age of Catastrophe." *Meridians* 8, no. 1: 180–204.

Brown, Khalif, Jordan Frost, Asheton Hogan, Beyoncé Knowles-Carter, and Michael Len Williams. 2016. "Formation" [Beyoncé Knowles-Carter]. On *Lemonade* [Streaming]. Quad Recording Studies: Parkwood-Columbia.

Byrd, Ayana. D., and Lori L. Tharps. 2014. *Hair Story: Untangling the Roots of Black Hair in America* (1st rev. ed.). New York: St. Martin's Griffin.

Cashmore, Ellis. 2010. "Buying Beyoncé." *Celebrity Studies* 1, no. 2: 135–50. https://doi.org /10.1080/19392397.2010.482262.

Caulfield, Keith. 2016. "Beyoncé Earns Sixth No. 1 Album on Billboard 200 Chart with 'Lemonade'" *Billboard,* May 1. http://www.billboard.com/articles/columns /chart-beat/7350372/beyonce-earns-sixth-no-1-album-on-billboard-200-chart-with -lemonade.

Collins, Patricia Hill. 2005. *Black Sexual Politics: African Americans, Gender, and the New Racism.* New York: Routledge.

Cooper, Brittney C. 2014. "Iggy Azalea's Post-Racial Mess: America's Oldest Race Tale, Remixed." *Salon,* July 14. http://www.salon.com/2014/07/15/iggy_azaleas_post_racial _mess_americas_oldest_race_tale_remixed/.

———. 2017. "Five Reasons I'm Here for Beyoncé, The Feminist." In *The Crunk Feminist Collection,* edited by Brittney C. Cooper, Susana M. Morris, and Robin M. Boylorn, 226–29. New York: Feminist Press at CUNY.

Corbett, Corynne. 2012. "Exclusive: Solange Knowles Shares Her Natural Hair Secrets." *Essence,* May 31. http://www.essence.com/2012/05/31/exclusive-solange-knowles-shares -her-natural-hair-secrets.

Davies, Madeleine. 2016. "Do Not Call Iggy Azalea a 'Becky' Even Though She's Acting Like One." *Jezebel,* April 26. http://jezebel.com/do-not-call-iggy-azalea-a-becky-even -though-shes-acting-1773208376.

Elias, Ana, Rosalind Gill, and Christina Scharff. 2017. "Aesthetic Labour: Beauty Politics in Neoliberalism." In *Aesthetic Labour: Rethinking Beauty Politics in Neoliberalism,* edited by Ana Sofia Elias, Rosalind Gill, and Christina Scharff, 3–50. London: Palgrave Macmillan.

Gaines, Zeffie. 2017. "A Black Girl's Song: Misogynoir, Love, and Beyoncé's Lemonade." *Taboo: The Journal of Culture and Education* 16, no. 2: 97–114.

Goodman, Jessica. 2016. "Beyoncé Collaborator Diana Gordon Breaks Down Lemonade Songs—and What's Next for Solo Career." *Entertainment Weekly,* August 2. http://www .ew.com/article/2016/08/02/diana-gordon-interview?xid=entertainment-weekly _socialflow_twitter.

Gordon, Wynter, Beyoncé Knowles-Carter, and MeLo-X. 2016. "Sorry: Beyoncé." *Rap Genius,* April 25. https://genius.com/Beyonce-sorry-lyrics.

Graham, Roderick, and Shawn Smith. 2016. "The Content of our #Characters: Black Twitter as Counterpublic." *Sociology of Race and Ethnicity* 2, no. 4: 433–49. doi:10.1177/2332649216639067.

HIDZ, sereinik, billydisney, Christine Werthman, dmes143, Michael Heal, JohnGanz, Anna Oseran, and Insanul Ahmed. 2016. "Becky with the Good Hair," in *Sorry.* *Rap Genius.* https://genius.com/9043514.

Hine, Darlene Clark. 1989. "Rape and the Inner Lives of Black Women in the Middle West." *Signs* 14: 912–20. http://www.jstor.org/stable/3174692.

Hobson, Janell. 2005. *Venus in the Dark: Blackness and Beauty in Popular Culture.* New York: Routledge.

———. 2016. "Feminists Debate Beyoncé." In *The Beyoncé Effect: Essays on Sexuality, Race and Feminism,* edited by Adrienne M. Trier-Bieniek, 11–26. Jefferson, NC: McFarland.

———. 2019. "Getting to the Roots of 'Becky with the Good Hair' in Beyoncé's *Lemonade.*" In *The Lemonade Reader,* edited by Kinitra D. Brooks and Kameelah L. Martin, 31–41. New York: Routledge.

hooks, bell. 1992. "Selling Hot Pussy: Representations of Black Female Sexuality in the Cultural Marketplace." In *Black Looks: Race and Representation,* 61–77. Toronto: Between the Lines.

———. 2016. "Moving Beyond Pain." bell hooks Institute, May 9. http://www.bell hooksinstitute.com/blog/2016/5/9/moving-beyond-pain.

hooks, bell, and Pamela Johnson. 2001. "Straightening Our Hair." In *Tenderheaded: A Comb-Bending Collection of Hair Stories,* edited by Juliette Harris, 111–15. New York: Pocket Books.

Hunter, Margaret L. 2005. *Race, Gender, and the Politics of Skin Tone.* New York: Routledge.

Jacobs-Huey, Lanita. 2006. *From the Kitchen to the Parlor: Language and Becoming in African American Women's Hair Care.* Oxford: Oxford University Press.

Knowles-Carter, Beyoncé. 2016. "Lemonade Credits." Beyoncé.com. www.beyonce.com /album/lemonade-visual-album/?media_view=songs.

Kot, Greg. 2016. "Beyoncé's 'Lemonade' Contains Singer's Most Fully Realized Music Yet." *Chicago Tribune,* April 24. www.chicagotribune.com/entertainment/music/kot /ct-beyonce-lemonade-album-review-20160424-column.html.

Lake, Obiagele. 2003. *Blue Veins and Kinky Hair: Naming and Color Consciousness in African America*. Westport, CT: Praeger.

Lau, Kristie. 2012. "Solange Knowles Proudly Defends Her Afro after Critics Call Her Natural Hair 'Unkempt' and 'Dry as Heck.'" DailyMail.com, June 12. http://www .dailymail.co.uk/femail/article-2158324/Solange-Knowles-proudly-defends-afro-critics -natural-hair-unkempt-dry-heck.html.

Lemieux, Jamilah. 2014. "White Women on #TeamNatural? No Thanks." *Ebony*, June 30. http://www.ebony.com/style/white-women-on-teamnatural-no-thanks-405#axzz4ev OOvSIZ.

Marquina, Sierra. 2016. "Iggy Azalea Chimes in on Beyoncé's 'Becky' Lyric, Doesn't Think It's 'Great to Use Stereotypical Names.'" *US Weekly*, April 27. http://www.usmagazine .com/celebrity-news/news/iggy-azalea-chimes-in-on-beyonces-becky-lyric-stereo typical-names-w204451.

Mendizabal, Amaya. 2016. "All 12 of Beyoncé's 'Lemonade' Tracks Debut on Hot 100." *Billboard*, May 2. http://www.billboard.com/biz/articles/7350446/all-12-of-beyonces -lemonade-tracks-debut-on-hot-100.

Mercer, Kobena. 1994. "Black Hair/Style Politics." In *Welcome to the Jungle: New Positions in Black Cultural Studies*, edited by Kobena Mercer, 97–130. New York: Routledge.

Metacritic. N.d. "Lemonade by Beyoncé." Accessed April 18, 2017, at http://www.metacritic .com/music/lemonade/beyonce.

Mizoguchi, Karen. 2016. "Is Rita Ora the 'Becky with the Good Hair?' Beyoncé Fans Attack the British Singer on Social Media as Rachel Roy Steps Out after Lemonade Release." *People*, April 25. http://people.com/celebrity/rita-ora-denies-being-the-becky -with-the-good-hair/.

Mock, Janet. 2017. "Being Pretty Is a Privilege, But We Refuse to Acknowledge It." *Allure*, June 28. https://www.allure.com/story/pretty-privilege.

Morgan, Joan. 2015. "Why We Get Off: Moving towards a Black Feminist Politics of Pleasure." *Black Scholar* 45: 36-46. doi:10.1080/00064246.2015.1080915.

Moss, Sonita R. 2016. "Beyoncé and Blue: Black Motherhood and the Binds of Racialized Sexism." In *The Beyoncé Effect: Essays on Sexuality, Race and Feminism*, edited by Adrienne M. Trier-Bieniek, 155–76. Jefferson, NC: McFarland.

Mossman, Kate. 2014. "Iggy Azalea Interview: 'I Have Never Had Any Musicians Tell Me That I Wasn't Authentic.'" *Guardian*, June 28. https://www.theguardian.com/music /2014/jun/28/iggy-azalea-interview-rap-talk-ironic-cool.

Muther, Christopher. 2014. "Chemical-Free Black Hair Is Not Simply a Trend." *Boston Globe*, May 28. http://www.bostonglobe.com/lifestyle/2014/05/28/chemical-free-black -hair-not-simply-trend/kLVdugv5MChUejSkDXoO3J/story.htm.

Nash, Jennifer C. 2012. "Theorizing Pleasure: New Directions in Black Feminist Studies." *Feminist Studies* 38: 507–515.

New School. 2014. "bell hooks: Are You Still a Slave? Liberating the Black Female Body." YouTube video, 1:55:32. Posted May. https://www.youtube.com/watch?v=rJkohNROvzs.

Olutola, Sarah. 2019. "I Ain't Sorry: Beyoncé, Serena, and Hegemonic Hierarchies in Lemonade." *Popular Music and Society*, 42, no. 1: 99–117.

Pareles, Jon. 2016. "Review: Beyoncé Makes 'Lemonade' Out of Marital Strife." *New York Times*, April 24. http://www.nytimes.com/2016/04/25/arts/music/beyonce-lemonade .html?_r=0.

Patton, Tracey Owens. 2006. "Hey Girl, Am I More Than My Hair?: African American Women and Their Struggles with Beauty, Body Image, and Hair." *NWSA Journal* 18: 24–51. doi:10.1353/nwsa.2006.0037.

Robinson, Cynthia L. 2011. "Hair as Race: Why 'Good Hair' May Be Bad for Black Females." *Howard Journal of Communications* 22: 358–376. doi:10.1080/10646175.2011.617212.

Robinson, Zandria. F. 2016. "How Beyoncé's 'Lemonade' Exposes Inner Lives of Black Women." *Rolling Stone,* April 28. http://www.rollingstone.com/music/news/how-beyonces-lemonade-exposes-inner-lives-of-black-women-20160428.

Rooks, Noliwe M. 1996. *Hair Raising: Beauty, Culture, and African American Women.* New Brunswick, NJ: Rutgers University Press.

Saro-Wiwa, Zina. 2012. "Black Women's Transitions to Natural Hair." *New York Times,* May 31. http://www.nytimes.com/2012/06/01/opinion/black-women-and-natural-hair. html?_r=1&.

Shusterman, Richard. 2011. "Somatic Style." *Journal of Aesthetics and Art Criticism* 69: 137–59. doi:10.1111/j.1540-6245.2011.01457.x.

Sir Mix a Lot: Baby Got Back (Official Video). 1992. YouTube video, 4:13. Posted by "Kevy," April 5, 2014. https://www.youtube.com/watch?v=qr89yq2wC90.

Spillers, Hortense J. 2003a. "'All the Things You Could Be by Now, If Sigmund Freud's Wife Was Your Mother': Psychoanalysis and Race." In *Black, White, and in Color: Essays on American Literature and Culture*, by Hortense J. Spillers, 376–427. Chicago: University of Chicago Press.

———. 2003b. "Interstices: A Small Drama of Words." In *Black, White, and in Color: Essays on American Literature and Culture*, by Hortense J. Spillers, 152–75. Chicago: University of Chicago Press.

Swann, Jennifer. 2016. "The Complete History of 'Becky with the Good Hair,' from the 1700s to 'Lemonade.'" *Fusion*, May 4. http://fusion.net/story/298448/history-becky -with-the-good-hair-beyonce-lemonade/.

Tate, Greg. 2016. "Review: Beyoncé Is the Rightful Heir to Michael Jackson and Prince on 'Lemonade.'" *SPIN*, April 28. https://www.spin.com/2016/04/review-beyonce -lemonade/.

Tate, Shirley Anne. 2007. "Black Beauty: Shade, Hair and Anti-Racist Aesthetics." *Ethnic and Racial Studies* 30: 300–319. doi:10.1080/01419870601143992.

———. 2015. *Black Women's Bodies and the Nation: Race, Gender and Culture*. Houndmills, Basingstoke, Hamp.: Palgrave Macmillan.

Taylor, Paul Christopher. 2016. *Black Is Beautiful: A Philosophy of Black Aesthetics*. Hoboken, NJ: Wiley-Blackwell.

Tinsley, Omise'eke Natasha. 2016. "Beyoncé's Lemonade Is Black Woman Magic." *Time*, April 25. http://time.com/4306316/beyonce-lemonade-black-woman-magic/.

Trudy. (@thetrudz). 2016. Twitter post, April 23, 11:18 p.m. https://twitter.com/thetrudz/status/724075029869154304?ref_src=twsrc%5Etfw.

Viera, Bené. 2016. Facebook post, April 24. https://www.facebook.com/benevierapro file/posts/1159149127436969?comment_id=1159745794043969¬if_t=comment _mention¬if_id=1461598231801925.

Warner, Kristen. J. 2015. "They Gon' Think You Loud Regardless: Ratchetness, Reality Television, and Black Womanhood." *Camera Obscura: Feminism, Culture, and Media Studies* 30: 129–53. doi:10.1215/02705346-2885475.

Weidhase, Natalie. 2015. "'Beyoncé Feminism' and the Contestation of the Black Feminist Body." *Celebrity Studies* 6, no. 1: 128–31. https://doi.org/10.1080/19392397.2015.1005389.

Wolf, Naomi. 2002. *The Beauty Myth: How Images of Beauty Are Used against Women*. New York: Harper.

Yawson, Ama. 2014. "How to Get Rid of Black Women with Kinky Hair." *Huffington Post*, July 16. http://www.huffingtonpost.com/ama-yawson/how-to-get-rid-of-black-kinky -hair_b_5585380.html.

MARY SENYONGA

14. The Livable, Surviving, and Healing Poetics of *Lemonade*
A Black Feminist Futurity in Action

The release of Beyoncé's *Lemonade* (2016) could not have come at a better time. At a moment when Black lives were denigrated and futures were limited by pervasive state-sanctioned violence and everyday encounters of anti-Blackness through the personal and institutional, the visual album became a mirror through which Black people and Black women and femmes could see themselves reflected. In her temporally suspended Southern commune where Black women and femmes harvest produce, share meals, and reserve space to experience the quiet moments of being, Beyoncé's *Lemonade* affords a catharsis for the multiple pains of Blackness, a multiplicity whose complexity is increasingly overshadowed by the hashtags or videos of public beatings, all mediated through digital culture. Such representations have turned anger into action, yielding the same volatile responses to the nonindictments against the persistent attacks on Black lives (Crenshaw et al. 2015).

In this chapter, I use *femmes* to account for the people who are not captured through the binary of "male" and "female" and are similarly marginalized by masculinity (Lewis 2011). As a Black queer feminist, this practice in naming femmes is part of my work in disrupting the normativity of positing gender as "male" and "female," which reifies white supremacist structures of gender. While *Lemonade* is enjoyed by audiences spanning various social identities, it is particularly important for Black women and femmes. Controlling images of Black women and femmes curtail complex and nuanced narratives to reinforce

the racialized order that limits Black women and femmes to subservient roles (Collins 2014). Audience responses from Black women and femmes[1] suggest that *Lemonade* resonated with viewers because of its ability to capture dimensions of pain ranging from romantic betrayal, intergenerational trauma, and anguish from anti-Black violence. It is a celebration of African diasporic heritage in dress, spiritual memory, and practice. It is movement through emotions that provide validation for anger and disappointment yet explores the possibility of finding life after heartbreak. It is a piece that, through its validation of and future visioning for Black women and femmes, takes on the call of performing a Black feminist futurity wherein we can imagine more than just suffering as the condition of Black life (Campt 2017).

In this chapter, I analyze the impact of *Lemonade* especially as a visual model of healing rather than as an autobiographical testament. Rather than testing this work as a text whose narrative represents something real or authentic about Black life, I focus on *Lemonade*'s profound impact on Black women and femmes. In other words, this chapter defines *Lemonade* primarily as a healing text. I argue that because Beyoncé's work narrates the experience of infidelity and intergenerational trauma while also representing ways of working through such pain, it offers a space for her audience to heal through their identification with the presented themes. I focus on Black women and femmes given the visual album's cultural celebration of this particular but often underrepresented population. This chapter therefore engages disciplines such as Black feminist epistemologies and cultural studies to provide a close reading of the visual project and focus on how Beyoncé's visual album illuminates the power of moving through emotions, the importance of Black women and femme life making, and the role of cultural memory.

A COLLECTIVE RESONANCE:
THE POWER OF NAMING PAIN

Lemonade opens with "Intuition," a chapter that announces the project's aim exploring vulnerable feelings elicited by betrayal. The song "Pray You Catch Me" serves as the sonic accompaniment for a scene set within a field of tall grass; the viewer looks out at a worn brick building. As the camera pans over Beyoncé, draped in a black skirt, hoodie, and headdress and kneeling with her head bowed in front of a red curtain, she appears more casual in her informal attire in contrast to her usual stage presence. Gone are the sequined, bedazzled,

skin-baring leotards that complement her high-energy performances. On this stage-like setting, we are met with a different kind of performer who uses her body, lyrics, and monologue to express vulnerability. As she sings, "You can taste the dishonesty, it's all over your breath / As you pass it off so cavalier, but even that's a test," Beyoncé offers an instance of introspection as she walks through the tall brush, looking toward the camera to proclaim the pain of infidelity. As the music subsides, we hear the words of Warsan Shire cogitating on the pain of infidelity. Her words accompany a montage of vignettes: Black women and femmes dressed in Southern gothic clothing standing in tunnels, Black women/femmes lounging on the porch of a Southern estate, and, later, Black women poised in the backyard of the large estate. Through Shire, Beyoncé expresses her thoughts:

> I tried to make a home out of you, but doors lead to trap doors, a stairway leads to nothing. Unknown women wander the hallways at night. Where do you go when you go quiet? You remind me of my father, a magician, able to exist in two places at once. In the tradition of men in my blood, you come home at 3 a.m. and lie to me. What are you hiding? The past and the future merge to meet us here. What luck. What a fucking curse. (2016)

After this proclamation, the organ on "Pray You Catch Me" punctuates the return to the sonic performance of betrayal. Through the portrayal of only Black women and femmes in this fictive Southern commune, the beginning scene of *Lemonade* announces the focus of the project. The women of *Lemonade* move through spaces that articulate and reflect the mundanity of Black life. These mundane spaces occupied by Black femmes stand in stark contrast to the masculine-focused spectacle of Black marginalization (Sharpe 2016). As the project progresses, Black women and femmes in this commune lounge in rocking chairs, harvest produce, collectively make and share meals, care for one another, and bear witness to declarations of resistance. "Intuition" serves as a necessary introduction to this fictive world of Black women and femme life making despite the confines of marginalization.

Within Beyoncé's visual album, the line between fictive yet culturally significant artistic representations and specific autobiographical references may be indistinct and intentionally unnamed, yet this facet of the work is perhaps less significant than the visual album's collective impact. As a text, *Lemonade* offers the vehicle through which collective healing can, has, and will continue to take place (Bradley and hampton 2016; Edgar and Toone 2017; Harris-Perry

2016). Audience responses to the album evidence such a profound impact. With Amanda Nell Edgar and Ashton Toone's study on audience responses to *Lemonade*, Melissa Harris-Perry's dialogue with Black women about the visual text and Candice Benbow's #LemonadeSyllabus, we are afforded a view into how the album is a generative site for audiences to imagine racially just landscapes informed by a Black feminist lens and a cathartic tool for Black women and femmes to put language to feelings of marginalization. Finally, identification with the album engenders aspirations toward freer ways of living (Edgar and Toone 2017; Harris-Perry 2016). This section engages these three sources of audience responses to highlight the visual text's capacity to evince healing models that center Black women and femmes within a landscape that has long elided such possibilities. It also looks to Black Feminist visions of freedom as well as bell hooks's Sisters of the Yam support group to illuminate the necessity of Black women and femme-specific spaces.

Considering the responses to *Lemonade,* I situate community healing as the space to engage in healing processes in a collective. Community healing in this work is informed by Black feminist perspectives and healing pedagogies that have illuminated the promise of healing collectively from racial trauma, gendered violence, and other identity-based confrontations with marginalization (Combahee River Collective 1977; hooks 1993). As a Black feminist imperative, collective healing forgoes the call of individualistic, self-serving instant gratification (Combahee River Collective 1977; hooks 1993). The Combahee River Collective emerged in the 1970s as Black feminists within the National Black Feminist Organization sought a space that articulated marginalization by including all forms of systemic subjugation in their mission to dismantle oppression. Born out of a desire to dismantle interlocking systems of dominance, the collective issued a statement that expanded on the history and state of Black feminism, its political stance as a political organization, the tensions in organizing Black feminists across various social identities, and the practice of living a Black feminist life. The collective's commitment to dismantling systemic oppression was underscored by a desire to attend to Black women and femmes' well-being given the historical and contemporary nature of liberatory spaces that push their experiences to the margins. The collective wrote, "Black feminists often talk about their feelings of craziness before becoming conscious of the concepts of sexual politics, patriarchal rule, and most importantly, feminism, the political analysis and practice that we women use to struggle against our oppression" (Combahee River Collective 1977). As they worked for an end to all interlocking systems of domination, the

Combahee River Collective maintained the importance of attending to Black women's well-being in a world that is set on our undoing.

Moreover, by reflecting on Black feminist and queer-of-color epistemologies, I articulate healing as a process, not an end goal that may involve the intentional act of recognizing the historical traumas that have afflicted generations of racially oppressed peoples, challenging the marginality that would impede our survival, and bringing into relief the everyday acts that are both spectacular and mundane that foster sustenance in a world that demands Black death as the normal subject position of Black people (Gumbs 2010; Sharpe 2016). In her work on naming Black life in the wake of slavery, Christina Sharpe (2016) locates mundanity in the face of predictable and impending Black death as a method of performing what she calls "wake work." Furthermore, collective healing poses as a useful means of approaching the world Beyoncé portrays in *Lemonade* that reflects a process of intentionally forging community with other Black women and femmes. Healing as a collective process for Black women and femmes has taken many forms, and by bell hooks's example, we may recognize support groups created by and for Black women and femmes as a powerful intervention to the object realities with which Black women and femmes daily contend.

Edgar and Toone (2017) argue that through the visual album's rich symbolism and intimate narrative, audiences constitute interpretative communities as they engage the text to make meaning of and extrapolate visions of antiracist alternatives. They employ Pierre Bourdieu's articulation of habitus as the system of "durable, transposable dispositions, structured structures predisposed to function as structuring structures" to organize their argument of audience responses to *Lemonade* as reflective of their ideologies regarding antiracist alternatives to white supremacy (1977, 72). Edgar and Toone interviewed thirty-five participants who watched and listened to *Lemonade* to understand how they made sense of the themes in the text and what it meant for their views of the world. An audience-focused analysis of *Lemonade* provides generative insight on the impact of the album not simply as a media production that was filled with beautiful visual moments, but as a deeply complex media text that attended to racial marginalization, intragroup tensions, and possibilities for healing.

The capacity of media to socialize audiences toward maintaining majoritarian perspectives necessitates an understanding of audience members' ability to become critically engaged viewers (Yosso 2006). The racialized landscape of media contained within content produced and informed by white, cisgender, straight people and ideologies facilitates limiting portrayals of Black women

and femmes. Furthermore, the freedom of Black performers to express Blackness has historically been curtailed by structural oppression (Edgar and Toone 2017). *Lemonade* resonated with Black women and femmes because of its ability to traverse Blackness and present what participants identified as "unapologetic Black pride" (Edgar and Toone 2017). Participants expressed the importance of seeing Blackness portrayed not only in a positive light but as a diverse cultural identity that could act oppositionally beyond the limits of whiteness. The participants' responses revealed that the visual text operated on several levels: within the public sphere as a global cultural production, on an intimate level by providing culturally affirmative visuals for Black women and femmes, and moving back to the public sphere in its ability to inspire audiences to similarly engage in unapologetic gestures of Black pride as well as educate others about racial realities. One of the participants, a Nigerian woman named Haley living in the United Kingdom, explained to Edgar and Toone that she styled her hair in similar fashion as the women and femmes in the "Sorry" video. She explained that after watching *Lemonade*, she "felt really, really, really different" (Edgar and Toone 2017, 7). This difference emboldened her to express her racial pride publicly, suggesting that the visual text evinced public Black possibilities that felt occluded prior to the release of the album. Edgar and Toone argue that Haley's transference of her private resonance with the album to a public sphere through her altered hairstyle can be understood as a signifier of cultural affinity and a reflection of the visual text's relevance in affirming Blackness on a public level: through providing portrayals that refute stereotypical images of Black people and by inspiring Black audiences to celebrate their Blackness.

Similarly, in Harris-Perry's dialogue on *Lemonade*, we are offered varied perspectives on the emotional response to and kinship with the narratives running through the visual album. Within Harris-Perry's dialogue, L. Joy Williams of the Brooklyn chapter of the NAACP writes, "But this doesn't even have to be about Bey & Jay. She did this for all of us. The album and the visual art alongside it became a representation of the betrayal, anger, and despair that Black women (at least me personally) feel from the world and feel from Black men collectively and individually" (Harris-Perry 2016). Beyoncé's individual narrative stands out among the interwoven interjections, whether verbally or visually portrayed, of other women and femmes, both famous and not. However, it is the practice of creating a space for commiserating about common experiences that takes *Lemonade* from being a beautifully emotive album to a cultural production that speaks to the lived experiences of those residing at the margins, who require a catharsis

for their pain. Williams further attests to the power of the album in likening the viewing experience to a spiritual one, "You know that high you feel after the spirit moved? That's me right now, just rockin' on my couch" (Harris-Perry 2016). The high of being seen and portrayed with such accuracy and care pushes back against the circumstances that preclude the expansiveness of Black life.

The visual album's resonance with Black women and femmes may be understood because of what Johanna Hartmann (2017) describes as an "embodied performance." She argues that Beyoncé and the women and femmes of *Lemonade* signify Black cultural referents more generally and the Black female/femme body in particular. From hairstyles, dress, and the signification of gender, sexuality, and motherhood through the Black female/femme body, the symbolism of the visual album produces meaningful articulations. At the close of "Pray You Catch Me," Beyoncé turns to the camera while standing atop the red-curtained billboard before she looks down at the pavement. With her hands stretched out at her sides, she takes a step forward over the ledge and leans her body forward, falling toward the pavement below her. The vocals fade out as whirring, metallic noise as if wind is passing rapidly with fire burning–like sounds accompanying her descent toward the ground. Instead of hitting the ground, Beyoncé is submerged in water; shedding her black hoodie, she proclaims, "I tried to change. Closed my mouth more. Tried to be soft, prettier, less awake." As Beyoncé continues through Shire's poetry, she floats underwater in a bedroom where she gazes upon herself. Interpreting this scene as her submersion into water rather than a possible suicide may suggest a rebirth as she incorporates religious signifiers such as the Bible. Later she represents herself as Oshun (the Yoruba deity of rivers, fertility, and sexuality) in a yellow dress and emerges from double doors as waves of water rush at her feet as she navigates the next chapter, "Denial," accompanied by the song "Hold Up." Hartmann suggests that verbal and visual significations abound through the visual text, such as Beyoncé looking at her double when she says "mirror" or when she says "and plugged my menses with pages from the holy book" with a Bible drifting in the room (Hartmann 2017; Beyoncé 2016).

During the interstitial moment taking place between "Pray You Catch Me" and "Hold Up," Beyoncé transforms the consideration of suicide into a leap of introspection. The moment of that jump where cement becomes the water through which she is born again as Oshun holds the weight of processing a heavy burden. For Harris-Perry, it revealed a similar sentiment, with the image leaving a lasting impression:

I never caught my breath after watching Beyoncé hurl herself from that ledge and having to take that long plunge with her. It was a terrifying answer to a question I have asked myself with frightening regularity in recent months. What if I just gave into the darkness I feel by going over the balcony? To suddenly take that journey rendered me numb. To realize I am not alone in having imagined the fall is what finally let me feel again. (2016)

For Harris-Perry, identifying with this moment in the visual album provided a space to finally feel again after venturing through the darkness of considering a self-induced end. Forging a means of living despite the traumas of the personal and the systemic reinforces the necessity of healing for Black women and femmes. To process, name, and validate Black women and femmes' pain constitutes what Alexis Pauline Gumbs identifies as "a logic of survival that is both futuristic and solidarity-driven, across space and time" (2010, 103).

Media portrayals of Black women and femmes dealing with mental health issues provide necessary space to reflect on one's own struggle. Toni Cade Bambara's *The Salt Eaters* (1992) begins with the character Velma attempting suicide. A community activist, Velma witnesses, resists, and suffers from systemic oppression. Her journey toward healing is guided by Minnie, a practitioner of nontraditional healing. This cultural production resonates with Black women and femmes in similar fashion to Harris-Perry's resonance with Beyoncé's jump. While bell hooks contends with the nature of Beyoncé's celebrity as she questions her authenticity, and even characterizes her as a "terrorist," the comparison between the genesis of her Sisters of the Yam support group and audience responses to the jump following "Pray You Catch Me" demands attention. After several of her Black female students proclaimed their identification with Velma, hooks and her students sought to create a space to name Black women's pain and find paths toward healing. hooks started a support group, naming it Sisters of the Yam at a time when her Black female students expressed immense emotional pain. This is a pain that has been excluded from the limited archetype of what it means to be a Black woman—strong, in service to others, unfeeling (Collins 2014).

Although hooks and her students crafted a space to name and work through pain, hooks's critique of *Lemonade* contends that the emotions portrayed within the visual album artificially serve a facile consumption at best and at worst act as a dangerous affirmation of violence. Taking "Hold Up" to task for Beyoncé's joyous havoc as she swings her bat onto cars while singing, "Can't you see there's no other man above you? / What a wicked way to treat the girl that loves you,"

hooks asserts that such imagery condones violence as a proper means of obtaining power to redress gendered stratification. hooks suggests that as a "goddess-like character," Beyoncé's yellow dress with her chest exposed sexualizes violence and legitimizes such a tactic in response to romantic betrayal. However, may we also recognize Beyoncé's autonomy and rejection of sexualized depictions of Black female/femme bodies? I argue that to limit *Lemonade* as a tool of capitalist consumption suggests that only a dichotomy of utility can be used to understand cultural productions. In other words, we can simultaneously understand Beyoncé and others as engaged in creating cultural productions enmeshed in capitalist machinations and forms of empire building but also hold space for the possibility that oppositional narratives may be provided by these very artists. Furthermore, if we consider *Lemonade* as a project complemented by Jay-Z's *4:44*, the work is not meant to position Black women and femmes as victims in memoriam as hooks suggests, but rather to provide a portrayal of what it means to name and process pain as within *4:44*, which depicts what it means to be held accountable for causing such pain.

After all, an alternative reading of "Denial" and "Hold Up" would suggest that Beyoncé employs cultural references to Black women and femmes' public avowals of pain. Such public performances of pain relate to the cultural signifiers within the Black Atlantic assemblage and provide a cathartic visual for Black women and femmes who have been betrayed within romantic relationships. As she strolls along a street, Beyoncé grabs a bat from a young boy, a smile creeping over her face before she commits to the destruction of various controlling and masculinized objects in the public sphere—the cars parked on the street, the surveillance camera, and shop windows. Where hooks suggests that Beyoncé is engaged in unrestrained sexualized violence for violence's sake, Omise'eke Natasha Tinsley provides an alternative reading. Tinsley likens Beyoncé's yellow dress, her watery entrance, and her gleeful destruction within "Hold Up" to Oshun, the orisha (deity) of water, sexuality, and creativity. Oshun's generosity brings meaning to life while her "wrath begins with rolling laughter that foreshadows disaster" (Tinsley 2016). hooks's uncomplimentary "goddess-like" appraisal of Beyoncé thus becomes more accurate than intended. She is in fact invoking a deity, one that has profound relevance for Black diasporic communities from Nigeria, throughout the Caribbean, to South America (Tinsley 2016). Furthermore, Beyoncé's exuberant destruction hinges on the externalization of anger that Black women and femmes are often not afforded lest they be labeled with the "angry Black woman" stereotype. While Black women and femmes

will not take to their respective streets to wreak havoc on parked cars and fire hydrants, the joyful reactions of Black women and femmes within the visual text highlight the cathartic nature of this physical release. Upon Beyoncé's first strike to a parked car, a Black woman with an Afro looks on in awe, her mouth open as she expressively encourages Beyoncé in her destruction of property. Other Black women and femmes are seen dancing as Beyoncé climbs atop a car to dance during her wreckage. "Hold Up" culminates in Beyoncé approaching the camera and brandishing her bat as she takes a swing at the camera, with the force of her strike compressing the color into black and white.

The following chapter, "Anger," incorporates camera techniques and music typically used in horror films. A band and smiling majorettes marching in slow motion through the streets serve as the introductory visual of this chapter. What would have been a joyous visual is given an almost sinister air through this slow-motion effect, amplified by the music box rendition of Tchaikovsky's *Swan Lake* (Hartmann 2017) and an eerie whirring noise mixed in the soundtrack as Beyoncé recites, "If it's what you truly want, I can wear her skin over mine. Her hair over mine. Her hands as gloves. Her teeth as confetti. Her scalp a cap. Her sternum my bedazzled cane. We can pose for a photograph, you and your perfect girl" (2016).

The image then shifts to a black-and-white shot of Black women in white dresses, their long sleeves tied to one another as they bend and contort in angular positions in a garage. The eerie background sounds persist as the camera pans over a dark staircase, Black women are cast in shadow as the walk away from the camera, and a Black female drummer watches the camera. Beyoncé stands sideways, the camera capturing her profile again with her hair braided in cornrows. After the joyous wreckage following "Hold Up," Beyoncé has accumulated more rage, which she must reckon with and through "Don't Hurt Yourself" as she snarls out her demand posed as a question: "Who the fuck do you think I is?" Draped in a fur coat and wearing gray calf-length leggings and a gray cropped top, Beyoncé is equally braggadocio and demanding as she taunts the camera and makes aggressive eye contact. She follows her initial demand by proclaiming, "You ain't married to no average bitch, boy."

Upon *Lemonade's* release, the character of online sentiments—collaborative efforts of women and femmes to contextualize the themes of the text—cumulatively revealed the processes by which Black women and femme circles materialized as healing spaces within contexts that transcended physical limitations of geography and disregarded shifting generational terrains. The collaborative

effort of the *Lemonade* syllabus stands as one of many examples of the impact of the project. Following the release of the visual album, Black women and femmes became engaged; they took their questions and analysis of the project online to fully excavate the meaning and themes that were portrayed in the film organized around the hashtag "#LemonadeSyllabus," started by Candice Benbow (2016). What came out of the call for resources was a compilation of over two hundred sources that in conversation with *Lemonade* provided additional mirrors to the lived realities of Black women and femmes and directed guides toward healing (Benbow 2016). As a collective production of knowledge, the *Lemonade* syllabus evidenced Gumbs's conception of intergenerational collaboration, a collective effort spanning generations currently and simply through the bloodlines of family—a generative space that recognizes the transference of knowledge that is not confined by age (2010). Benbow describes the response to *Lemonade* as a moment wherein the themes of the text such as heartache and joy resonated with Black women and femmes (2016). Furthermore, Black women and femmes sought a space to theorize and articulate the album's Black feminist language. Resources within the syllabus spanned a range of Black feminist texts that further contextualized Black women and femmes' marginalization, including films, music, poetry, and photography; models for self-care; and other such aesthetic material that reflected the specificity of Black women and femmes' experiences and needs.

CULTURAL MEMORY AND FUTURE:
DIASPORIC BODIES AND A BLACK SENSE OF PLACE

Reflecting again on Hartmann's assertion that "embodied performance" provides a generative subject for analysis in examining the relevance of Beyoncé's visual album, I turn now to the cultural symbolism of place within *Lemonade*. Beyoncé and the women and femmes of *Lemonade* are important signifiers for Black diasporic culture through various forms of Black natural hair, clothing, and body adornment. As Paul Gilroy (1995) characterized the Black Atlantic as constituted by various African American, Caribbean, and Black English cultural signifiers articulated through language and dress, we too can understand the world of *Lemonade* as engaged in this assemblage of Blackness. Aesthetics communicate cultural affinity and can evince political standpoints that gesture toward Black freedom. By incorporating African cultural referents in Gilroy's articulation of the Black Atlantic, signifiers such as Ankara print clothing and Sacred Art of the

Ori body adornment illustrate the global hybridity of Blackness. The global reach of the visual text thus announces the nature of Blackness as culturally diverse and presents a narrative counter to dominant portrayals of Black women and femmes. This section considers cultural studies' analytical approaches and black geographies to illuminate the importance of the cultural symbolism contained within the text. The Southern commune of *Lemonade* acts as a site that animates what Katherine McKittrick defines as "a Black sense of place" (2011).

The chapter "Apathy" recapitulates the music box rendition of Tchaikovsky's *Swan Lake* before we are invited to Beyoncé's night out, which takes place on a bus filled with Black women and femmes' adorned in Sacred Art of the Ori as drawn by Nigerian artist Laolu Senbanjo, and her interior performance with Serena Williams. The chapter opens with Black women and femmes seated along the length of the bus. They face one another as they sway their bodies in unison. As they bend forward, dancing to music not yet heard, their hairstyles are prominently revealed, ranging from thread-covered coils to bantu knots. Their skin is made ornate with the Sacred Art of the Ori body paint, with the white paint drawn in intricate designs of circles and geometric shapes. A disco ball in the bus punctuates the black-and-white image with reflections of light flashing across the dancers, Beyoncé's body, and the walls of the bus. Beyoncé is revealed at one end of the bus, wearing her fur coat and her hair in cornrows as she recites, "Her heaven will be love without betrayal."

Swan Lake subsides, and the song "Sorry" begins as the camera pans over the exterior of the Southern commune. As the scene moves inside, Black women and femmes are similarly seated as they were in the bus, now seated in chairs throughout the halls of the commune, their hands resting on their knees. At a distance, we see Serena Williams descend the staircase, moving through the now-empty halls while maintaining eye contact as she approaches Beyoncé, who is languidly seated in a throne. Beyoncé sings, "He trying to roll me up, I ain't pickin' up / I'm headed to the club. I ain't thinkin' bout you," accompanied by her Black women and femme dancers mirroring her dancing as she circles her body around before bouncing along to the bass of the song in the bus. With Serena dancing at her side, Beyoncé continues to lounge in her throne in the scene at the commune. The performances within and outside the physical commune are linked in their jubilant defiance. Beyoncé and her dancers raise their middle fingers in time to the call "middle fingers up, put'em hands high" with Serena Williams gesturing a "peace sign" at "tell him boy bye." Both the interior and the bus performance are visible only to the Black women and femmes of

the commune. Serena dances freely in a black leotard in front of a self-possessed Beyoncé, while Beyoncé and the dancers of the bus convert this transportation vehicle into their personal space to relish in their collective exuberance. As Beyoncé and the dancers stand outside the bus dancing in Ankara print leggings, leotards, and the like, their clothing, painted bodies, and hair present Blackness as operating through a transcultural understanding. Bodily gestures, clothing, and hair are given symbolic meaning through Beyoncé and the Black women and femmes within the visual text.

In order to situate *Lemonade* within a transcultural understanding, it is helpful to consider Gilroy's (1995) assertion that the Black Atlantic must be understood beyond an ethnopurist framework wherein Blackness is divorced and unaffected by European influences. Rather, the Black Atlantic mandates an understanding of Blackness as it has encountered, been curtailed by, and responded to whiteness. With this in mind, Ankara print leggings and Southern gothic clothing can be understood as visual signifiers of the encounter and influence among African, European, and Western cultures. Moreover, Michael Kgomotso Masemola and Pinky Makoe (2014) contend that as African cultural productions and aesthetics enter the space of the Atlantic, both celebration and transculturation can be experienced within the assemblage. The world of *Lemonade* thus celebrates and engages in a transcultural understanding of Blackness through depicting gothic clothing that has been fashioned out of Ankara print, Black women and femmes adorned in the Sacred Art of the Ori body paint, and hairstyles that span the diversity of natural hair. These visuals not only articulate and celebrate the diversity of Blackness but lend themselves to serve as inspiration for Black women and femme viewers to explore their own practices of cultural affirmation in dress and hairstyles (Bobo 1995; Edgar and Toone 2017).

Where some cultural productions seek to portray an "essential black subject," the cultural symbolism in *Lemonade* pivots on the South as a physical referent of a Black sense of place while still communicating a diverse portrayal of Blackness (Hall 199; McKittrick 2011). With the visual album set in New Orleans, audience responses to the album noted the intention of this setting. Katherine McKittrick (2011) introduces a necessary understanding of a Black sense of place to explore and make sense of how Black people bring meaning to inhabited sites despite white supremacist projects that seek to violently rid forms of Black belonging. She writes, "A black sense of place can be understood as the process of materially and imaginatively *situating* historical and contemporary struggles against practices of domination *and* the difficult entanglements of racial encounter" (2011, 949). The

plantation in McKittrick's view is a geographical site wherein bodies have been differentially marginalized and controlled and therefore such sites articulate the language of racialization. However, to situate the plantation or even the South as singularly determined by historical and contemporary marginality reifies the "placeless" designation that is imposed on Black communities. Bringing this conceptualization to the Southern commune within *Lemonade* reveals the necessity of wrestling with the South as a site that has historical significance for Black people, but also as one imbued with meaning especially through Black people's life making, which facilitates Black existences defined not only by states of subjection (McKittrick 2011; Sharpe 2016).

As *Lemonade* moves through the stages of heartache, Beyoncé lays out a narrative that is contextualized from her standpoint as a Black woman from the South. Considering Bowers's and McKittrick's definition of a Black sense of place, we can similarly identify how *Lemonade* offers narrative(s) grounded in the historical, cultural, and specific geographical location of the South. "Daddy Lessons" is rife with imagery that points to the particularities of life in the South while addressing familial trauma. Interspersed with images of young girls and their fathers, Beyoncé horseback riding, and Beyoncé with her own father, the country-like twang of "Daddy Lessons" presents a view of Blackness that is not often depicted. Rarely are Black people associated with images of horseback riding, leisure within natural settings, and other such rustic imagery that evokes rural sites—in other words, imagery within environments assumed by many as strictly tied to white narratives of the South. In Harris-Perry's dialogue with Black women about *Lemonade*, Treva B. Lindsey writes, "Beyoncé is centering the South and also connecting this to the Black global South. She is unapologetic in her Blackness, her woman-ness, and her Southernness. *Lemonade* is an archive of Black womanhood/girlhood honed in the South. The South emerges as the past, present, and future of Black womanhood. The visual album rejects the holding of the South as solely a place trapped in history" (Harris-Perry 2016).

The South as portrayed within *Lemonade* is not a place continuously bound within the traumas of slavery, which one must forget or leave behind, but is enlivened through the portrayals of lives intentionally situated within a landscape filled with historical, spiritual, and cultural wealth. The marginalized ways of knowing that inform the world of *Lemonade* call us to envision what Black life looks like beyond the limits of oppression.

Within *Lemonade*'s diegesis, where Southern gothic–attired Black women and femmes share each other's company, sustain each other's life through the practice

of feeding one another, and inhabit space as if to become part of the fruitfulness of the landscape, we are transported to Julie Dash's film *Daughters of the Dust* (1991). In both productions, we are presented with networks of women and girls; we may call them family in one sense, though they are not solely defined by blood. Dash's account of the Peazant family, members of a secluded Gullah community positioned to leave the fictive island of Dawtuh, explores the tension arising between seeking better opportunities and the possibility of losing one's cultural heritage. As the past and present collide, there is space to honor an African dia-sporic past, present, and future. Christina Sharpe's (2016) reading of *Daughters of the Dust* draws on Black redaction and Black annotation to reimagine Black marginalization as it has occurred and continues to take place, as well as Black ontologies beyond subjection. Sharpe points toward Dash's decision to depict indigo-stained hands rather than the image of lashed backs or other normalized depictions of violated Black bodies to indicate the lasting impact of slavery as an instance of Black redaction. While evidence of working within the toxic indigo pits would not be visible until decades after the end of slavery, Dash incorporated this image as a reminder of the condition that called audiences to consider the larger breadth of chattel slavery (Dash 1991; Sharpe 2016).

As the Peazant family sets out on the brink to leave Dawtuh, they contend with the responsibility of retaining their distinctive cultural and spiritual practices. To memorialize the event and possibly to retain part of their past as they embark on their future, they photograph the men of the family to make memory out of this transition. As men gather along the shoreline with Mr. Snead at the camera, "the past and the present merge" (Beyoncé 2016) as the unborn child drapes her arm around her father, Eli, her presence visible only through the camera.

In Beyoncé's refuge from the men who cause her heartache, we see what it looks like to center Black women and femmes in a world that demands that they be the mules of the earth. In the chapter "Resurrection," Amandla Stenberg acts as the photographer for the group of Black women, femmes, and girls of all ages in *Lemonade*. As they gather in front of the camera, an off-screen woman asks, "So how are we supposed to lead our children to the future? What do we do? How do we lead them?" bringing attention to the need to theorize ways toward healing. She answers, "Love. L-O-V-E, love," as we are presented with Black women and femmes of varying ages, skin tones, and hairstyles. The combined visual and audio signifiers attempt to memorialize the active practice of creating a world where Black women and femmes can thrive despite the traumas inflicted by supposed lovers and the world at large.

In using *Daughters of the Dust* as a visual reference, *Lemonade* further substantiates a Black sense of place. Where *Daughters of the Dust* attends to the moment following chattel slavery to examine its afterlives, *Lemonade* contends with the site of the South as contextualized by life making. In doing so, *Lemonade* extends the evidence of the afterlives of slavery wherein Black places have taken root at the sites that were once exclusively determined by modes of domination.

BLACK WOMEN AND FEMME LIFE MAKING

The chapter "Forward" follows the moment of memorializing the life making in which Black women and femmes engage within the Southern commune. The song takes a reflective, meditative tone to honor mothers who have lost their children to police and vigilante violence. Sybrina Fulton, mother of Trayvon Martin; Gwen Carr, mother of Eric Garner; and Lesley McSpadden, mother of Michael Brown, hold their sons' photos. Their sons are memorialized within these portraits not as the deserved targets of violence the media had painted but rather simply as they were. The mundanity of their class portraits in contrast with their mothers adorned in grand mudcloth and Ankara clothing further illustrates the condition of Blackness. By drawing attention to this contrast, the critique in "Forward" echoes the rupture that Sharpe suggests that wake work produces. Sharpe calls us to understand wake work "to be a mode of inhabiting *and* rupturing this episteme with our known lived and un/imaginable lives" (2016, 18). The episteme that she alludes to is the foreclosure of Black existence within the limits of Black people as the continuous embodiment of terror.

In disrupting this epistemological device of violence, Sharpe is "interested in plotting, mapping, and collecting the archives of the everyday of Black immanent and imminent death and in tracking the ways we resist, rupture, and disrupt that immanence and imminence aesthetically and materially" (2016, 13). In similar fashion to Dash's indigo-stained hands as a visual signifier of chattel slavery, the scene does not rely on graphic referents to announce violence against Black bodies as part of the condition of Black existence. The afterlives of slavery in this moment remind us of the nature of violence done to Black bodies while suggesting memory as a technique in living through these violences. Following the scene with Sybrina Fulton, Gwen Carr, and Lesley McSpadden, a woman dressed as a Mardi Gras Indian walks around an empty dining table intermittently shaking a tambourine over select chairs. The diegetic soundscape accompanies her circling of the table. With her footsteps, tambourine, and the

lightly recited "magic" offscreen, the scene adopts a spiritual tone. The possibility of this scene conjuring the spirits of the victims of police and vigilante violence is announced in that moment.

Beyoncé's performance of "Freedom" for the Black women and femme commune, which includes the mothers of the previous scene, also alludes to what Sharpe has defined as "insistent Black visualsonic resistance to that imposition of non/being" (2016, 21). Prior to the performance, the chapter "Hope" opens with the Black women and femme commune as they wash and prepare food. Beyoncé recites Shire's poem, "Nail Technician as Palm Reader," as she walks through the brick fort: "The nail technician pushes my cuticles/back, turns my hand over, / stretches the skin on my palm / and says *I see your daughters and their daughters*." The poem suggests a generational thread that engenders aspirations of liberation as it proceeds the performance of "Freedom." In the face of the persistent affronts to Black life, lyrics such as "I break chains all by myself / Won't let my freedom rot in hell / Hey! I'ma keep running, cause a winner don't quit on themselves" are strong proclamations that resist the normalization of violence done to Black bodies. The sonic performance coupled with the site of the Southern commune additionally evinces what Black life making may look like in the face of legacies of slavery. Musical resistance to Black marginalization, coupled with newly formed collective gathering spaces for Black women and femmes, become powerful signifiers of a critical praxis of healing.

During the chapter "Redemption," Shire's poetry strongly gestures toward the intergenerational nature of healing. As Beyoncé recites a recipe for lemonade, she identifies her grandmother as the progenitor of healing in places that curtailed survival, and the album reaches a place of reconciliation. Young Black girls run out from behind the screen door, their joy emanating as string instruments begin to intensify. Two Black women look at the camera, each holding a side of a curtain, opening it to reveal Black women and femmes walking through the commune outside. Black women, femmes, and girls are also gathered at a long dining table. Life at this moment is joyous. Beyoncé sits on the porch of the commune, taking a reflective moment and recites, "Grandmother the alchemist. You spun gold out of this hard life. Conjured beauty from the things left behind. Found healing where it did not live. Discovered the antidote in your own kitchen. Broke the curse with your own two hands. You passed these instructions to your daughter who then passed it down to her daughter" (Beyoncé 2016).

The scene is followed by "All Night," a song that declares the possibility of reconciliation following romantic betrayal. Clips are sewn together of Beyoncé

and Jay-Z's relationship through the years, including the time they got matching tattoos, their wedding, and moments with their first child, Blue Ivy. These are interspersed with visuals of everyday couples of various races, ages, and sexualities, as well as her mother, Tina Lawson's marriage to her second husband. The visuals of "All Night" expand the narrative of reconciliation beyond the context of her intimate narrative and include others in this narrative toward healing.

At the end of *Lemonade*, "Formation" makes a reappearance as a coda to the visual project. With lyrics that encourage material attainment as the ultimate form of revenge, the visuals for "Formation" could have been built around a world of riches with flashes of jewelry to expensive cars. In lieu of such easy references, the visuals are evocative of the current moment of Black life, particularly Black life set in the South. In this moment, Beyoncé sings on top of a sinking police car, an image that becomes our visual proxy for Hurricane Katrina–stricken New Orleans. This is contextualized by other images that bring forth the everyday moments of Black joy, normalcy, survival, and the historical imagery of the South that lives on today. The first fifteen seconds of "Formation" visually portray various scenes from a low-lit dance party to a minister at the pulpit. Among half-sunken buildings, Beyoncé and her company, dressed in the finest of Southern gothic wear, allude to Sharpe's description of Black life (2016). We can understand Black life as complexly constituted by tragedies, celebration, historical and cultural wealth, and an attitude that wears resilience boldly.

While some understood the visuals as attending to the complexities of Black life, others critiqued the video for exploiting hurricane-stricken New Orleans to (inauthentically) connect Beyoncé with everyday people. Alice Wallace (2017) asserts that *Lemonade* at large can be understood as connecting with audiences only if we are to believe the narrative in fact as an autobiographical account of betrayal, heartache, and healing. Wallace contends that although the video for "Formation" employs visuals that may engender Black pride in the face of everyday violence, the subject matter of the song contradicts such a message. As Wallace questions Beyoncé's use of New Orleans, I consider how we may both acknowledge the pain this visual may cause for those who survived Hurricane Katrina as well as wonder if we can understand this use as engaging in what Sharpe has described as visual culture's attempt to "observe and mediate this un/survival" (2016, 14).

The video for "Formation" was directed by long-time Knowles-Carter collaborator Melina Matsoukas, with cinematographer Arthur Jafa contributing to the project (Cochrane 2017). Known for his work on *Daughters of the Dust*,

Jafa's artistic work has meditated on Black subjection in varying ways. His project entitled Love Is the Message, the Message Is Death, set to Kanye West's gospel-inspired song "Ultralight Beam," is a video collage cataloging significant Black imagery from civil rights demonstrations to Serena Williams crip walking following a tennis match win, and from the 1992 LA riots to Black people dancing and Beyoncé dancing on a balcony in the "7/11" video (Jafa 2017; Cochrane 2017; Molesworth 2017). The visual montage takes viewers through an array of emotions, from elation to anguish, as Jafa contends with both the subjection and the life made outside the confines of subjection. As a piece that uses visuals that are at once affirming and distressing, Jafa acknowledges that he is in fact interested in displaying the terrors that befall Black people. However, he describes the project as "also obviously about how magnificent black people are, you know? We are treated in a certain fashion and we respond in a certain fashion. And I think the way we respond is superhuman" (Molesworth 2017).

As we consider this standpoint in providing a visual project that is at once frank in its depiction of both the violence committed against Black people and a celebration of Black life making, maybe we can consider a similar aim within "Formation." We cannot ignore that the visual album is both affirming for some audiences and traumatic for others, but we can recognize that it attempts to mediate the violence that seeks to limit Black existence. We may understand Beyoncé's proclamation of "I love my baby's hair with baby hair and afro" as a moment of celebration of Black natural hair and a means to validate such aesthetics through intercommunity language. We may consider the young Black boy's dancing in a black hoodie to an audience of police officers who then hold their hands up as a reversal of the immanent death that we have already witnessed. "Formation" wrestles with the realities of Black life while trying to evince moments of Black survival in a world that has been made on the back of Black unsurvival.

CONCLUSION: A GESTURE TOWARD BLACK FEMINIST FUTURITY

In *Lemonade* lies the hope that there is an afterlife following heartbreak. There are possibilities in letting out anger. There's a futurity in a story that centers the survival and thriving of Black women and femmes. *Lemonade* grapples with the pressing question Tina Campt asks: "How does a black feminist grapple with a future that hasn't happened but must, while witnessing the mounting disposability of black lives that don't seem to matter? What constitutes futurity in the

shadow of the persistent enactment of premature black death?" (2017). Placing Beyoncé in the realm of Black feminist thinkers and practitioners—she has already publicly proclaimed herself a feminist—we can see that *Lemonade* offers the possibility of centering Black women and femmes in the project of working toward a futurity that is cognizant of endemic Black death. Through *Lemonade* as a project that fully embodies one's emotions, finding the tools for healing is the salve necessary for reconciliation, growth, and living beyond subjection.

NOTE

1. These responses include online forums, memes, syllabus development, and other engagement wherein women and femmes not only reflected on the text's resonance with their lives but the cultural impact of the visual album.

REFERENCES

Benbow, Candice. 2016. "Lemonade Syllabus." May 6. https://issuu.com/candicebenbow/docs/lemonade_syllabus_2016.

Beyoncé. 2016. *Lemonade*. Parkwood Entertainment/Columbia Records.

Bobo, Jacqueline. 1995. *Black Women as Cultural Readers*. New York: Columbia University Press.

Bourdieu, Pierre. 1977. *Outline of a Theory of Practice*. Cambridge: Cambridge University Press.

Bradley, Regina and dream hampton. 2016. "Close to Home: A Conversation about Beyoncé's 'Lemonade.'" *The Record*. NPR, April 26. http://www.npr.org/sections/therecord/2016/04/26/475629479/close-to-home-a-conversation-about-beyonc-s-lemonade.

Cade Bambara, Toni. 1992. *The Salt Eaters*. New York: Penguin Random House.

Campt, Tina. 2017. *Listening to Images*. Durham: Duke University Press.

Cochrane, Lauren. 2017. "Arthur Jafa: The Go-To Visual Artist for Jay-Z and the Knowles Sisters." *Guardian*, June 13. https://www.theguardian.com/film/2017/jun/13/kubrick-jay-z-solange-beyonce-video-artist-arthur-jafa.

Collins, Patricia Hill. 2014. *Black Feminist Thought: Knowledge, Consciousness, and the Politics of Empowerment*. New York: Routledge.

Combahee River Collective, 1997. "The Combahee River Collective Statement." http://circuitous.org/scraps/combahee.html.

Crenshaw, Kimberlé, Priscilla Ocen, and Jyoti Nanda. 2015. "Black Girls Matter: Pushed Out, Overpoliced and Underprotected." African American Policy Forum. https://

www.atlanticphilanthropies.org/wp-content/uploads/2015/09/BlackGirlsMatter _Report.pdf.

Dash, Julie. 1991. *Daughters of the Dust*. Kino International, Film.

Edgar, Amanda Nell, and Ashton Toone. 2017. "'She Invited Other People to That Space': Habitus, Place, and Social Justice in Beyoncé's *Lemonade*." *Feminist Media Studies* 19, no. 1: 87–101. https://doi.org/10.1080/14680777.2017.1377276.

Gilroy, Paul. 1995. *The Black Atlantic: Modernity and Double Consciousness*. Cambridge, MA: Harvard University Press.

Gumbs, Alexis Pauline. 2010. "We Can Learn to Mother Ourselves: The Queer Survival of Black Feminism, 1968–1996." PhD diss., Duke University.

Hall, Stuart. 1996. "New Ethnicities." In *Critical Dialogues in Cultural Studies,* edited by David Morley and Kuan-Hsing Chen, 442–51. New York: Routledge

Harris-Perry, Melissa. 2016. "A Call and Response with Melissa Harris-Perry: The Pain and the Power of 'Lemonade.'" *Elle,* April 26. http://www.elle.com/culture/music/a35903 /lemonade-call-and-response/.

Hartmann, Johanna. 2017. "Sound, Vision, and Embodied Performativity in Beyoncé Knowles' Visual Album *Lemonade* (2016)." *European Journal of American Studies*. 12, no. 4: 1–13. https://journals.openedition.org/ejas/12415.

hooks, bell. 1993. *Sisters of the Yam: Black Women and Self-Recovery*. Boston: South End Press.

———. 2016. "Moving Beyond Pain." bell hooks Institute, May 9. http://www.bellhooks institute.com/blog/2016/5/9/moving-beyond-pain.

Jafa, Arthur. 2017. "Love Is the Message, the Message Is Death." Los Angeles: Museum of Contemporary Art.

Masemola, Michael Kgomotso, and Pinky Makoe. 2014. "Musical Space as Site of Transculturation of Memory and Transformation of Vonsciousness: The Re-Affirmation of Africa in the Black Atlantic Assemblage." *Journal of Music Research in Africa* 11, no. 1: 63–70.

McKittrick, Katherine. 2011. "On Plantations, Prisons, and a Black Sense of Place." *Social and Cultural Geography* 12, no. 8: 947–63.

Molesworth, Helen. 2017. "Arthur Jafa: Love Is the Message, The Message Is Death." *MOCA,* April. https://www.moca.org/exhibition/arthur-jafa-love-is-the-message-the -message-is-death.

Sharpe, Christina. 2016. *In the Wake: On Blackness and Being*. Durham: Duke University Press.

Tinsley, Omise'eke Natasha. 2016. "Beyoncé's Lemonade Is Black Woman Magic." *Time,* April 25. http://time.com/4306316/beyonce-lemonade-black-woman-magic/.

Wallace, Alice. "A Critical View of Beyoncé's 'Formation.'" *Black Camera* 9, no. 1: 189–96.

Yosso, Tara J. 2006. *Critical Race Counterstories along the Chicana/Chicano Educational Pipeline*. New York: Routledge.

ABOUT THE CONTRIBUTORS

CHRISTINA BAADE is professor and chair of the Department of Communication Studies and Media Arts at McMaster University, where she is also affiliated with the program in Gender Studies and Feminist Research. Her publications include her award-winning book, *Victory through Harmony: The BBC and Popular Music in World War II* (Oxford University Press, 2012), and the coedited collection, *Music and the Broadcast Experience* (Oxford University Press, 2016).

LORI BURNS is professor of music at the University of Ottawa. She is author of *Disruptive Divas: Critical and Analytical Essays on Feminism, Identity, and Popular Music* (Routledge Press, 2002), coeditor of *The Pop Palimpsest* with Serge Lacasse (2018) and *The Bloomsbury Handbook to Popular Music Video Analysis* with Stan Hawkins (2019), and series coeditor of the *Ashgate Popular and Folk Music Series*.

H. ZAHRA CALDWELL is assistant professor at Westfield State University in the Ethnic and Gender Studies Department. She is a historian, educator, and cultural commentator who teaches in the fields of history, Black studies, and women studies. Her current project looks at the contributions and challenges of Black women activist artists between 1930 and 1960.

BYRON B CRAIG holds a PhD in communication and culture from Indiana University Bloomington. He is an assistant professor at Illinois State University in the School of Communication. His current research examines the rhetoric of anti-Blackness, trauma, and social injustice through sites of public memory in American life.

CIENNA DAVIS is a doctoral student at the University of Pennsylvania's Annenberg School for Communication. She received her MA in North American studies from the Freie Universität Berlin and her BA in ethnic studies and communications from the University of California San Diego. She is the founder of the Black feminist collective Soul Sisters Berlin.

JANELL HOBSON is professor of women's, gender, and sexuality studies at the University at Albany. She is the author of *Venus in the Dark: Blackness and Beauty in Popular Culture* (Routledge 2005, 2nd ed. 2018) and *Body as Evidence: Mediating Race, Globalizing Gender* (SUNY Press, 2012). She is currently working on a new book on black women's histories in popular culture.

REBEKAH HUTTEN is a doctoral student and Schulich Scholar in musicology and feminist studies at McGill University. Her research integrates approaches from critical race theory, disability studies, and genre theory to study twenty-first-century North American popular music. She holds an MA in musicology from the University of Ottawa.

BIRGITTA J. JOHNSON is an associate professor of ethnomusicology in the School of Music and the African American Studies Program at the University of South Carolina. Her research interests include music in African American churches, musical change and identity in Black popular music, and gospel archiving.

JARED MACKLEY-CRUMP is an ethnomusicologist who has taught event management and popular music at multiple universities in Aotearoa New Zealand. He researches issues of cultural change and identity in festival spaces, with particular reference to diasporic Pacific communities and popular music.

KRISTIN MCGEE is associate professor of jazz and popular music studies at the University of Groningen. Her research examines popular music and audiovisual media from feminist and critical race perspectives. She has published *Some Liked It Hot: Jazz Women in Film and Television, 1928–1959* (Wesleyan University Press, 2009) and *Remixing European Jazz Culture* (Routledge, 2019).

TAYLOR MYERS is a PhD candidate in music theory and a part-time lecturer at Rutgers University, where she obtained a master's degree in 2015. She has presented and published on the subjects of genre theory, feminism, and vocal

timbre in popular music. Her dissertation focuses on the analysis of genres within popular music.

ANNELOT PRINS is pursuing her PhD in the Graduate School of North American Studies at the Freie Universität in Berlin. Located at the intersection of gender, celebrity, and cultural studies, her dissertation examines how millennials in the United States articulate their visions for a politics of social justice through practices of pop-cultural consumption.

ELENA HERRERA QUINTANA is finishing her PhD at the Complutense University of Madrid on the relationship between pop culture, feminism, and critical race theory, with special attention to Beyoncé's work. With María Jesús Marinda, she coedited *¿Dónde estabas en 1975? Recapitulando: 40 años de vida cotidiana en España* (Libros.com, 2015).

STEPHEN E. RAHKO holds a PhD in communication and culture from Indiana University Bloomington. He is a lecturer at Indiana University Bloomington in the Kelley School of Business. His current research examines the rhetorical intersections of race, personhood, and capitalism in American public culture.

RICHÉ RICHARDSON is on the faculty in the Africana Studies and Research Center at Cornell University. She is the author of *Black Masculinity and the U.S. South: From Uncle Tom to Gangsta* (University of Georgia Press, 2007) and *Emancipation's Daughters: Re-Imagining Black Femininity and the National Body* (Duke University Press, 2021).

KRISTIN DENISE ROWE is an assistant professor of American studies at California State University, Fullerton. She earned her PhD in African American and African studies from Michigan State University. Her research interests include Black feminism(s), beauty culture, hair politics, embodiment, art and popular culture, and new media.

MARY SENYONGA is a doctoral candidate in social sciences and comparative education focusing on race and ethnic studies within the Graduate School of Education and Information Studies at UCLA. Her research employs Black feminism, critical race theory, and queer of color critique to investigate how Black women and femmes both resist and heal as they attend Traditionally Oppressive Institutions.

SIMONE PEREIRA DE SÁ is professor in the media studies and postgraduate communication programs at Federal Fluminense University in Rio de Janeiro, where she coordinates the Research Laboratory on Urban Cultures and Communication Technologies. Her research examines Brazilian pop music, vídeo clips, and fandoms in digital culture.

J. BRENDAN SHAW is assistant professor of English in the Humanities Department at Central State University in Ohio. His research draws on Black feminist thought, queer theory, and affect theory to examine how Black women use technology to make art. He has previously published in *Feminist Formations* and *Prose Studies*.

REBECCA J. SHEEHAN is a lecturer in gender studies at Macquarie University and an honorary associate at Sydney United States Studies Centre.

MARQUITA SMITH is assistant professor of English at Rowan University. Her critical writing on the intersections of sexuality, race, and gender in Black culture appears in venues such as *Postcolonial Text*, *James Baldwin Review*, *Popular Music and Society*, *Popular Music and the Politics of Hope: Queer and Feminist Interventions*, and *The Black Scholar*.

THIAGO SOARES is associate professor at the Federal University of Pernambuco in Recife, Brazil. His research is supported by the Brazilian Research Institute CNPq within the Postgraduate Program in Communication at the Federal University, where he investigates the relationship between pop music, performance, and politics.

KIRSTEN ZEMKE is a senior lecturer in ethnomusicology in the School of Social Sciences, Te Puna Mārama at the University of Auckland, New Zealand. Her areas of research and teaching include hip-hop, New Zealand hip-hop, gender and popular music, queer studies, rock history, and Pacific popular musics.

INDEX

Bela-Lobedde, Desirée, 213, 218–19
Belém do Pará, 199–201, 208n1
The Bell Curve (Murray and Herrnstein), 275
belonging, 15, 181, 380–81
Benard, Akeia A. F., 222–23
Benbow, Candice Marie, xi–xii, 6, 16–17, 19, 23, 166, 371, 378
Benoist, Marie-Guillemine, x
Bernstein, Jonathan, 349
BET (Black Entertainment Television) Awards, 288, 302–6, 309n20
Bey, Marquis, 18, 274
Bey-arts aesthetics, x–xi, xiii
Beychella. *See* Coachella Festival
Bey Feminism, 12, 331n2
Beyhive, 5, 135, 137, 165, 182n1
Beyoncé: academic work on, 22–23; and aesthetic labor, 61n2; agency of, 6–7, 9–10, 23n7, 349; and Amarantos, 192–95, 198–202, 207–8; antiracist message of, 226, 306–7; and appropriation of queerness, 241–42; artistic maturity of, 308n6, 308n8; and audience, 42–43; and beauty standards, 347–49; and "Becky with the Good Hair," 350, 354–55, 360; and Bessie Smith, 41–42; and BET Awards performance, 302–6; and *Beyoncé* (album), 138–39; and Beyoncé studies, 5–21; and the Black body, 268–72; and Black bourgeois respectability politics, 272–74; as Black diva, 198–99; and Black female cool, 39; and Black feminism, 49–50, 345–48; and Black feminist futurity, 387; and Black political mobilization, 274–78; and Black pride, 175–76, 297, 373, 385; and Black queer and trans women, 107n17; and blues aesthetic, 53; and capitalism, 177–80, 242–43; and celebration of the Black male body, 268–72; celebrity, 9–10, 297, 375; Coachella Festival, 59–60, 101–4, 168, 175, 180; and colorism, 81; connection with audiences, 42–43; and convergence culture, 147–48; corporality of, 199, 207, 307, 353–54; and Cox, 244–46; and creative control, 129n10; and Creole identity, 15, 65, 68, 73–76, 81, 97, 98; cultural productions of, 41, 50; in cultural symbolism of place in *Lemonade,* 378–83; and diasporic

ceremonies, 77–80; and disruption, 315; and emotional expressions in "Sorry," 329; and *Everything Is Love,* 1–3; and fandom, 181; and fashion, 19, 177, 296–97; and female subjectivities, 328; femininity of, 94–97, 194, 246, 287, 347; and feminism, 11–14; and femme life making, 384–85; fierceness of, 237, 241, 243–44, 246, 254; and "Formation," 53–54, 98–101, 385–86; and "Freedom," 51–53, 126–27, 298–301; and gender roles, 319; and genres, 320–21; and gestures in "Sorry," 328–29; and *The Gift,* 1–4; and gospel covers and remixes, 159–61; Grammy acceptance speech, 59; and hair politics, 359–61; hairstyle of, 96, 347; and "Hold Up," 51; hyperfemme presentation of, 254–55; iconicity of, 43, 92–97, 107n16; image of, 6–7, 12, 15, 96, 293; inauguration performance, 89, 93; and infidelity, 51, 67, 317–18, 319, 354–55, 362n5, 370; and interiority, 356–59; and intersectional identification, 171–74; intersectional identity of, 5, 89–91, 213; and intersectionality, 181; and *Lemonade Served Bittersweet,* 249–53; and LGBTQ recognition, 176; and mass consumption, 309n21; media response to, 67–68; and Mock, 243, 249; and motherhood, 14, 24n13, 170, 174–75; and multimodal intertextuality, 320, 329–30; musical form of, 289–95; and musical politics, 287–88; and neoliberalism, 7, 11, 181, 213, 228–29; and new Southern studies, 90–91; and objectification, 6, 9–10, 223; and online survey method, 168–71; persona(s) of, 17–18, 50, 241, 295; places and spaces, 314–15, 327–28; and plantation spaces in *Lemonade,* 119–23; politics of, 65, 115–16, 128n4, 287–88, 306–7; and postfeminism, 226–29; and post-racial politics of celebrity, 261–68; and queen diva identity, 240–41; and quotidian Blackness, 273–74; and racist tropes, 238; reception in Spanish media, 212–30; and resonance of *Lemonade,* 369–78; and respectability politics, 174–77; and Sasha Fierce as performative alter ego, 15, 50, 75, 206, 241; and sexuality, 6, 170, 214, 222,

I, 299; narratives of Black women's hypersexuality, 13; on the political impact of Black women's popular music, 37–38; on political potential in Beyoncé's work, 116; and spectacular opacity, 4

HBO (Home Box Office), 16, 116–17, 331n4, 349

Headliners Hair Salon, 96

healing, 19, 118, 124–26, 370–72, 375, 377–78, 384–85

health care, 263, 276

Hefner, Hugh, 95

HeForShe movement, 12

"Hell You Talmbout" (song), 267

"He Loves Me (Lyzel in E Flat)" (Scott), 161n3

Hentoff, Nat, 43

Hero (album), 161n4

Heron, Gil Scott, 305

Herrnstein, Richard J., 275

hetero-centrism, 242

heteronormativity, 14, 92

heterosexuality, 175, 315

hierarchies, 67, 70–71, 75–76, 81, 120, 197, 275, 342–44, 355

Higginbotham, Evelyn, 13

high art/avant-garde aesthetics, 128n4

hijab, 246

Hine, Darlene Clarke, 351–52, 356

hip-hop: and Black masculinity, 321, 329; and Black rebellion, 130n15; and Black women, 17, 316, 318, 330; boasting tradition, 2; and bounce, 239; and exhorting listeners, 146; feminism, 10–11, 264; and kinging practices, 15; and mansion settings in videos, 325–26; and poptimism, 8; and re-performance, 328–29, 331n2; and "Sorry," 320–21, 325–26, 328–30

historical codes, 302

historically Black colleges and universities (HBCUs), 3, 59, 102–4, 242

historical traumas, 74, 80, 372. *See also* slavery

Hobson, Janell, 12, 23n6, 77–78, 128n6, 129n7, 130n12, 345, 347, 350

Hoje ("Today") (song), 204, 206–7

"Hoje Eu Tô Solteira" ("Today I'm Single") (song), 200

"Hoje Eu Tô Solteira" ("Tonight I'm Single") (song), 192

"Hold Up" (song), 51, 52, 119, 122, 129n7, 249–50, 253, 374–77

Holiday, Billie, 325

Holy Spirit, 146

Homecoming (film), xiv, 1, 3–4, 98, 101–4, 107n19, 130n14, 324

Homecoming Scholars Program, 104

homemaking, 111–12, 118–19

home spaces, 118–21

home videos, 123, 125–26, 274, 308n7

hooks, bell: on Beyoncé's neoliberal values, 7, 12, 305, 346; and Black female sexuality, 361n3; on Blackness, 321; and commodification of black bodies, 179, 247; critical spectatorship, 350; critique of *Lemonade*, 49, 115–16, 179, 247, 264, 348, 375–76; definition of feminism, 49; dialogue with Laverne Cox, 244–47; on hair and appropriation, 96; and support groups, 371–72, 375–76; and survival, 243, 254; and talking back, 317

"Hope" (*Lemonade* chapter), 384

Horne, Lena, 50

horseback riding, 381

Horton-Stallings, LaMonda, 240

Hot Gospel Songs chart, 161n4

Houston anti-trans ordinance, 20

"How Sweet It Is to Be Loved by You: The Beyhive" (Ghansah), 61n2

"How Three Sweet Southern Girls Became TV's Hit Team" (cover feature), 106n13

Huffington Post, 216, 357–58

The Hunger Games (film series), 128n2, 130n16

Hunter, Margaret, 343

Hurricane Katrina: and appropriating the tragedy of, 20, 68; and Black feminist utopian thinking, 114; and Brooks on Beyoncé's *B'Day*, 80; and "Don't Hurt Yourself," 53; and "Formation," 20, 65, 68, 78–79, 92, 98–99, 276, 303, 385

Hurricane Maria, 23n2

Hurston, Zora Neale, 130n17, 247

hypercapitalism, 298

hyperfeminine beauty aesthetics, 95–96

hyper-femme presentation, 237, 240–41, 244, 254–55

hyper-masculinity, 329–30

hyperscrutiny, 354, 360

hypersexuality: and Black women, 9, 13, 75, 221, 223–24, 227–28, 264; and feminism, 12–13; and Jezebel trope, 75, 176, 238, 268, 351; and male gaze, 10, 240; and slavery, 268

I Am . . . Sasha Fierce (album), 23n8, 50, 201, 202, 241

Ibo Landing, 69, 71–72, 77

identities: biracial and multiracial, 344; and Black femininity, 104–5; and Blackness, 71, 75, 273–74; and bodies, 328; and branding, 263–64; celebration of Black identity, 103; and diva fandom, 241; and fandom, 166; femme, 238–39; intersectional, 91, 170, 171–75, 181, 317; marginalized, 178, 181; and multimodal intertextuality, 314–15; national, 92–93, 97, 101; and oppressions, 171, 181, 371; and performance, 175, 196–97; politics of, 246; and power, 171; queer, 75, 125, 129n11, 130n16; and racial self-identities, 263; regional, 91; Southern, 91, 98. *See also* Creole identity

"I Have a Dream" speech, 302

Ikoro, E., 325

imagery: animal, 96; of Black subjection, 386; in "Daddy Lessons," 381; fancy girl, 73–74; in "Formation," 80, 268, 273–74, 277, 303; in "Hold Up," 129, 376; and oppositional optics, 267; of racist misogyny, 270; sacred, 160–61; of the Southern plantation, 129n7

immigration population in Spain, 216, 220–21

"The Impersona of Lena Horne" (Vogel), 50

inauguration performances, 89, 93, 105n2

incarceration, 261, 275, 305

inclusion, 20

incorporations, 196, 208, 302

incrementalism, 6

independence, 175, 177–78, 205, 319

"Independent Women, Part I" (song), 89–90, 93–94, 97, 103, 206–7

"I Need You Now" (song), 157

infidelity, 51, 67, 317–18, 319, 354–55, 362n5, 370

initiation ceremonies, 77

injustice, 90, 274–78, 302, 315, 328

inspirational gospel subgenre, 141

Instagram, xiii, 11, 15, 168, 227. *See also* social media

institutional census, 215

intentional blackness, 273

intercommunity language, 386

intergenerational collaboration, 378

intergenerational healing, 384

intergenerational politics, 360

interiority, 19, 37, 43, 350–52, 356–59, 361

interjections. *See* spoken-word vocals

Internet memes, 129n10, 387n1

interpretive communities, 372. *See also* audiences

interracial politics, 268–71

intersectionality: and the Afro community in Spain, 214–17; Beyoncé's, 5, 89–91, 170–71, 173, 213; and Black feminist thought, 315–17, 330; and Black women, 47, 57, 66; Crenshaw's concept of, 13, 315–16; and fans, 181; and feminism, 5, 11, 219–20, 229, 230, 313, 315–16, 329, 331n6; and inclusion of Southern Black queerness, 239; injuries, 328; and realities of Black love, 248; and solidarity in protest politics, 274; in "Sorry," 329

intertextuality. *See* multimodal intertextuality

intimacies, 15, 81, 113, 118, 350, 359, 360–61

intracommunal color hierarchies, 67, 70–71

intracommunity conversation, 43, 53

intragroup tensions, 372

intramural spaces, 361

introductory material, 291

Intrusive I, 299

"Intuition" (*Lemonade* chapter), 118–20, 369–70

Investigaciones Feministas (Feminist Research) (journal), 226–27

invisibility, 180, 221, 223, 230, 270

"Irreplaceable" (song), 107n18

"Is Beyoncé Feminist?" (Cabré), 214, 222–23

iterations, 314

"'It Jus Be's Dat Way Sometime': The Sexual Politics of Women's Blues" (Carby), 60–61n1

Ivy Park (clothing brand), 107n17, 177, 216, 243, 244

Jackson, Michael, 7–8, 24n9, 107n16, 297

Jackson, Ronald L. II, 269

Jackson, Sarah, 228

Jafa, Arthur, 385–86

James, Robin, 5, 9, 13–15, 24n17, 117, 129n9, 178–79, 223, 301–2

Jantel, Rachel, 269

Beyoncé's presence in, 115; and Beyoncé's sexualized femme performance, 240–41; and Black female cool, 36–37; and Black feminism in, 39; Black women in, 97, 227, 238; and double-voiced utterance, 289; Hall on, 308n2; and liberation/oppression question, 6; in peripheral contexts of Latin America, 194; politics of, 261; and protest music, 305; and the US South, 89

Popular Music and Society (journal), 17

Portrait d'une Negresse (Benoist), x

post–civil rights era, 262–63, 268, 273, 275, 287–88

postfeminism, 11–12, 226–29

"Postmodernism and Popular Culture" (McRobbie), 230

postmodern racism, 268

postracialism, 3, 15–16, 67–69, 97, 217, 226, 262–64

potentiality, 352, 361n3

praise songs, 144–45

"Pray You Catch Me" (song), 119, 369–70, 374–75

prechorus in musical form, 289–93, 301

presence, 196

Presley, Elvis, 40

pretty privilege, 348

pride. *See* Black pride

Prince Harry, 2, 23n5

Prisoner 22, 298

private spaces, 120, 246, 317

production of meaning, 196

profit making, 170

proprietary blackness, 167, 173

protest: culture, 297, 303; and disruption, 265; music, 267–68, 280, 288–89, 301, 303–5, 309n19, 309n21; politics, 274; pop, 236, 267. *See also* "Formation"; "Freedom"

public bus, 323, 330

public perception. *See* audiences

public personas, 117–18, 246, 263

public sphere, 11, 126, 172, 263, 274, 373, 376

Pullen, Kirsten, 10, 15

The Purge (film series), 128n2

Q Buedette, 249–51

Queen Bey: A Celebration of the Power and

Creativity of Beyoncé Knowles-Carter (Chambers), 17, 19, 129n6

Queen B(?) trickster figure, 238, 240, 254

queen diva, 237–43, 254–55

Queen Latifah, 240

queerness: appropriations of, 20, 68, 176, 238; and Beyoncé studies, 107n17; and Black authenticity, 274; as commodifiable, 243; and exclusion, 75; and femme voices in "Formation," 237–42; and fierceness, 241; and "Formation," 99; and identification with Beyoncé, 173; and inclusion, 20; and *Lemonade Served Bittersweet*, 251–53; and utopianism, 112–14. *See also* slay

quotidian Blackness, 269, 273–74

quotidian gestures, 113, 122, 125

Race, Gender, and the Politics of Skin Tone (Hunter), 343

race and racism: and Aboriginal Australians, 172; anti-Black, 80; and beauty standards, 222, 343; and Beyoncé's antiracist message, 226, 297; and Black celebrity, 9–10; and Black popular culture, 308n2; and Black women, 47, 227; and colorism, 65, 72; consciousness of, 170; digital representations of, 269–70; in everyday occurrences, 112; and gender, 13, 47, 170, 173–74, 264, 269–70, 327–30, 343; hierarchies of, 120, 275; Mills on, 217; politics of, 262–68; postmodern, 268; and racial rejection, 225; in Spain, 214–17, 219–20, 229–30; survival against, 242; tropes of, 238–39, 248; typologies, 225; and the US South, 106n7; and white ignorance, 218–20. *See also* antiracism; Black America; systemic racism; white America

racial capitalism, 180

racial identity, 167, 173, 175, 212, 228–29, 263

racialization, 316, 381

racial pride, in online survey, 169–70, 173–74, 178. *See also* Black pride

radicalism: aestheticization of, 306; anticapitalist, 305; antiracist, 306; and Beyoncé's glamorization of, 20, 298, 305; of Black feminisms, 115; and Black resistance, 112; and the building of home places by

Sacred Art of the Ori body paint, 77–78, 250, 323–25, 328, 330, 354, 378–80

sacred covers of secular music. *See* gospel covers and remixes

sacred ritual of witches, 77

The Salt Eaters (Bambara), 375

sampling: of Adichie's speech, 11, 212, 291–93; of Big Freedia, 274; and copyright law, 129n10; and "Freedom," 298; and Kirk Franklin, 161n4; of Memphis Minnie in *Lemonade,* 53; of Messy Mya, 78, 98–99, 242

Sandberg, Sheryl, 11–12

Sanelly, Moonchild, xvi, 4

San Francisco Theological Seminary, 160

Sanneh, Kalefeh, 8

Sapphire (angry Black woman trope), 75, 238, 241, 269, 351

Sasha Fierce, xi–xii, 15, 50, 75, 206, 241. *See also* fierceness

Saturday Night Live (television show), 24n15, 67, 261

Saujani, Reshma, 19

#SayHerName, 101

"Say My Name" (song), 104

scholar-fans, 166–67

School Daze (film), 98, 103

Schram, Sanford F., 275

Scott, Jill, 161n3

Seale, Bobby, 100

search results, 270

A Seat at the Table (album), 37, 45, 47, 55–58, 59–60

second bridge, 293, 295

section-within-section format, 301

secular-to-gospel covers. *See* gospel covers and remixes

segregation, 42, 105n2, 323

Sekou, Osagyefo, 179

self-care, 181

self-celebration, 242

self-commodification, 9–10

self-conception of Black women, 71

self-consciousness about whiteness, 173

self-definition, 35–36, 50, 51–52, 58, 264

self-determination, 36, 51–52, 58, 68, 69, 178, 280

self-empowerment, 253

self-fashioning, 97

self-identification, 75, 199, 212, 215

self-love, 176

self-preservation, 351

self-protection, 123, 351

self-transformation, 181

self-veneration, 57–58

"Selling Hot Pussy: Representations of Black Female Sexuality in the Cultural Marketplace" (hooks), 361n3

semiotic modes, 331n3

"Sem Querer" ("Unintentionally") (song), 204–5

Senbanjo, Laolu, 77–78, 250, 324, 354, 379

Serra, Clara, 219–20

"7/11" (song), 327, 386

sexism, 49, 68, 172, 293, 317, 343, 360–61

sexual agency, 14, 75, 238

sexuality: and agency, 14, 75, 238; and "Becky with the Good Hair," 355; and Beyoncé's intersectional identity, 170; and Beyoncé's performance style, 6, 214, 222, 237, 240–41; and Black female interiority, 352; and Black femininity, 346–47; and colorism, 15, 73–75; and empowerment, 176; and exclusion, 228; and the Jezebel trope, 75, 176, 238, 268, 351; and Queen B(?) trickster figure, 240; and respectability politics, 174–78; and sex positivity, 10–11, 13; and violence, 72–74, 376. *See also* hypersexuality

sex work, 74, 119, 253

Shackleford, Ashleigh, 20

"Shake It Off" (Swift), 37

shared community, 125–26

Sharpe, Christina, 372, 382, 383–85

Sheard, Kierra "Kiki," 161n3

Shire, Warsan: "Anger" chapter, 325; "Apathy" chapter, 329; *Billboard* on, 341; chapter organization, 317; "Don't Hurt Yourself" (song), 353; on infidelity, 370; "Nail Technician as Palm Reader," 384; obituary passage, 318, 320, 327, 329. past and present, 121; "Pray You Catch Me" (song), 119, 374; religious-tinged poetry, 161; throughout *Lemonade,* 117

shrink blackness, 175

and multimodal intertextuality, 314–15, 317–18, 327–30; photography studio space, 327; places and spaces, *322*, 327–28; and the release of *Lemonade*, 349–50; scene one (inside the bus), 323–25; scene two (outer porch, interior hallway of plantation), 325–26; scene three (outside the bus), 326; spoken-word vocals in, 317–18, 320; visual text, 119, 379–80; and Yoruban body paint, 77–78, 250, 323–25, 328, 330, 354, 378–80

Soss, Joe, 275

"Sou Eu" ("It's Me") (song), 206

Soulchild, Musiq, 141

soul music, 46, 274, 299–300

sound franchises, 260, 267, 278, 280

sound-politics, 267

Southern aesthetics and traditions, 95–97, 103–5, 274, 385

Southern bayou culture, 79

Southern Beauty: Performing Femininity in an American Region (Boyd), 95

Southern commune in *Lemonade*, 368, 370, 379–84

Southern dance crews, 297

Southern epistemologies, 89–90, 101

Southern gothic clothing, 370, 380, 385

Southern identity and heritage, 91, 98–99, 295

Southern plantation spaces. *See* plantations

Southern studies, 90–91, 96. *See also* US South

spaces of invention, 265

Spain: and activism, 218; and Africa, 216; Afro feminism in, 220–21; and Afro Spanish community, 214–17, 220–21; color blindness in, 215; and feminist and race-based reactions to Beyoncé, 212, 222–25; and intersectional feminism, 229–30; race and racism in, 214–17, 219–20, 229–30; slavery in, 215–16

spatial concentration, 244

Spears, Britney, 198

spectacular opacity, 4

Spillers, Hortense, 355

"Spirit" (song), xiv–xv, 23n6

spirituality, 19, 76–78, 264

spirituals, 298–99, 309n16

spiritual self-expression. *See* gospel covers and remixes

spoken-word vocals: in "Anger" chapter opening, 377; in "Apathy" chapter opening, 323; in "Formation," 274, 293; in "Hold Up," 119; in "Hope" chapter opening, 384; and musical form, 293; in "Pray You Catch Me," 370, 374; in "Redemption" chapter opening, 384; in "Sorry," 317–18, 320; in Williams's "Partition," 158

spontaneity, 195

Squires, Catherine R., 263

stage personas, 50

stage shows, 42

standard form, 290, 292, 300–301

stardom, 207, 295, 308n10, 345

Star Search (television show), 308n7

star texts, 287–89, 290, 292–93, 295, 297, 303, 305–7

state violence, 79, 125

Stenberg, Amandla, 125–26, 130n16, 382

stepping and step-style dance, 3, 101–3, 303

Steptoe, Tyina, 106n15

stereotypes: and the Black diva, 198; and Blackness, 373; and Black women, 8, 75, 97, 219, 238, 351, 376; and colorism, 71–73; controlling, 13; and femininity, 244–46; rebuttal of, 254; and respectability politics, 174–77; and the US South, 92

Stewart, Lindsey, 19, 264

"Stewball" (spiritual), 298

stigmatization of migrant and Black people in the media, 221

stillness, 19, 118–19, 125–27, 130n17

stock representations of Black bodies, 268–70

Stomp the Yard (film), 103

#StopShootingUs, 226

Storm, Elodie Mailliet, xi

Story, Kaila, 225

Straight Ahead (album), 43–44, 55–56

"Strange Fruit" (song), 325

Streeter, Caroline, 74–75

street life, 321

structural racism and oppression. *See* oppressions; systemic racism

subalternity, 207, 217, 226, 228

subcultures, 6, 173

subjection, 381–82, 386–87

subjectivities: and Black women, 6, 315, 317,

Index **419**

72–74; sexualizing, 376; and Shire's poetry, 325, 353; slow, 23n3; and Solange, 56; symbolic, 268–69; against trans women of color, 252; vigilante, 78, 383–84. *See also* police brutality

"Violence, the Body and 'The South,'" (Baker and Nelson), 90

virgin/whore dichotomy, 9

visibility: and audiences, 296, 302; and Benbow's "Lemonade Syllabus," 166; of Beyoncé's labor, 180; and Black female hypervisibility, 9; and Black invisibility, 270; of Blackness, 262; and Black women's invisibility, 221; and invisibility of Black female narratives, 223; and the invisibility of the race/ethnicity experience, 230; and Ludmilla's media visibility, 203; politics of popular, 263–64; trans, 245–46, 254

visionary pragmatism, 113–14

visual albums, xi, 17–19. See also *Beyoncé; Lemonade*

visual imagery, 268, 273–74, 277

visual reclamation, 125

visual text, 371, 373–74, 377, 379–80

VMA performances. *See* MTV Video Music Awards

vocal performance aesthetics, 137, 143–44, 151–52, 159, 203

vocal strategies and techniques, 143–44, 317, 321, 330. *See also* spoken-word vocals

Vogel, Shane, 50

Vogue (magazine), xiii

voting, 101, 263

vulgarity, 222–23, 261

vulnerability, 177, 329, 342, 349, 351–52, 357, 369–70

"Wade in the Water" (Negro spiritual), 309n16

wake work, 372, 383

Walker, Alice, 24n12, 130n17

Wallace, Alice, 385

Wallace, Alicia, 20

Wallis, Quvenzhané, 126

Wallowing in Sex: The New Sexual Culture of 1970s American Television, Charlie's Angels (Levine), 93

Wall Street Journal (newspaper), 262

Wanzo, Rebecca, 247–48

Ward, Mako Fitts, 20, 115–16, 176, 298, 305, 309n13

Warhol, Andy, 95

Warner Music Brasil (label), 192, 203–4

Warnes, Jeffiner, 141

Watson, Paul, 5, 8–10

Wear Something Silver concert, 47

Weems, Carrie Mae, 117, 129n7

Weidhase, Natalie, 12–13, 23n7, 262

We Insist! Freedom Now Suite (album), 44

Wells, Ida B., 13

Werner, Ann, 243, 249–50

West, Kanye, 303, 318–19, 386

West African body painting. *See* Yoruban body paint

West African deities. *See* Yoruba-based deities

West African spiritual traditions, 76–78, 324–25. *See also* Yoruba-based deities; Yoruban body paint

Whack, Tierra, xvi, 4

"What's Love Got to Do with It" (song), 361n3

"When the Levee Breaks" (Memphis Minnie), 53

"Where Do You Go When You Go Quiet?" (Maner), 130n17

white America: and agency, 6; anger and resentment, 260–62, 266; audiences and consumers, 24n15, 103, 261, 268–69, 278, 296, 302–4, 309–10n21; beauty ideals, 229–30; and "Becky" identity, 319, 328, 331n10, 354–55, 357–58; and Beyoncé's intersectional identity, 170; and Black and queer activism, 240; and Black female sexuality, 74–75; and Black women, 51; blindness, 217; bourgeois conceptions of beauty and femininity, 270; and branding identities, 263–64; capitalist agendas of, 242–43; critics and reviewers, 54–57, 116; and domination of music industry, 243; and double-voiced utterance, 288; epistemologies, 2; and feminism, 11–14, 46, 220, 224, 230n2, 319, 329; and "Formation," 24n15, 78, 101, 268–69, 270, 277–78, 301; gazes, 268–69, 272–73; hegemonic dominance and repression, 53; heteropatriarchy, 75; mainstream, 103; in music videos, 8–9; as normative subjects, 217, 270, 315–16; and

MUSIC / CULTURE

A series from Wesleyan University Press
Edited by Deborah Wong, Sherrie Tucker, and Jeremy Wallach
Originating editors: George Lipsitz, Susan McClary, and Robert Walser

The Music/Culture series has consistently reshaped and redirected music scholarship. Founded in 1993 by George Lipsitz, Susan McClary, and Robert Walser, the series features outstanding critical work on music. Unconstrained by disciplinary divides, the series addresses music and power through a range of times, places, and approaches. Music/Culture strives to integrate a variety of approaches to the study of music, linking analysis of musical significance to larger issues of power—what is permitted and forbidden, who is included and excluded, who speaks and who gets silenced. From ethnographic classics to cutting-edge studies, Music/Culture zeroes in on how musicians articulate social needs, conflicts, coalitions, and hope. Books in the series investigate the cultural work of music in urgent and sometimes experimental ways, from the radical fringe to the quotidian. Music/Culture asks deep and broad questions about music through the framework of the most restless and rigorous critical theory.

Marié Abe
Resonances of Chindon-ya:
Sounding Space and Sociality
in Contemporary Japan

Frances Aparicio
Listening to Salsa: Gender, Latin Popular
Music, and Puerto Rican Cultures

Paul Austerlitz
Jazz Consciousness: Music, Race,
and Humanity

Christina Baade and Kristin McGee
Beyoncé in the World: Making Meaning
with Queen Bey in Troubled Times

Emma Baulch
Genre Publics: Popular Music, Technologies,
and Class in Indonesia

Harris M. Berger
Metal, Rock, and Jazz: Perception
and the Phenomenology
of Musical Experience